LEONARDO

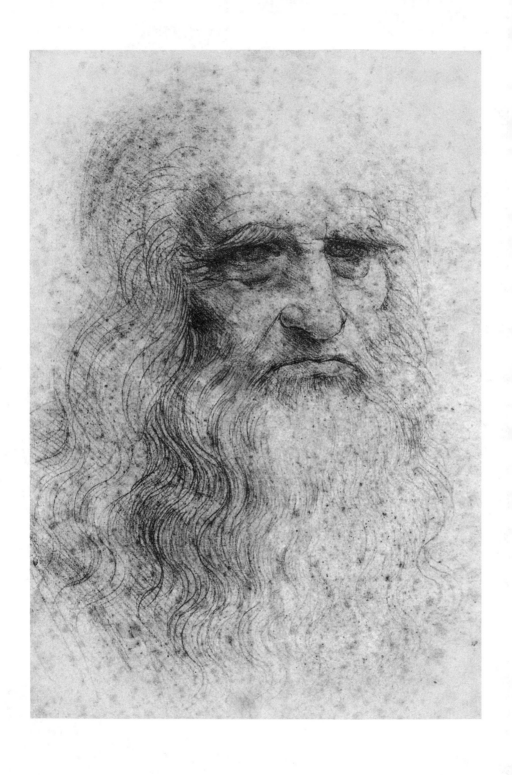

LEONARDO

A BIOGRAPHICAL NOVEL

CURTIS BILL PEPPER

1982

Alan C. Hood & Company, Inc.
CHAMBERSBURG, PENNSYLVANIA

Leonardo: A Biographical Novel

Copyright © 2012 by Curtis Bill Pepper

ISBN: 978-0-911469-36-3

Library of Congress Cataloging-in-Publication Data

Pepper, Curtis Bill.
Leonardo : a biographical novel / Curtis Bill Pepper.
 p. cm.
ISBN 978-0-911469-36-3
1. Leonardo, da Vinci, 1452-1519--Fiction. I. Title.
PS3566.E65L46 2012
813'.54--dc23

 2011034742

Designed by James F. Brisson

Published by Alan C. Hood & Co., Inc.
Chambersburg, Pennsylvania 17201

10 9 8 7 6 5 4 3 2 1

For Beverly

❧ ACKNOWLEDGMENTS ❧

MANY HANDS AND HEARTS helped me across the years in writing this book. Some of them provided a writer's refuge in their homes—Marshall and Maureen Cogan, Jerry Leiber, Barbara Rose, Adriana Sartogo. Others retained secluded writing corners in their restaurants—Edward Youkilis, Maurizio and Fausto Todini, Giovanni detto Peppino, Irma Pericolini, Teresa DiGiacomo and Rita Lombardi, Antonella Mortaro and Carlo Barcarolli.

Still others offered literary counsel—Alberto Vitale, Ken Emerson, Marlene Adelstein, Rosemary Righter, Diane Kelder, Phyllis Tuchman, Fr. Michael Tavuzzi O.P., Brian O'Doherty, James Galvin, Alessandro Vezzosi, George Tatge, Jorie Graham, Peter Sacks, and John Pepper.

I am grateful for Carlo Pedretti's counsel on *The Last Supper* and his invaluable *Commentary* on the literary works of Leonardo, drawn from notebooks and drawings within various codices in Milan, Turin, Paris, and the Vatican. Other historians also led the way beyond the myth and reality of Giorgio Vasari, including: Andre Chastel, Antonina Vallentin, Ivor B. Hart, Martin Kemp, Pinin Brambilla, Charles Nicholl, Serge Bramly. On Leonardo's anatomy: O'Malley and Saunders; on mechanical sciences, Leslie E. Robertson.

I am also indebted for access to various research libraries in the Louvre; the American, French, German, and British academies in Rome; and the municipal archives of Florence.

Carol Edwards delivered a meticulous, inspired copyedit—not only in clarifying the grammar and a frequent fusion of times and places, but also in her remarkable perception of the mind and spirit of Leonardo. Sharon Nettles, in turn, combed through the copy—proofreading and preparing it for publication with infinite care and concern for every detail.

Kay McCauley, my delightful yet relentless literary agent, will never be forgotten for her devoted loyalty across the years. Nor could *Leonardo* have emerged without James O'Shea Wade, my intrepid editor whose professional and personal counsel kept us on course.

And of course, there was always Beverly—more than wife, more than friend. Bless her in ways beyond the counting.

CBP

All visible things have been brought forth by nature, and it is among these that painting is born. Since nature is truly the Daughter of God, the painter is the Grandson of God. To him is given the power to create all things in the universe through essence, presence, or imagination. . . .

—Leon Battista Alberti, *Della pittura*

We are all bastards; all, that most venerable man, which I did call my father was I know not where when I was stamp'd . . .

—Shakespeare, *Cymbeline*, act II, scene V

THE PASSAGES

PART ONE

THE EARLY YEARS

THE ANCIENT HILL TOWNS of central Italy lie scattered like the remnants of old dreams along the flanks of the Apennines. You see them perched on a mountain spur, clinging to a precipice, or riding the top of a hill—isolated and gaunt as wave-lashed rocks from a vanishing tide. Their stones come from the ribs of the mountains, which hold them. Through the centuries, storms lashed them, armies pierced their portals, and fires gutted their churches and towers. Yet they remain, anchored to their slopes as though they possess the secret of living forever.

This apparent immortality includes the ability to disguise themselves in remarkable ways. In the winter, they rise above a sea gray mist in the valley like battered and blistered ships in a fogbound sea. At night, their encircling lights assume the form of an encamped army on the eve of a great battle. With sunrise, the wimpled night withdraws through narrow, twisting lanes, church bells ring for early Mass, startled pigeons take to flight, and the towns appear to rise upward into the sun's rays.

Their encircling walls, or what is left of them, appear to wait for someone to climb the hill and discover their buried secrets. And indeed, upon passing their arched portals, one walks at random into the past, where men and women pause with a nod or glance, as though they have expected you since the days of the Renaissance.

So it is today in Il Borgo, the old quarter of Vinci, where the boyhood world of Leonardo da Vinci lingers on, as in a fading fresco. From the dark interiors of old palazzi in the ancient *borgo,* women continue to peer through shuttered windows at cobbled streets where once he walked. Their speech across a courtyard, as they run out a line of wash, contains Tuscan phrases and proverbs he heard in his home. In the church of Santa Croce, where he was baptized, the faces resemble those he used in his *Adoration of the Magi.* In the cafés, men shout the same oaths during card games or backgammon, they drink the same Vernaccia wine, and in the cool of the evening under trellised vines,

they roll bocce balls in a game invented by the Etruscans long before the rise of the Roman Empire.

High up on the mountain, there are dense forests and cascading waterfalls, shaded slopes, and hidden caverns. Below this, the woods give way to open fields strewn with bloodred poppies beneath the infinite blue of the Tuscan sky. Here the sun steeps the soil with human warmth until lowering itself into the benediction of twilight—a magical hour, celebrated by the joyous calls of feeding swallows and the first evening songs of nightingales.

The town itself sits on one long spur. In Leonardo's time, this consisted of some thirty red-roofed houses, the small fortress, a church with its bell tower, an olive mill, a blacksmith's shop, a feed store, and finally a brick and kiln factory on the road leading down into the flat valley where the river Arno runs to the sea and where once there was an Etruscan city of great importance. It lay next to a lake fed by the river, allowing for maritime trade. The Etruscans were experts on where to build cities, how to drain marshes, and how to bury their dead.

Great white oxen, plowing its alluvial basin, turned up shells and fossilized remains of sea life. During his boyhood, Leonardo described them in his first sketches. Eventually, he used their presence to refute the biblical story of the Flood, among other challenges to the inherited knowledge of his time.

2.

In later years, some people in Vinci believed Leonardo had been generated by one of the mythical *folletti*—mischievous little creatures that made love to young women. Playful spirits free of moral restraint, they had the ability to enlarge or shrink their bodies at will, slip through cracks in a door, and drift with the invisibility of wind.

To obtain the women of their desire, they infused them with memories of an earlier sensual pleasure. So primed to a high state of inguinal excitement, the hapless victims were caught unawares at night during slumber, while in the woods hunting mushrooms, or in the most vulnerable position of kneeling by a stream while washing clothes—these events occurring invariably when their husbands were far away, cutting timber or tending herds of sheep.

Vinci's parish priest, Don Pietro, traced this popular belief back to the thirteenth century. Filippina, a quick-witted peasant, found herself pregnant while her husband was away in the hills with a flock of sheep—a fate shared by other respectable ladies delivering babies after seven or eight months' gestation. So with a wisdom that made him loved by all, Don Pietro accepted his flock's

belief in the invisible *folletti*—especially during summer nights, which brought them out in droves.

Most of the townsfolk, however, knew this was total nonsense. Leonardo's father was none other than the local notary, Piero di Antonio da Vinci, who found Leonardo's future mother in the home of a wealthy Florentine banker and client, Vanni di Niccolò di Ser Vanni.

He first saw her picking roses in the garden of the Vanni palazzo on via Ghibellina. From its veranda, he watched her kneeling at the flower bed, a dark, slender girl in a short blue *gamurra*.

"What a lovely *fantesca*," he said, meaning "family servant."

"She's Caterina, our *serva*," replied Vanni, meaning she was a slave. "We paid seventy florins for her nine years ago, fresh off the ship from Caffa, our Florentine port on the Black Sea. Most of them are pockmarked or diseased from the rats and dead bodies in the bottom of the ship, but she was perfect."

Ser Piero looked again at the girl in the garden. He was a tall, lean Tuscan with a virile shock of dark hair, a high forehead, and bushy eyebrows bristling over gray eyes. His nose began in a straight, noble line but broke midway into a slight hook. His mouth was broad, with full lips, supported by a strong chin. He moved rapidly, even when writing briefs, as though he knew exactly what he wanted and was forever in a hurry to obtain it. Yet during unguarded moments, such as now, his eyes wavered and he seemed much less certain of who he was or where he was going.

"She does have a strange beauty," said Vanni. "The Venetian trader Girolamo Ballador swore she was the virgin daughter of a Circassian prince with a mother named Hagar. Would you believe it?"

"Why not?"

"It's too much, that's why," replied the banker. "Hagar was the Egyptian servant of Abraham and mother of his son Ishmael. That's when it all began. From Abraham came the Jews; from Ishmael, the Arabs. You can't believe anything these *maladetta* traders tell you, though Caterina insists her father was a great prince who had wanted a son."

Piero looked once more. Caterina was nearer now, and he enjoyed the gentle sweep of her shoulders above an armful of roses.

"How old is she?"

"Eighteen," replied Vanni. "She claims she's still a virgin, though Monna Agnolo suspects my *uccello* has risen to the occasion."

The fat banker laughed. He had a bad liver, his legs were swollen, and he could hardly walk. But the idea delighted him. He winked at his trusted friend and notary.

"She deserves one that can still fly like yours, *caro amico*."

Ser Piero hesitated. This was happening too quickly. He wanted the girl, but this was too dangerous. Vanni was a friend, but his wife, Monna Agnolo, despised Piero. As executor of the Vanni estate, a codicil to the will gave him total control of their via Ghibellina palazzo. Monna Agnolo, however, would get Caterina and probably sell her. So after Vanni drifted into the Great Sea, he would have to deal with her.

Despite this, the image of Caterina in the garden lingered with him during the night. There was nothing wrong in having a slave. After the Black Death of 1348 swept away half of Florence, the slave trade was legalized and slaves flowed in from everywhere—mainly Tartars, but also Russian Circassians, Greeks, Moors, Ethiopians. You saw them in workshops and palazzi, swarthy or yellow boys and girls of eleven or twelve. The taller, fair-haired ones were serving maids and grooms of Florentine ladies, and frequently concubines for their husbands. Some of them were freed. Cosmo de' Medici's son by a Circassian slave girl became a canon at the church in Fiesole.

A popular song came to Piero as he drifted off to sleep:

> The charming little slave girls,
> Shaking out clothes in the morning,
> Fresh and joyful as hawthorn buds.

The next morning, on his way to Vanni's palazzo, Piero met Caterina returning from the market. He insisted on helping to carry her groceries. He felt her arms for the first time, and she smiled like an opening flower. Her skin had the dark hue of Sicilians, with their Arab blood, and her eyes were gray-green. So maybe she was a Circassian. One of them at Lucca had the same eyes.

At the palazzo, Caterina brought him a glass of sweet wine. She was close, and he could detect the scent of her body. Her hand lingered in passing the glass. Caterina knew what this man wanted, just as she wanted to escape the daily humiliation of Monna Agnolo. He touched her thigh, and there was the shadow of a smile—much as Leonardo later depicted the Virgin at the moment the angel says she is destined to bear the Son of God.

3.

Late in November, three months after the death of Vanni di Niccolò, Ser Piero brought Caterina to his parents' home at Vinci. As could be expected, his mother, Lucia, was first to note that Caterina was moving in the manner of

a woman with child. When her husband, Ser Antonio, heard of it, he took his son aside.

"You made a terrible mistake," he said.

"I know." Piero sighed.

He knew because she had told him one night after they made love. "Are you happy?" she had asked. "Yes," he had said. "You are beautiful and everything any man could want." Then she told him she wasn't everything, because there was also a child on the way. She waited for some reply, but he lay still and said nothing. Finally, she took his hand and placed it on her stomach. "There," she said. "There's your son." He pulled his hand away, and she knew he would never marry her. "What are we going to do?" she asked. "I don't know," he replied.

He knew only that this was a disaster. He couldn't marry a slave, and he didn't want that baby under any condition. Yet he could do nothing about it. Under a 1363 Florentine statute, anyone impregnating a slave had to pay its owners three-quarters of its value, provide for the birth, and raise the child under conditions equal to those of its father.

That was how it had gone, and now Antonio was furious.

"You're stuck with this," he said. "Don't think you can hide it here in Vinci. Monna Agnolo and her notary will be waiting for you to break the law."

"I know."

"You know! You know!" snapped his father angrily. "If you knew so much, you wouldn't have pissed on your doorstep."

The son nodded to indicate he knew that, too. His goal in life was to be a notary for the Signoria, the governing assembly of Florence. It was a position that brought wealth and power, and it was within his reach. The Vincis had been notaries and law officers for the Florentine Republic since the 1300s, when their paternal ancestor, the notary Ser Michele, had adopted Vinci as a patronymic. Piero's grandfather, Ser Piero di Ser Guido, had made it. Antonio had failed, but he knew his son could get there if he kept his nose in his books and used his staff to draw maximum interest.

"I'm thinking of our enemies," Antonio replied. "They could turn this into a joke. Piero da Vinci is too busy multiplying slave girls to ever become notary to the Signoria."

"They'll do anything." Piero sighed. "So we'll have the baby and raise it in the family, but then we'll get somebody to take her off our hands."

"That won't be hard. She's better-looking than anyone else around here."

Antonio smiled, thinking of a grandchild. He was eighty, Lucia fifty-nine.

"If it's a boy, we might keep him."

"Why not?" Piero paused in a rare moment of prophecy. "Circassians are brave warriors, and the Arabs have good blood. They invented algebra, astronomy, and brought us Ptolemy and Aristotle. We might even be proud of him. Bastards are often the best of the brood."

When Piero told Caterina he would recognize the child at baptism and raise it in the Vinci home, she wept with joy. Her tears moved Piero, and he began to kiss her with growing desire. His future wife would come with a dowry, wrapped in florins and with family links to power, but she could never match this woman. As the old saying had it, *If you want gold, take her ugly or old.*

Caterina accepted him, but the next time she told him to go away. She had overheard Antonio and Lucia saying they would register the child at the commune without her name to avoid any record of the boy having a slave mother.

"Don't ever touch me again," she told Piero. "My father was a prince who loved me, but his wife sold me to your slave merchants. Now you're doing it to my child. You're worse than those cruel men who put us in the bottom of the ship with everyone's filth and the dead ones all around us."

Piero had heard this before, most often at night—her childhood nightmare among putrefying corpses in the black hull of a slave ship. But now it was directed at him with the fierce pride and hatred of an enraged Circassian-Arab. He imagined it pouring into his unborn child and shuddered with fear. Ser Piero never again made love to his Caterina.

4.

Leonardo's arrival in this world occurred in Anchiano, a small settlement two miles up the first slope of Mont' Albano. It happened unexpectedly in a farmhouse, amid an olive grove and the mulberry trees of Francesco's expanding silkworm colony.

The land, with a sweeping view of the valley, belonged to another notary, Ser Tomme di Marco, who shared the mulberry crop with Piero's brother, Francesco, and allowed the Vincis to occupy his farmhouse during July and August, when midsummer heat baked the huddled houses of Vinci. Antonio intended to buy the property eventually as a summer home for Piero, who had found an ideal bride.

Albiera di Giovanni Amadori, sixteen, daughter of a wealthy Florentine shoemaker, came with a sizable dowry. After their marriage, in June of 1452, she would stay at Vinci, or at her family home on via Nuova, near Santa Croce, until Piero arranged a residence for them in Florence.

Despite her pregnancy, Caterina went regularly to Anchiano to help feed the silkworms. She loved being there, away from Piero, who, thank God, was often in Florence on business or arranging for his marriage. Though heavy with child, she continued to ride up the mountain on Duro, an old, slow-plodding mule.

One afternoon in mid-April 1452, she rode over a carpet of wildflowers, amid large clumps of yellow broom and the pink-and-white blossoms of apple and cherry trees. Lucia came with her to pick wild greens, which clean the intestines and put iron in the blood—a vital tonic for expectant mothers. While picking the herbs, Caterina felt suddenly tired, and Lucia took her to the Anchiano house to rest. Upon opening the door to the bedroom, they encountered a giant snow-white owl trapped in the room.

Seeing the two women in the doorway, the great bird attempted to escape. Lacking proper space for a liftoff, the winged creature crashed into Caterina in the doorway—the claws and wings upon her with the owl's piercing, childlike cry. Caterina screamed like the bird and fell to her knees. Water flowed from her, and Lucia realized the baby was going to be born in this isolated farmhouse on the slope of Mont' Albano.

She helped Caterina onto a bed, then ran into the courtyard to beckon a young man who was repairing the roof of the olive mill. She gave him her gray mare so he could hurry for help.

Returning to the bedroom, she found Caterina already experiencing the onset of labor. A little later, Olga, the midwife, came riding up the hill on her little donkey, Nascita, which she used for such emergencies. She was followed by Monna Pippa—a *strega*, or "witch," according to many villagers. Pippa came on foot, though many said she could also ride through the air on a broomstick or astride a white she-goat.

The sun descended—a deep red glow sinking into dark clouds, followed by a distant clap of thunder. A sudden gust of wind slammed a shutter, and Caterina cried out with fright, fearing the bird had returned.

After that, there was the kind of heaviness in the air that precedes a storm. The wind returned, slowly at first, and Caterina's contractions began again. They grew in intensity as the storm fell upon the mountain, driving rain against the house and banging loose shutters and doors. With nature's fury, the mother's cries increased, as did Olga's urgent commands to push harder and breathe deeper.

Amid Caterina's cries, Olga's hands helped the little head to emerge. Then the body slithered out—a large baby boy who seemed to be asleep until Vinci's veteran midwife held the infant upside down by the ankles and gave

him a solid whack on the bottom. The eyes opened, the lungs took a deep breath, and Leonardo da Vinci entered the world with a scream of protest.

The next day—Sunday, April 16, 1452—the grandparents took the mother and her infant to the parish church, Santa Croce, to have the baby baptized. Ten friends served as witnesses—five men and five women. With Piero in Pisa on business, Antonio attested to the event in a document, written in the precise, neat script of a notary, but omitted the mother's name:

> A grandson of mine was born, son of Ser Piero, my son, on April 15, Saturday, at the third hour of the night. He bears the named Lionardo. It was the priest Piero di Bartolomeo, of Vinci, who baptized him in the presence of Papino di Nanni Banti, Meo di Tonino, Piero di Malvolto, Nanni di Venzo, Arrigo di Giovanni the German, Monna Lisa di Domenico di Brettone, Monna Antonia di Giuliano, Monna Nicolosa del Barna, Monna Maria, daughter of Nanni di Venzo, Monna Pippa di Previcone.*

5.

Within a few months, a "local solution" began to appear for Caterina. A worker in the brick factory fell in love with her. He was the same one who had raced down the hill for help at the time of the birth—Antonio di Piero Buti, a handsome dark-haired youth and expert lime burner. He was known by the name Accattabriga—a nickname given to mercenary soldiers possessing courage in battle.

Caterina and Antonio were married the first Sunday in October. They went to live at Campo Zeppi, where his family had been for as long as anyone could recall. The small farming settlement, two miles west of Vinci, had its own parish, San Pantaleone. As a result, Caterina did not see the Vincis on Sundays or feast days, though occasionally she encountered Lucia at the Saturday market in Vinci.

* The "Third hour" would have been three hours after sunset. In Florence, the calendar day began with onset of night. In 1539, astrologer Johannes Schoener, using the semidiurnal arc for this day at the latitude of Florence, fixed the sunset at 6:52 P.M. Thus Leonardo's birth— "at the third hour"—would have occurred at 9:52 P.M., local mean time. Also, the Florentine new year did not begin on January 1, but, rather, on the day of Christ's conception: March 25. So they cited "In the year of the Incarnation," rather than, "In the year of the Lord."

One market day, when Leonardo was two years old, Lucia paused to admire him. He stood stiffly next to his mother while Caterina held Piera, her new child by Antonio.

"Bless us, he's getting to be a big boy," she said.

"Not yet," replied Caterina, taking the boy's hand. "He's still taking milk."

The following April, shortly before Leonardo's third birthday, Lucia appeared at Caterina's door with a birthday gift for the boy—a little blue linen suit with a white letter *L* monogrammed on the breast pocket. In the kitchen, as Caterina prepared chamomile tea with honey cakes, Lucia came quickly to the point. Piero's young bride, Albiera, was still without child.

"Three years almost." She sighed. "And nothing happens. So we think it's time to bring Leonardo to his new home."

That evening, Antonio told his wife they had to give up the boy. It would break their hearts, but they had agreed to it. The child belonged to his father, even though he had not made him a legitimate Vinci. Also, Ser Piero had arranged for Antonio to work in the local brick and kiln factory.

6.

A few days before Leonardo was taken to his father, Caterina took him with her to cut wild greens for the rabbits. She bore on her head a large wicker basket, and the little boy followed her to an outlying field. When the basket was half-full, she placed it in the shade of a tree, and Leonardo crawled into it and fell asleep.

The boy of three never forgot what followed. He was awakened by the sound of wings. A large black bird swooped down from the blue sky, until all was dark as the night. He felt wind on his face and heard the scratch of claws. Then the canopy of dark wings folded, and he saw the huge bird perched on the edge of the basket. The feathers had the sheen of blue and green shifting into black, and as they moved, he saw a buried rainbow within the creature's deepening night.

The bird, a black kite, began to preen itself. Its forked tail rose and fell, sweeping across the child's face, touching his lips, and entering his mouth. Years later, he recalled how the dark-winged creature came from the sky as an omen of his destiny: "It opened my mouth and struck me with its tail many times between the lips." It was as though he, too, was destined to rise into the sky on wings.

7.

At Vinci, Caterina found them waiting for her in the living room. Lucia, Antonio, and Francesco stood before the sideboard with its old blue plates. Piero and his young wife were next to a clumsy painting of fruit and vine leaves resembling dead bats. The wife smiled and nodded. She had a lovely smile and was rather pretty—a small woman with eyes like almonds, a slender nose, and delicate lips framed by dark brown hair falling to the shoulder.

Caterina set her son on the table and placed his little hand in that of Piero.

"This is Piero, your father," she said, feeling revulsion in touching him.

He was a stranger now, older than the one in memory. There were lines around his mouth, his bent nose seemed larger, his gray eyes cold and withdrawn. Leonardo was of her flesh more than his. He had the straight nose of her father, and the blue-green eyes of her Adyghe people. Also, his hair was golden like hers had been as a child, and he sat before them with the bearing of a young prince.

"And, Nardo," she said, using his nickname, "this is Albiera, your new mammina."

"You're beautiful," Albiera murmured, leaning over to kiss him. "I have a little name, too. It's Albi. Isn't that easier?"

Alone with Leonardo, Albi led him to a child's bedroom—its clothes chest decorated with paintings of mounted knights, a little desk and chair, a low washstand with an ivory hairbrush and comb, and a tiny seat with a night pot. There were also toys from Florence—a bronze elephant on wheels, a gyroscope, a kaleidoscope with colored bits of glass, a parachute to be sent into the air by spool and string, and a book of Aesop's fables. For a while, he played with the toys. Then he became restless.

"Mamma," he said. "When is Mamma coming back?"

"We promised to wait, remember? Come, I have more surprises!"

At the stable, she showed him the horses and mules, and placed him on the back of old Duro, the mule Caterina had ridden to Anchiano with him in her womb. They helped Francesco feed the rabbits, then played with Fibo, a new puppy. Back at the house, however, he began to look for his mother. When he did not find her in any room, he went into the garden and sat at the table where he had seen her last.

That night, the boy cried himself to sleep. The next morning, he refused to eat some ravioli with sugar. When Lucia tried to force it into him, he resisted, and the bowl of ravioli fell to the floor, where Fibo gobbled it up.

After that, Leonardo continued to throw up his food. Five days later, the child was too weak to rise from bed. Albi watched this with growing alarm. Clearly, they had to take the boy away from Lucia—or lose him. She had been trained, however, in the strict Florentine custom, to obey her husband, never usurp his authority, nor flaunt the wishes of her mother-in-law. She took her husband upstairs to their bedroom.

"We're going to lose your son, Piero. Let's face it: He's afraid of your mother."

"She loves him."

"He gets spoons shoved down his throat and she yells at him."

"I know . . . yes, you're right. What can we do?"

"Tell her I plan to sing him a lullaby, and make sure we are left alone in his room."

She put Leonardo in his bed, placed a cup of warm milk on the bed stand, and jammed the door shut with a chair. As she sat on the bed, the boy rolled away, pleading to be left alone.

"I love you, little one," she whispered, drawing him close.

He began to seek her milk, his mouth moving on her breasts, his hands trying to pass through her gown. She opened her chemise to give him her breast.

"Drink, little one," she said, feeling his mouth on her. "Oh my God," she murmured.

When he could get nothing from her, he began to whimper, and she slid a spoonful of milk into his mouth, then another, until he had taken it all and fallen asleep. She also slept, only to be awakened twice by Piero and Lucia at the door. Each time, she told them all was well and to leave her alone.

The following day, Albi continued to feed Leonardo in his room. Two days later, she took him to the kitchen, where he was fed while sitting on her lap. Soon he began to eat by himself, though seldom without the presence of Albi.

8.

By the time Leonardo was six years old and ready for school, everyone in Vinci knew the son of Ser Piero, the Florentine notary, was illegitimate. In his 1457 tax return, Antonio described the five-year-old boy as "Lionardo, son of the said Piero, born illegitimate to him and Chaterina who is now wife of Achattabriga."

Everyone also knew Leonardo's mother had been a slave whom Ser Piero had brought to Vinci—a slave of "good blood," whose father had been a tribal

chief somewhere in Russia, with hundreds of horses, and whose mother was from the Holy Land. She had strange eyes and was so beautiful that Accattabriga had legalized her as his wife. Everyone knew this except Leonardo.

One evening after dinner, sitting in the garden with Piero and drinking a glass of sweet Vernaccia, Albi suggested they tell the boy that his mother had been a slave and that he was born out of wedlock.

"We should tell him," she said. "Before he learns of it elsewhere."

Piero drank his wine and made no reply.

"Piero, please believe me. If this boy discovers we haven't been honest with him, he'll lose trust in us . . . especially in you, his father."

"All right, I'm going to Florence tomorrow. You can tell him Caterina left to marry another man at Campo Zeppi, but I don't want him going down there. He does what I want, because he needs me for his future."

"His *future*? As he is an illegitimate child, your notary guild won't take him. Nor can he be an apothecary or a doctor or take up any other major profession. He won't even be admitted to the university. So what future do you have in mind?"

"He can do other things," Piero replied, filling his glass. "Bastards have lots of guts and drive. They become great soldiers, princes, cardinals, Popes . . . you name it."

"That's true for high-born offspring, but even they have to marry down to a lower level. So what happens to this boy of a notary who must sink to a lower status because you haven't made him legitimate? He doesn't even have a name, other than Leonardo."

"He's Leonardo da Vinci."

"That's the family name, but he doesn't have a legal right to it unless you legitimize him as Leonardo di Piero da Vinci. So he is simply Leonardo *from* Vinci."

"Don't be stupid!" he cried, slamming his hand onto the table. "What in God's name do you want, woman? If I legitimize that Circassian slave boy, he'll have the right of first inheritance, before our children. Then what'll happen? They'll hate him and you, too. Do you want that?"

"No, I'm not stupid, and your son is not a slave boy."

"So he'll be our only son, is that it?"

She turned away, trying to control herself. Every month, she went to Florence for fertility treatments in the stinking back room of Luca Landucci's apothecary shop. She tried all of the ancient remedies, but nothing happened. When her period was due, Lucia stared at her every morning, waiting for an inward smile or happy laugh. . . . *Yes, it's happened. I am also blessed among women.*

Piero saw her sadness and took her hand.

"I'm sorry, Albi."

"Can't we do it once, just for the fun of it?"

That night, they made love with a passion unmatched since their first days. Afterward, he lay close to her.

"I love you, Albi. Nothing else matters."

She felt him against her and wanted him again. Maybe it would finally happen, making love this way . . . a child of her own flesh and blood. It would make everyone happy, and Piero would strut and boast of his son . . . his real son.

Oh, dear God, she thought. Leonardo will ask, Mammina, what's wrong with me? If I'm not his real son, whose son am I? Was that why she had abandoned herself to him? To create a child who would separate her from Leonardo?

The tears began then. He could not see them, and she made no sound.

FLORENCE

August – September 1458

PIERO AROSE AT DAYBREAK to leave for Florence, where he had business with the Medici. At the stable, he met his brother Francesco, or "Checco," who wanted to trade some of their best farmland to increase his mulberry tree acreage.

"Babbo's too old to understand," he said, meaning Antonio, their father. "Silk is worth a lot more than wheat or wool. Our land in the valley takes too much time and work. With the extra field at Anchiano, we can double our mulberry trees and triple our profits."

"What does Babbo say?" asked Piero.

"His father and grandfather won't talk to him when he goes to heaven."

"Tell him all is forgiven in heaven. People don't fight there; they just love one another."

Checco was not amused. "You said if I ran this place, I wouldn't have dry teeth."

"All right," Piero replied, mounting his horse. "We'll talk about it when I get back."

He walked his gray gelding down the sloping cobblestone street and through the gate in the town walls. The dirt road descended gently into the plain below, where he broke into a trot. At first, he rode through vineyards with dark particles of the night beneath the green leaves and yellow clusters of ripening grapes. Then he came to brown fields of harvested grain. This was his father's land, and old Zeno, who sharecropped for them, was plowing near the road.

Piero slowed his mount to observe two oxen pulling the wooden plow, its iron blade turning up a running wave of black loam and yellow grain stubble. He watched it rise into a golden crest, then fold over with dark, moist undersoil.

There it was, he realized, the cycle of death and rebirth, *ad perpetuum.* Checco was a fool. Silk might bring greater profit, but this land brought security. Stored grain protected you against famine and the plague, for one

followed the other. The Vincis had always prepared for such disaster, from father to son, just as he would do for his sons—his legitimate son. Leonardo was obedient and very bright, but he was a bastard, and you could never trust bastards. Albi was all mixed-up with the only boy they had. But it would pass as soon as she dropped one of her own. . . .

He began to canter and soon was on the Florence-Pisa road along the Arno. It was pleasant here, with a cool breeze coming off the river. Yet he was also riding into the rising sun. He had to cover as much ground as possible before the heat came upon him.

On the road, he encountered numerous carriages coming from Florence. When he stopped at the Locanda Falcone to rest his mount, another carriage was arriving from the city. It was glossy black, trimmed with gold, and drawn by a splendid span of white horses with brown plumes—a Medici color.

He waited, wondering who might be traveling in such style. The carriage door opened, and a tall, thin figure emerged in a brown cloak with red piping— Ser Bernardo Ginori, notary for the Signoria of the Republic of Florence.

He noted with annoyance how nimbly old Bernardo descended from the carriage, scuttling down like a crab. *Cristo,* when was that old fart going to die? One day, he told himself, he would ride in such a carriage. His grandfather had been notary to the Signoria, and he would get there, too. Old Bernardo couldn't last forever—almost seventy, thin as a flagpole, a nose like a hawk, still climbing the stairs, still bowing and scraping.

"Good day, Piero! How goes it with you?"

"Quite well . . . *grazie a Dio.*"

Piero was surprised. The Ginoris and Vincis had been notaries for generations—variously enemies and friends. Old Bernardo had never been close, however, and this greeting could only mean he wanted something.

"Been traveling?" Bernardo asked.

"Pisa . . . and a couple of days at Vinci."

"You heard about the call to parliament?"

So that explained the traffic on the road and why old hawk face wanted to talk. Members of the major guilds, and those with the hereditary right to vote, were being summoned to deal with a popular revolt against living costs and high taxes imposed by the Medici. Assembled in a call to parliament in the Piazza della Signoria, some 3,000 eligible voters—from a city of 65,000, after the last plague—would shout approval or disapproval of emergency powers for a special committee to resolve the crisis.

For an oligarchy of merchants and bankers ruling an ostensibly free Republic of Florence, a call to parliament was essentially a show—simple, swift, and effective. Yet it was also potentially dangerous, requiring mob

approval. Without allies in the piazza, the Medici risked losing control of the Signoria—a powerful triumvirate of eight prominent citizen priors, serving two-month terms from the four quarters of the city, plus twelve *buonuomini,* or "good men," to act as counselors, and a regulatory chief magistrate, the *gonfaloniere della giustizia.*

"Are you worried?"

"Worried? Who's worried?" sputtered Bernardo, white hairs bristling from the nostrils of a red nose, the mouth clamped shut in a fierce grimace. Shifting eyes, however, betrayed his fear. If the Medici fell, he would fall with them.

"You never know," replied Piero, enjoying his rival's discomfort. "Florentine mobs can be violent. They tore apart the notary of the duke of Athens, you'll recall. They ate him, testicles and all."

"They'll break their teeth on mine!" cried Bernardo.

To play safe, however, he touched his testicles with the forking of his index and little finger while quoting Terence on how to expel any evil: "*Cumtactis pallibus, pilo extracto ad sanguinem, iectatura fugata est.*" ("Touch the testicles, scratch until it bleeds, and the evil is gone.") Feeling more secure, the foremost notary of Florence emitted a loud fart and sighed with relief.

"Everything's under control. Each one of our people will bring ten others to the piazza. We'll shout louder, no? And I know we can count on you, Ser Piero."

Piero hesitated. He could promise to shout for the Medici as part of a mob. But to round up ten people and bring them to the piazza would identify him with the Medici party. If they lost, he would never become notary to the Signoria.

"I'm sorry. I must return immediately to Pisa."

Bernardo frowned. "I told them we could count on you and they said, 'Yes, we know him. Ser Piero da Vinci is one of us.'"

That meant his name was on a list, probably on Cosimo de' Medici's desk. Somehow he had to avoid this.

"I'll do my best."

"Bravo! I'll tell them we can count on you. Also another matter. . ." Bernardo lowered his voice. "The Servites need a new notary, and I thought you'd be perfect for them."

That was important. Those friars were rich. Here was another step up the ladder.

"Thank you, Bernardo."

He mounted his horse and rode more slowly toward Florence. Cosimo

had ruled the republic for twenty-four years. Like an old fox, he knew his fellow citizens would never tolerate a tyrant, a prince, or *gran signore*. Instead, he ruled a hollow republic through control of the Signoria and its ability to destroy his enemies. So now he had Bernardo rounding up allies fleeing the August heat in Florence for their country villas.

When he arrived at his office, near the Bargello on via del Palagio del Podestà, Piero found a letter from Fra Benedetto, prior of the Convent of San Marco. It was probably news of another bequest for those powerful Dominicans. He had notarized several properties for them.

That was what counted—an enduring power base. No matter what happened in the piazza, these friars, the churches, the abbeys, and the convents—they all remained. They thrived on faith and on guilt from the loss of faith. They were enriched by birth and again by death. Yes, signori, the greater the human loss, the greater God's gain. Here it was again:

> Most Esteemed and Honorable Friend:
> I must meet you as soon as possible on the Cafaggiolo land issue and other matters of interest to our Benefactor. . . . May God bless and keep you and your loved ones.
> + Fra Benedetto

Here was what he needed to escape Florence. "our Benefactor" was the number one citizen of Florence, Cosimo de' Medici, who had rebuilt the San Marco monastery, and prayed in one of its cells, with their frescoes by Fra Angelico. The "land issue" was a project to expand the Medici country estate at Cafaggiolo, outside Florence. To do this, however, he would have to buy out various heirs scattered between Lucca and Pisa. He left quickly for the Dominican convent at Piazza San Marco.

Passing Palazzo del Podestà, he saw a group of people gathered before a notice posted by the commune—one of many, which had been read by mounted heralds during trumpeted rounds of the sixteen *gonfalons*, the civic units within the four quarters of Florence. Drawing closer, Piero read:

> To All Citizens of the Republic of FLORENCE:
>
> In the Interests of our Great Republic + for the Well-Being and Peace of its Citizens + and to prevent further weakening of our State by enemies within Our Walls + and with God's help + and a Firm Resolve to end increasingly Dangerous Divisions

threatening the Security and the Survival of all Citizens + We hereby proclaim a CALL TO PARLIAMENT in Piazza della Signoria, on the Lord's day of Friday, August 11, Year of The Incarnation, MCDLVIII +

SER BERNARDO GINORI	SER LUCA PITTI
Notary Signoria della Repubblica	Gonfaloniere della Giustizia

He smiled. Here was a perfect example of Medici rule. Luca Pitti, a leader of the reformist forces to depose the Medici, had dreamed of building the biggest palazzo in Florence on a hill across the Arno. Its vast gardens and grandeur would shame the haughty Medici. Old Cosimo watched and waited. When Pitti went bankrupt and faced prison for his debts, Cosimo made his political enemy a *gonfaloniere* of Florence. This saved owl-eyed Pitti and his palace. It also required him to support this Medici in defeating his former comrades. The farce was notarized by old rattlebones himself—Ser Bernardo, another Medici puppet.

Thank God he would have to leave to see Fra Benedetto, without losing the prospect of the rich Servites, or shouting like a puppet in a piazza. In Florence, you had to sleep with one eye open.

At the monastery, a little lay brother led Piero through a central courtyard, the Cloister of the Dead, within an arcade of graceful columns and a fountain encircled by beds of roses. It was quiet and peaceful here with the fountain's murmuring waters. The shouts and rumble of horses and wagons in Piazza San Marco sounded like a distant sea.

Climbing the stairs to the first floor, he encountered Fra Angelico's *Annunciation* fresco. The Virgin was beautiful, like Caterina when he had first seen her kneeling to gather roses. The sacred words of the angel Gabriel were being uttered at this moment: *Rejoice! The Lord is with you!*

The lay brother escorted him down a corridor with cells on either side. One of them was open, and he saw a pallet on the floor, a table, a washstand, and, on the wall, a fresco of the Crucifixion, with a Dominican friar kneeling at the foot of the cross. Cosimo came here to pray, meditate, and confess his sins. Finally, they arrived at the prior's two connecting cells, the first one serving as his office.

Fra Benedetto rose from his desk to clasp Piero's hand against his paunch. He was a short man with powerful shoulders, dark brown eyes, and the cautious look of a merchant or banker. Behind him on the wall was another fresco of Saint Dominic kneeling below the crucified Christ.

"Ser Piero! What an honor!"

"The honor is mine, Father. I just received your note and will obtain the Cafaggiolo land for our benefactor."

"Excellent! I will tell him you are taking care of it." He pressed the notary's hand more firmly and confided, "He knows who you are, and he speaks well of you."

"Thank you," replied Piero, pleased to have this under control. "Now about the land—several owners are old and sick. If any of them die, litigation could hold this up for many years. To avoid this, I must leave Florence immediately."

"Alas, we all have to die." Don Benedetto sighed. "Let's hope it won't touch any of those poor souls in the next fortnight. . . . As I mentioned, there's another, more important matter. My dear friend, you are needed to bring your friends to the call to parliament. They're asking ten of each supporter. But knowing you, I told them you could bring twenty. They said they know that you can do at least twenty, if not many more."

Piero told himself he wasn't there. He was with Saint Dominic in the fresco on the wall. He heard his distant voice: "Sì, Padre, you can count on me, I will do as you ask."

VINCI

September 1458

IN EARLY SEPTEMBER, Albi accompanied Leonardo to his first day at
Vinci's parochial school for boys. She had told Leonardo that his father
and mother had not been married in a church, so they had separated. His
mother, who loved him very much, had raised him until his father took him
into his home.

"Her name is Caterina, and she's very beautiful. Her mother came from
the Holy Land of Jesus Christ, and her father was a Circassian prince who had
many lands and horses."

"Where is that?" he asked.

"At the Black Sea, beyond a country called Greece. But then something
happened. Her father wanted a boy like you, not a girl, so he sold Caterina as a
slave to a banker in Florence, where your father met her."

"What's a slave?"

"Someone who is not free. But now she's free and happily married to
another man, named Antonio, who loved you like a father when you were little.
They live below us at Campo Zeppi, and one day I'll take you to meet them
and a little boy and girl who are your half brother and half sister."

"Are you sending me away?"

"No, of course not."

"You're my momma, too, aren't you?"

"Yes, love. Yes."

In the afternoon, she returned to take him home from the school. As the
boys came through the gray stone archway, she noticed that he was taller than
most of them—a golden-haired boy with excitement in his eyes, which he was
trying to hide.

She took his hand, but he pulled away with a glance at the other boys
nearby. So, she thought, one day and he already walks alone. She felt a sudden
sorrow, then a surge of pride and joy as they began to walk home.

"It went well?"

He nodded and they walked in silence.

"You enjoyed it?"

"It was very interesting. They have a large shell that has the sound of the sea."

It is too much, she thought. Such pure and innocent wonder. She could never love another child as she loved this one walking by her side.

On the last day of the week, Leonardo left for school alone, wearing a black smock with a white collar and carrying a lunch of flat hearth bread with cheese. He was sure of himself now, without need of Albi. For this boy of six, the first day had become the second, then the third, and so the days had tumbled into one another. The schoolroom windows opened onto a playground with elm trees next to a high stone wall. On the classroom wall, there was a cloth poster with the alphabet illustrated by drawings of various animals. He could read the letters and the names of the animals better than anyone else. Albi had taught him to read long ago.

There was also a chalkboard of gray slate behind the desk of their teacher, Don Silvio, bent and thin in his black soutane. The priest's hands shook so much, he had to use a pointer to indicate the alphabet letters.

Leonardo knew the boys now and their names, too. The biggest one, Tonino, was the son of Vinci's butcher, and the hardest to beat in the afternoon games. There were three of them the running jump, the rope climb, and wrestling. Leonardo won them all. It wasn't difficult, except the first day he lost at wrestling because he lifted the butcher's boy by the leg and threw him onto the ground—unaware you were not allowed to grab below the waist. That evening, Checco taught him special ways to win this kind of wrestling, and the next day he threw everyone who challenged him. Each time he did it, he heard a humming in his ears.

Tonino was very angry when he lost. On this day, before class, he had warned him, "Just you wait. . . . I'm going to break your balls today."

At midday, during sport recess, the boys gathered to watch him wrestle Tonino. The sun was very bright. When it was in his eyes, Tonino charged like a bull and knocked him down. At the next charge, Leonardo caught him in a headlock and flipped him over his shoulder. The boy fell hard, and Leonardo leaped upon him to pin him down . . . and win.

Amid the cheering, Tonino leaped to his feet.

"Bastard! You bastard!"

Leonardo knew the word, but only as applied to animals.

"I'm not an animal."

"Did you hear that?" asked Tonino, turning to classmates around them.

Those who had cheered him began to snicker. The butcher's boy pushed against him with an ugly sneer.

"How stupid can you be? Everybody in Vinci knows you're a mongrel bastard and son of a slave . . . don't we?"

The boys nodded, and Tonino laughed.

"My mother is better than any of you," he said proudly. "Her father is a great prince with many lands and horses at the Black Sea."

"Who sold her as a slave."

"Not anymore. She's free and with her husband at Campo Zeppi."

"Slaves are sold like meat. Your mother's old meat went to another cock when your father had all he wanted."

"No, no!" he cried, leaping at Tonino.

They fell to the ground, and his elbow smashed the boy's nose. Blood appeared upon his hands, and Tonino became hysterical.

"Help! He's killing me!"

Don Silvio ran into the yard and separated them by jerking Leonardo's ear.

"No! Not me!" he cried.

"He's a liar!" yelled Tonino, leaping up. "He started it. Ask the other boys."

Tonino glared at them, his nose still bleeding, and the boys began to nod. Yes, they said, Leonardo had knocked Tonino down and smashed his nose.

"Wait!" Leonardo cried. "That's not how it happened."

"It's enough," replied Don Silvio. "I warn you, boy. One more fight and you're expelled from this school. Now, come back to class."

Stunned and furious, he turned to his classmates for support. There were nine of them—his first boyhood friends, especially Carlo and Dino. They had laughed and played together, and they had seen his collection of butterflies, snail fossils, and the locked stag horns. He spoke to all of them.

"Tell Don Silvio what he said and how it began."

For a moment, they paused. Then one by one, his friends looked away and followed Tonino back to the classroom. Alone in the courtyard, with his first exposure to human betrayal, he told himself they were all cowards. He had thrown them onto their backs in the dirt and busted Tonino's nose. That's where they belonged. All of them, flat on their backs with busted noses.

After class, he wanted to run home. Instead, he walked slowly to show he was undefeated and feared no one. A group of boys trailed him, led by Tonino, dried blood in the crevices of his nose.

"Bastard! Slave bastard!"

He turned to fight again, but Tonino backed off. As he reached the road, a stone flew past his head. Then another scudded at his feet. When he looked back, his former friends were staring at a sky raining stones. He began to walk again, wondering how he could ever go back to that school. Something of beauty had been destroyed. The joy of the playground, the laughter and warmth of friends, was gone.

Bastard! Slave bastard!

So this was how it was, and it was only the beginning. The words of shame and betrayal would return, along with the hurled stones of disgrace. In his butcher shop, Tonino's father would tell housewives about it. Leonardo, the son of Ser Piero da Vinci, had broken Tonino's nose when he learned he was a bastard son of a slave woman, and Don Silvio said the boy was a born assassin. The housewives would love the gossip. Ser Piero would be furious about this. . . .

On via Empoli, near his home, an old woman in the street paused to stare at the little boy in a torn school smock, blood on its white collar, his golden hair tousled. She nodded as though she knew all about it.

How stupid can you be? Everybody in Vinci knows you're a mongrel bastard and son of a slave.

No, he told himself, this was just another old lady. They were always staring at boys and girls. But then two men stopped talking to look at him. When he glanced back, they were still watching.

Slaves are sold like meat. Your mother's old meat went to another cock when your father had all he wanted.

Two girls approached. One was whispering to the other. In passing, they stared straight ahead—then broke into giggles and laughter. He began to run, sobbing, his eyes to the ground. Nothing would ever change this. He was separate and alone. Everyone would see this, no matter where he went in the world.

2.

When Leonardo failed to return from school, Albiera suspected he was in trouble.

"You worry too much," Lucia said. "Boys are like that. He's probably gone home with a school friend. Piero used to do that."

At dinnertime, he was still missing.

"I'm really worried," said Albi. "I'm going to find him."

At the school, she summoned Don Silvio from his dinner. Upon hearing what had occurred, she rushed homeward in despair. God help us, she thought. He wasn't prepared for this part, the terrible part, and it was all her fault. For years, she had worried about some snot-nosed brat or a churchgoing bitch in Vinci. He was too beautiful and too smart for it not to happen.

She began to run in the dark road and fell. Her knee bleeding, she ran on toward the house. Lucia met her at the kitchen door.

"They found him! He's hiding in the barn, in the stall with the mare and her new foal, but he won't come out. Each time they try to grab him, he runs around, until the mare's gone wild. . . . Somebody's going to get hurt!"

At the barn, she found Antonio and Checco in the lantern light next to the large stall. Leonardo was sitting on straw at the far corner, his head bowed onto his clasped knees, the foal lying in front of him. Seeing Albi, the mare came up to the split railing—wild, red-eyed, ears folded back, nostrils flaring.

Albi began to open the gate, but Antonio stopped her.

"That horse will kill you. . . . The kid's driven it crazy."

Ignoring them, Albi pulled up her tunic and climbed onto the railing.

"Nardino . . ."

The boy remained still, his head bowed.

"Don't try it, Albi," warned Checco. "That mare will trample you to death."

"Please, Checco! Leave me alone with him."

After they left, she lowered herself into the stall.

"Donna . . . Donna."

She spoke slowly, and as the mare came to block her, she continued to whisper its name. She caressed its neck and flank while moving toward the boy and the foal. As she neared them, the little newborn leaped to its feet and scampered to the opposite corner. The mare followed.

Albi sat in the straw next to Leonardo. She said nothing, and they both watched the foal feed. She took Leonardo's hand. It was cold, and she put it to her cheek.

"Mamma . . . Don't cry, Mamma."

He put his arms around her. "Mammina, please don't cry."

She hugged him, and the mare watched them holding each other in the corner of the stall while her foal took its milk.

CAMPO ZEPPI

September 1458

SHORTLY AFTER DAYBREAK, with the first sunlight on the high slopes of Mont' Albano, he began to walk through Vinci toward Campo Zeppi in the valley below.

Albi had promised to take him there, but later that night he had dreamed his father had locked him in his room. He had awakened and listened for sounds in the house. Sometimes his father returned from Florence late at night. He had heard a horse on the upper road, but it had gone away. After that, he hadn't been able to sleep, and now he was on his way to find his mother before anyone could stop him. Albi had said she was beautiful. Her father was a warrior prince. So she was a sort of princess, too.

At San Pantaleone, near Campo Zeppi, he began to recall the place . . . the old church and a giant chestnut tree within a low stone wall. He remembered the tree, and he sat on the wall to wait for someone to tell him where his mother lived. An old woman came down the road. She carried a wicker basket of field greens balanced on her head, and she walked slowly, using a stick. When she saw him sitting under the great tree, she stopped. Steadying her load with one arm, she turned to face him.

Her eyes gleamed. "You're little Nardino!"

He nodded.

"The one who went to live with the notary?"

He nodded again.

"I'm old Malia."

He slid off the wall and stood before her.

"My rabbits," she said. "You helped me feed them. . . . So you're going to see your mamma? . . . It's that house, the second one on the left."

She pointed her walking stick. He saw two distant farmhouses at the top of a sloping field on the other side of a small river.

"Thank you."

Walking down the road, he felt his heart beating faster. Albi had said his real mamma, Caterina, had two more children, a little girl and a baby boy. "They're your half sister and half brother," she'd said. That meant one half was very close and the other half not so close.

Looking beyond a field of cut grain, he could see the two farmhouses separated by a courtyard for threshing grain. A woman came out carrying a mattress. She had long dark hair, pulled back like Albi's, except it was longer and her face was darker than Albi's. He watched her open the mattress, then empty its straw on the threshing floor, next to a pile of fresh straw. Then a little girl appeared, and they both went back into the house.

That was his mother from the Black Sea, whose father was a warrior prince. He was excited but also scared. Maybe he should have waited and not come alone. Yet he wasn't really alone. Not here anyway. He remembered this stream, just as he had recalled the old chestnut tree, and the distant house where the dark-haired woman appeared again with another mattress. A large white dog followed her, and there was a memory of that dog licking his face.

A wagon appeared on the road, a big wagon piled high with logs and drawn by two white oxen. They were immense beasts and they rocked sideways with a clanging of bronze neck bells. Their eyes were black as midnight, and he quickly backed off the bridge over the river to allow them to pass.

Two men sat on a high seat. The one holding the reins cried, "Hahoo!" and pulled the oxen to a halt. He was dark, with immense shoulders and arms. It was a friendly face with a pug nose.

"Good day, Master Leonardo!"

A yellow cur dog, trotting in the shade between the rear wheels, scurried up to smell his legs. He did not know what to say. The man yelled at his dog.

"Pippo! *Vai via!*" he cried, leaping down to kneel before the boy. He was smiling, and he smelled of leather. Then he put a large hand on the boy's head and felt his shoulder and his arm muscle.

"You're well built, Nardo. And you're a good-looking boy. I'm your stepfather, Antonio. . . . Remember?"

He remembered and he didn't remember. The smell of leather, the big arms and pug nose, the soft brown eyes, and maybe the voice were familiar.

"Nardino!" cried Antonio hopefully.

"Yes . . . yes, Papà."

Antonio laughed and kissed his forehead. Then he lifted him up to show to his companion above him.

"My stepson!" he cried. "Sometimes I see him in the market, always growing bigger. Soon he'll be way up there, like this!"

Antonio held him high in the air, and the boy laughed. Those arms were like oak limbs.

"Does your mother know you're coming?" he asked, lowering him to the road. He shook his head.

"Does your family in Vinci know?"

He shook his head again, and Antonio frowned.

"Did you run away from home?"

"Not really," he replied. "Albi promised to bring me, to see my first momma."

This seemed to please Antonio. "Did you hear that, Mario?" he asked his companion. "This boy has two mommas. How about that?"

"I had only one, and my old man said it was one too many."

Both men laughed. Then Antonio kissed him on both cheeks.

"You're beautiful and you're a strong little man. Give me your hand."

The large, rough hand of his stepfather closed gently upon his own.

"*Buongiorno,* Nardino."

"*Buongiorno* . . . Papà."

2.

Caterina saw Antonio's wagon at the river bridge and wondered if the old axle was broken again. Then he picked up some child. It looked like a little golden-haired boy. . . . A boy!

O Dio, she thought. It's him. Trembling, she ran into the house to change her gown and comb her hair. When she came out again, the wagon was gone and there was no one on the road. That meant Antonio had taken him back to Vinci. The boy had come without Albi, and Antonio didn't want any trouble with the Vincis. He said it all the time. They had agreed not to see the boy, to help him to forget his mother. Yet he had not forgotten. He still loved her, and he had come to find her—only to be turned away. She began to cry. She had thought it was past, the sudden tears, and the heavy sadness. Yet there it was again.

With a sigh, she returned to the scattered straw. There was much to be done—other mattresses to be emptied and filled with fresh straw. Then she heard Rocco barking and saw him running toward the stream by the lower field. He plunged into the canebrake, and the barking ceased. Then she saw the two of them emerge, walking across the field toward her.

She began calling his name, and when she opened her arms, he began to run toward her. She knelt to embrace him, murmuring his name. The scent of her hair came back to him as in a dream, and in the darkness of her arms, he could hear the sound of her breathing.

3.

After all the mattresses had been emptied, he began to help his mother fill them again with fresh straw. They worked beside each other. It was hot in the sun, and bits of straw clung to her dark arms. Her neck and shoulders glistened, and there was the pungent odor of sweat and straw. When a mattress was fat and round like a cow's belly, they pushed it aside to fill the next one, until they had four big ones and two little ones. Then he helped to fold the ends while she sat on the threshing floor and sewed them up with the sacking in her lap. She noticed him looking at her and smiled.

"My son," she said, speaking to the needle and thread.

Albi had said she was a Circassian princess. You could tell this from the scent of her body. She carried the blood of her warrior people.

"Are you really a princess like they tell me?"

"Not really. My father was the natural son of the great Bahri Sultan Hajii al-Muzaffar. So he had no title other than Blaneshu, meaning 'brave knight' in our Adyghe tongue. But his tribe called him 'Dzapsh,' or 'Prince of the Army,' for in battles against the Mongols in the North Caucasus, he had the fierce pride and bravery of a great prince."

"And your mother?"

Caterina shook her head and spoke again to the needle.

"She was an actress and cabaret singer in Jaffa, very beautiful and named Hagar, from the Bible. She always came to see me in the convent. Then Blaneshu, who wanted a son, sent for her, and I never saw her again. At the convent, they said his wife poisoned her, for she sent no more money. So they stopped using my name, Satanay, which means 'beautiful flower.' I became Kan-tsuk, meaning 'foster child,' and they sold me to a Genoa slave trader as a virgin princess to get more money."

He took her hand, and she put down the needle to hold him across an open mattress. She was weeping, and whispering into his ear.

"But I have you, my son . . . my beautiful son with the blood of a Circassian warrior. No one can ever be your equal."

He kissed the tears in her eyes, saying he loved her. Then she looked beyond him, and her eyes were suddenly sad. It was Albi coming up the road on Donna, wearing blue leggings with a white tunic and a large yellow hat with feathers of many colors.

Caterina rose to embrace her and take the horse, and Albi came toward him. She was smiling, so he knew she was not angry.

"There's my little man."

He stood up and waited.

"You had quite a walk, didn't you?"

He nodded.

"You also had me very worried. Next time you run away, will you let me know, so that I won't be worried and sad?"

He looked down at a mattress. It was only half-closed. Albi knelt before him and took his hands in hers.

"And to show those boys what a big man you are, we're going to get something for you. Your grandfather, the great prince, had many horses on the wild plains of the Caucasus. So we'll get one for you! A little pony for you to ride to school like a shining knight, or to explore the mountains, or even to run away again . . . but so fast you can come back before anybody knows you're gone!"

"Like a Circassian against the Mongols!" he cried, and ran to tell Caterina.

She was sitting with the baby, Franco, under the walnut tree. Albi followed and asked to hold the baby. She sat in a chair, with the child on her knees. Leonardo saw his two mothers with the infant in the filtered light under the tree. It was like Don Piero's prayer cards of Saint Anne, the Virgin Mary, and baby Jesus . . . except Saint Anne was always standing behind Mary, stiff as a hay pole, and she wasn't as young and pretty as Caterina.

Finally, Albi said they had to leave. He kissed Caterina good-bye, and she helped him onto the horse behind Albi. Little Piera stood next to her mother and waved good-bye. At the bottom of the field, he looked back. Caterina and Piera were still there. When they saw him turn, they waved again.

"When your father comes, we won't tell him about this."

"Yes, Mamma."

"Also, you know what? I'm going to start taking you to Florence so you'll know it better when we move there."

"Then I can go to a school where they don't throw stones."

"Nardo, boys throw stones at one another everywhere. They fight, but then they make up, especially when a boy has his own pony. We'll have Checco find you one, and we'll tell your father it's from my family, so he won't dare to send it back!"

"Yes!"

"And promise you'll care for it and love it just as much as you do me?"

"Yes . . . except I love you more."

VINCI

September 1458

FROM THE RIVER ROAD ALONG THE ARNO, Piero could see his village on the lower slopes of Mont' Albano. It had been a forced ride, and he slowed his horse for the final climb up the long hill.

Where old Zeno had plowed a few weeks ago, the golden field was now dark and seeded for another buckwheat harvest . . . just as he, too, would harvest more victories in Florence. Who would have expected this? He had brought thirty partisans into the piazza, and Cosimo de' Medici had sent word through Fra Benedetto: "I pray you, tell our friend, the notary Ser Piero da Vinci, that at yesterday's Parliament, a day to remember in the history of our Republic, he performed like a hero on the field of battle."

He would never forget that day—awakening in his room at the Red Lion Inn to the sound of a heavy rainstorm, only to discover it was a cavalry moving through the streets. Hurrying outside, he had joined a stream of people moving toward the Piazza della Signoria—down via dei Pittori into via Cacciajoli, where the cavalry had paused before turning left into the piazza. Here the crowd had separated to avoid its steaming vestiges, wondering what kind of army in the night had dumped so much horse shit on the streets of Florence.

In the piazza, he entered a sea of furious Florentines. Their field for a democratic vote on their destiny was occupied by armed forces. At the Palazzo della Signoria, seat of the parliament, Carlo Manfredi, lord of Faenza and a condottiere in the pay of Florence, was mounted on a white warhorse before his troops—three hundred cavalry and fifty footmen. The early sun glistened on his gold-and-silver armor as the white plumes of his helmet trembled beneath the red-and-black dragon of his battle standard. At the far end of the piazza, blocking all other exits, the infamous mercenary, Simonetta, rode a black charger before a similar array of cavalry and footmen. Clearly, the Medici knew they could be defeated.

As the crowd increased, Piero found himself near Giovanni Amadori, Albi's father, along with two of Giovanni's brothers and three cousins—six of

the thirty people whose names he had turned over to Bernardo. They were shocked and worried, especially Giovanni.

"This is serious, Piero. Maybe the reformists will carry the day."

"If they do, we're all in trouble," replied one brother, glaring at Piero.

"We never expected this," grumbled the second brother. "Did you give them all our names?"

Piero held his ground. To admit doubt or fear would only make it worse.

"Yes, I gave all your names. What's the matter with you all? Can't you see a Medici victory, even before it starts? Are you blind?"

He turned away, feigning disgust, only to be surrounded by others from his list with similar fears. With growing bravura, he told them to shout for the Medici, since victory was certain. Hearing this, many others, who had either held back or sided with the reformists, now begged him to be included. Messer Neroni, the reformist leader, overheard them pleading to Piero and turned on him.

"You miserable Medici puppet, the people will send you into exile forever!"

Shaken, Piero retreated through the crowd to the loggia of the palazzo. The priors had appeared, and the heralds blew their trumpets for silence. The cavalry horses mistook this for a call to battle and broke ranks, their eyes wild, their hooves thundering on cobblestones, scattering terrified citizens. The crowd reassembled, and the parliament finally opened.

Luca Pitti, *gonfaloniere* of the Republic of Florence, read a proposed list of Medici partisans who would form a special commission with emergency powers to solve grave problems threatening the republic, while temporarily suspending its constitution.

The reformists began to shout, protesting a Medici takeover. Pitti was a pig's ass and a filthy Judas. Neroni, their leader, climbed onto the loggia to address the people, only to slip and fall onto the back of a dog. There was a yelp from the dog, amid general laughter. Ser Pitti paused, tiny eyes darting with fright, the fat face flushed red. Silence descended, and he read the critical question of the day: "Does this proposal . . . as presented by the commune of our great republic . . . meet with the approval . . . of the people . . . gathered here today . . . in a solemn and binding parliament?"

Before he could finish, Medici partisans began to chant, "*Sì! – sì, Me-dici!*" drowning out the voices of the reformists. Finally, their chant grew into a roar of approval to place control of their commune once again into the hands of Cosimo de' Medici.

Leaving the piazza, Piero noticed Neroni being embraced by two of his followers. What did they have to be happy about? Glancing back, he saw the

reformist leader was in tears. Poor man, Piero thought. He had failed to realize that Florentines wanted something more than the right of self-rule. In a time of chaos, they wanted order and security in their lives.

Later that day, at a victory dinner in the San Marco convent, Don Benedetto brought him the praises of Cosimo, and old Bernardo told him that the Servites had agreed to make him their notary, with an office in their San Donato convent. So now he had to spend more time in Florence. If the Servites or Cosimo should need him in an emergency, he had to be there.

Albi wouldn't like leaving Leonardo behind, but she would be able to see her family more often, visit her friends, and take the fertility treatments without making the thirty-mile trip every month. The boy wouldn't like it, but life was full of surprises. The sooner he learned it, the better for him.

Arriving home, Piero found his father and brother in the cellar, cleaning a large wine vat. Antonio and Checco had flushed it with water and were now preparing its interior with burning hemp that had been soaked in sulfur.

"We won," Piero announced proudly. "The Medici defeated their enemies, and Cosimo cited me as a hero on the field of battle."

"Good," replied Antonio.

"I have important new clients, the Servites—very powerful, and they gave me an office in their convent."

"Very good."

"Where's Albi?" he asked, irritated at his father's indifference. Albi would squeal with delight when she heard Cosimo's words.

"Leonardo ran away, and she went looking for him."

"That boy needs discipline," said Piero.

"They stoned him at school. Called him a bastard," said Checco.

"He ran away from that? Doesn't he have any balls?"

"They said his mother was a slave and you humped her like a dog."

There was the sharp odor of sulfur. Antonio and Checco closed the vat and hammered the lid into place. It echoed like a tomb.

FLORENCE

October 1458

I T WAS A NARROW, INTIMATE CHAPEL with a vaulted ceiling and a tall lancet window behind the altar. There was no one there when they entered. For Leonardo, at seven, it was a new, overwhelming world.

The chapel's frescoes of Saint Peter and Adam and Eve, by Masolino and Masaccio, were unlike anything he had ever seen. Here were people from the streets of Florence—a woman holding a bare-bottomed baby, a beggar shivering in the cold, a crippled boy, a man with a beard and the tender eyes of a child, a youth with auburn hair like his own, and then—a naked man and woman. He had never seen his father naked. He had seen Albi's bare legs on a horse, and he had seen Caterina's breasts when she nursed the baby, Franco.

"They are Adam and Eve," Albi explained.

They had beautiful bodies, their skin was flushed, and being naked didn't seem to bother them.

"It's while they were still innocent."

He nodded because he knew this. He had already seen these same two nude people on the golden doors of the Baptistery next to the cathedral. They were not as wonderful as they appeared now in this little chapel.

"You were like that beautiful baby," said Albi, looking at the *Donation* fresco with a woman holding a bare-bottomed baby.

"Not as beautiful as you," he replied. "You're the most beautiful mamma in the whole world."

"Nardo! I'm not even a mamma yet, except for you."

"You'll make babies, little brothers and sisters, very beautiful ones, and I'll love them very much."

She had never expected to hear this from him, and she knelt to take him in her arms. In a chapel where the miracles of Jesus and Peter appeared to be natural events in the daily life of Florence, she felt that God had spoken to her through this boy in her arms. He had promised her a child, as He had other women in the Bible.

"Oh, thank you," she murmured, her voice breaking.

She went to the altar to pray, and Leonardo felt suddenly alone. Then he looked at the frescoes, and he was no longer alone. The baby, the crippled boy, the old beggar, the naked man and woman, even Saint Peter and Jesus—it was all one family, and he was part of that family. They had been waiting for him, and many were looking directly at him. He closed his eyes and saw the frescoes with an inner eye. Maybe these were people from old dreams, or maybe from dreams to come. Then he saw Eve again, and she was Albi.

A group of art-workshop apprentices brushed past him, laughing and joking as they joggled for positions to set up their easels. They were all quite young—between ten and fifteen.

He looked at the panel of one boy, who was copying Adam and Eve in the Garden. Eve was already outlined. But there were too many lines, like a fence around her. That boy would never discover her in an old dream or anywhere else. The next student had set up under Saint Peter, whose moving shadow was healing the sick and the lame as he walked down a street in Florence. This boy's drawing had no lines like fences. You could find Saint Peter as he moved from shadow into light, with the shifting of one color into another. Two other students were also looking at the work.

"Rossi doesn't want to do Eve. I wonder why," said the first one.

"He prefers doing boys," replied the second.

The other students snickered, but Rossi made no reply. He was a dark, slender youth, his light brown hair reaching to his shoulders.

"He says he can feel Saint Peter's shadow even though you can't see it. I wonder what it feels like."

"It's warm and wet like you know what."

Everyone laughed, and Rossi looked up in anger. Fights were not uncommon among rival students, who felt the intense challenge of copying the powerful frescoes.

"Shall we go, Nardo?"

He lingered, comparing Rossi's panel with the fresco. No shadow was visible in either of them, but you could sense it passing from Saint Peter onto the old man and the crippled boy. You could feel it, if you let it come into you— as he did now with Albi near him.

"Can I have what they have?" he asked as they emerged from the church.

"What do you mean?"

"Paper and colors . . . things to draw with like they do."

"Of course, Nardo. We'll get some today."

Whatever he wants, she thought. He had given her something no one

else had ever done—a promise before God. Perhaps it had even come from God. If Nardo wanted to be a painter, he could have anything he needed. She would take him to every church, to every work of art in Florence, and they would visit the workshops of masters like Pollaiuolo, Gozzoli, and Verrocchio.

MONT'ALBANO

October 1460 – April 1463

Two years after his encounter with Masaccio's frescoes, and Albi's gift of drawing material, he obtained Cennino Cennini's *The Book of Art*—a craftsman's handbook on how to draw everything from trees and plants to saints' diadems and beards in fresco and on wood panels. Among other craft secrets, it explained how to mix colors, prepare panels, paint on cloth, glass, and walls, gild and burnish, and how to cast bronze sculpture.

There had been many trips to Florence to look at art in churches, convents, and private chapels. When Albi left him to go shopping or to visit her family, he copied paintings and frescoes, noting Cennini's rules on structure, perspective, the color buildup of flesh, the draping of robes to indicate anatomy, the use of shade and shadow in creating form and depth, and especially the role of light in creating a living space.

He recalled everything and was soon able to detect the influence of one artist upon another, as well as any deviation from the nature or essence of a subject. On one trip, they watched Benozzo Gozzoli at work on his *Procession of the Magi* fresco in a chapel of the Medici Palace. As they left, Leonardo criticized the master.

"His horses are ridiculous."

"Don't you like them?" Albi asked, surprised and amused.

"They're toys for children, not real horses."

"Nardo!" She laughed. "Maestro Gozzoli is a famous painter!"

"Who knows nothing about horses. I'll do Pegasino better!"

Pegasino was the red pony Albi had given him after his traumatic fight at school—a small yet sturdy gelding of fourteen hands from a Gaston breed used by Swiss mercenaries in mountain warfare and a favorite of dwarfs in the princely courts of Italy. Albi said it was a little Pegasus—the winged horse that Bellerophon rode through the skies. So it became Pegasino.

Leonardo's first trips on this mount were to Campo Zeppi, where he enjoyed drawing Caterina with the baby, Franco. Then he rode up to Anchiano,

where he sketched the cycle of Francesco's silkworm colony. Finally, he turned to the higher, difficult slopes of Mont' Albano, where the little pony scrambled up the steepest trails.

Here, on the slopes of the old mountain, he found a world of his own. Here he was no longer the son of a slave or an unwanted bastard. Here the yellow broom and red poppies threw no stones. The returning swallows dipped in flight, as though delighted to find him so high in the sky. A purple hyacinth, emerging from a fissure in a granite boulder, nodded in the wind—a lone sentinel, welcoming him into his pure world of eternal return.

Alberti, also a bastard, knew the answer. Since nature was truly the daughter of God, its painter was the grandson of God. Maybe he had a ghostly grandfather who was a Circassian prince and warrior . . . or maybe not. It didn't matter. This was what counted.

These first drawings, executed between the ages of eight and eleven years, revealed his growth and the knowledge he had gained from Cennini's book—especially a persistent search for accuracy. Flowers were drawn, dissected, noted in detail, then re-created again—a few strokes capturing their beauty and innate mystery. Francesco's silkworms were followed from larvae to butterflies, with a sad note: "Brief Glory!" Birds were shown in flight, with an envious comment: "Happy soul! You fly while we stumble!"

One day, in early March of 1463, while climbing the slopes of Mont' Albano to observe bird flight, he discovered a cave he had never seen before—high above the base of a cliff, amid tangled undergrowth and jagged rocks.

Leaving Pegasino behind, he climbed to the cave's opening, where he felt a current of cold air and realized this was no ordinary cave. It went deep into the mountain—a dark and forbidding challenge. Pressing forward in the dim light, he groped his way along the dank walls, each step increasing the sensation of entering a forbidden and dangerous place.

"Old mountain, here I am!" he shouted in defiance, only to have its echo thrown back at him.

Going farther, he was finally enveloped in total darkness. Behind him, the cave entrance was a distant circle of light. He shouted again, but this time there was no echo. With sudden terror, he felt trapped in the bowels of the mountain. He had pierced the heart of his echo and buried himself.

"I was filled with two emotions," he recalled later. "Fear and desire—fear of the threatening dark cave, desire to see if there might be some marvelous thing within it."

Returning the next day with flint and an oil lamp, he continued onward to where the cave opened into a large chamber. Imbedded in its walls, he found various fossilized shellfish, then the hidden wonder of this mountain tomb—

the skeletal remains of a whale, or a prehistoric sea monster, with an immense jutting jaw, a high-arching spine, and a long serpentine tail. Clearly, the mountain had somehow engulfed this biblical leviathan when it perished.

He was able to pry loose a petrified oyster. Unable to detach the monster's bones, he sketched it in his notebook. At home, he drew the oyster, free of its petrified clay, clinging to ocean rock below the waves. The sea monster was also re-created around its giant skeleton, the massive jaws open in despair, the great tail lashing with fury.

These first drawings were unusual, less for quality than for the procedure used. The boy had begun to search for the essence of whatever he was attempting to draw. The laws of nature governed all forms of life, providing for separate yet interdependent existences. An artist had to become a "thinking mirror" in the re-creation of life, and in Cennini's words, "present to plain sight what does not actually exist."

Aware of his fossils' great age, from recorded time in the Bible, he noted: "From the heart of Mont' Albano, a mystery! If the sea monster could swim here during the Flood and become trapped in the cave, how did the little oyster manage to arrive from the distant sea?" And in a later note: "If the Flood covered the entire world and rose to 10 cubits above the highest mountain, how could it have receded from all the valleys and plains in only 40 days? Impossible!"

This denial of the biblical account of the Deluge was only the beginning. More followed, as he began to explore the interior of man and the heavens—journeys taking him into uncharted realms, yet never without the danger of violating the laws and beliefs of his time.

VINCI

November 1463 — August 1464

WHEN ALBI ENTERED THE ELEVENTH YEAR of marriage without a pregnancy, Don Piero told Lucia that their only possible chance lay in a fertility belt belonging to the nuns of Santa Margherita at Prato.

"What's that?"

"It's a special belt woven by the sisters, containing secret prayers to the Holy Spirit and the Virgin Mother for a woman who wants a child."

"Does it really work?"

Don Piero nodded with his eyes closed. This was an article of faith. "The belt is very potent. It has performed many miracles."

"What makes it so potent?"

"The girdle of Our Lady. In the Prato Cathedral, the belt is placed in the reliquary with the holy girdle to absorb its powers, and that does it."

"O, *Madonna mia*. How can we get such a belt?" she asked.

Don Piero closed his eyes again to indicate it was a delicate matter. Then he opened them and smiled. "The chaplain for the sisters is my cousin."

A week later, the priest returned from Prato with the holy belt in a red lacquer box with bronze fittings and a lock that glistened like gold. Albi had to wear the holy girdle for forty days and forty nights. Moreover, it had to be placed on her belly, touching her flesh, by a boy who was still a virgin.

"A virgin boy? We have Leonardo."

"How old is he now?"

"Almost twelve."

"He's probably still a virgin. But with this boy, you never know."

After being cleared by the priest, Leonardo was summoned to put the belt on Albi. As he entered her bedroom, she was sitting on the side of the bed, wearing a light blue gown. She did not look at him or the priest. Lucia was on the other side of the bed, staring at the box. Don Piero removed the belt from

the box. It was an open weave of natural linen with a scent of roses and wild lavender. In the middle of the belt were two pockets, where the nuns had inserted special prayers, asking the Virgin and the Holy Ghost to help Albi have a baby.

The priest quickly recited a litany of prayers, apparently in a great hurry to put the belt on Albi.

"Lift up the gown," he ordered.

Albi raised the gown, revealing her naked waist and abdomen.

"Now . . . put it on her . . . now!" exclaimed Don Piero, as though directing the saddling of an unbroken colt.

Kneeling on the bed with Albi, Leonardo saw the soft flesh of her belly, its fold going into the little opening of her navel.

"Not in front," the priest growled. "The buckle goes in back, so the prayers are on the belly, in place for the baby."

To get it right this time, Leonardo moved closer, until his knees touched Albi's back. Holding the belt in place, he felt the warmth of her body. She was waiting for him as the only one who could do it. The priest had said so. He was her virgin boy; the belt was her Holy Ghost.

"There . . . how's that?"

With the buckle closed, he leaned back. She turned and smiled.

"Get away!" cried Don Piero, pushing him off the bed to read a final prayer hastily and close the empty box. Then he left quickly, as if the Devil in person was on his heels.

2.

Lucia knew Albi was with child when she saw her enter the kitchen.

"It's happened?"

"Yes."

"Have you missed your time?"

"Not yet."

"Then how do you know?"

"I woke up and felt it had begun," replied Albi, knowing she was finally blessed among women.

Piero strutted with pride. He had finally made it. Without him, the priest's fertility belt was a joke. Leonardo, however, believed he had done it. In putting the belt around Albi's waist, he had felt its power going from him into her. In that instant, the child became possible. His father was nothing more than a sidelined cuckold, like Saint Joseph. For years, the old man had tried it

with a new moon, a full moon, and everything else—only to fail, until his bastard son of a slave and the Virgin's girdle made it possible.

Albi's overjoyed mother, Francesca, insisted her daughter have the baby in Florence. She herself had experienced trouble in delivering Albiera. There was a new women's wing in the Ospedale di Santa Maria Novella, founded by Folco Portinari, the father of Beatrice—Dante's immortal love, who had died in childbirth.

Piero agreed Albi should be in the care of a professional doctor. When her time drew near, he would take her to Florence, where—God willing!—she would give him the boy he wanted.

3.

Piero, disgusted with the odors from Leonardo's nature studies, ordered that his son's door remain closed. Nothing helped, however, during a July heat wave, prior to the family's seeking the cool breezes at Anchiano. The stench engulfed him while lying in bed with Albi. He went to his son's room and found it locked. When there was no reply, he forced the door open.

He saw an array of bone fossils on the shelves: dissected bird wings, a stuffed white owl, the heart of a deer pickled in white vinegar, mounted moths and butterflies, a lizard with the attached wings of a dragonfly, and the locked horns of two rival stags that had perished from an inability to separate themselves.

He was sniffing these when he saw a notebook on his son's desk. It lay open to a drawing of what he had believed was his private property, to be shared with no one else in the entire world—his wife naked to the waist, her breasts now large in the seventh month of her pregnancy.

He turned the page and saw Albi's bare abdomen, swollen with child. On other pages, he found sketches of other parts of her anatomy—the eyes, the nostrils of her nose, an ear with hair sweeping over it, the gentle curve of her calves, the bare feet with their delicate instep, the arms, and many studies of the breasts with altered positions of the body—a method of study, begun by a boy of twelve.

Furious, Piero returned to his bedroom. "Albi, what in God's name is this?"

"What do you mean?" she asked, seeing the notebook and knowing exactly what he meant.

"Look at it!" He threw the book onto their bed.

"Your naked body! Seen by my son! What in God's name are you doing with him?"

The book was open to a page showing her with flowers in her hair. Thank God, she thought, he didn't find the others showing me naked as Eve. Leonardo was currently in his Virgin Mary phase, so it was mainly breasts and the belly.

"Did you show your entire body to that boy?"

"Of course not," she replied, lying.

Piero would never understand the innocence and beauty of it, nor how it had begun when she awakened one morning and found Leonardo at her bedside, drawing her while she was asleep. "Oh, how beautiful," she had said, seeing the sketch with her hair spread upon the pillow, her shoulder bare. "I haven't finished yet," he had said, waiting to see more of her. *Santo Dío,* she had thought, why not let him see them? She had given them to him when they were dry. How could she refuse them when they were filled with milk? So she had lowered the cover. That was how it had begun.

"I don't believe you," Piero was saying. "How could he draw all this stuff without looking at it?"

"It's very simple," she said. "He imagines it."

After the first day, it was always a little bit more. When she rose to dress, she let him look at her. If her breasts were natural, so was the rest of her body. And now, as a son and an artist, he was drawing her with child.

"Are you telling me that he imagined this, too?" He pointed to a drawing of her combing her hair after a bath, her open robe revealing her naked body.

"He sees many naked Eves in the churches."

"So you're his naked Eve at her bathtub? *Perdío,* who does he think he is?"

"He sees me as his mother and likes drawing me this way. What's wrong with that?"

"Why can't he draw you with your clothes on?"

"He begins with the anatomy, the body. The clothes come later."

"Why?"

"He says it's like a foundation for a house."

"Well, I don't want him messing with your foundation. Ever since he put that belt on your belly, he's been strutting around like it was his baby."

"That's ridiculous. The boy is happy. Don't you want him to be happy?"

"I don't give a damn what he is! I want some respect! That means no more naked drawings and, by God, he's not coming with us to Florence. . . . Where is he? I'll tell him now."

"No, let me do it."

"Why you?"

"Because if you do it, he'll think you don't like him. I'll explain it in a way that doesn't turn him against you."

4.

Albi delayed telling Leonardo of his father's decision until mid-August, shortly before her departure for Florence. They were in the fields at Anchiano, gathering wildflowers for Lucia, who was opening the house for the summer.

She was eight months with child and soon became tired. They sat on a low hillock and Leonardo, delighted with the scene, began to sketch her. The moment had arrived, and Albi sought to soften the blow.

"Your father's worried about your failing at school because you skip so many classes. So he doesn't want you to go with us to Florence for the baby's birth."

"That's not true. I have the best grades, except in Latin. So I'll go, anyway."

"He'll be very angry."

"He doesn't like me. He's never liked me."

"That's not true."

"Don't say that, Mamma. We both know how it is. He's my father, but he's never made me his legitimate son or given me his name. I'm just Leonardo from Vinci."

"Your father loves you in his own way."

"I don't feel it like I do with you. Anyway, school will soon be over, so I'll go to Florence and stay in my room."

Piero had moved into the palazzo of the Guild of Bankers and Money Changers, on Piazza di Parte Guelfa, near the church of San Biagio—an upperclass quarter next to the Signoria. Leonardo had a room on the top floor, off the kitchen. It was next to another room used by Tara, a Russian slave girl whom Cosimo de' Medici had given to Piero for his help in the call to parliament.

"He says Lucia will be using your room."

"Then I'll stay with Alessandro."

Occasionally during their trips to Florence, they had stayed at her parents' home near Santa Croce. Albi had slept in the room of her childhood, and Leonardo had shared a bedroom with her younger brother, Alessandro, who was four years older.

"Alessandro likes it when I stay with him. So there's no problem there."

"I don't know. . . . We can see about it."

"So I'm right. He doesn't want me there. There'll be a new baby, a son he can love and who will become a notary, while I'm left at Vinci like Checco with the animals and silkworms."

Close to tears, she looked away. He saw it and relented.

"Don't worry, Mamma. It'll be all right. He can't ever separate us."

She smiled sadly, and he resumed drawing her in a pink *gamurra* with pink ribbons in its open puff sleeves. Her face, in the shadow of a broad straw hat, had a roseate hue from the reflected color of the gown and from the pink coral earrings in the dark cascade of her hair.

A basket of flowers was at her side and, on the slope behind her, there was a rich carpet of red poppies, pink hyacinths, blue harebells, and purple columbines. At the edge of the field, yellow broom skirted its more somber neighbors, the silver-gray olive and yellow-green fig trees. Higher up, on the crest of the hill, black-green cypresses marched in perfect file beneath a soft blue sky, their ranks occasionally broken by sleepy paramours, the parasol pines.

"May I have this one to take to Florence?" she asked.

"If it's good enough."

"They're all good."

"No, some are better than others, but none are ever what I want."

"I don't understand. You've drawn me so many times, you could do it blindfolded. Just a few lines and there I am—out of nowhere, with a cow's belly!"

"I feel it when I begin, but when I finish it's not there . . . not all of it anyway."

"'It'? What does that mean?"

How could he tell her, or anybody? It began with a wanting to put it down clearly, as he felt it when he saw it. At the same moment, however, there was an imagined form that seemed to come from an inner eye. Especially with Albi, there were always the two merging forces—the immediate vision and an interior image.

"I see two of you . . . one that's here before me, and an another one inside me. If it goes well, they come together."

"What does the inside one look like?"

"Very beautiful."

"More than the one on the outside?"

He frowned. "They're different. The imagined one is always there, even when you go away somewhere."

"I'm jealous. You can do things with her that I don't know about!"

"The imagined one wouldn't exist without you, so I love them both equally."

"I don't understand that very well."

"Neither do I," he replied, and they laughed again.

A shepherd with his flock began to cross the field. They moved like the shadow of a drifting cloud, and a dog raced back and forth, snapping at strays. After they had passed, the dog returned and plunged into a thicket of yellow broom. Then it emerged, barking wildly for the shepherd, who began running. Albi stood up, excited.

"Let's see what it is!"

In the thicket, they discovered a ewe had just given birth. The newborn lamb lay motionless, its head still within the placental sac. The shepherd arrived and, with a short cry, tore it open. Then he put the lamb in his lap and began to pump its forelegs in an effort to start its breathing. Then he raised the animal's limp head, but it fell without life.

"Madonna, help us!" he cried, lifting the inert lamb into his arms.

"Madonna, come to us now," repeated Albi.

Placing his mouth over that of the lifeless creature, the shepherd drove his breath into its lungs. His dark eyes bulged and his faced turned red as, with deep moans, he sucked the animal's fetid air into his lungs . . . until suddenly the lamb shivered, then kicked and jerked its head away.

"O Signore mio!" sobbed the shepherd, his mouth smeared with blood and foam as he cradled the lamb.

"Thank you, Lord," murmured Albi.

Kneeling with Leonardo, she stroked the little creature, then touched the shepherd's gnarled hand.

"Bless you . . . you beautiful man."

He smiled with pink tears. Albi was also weeping.

"Oh, Nardo! Life is so precious yet so fragile. It hangs on such little things, such tiny moments."

She held him, their cheeks wet with her tears.

"I'm frightened, Nardo."

Then she said, "I need you in Florence. I don't care what Piero says."

September 1464

H E SAT IN THE FRONT ROW, where he could see the chapel and its frescoes of the Virgin. He had to speak to her, but he was not certain which fresco was better suited for this. The first one showed Mary at the moment of her birth. In the next one, she was a girl standing before the elders of the Temple. Neither of these would do, because in both of them she was too young to understand what he had to tell her, and why he did not want to do it.

"Go and tell her," Albi had said at the hospital. "Go and tell her for me. She knows how much you love me. . . . O, Dío, here it comes again! . . . Oh, please God . . ."

She grabbed Leonardo's arm, her lips moving without words, her eyes pleading for help. Then Francesca and Lucia arrived with a short, dark-eyed doctor and a big blond woman who was the midwife. As they lifted her onto a trundle, she looked back at him. When he said nothing, she asked again through her pain. "Nardo, come closer. . . . Speak to me."

He stayed beside her while she was wheeled down the hallway.

"So you'll do it, won't you?"

"Yes."

"Oh, I knew you would!" She reached for his hand. "Tell me again. Tell me it's true, so I can really believe it."

"Yes, it's true."

It was this that had sent him down the stairs of the hospital and across the little piazza to Sant' Egidio, adjacent to the hospital, with her words following him to the front pew of the candlelit chapel.

Once, during their first beautiful days in Florence, she had brought him here to admire the frescoes. After those of Masaccio in Santa Maria del Carmine, they were the second wonders of the city—the scenes of the life of the Virgin by Andrea del Castagno, Alesso Baldovinetti, and Domenico Veneziano, along with an apprentice, Piero della Francesca.

They had sat where he was now. Recalling this, he moved over to where she had been, her warm breath upon his ear: *Isn't she beautiful? I wonder how she felt when it happened.*

That was how it had been, and they followed the Virgin from the time she received the angel's annunciation in a Florentine garden to the final fresco, where she lay dying. A gathering of men and women were bent over her with sad faces and clasped hands. She seemed unaware of them—staring sleepily at the upper region of the fresco, where she was already on her way to heaven in the company of flying angels. This was what he needed. Mary in her last moments would surely understand the pain and terror in his heart.

"She wants me to tell you . . ." He spoke in a whisper. "She says, 'Please tell our Holy Mother to save my baby. It doesn't matter what happens to me.'"

It was useless. The Virgin was going to sleep, dying. He looked at another fresco, this one of her standing at the foot of the cross.

"Listen, Mother Mary . . . after Jesus died, you lived many years. Maybe you made other brothers and sisters of Jesus. Or maybe you didn't. But you must know how it is for little boys and girls to lose their mothers and be left alone in the world."

This was better. He felt she was listening to him.

"So you understand why we must save Albi. The little baby, he doesn't want her to die. But he's got his feet twisted up inside, like he's on a cross—in her womb. You can see that, can't you? A little Jesus on a little cross? So you can take him to heaven like that. Then they won't cut Albi open and make her die. Please do this for us, Holy Mary."

He bowed his head and began to sob. Near him, an old woman was weeping, and behind her, a man had knelt in prayer. Neither of them heard him sobbing, nor did he hear them. There was at least that much mercy in grief. It immured its victims from the pain of others.

When he looked up, Mary seemed to have turned back to her son. She had not heard him. Or she was going to do nothing about it. He rose quickly and ran from the church into the piazza. It was the hour of twilight. As he ran, the feeding swallows swooped low with shrill cries, crisscrossing above him like the angels around Mary on her way to heaven.

2.

The pain came back in waves and each time she had to make room for them. They came from below, rolling upward through her. When they went away, she would see the big nurse and the little doctor standing over her. After a bit, another wave would come, and each time it was worse. She began to count

them, but they started coming faster and she lost count. Then the pain came and she thought, O Dio, this is it. Now my little boy will be coming out of me.

It slammed with such violence that she went under it. As she went down, she saw flashing lights. Gasping for air, she tried to tell them.

"Please, save him. . . ."

"Be brave, signora. We're trying to get it in position to come out."

The nurse's face was on the ceiling above her—a big fat face, dripping with sweat. It had blue eyes and a large mouth and stringy blond hair.

"Don't let him die!"

"Stop screaming, signora. Try to help us. Push . . . push down hard . . . harder!"

Hands pressed upon her abdomen; then other hands entered into her, twisting and pulling, until suddenly she felt the sickening wrench of her baby.

"You're breaking him!"

"Signora, stop screaming!"

"He's dying! I can feel him dying. . . . Cut me open. Save him!"

She clawed at her abdomen, tearing her flesh. The face on the ceiling began to blur. The room was closing down, crushing her.

"Mamma! Help me, Mamma!"

She knew her mother was there, outside the door. If she called loudly enough, her mother would hear her. She tried to rise, but the ceiling crashed upon her, and she fell backward through a flash of light, sinking down through darkness until she came to the bottom, where all was still. Holy Mother, help me. I'm in a grave without my baby. I must go back up and save him. She tried to rise, but the weight and pain lay upon her.

"Albiera . . ."

That was her mother's voice, but she was down below and unable to move.

"Albi, my little one! Speak to me!" The lips were on her, and there was a hand on her brow.

Then it was the nurse. "It's the fever, signora. If you don't go now, we'll lose both of them."

"Come, Francesca, come away."

That was Lucia, trying to take her mother away.

"Let me go! This is my daughter!"

Again the nurse spoke. "Signora, you must leave. We have to save the baby."

"And let you kill my own child? . . . Never!"

"You don't own her anymore!" That was Lucia's old woman's screech. "She belongs to Piero now, and he wants the boy, no matter what happens!"

"Oh, my little girl!"

Now she felt her mother's lips and her tears. Then the hands returned, jerking her roughly as they bound her arms and legs to the table and inserted a wooden mouthpiece.

"Are you ready?"

"Yes, Doctor."

A searing fire pierced her belly, the pain streaked through her, and lights darted into her head. The hands were wet and warm, and she knew it was her life spilling away as they lifted up her little child. Oh, sweet Mary, she said, her lips moving without sound. You answered my prayer. You saved my little boy. Please let me see him before you take me into your arms.

The wooden gag was withdrawn, and she felt the weight lift away. She was floating, without pain, and then she saw them. They seemed to be in water, or maybe it was raining on them—the little baby held upside down by the ankles, the midwife spanking his bottom, the tiny head swinging back and forth.

She heard herself telling them what to do: "If he doesn't breathe, pump his arms. . . . Oh, you must hurry. Bring him to me. . . . Give me his mouth. . . . I can do it . . . now."

She felt herself sinking back into darkness. She tried to stay with them, but their voices began to fade. Then she heard no more.

Albiera's uterus failed to contract and blood poured into her open abdomen. The doctor sought to halt the hemorrhaging with clamps and sponges, but the blood continued to flow, until she went into shock. Within a few minutes, her heart ceased beating.

"That's it," said the doctor. "But better now than in a day or two."

He took the child from the midwife and smacked its bottom a few times. When it failed to respond and he heard no heartbeat, he dropped it into the sink.

"Call a priest."

"I did. They're all out somewhere."

"That's too bad. They won't baptize when they're cold."

"You want the family to come in now?"

"No. It'll only make it worse."

At the sink, the midwife washed the dead infant, severed the umbilical cord, wrapped the body in cloth, and enclosed it in a bag. After the doctor had closed the abdominal opening, the midwife began to cleanse the body with sponges. She had seen many births and deaths, and she thought she was inured to every loss. Despite this, she wept as she washed Albiera.

"This was a special woman," she said.

"At least she didn't know the baby was dead."

"She knew. She tried to tell us how to revive it."

"By blowing into its mouth? She was delirious, babbling nonsense."

3.

Crossing the piazza, he saw them coming out of the hospital, then descending the steps toward a waiting carriage. Mamma Francesca was sobbing. Piero and Lucia were helping her. He stopped, his heart pounding. No, he told himself, it didn't happen. It's not her. It's the baby. It has to be that. The Virgin looked at me. She heard me. He closed his eyes and smelled fresh manure from the carriage horse. He wasn't here. He was at Vinci, and Albi was with him. They were riding together on Donna. He was holding her close and she was crying, "Leonardo!"

He stopped below them. Momma Francesca was seated on the hospital steps, her face buried in her hands. Piero and Lucia were sitting next to her.

"Go," she said. "Go away and leave me."

"*Signora mia,*" replied Piero. "There's nothing more we can do here. We're taking you home."

"The carriage is here," prompted Lucia.

The sobbing woman shook her head. Her hooded mantle was slate gray, like the stone steps. Her white collar resembled those of angels, and her light gray hair hung down over her hands.

"You can't stay here," declared Lucia. "We have to prepare for the funeral, and you have to come with us."

Francesca looked up at Lucia. Her face was dark with grief, like the women at the bedside of the dying Virgin.

"Go with you? Never in a dried fig!"

"Stay calm, signora," replied Piero. "We're trying to take you home."

"Home! My home is with my little girl! You let them kill her, and for what? The baby's dead, too! . . . May God forgive you!"

"How dare you!" cried Lucia, springing up in anger. Piero closed his eyes and shook his head.

"You should not have said that." His voice was breaking. "Oh my God, I wish you hadn't said that."

His lips trembled, and he put his arm around Francesca. Seeing this, Lucia sat down. She saw her grandson at the bottom of the steps, next to the waiting carriage, but there was no sign that she recognized him.

Leonardo left them there—his grandmother staring wordlessly, his father sobbing with Francesca—to run up the steps and into the hospital. The first person he encountered was a little Oblate nun.

"My mother just died. . . . Please, where is she?"

"Your mother? O Dio . . . what happened to her?"

"She had a baby."

"When did it happen?"

"Just now . . . a few minutes ago."

"Come," said the little nun, taking his hand. The Oblates, dedicated to hospital care, were drawn from the aristocratic families of Florence. This one had the sweet face of a Filippo Lippi angel, with soft blue eyes and a wart on her upper lip.

"I'm Sister Agatha," she said as they walked down the corridor. "What's your name?"

"Leonardo."

"What's in that book hanging on your belt?"

"Drawings," he said, wishing she would shut up.

"My brother's an artist," said the little nun. "He's Marco Rossi, and he was taught by Verrocchio."

At the emergency room, they found the door open. A large blond woman stood at a corner sink, washing some knives and a large pair of scissors.

From the doorway, he stared at the delivery table. It was made of white marble, and it slanted downward and had draining grooves, like a meat platter. It had been cleaned, but at the bottom edge there were bright pink traces of blood. That was all that was left. Her whole life, all of her love and hopes and dreams—all of it had been brought to this room, to this table, and all that remained were meat platter rivulets of her blood. No baby. Nothing to hold or love. Just a pink smear that would wash away.

Sister Agatha spoke to the big woman at the sink.

"Were you the midwife for the last case?"

"What do you want?"

"Where is the mother?"

"They took her away."

"Where?"

"Where? For God's sake, Sister, how long have you been here? Where do they take the dead? They're under your church and your Holy Virgin chapel. All of them are there, beneath you in a stinking morgue. That's where she is!"

He came forward to look at the woman so filled with anger.

"Who are you?" she demanded.

"It's the son . . . her son."

"Oh my God," moaned the midwife. She squeezed a sponge and threw it into the sink.

"You are Nardo?"

He nodded.

"She called your name and wept because she was leaving you."

He nodded again.

"Your mother wasn't just another woman slaughtered here to save a child. Your mother was something else . . . very rare and beautiful."

She paused, tears in her eyes.

"Your mother was a saint."

"Where is she now?"

"As I said, they took her to the morgue."

He turned to Sister Agatha. "Will you take me there?"

"I'm sorry. Nobody goes there."

Nobody except the dead, he thought. That's where she is now . . . alone among them. Then he heard Sister Agatha calling after him.

"Where are you going? No! You can't go there!"

4.

He quickly found the way into the basement, and then into a tunnel—a narrow brick-lined passage with oil lamps and terra-cotta figures of Christ at the Stations of the Cross. Above him, he heard the rumble of horses and carriages, so he was passing under the piazza. This was how the nuns went to Mass without being seen . . . and how the dead were removed to the morgue.

At the end of the passage, he entered a large vestibule. To the right, he saw a chapel lit by two candles, and in it was the corpse of an old woman. She was dressed in white taffeta and ready for her funeral. The chapel had a flight of stairs—to bring the dead up to the church for their funerals. To his left, a room lay in darkness.

In between, a double doorway probably led to the morgue. Hearing voices behind the doors, he backed into the dark room. Two hospital orderlies appeared, wheeling an empty stretcher. One of them paused to lock the doors with a large key.

"Never forget to lock it," the orderly warned.

"So nobody can escape?" asked the second orderly.

"It's not a joke. A runaway slave got in here a couple of years ago, looking for gold wedding bands. He chopped off swollen fingers. Christ, what a mess, with massacred hands and families screaming at us."

"Did they catch the thief?"

"They hanged him, and they'll hang anyone else breaking in here. . . ."

The voices trailed off. Leonardo realized he had to move quickly, before they returned and found him looking for Albi. Even so, he told himself, they can't hang me. He wasn't stealing anything except a last good-bye.

In the darkness, he felt the end of a table, then the stump of a big toe. With loathing and fear, he jerked his hand away. Then he recalled the dark cave at Vinci. No, by God, he thought, reaching again for the toe. It was cold and hard, like a shriveled turnip. The smaller toes were its dried roots. He moved up the thigh, touching the genitals, then the flabby arm, and finally the face—feeling it as the blind do in seeking to recognize someone. The cheeks were sunken and covered with prickly beard stubble, the eyes lay deep in their sockets, and the mouth was open. He inserted his finger into it. There were only a few teeth. This was an old man . . . very old.

All right, he thought, we know each other. And now I have to get past those doors, before those two idiots come back. From the chapel with the old woman, he returned with a burning candle. The corpse on the table was indeed an old man—snow-white hair, beard stubble, and blue-veined hands clasped upon a swollen belly. In the corner, there was a sink with sponges, rags, and two wooden buckets. This was a room for washing and preparing the dead.

To his right, behind a black curtain, he found a locked door. It was in line with the other doors into the morgue, and he began to look for its key. Standing on a wooden bucket, he found it in a common hiding place—above the door lintel. The door opened onto a long, vaulted room with many naked dead. They lay upon marble-topped tables in two rows, as in a hospital ward. All of them had a white name tag tied to the big toe of the left foot. Most of the tags hung down near the instep, but some were stuck like flags between the toes. Over it all lay the fetid smell of a stagnant pond.

In the first row to the left, he came upon a man who resembled his father—the same hooked nose and mouth, the eyes half-closed, one leg flexed as though he had been tagged while trying to outrun death. Moving on, he found a fat man with a bloated face and the fixed stare of death's single moment. The next one with closed eyes appeared to be sleeping—a blond youth with a small chest wound, probably from a sword. It was a beautiful body, with a large penis curving over its sac, and soft beard stubble.

The women were grouped on the right, as when seated in the church above. They appeared less restless in death—their legs together, their hands over their breasts or modestly resting on their private parts. One, however, lay with her legs apart, and hair was in disarray, as though she had been violated either before or after death.

Turning away with a growing fear for Albi, he paused at the foot of one table. The body resembled Albi's, but the face and chest were covered with a cloth. A stiff, extended arm blocked his way. He shoved it back and raised the cloth. It was a woman with the right side of her face eaten away, exposing an empty eye socket, white molar teeth. Her left eye was staring in fright, the mouth open in an ultimate scream. He shuddered. Was this a disease, or had dogs eaten her? Turning to leave, he found her stiff arm again blocking his way. He pushed it to leave, and it swung back like a gate.

He then approached a woman with a white bag under her arm. She resembled Albi . . . the same mouth, delicate nose, and long dark hair. *O Dío,* it was Albi! Suddenly there . . . and naked, like all the others.

He had drawn her nude many times. But seeing her exposed on a marble slab was embarrassing. The long incision that had split her open had been closed with a crisscross of black stitches. He counted six of them, irregular and done in haste—the black thread emerging to ride across the blue edge of the raw wound, then plunge again into her milk white loin.

Her eyes were closed as in sleep, and the dark hair was in disarray. He ran his fingers through it, removing a matted strand from her cheek and mouth. She was still slightly warm. He bent over to kiss her on the brow, and his tears fell upon her cheek. Then he told himself he had to start now. Those orderlies could return at any moment.

Opening the white bag, he saw the little head with a fuzz of dark brown hair. Here was the child that had taken her into the Great Sea. Lifting it free, he saw it was all that she had desired—a chubby baby boy with folds of fat on the arms and legs, the little hands half-closed, the face with a broad mouth and the flat nose of a newborn infant. Shaped by Albi's prayers and dreams, it was the little child he had promised to draw in her arms.

"Here we go," he whispered, lifting Albi into a sitting position against the wall. A reddish yellow secretion seeped through the stitches of her wound. Its bright bubbles trickled down her loin. He wiped them away with his sleeve.

"And now you, little brother," he murmured, putting the child in her lap, its mouth at her breast.

He stepped back to look at the drooping figures. The two cadavers now appeared more dead than ever. No matter, he had to start from somewhere. One last barrier remained before the realm of the dead—closed eyelids. He opened those of the infant and deep blue eyes stared at him. The baby seemed to be waiting for him to speak. Did the eyes also live on after death, like hair and fingernails?

"Hello . . ."

It sounded weird, but he tried it again, using Albi's intended name for him.

"I'm Leonardo . . . Nardo, your brother . . . and you are Lorenzo . . . little Lorenzino. I've been waiting a long time for you."

Those eyes were old—old as the seas. They had seen nothing of life, yet they appeared to contain the wisdom of the world. Did this occur when you died in the womb? God help me, he thought, turning to Albi. Trembling, he opened her lids. She also stared at him, yet this was different. Dark as the heart of a rose, these spoke from the other side of death, from the shadow world of dreams: *Here I am, darling. Do it quickly, while I can see you. . . .*

He began to draw, and, indeed, their eyelids soon closed. He opened them again and continued to work rapidly. After sketching the embracing forms, he was doing detailed studies when he heard someone at the far end of the morgue.

"Eh, Mario!"

The young orderly stood in the door Leonardo had left open—a stupid mistake. Closing his notebook, he ducked below the table of the mauled woman and saw a rat—an immense beast with a long tail and red eyes. It stared at him without moving. So this was it. The rats had eaten her face.

"Would you believe it?" yelled the orderly. "Those idiots left the washroom door open again!"

He heard the door close, and realized he was trapped. He stood up, facing barred windows in the brick vaulting. Outside, the evening light was fading. He would soon be left among the dead with only the faint light of a few oil lamps. He ran to the morgue's main doors to explain he was no thief. He had merely come to say good-bye to his mother. . . . No, that was wrong. If the police came, they would take his last drawings of Albi.

On the other side of the doors, the old orderly was describing a woman who had given her husband more horns than a barrel of snails.

"So she told the priest, 'Father, you say charity is the first law of the Church, and I believed you. That's why I give it away. . . .'"

Amid their laughter, he heard the key in the double doors. Desperate, he ducked under the table—below the corpse resembling his father. The floor was wet and sticky, and it stank. Yet he was safer here, with no empty tables nearby.

The doors creaked open, and he saw the gray-stockinged legs of the men as they rolled a stretcher toward the women's row. As they passed, he crawled beneath the last two tables before the exit—coming then to a large pool of blood. At its edge, two rats watched him. Human flesh and blood had given them the courage of wolves.

"Holy Christ!" yelled the old orderly. "That dead woman's holding her baby!"

"Let me out of here!" screamed the young one.

As Leonardo ran through the doors, the frightened orderly began yelling after him.

"There he is! . . . The thief!"

In the side chapel, a priest was coming down the stairs from the church. Leonardo ran past him up the stairs, emerging into a startled gathering of worshipers at Vespers. Behind him, his pursuer screamed for help.

"Stop the thief! Grab him!"

A man at prayer looked up but did nothing. At the entrance, a sacristan leaped for him but missed. He ran out into the piazza, surrounded by the first dark shadows of night. Hearing the shouts behind him, several passersby turned.

"There's the thief!" he cried, pointing as he ran.

A few youths took up the chase, running with him down via Folco Portinari until he entered the dark alleys of Borgo degli Albizzi. No one followed him here, and he met no one. The back alleys of Florentine palazzi were littered with the dumpings from toilet chutes, collected at daybreak for farmland fertilizer. Night pots were also dumped from windows. Leonardo, skirting excrement, barely missed two yellow showers heralded by shutters opening overhead.

Finally, he emerged onto the via della Vigna Vecchio, near the Stinche prison, with its perennial crop of bankrupt Florentines and Medici enemies. Looking back, he saw no one. They might have encircled him, however, and he continued to run until he came to his father's home in the palazzo of the Guild of Bankers and Money Changers.

Yet even here, he knew he was not safe. By now, the entire hospital knew of a woman who had risen from the dead to nurse her baby. And Sister Agatha, or the orderlies, would say a boy had done it. That was enough for the Eight of the Guard to find him . . . and for his ambitious father to send him back to Vinci.

5.

Entering the palazzo, he heard his father in the living room. He was angry about something.

"I know we have to strip her of all jewelry, and I know she may wear nothing more than a simple muslin dress. I'm a notary, signore. Why are you bothering me with these stupid details?"

"I'm sorry, Ser Piero, but I am required to cite the sumptuary laws. Only two torches are allowed. If you use candles, they can't exceed four, nor contain more than forty pounds of wax, and they must be extinguished immediately after the funeral and returned to the dealer."

"I know, I know. The dead don't need light . . . but, by God, the living do."

Leonardo looked into the room. His father was seated at the window table with Luca Landucci, the pharmacist who had given Albi fertility treatments and was now discussing her burial.

"The mourners will be six, and you know the price. You pay for the black cloth of their robes, but afterward the robes are sold to help build and repair churches."

"Have you finished?"

"The funeral is set for noon at San Biagio, rather than ten o'clock, because of two others before your wife."

"My wife and the baby," said Piero, correcting him.

"I regret to say the child was not baptized. It cannot go into sacred ground."

"The prior of San Marco is arranging for an exception to that."

"He tried, but it was too late. The baby must go to Santi Apostoli."

"Holy God, my little boy buried in limbo," moaned Piero. "So we won't even find him in heaven."

Leonardo felt suddenly sad for his father and entered the room. Piero turned upon him with bitterness of the moment.

"Where've you been? We needed you."

"At the hospital."

"You ran away like you always do. My wife and son die, and you run away. Don't you have any feelings for my family?"

"I'm sorry."

"I don't understand you. Albiera was like your own mother. If you loved her, you would never have run away. Now leave us alone."

In his room, he sat on his bed, trying to control his anger and grief. At Landucci's, they would gossip about Ser Piero da Vinci and how he had lost his wife, and about the bastard son of a slave who had no love or feeling for his family. To hell with all of them. All that had mattered was Albi . . . and now she was gone. Except she wasn't really gone. She was everywhere in this house—in his room, which they had put together, and its window, where they had enjoyed sunsets over Florence. Most of all, she would be with him in her portraits.

He opened his sketchbook to the drawings from the morgue. *Cristo,* they were disgusting. Albi was nothing but a corpse. The baby on her bosom had

the revolting look of a dead fish. He traced the lines again, as one turns back on a lost trail, only to realize he had lost all control. It was a nightmare. Worse, he had no feeling for any of it, other than anger and loathing. Somehow, he had to find her. From an earlier sketchbook, he returned to Albi at Anchiano. Beneath it, he had written: "Blue shadow under hat in yellow sunlight, face roseate with pink *gamurra*. Opaque bodies take on color of opposite object, to degree depending upon the distance. . . . She's jealous of the inner image!"

There it was—the image within him, beyond the reach of death. With pen and ink, he blocked in forms of a mother and child. Then he configured the mother with Albi at Anchiano. With this, he turned to sketches in the hospital, before she went into labor. Here were other elements in her face and eyes—mortal shadings of her moving into motherhood. From these, more drawings followed, until he finally obtained a portrait of Albi with wonder and a mother's pride in an emerging smile.

He was now ready for the baby. In the morgue drawing, it was too small and distant from its mother. Once again, the drawings passed one into the other, until he had a child that appeared fully alive, with an infant's capacity for continuous spontaneity.

For the rendered portrait on a large folio of light brown paper, he did several in studies in ink, using red chalk for flesh tones, with brown, gray, and white colors for shadows, shadings, and highlights. Finally, one picture caught them in a private moment—the laughing child reaching for a rose in the hand of its mother, whose smile reflected her love and care. Yet on her lips there lay the shadow of buried sadness.

Where had that come from? It wasn't in the preparatory sketch. Yet there it was, surfacing by itself with the laughing child in her arms. So it belonged there, within this moment—Albi with an awareness of her tragic destiny and the death of her child.

"There you are," he said, propping it up on a chair next to his bed. Then he placed the lamp before it. The mother with her shadow smile and the laughing child appeared to move in the flickering yellow light.

"Good night, Mamma. Good night, little brother."

6.

Lucia saw the portrait the next morning when she awakened Leonardo to run some errands for the funeral.

"That looks like Albiera."

He nodded sleepily. Lucia stared at his large chest and arms. The boy was going to be bigger and stronger than his father.

"What's she doing with a baby?"

"She wanted one."

"Poor Albiera, she tried so hard. It's a cute baby. Whose is it?"

"Hers."

Lucia looked more closely. "No, hers was born dead."

"No more. Not now. Not here."

Lucia left, and Leonardo began to dress. He was pulling on a pair of green stockings when his father came to look at the portrait. He sat on the edge of the bed and stared at it. Leonardo sat beside him, feeling the bitterness of the humiliation the day before. To hell with you, he thought. I've got her now, where you'll never go. He felt his father's doublet against his bare arm, and he moved away.

"Very good . . ." Piero sighed. "The baby's also good. It's a real live baby."

He looked at the brown and gray hairs protruding from his father's nostrils. This man had never held him in his arms, nor said his name with love.

"Lucia says you saw him after we left."

He nodded.

"Lorenzo. That was going to be his name. Lorenzino . . . little Lorenzo."

"That's a nice name."

"I went to register him at the commune. Lorenzo di Piero da Vinci. But they refused, saying he had never lived nor been baptized. They knew everything about him. In Florence, God help us, there are spies everywhere."

He was speaking with his eyes closed, his hands on his thighs. Keep them closed, Leonardo thought. Otherwise, you'll see me . . . the son who did not die. Who was never legitimized as Leonardo di Piero da Vinci. Who has nothing more than the name of a town. To hell with you for all of it.

Piero opened his eyes and looked at the son next to him on the bed.

"I said to them, 'How is this possible? This was my son, my true son. I felt him alive in the womb. He kicked my hand, and I said, "Oh, Lorenzino! Take it easy!"' He was already a strong boy, and he would have been a great notary . . . you know what I mean?"

His father stared, expecting an answer. He made no reply.

"I asked them, 'Where can I bury the little boy who played under my hand in his mother's womb?' 'In limbo,' they said, 'in the graveyard for such babies.' Then I said, 'If he's in limbo, how will his mother in heaven ever hold him in her arms?' And they said, 'You were unfortunate. The priests were elsewhere, taking care of the living.' So I asked, 'What do I have to do—make a reservation for death?'"

This was profoundly sad. Impulsively, Leonardo took his father's hand. Maybe it was the one that had felt the moving infant in Albi's womb. He

pressed it, but there was no response. Then it was withdrawn, and his father stood up.

"Will you let Lucia have this picture to take to Vinci?"

He looked at the eyes that had never seen him, at the withdrawn hand of care, and he wanted Albi more than ever. He recalled her in the dream, smiling as he came to her: *Oh my love, I knew you would find me waiting for you....*

"I asked you, Nardo. Will you give this to Lucia for Vinci?"

"Yes . . . of course."

VINCI

September — November 1464

LUCIA PRECEDED HER FAMILY TO VINCI. Upon arriving, she removed a string of garlic from near the kitchen window and hung in its place the framed picture of Albi with her child. Leonardo had given it greater relief, using diffused light and color, against the distant slopes of Mont' Albano. In the light from the garden, Albi glowed with the happy child in her arms.

Olga and Monna Pippa soon rushed over to hear about the death in Florence. Upon entering the kitchen, they saw Lucia dressed in black mourning. With little cries and moans, they put their arms around her.

"May God help you," said Olga, whose sympathy for any friend was boundless.

"And all of us," added Monna Pippa, whose occult visions extended to other regions.

Olga then saw the picture by the window.

"Oh! That looks like Albi."

"It is, to be sure," replied Lucia proudly. "Drawn by our Nardino."

Olga and Pippa approached the picture with caution, Pippa's hooked nose sniffing it for further evidence. Then she pulled back to give her opinion.

"A little Madonna."

Lucia decided this was exactly what she needed to shift the talk to safer grounds.

"How true," she purred. "That's what Antonio says. It looks like a Madonna with Child."

Word spread through the village of a miraculous return of Albi as the Madonna. Don Piero heard of it, and noting hardly anyone at Vespers, he hastened over to see for himself. Outside the Vinci home, he noticed Mario the Wanderer, who followed feast days from town to town, with the usual supply of hard candy, kites, whistles, masks, and rosary beads. He also had prayer cards of the Virgin and Child, over which had been inscribed: "The Miracle Madonna of Vinci."

Upon entering, Don Piero found members of his flock praying as they prayed in his church. The priest shuddered. *Santo Dio,* this was cause for scandal. If the bishop heard of it, he might even send in a new pastor. A young woman kneeling next to him began to weep. He knelt to comfort her, and tears fell on the black sleeve of his cassock. How often did this occur in his church? These were tears of repentance from a heart filled with God. Who was he, a poor sinner like everyone else, to question where God showed His face?

With humility and wonder, Don Piero joined the others in singing a hymn to the Blessed Virgin. It was then, while opening his heart to God's mysteries, that the priest found a solution. Surely it would please everyone and save him from the bishop's wrath.

2.

After stabling the horses, Leonardo found the kitchen crowded with people holding a vigil for Albi. They were gathered in front of her portrait, which was lit by many candles, but he wanted none of it. The only people who cared for her were Caterina and Antonio, and they weren't there. Also, the picture wasn't right. Albi's left hand needed deeper flesh tones, and the child's left foot was too small.

He went to his room to examine the first portraits. How was it possible not to have immediately seen such errors? He was still at his table when Lucia came to say that Piero wanted to see him. Downstairs, he found everyone had left. His father and Don Piero were sitting in the garden, drinking a glass of wine.

"Sit down, son. Our pastor has a great idea for your career."

He sat next to the priest, who placed his hand on Leonardo's to further convey his feelings.

"*Caro figlio,* it appears that God has again guided your hand. This time, your beautiful *Madonna and Child* belongs in our church, where it may be adored more than in a family kitchen. So I am grateful your father has agreed to this."

Piero smiled, as though for a client. Leonardo was disgusted and shook his head.

"Excuse me, but I don't want that."

"What the devil are you saying?" demanded Piero. "Our pastor wants to put your picture in his church with those of other master painters. You should be grateful for such an honor."

"I am grateful, but I don't think Albi would want this. It's like sending her away from home . . . like we don't love her anymore."

Don Piero nodded, but his father shook his head angrily.

"Our feelings for Albi don't depend on where we hang her picture. Besides, you gave it to me, and I'm sending it to the church. I can't have people trampling through my kitchen all day long."

There was nothing more to say. Leonardo rose to leave, but Don Piero wanted another word.

"My son, I baptized you, and I have witnessed God bestowing gifts on you. Would you give me the small gift of a walk with me?"

As they left the house, the priest took his arm.

"Nardo, I don't want the picture if you wish to keep it. You know that, don't you?"

He nodded, and the priest said, "Many others also love it, and isn't that an artist's role? He has a vision of beauty and gives it to the world, as you've given Albi to us. After that, he proceeds to create another work of beauty."

They walked in silence until they had entered the church. The priest paused before a small chapel with a portrait of Sant' Agnese of Pistoia.

"You know something, Nardo?" The church was empty, but he lowered his voice to a whisper. "No one stops to pray or even say hello to poor Agnese. People in Vinci hate the Pistoiese, who always outsmart them. So I'd like to give this picture to my cousin for his church in Prato, and put your Madonna here. What do you say to that?"

Leonardo imagined the picture above the altar. Then he saw Albi laughing with delight.

"I'll have to fix it first. A few corrections."

"God bless you, my son. And by the way, your father is close to Andrea Verrocchio. He's notarized commissions for him with the Medici. I suggested he ask this famous master to take you on as an apprentice."

"No, thank you, Padre. My father has given me nothing, and I want nothing from him."

Two days later, Leonardo gave Don Piero another portrait, retaining the original one at home. He had redrawn the child and Albi's left hand. She now sat in a window, set against a landscape with a valley river and distant mountains. More than ever, the mother and child were in a secret world of their own.

The parish soon learned of the gift, and many people hurried over to see their new Virgin—only to learn she was in Florence being properly framed. And indeed, a week later the Vinci's *Madonna of Childbirth* reappeared in a gold-leaf frame above the chapel altar, illuminated by candles of the faithful. Shortly after this, Ser Piero returned from Florence and called his son into his study.

"I have excellent news for you, Leonardo. I showed your Madonna picture to Verrocchio while it was being framed, and he was very impressed. As you know, he's a client, but it was your picture of Albiera that interested him."

Clearly, this was due to Don Piero. But at least his father had agreed to it. "Thank you."

"He would like to see you and more of your work, with a view to taking you on as an apprentice. He's very particular in selecting boys for his workshop. But I think it'll work out, and you may even become known as Leonardo del Verrocchio."

"Is that what you want?"

Piero frowned at this. Then he tried it again.

"It's not what I want. It's what happens with artisans. Verrocchio's real name was Andrea di Michele di Francesco de' Cioni, but he adopted the name of his master, a goldsmith named Verrocchi."

"Well, I'm Leonardo da Vinci. I don't want another name."

"Calm down, son. I'm trying to help you."

"Will I still have my room to come home to?"

His room was on the top floor of the palazzo, with a dormer window, and full of light. Albi had insisted he have it, and she had helped him install shelves for books and art supplies. It was down the hall from the kitchen and the bedroom of Tara, the Tartar slave girl Piero had received from Cosimo.

"You'll always have your room here."

"I mean my room in Florence. Everything I need is there. I'm used to it and work well there."

There was a nod with the eyes closed, then a notary's thin smile.

"You might eventually live with your master. That often happens with talented pupils until they become masters and make a lot of money with clients like the Medici and the religious orders." There was a sly wink. "You can go into the Madonna business. Everyone loves them when they are young and delicious like Albi."

Leonardo cringed with revulsion. Was no memory sacred to this man? Did no love linger in his heart? Nothing more than a young and delicious Albi to be peddled for a handful of florins?

"Thank you," he said, rising to leave. "I'll be ready when Verrocchio wants me."

With mounting sadness, he climbed the stairs to his room. This had been his world for as long as he could remember. Here were his first memories of childhood with Albi. Here were his nature trophies from his family on the

wild slopes of Mont' Albano. Soon, however, his father would send it all away. He wanted the house empty, to start again with another woman in Albi's bed, another shot for a legitimate son.

More than ever, he was a stranger under his father's roof. Someday soon, he would leave. But until he was secure with Verrocchio, he needed the room in Florence. Albi would be there in a thousand scattered memories . . . and in the deepest regions of his being, where no one could ever find her.

PART TWO

FORGING OF A MASTER

VERROCCHIO'S WORKSHOP

April 1466 — August 1470

L EONARDO ARRIVED IN FLORENCE in late April 1466, expecting to
enter the workshop of Andrea Verrocchio. The youth from Vinci was
tall and of exceptional strength. Soft-spoken and courteous, he wore a
short rose-colored tunic in the manner of a nobleman.

The master had asked him to wait until he was fourteen, on April 15, and
he left a week later. Many in the crafts were apprenticed at eleven or twelve,
others a year or two later. In Florence, a boy of fourteen entered a man's estate
and was subject to a call to parliament during times of crisis, if his family was
eligible to vote.

With his departure, the Vinci home was set for a generational change.
Ser Piero had married again, a year after the death of Albi. Then Piero's father,
Antonio, died from pneumonia during a February frost that killed many
mulberry trees—slipping away in his sleep as quietly as he had lived, after
failing to become a prominent Florentine notary

In the family tradition, Piero's new wife was the daughter of another
notary, Ser Giuliano Lanfredini. As might be expected, considering Ser Piero's
needs and ambitions, she came with a handsome dowry. Leonardo had refused
to attend the wedding, and he was building a villa with Antonio in Pistoia
when Piero brought her to see the home at Vinci.

He was thus unprepared for the shock of meeting his new stepmother
upon moving into his room on the top floor of the Florentine palazzo. Barely
sixteen, Francesca Lanfredini could have been his sister, and Ser Piero, at forty,
her father.

He found her alone in the kitchen, wearing a pale blue nightdress. Francesca
had come upstairs from the master bedroom to light her lamp, but she was unable
to lower the raised pilot flame. Obligingly, he freed the pulley cord and lit her
lamp. In the soft light, she bore a haunting resemblance to Albi.

"I'm sorry," she said. "I was away when you came today. I've heard so
much about you."

He nodded. Who would have expected this? There were the same dark hair and delicate features, except for the stubby nose of a piglet.

"Your father says you are a gifted painter, and you'll be with Andrea Verrocchio."

He nodded again. Her shoulders and breasts were also similar. As if reading his mind, she smiled and drew her gown closer.

"I saw your portrait of Albi at Vinci," she said. "It's very beautiful. . . . Could you do one of me like that?"

"With a baby?"

"Not yet!" She laughed. "But Piero wants one soon, and a lot more!"

What in God's name was this? Shocked and confused, he bid a hasty good night and retreated to his room. In bed, he imagined her in the blue nightdress, the soft light on her face and the familiar shape of her body. It wasn't Albi . . . not with that piglet nose, nor those cold, calculating eyes.

No, he told himself, don't think about it. That woman is a threat to everything you want in Florence.

2.

He rose early the next morning—the first day of a new life. Now he would meet Verrocchio and be taken into his workshop. He had prepared for this day during the past year, assembling a portfolio of his work with studies of flowers and birds, as well as several new portraits of Albi.

With the portfolio, he walked with mounting excitement to Verrocchio's workshop on via dell' Agnolo. There were two large wooden doors and a smaller one on the right with a bell handle. He pulled it, and after a few minutes, a thin man in a gray tunic splotched with paint opened the door. He had a long nose and the sad eyes of a hound dog. Seeing a boy with a large portfolio, he shook his head.

"So you want to see the master?"

"He expects me. I am Leonardo da Vinci."

"Does he really? Wait here."

After ten minutes, the door opened again. This time, it was a blond youth in a brown tunic covered with white marble dust.

"The master says to come back in two days."

Leonardo waited, and the boy offered a smile.

"I'm sorry," he said, closing the door.

Had the master changed his mind? At first, he had appeared anxious to meet Leonardo. Then he had sent word to wait until Leonardo was fourteen.

Now he wanted two more days. Maybe the workshop had no more openings. If so, how could he face his father, or a return to Vinci?

Seeking relief, he left his portfolio at home and crossed the river Arno to climb the Bellosguardo hill overlooking Florence. This was known as "climbing the ladder"—and indeed, from its high bluff he had a breathtaking view. The City of the Flower was shaped like a budding lily. It lay astride its river with four stone bridges—three of them humpbacked with shops and houses. From the ramparts of its encircling walls, sixty towers bore the red-and-white flag of the republic.

Inside the city, another forest of towers rose above ancient, brooding palazzi. Above them all, soared the bell towers of the Palazzo della Signoria, the Badia, the Podestà, and Giotto's lyrical campanile next to the great cathedral, Santa Maria del Fiore. Its immense dome by Brunelleschi hovered over the city like the Madonna of Mercy sheltering humanity under her extended gown. Perched on top of the dome was a lantern-shaped temple enclosed in scaffolding by Michelozzi. Its wooden poles and crossbeams resembled bird wings in the blue sky—the ultimate reach of Florentine architecture toward the infinity of heaven.

Beyond the city lay a patchwork of green-and-brown farmlands. Here the colors were more diffused. Cennini had said nothing of this. Other than linear perspective, here was a perspective of color. Also, the outlines of trees and houses lost clarity with distance. So there were progressive variations between color and form as they receded in space.

There had to be some law governing this. Was it in proportion to the lessening of light, or the density of intervening air? A similar loss of perception occurred with distant sounds. For example, the bedlam of Florentine streets and markets, the mixed shouts and cries of men and animals, arrived at the hilltop with the rumble of a distant wagon train.

He decided to draw the scene, then realized he had left without a notebook. At a loss, he began to draw it in his mind—sketching first the shape of the city with its winding river, the walls, and then the distant *contado,* the farmland that fed Florence.

A network of white roads linked the patchwork of fields with wagons heading toward the city. He counted six of them—three large ones probably bearing meat and oil, and two smaller ones with fruit and vegetables. A large wagon, laden with barrels and drawn by two white oxen, most likely contained straw-colored Vernaccia wine—its vintner, like those at Vinci, swearing on the head of his mother that his wine would awaken the dead.

So the city was nourished and lived—a mindless creature feeding upon itself. To enter it and survive, he needed the security of Verrocchio's workshop.

Only then could he begin to explore the unknown realms of science and art. In the workshop, he would extend the laws of perspective, the negative principles of light and shadow, and the use of space to define form. Cennini had said nothing of this, either, but surely Verrocchio would know about it.

In the hospitals, he would dissect cadavers, since only through the dead could you comprehend living organisms. He needed all of this and more to enter the mind of nature and bring its power and life into his painting. That was what he sought, and when Verrocchio realized this, he would surely take him into his shop.

Feeling relieved, he descended the hill and crossed the Arno at Ponte Santa Trinità, next to a monk's hospice with its sundial, which he had duplicated for Don Piero at Vinci. From there, he plunged into the city—into the narrow streets beneath running streaks of sky, the sunlit piazzas with church facades like faces lifted toward God, and the patrician palazzi, their grim fortress walls of rusticated stone rising upward into a play of running arches and sunlit loggias, which bore mute testimony to the duality of danger and joy in Florentine life.

He had walked these streets often with Albi. Now they drew him onward with new wonders as the chaos of the day swirled around him. Donkey wagons skirted left and right, their drivers yelling "Eeeooh!" as though calling pigs. Street vendors screamed, beggars moaned, gamblers shouted curses, and, in isolated courtyards, prostitutes jingled their bells. From balconies came the jabbering of caged monkeys and parrots, mixed with the shrieks of housewives calling their neighbors.

At the Mercato Vecchio—the Old Market and heart of the city—the confusion and turmoil increased. Here a noisy, jostling crowd of Florentines—merchants, housewives, priests, nuns, house servants, well-born ladies in closed litters, as well as beggars and pickpockets—obtained their daily food from the street stalls and basket stands of farmers from the *contado*. Amid the noisy cauldron of the shouting vendors, other criers offered jobs or rewards for lost property, peddlers banged pots and pans, while the junkman's call resembled a broken carriage wheel: *"Chiabbratta-baratta, b'ratta!"* ("Something to swap or sell!")

By the time he left the market, twilight had arrived in a flood of golden light. In the fading light, he looked at the lantern atop the cathedral, encased in Michelozzi's scaffolding. An immense metal ball was to be placed on top of it with a cross in the sky. It would have to be done in stages, he decided, using platforms with Brunelleschi's cranes to lift it up the steep, sloping roof.

He turned to the Baptistery of San Giovanni—an eleventh-century octagonal temple with arches and panels of black and white marble. Albi had often brought him here to look at its four portal doors bearing the gold-plated

bas-reliefs of Andrea Pisano and Lorenzo Ghiberti. The first time, after a spring rain, the street flagstones were wet and black, and the portal figures a glistening gold. Albi had whispered as though in church: *There's Mary having her baby. . . . I want to weep every time I see it.* Then, taking his hand, she had placed it upon the bronze figures. *Feel them, Nardo . . . feel what your eye can't see.*

Once again, his fingers touched them, lingering on the bodies and faces. But Albi was gone and he was alone. Then he saw Mary looking at him from her bedside, and he was no longer alone. This woman and her child, and all the other biblical men and women, would be with him, as they existed in the hearts and prayers of millions. From this cradle of faith, this matrix of dreams, he would bring them into the world again immortal protagonists for immortal art.

3.

The cultural and artistic splendor of Florence, which fed Leonardo's hopes and dreams, was inspired by a new vision of man and the universe. Emerging from shadows of the Middle Ages, it ushered in a new and brighter age—a Renaissance, or rebirth, of cultural and spiritual life in Italy, with repercussions elsewhere in Europe.

Florence epitomized the power and glory of those promising years, especially during the 1400s, or Quattrocento. Some forty families, with immense wealth from banking and foreign trade, enriched their palazzi, churches, and religious orders—commissioning works of art and architecture, and supporting scholars of literature, philosophy, science, and astronomy.

Carved and painted images were the media of the day. In Leonardo's Florence, some three hundred artists and architects filled this need. A picture of the Madonna became an intimate member of a family. Frescoes in the sanctuaries of chapels, and on the glory of altars, testified to the continuum of a God-given faith from the birth of Christ to Judgment Day. Artists and architects serving these diverse enterprises were often masters in other fields.

One of them was Andrea di Michele di Francesco de' Cioni, who took his name, Andrea del Verrocchio, from his first master, a noted goldsmith, Giuliano del Verrocchi. An accomplished goldsmith, painter, sculptor, woodcarver, and musician, Verrocchio was also versed in mathematics, geometry, and the new science of perspective. With these gifts, he was an excellent teacher, and entry into his workshop—or that of his archrivals, Antonio and Piero Pollaiuolo—meant the apprentice would receive the best-possible instruction in the arts.

The training, long and arduous, usually took six years. After that, with the master's approval, the *garzone* was eligible to become a master in his own

right. He joined the Guild of Apothecaries and Doctors, which included painters and writers, who depended on pharmacies for their materials. Painters also had their own Confraternity of Saint Luke, who was said to have painted a portrait of the Virgin Mary. Sculptors belonged to the Guild of Masters of Stone and Wood.

A painter was known as a painter, and a sculptor was a sculptor, for they were artisans, similar to cabinetmakers, tailors, or goldsmiths. The term *artist* was rarely used. Yet as practitioners of the noble arts, they, along with architects, were generically known as artists.

4.

He sat before the large worktable while Verrocchio looked at the drawings in his portfolio. On the table were two boxes of charcoal and colored chalk, a tin of quills, an ink pot, a parabolic ruler, and a scalpel white with gesso. The master's hands were large and powerful. His arms were large, too, and he had a bull neck and massive shoulders.

They were in the master's private studio within the workshop. To the right of the desk, there was a drawing table. Next to it, on a work stand, was a panel painting of a Virgin and Child, set against a distant landscape. The Virgin's eyes were cast down toward the infant in her lap. This was lovely, but the playful child had stubby, lifeless hands. How, Leonardo wondered, could the master have gone wrong here? And while the clothes of the Virgin were richly worked and realistic, the landscape lacked perspective and the reality of nature.

"These drawings are of your mother and her baby?"

The master was staring at him—a square, stern face with slanted, wing-shaped eyebrows and dark, brooding eyes.

"My stepmother."

"Oh, yes. I was told your mother was a Circassian slave."

"And a beautiful woman."

The master nodded. "They can be beautiful. Cosimo had a son by one of them . . . but here you've portrayed your stepmother and her son as a Madonna and Child. . . . You did these after they died?"

"I did others before that."

"But to obtain these, you went into the morgue at Sant' Egidio?"

"Yes."

"Why did you do that?"

This wasn't going too well. The master seemed upset. Then he appeared to relent with a nod.

"Forgive me. . . . You don't have to answer that. Many people these days want death masks like the ancient Romans." He looked again at the drawings. "But these are more than that. They're living portraits. Most of my students go the other way. They make living people look dead."

He smiled, then nodded. "Your father says you had no teacher. That you began to draw as Giotto did, on stones while tending sheep."

"Not stones. Albi, my stepmother, gave me the drawing materials."

"Was she an artist?"

"No, but she knew all the important ones, and she took me to see their work."

"Who were these important artists?"

"They were not always important."

The slanted brows lifted in surprise. "All right. Tell me about the ones you believe to be important."

"Masaccio. It began with him. Also Giotto, Gentile da Fabriano, and Donatello. They taught Masaccio space and form, but not light. He got that all by himself."

"How do you know that?"

"I have never seen anyone else with it. Have you, master?"

"How do you perceive his light?"

"I see it in four ways. There's ordinary daylight, then direct light, as from the sun or from an open door or window. Then there's reflected light, and the other kind, which is altered in passing through objects like the gauze of windows or a thin veil over a face."

He expected some sign of approval, but there was only a frown.

"You found all this in Masaccio?"

"Yes, Master."

"Where do you think he obtained it?"

"Oh, from nature. Since no one else possessed it, he could only have found it there."

"You mentioned Donato," he said, using the familiar name for Donatello. "But you seem to prefer painting. Doesn't sculpture interest you?"

"Oh, signore! Everything interests me. There is nothing in man or nature that does not ask questions."

"Those are very elegant words for a boy of thirteen . . . or are you older?"

"I became fourteen last week. I waited, as you requested."

Verrocchio wondered what to do with this precocious boy. He had never had seen anything quite like it. Other boys came to the shop like lost sheep. This one, with the gray-green eyes of a Circassian, was more of a wolf. Also, he seemed older than fourteen. Tall and powerfully built, he looked sixteen or

more. There was also a rare beauty, especially in the face. It could be that of a Greek god or a virile saint like Saint Peter—the high, noble brow, the straight nose and broad mouth, the strong chin, and the long auburn hair falling to a dark green doublet with silver buttons and a lace collar.

Nobody in the workshop dressed that way—not even himself. Also, this boy was too far ahead. An apprentice never attempted a style of his own until he had absorbed that of his master. This one, however, had skipped all of that and was full of cocky ideas about painting. No, he wouldn't fit in the workshop. This was unfortunate, because he was behind on projects, and they needed another apprentice.

The boy was smiling again, as though he had been accepted. His father had probably told him it was all set. Indeed, Ser Piero had offered a florin a month for the boy's room and board. Clearly, that ambitious notary wanted to start another family without this illegitimate son in the way. To avoid angering the notary and losing his services, he would send the boy home to await a call, while finding him another workshop, probably with Antonio Rossellino or even his rivals, the Pollaiuolo brothers.

There was a knock on the door and an apprentice entered. Leonardo recognized him as the blond youth who had apologized in turning him away from the shop.

"What is it, Gianni?"

"Biagio needs the head now."

"I told him to take it," snapped the master, withdrawing from the table drawer a sheaf of pattern drawings.

They spilled out onto the table—studies of heads, arms, legs, and folds of garments used in unifying the shop style. He withdrew a portrait of a young woman with elaborately braided hair. Its lines had been punched for transfer to a panel, and in the window light they glowed with life. Her head was inclined, the eyes downcast with a smile, as though gazing at a child in her arms. A few stray tresses of hair fell across the plane of her temple and the fold of her cheek. Leonardo was overwhelmed. Here was the work of a true master. In a few lines, he had created a woman whose life and beauty rode on each curve of the pen.

Verrocchio gave the template to Gianni. "Tell Biagio to wait for me."

He turned to Leonardo, who seemed to realize he was being rejected.

"What's the matter?"

"I'm ashamed," the boy replied. "I thought I could draw, but I know nothing. . . ." He faltered, then smiled. "But I'm excited because I have so much to learn from so great a master."

Verrocchio paused. What in God's name could he say to that? The boy smiled again.

"Are you going to transfer that drawing onto a panel?"

"Yes."

"May I watch you do it?"

"Yes." He sighed. "Come along, but then you can go home, and we'll send for you when we're ready."

Leonardo followed the master with relief and pride. He had made it. This great man's workshop would become his home.

They entered a large studio used for sculpture. Light entered through varnished muslin of a long window. Marble dust lay on the floor and in crevices of the stone walls. Ropes with pulleys hung from two large beams. Many works were in progress—a marble altar rail, a tabernacle for a street corner, and an immense bell with a band of dancing putti in honor of Cosimo de' Medici.

From the sculpture studio, they crossed an open courtyard with blocks of marble and travertine, bronze ingots, copper sheeting, a forge, and fagots of poplar, linden, and willow. On the other side of the courtyard, they entered the opposite wing of the palazzo, devoted to painting and the humdrum craft and repair typical of a workshop—a religious banner, two chests with a headboard, a suit of armor, and a shield with a faded coat of arms. Beyond these, along the wall, were plaster models of arms and legs with assorted hands and feet.

They came next to a tempera painting of a headless Virgin with Child on a work stand. Leonardo wondered what the master would say about this clumsy effort. The Virgin held her child upright on a balustrade, as though the infant were about to fall or go into a dance. It wore a necklace of tiny rubies containing a small crucifix, with the right hand raised in benediction.

Verrocchio shook his head in disgust.

"Biagio, that crucifix is thirty-four years ahead of its time."

"It's a symbol of the child's divinity," said Biagio. "Like the benediction."

"We don't need symbols or that ugly necklace."

Biagio stared at the necklace and wrinkled his long nose as though sniffing for some clue. Leonardo waited. This was the arrogant assistant with the face of a hound dog who had turned him away the first day.

"Can't you see it?" prompted the master. "It turns baby Jesus into a toy doll. We have to remove it."

"The abbot wants it."

"Then tell him to paint it himself. If we give these scripture-creeping monks a free rein, they'll drag us back to Cimabue. . . . Where's the drawing for her head?"

Gianni gave it to him, and he placed it beside the head of the infant Jesus.

"Good, the proportion is right. These babies tend to have bigger heads than the mother, especially Fra Filippo's bambini."

He positioned the drawing on the stump of the Virgin's neck. It was now ready, Leonardo knew, for transfer to the bone white surface of the panel by punching, or passing charcoal markings through its perforated lines. After that, the master would apply the first basic colors for the buildup of flesh tones and finish it himself—or, depending on the painting, turn it over to his shop foreman.

A selection of color pigments lay on an adjacent table in small tins. Several had already been mixed with water and egg yolk, used in tempera painting. Verrocchio inspected them.

"Green," he said. "We're going to need light green for the underpaint."

"I know," replied Biagio. "Where's the green, Gianni?"

"I'm sorry . . . I thought you wanted me to stay with the Rucellai panel."

The master frowned. "Biagio, what the devil is happening here?"

Leonardo glanced at the tins of color pigments, then turned to the master.

"May I do it for you?"

"Do what, for God's sake?"

"Work up a light green. We have it here," he said, taking three containers.

Verrocchio looked at them. "Azurite, *giallorino,* and *arizica . . .* not bad, boy. How'd you know to choose them?"

"From Cennini, master."

"I thought your mother bought everything for you."

"Including his *Book of Art,*" he replied, straddling a workbench with the color pigments before him. "It would help if we had some wild yellow plums. But I can start now, master, if it so pleases you."

"Wait," demanded Biagio. "Who is this boy?"

Verrocchio shook his head, but Biagio persisted. "If we need green, let Gianni do it. He knows how."

There was no reply. The master and the entire workshop watched the new arrival take a nugget of azurite, crush it in a bronze mortar, then lay it onto the bench top of red porphyry stone. Using a smaller piece of flat porphyry, he began to grind the crystals into a fine powder. Some grains of the blue mineral came onto his dark green stockings.

With a sigh, Verrocchio turned to his assistant, Biagio d'Antonio.

"He's going to ruin his clothes. Give him a work coat."

5.

For three days, Verrocchio postponed his decision on whether to take Leonardo. The boy's ability to mix colors was followed by other revelations. He learned quickly, and he handled menial, tedious details with patience and care. He was soft-spoken, and he mixed well with his companions. He played the lyre beautifully and sang with the others after the late-morning meal prepared by Mamma Agnese, the housekeeper, who was delighted with him. The boy with the wolf's eyes had been accepted by the sheep. Even Biagio, who grumbled and distrusted any newcomer, seemed pleased with this one.

There was immense promise in him. His drawings lacked in anatomy, but they had an intuitive strength that was exceptional. However, that was only the beginning. You could know Cennini by heart, and have the courage of a hundred wolves, but that alone would take you nowhere. At the end of the third day, he brought the youth into his studio at the rear of the shop.

"I must be frank with you," he said. "At first, I worried you would not fit in here, into our family. But I believe I was wrong, so I'm going to give it a try."

"Why were you worried, master?"

"Many hands are involved in any work we produce. They must all resemble those of the master."

"I understand that."

"I know you do. But you also have a stronger creative force than any boy I've seen at your age. This is a daemon of unknown destiny. I don't know how far it will take you, or how much trouble it may cause me."

"How can a creative force be a daemon?"

"For the Greeks, it was a good spirit that inspires us. For the Christians, it's an evil devil." He smiled wryly. "The priests suspect human creativity. It occurs outside of their control."

Leonardo was amused and relieved. "I assure you, master, my daemon is a friendly Greek, not a Christian."

The master shook his head. "It's not always friendly. Every creative force has an equal power to destroy. Never forget that. It's the first and most important lesson I can give you." He hesitated. "An artist with your drive must have one mistress only . . . your work. All your thoughts and dreams must be there, nowhere else. No matter what happens, follow them and keep working. Even a simple sketch can turn you around. The daemon will respond to that. Especially yours. It will take you far . . . and eventually away from here."

Verrocchio now realized why he was talking this way. This boy would take every lesson from his master, until they were like father and son . . . then one day he would leave. He seemed to realize this.

"Away from you? Not for a long time, I hope."

"I hope so, too. We can use your daemon, Nardo . . . as long as it behaves itself."

"It will. . . . I'll teach it to behave."

He smiled, and Verrocchio nodded. It was a worthless promise. Daemons had minds of their own, which could never be harnessed, even by those who sheltered them.

6.

Within the new world of the workshop, Leonardo never lost his identity in the primal world of nature, which he had begun to explore as a child. Later, he stressed in his *Treatise on Painting:* "Those who study only the authorities and not the works of nature, are but grandchildren of art . . . why go to a well when you have a river at hand?"

To explore it in depth, however, he needed the pathways of natural history, physical science, and mathematics. These would allow him to reduce experience into graphic statements as a way of exploring the unknown and establishing the truth of any assumption. In this, he proclaimed his second article of faith: "There is no certainty in sciences where mathematics cannot be applied."

Verrocchio taught him mathematics and perspective, and introduced him to Leon Battista Alberti's treatise on painting—*Della pittura,* the first book of its kind to discuss theory and technique in the context of nature, beauty, perspective, and ancient art. Leonardo was overwhelmed. Alberti's words, his critical theories and criterion of excellence seemed to be his own. Indeed, he took what he wanted from him—as he took without scruple from others.

There were other, surprising similarities. Alberti was the illegitimate offspring of an exiled Florentine family, while he, Leonardo, was illegitimate and an exile in his father's home. Both had come to Florence to prove themselves. Alberti had succeeded as mathematician, natural scientist, painter, architect, athlete, poet, musician, and philosopher. Leonardo realized he had to go beyond this, or remain in the shadow of this man whom he resembled in so many ways.

Among other scholars and teachers, one man opened the doors of the universe to him: the legendary Florentine Paolo dal Pozzo Toscanelli—physician, cosmographer, astrologer, mathematician, and philosopher—whom he first met at the funeral of Donatello in December 1466.

7.

A river fog and cold rain had shrouded the city for a week. During the night, however, it had blown away and now, as the group walked along the Arno, they could feel the sun upon them, cutting through the crisp winter chill. Verrocchio sought to explain the history of the moment.

"Today the bells are tolling for more than one man," he said. "We are losing another galaxy in our new age of art and learning. The first one with the Pisano brothers, and Fra Angelico planted its seeds. The second, with Masaccio, Donatello, and Brunelleschi was its flowering. . . ." He paused, glancing at Leonardo. "The new stars are only the horizon."

Upon arriving, they found a large crowd gathered before Donatello's home on via del Cocomero, where he had lived alone for ten years after the death of his beloved companion, Filippo Brunelleschi.

Most of Florence was there in homage to the great sculptor—artists and scholars, notables of every rank, foreign diplomats, and many peasants and workers who saw themselves in Donatello's saints and heroes.

As Master Andrea's workshop group of five waited in line to view the body, he pointed to other artists arriving.

"There's Paolo Uccello," he said. "He wasted a formidable imagination for many years working on mosaics at St. Mark's in Venice, and painting windows for Florence's Duomo. Then at forty, he became a master of perspective. Look at his haunting *Deluge* in Santa Maria Novella, or his *Rout of San Romano* in the Medici Palace."

He then nodded toward an old man who was walking slowly in a black cape with red piping, accompanied by a youth.

"That's Filippo Lippi with his apprentice, Sandro Botticelli . . . and something else to remember. After Masaccio and Donatello, Florentine art fell into two camps. One group took the high road, focusing on reality and depth, like Paolo Uccello and Andrea del Castagno. The others chose the low road, concentrating on delicate line and color, like Domenico Veneziano and this Fra Filippo. He's another Medici favorite, a Carmelite monk, a liar, a drunk, a letch, and a fraud. But he's painted delightful Madonnas, mostly peasant girls. One of them, however, was a novice in the Prato convent. When he ran off with her, the nuns and the girl's father were hysterical, and Cosimo got the Pope to dispense of the runaway monk. Then they had a son, named Filippino, who'll probably be a painter someday."

"He must be worn-out," said Gianni.

"He's sixty and still at it." The master smiled. "It's a miracle some husband or father hasn't poisoned him."

Everyone laughed. In the moving line, they were near the house, and he began to talk about Donatello.

"None of you ever saw him at work, not even you, Biagio, because he was paralyzed for a long time. In the end, he could only look at you and smile. Then he couldn't even do that, but his eyes spoke for him. . . ."

He paused and his little group waited—Biagio, Nanni, Renzo, Gianni, and Leonardo.

"This man was my true master. He raised a living Christ out of clay for the pulpits at San Lorenzo. When you go there, study the man's face and body. Feel the energy and life. This is not a corpse returned to life. It's a man who never died, because all humanity is there within him. . . ."

He paused, again searching the faces before him. Leonardo had grasped it. You could see it in his eyes.

"So when you enter this house, I want you to look beyond the dead body. Try to imagine it alive, creating a work that will live forever. If your work ever comes anywhere near Donato's, you will also live forever."

The line moved forward, and they entered a small courtyard of the palazzo; wooden stairs led up to the first floor. The stairway was crowded with people going up and coming down. At the top, Verrocchio's group made their way down a corridor to a bedroom, where they finally saw the artist on his bed, dressed in a black muslin tunic with black stockings. His hands were folded upon his stomach, and four large church candles stood at each corner of the bed.

The body was small on the bed and the face was also small and had the perked ears of a bat. The nose had a hook to it, and the mouth was large for such a face. Looking beyond the corpse, Leonardo saw a nude youth portrayed in chased bronze on a pedestal—Donatello's *David*. The face had exquisite beauty, framed by long tresses beneath a wide-brimmed huntsman's hat crowned with laurel. The polished and gleaming body had the budding breasts of a girl, a round female belly, and a little scrotum with a stubby, extended penis.

Leaving the room, he found Andrea in the kitchen, talking to an old woman who was sitting in a chair with a bunch of yellow roses in her lap.

"Goat's milk," she said. "I went to get it, like the doctor told me. It happened then."

"How could you have known?" Andrea said. "Only God knows such things."

"Don't talk to me about God. I'm not speaking to Him."

"Master Andrea . . ."

"Ah! Ser Lorenzo!"

It was the young Lorenzo de' Medici. Leonardo had seen him once at the Duomo, on the feast day of San Giovanni, with his ailing father, Piero, who had assumed the Medici rule after Cosimo's death.

He had a tawny complexion, like Cosimo, with straight black hair that parted in the middle and fell to his shoulders. The broken nose was scooped—flat in the middle, with a rounded tip and wide nostrils. The simian nose, the furrowed brow and jagged black eyebrows over dark, piercing eyes, gave the face a virile, almost brutal appearance. Yet, as he smiled, there was the sensitive face of a poet—a formidable figure, confounded by the nasal voice of a female dwarf.

"My father has discussed your model for Cosimo's tomb with the clerics of San Lorenzo. . . ."

Here it comes, Verrocchio thought. Piero de' Medici had haggled for months over Cosimo's tomb and floor marker. Now priests smelling like goats were going to creep over it. Madonna, this had to stop.

"Maestro Andrea, you have created the perfect tomb and floor marker. My father is deeply grateful and hopes you will install the marker as soon as possible."

"Thank you, sire," he replied, greatly relieved. "By the way, I was surprised to see your *David* in Donato's bedroom."

"My father sent it to him, knowing he loved it. He deeply regrets not being here today. Did you take a death mask?"

"We were not asked."

"That's a pity. We would have liked one."

The sculptor indicated Leonardo. "He can get the material and do it in half an hour."

Lorenzo stared at Leonardo.

"You'll use that boy for this?"

"He's a disciple, not a boy."

Leonardo never forgot that reply—the bristling defense and what it implied. His master had advanced his workshop status by two years. No longer a *ragazzo,* he was a now a *discepelo.* More than an honor, it was a sign of trust and affection.

Lorenzo smiled and nodded. "Forgive me, I should have known, Messer . . ."

"Leonardo da Vinci."

Verrocchio watched the exchange with wonder and pride. Lorenzo spoke as a Medici prince who dealt with Popes and princes and kings. Leonardo

replied as a prince from the realm of art. It was not lost on Lorenzo, who smiled again.

"It's a pity we'll not have a mask of Donato. Cosimo loved him, and my father provided for him to the end."

"Indeed, a pity," Leonardo agreed. "But a mask, taken from the outside, can never enter the inside of a mind or a soul. It remains an outside form."

"It depends on the form. For Plato, the ideal form can generate its entire self."

"If Plato is right, then painters and sculptors are a prime example of God's existence."

"As are poets," insisted Lorenzo Medici.

"Less so, I believe."

"Oh? Tell me why."

"Because it is nobler to imitate the primal elements of nature, which are real, than the reported words and deeds of man."

"Are you implying that a flower has greater innate nobility than a knight?"

"Renzo . . ." It was Giuliano, Lorenzo's brother. "They are ready for the removal."

Lorenzo nodded and turned to Leonardo. "We must continue this sometime with Marsilio Ficino. He'll give you a hard time!"

"Not as hard as you, I fear."

The Medici heir smiled. "Good day, Messer Leonardo. Master Andrea, my father will call you when he feels better. He also wants you to finish the lavabo in San Lorenzo."

"Thank you, sire."

Verrocchio shuddered. He had inherited a dead man's job. Donato was to have done the monumental washbasin for the Medici church. Yet there was no way to avoid this. Now other Medici commissions would be coming to him—if not to Rossellino, Benedetto da Maiano, or, more likely, the Pollaiuolo brothers.

With Lorenzo gone, Leonardo turned to his master. "Are you angry with me?"

"No, it ended well. But remember, the Medici do not like to lose at anything, especially this one. We must be careful, Nardo. Piero won't live much longer, and Lorenzo will rule Florence for a long time, or until the family disease also grabs him."

They joined their group outside. Many others had arrived, including Antonio Pollaiuolo with his brother, Piero, and their apprentices. Verrocchio nodded to his rival with a feeling of envy. Antonio had a brother to help him.

So did Antonio Rossellino, and Luca della Robbia had his nephew, Andrea. A family workshop with roots like that prospered and endured. He had only a mediocre, uninspired assistant like Biagio, who would soon leave, taking the workshop's secrets with him.

"Those are the Pollaiuolo brothers," he told his waiting group. "The older one, Antonio, is more talented than his brother, Piero. He began as a goldsmith, like a lot of us, and he's a gifted draughtsman who knows human anatomy. But his three *Labors of Hercules* for Cosimo de' Medici have muscles like a bag of nuts. That tells you everything. He has admirable technique but no heart. If you lack that, nothing can help you."

"How did he learn anatomy?" asked Leonardo.

"Before the medical school moved to Pisa, we watched them dissect cadavers at Santa Maria Novella."

"Can we no longer see it done here?"

"Sometimes they do a hanged criminal or a runaway slave. Antonio still goes to them."

"I'd like to go, too. . . . May I?"

Verrocchio frowned at the thought of his prize pupil going to his hated rival for anatomy lessons. At that moment, he saw Paolo Toscanelli.

"There's your man," he said, calling to Paolo. "He taught me, and he knows more than anyone else."

A tall man with a long white beard, leaning on his cane, glared at them with the eyes of an eagle. Verrocchio took care not to favor Leonardo over the others—especially Biagio.

"Paolo, these young men are in my *bottega*. They want to study anatomy."

The eagle's eye swept over them—from Biagio, the eldest, to young Leonardo.

"Balls. They're all too young."

"I've dissected many animals," said Leonardo. "And I tried to do a corpse at the graveyard in Vinci, but they stopped me."

Toscanelli turned to Verrocchio. "Who is this little devil?"

"He's Leonardo da Vinci."

The eyes bore upon him, looking for some flaw.

Verrocchio saw this. "Why don't you try him and see what he can do?"

There was a grimace, then a nod. "All right, *ragazzo*. Tomorrow, before midday."

A sudden stir in the crowd was followed by silence. The coffin, draped in black with the dove of the Holy Spirit embroidered in gold, was being borne through the doorway. The funeral cortege followed, preceded by choirboys

and a chanting priest bearing a cross. The Medici brothers, family members, and a long column of mourners trailed the bier, borne by black-hooded men of the Misericordia—an ancient voluntary lay order of prominent citizens assisting in matters of death and burial.

The streets were lined with people, and Leonardo saw in their faces a profound grief, as though this artist belonged to all their families. Many of the old and infirm sat in household chairs along the street. As the procession passed, they crossed themselves. Some waved good-bye to an old friend.

8.

The following day, Leonardo called on Toscanelli in his old palazzo behind San Giovanni. A slave girl opened the door. Her face was like that of Tara, who belonged to his father. How could the republic survive without these poor creatures? Then he heard the old man's voice.

"Who is it?"

"A young signore."

"Oh, the Leonardo *ragazzo.* Bring him in here."

He was led through a room with books and maps, into another room containing various cosmographic instruments he had never seen before—an astrolabe for taking the position of the stars, a quadrant for altitudes and angular elevations, a diopter to calculate levels, and a cross-staff for reading angles. The involuted lines and astrological symbols on the astrolabe's copper plate were most mysterious.

"Where's the *ragazzo?* Why isn't he with you?"

"Here I am, signore!"

He entered a vast room with a large window, a skylight covered by a black curtain, and more tables with maps. The old man with the long white beard sat in a large wooden chair, dressed in the brown tunic he had worn at the funeral. Another large chair in front of him was empty.

"That's not for you. Go look at that," he said, pointing his cane at a terrestrial globe.

Leonardo had never seen anything as elaborate and beautiful. He located a landmass marked *Italia,* then *Espagna* next to it. Both were extended into the sea, labeled *Mare Nostrum.* On its southern shores lay a club-shaped form— *Africa.* Looking north, he found other countries marked in script: *Francia, Germania, Scandinavia,* and, to the left, *Inghilterra.*

"Turn it," said Toscanelli, now standing beside him.

He rotated the globe, leaving *Inghilterra,* or England, to enter a vast body of water. Crossing this, he came to another landmass with a ragged shoreline

of bays, inlets, and outlying islands. Moving inland, he found indications of mountains, rivers, and great plains. Then he saw its name—*Cina*—taken from the maps of Marco Polo and others who had followed the Venetian to this distant world. Below it lay a land that resembled a hog's heart: *India*.

"Keep going, boy!" cried Toscanelli, stomping his cane.

Turning the globe, he continued his westward journey across a desolate landscape to finally enter the *Medeo Oriente*. This had been thoroughly mapped by Arabs and Egyptians and, in recent years, by Florentine merchant fleets. From there, he crossed over *Grecia* and returned again to *Italia*.

"Well, what do you make of it, boy?" demanded the patriarch, the eagle eyes peering out above the white beard, the cane stomping like a horse.

"Don't you see it? The world is round! It's a spinning ball! It revolves around the sun, and the other stars are simply planets like ours! So, my little friend, what do you make of all of that?"

"I'm not surprised at all."

"Hah! So you also dug this up in your graveyard?"

"No, sire. It's like this. If you removed the light of the sun, everything living would die. So the sun is the center of life, and it must therefore be the center of the universe."

"Bravo! But how do you know the earth is round?"

"How else do we lose sight of ships at sea, if not below the curve of the earth? So we are round, like the moon or a cheese drum."

"Hold on! The priests say that's all macaroni water. Why, they ask, do we not fly off at the bottom of the spinning ball?"

"The force that pulls all of us, even a feather, toward the earth's center is greater than any other opposing force. Does water fly out of a swung bucket?"

Toscanelli roared with laughter. "Oh! You are a terror! Thank God the priests didn't get you!" He sank back into his chair. "Now, sit down here, before me."

The old man leaned forward. "Do you know how to draw cities and mountains and rivers from the air?"

"No, sire."

"I will teach you. Do you know how to read the stars? I will also teach you that, for I need someone to help me. Come every Wednesday and Friday morning."

"I can't leave my master on those days. May I come Saturday afternoon and Sundays?"

"We can try it."

So Leonardo began to frequent Toscanelli's house. The old man taught him to look into the skies, across the seas, and into the mysteries of the human

body. He also promised him that he would witness a human autopsy, when possible, at the Santa Maria Novella hospital.

Leonardo assisted Toscanelli in formatting and illustrating his maps. One of these contained Toscanelli's concept of an unexplored landmass, or continent, between Europe and China. A copy of this map was sent to an Italian living in Lisbon—Cristoforo Colombo. Ten years after the death of Toscanelli, Colombo would set sail to realize his dream of voyaging westward to India. On the vast, trackless face of the ocean, with no certainty of returning alive, he would bend over the map of the great Florentine and summon the courage to sail onward.

9.

During the next two years at the workshop, Leonardo mastered the basic studio skills, including how to create and lay on colors, bind brushes, make sizing, prepare panels for tempera painting and walls for frescoes, lay gold on fabrics and wood, set jewelry, solder metals, carve wood, model in clay, and sculpt in stone.

He was close to seventeen and ready to prepare paintings and sculpture for the master, while executing minor, usually ornamental, elements. At this point, his career took another turn.

In the course of training, he had learned the usual craft secrets while also improving on many of them. One of these was an adjustable leather hood, which simplified Cennini's method of making gesso masks from dead or living subjects. As a result, Verrocchio put him in charge of making the increasingly popular death masks. It was routine, with little risk of trouble from the youth's creative daemon. He soon discovered, however, that he might as well have placed a falcon on a tree limb and expected it to stay there.

It began when Leonardo was summoned to do a death mask at a home near Santa Croce. He took Gianni with him, and upon arrival, they found the subject for the mask was still alive but in a coma. The daughter and her husband apologized for their babbo. Then, upon learning that a second, postmortem visit would cost more, they agreed that Leonardo could take Babbo's mask immediately.

Leonardo coated the face with olive oil and inserted two trumpet-shaped silver tubes into the man's nostrils, taking care not to spread them. Babbo was ready, and they applied white plaster made of soft stone from Volterra—baked in fire, then pounded into a paste with tepid water—covering it finally with the leather hood.

The procedure went smoothly until Babbo began to stir, then return to life with considerable vigor. Leonardo and Gianni, driven by muffled cries from the old man, sat on his arms and legs until the plaster had hardened.

Leonardo lifted off the mask, and the old man, his face glistening with oil, his eyebrows speckled with plaster, glared like an enraged eagle.

"Daughter of Satan! You buried me alive!"

"Oh no, Babbo. We only—"

"Don't Babbo me, you harlot. I couldn't breathe, and you sat on me like I was dead. . . ." He paused, seeing the two young men in brown workshop tunics. "You call that a doctor?"

"They make masks, so we did it while you were asleep to make it more lovely."

"And we got it at half price," announced the son-in-law proudly.

"How much?"

He hesitated, then looked at Leonardo.

"You don't know!" cried Babbo. "I'm not dead yet, and you're already throwing away my money. You stupid asshole! I'll curse you from the grave!"

"O Dio!" cried the daughter, collapsing onto the bed with her father.

Amid the confusion, the two apprentices quickly escaped with the mask. Laughing and in high spirits, they walked along the Arno toward the workshop. At one point, Leonardo held the mask aloft like a trophy.

"You'll see, Gianni. With this mold, he'll appear alive. If we study it well, there's no reason why we can't do it all the time and charge them double for it."

"Is there any real difference?"

"You'll see it. . . . Here, maybe you can feel it, too."

Placing the mask on a parapet above the river, he took Gianni's hand and placed it within the imprint of the mold.

"The spirit is still there. . . . You can feel it."

Their fingers moved into the inverted features of life. As they entered the eye sockets, Leonardo tapped Gianni's index finger.

"There . . . you feel it?"

"I feel something else, Nardo."

He also felt it—Gianni's hardness against him, his voice low and strange, the boy's eyes searching his. Gianni pressed closer, and Leonardo felt an instant arousal. It ran through him without control, and he also wanted to touch this boy that way. Those lips were like a girl's, and the face had a delicate, porcelain-like beauty.

"So you want me, too. . . . I knew you would."

It was true: at least he felt he wanted it—but not like this. Young men all over Florence had one another, including some of their friends, and he often thought of Gianni in that way. But this was too sudden, too out of control.

He looked at a woolen mill on the opposite shore of the Arno. The river, swollen from recent rains, was running fast. But the mill wheels, protected by channeled streams, were turning at a regular pace. Drawing gave you that control. It freed the creative daemon, as the master called it, from being shunted into sex—or from turning on you with vengeance.

"I feel you, Nardo. . . . You want it, too."

"Not like this. We're artists, not animals."

"So why don't you draw me?"

"What made you say that?"

"I have a better body than Jacopo," Gianni replied, referring to a male model used by the workshop.

Perhaps that was the way. In drawing Albi nude, he had retained control while enjoying an intimacy they would otherwise never have known. Also, the excitement of it had led to some remarkable drawings.

"Well, how about it?"

It would be like drawing any other male model. But when he spoke, his voice was husky and seemed to belong to someone else.

"Maybe . . . maybe sometime."

"Why not now?"

"I'm not ready now. That's why."

10.

Verrocchio enjoyed the Babbo story, but he was uncertain about Leonardo's ability to create living heads from death masks. He was willing, however, to give his student a chance to show what he could do.

A week later, two masks were pulled—that of the wife of a wealthy cloth merchant, and that of a doctor who had been unable to cure himself. The woman had been consumed by disease, the doctor bloated by blocked intestines. Both masks were grossly disfigured, and Leonardo asked permission from both families to delay delivery for a "freshening up." With relief, they told him to take all the time he needed.

He turned to the workshop book on human anatomy, based on Cennini's dictums. It was filled with notes, but not what he needed. He sought Verrocchio in his private studio.

"I need more than Cennini on the face."

"He gives you everything. You have three parts—the forehead, the nose, and the chin. Each one is a unit of measure, and so on."

"What if I have only a chin? Or half a face? I have to know how to calculate what's been lost."

Verrocchio was delighted. "A good question, Nardo. Why don't you find out?"

He began with four plaster busts in the workshop, which had been cast from life. Using a calibrated grid screen, he measured them in minute detail. To check these findings, he also measured the faces of his companions at work. From there, he went into the marketplace. A few days later, he returned with a sheaf of notes. He was excited but sought to hide it from his master.

"Cennini was right."

"We know that. What else?"

"I have expanded it to include all possible variations."

Verrocchio read his pupil's notes with mounting wonder. Beyond Cennini's basic configurations, Leonardo had developed a network of thirty-four measurements, which revealed that every human face had the same proportions in its separate parts:

> Space between slit of mouth and base of nose is $1/7$ of the face. Space from mouth to below chin, $1/4$ part of face. Between midpoint of nose and below chin, $1/2$ face. Between centers of pupils of eyes, $1/3$ of face.

He had also codified variations within any assembly of features—especially the nose, the mouth, the chin, and the forehead:

> Of noses, there are three kinds: straight, concave, and convex. Of the straight kind, there are only four varieties, that is, long, short, high at the tip, and low at the tip. Concave noses are of three kinds, with concavity on the upper portion, in the middle or the lower part. Convex noses vary in a similar way. . . . I have not considered monstrous faces which are of no concern here.

Verrocchio realized he was looking at the universal building blocks for any human face. Even more, they were linked in such a way that one could rebuild half a face, or take a dead one and give it life. He looked at the youth in his tan work coat.

"Very good . . ." He hesitated, aware he'd been about to say *figlio*.

"So may I begin?"

"Go ahead." He laughed. "This will awaken more of the living than the dead."

In the following weeks, grieving Florentines began to receive terra-cotta busts depicting their dear ones in better health than they had been for years prior to their demise. It was a great relief to know that a postmortem revival was available to anyone, living or dead. Such masks cost double the price, but advance orders poured in—grasping at life before it was swept away into the Great Sea.

II.

Leonardo's stepmother, Francesca, followed his workshop activities with intense interest. She had the normal, rapacious ambition of any notary's daughter, or any upper-class Florentine housewife—to obtain the best for herself and her husband. That meant Piero would one day be notary to the Signoria, while she would produce a legitimate male heir and notary like his father.

Her stepson's success with death masks could serve them in various ways. For one thing, he was going into the homes of the rich and famous. There, amid the disarray of death, he was witness to intimate lives and family secrets— priceless information that could be bartered for confidences and all sorts of favors. This was partially true, yet not to the extent of her fantasy. Leonardo tried to explain this, but nothing bridled her imagination or the gossip she attributed to intimate talks between him and his clients. Often it was embarrassing.

One Sunday at lunch, Francesca announced to the assembled guests that Leonardo was to do her portrait. Anna Maria, her mother, released her grasp on a capon wing to ask when it was happening.

"I don't know. . . . When will you, Nardo?"

He would never do one, nor replace Albi in any way.

"Well, Nardo?"

He smiled to break the impasse. "One day, when the time is right."

Francesca nodded that she understood and could wait—but not for long.

In the following month, March, Toscanelli caught a chill while looking at the stars from his rooftop. Leonardo found him in bed, and after making certain he needed nothing more than his slave girl, he returned home earlier than usual. Entering his bedroom, he discovered Francesca sitting on his bed with one of his sketchbooks.

"Oh, you're early!" She forced a smile. "I came to get my copy of Alberti . . . and found this."

She placed it on the bed, open to a drawing of Albi combing her hair after a bath. It was one of his favorites. As in the drawing, there was a diffused glow on Francesca's breasts and thighs, visible through her open robe.

"Since Piero's away, I was going to bed early."

She smiled, and he shuddered. The hair and face and even the gown were similar. Noting his eyes, she demurely drew the gown closer, which only revealed more of her nudity. She smiled again to indicate it didn't matter.

"Are you upset with me? You shouldn't be. Here, come sit with me."

She took his hand, and he sat beside her on the bed.

"Now I understand everything."

"Everything?"

He didn't want to hear any more. He had to get up and go away. Then her arms were around him, and her hand was holding him.

"I need you so much. . . . There's only you."

Her lips brushed his cheek.

"It's always my fault," she said. "Nothing happens, and it's always me."

So it was for that. To do what his father couldn't do. The old man wasn't good enough for it.

12.

Before dawn, he descended silently to the first floor, where his father slept with Francesca. Passing their closed door, he wondered if she was awake and also thinking about what had happened—and what to do about it. He continued down the wooden stairs into the palazzo's courtyard and then into via delle Prestanze.

In the gray light, the street was empty. A limbo, he thought. This is where Dante walked, through a limbo in his descent into hell:

> Through me you enter the woeful city,
> Through me you enter eternal grief,
> Through me you enter among the lost. . . .
> Abandon every hope, you who enter.

From a dark alley, a draft of cold air washed over him. He closed his eyes and inhaled. It felt good, but it was still the gray limbo Dante had encountered in his *Inferno*. The immortal Florentine had probably walked these same cobblestones in the same gray light before dawn. If they met now, he would introduce himself: Illustrious master, the town where I was born lies on the

slopes of Mont' Albano, which descends in gentle ways toward the river Arno. As a child, love also entered my heart for a young woman who had replaced my mother. And as with Paola and Francesco, it is rooted so deeply within me that I can never part from her. Even when I am plunged into carnal acts, which disgust me, I see her and no one else. All else is horrible. Human intercourse and the members that serve it are repulsive. You become an animal. . . . Master, tell me what to do, for you also betrayed your great love, Beatrice, with your so-called screen ladies. . . .

Turning into via di Calimala, the street of the cloth merchants, he encountered six black-hooded members of the Misericordia, bearing a shrouded litter on their shoulders. He shuddered and hurried onward. The gray light was giving way to dawn, and the city was coming to life in its jumbled ways.

At the Ponte Vecchio, he came upon meat wagons with braying donkeys and barking dogs. Butchers were carrying sides of beef and game into the bridge shops. They wore dark blue aprons, and the canvas sacking on their shoulders was black from dried blood. The beef carcasses, bright red and with streaks of white fat, bounced on their shoulders. Dogs swarmed after them, licking fallen drops of blood.

He stopped in the middle of the bridge. The first rays of the sun lay upon the city, touching the dark, brooding tower of Palazzo della Signoria, the candy-colored bell tower of Giotto, the brick red dome of the cathedral, Santa Maria del Fiore, and its lantern temple within Michelozzi's scaffolding. One day soon, the whole workshop would be up there. Andrea had won the commission to create the great copper ball for the top of that lantern.

The sun rose higher, its rays touching red rooftops and pink towers, church facades of black, green, and pink marble, huddled abbeys and nunneries, sprawling hospitals, and crowded tenements in their maze of narrow, twisting streets. Colors began to appear as in a field of wildflowers. Then in a sudden, iridescent moment, Florence appeared to rise upward into the sunlight.

Below him, the river moved in its own time, with lingering remnants of night—its waters yellow-brown near the bridge, gray farther upstream, then gray-blue in the distant mist. Its waters, swollen from spring rains, had begun to recede. By late August, it would be quite low and without the power needed for woolen mills along its banks.

Here was a mechanical problem. Harness the river for future use. The solution was simple. Employ these mill wheels, and the power of the river during the high waters, to raise immense blocks of stone equal to the weight of a mountain. Later, a controlled lowering of the weight, governed by relay screws

and transmission gear, would release stored power to drive the mills during periods of drought.

As he began to sketch the concept, the first sunlight fell upon the humpbacked bridge and its jostling crowd. Suddenly, it appeared to be a different, gentler world. There was a grace in the faces of people around him. Even the butchers seemed less brutal. In this light, a boy appeared with delicate features, golden hair, gentle eyes, and the lips of a girl.

He dropped the river concept to sketch the boy. Seeing this, the youth paused and smiled like Gianni. Clearly, he was also like Gianni in the other way. Somehow you could feel it. Perhaps it was how they moved, or in the manner of speech. Whatever, they probably had no choice, being destined from birth to be that way. This could be explored in embryology . . . a possible twining of female cells with the male. If so, what percentage of deviant cells would create a desire for the same sex? Perhaps remnants of this entered into forbidden dreams or sudden, unexpected desires, which might explain occasional desires for Gianni.

He looked toward the rooftops of Florence. In those palazzi, streets, and markets, in the cloistered cells of convents, there had to be thousands of others with similar desires, suppressed for fear of disgrace. Feeling suddenly free, he turned back to his sketchbook. Andrea was right. When lost, your daemon would show the way. That boy could be the angel in an *Annunciation* with Albi as the surprised yet compliant handmaiden of God.

13.

A week before Easter, in April 1469, Leonardo moved into Verrocchio's residence above his workshop on via dell' Agnolo. His room was on the *piano nobile,* or second floor, where Andrea lived. It looked onto a garden and was large enough to be used as a studio. He was delighted with it and with the prospect of living with his master. More than anything, however, he was relieved to leave his father's palazzo and Francesca.

Following their desperate encounter, he had sought to avoid her, hoping it would pass. Yet it only became worse. She stared with deep sighs that revealed everything. If his father heard of it, Francesca would claim she had been seduced. He imagined Piero's rage and fury. Yet what could the old man do? He was trapped, like millions of cuckolds, by fear of public shame. If it became known that Ser Piero da Vinci had horns from his own son, he would be a joke in the streets and never a notary for the Florentine Republic. So you paid for your dreams, and Piero would pay anything for this one.

A new life began for the young artist—now seventeen—with lectures at the Stadium Generale and anatomy lessons from Toscanelli. He acquired new friends among the Florentine youth—two of whom would remain close for many years. Atalante Migliorotti, another natural son of a well-known notary, became a noted musician in the courts of Italy. Leonardo taught him to play the lute and other instruments he had built—the *flauto,* or recorder, and the *cornetto,* a lip-vibrated instrument having finger holes along a wooden tube with a rare tone and volume.

The other friend was Tommaso di Giovanni Masini, son of a gardener from Peretola, a nearby village. Tommaso was tense, quick-witted, and given to dreams and visions. Trained as a goldsmith and mechanic, he believed the secret to eternal life lay in astrology and the occult sciences. And since Leonardo and Atalante were both illegitimate, he also claimed his father was Bernardo Rucellai, a Medici relative, and that his real name was Zoroastro.

Leonardo was the center of the group. His auburn hair touched his shoulders, and he had a face of such classic beauty that people stared at him in the street. He was also stronger and more gifted than his friends. He could bend horseshoes with his bare hands, stop a running horse by seizing its reins, or mount one at gallop by grasping its mane. This was all the more amazing, since he ate only vegetables.

He avoided all extremes—coarse jokes, bawdy songs, and wine that "revenges itself on the drinker." He seldom swore or raised his voice. He laughed rarely, and usually without sound. He smiled often, however, and was kind to animals, children, and old people. Fools amused him, but pomposity and pretense drew his scorn. In his notes, he satirized the bizarre fashions of Florentine men:

> [They] wore the ends of their garments slashed from head to foot . . .
> [and] not content with this brilliant invention, they even slashed the
> slashes. Then sleeves grew so long and full that each one was larger
> than a coat. Collars grew so tall, they hid people's heads. And people
> wore their clothes so tight that some died from this torture . . . with
> their feet in shoes that cramped their toes on top of each other, giving
> them corns.

He had created his own fashion with a singular garment—a rose-colored knee-length tunic with a scalloped hem. Fastidious in his personal care, he made his own toilet articles: hog-bristle brushes, a hollowed steel razor for shaving, a depilatory composed of lime and yellow arsenic, and perfumes distilled from jasmine and lavender.

Not only one's clothes, the manner of living also reflected a person's interior, as described in his notebooks: ". . . he who wishes to see how the soul inhabits the body, should look at how the body uses its daily surroundings. If the dwelling is dirty and neglected, the body will be kept by its soul in the same condition—dirty and neglected."

Yet his soul had other dwellings, beginning in childhood with Pegasino on the slopes of Mont' Albano. There, where nature was the daughter of God, he was the grandson of God. Caterina had said he was also the grandson of a Circassian warrior fighting the Mongols. Yet this wasn't a reality in his life. He didn't feel the blood and bones of a Circassian within him, though an image of this remote prince of armies did appear to him occasionally in moments of danger.

So it was that nature had redeemed him on Mont' Albano. The fossil rocks, with their outcroppings of wildflowers, asked no questions about the unwanted bastard. The eagle, wheeling before the wind, beckoned him to join it in flight beyond the scorn of schoolboys. In this manner, he took courage and strength from nature. In harnessing its laws, he obtained a power unknown to other men. In entering its depths, he was no longer an outsider. In laying bare its heart, he found a primal purity. Finally, art secured him from the treachery of the world, where, as Albi and Caterina had said, no one would ever be his equal.

In Florence, his cosmic family was extended into science and mathematics, engineering mechanics, and human anatomy. Eventually, and perhaps inevitably, it was to coalesce in a search for universal knowledge with a work of art beyond the reach of mortals—the ultimate and final defense of self.

In this pursuit, he soon discovered that one unknown invariably led to another. In a rare, unguarded moment, he revealed his anguish in the swift current of time. It appeared amid designs for a water clock governed by a lead weight with compressed air: "There is no lack of ways and means of dividing and measuring these wretched days of ours, wherein we should try not to live in vain or squander our lives without leaving any fame or lasting memory of ourselves in the minds of mortals . . . so that our poor passage through all not be in vain."

14.

Vinci shaped Leonardo, Verrocchio trained him, and Paolo Toscanelli, that singular Florentine genius, extended his horizons—leading him into stellar heavens, across the oceans, and into the anatomy of man. The city of Florence also played a crucial role. It gave him his dreams, it nourished them,

and, in the richness and variety of its own life, it never ceased to condition his vision of the world and his own future.

His training as a military engineer, for example, began in the workshop of the Duomo, where he found an array of machines Filippo Brunelleschi had invented in order to erect the great dome of the cathedral—among them, geared winches, three-speed hoists, and a revolving crane. In the city's woolen mills and cloth factories, he noted the potential of mechanical speed, the beauty of humming cogwheels and other relays in transferring power. Here was the future, as he later noted: "This comes next after printing. It is no less useful, and in the hands of men, can be more profitable . . . a most beautiful and subtle invention."

His skills in producing court spectacles began with Florentine religious shows, pageants, and allegorical floats during the sixty feast days each year—not counting Sundays, or when a grand ecclesiast or prince came to town. On those days, shops closed their shutters and all commerce ceased. From palazzi, tenements, and distant farms, people poured into the streets to enjoy the magic of the day.

Verrocchio's workshop, among others, helped create the elaborate floats for these festivals, including, eventually, the most pagan and riotous of all *festas:* Carnival. Wearing costumes and masks, many men appeared as women, while women became men. Nuns emerged from their convents as cavaliers, wearing pants, with swords at their sides, and priests came out as nuns. Others retained their sex, but little else. Elegant ladies, for example, dressed as courtesans or slave girls. Compounding the euphoria, Verrocchio's shop turned out disguises—Carnival masks, costumes, and surprise accessories, such as glowing halos for angels, or devils squirting sulfur fumes.

Despite pickpockets, broken bones, and an occasional death from drunken brawls, Carnival was always a great day, to be talked about until the next year. Nor was Florence alone. An identical madness also convulsed other Italian cities, including Rome, where it all began with the ancient and dissolute feast day of Saturn.

15.

Following the *festa* of San Giovanni in June 1469, Piero de' Medici summoned Verrocchio to the Medici Palace on via Larga. This was not surprising. He had been commissioned—chosen over Antonio Pollaiuolo—to create a great copper globe for the top of the Duomo. His design for the project had been sent to the Opera del Duomo engineers, and Piero was to give final approval.

At the palace, however, he found Piero de' Medici had something else in mind.

"As you know, Messer Andrea, we Florentines are our own worst enemies. We fight with one another as though we wished to destroy the republic."

Piero grimaced at the thought. Or perhaps it was his gout.

"I would like a plaque to illustrate the dangers of discord . . . to hang in the council room of the Signoria, where those fools sound like croaking frogs."

They were in the library of the Medici Palace. Piero sat at his desk, which was littered with his prized cameos. His eyelids drooped from the family disease, and the glands of his neck were swollen. In speaking to Maestro Verrocchio, who remained standing, he used the familiar *tu* as though addressing a servant. The making of art was not for upper-class signori, and even the greatest artists were treated as humble artisans—a concept that would eventually give way with Leonardo, Raphael, and Michelangelo.

"Perhaps Mars, as the god of war?"

Piero frowned. "I don't want to celebrate this. We need something to show the devastation caused by discord."

"Then a woman . . . a tempestuous virago."

"Why a woman?"

"It will be more acceptable to the Signoria. Many of them suffer from the haggling wives."

Piero smiled. "Maybe you're right. Let me think about it. . . ."

"I could make some sketches for you."

"Good. Let me have them soon. Also, Donna Lucrezia would like you to do another *David* for us."

This was astonishing. "But sire, you now have Donatello's *David* in your courtyard."

"She wants another one."

Verrocchio could think of only one reason for this. Piero's wife, Lucrezia Tornabuoni, was deeply religious and even composed hymns. Donato's *David,* created for Cosimo, was exquisitely beautiful. Yet it was also much debated in Florence—a flagrantly sensual youth, with budding breasts, a coquette's smile, and the soft tresses of a girl. A long feather, from Goliath's fallen helmet, pointed upward along the inner thigh toward firm little buttocks.

Everyone knew about Donatello. But to blatantly impose his sexual ideals upon this religious figure was intolerable. The shepherd boy became King David, savior of his people and one of greatest of the Hebrew national heroes. The Messianic hope in Christ encompassed the house of David, since Joseph, who acknowledged Christ as his legitimate son, descended from David's seed. So, it was asked, how could Jesus come from a *finnocchio?*

"Is Monna Lucrezia not pleased with the one you have?"

Piero smiled. "You mean, would she like a more manly one?"

"If it so pleases you, sire, that would help me to understand."

"Make it the same size, but less erotic. . . . You seem reluctant, Messer Andrea."

"No, it's an honor . . . a great honor. He was my master, and I owe much to him."

He doubted, however, that he was ready for this challenge—two *Davids* of the same size by master and pupil. The vile Florentines would be waiting for this one. Even if he produced a masterpiece, no one would have the courage to say that he, like David, had been able to defeat a giant—Donatello. It would be safer to attempt this later in his career, when he could more securely face such a challenge, and maybe even Donato's heroic horse and rider, the great *Gattamelata* in Padua. . . .

"Well, what do you say, Messer Andrea?"

There was no choice. If he refused, it would go to Antonio Pollaiuolo. Then Florence would say he lacked the courage to face off with the great Donatello.

"Yes, sire . . . I will do a *David* for you."

16.

In late September 1469, a cloth presser committed the most heinous crime of violating a twelve-year-old girl in such a way that she died. He then buried her in a field beyond the Porta della Giustizia. Dogs eventually dug her up and brought parts of the body into the city. After a lengthy search, the man was found and confessed his crime. He was then beheaded at the public gallows, not far from where he had buried his victim.

The monks at the Santa Maria Novella hospital saw no reason why such a monster could not be turned over to the professors of medicine for anatomical studies. There was, of course, Pope Boniface VIII's bull, *De sepulturis,* which threatened to excommunicate "those who eviscerate the bodies of the dead and barbarously boil them so that the bones, separated from the flesh, may be carried for sepulture into their own country."

This, however, was directed against Crusaders bringing home the bones of fallen comrades. It had nothing to do with dissecting cadavers to advance medicine and prolong life. Further, much had changed in the 169 years since the bull first appeared.

Italian anatomists, familiar with Galen, the second-century Greek physician to Emperor Marcus Aurelius, and the brilliant Arab scientist

Avicenna, were increasingly active, using corpses of slaves and criminals. The popular anatomy handbook, *Anathomia,* by Mondino de' Luzzi, a professor at Bologna University, contained superficial studies of three corpses, two of them women. With this in mind, the monks admitted the rapist to Santa Maria Novella for dissection, listing him as "Patient #63 M-D," the latter designation meaning he was a decapitated male.

Paolo Toscanelli brought Leonardo to witness the event. Three years previous, he had given his pupil Mondino's forty-page autopsy manual, *Anathomia,* and Avicenna's *Canon of Medicine.* Using these, Leonardo had dissected various animals and meticulously drawn their organs and the muscles as motor agents. The beheaded rapist would be his first human corpse and, on the way to the hospital, Paolo told his pupil and friend what to expect.

"After they open the cadaver, Professor Girolamo Fico will lecture us. You'll recognize his theories because you have them in Avicenna. He follows Galen, who believes the soul resides in the brain. At Ferrara, however, they side with Aristotle and insist it's in the heart. So old Fico hates them."

Entering the hospital's lecture hall, they found a group of doctors and students in scarlet robes and black tunics gathered in a semicircle around the cadaver. Above them, on an elevated lecture podium, a gaunt figure with a scraggly beard and bushy white eyebrows resembled a goat on a throne. He wore a scarlet robe with white fur trimmings, a matching cap of velvet, and he held a long wooden pointer like a blind man. Toscanelli nodded to his colleague.

"*Buongiorno,* Professor Fico."

"Paolo! Where have you been?"

"I brought my pupil, the painter Leonardo da Vinci."

"A painter?" replied the professor, squinting at the youth, who was wearing his usual short rose-colored tunic. With a flourish of the pointer, he tapped the heads of those in front of the table. "Make way for Professor Toscanelli and his painter-pupil!"

The group stood back, and Leonardo found himself before the corpse. It lay faceup on a gray marble slab. The severed head, positioned above the neck, had rolled onto its side. Staring into the gap between, Leonardo saw a ganglion of severed vessels and nerves, crushed white bone, gray tubes of the esophagus, the windpipe, and tendon gristle.

Death had rushed in through that gap, yet at different speeds. The torso, a gray-white on a gray slab, was already deep into the region of perpetual night. Yet its severed head, an offshore island, seemed to retain visible remnants of life—dark eyes wide with fright, a mouth open from its last aborted cry. Dark brown hair lay matted with dried blood on its temple. A few strands, torn from their roots, lay alongside its nostrils.

He imagined the severed head of San Giovanni as portrayed by painters, who knew nothing of human anatomy, arriving upright on Salome's tray after her erotic dance for her incestuous uncle. Even with a clean cut, the head would have toppled over—its faith soaring above the bloody tray as music pitched beyond the range of the human ear.

"All right, Nando, let's begin."

A large, balding man had appeared, wearing the blue tunic of a barber. With ponderous care, he placed a small saw and a variety of knives beside the severed head. Recognizing Toscanelli, he nodded respectfully. The old patriarch, gray eyes twinkling, shook his head with mock concern.

"Nando, do I see the shaving blade you use on me?"

"Of course not, professor . . . not yet!"

Everyone laughed, but Professor Fico was not amused. "Proceed, Nando!"

With one stroke, Nando made an incision from the throat to the upper stomach. From there, with greater care to not cut into the abdominal organs, he continued to the pelvis. This brought postmortem bleeding from residual pockets of flesh and fat. Leonardo noted in his sketchbook that the blood oozed out, rather than spurting with the pulsations of a slaughtered pig or a headless chicken running around a barnyard.

The barber next made three lateral incisions—across the groin, another below the rib cage, and one beneath the collarbone. His fat hands then retracted the lower abdominal wall. Moving up to the thorax, Nando pulled back its chest muscles, streaked with white and yellow fat. The sternum was now revealed—a heart-shaped white bone connecting the two rib cages. That done, he looked up for permission to proceed.

"I have a new saw for this, professor . . . very beautiful."

"Then use it and don't talk so much."

Leonardo noted it was a fine-toothed blade in a hickory bow, and it made a high whine in cutting into the bone. Above this noise, Professor Fico began his lecture.

"We are now cutting through the sternum to the chamber of the heart. Once there, I will describe the functioning of the human organism. . . . Indeed, with all modesty, I will show you the origin of human life."

Professor Fico, his wooden pointer above the corpse, began in a squeaky voice to reveal the source of life.

"The human body is nourished by two elements—food and air. Food goes from the stomach into the intestines, which we see here; then, as digested liquid, it passes through this portal vein into the liver, which converts it into the active ingredient of life—human blood that contains natural spirits, common to all forms of life, from plants to human beings."

Leonardo glanced at Paolo, who winked to indicate this was nonsense. How was it possible for the liver to create living blood without the heart and lungs?

Fico pointed to the dark brown liver: "From here, the blood with its natural spirits flows through the veins to feed the tissues of the body. After that, it starts back, a sluggish purple ooze filled with impurities from food and drink. You can see it, the purple color of death, in the veins of your wrists or on the back of your hands."

The professor paused for everyone to look at the blue veins of death in their wrists and hands. A short moan from the saw returned them to the cadaver. The sternum, with its hidden mysteries, was cut in half. Nando dug his hands under the rib cage and, with a cracking of sinew and bone, broke the sternum apart like a split melon.

The heart appeared, wrapped in its pearl-colored pericardial sac, with terminals of two pulmonary arteries arching toward the russet lobes of the lungs. The barber freed the heart of its sac, and Fico pointed in triumph to the fist-size organ—dark red, with rivulets of yellow fat, like an inert hunchback.

"Now we witness a biological miracle!" he exclaimed with quivering goat whiskers. "The wasted purple blood is refined by being driven through a porous septum, or wall, inside the heart. In a systolic vacuum, the heart takes the anima, or air spirit, from our lungs and mixes it with refined blood coming through the septum, creating a biological flame . . . a furnace in the heart." The pointer bounced from the lungs to the heart.

"This heat produces our vital spirit, higher than the natural spirit and the key force of life. Meanwhile, excess heat escapes through the pulmonary arteries to the lungs, along with any leftover impurities, to be exhaled as sooty vapors into the air."

Many students, and a few doctors, breathed out and looked upward as if to see smoke. It was, Leonardo decided, a gathering of idiots who took one step at a time, but never into the dark, where truth could be found. These would be the future doctors who would dress in red robes, prescribe medicine from horseback, and kill more people than they saved.

"The blood, now purified and scarlet with its vital spirits, shoots out, a leaping red fountain, to again feed the body's tissues. Here we witness the final and most awesome miracle. Some of those vital spirits also enter the brain to be further refined into animal spirits, which endow our minds with God-like powers to explain the mysteries of science and medicine . . . and so take dominion over all other forms of life."

With this breathless peroration, Professor Fico was ready for questions. One of them concerned the soul. Did it dwell in the heart or the mind?

"As I told you," he replied testily, "life is refined in its upward climb—from the first vegetative filter in the liver, through the furnace of the heart, to the creative power in the brain. Ergo, the soul resides at the highest point of life, in the brain."

Leonardo saw it mechanically—a life force passing through a series of relays. What propelled it? Was it not the same force in nature's many transcending forms of life—from a single flower as in man with a mind that reflected God? If so, then man was but a biological replica of other interacting forces in the natural world. He raised his hand, and the professor nodded indulgently.

"The painter-pupil, who's drawing pictures, needs some help in reading them?"

"Thank you, messer. . . . Without the vital spirits of the heart, the brain would be unable to refine them into higher spirits and so contain the soul?"

"That's correct."

"And what causes the heart to beat?"

"Being ignorant of physiology, you would not know this. It is the reversal nerve, which propels other involuntary muscles in the body."

"I recall that from both Mondino and Avicenna. But could the origin of this specific nerve be in the heart?"

"What difference does that make to a painter?"

"The difference is this," he replied, choking back his anger. "If the heart's motion comes from a nerve in the brain, then the soul has its seat there, as you have described it. But if the motion of the heart originates in itself, as Aristotle tells us, then clearly the soul resides in the heart."

"Paolo! You said this was a painter. . . . He's a spy from Ferrara!"

Toscanelli laughed, as did everyone else. Fico motioned for silence.

"My reply is simple, though it will appear complex to idiots who follow Aristotle. The heart has no powers of creation, unlike the brain. Does that answer your question . . . or did it come from that wicked goat at your side?"

Amid further laughter, he dismissed the class while motioning for Paolo to remain.

"Paolo, you devil, why don't you ask your own questions?"

"It was young Leonardo's, not mine. You'd do well to listen to him."

"A painter, you said. Can he draw?"

"Like a master. He has drawn the heavens and the oceans for me."

"Can he draw this heart from all sides, and also the inside?"

"Of course he can do it. . . . Right, Nardo?"

"If I have lamps, some basins of water, and a quiet place to work."

The goat beard shifted from left to right.

"How will he know what to look for and the clinical names?"

"I've taught him," replied Toscanelli. "And he's familiar with Mondino and Avicenna."

"How old is he?"

"Seventeen, but closer to thirty."

"I don't believe this," said Fico. "But what can I lose? We were going to dump this cadaver into the pit anyway."

Toscanelli winked. "Nardo, get your drawing materials. We'll have it all ready in an hour."

17.

When Leonardo returned, he found the corpse in the hospital mortuary. It was on the table in the side room, where he had encountered the old man in the dark during his search for Albi. This time, there was light—two surgical oil lamps with bright flames flanking the table.

The heart had been removed and placed on an adjacent table. It lay on its side, like an inverted fist. Next to it were several surgical scalpels, two basins of water, towels, and a note attached to several sketches:

> Caro Nardo,
> Here's rough guide to help you recall what you already know. Go slowly, and you'll make it. Good luck. . . . Paolo

Paolo's sketches showed the heart's two lower ventricular chambers and two "upper closets of the ventricles"—a distinction overlooked by Fico. Also shown were the entries and exits of veins and arteries, including those serving the muscles of the heart. The diagrams were taken, Leonardo knew, from crude illustrations in the Mondino handbook. Fico wanted more than this—drawings showing the heart with a clarity beyond the reach of words. All right, he thought, I can do it. And it'll be better than anything that old goat has ever seen.

He touched the heart, feeling its cold bundle of muscles and vessels. It was about half the size of an ox heart, and twice that of a dog, yet similar in many ways. The thick muscles at its tip, the fringe of yellow fat, and the stumps of the veins and arteries were familiar. For clarity, however, he excised the lungs of the cadaver and aligned them on the table with the heart. Now he could follow Fico's theory of the blood—and, if there was time, to illustrate that, as well.

He began with a series of drawings of the heart's exterior—its left posterior and anterior sides, then the right posterior, showing the great cardiac

vein, and the left anterior, with its left coronary artery—noting under this drawing, "The heart's own veins and arteries intersect like a man crossing his arms."

He was now ready to separate the heart's chambers. With his index finger in the right chamber, he felt its septum, or interior wall. Using this as a guide, he proceeded to dissect that chamber vertically, then the left one, until they finally parted. The dividing wall of the heart lay before him—uncut and still attached to its posterior side.

There it was—the landscape of the human heart. Through these two chambers, with their arteries, valves, and the porous middle wall, the life of this man had been held upright and imbued with vital spirits to run or fight, build cathedrals or command armies, make love or violate an innocent child.

Three hours had passed since he had begun, and the next drawings would be the most difficult. He had no more clean water, and the stench of the corpse had become oppressive. The lamps cast his moving shadow across the dead man, and rats scurried fearlessly around his feet. At one point, the swollen intestine broke, emitting a foul odor. Feeling nauseous, he washed his hands in the bloodred water, then forced himself to continue. Later in his notes, he warned others of "a natural repugnance in passing the night hours in the company of these corpses, quartered and flayed and horrible to behold."

An hour later, two hospital orderlies arrived with a mortuary corpse—not the same pair as five years ago. On leaving, they stopped to look at the cadaver, its head severed above the neck stump.

"You see that, Renato? The head's cut off."

"Jesus, I never saw one like that."

"It's him . . . the son of a bitch who killed that little girl."

"Professor, doesn't this make you want to vomit?"

Leonardo smiled and shook his head. "But it'd help to have some fresh water for my hands and some to drink."

"Renato, go get the professor some water. You want some wine, too?"

"No thank you, just water."

"Those intestines, they stink something awful. You want Renato to take them away in a slop bucket?"

Leonardo shook his head, and Renato left. The first one, whose name was Giorgio, remained to watch the drawing.

"Professor, isn't that where tears come from?"

"Why do you ask?"

"When I cry, I feel it in the heart."

"No, it occurs in the head."

"Then why do I feel it in my heart?"

"The heart gets a message from the brain. Everything you feel or touch or taste . . . all of your senses come together in a place of common sense in your brain. From this seat of judgment it sends messages, telling your body what to do about its feelings."

"That poor bastard you're cutting up, he must've been missing some of that. Like epileptics we get here, kicking and flapping like they were losing their souls."

Losing their souls . . . There it was, buried in a blundering remark on epileptics' loss of sensory control. The soul lived through the senses, as Verrocchio had explained long ago. The eyes were its windows to the world, just as the ears brought it music and speech, and the sense of touch gave it pleasure in love. That meant the soul had to reside in the brain, not in the blind chamber of the heart. Aristotle was wrong and old Fico was right.

Renato returned with water, bread, cheese, and olives. Both orderlies waited for him to eat. Then they left. Refreshed and excited on being free of Aristotle, he excised the liver and sketched its large vein to the heart's right ventricle as described by Fico. He was almost finished when Paolo arrived in the early morning.

"I knew you'd be here. I couldn't sleep, thinking of you. . . . Now let's see."

He picked up a few sheets showing the heart.

"By God, Nardo, you did it! They're excellent . . . much too good for old Fico."

Then he saw the drawings tracing Fico's physiology of a three-stage ascendancy of the spirits—from the liver to the heart to the brain.

"*Santo cielo,* this is stupendous. I've never seen anything like it. . . . Brunelleschi didn't need books on geometry. It came to him, like this, out of the air . . . or is it some brain filter unknown to Fico?"

"I met an epileptic who gave me a hand."

18.

Bedridden with gout and aware that his days were numbered, Piero de' Medici warned his fellow citizens of grave troubles ahead if they did not mend their ways.

"You strip your neighbor of his goods; you haggle over matters of justice; you evade the law and oppress peaceable citizens. . . . I don't think that the whole of Italy offers as many examples of violence and rapacity as Florence.

Did your city give birth to you so that you might murder her?"

He was not alone in his fears. After Piero slipped away from this life to enter the Great Sea—December 2, 1469—seven hundred leading Florentines met in the convent of Sant' Antonio to confirm the passage of Medici power from Piero to his eldest son, Lorenzo, not yet twenty-one.

Lorenzo saw their anxiety and understood it well. Plots to depose his family and exile their supporters were a constant threat. His grandfather Cosimo had been imprisoned and exiled before returning to power a year later. His father, Piero, had narrowly escaped assassination from the Party of the Hill—plotters meeting at Luca Pitti's palace on a hill beyond the Arno.

The heir apparent recalled the historic moment in his memoir, reflecting his fear and sadness: "Their proposal was naturally against my youthful instincts. Yet mindful of the great burden and the dangers, I consented to it unwillingly . . . to protect our friends and our property, since it fares ill for anyone in Florence who is rich yet with no say in the government."

The new Medici prince was well prepared for his role. He spoke Greek and Latin, he was at home in the classics, and, as a poet, he wrote in the spirit of the literary heralds of a new age—Dante, Petrarch, and Boccaccio. At eighteen, he had been sent on diplomatic missions to the courts of Milan, Venice, Ferrara, Bologna, and Naples. He had left with his father's counsel "to be old before your time and behave as a man, not a boy," and had returned with success. More than ever, he now had to be old beyond his time.

19.

The handle turned on the locked studio door and he heard the voice of Leonardo.

"*Maestro mio?* . . . I'm leaving for Vinci, but I have a surprise for you."

Verrocchio didn't want to see anyone. He had been in his studio since daybreak, seeking some solution for his *David*. Piero had asked for it, and now Lorenzo wanted it. He had the torso but lacked the head of the shepherd boy who had walked onto a killing field, armed with only five riverbed stones against a towering giant in gleaming armor. To be credible, the face had to contain the faith, courage, and cunning to confront the immense Goliath.

Earlier that morning, he had come across one of his previous sketches. He did a variant of it, then another, until a singular face emerged—smaller and darker, with a mystery and a certain beauty. Then to his horror, he realized it was the face of a boy he had killed in his youth. *Cristo,* not again! He pushed it aside with loathing, yet the memory remained. . . .

"Andrea? . . . Aren't you there? It's me, Nardo."

It was happening once again: the thrown stone in the sunlight, the jerk of Tonino's head, blood spurting from its temple, the boy pleading, *O Dío!* . . . *Help me, Andrea!* . . . His hands on the spurting blood . . . *You won't die, Tonino, I promise!* . . . And then Tonino: *O Dío! I can't see; it's all going black!*

Porco cane, what was this? Tonino returning to redeem the promise? On the head of David, he would never die. Verrocchio shuddered with loathing. Leonardo did this sort of thing with his stepmother, but he hadn't killed her with a stone. . . .

"Andrea, can you hear me? I'll leave it here for you."

"Wait, Nardo!" he called, opening the door.

The face was better than Tonino's—thinner and more intense. Also, the nose was larger, the chin more prominent. And David would have had that smile.

"What have you brought me?"

"Your *Discord* project for Piero de' Medici."

Leonardo placed it on his desk—a clay bas-relief, taken from his sketch for *Genius of Discord,* the public plaque, which Piero had wanted to shame the squabbling Signoria.

"It's excellent, Nardo, but I asked Perugino to see what he could do with it."

Pietro Perugino had taken charge of the shop as the new resident painter and assistant to the master.

"He did nothing. He's a painter, not a sculptor."

Here was the pride and defiance of David—broad cheekbones, thrust of the chin, strong jaw under the smooth plane of the cheek.

"Did Perugino give you permission for this?"

"He said I could try. Since he's away, I thought you might like it."

The master moved his thick fingers over the work. His original concept was there, as in a returning dream. Done in lowest relief with crisp clarity, a broad Florentine piazza was framed by buildings in architectural harmony with a group of citizens in reasoned discourse. Into this gathering, a haggard woman rushed with fury, brandishing the long staff of discord. Some people prepared to attack her. Others cowered or ran away. Still others merely looked and did nothing . . . typical Florentines, as he had conceived it.

"Do you like it, master?"

"The figure at the bottom left has Pollaiuolo's bag-of-nuts muscles. But the overall modeling is excellent. I couldn't have done better myself."

Was that true? Could he have created such a vast scene in so small an arena? This wasn't simply a piazza. It was all of Florence, along with its haggling citizens, as Piero had wanted. Once again, Leonardo had imbued a work with

a vision and beauty that belonged to him alone. So here was his *David*. The head had to be reduced for a smaller torso. He was also older than David's fifteen years, but so was David old beyond his years—old as his land and its people, old as the dreams of this youth from Vinci.

"Nardo, can you stay a bit longer?"

The youth hesitated. On the way to Vinci with Gianni, he had planned to draw a remarkable valley. To catch the afternoon light, he had to leave immediately. Andrea, however, was pointing to his *David* torso.

"I need your head for him. . . ." He smiled, embarrassed. "I could do it from memory, but reducing its size is more difficult. It will take less than an hour."

Leonardo laughed, delighted. "For years, I've wondered who I was. Now I'll be able to see it happening."

"You won't see much standing behind the model, but think of a head as formed by a series of vertical planes receding in depth."

He began to work, molding and pounding into the passive clay this youth from Vinci. After shaping the nose and chin, he felt a surging emotion upon approaching the plane of the mouth—only to realize he knew the lips intimately. They were those of his beloved Camilla. This was dangerous. In merging two beautiful faces, of a youth and a woman, he risked creating exactly what the Medici did not want—an erotic creature resembling their unwanted *David*. *Perdio*, it didn't matter. There was no choice now, no turning back. Whatever there was of female in this youth would go into this *David*.

As always, freedom from doubt compounded his powers. After an hour, he looked at the finished work and wondered how it had happened. This occurred often upon emerging, yet never like this. The slender four-foot youth was lean as a young colt. A short sword would be held in one hand, with the other hand on his hip in graceful repose after killing the giant. The severed head would lie at his feet, with a gaping wound in its forehead. In Donatello's marble *David*, the stone was buried in Goliath's forehead. Here, *grazie a Dio*, there would be no killing stone.

"Incredible!" exclaimed Leonardo. "It's me and not me!"

"That's just it—will Lorenzo see you or David?"

"He'll see his David. Shaping my head for this torso, you created a third person. Besides, people see what they want to see. You taught me that. A simple peasant girl can be a Virgin Mary."

"We'll soon find out. He wants it as soon as it's cast."

August 1470

LEONARDO AND GIANNI LEFT BY HORSEBACK at dawn the following day. Taking the Porta al Prato gate, they passed Poggio a Caiano with its luxurious Medici villa, then cantered along the banks of the Ombrone to Casini. On the first slopes of the Apennines at Quarrata, they paused to rest their mounts. Gianni asked about the plan to sketch a mountain valley.

"It's north of Vinci, but worth the extra ride," Leonardo replied. "A valley where you see the first stirrings of Creation."

"And tonight we'll see the universe from your room at Vinci."

"You'll have your own room, Gianni."

"So when will we draw each other, like you promised?"

"I promised nothing. I said it was an interesting idea. That's all I said."

"You don't have to get angry."

"I'm not angry, but if you keep it up, we can call this off."

"You see? You are angry."

"*Basta*, Gianni! I'm fed up with your pushing this when you don't understand it."

The road became steep, and at intervals they walked their mounts. On the higher slopes, there was a cool breeze coming up the valley from San Rocco. Finally, at a break in the mountain range, they pastured their horses and walked over to the edge of the steep bluff at Poggio del Belvedere. Below them lay the vast valley and marshlands of the Padule di Fucecchio. Gianni spoke softly, as if in church.

"*Per Dío,* what a view."

"It's the dawn of the world. . . . I drew this last year, and I'll keep at it until I get it right."

"How will you know?"

"You have to find its interior spirit, as in a living person."

Gianni looked at the valley and shook his head.

"Think of it this way," Leonardo suggested. "The earth is like a living being. Its waters and winds, its rocks, flowers, and trees are part of that being. So this valley's spirit is formed by an intermingling of its many living parts. . . . Does that help?"

"Sounds harder than ever."

"You can never get it entirely, Gianni. You may think you have it, but then it's not all there."

"Just like you, Nardo."

"*Cristo!* Open your eyes to something else."

"All right, all right!"

Across the floor of the valley lay farmlands and cultivated fields, with rows of trees extending into a distant haze at the foothills of a mountain range. Nearer to them, a deep silence lay over a lake with marshlands of primal life. A river in flood, with a drifting rowboat, narrowed into a torrent, then leaped over shallow falls. It was the hour when the spirit of forms moved within the fading light and deepening shadows.

To their left, man's fragile existence was perched on a precipice above the vast valley in a castle of bristling towers and grim battlements. On their right, another cliff rose starkly upward to the sloping shoulder of the Monsummano Alto plateau, its bald rocks and scattered trees shimmering in the slanting light of the afternoon sun.

They began to draw, and Leonardo felt himself entering every distant rock and rivulet, every shadow and sheen of reflected light. He gave himself totally to it and, in the release of his creative powers, lost all sense of where he was, or the presence of Gianni drawing beside him.

He worked rapidly, blocking in the opposing cliffs before descending into the waiting valley. The lake appeared under his pen, its streams and drifting boat emerging as from the shrouded shores of a primal world. He moved on, laying in the other elements—wind-grieved rocks, flowing waters, shallow falls, sunlight shimmering in trees, the cliff-encircled castle under a blue dome of sky—until it all appeared to have been caught in a single moment of time.

He had come closer than ever before to capturing the pulse of Creation. There were no birds or animals or people, nor any narrative. Yet the entire world was there, as from the beginning of time. It had poured through his heart and now it lay before him in soft black chalk, pen, and brown ink on ochre paper. Barely twelve by eight inches, it was heroic in concept and could fill an entire wall.

"Look at this, Gianni. Monumentality depends on scale, not size. . . . You can see it here, in these primal forms."

"Like this?"

Gianni's erection seemed immense—rigidly upright against the sky.

"Monumental, right?"

It was twice as large as the castle towers, its tip higher than the flying pennants of the battlements. Leonardo felt his own surging up, throbbing for release from his legging.

"Let's see," Gianni said, helping it to spring forth.

Now his was next to Gianni's. It also rose up from the valley to intermingle with the shimmering trees on the bluff. The boy began to stroke it.

"What a lovely *verga*," he murmured, using a Quattrocento word for *uccello*, or "cock."

It was going to happen now, along with everything else. He entered trembling, and his spirit took flight. The entire valley with the distant mountains, the farms and fields, the lakes and marshes, the flooding river and splashing falls, the castle with great rocks, the trees shimmering in sunlight— all of it poured forth from him again.

2.

So it began for Leonardo. From the beginning, however, he realized there was more than the beauty of Gianni or the pleasure of his body. It occurred on their second day at Vinci, after telling Checco and Sandra they planned to sketch the home at Anchiano with its fields on the slope of Mont' Albano.

Upon arrival, Leonardo showed Gianni the house. The bedroom was the same, except there was a new bed with a light green coverlet of embroidered primroses.

"This is where I was born," he explained.

"*Che bella!*" exclaimed Gianni, taking off his clothes.

"No, wait," he said. "We can come back later."

He had planned to draw the field of wildflowers and parasol pines where Albi had wept when the shepherd blew life into his stillborn lamb.

"Wait for what?" asked Gianni, scattering pink-and-green leggings and a lace-trimmed chemise across the floor.

Gianni came toward him, walking like a girl, with little breasts and a swinging semierection. On the bed, Leonardo stroked the boy's hair, kissed his eyes, then his cheek, and then all of it was under him. Trembling with desire, he entered once again.

This time, there was no confluence of the valley of Creation. No field of flowers and parasol pines with Albi. There was only a crinkled field of silk primroses. He saw the seductive body of Donatello's *David*—the boy's glowing

body, the hair falling in golden waves over a little girl's breasts, the tiny *pisellino* and firm round buttocks rising up with frantic cries for more and more . . . until he fell away, spent and empty on the crumpled coverlet of flowers. Gianni smiled, and it was Donatello's little slut, staring without care or concern at the dead sculptor.

Frightened, he rose from the bed. Here was the death of an artist. It came with Gianni's *verga* and then his own *membrum virile*—plunging them into the disgusting epilepsy of copulating animals. A living creature with a force of nature, it had a mind of his own . . . as described in a notebook entry:

> Concerning the *Verga*. It holds conference with human intelligence, and sometimes has an intelligence of itself. When the human will desires to stimulate it, it remains obstinate and follows its own way, sometimes moving of itself without permission of the man or any mental impetus.
>
> Whether he is awake or sleeping, it does what it desires. Often the man is asleep and it is awake, and often the man is awake while it sleeps. Often when the man wishes it to be used, it desires otherwise, and often it wishes to be used when the man forbids it.
>
> Therefore it appears that this creature possesses a life and intelligence alien from the man, and it seems that men are wrong to be ashamed of giving it a name or of showing it, always covering and concealing something that deserves to be adorned and displayed with ceremony as a ministrant.

Despite this, there was a constant fear of its invading his life, or weakening his creative powers. He drew exquisite renderings of the human skull and of a fetus curled up in the female womb, but he never dissected a human or animal penis. In one drawing of a man's erection, he portrayed two imagined channels—one for urine, the other for sperm from the spinal column.

THE DUKE OF MILAN AND
THE SFORZA MONUMENT

January – March 1471

SHORTLY AFTER EPIPHANY, Verrocchio received an urgent summons to the Medici Palace on via Larga. Clarice Orsini, the Roman wife of Lorenzo, wanted her home decorated for a pending visit of the duke and duchess of Milan. Madonna, this was impossible. He was seriously behind with the great copper ball for the Duomo. More than the desire to see any duke from Milan, all of Florence was waiting to see it raised to the top of their cathedral.

That ball was a monster. Without warning, it had broken its mooring, like a wild demon, and almost killed Leonardo. Two tons of iron had fallen, with a copper spur piercing the youth's thigh. Jesus help us. Before you knew it, Leonardo had poured white wine into the wound and was sewing it up like a housewife closing a stuffed leg of lamb. The sight of the needle piercing his flesh was sickening.

"How can you do that?" asked Verrocchio, his mouth dry with fear.

"Sooner the better, to halt infection."

"Thank God it wasn't worse."

"I expected it. . . ." The youth paused. "Anything sealed off in this manner becomes dangerous. We've trapped a tremendous amount of energy. Now it's like a loaded cannon."

"*Perdio,* don't say that."

"You have to face it, Andrea. It's part of nature. A dam seals off a river at great peril to those below. Until we get this ball on top of the Duomo, anything can happen."

That had been a month ago—a nightmare and a warning. Meanwhile, Nardo was able to walk again, and he was the only one capable of handling Donna Clarice.

"Go and see what she wants."

"She expects you, not me."

"Tell her I'll come as soon as possible. I think she wants Sforza banners and their coat of arms scattered around the place, with white doves in the guest bedroom of the duchess."

"How thrilling."

"Nardo, these are our patrons. At least we have to meet them halfway. If you see Lorenzo, don't argue with him."

"Why would I?"

"You did at Donato's funeral. Remember, he hates losing at anything, just like you. So be careful."

"Don't worry."

"I don't believe you realize the dangers. These Medici are not a band of angels. They bankrupt their enemies. Thousands of people are in prison or in exile. To prevent the rise of other great families, they rule on every important marriage license. Lorenzo may be a magnificent prince for some people. Or write poems and haggle about Plato. But when threatened, he can be ruthless and show no mercy."

2.

As he entered his palace, the ruling Medici saw Leonardo da Vinci in the courtyard, looking at Verrocchio's *David*. This was Clarice's doing. Along with a thousand other fluttering Florentine ladies lodging members of the ducal court, she wanted her palace decorated for the duke and duchess. Verrocchio had agreed to help, but he had sent his assistant.

Approaching him, Lorenzo recalled their meeting at Donatello's funeral four years ago. The boy had become a man, tall like himself, with the virile presence of one of Donato's heroes—auburn hair to the shoulders, gray-green eyes, with a bearing and dignity beyond his age. . . . Was he eighteen? If so, there were only three years between them.

"Master Andrea could not come?"

"He sends his apologies, Signore. The great ball for the Duomo must be finished soon."

Leonardo looked at the Medici's flat nose. Could this cause his high-pitched voice? Its bridge had been crushed, as from a fierce blow, leaving him with the flared nostrils of a ruthless mercenary. The soft brown eyes, however, were of a gentler soul. Someone probably loved this man in a most passionate way. Perhaps that was where he had been—returning at this hour in leather

leggings, dark green riding coat, and smelling of horse from a long ride.

"If it so please you, sire, I have come to determine Donna Clarice's desires, so that my master may attend to them personally."

Lorenzo smiled. "Why don't we go upstairs to Donna Clarice? Have you seen our chapel?"

He nodded, hoping it would end there. Years ago with Albi, he had seen Benozzo Gozzoli painting his *Procession of the Magi* in the Medici chapel. Copied from Gentile da Fabriano's *Adoration* at Santa Trinità, it lacked Gentile's colors and details of nature, which had influenced Donatello and Masaccio. The fresco was little more than a Gothic tapestry with a procession of fluttering angels, Florentine aristocrats in red hats, the Magi in golden robes, and Lorenzo, as a young king with an unbroken nose—an insipid little pageant for the Medici at prayer.

"What do you think of it?"

"It's like a fairy tale."

"Oh?" Lorenzo frowned. "How is that?"

Here we go, he thought. Andrea said he would test me.

"As a child finds refuge in a fairy tale, adults find a faith or some myth or personal fantasy."

The broad mouth moved slowly into a smile.

"How intuitive of you. It was a fairy tale for me when I was a boy, and now my poems often begin there. . . ." He paused, a flicker in his eyes. "But then, I recall that you think little of poetry."

"No, sire, I think most highly of poetry. In our shop, we often sing your songs, especially the one on the flight of youth. You hear it everywhere in Florence."

Lorenzo waved his hand, obviously pleased. "No matter, Plato says the artist and poet have similarly pregnant souls."

They had passed through several rooms, but Clarice was in none of them. Lorenzo left to find her, and Leonardo waited in the master bedroom. It was similar to others he had seen in upper-class Florentine homes, except this one possessed a greater elegance.

A four-poster bed of inlaid wood, large enough to sleep four people, had a canopy, a headboard, and a coverlet of light green silk embroidered with white Florentine lilies. It stood on a raised platform that contained drawers to store linens, bedclothes, and precious objects but also served as steps to get into the bed. Above it hung a tempera panel. It was the *Madonna with Child* by one of Cosimo's favorite artists, the wench-loving monk, Fra Filippo Lippi. On the wall opposite were three paintings of a battle. Andrea often spoke of them—

Paolo Uccello's *Rout of San Romano,* depicting the defeat of Sienese forces by Florentine troops in 1432.

Leonardo drew closer. These were more interesting than Gozzoli's parade of puppets. The central scene, with men and horses clashing in battle, was structured on Alberti's perspective grid—its lines visible in the raised and lowered spears, slanting crossbows, and the bodies of fallen warriors. Yet this, too, was only make-believe. In the foreground, brightly painted horses reared or tumbled like toys in a child's game where no one ever really died or was wounded in battle.

What was the meaning of this? Uccello had painted the starkly haunting *Deluge* fresco at Santa Maria Novella, portraying the fate of those not allowed aboard Noah's ark—the doomed ones, variously clawing at its hull, killing one another, or grasping at floating objects amid bloated corpses, with a raven picking at a dead baby's eyes.

So what did this sensitive, bird-loving artist mean by this mock battle, if not a mockery of war itself? If so, the central figure of a bucking yellow horse— its kicking haunches in midair—could only be a protest against the insanity of war, while its diagonal shanks and hooves pointed to a plowed field where a dog was chasing a rabbit or perhaps a deer into a forest. . . .

"Another fairy tale?" asked Lorenzo, who was now dressed for the day in a cream-colored silk shirt, green doublet, and Medici-brown sleeveless tunic.

Leonardo nodded. "This one seems to say it's better to plow fields and run with a deer than go to war . . . and the only figure aware of it is a horse."

Lorenzo stared in disbelief. "My dear Leonardo, you are amazing. I sleep here and I see that, but no one else does." He turned to the painting. "But since this is a sacred battle for Florentines, it's better no one knows how we see it."

There was a high nasal laugh, and Leonardo saw Lorenzo again as he had at Donatello's funeral—the broken assembly of features suddenly whole, even beautiful.

"How would you have done it, Leonardo?"

"The battle scene? My images would go beyond these fair forms."

"The fair forms of Plato?"

"Those of nature."

Leave it at that, he thought. Here was the school that had dismissed Donatello and Masaccio, taking the lower road of easy, predictable harmony, shallow colors, and linear grace. The only one with the courage to follow Masaccio through the natural sciences was Andrea, and his rival, Antonio Pollaiuolo.

"Tell me," Lorenzo insisted. "Your fair forms . . . how do you find them in nature?"

"An interior force within nature. You begin with that—a nascent, living power that has both spirit and substance. If you give equal play to those two elements, they should interact and produce a vital harmony far beyond any preconceived form or fixed formula."

"So a science of nature leads you to a science of beauty?"

"To beauty itself, nothing else."

"Why not a science of beauty?"

"I doubt beauty can be produced or even proved by empirical means. The science of nature can lead you to it, yes . . . but only indirectly, through nonconceptual thought. You surely encounter this in poetry. In a fleeting instant, a secret, essential moment of life is seen out of the corner of your eye . . . a complex, subtle structure beyond measure, like a snowflake. . . . I fear I have gone beyond your question."

"No, my dear Leonardo. With each word, we are closer. Eventually, at the summit, all the arts meet on one playing field. And your mix of Aristotle and Plato is close to our Neoplatonism. You should visit our Academy and meet Marsilio Ficino."

A shaft of sunlight broke into the room, falling on a clothes chest decorated with a bacchanal of nymphs and satyrs. Lorenzo reacted as though to a bell.

"I must leave you. Donna Clarice will be here soon. . . ." He paused. "You may inform Master Andrea that the pure youth of his *David* is awesome and as old as the Bible. The face haunts me. I feel that I have known it all my life, yet never seen it until now. . . . Also, the duke of Milan wants a great equestrian statue to honor his father, Duke Francesco, but he can find no one in Lombardy to do it. When he arrives, I will tell him we have two such masters, Antonio Pollaiuolo and Andrea Verrocchio . . . though I believe your master is the better one for this."

"Thank you, sire. Master Andrea will not sleep tonight . . . nor shall I."

3.

Prior to the arrival of the duke and duchess of Milan, Florentines flocked to their churches to pray for the success of the great event and for the health of Giuliano and Lorenzo de' Medici. They also prayed that added taxes, to pay for the royal visit, would not ruin them. And not a few intrepid souls prayed for both Medici princes to drop dead, or otherwise be removed for their families to replace them.

On the day of their arrival, Lorenzo the Magnificent, priors of the Signoria, and other notables met the ducal cortege at the entry to Florence.

There was much confusion. Behind a cordon of foot soldiers and mounted troops, the crowds chanted, "*Duca! . . . Duca!*" Children threw flowers, and a choir of maidens gamely sought to sing above the din. Finally, the *gonfaloniere della giustiza,* the highest state magistrate, extended the keys of the city to the duke, causing his horse to rear and turn as though it had had enough and was returning to Milan.

The following day, Andrea Verrocchio received a note from Lorenzo de' Medici. Duke Galeazzo would be pleased to meet with Master Andrea to discuss the project of a great horse and rider in honor of his father, Duke Francesco. The meeting was to be at the Medici Palace, following a religious spectacle on the third day. Verrocchio and Leonardo were delighted. From the master's many drawings of horses and riders, they selected a series to present to Duke Galeazzo.

Meanwhile, Galeazzo quickly became a popular figure. Even those aware of his depravity and sadistic crimes admired his elegance and courtly manner—especially the dispensing of ducats to anyone giving him flowers. They were shocked, however, that the duke and his entire court ate meat during Lent. This was an insult to the Lord, and many feared the worst.

The Lord's retribution, if it was that, arrived shortly before the meeting with Verrocchio. It occurred in the church of Santo Spirito during a spectacle showing the descent of the Holy Ghost at Pentecost upon the gathered apostles. The sacred tongues of fire, to have brought the gift of many tongues, also descended upon the wooden beams. The church quickly caught fire, driving everyone into the piazza, where they witnessed a far more dramatic spectacle—the house of the Lord going up in flames.

The raging fire, and Florentine talk of God's vengeance on flagrant sinners, terrorized Duke Galeazzo. At the Medici Palace, the superstitious duke retreated to his room and did not appear for dinner. The next day, before departing for Genoa and Milan, he gave two thousand ducats to rebuild the church—but he made no further mention of an equestrian statue of his father.

Verrocchio believed the burning church had consumed any hope of his ever doing the Sforza monument.

"He left without a word. We lost our chance."

"We'll hear from him," Leonardo insisted. "Or Lorenzo will remind him. Sooner or later, I know you'll do that horse."

"What makes you so sure of it?"

"They want it, and who else can do it for them?"

"You could, Nardo. Who knows? Maybe you will one day."

THE ANNUNCIATION

April – May 1471

THE DAY AFTER LEONARDO'S NINETEENTH BIRTHDAY, April 15, 1471, the Verrocchio workshop completed the great ball for the cathedral of Santa Maria del Fiore, known as the Duomo. At that point, the Opera del Duomo sent its chief architect, Ezio Sacchetti, and two engineers to make a final inspection of the work in the presence of Paolo Toscanelli.

They examined the copper plating soldered to its metal frame, tested its anchoring stanchions, praised its workmanship—and gave their approval. Then they reviewed Toscanelli's engineering plans for raising the ball to the pinnacle of the cathedral's dome. When he was satisfied that the Duomo engineers understood his directions, and the inherent dangers in lifting the great orb, the stage was set for the historic event five weeks later.

With immense relief, Verrocchio turned to a long-delayed *Annunciation* for the monastery of San Bartolomeo at Monte Olivetto—only to learn it faced further delay. Perugino, who was to finish the panel, had received a commission to do an *Adoration of the Magi* for the Servite Order in Perugia. There was no way to refuse him. It had been agreed that Pietro, as workshop foreman, could also accept outside commissions.

Verrocchio looked at the half-finished *Annunciation* panel—drawn in detail with black tempera on the white gesso panel, then overlaid with a lean yellow ochre underpainting of ethereal varnish, heightened with hatchings of tempera white. The Virgin, seated in the garden of a Florentine country villa, was reading a holy book, when suddenly the angel Gabriel appeared, kneeling on the lawn before her.

"I followed your drawing in every detail," noted Pietro.

"I see that, but we can't wait . . . and I have too much to do to even think about it."

"So who will do it?"

"Probably Leonardo."

It was an ideal solution . . . Nardo's first workshop painting, laid out in

every detail. He couldn't go wrong or create something the San Bartolomeo monks would reject. Pietro shook his head angrily.

"This was to be mine all the way."

"Look, Pietro, I'm not taking this from you. But surely a painting for the Servites is far more important for your career."

Verrocchio waited. Pietro had a round head with large ears, a big nose, flared nostrils, and a broad mouth that drooped at the edges. When he looked up, his dark brown eyes had the glint of a Florentine merchant.

"That Vinci boy will alter it."

"His name is Leonardo."

"He thinks he's better than anyone else."

"*Basta!*" cried Verrocchio. "Signor Perugino, I'm fed up with your jealousy. It's poisoning this place. You have to stop it, or go somewhere else."

He paused, seeking control. He didn't like this man, but he didn't want to lose him. Pietro couldn't draw as well as Botticelli or even Botticini during their brief stay. But he was better at running the workshop. Nor was Pietro ready to leave. He had come, as had the others, to learn the secrets of the workshop, discover its patrons, then join the painters' guild when he went off on his own.

"Maestro, please understand," he replied. "It's a question of control, not jealousy. If you want me to run this shop, it means I run everyone in it."

"I know that, Pietro . . . and you're very good at it."

Perugino nodded. Andrea, he knew, didn't give a fig for him. He cared only for Nardo, who wanted to take over the shop. One day soon, however, it wouldn't matter. People would come to him for paintings of Madonnas and popular saints, and he would become rich and famous. That's how it would be. He was Pietro di Cristoforo Vanucci, known as Perugino, from an ancient family in Castello della Pieve, not a slave's bastard from Vinci whose father had never made him legitimate.

"If you don't go, Pietro, you might regret it."

"All right . . . as long as that boy doesn't change it."

"Why would he? This is taken from my drawing."

2.

As could be expected, Leonardo immediately saw basic flaws in Perugino's *Annunciation.*

"It needs some changes to give it a unity and life."

"You can do that in laying on the colors," replied Verrocchio.

They were in Perugino's studio, preparing to move the panel to Leonardo's room.

"May I work in oil as well as tempera?"

"Agreed, provided it's within the shop style. Pietro followed my concept in every detail."

Leonardo hesitated. That was the problem. You could build on the master's workshop models, but Perugino had merely copied them. There was no life in the Virgin, Gabriel had chicken wings, and the spiritual arc between the maiden and the messenger somehow had to bypass an immense lectern worthy of a Medici tomb.

"All right, agreed." The master forced a smile. "You can improve on what's there, but don't add anything else. I don't want anything that's not my own."

"Of course not. God forbid."

"I know you, Nardo. Remember what I said."

In his room on the second floor of Verrocchio's palazzo, Leonardo covered one of its diagonal windows and modified the light to fall on the painting from the upper left. To take possession of the work, he copied the entire painting, making separate sketches of the Virgin and the angel Gabriel. In this way, the figures offered themselves to possible changes within the limits of Verrocchio's concept and his workshop models. The awkward hands of the Virgin had to be redrawn. Her downcast eyes had to be raised to allow a glimpse into her soul. Also, her gown and robe had to be altered, for she appeared to be already pregnant, before the Holy Spirit had its chance with her.

The next morning, Verrocchio was startled to find a large drawing of the Virgin—completely nude, with Perugino's robe no longer covering her modesty.

"Starting from the bottom, Nardo?"

"*Buongiorno!* Yes, we need a better foundation. Otherwise, we won't see her housing under the robe."

"Your house has very big breasts for a teenage Virgin."

The youth looked up, amused. "Pietro used one of your Madonna models. Perhaps, we should cut them down to Virgin size and fix the right arm, which is longer than the left."

"All right, virgin breasts and fix the arm."

"And her eyes? She's not looking at the angel."

Verrocchio hesitated. "Also the eyes. But that's all, understand?"

The youth smiled again. "Don't worry. It will be as an imprint of your own hand."

3.

He worked for a month in isolation. Verrocchio came to his room periodically to check on his progress. Gianni was allowed in a few times. There were also the

returning swallows of April, swooping into their nests under the eaves—their wing shadows fitful reminders of the creative force of the Holy Ghost in the garden, its flowers and trees, and regeneration of life with the return of spring.

At first, the Virgin was difficult. When he placed Albi in the matrix of the master's model, her dark complexion that of a Hebrew, Andrea insisted on a fair-skinned blond. The German prior of the San Bartolomeo convent wanted a Maria like the ones he had known in his fatherland. So they had compromised—light brown hair with blond highlights.

He felt closer to the angel Gabriel. While working on the feathers of the wings, there were bursts of birdsong and cries from starlings on the roof tiles. The joy of these little heralds continued as he stretched a carpet of flowers for the heavenly courier. Then he gave Gabriel a lily, which foretold the unfolding of Mary's destiny. Life's inception appeared in the flowering blossom. And in triumph over death, the lily would rise again from its bulb at Eastertide.

For the angel, he used the image of the youth on the Ponte Vecchio, dressed in a red cloak with pale blue epaulets and wearing a fluttering violet-gray sash around his sleeve. Curls cascading down the back of his neck stirred in eddies of the wind. The garden flowers rippled beneath settling wings— little faces of life in the dark humus of the garden, waving in unison, as though emerging from tidal waters of life upon the creation of the world.

Word of his progress seeped down to the workshop. Leonardo was working with oil colors, like the Flemish masters. The Virgin had light brown hair with golden strands. She had raised her hand to greet the angel, who was neither male nor female, but had gorgeous wings and a splendid lily. Nothing, however, equaled the shock and wonder of the panel when Leonardo returned it to the shop.

"It's like it's happening right now," murmured Renzo.

"And we're there looking at it," observed Nanni.

"What did I tell you?" boasted Gianni.

Gabriel, his wings still open from flight, had just arrived. The sacred moment was at hand, hovering in the twilight between the angel and the Virgin sitting on the terrace of a country villa. A cordon of cypresses stood guard against a gray evening sky, while a low wall enclosed the garden's *hortus conclusus*—symbol of Mary's sacred womb.

A pale, delicate hand was poised above the opened holy book. The other was raised in greeting. She was about to speak. It was a moment without parallel except for that when Eve emerged from Adam's rib—another birth to alter the history of the world. God would take flesh in her womb as guarantor and anchor of his dwelling among mankind.

The teenage girl had a moment to accept or refuse her awesome destiny. Then, without informing her promised husband, she consented to become an

active agent in the drama of God's incarnation. Her lips moved with the glory and tragedy of the predestined mother of God: *Behold, the handmaiden of the Lord, be unto me according to thy word.* . . .

"Are you pleased with the others' reaction?" Verrocchio asked when they were alone.

"They don't see the mistakes. For your sake, I hope the monks don't, either."

Leonardo didn't want to talk about it. Most of the trouble came from Perugino's use of Andrea's shop models.

"Why did you use yourself for Gabriel?"

"I didn't. It's someone else."

"You can't see yourself in profile. . . . Clearly you are there."

Shocked, he saw it. How could this be? Only bad artists used themselves this way. No matter, this was only the beginning. One day, he would capture the enormity of this woman's drama. Without Perugino's insipid pieties. Without workshop models. And, yes, without Andrea.

Early the next morning, Verrocchio discovered Perugino staring at the finished *Annunciation*. His face was dark with anger.

"Welcome back, Pietro. How do you like it?"

"You said he wouldn't change my painting."

"Look again. Your basics are all there."

"He made himself the angel. Dogs piss around an area to claim it. He does it in middle of a holy picture."

Verrocchio laughed. "Not bad, Pietro. I didn't know you had that in you. . . ."

He paused. Until Nardo could take over the shop, he had to get along with this man.

"Pietro, I know how you feel. However, this picture is mine. It doesn't belong to you or to Leonardo." He forced a smile. "But you are my rock and on you I build my shop."

There was a sullen smile. "Thank you, Andrea. I know my limits, but your boy doesn't. Sooner or later, he's going to make you look ridiculous in Florence. . . . It's beyond his control, and you know it."

Verrocchio had known it from the first day. Yet now it was different. They had grown closer, each respecting and caring for the other.

"The day will come," Pietro insisted. "Remember what I told you."

"Enough of this. I heard you the first time."

THE GREAT BALL
FOR THE DUOMO

May – June 1471

ARLY ON MAY 27, 1471, a large crowd gathered in the Piazza del Duomo to witness the raising of the great copper ball to the summit of their cathedral. It promised to be a magnificent spectacle. Indeed, nothing like this had ever been attempted before.

The immense orb was to be lifted up in stages to the high crown of the Duomo—a stone temple shaped like a lantern. Once there, it would be lowered onto the temple and anchored against the possibility of gales or lightning rolling it off the dome and down the streets of Florence—God's golden ball crushing hapless citizens with the fury of a demon from hell.

At the last minute, however, the southwest wind of a scirocco had arrived with dark clouds, which threatened to delay, or even cancel, the historic event. Florentines, gathered between Giotto's bell tower and the right tribune of the cathedral, looked for signs of change in the sky—rumbling voices upon a white lake of upturned faces. Verrocchio and his assistants also searched the sky with growing alarm. From the beginning, the giant ball had been a source of trouble. After nearly killing Leonardo, its curse had shifted to the winds, maybe even to God Himself.

The sun suddenly emerged from the clouds, and the crowd cheered. The wind also let up, until it appeared safe for the great ball to begin its journey to a resting place in the sky. Devout Florentines prayed and held their breath. Any mishap in this crowning of their mother church would be a dreadful omen of war or the plague—or maybe both.

The ball began to rise on a massive hemp rope, its leg stanchions resembling the talons of a great bird of prey. Brazed with sal ammoniac, a new technique, the copper sheeting of the great orb shone like gold. After a few yards, it halted before the polychrome marble of the church's lower wall. Then it rose again with greater resolve, until it came to a wooden platform at the base of the great dome.

The crowd cheered again, then fell silent as the great orb began the most difficult part of its upward journey. Five other platforms remained. Three of these rested on wooden beams inserted into bay windows on the steep slope of the red-tiled dome—supported by vertical pillars anchored into diagonal beams slanting across the roof to its white stone ribbing.

From below, the platforms resembled giant steps on the hump of the dome. Each one had an extended crossbeam to lift the ball from the lower platform, then slide it on pulley runs into position for its successive lifting. Above the three roof platforms, there were two others. One was at the base of the lantern temple on the top of the dome. The last platform, for the final lift, rested upon the scaffolding at the peak of the lantern, where the copper sphere would finally slide into its cupped perch in the sky.

The crowd watched in silence as the great orb continued its slow, laborious ascent to the first platform on the steep roof. When it arrived, they told themselves it was going to be all right, even though the sky had clouded over and the wind was kicking up again.

For the next hoisting, the ball was steadied against the rising wind with rope stays held by workmen from above and below. Again, it arrived safely. Transferred to a pulley on the next crossbeam, it began to rise toward the third roof platform. At this point, however, the wind struck with such force that the great orb broke free of its retaining ropes. Swinging and turning wildly, it crashed into a wooden pillar beneath the platform, shaking it badly with a deep groan from its hemp-bound joints.

In the piazza, the cries of alarm sank to a collective moan as the ball began a return to the middle platform. Before it could get there, however, a blast of wind swept a workman off the top platform. From below, the horrified crowd watched him sliding down the red-tiled roof like a little doll in a brown tunic.

Gianni had tripped on a rope while struggling to secure the ball. On the lower platform, Verrocchio, Leonardo, and Perugino heard his cry, then saw him slide past them with growing speed until he struck a diagonal roof beam. When he hit this juncture, Gianni tumbled over the beam and continued to fall, until he managed to halt his slide ten feet lower down. He was now flat on his belly, his right foot wedged into a gutter between the roofing and the stone rib, his bleeding hands clinging to a thin edging of the tiles. From there, the roof sloped almost directly downward.

He looked up at those above him, his eyes wide with terror. He began emitting little moans as wind blew over him on the back of the great dome. Leonardo called to his friend.

"Hold on, Gianni! I'm coming!"

Taking a coil of rope, he slid down his platform post to its roof beam. Using this for support, he inched his way diagonally across the steep roof to the beam's juncture with the stone ribbing. He then tied the rope around the beam and cast its looped end down to Gianni.

"Put your arm through it!"

Gianni reached but missed. Sliding farther down, he frantically grasped at the tiles until he managed to jam his torn and bleeding fingers into another tile in the roofing.

"Wait, Gianni! Stay there!"

Leonardo slid down the rope, linked his arm in its loop, and reached for Gianni—only to find it was a few inches beyond his grasp.

"Nardo, I can't hold anymore...."

"Wait!... I'm coming!"

Curling upward, Leonardo tightened the loop around his ankle to hang downward. The loop held, and he grabbed Gianni, who also seized his friend. This left them holding each other by their wrists. Gianni's hands, cut by tiles, were slippery with blood.

"Now climb up over me."

"I can't."

"You've got to, Gianni.... There's no other way."

"I can't do it!"

Gianni was dripping spittle, his face ugly with fear. It was disgusting. Even in the wind, you could smell the fear. It smelled like piss. This was stupid, really stupid. Down below in the piazza, the upturned faces waited for them to fall. And for what? All his life, all the dreams... for this? Gianni was Gianni, nothing more. Close your eyes; let him go, he told himself. But there would be the scream—*NARDooo!*—then the clump-thud of splattered body on cobblestones. *Dio ci salve.*

"I'll try once more. You hear me, Gianni? Let go of my right hand and grab my arm. Let go, *porco,* let go!"

Gianni seized him below the elbow, his bloody hand firm on the tunic sleeve.

Then he grabbed the second arm. With this, Leonardo felt the rope sliding off his ankle to the butt of his heel. He flexed his foot to extend his heel, and his tendons cramped with intense pain.

"*Cristo!* The rope's slipping! Do what I say now, or I'm letting go!"

"NOOOooo!"

"Put your foot against the gutter.... That's right. Now shove yourself up on your elbows... *stronzo!*... Shove harder!"

Gianni came slowly upward until he was on his elbows.

"Now get on your knees and climb over me. . . . Hurry, my foot's slipping!"

The youth came over him, his crotch wet with urine. It dribbled on Leonardo's face and burned his eyes. He closed them and, in the darkness, he smelled the shit in his lover's stocking hose. *Santo Dío,* this was death. This was how it came onto you—in the dark, with the wet and creeping stench of a crotch.

With Gianni still on him, his leg muscles went into spasm, his foot lost its flexing power, and he felt the rope coming off his heel.

"Hold my foot! . . . Hold it!"

"I've got it! . . . Give me your hand!"

He was pulled upward, and they sat together between the beam and the stone rib. He looked at the face he had loved. The fear was still there, in the eyes and tight mouth. His green legging was brown at the crotch and the odor was disgusting. Gianni's bleeding hand took his hand, caked with dried blood.

"I love you, Nardo."

"Forget it."

"Nardo! . . . Gianni!"

Pietro threw them a rope. Gianni went up first, tied at the waist. Leonardo followed.

"That was incredible," Pietro said. "I wouldn't do that for anybody, no matter how I felt about them."

To hell with you, Leonardo thought. On the platform, Andrea embraced him.

"What balls," he said.

"Balls nothing. I almost went down with him."

"Still, you saved him. . . ."

"I almost let him go. Nobody's worth it, no matter who they are."

He had never discussed it with Andrea, but everyone in the shop knew how it was with Gianni. Verrocchio smiled. "So your art comes first, before all else?"

"You've been telling me that ever since I came to you."

He looked across the huddled rooftops of Florence toward the hills of Settignano and Fiesole and imagined Albi again in the field at Anchiano amid the flowers and parasol pines. Beyond her were mountains with winding streams and valleys veiled in a purple haze. A blue-green light, as from the depths of the sea, fell upon her face, and the traces of a hidden smile played upon her lips.

Andrea turned to Pietro. The wind had let up, and the crew was waiting by the winch to raise the ball.

"All right, Pietro . . . bring her up!"

The great ball began to rise again. In the piazza, many prayed, while others touched their testicles with forked fingers to ward off further evil. Rising slowly, it arrived at the base of the temple. From there, it continued upward to the platform at the top on the temple. Transferred to Brunelleschi's revolving crane, it moved across the sky until finally lowered and bolted into its nesting place.

The sun emerged and the copper orb turned to gold. The crowd cheered and went home. Three days later, to the peal of trumpeters from the Signoria, Verrocchio's ten-foot holy cross was lowered and welded into its slot in the ball. The scaffolding was then dismantled, leaving the great orb with its cross high in the sky—a tribute to God and to the immortal glory of Florence . . . and to the delight of perching pigeons.

2.

Gianni had been saved, but the fear of death left its mark. Overnight, his blond hair turned white—a youth of twenty-seven years. A fortnight later, he began to have eye problems. Clearly, the traumatic fright had remained, poisoning some vital root of his being. At first, he made small mistakes, such as confusing two shades of the same color—an apparent oversight. Verrocchio, however, knew it was more than that, and he spoke to Gianni.

"You are still suffering from your fright on the cupola."

"I'm all right."

"Are you sure?"

"Yes, I'm sure."

The next day, he committed a more serious error—giving a violet cast to an ultramarine blue for the robe of a Madonna. The master was now alarmed and called the youth into his study.

"Gianni, I'm very worried. I want you to go home and rest for a week."

"Please, I'm all right. I won't do it again."

"No, do as I say. Go home and rest, and don't worry about it."

"What will my friends say?"

"Nothing. We'll tell them your mother's sick."

In the workshop, Gianni spoke to Leonardo. He was pale and trembling.

"I don't know what's happening to me. I'm scared."

"Andrea is right. Your body is saying, Let me rest awhile. Let me recover."

"Every day it gets worse. I'm afraid, Nardo. I'm afraid to go home alone."

"I'll come to see you."

"You'll come to see me?"

"Of course . . . tomorrow."

Gianni removed his brown tunic and dropped it on his workbench. After he had left, Leonardo looked at the garment and shuddered. It lay facedown, its arms spread outward.

3.

The next morning, Maestro Andrea Verrocchio received an urgent letter from Don Matteo, secretary of Annibale Grimani, bishop of Pistoia. His Excellency desired immediate delivery of his painting, *Madonna with Child,* in order to take it to Rome on his annual *ad limina* visit to the Holy Father, Paul II. He also wished to speak with the maestro about a great memorial monument for the Duomo in Pistoia.

Perugino was greatly impressed. "Now even the Pope will know of you."

"I doubt it. The bishop will probably give it to a Curia cardinal to gain access to the Pope. In Pistoia, people bring hams, cheese, and wine. In Rome, the price goes up."

"But at least important people will see it and talk about your art."

"Who knows? If it's a German cardinal, the painting can end up anywhere in the Holy Roman Empire. That's like throwing it into a river."

"Even so," persisted Perugino. "Cardinals are rich patrons of art."

Verrocchio ignored him. "Let's get the panel loaded onto Mercurio," he said, referring to the slow-plodding workshop mule.

He found Leonardo at work on a Crucifixion commissioned by Donato Acciaiuoli for the confraternity Santa Maria della Pietà. It was a joy to see this youth without the commercial cunning of Pietro—absorbed in a new kind of Christ. Since the three-foot crucifix was to be borne in procession, he had made the body of hollowed-out lime wood padded with cork, a head of cork with a deeply furrowed face, heavy brow, strong jaw, and broad nose.

Here again, Verrocchio realized, Leonardo was on new terrain. Unlike his own prototype for Christ, this was less refined. Yet it had a physical and spiritual power that raised the dimension of the small figure into an intense human being whose dying was close and real and profoundly disturbing.

"It seems to work, Nardo."

The youth looked up, surprised. "Thank you, *maestro mio.* Sometimes a new material or method takes me further. . . . Also, accidents can project you beyond yourself."

"There's also a mule waiting to take you 'further' than expected. We're going to Pistoia with the *Madonna with Child* for the bishop to take to Rome."

"How long will we be away?"

"Two or three days, depending on the bishop."

Leonardo hesitated. Gianni expected him every day. Tommaso would have to tell him that they would return as soon as possible.

4.

At Pistoia, Andrea and Leonardo found the bishop had been summoned to Viterbo by Cardinal Niccolò Forteguerri, Pistoia's famed theologian, diplomat, and warrior under two Popes.

"He'll be back in two or three days," explained his secretary, Don Matteo. "He wants to discuss a possible monument to Cardinal Forteguerri."

The master and his disciple stayed in the palazzo of the cathedral canons, and the next morning Leonardo suggested riding to Vinci for lunch. Checco and his wife, Sandra, were delighted to meet Master Andrea and show him Leonardo's childhood room with its lingering relics—the deer's heart and the great white owl, mounted moths and butterflies, a lizard with dragonfly wings. At the church of Santa Croce, old Padre Piero proudly led the Florentine master to a small chapel with the early portrait of Albi, lit by candles: the local *Virgin of Childbirth*. After lunch, Sandra gave Leonardo an embroidered linen tablecloth with napkins for Violante, his aunt in Pistoia. Leaving Vinci, they stopped at Campo Zeppi to visit Caterina—only to learn she was away, visiting her son in Pisa.

Bishop Grimani returned two days later. After praising the Madonna painting, he proposed a posthumous monument to Cardinal Forteguerri. How would the maestro conceive it? Verrocchio immediately began to sketch it—a near life-size figure of an enthroned Christ in high marble relief, held aloft within His mandorla by winged angels. Below this, the kneeling cardinal would be flanked by the three virtues of Faith, Hope, and Charity.

The delighted bishop dined with them that evening. On departing the next morning, Verrocchio planned to return as soon as possible. Leonardo objected to a later return with the slow-prodding Mercurio.

"We've been gone four days, and I'm worried about Gianni. Don Matteo promises to fatten the mule and return him with hams, cheese, and the bishop's wine. So I would like to return with you."

"Then let us go quickly."

5.

At the workshop, everyone had left except the new apprentice, Lorenzo di Credi. Leonardo asked about Gianni, but there was no news. He had not returned to work, nor was there any message from Tommaso.

He left immediately, walking along via di Calimala with its shops of the Dyers' Guild. Woolen cloth of many colors hung outside the shops—red, blue, orange, green, and the famous scarlet, or *oricello*—superior English wool, dyed for reshipment to Europe and the Middle East. From vats within the shops, colored liquids seeped into the gutter, leaving stagnant pools of oily blue sludge. Florence, unlike Pistoia, had paved streets, and heavy rains carried some of this into the river, though never all of it. The blue-black sheen of the slime imbedded itself between the flagstones, saturated the base of palazzo walls, and inevitably stained the hems of trailing gowns and capes.

This was a source of disease. Here the Black Death lay waiting to seize the city, as it did every six years or so, claiming the rich and the poor. Corpses were thrown into the street—mothers upon daughters, fathers on sons, their homes open for vandals and sex orgies. Boccaccio, in his *Decameron*, described the great plague of 1346 as a vengeance from hell, claiming 48,000 lives, or half of the population. Yet it wasn't only the dye shops. Stray dogs, passing horses, and livestock fouled the streets. From windows, chamber pots and garbage were dumped at random without warning. Men and also women relieved themselves in alleys and on the stairway landings of the palazzi.

There was a solution to this. Leonardo had designed it with Toscanelli, using concepts from *De architectura* of Vitruvius, the architect of Augustan Rome who had also inspired Alberti. They projected a series of satellite dwellings around Florence, along the Arno River and in the hills of Settignano. Five of these, housing three thousand, would accommodate fifteen thousand people—almost one-fourth of the city. The dwellings, in proportion to the human stature and removed from street noise, would have sewage drains to the river. The complex was to have two levels, as in the natural order of life—nobility and merchant aristocrats on top, with the masses below.

He had arrived at Gianni's palazzo. Nannina, the doorkeeper, was seated in the vestibule, cleaning wild greens. She wore a dark blue apron and was very fat. A little white dog slept at her feet. It was also fat, like all doorkeepers' dogs.

"*Buongiorno,* Nannina."

"*Buongiorno,* signorino. Where've you been? Your friend is very sick."

"What is it?"

She shook her head sadly. "He doesn't want to see anybody, except his mother. She's coming tomorrow from wherever it is, near Siena. But you're different. He's been asking for you every day."

"What's wrong with him?"

"See for yourself," she said, putting down her greens and taking a mass of keys from under her apron. At the top of the stairs, she opened a large door.

"It's better you go in alone."

The room was dark with the curtains closed, and there was an overwhelming stench from a chamber pot.

"Gianni . . . what's happened?"

There was no reply. The bed, he knew, was in the alcove. In the darkness, he moved toward it—only to kick the pot, which splashed onto his stockings and foot padding.

"*Cristo!* . . . Gianni! You hear me?"

Still no reply. With anger and loathing, he backed away from the spilled urine and feces to open the window curtains. Varnished white muslin let in a gray light. Looking across the room, he saw Gianni in bed—nude and turned toward the wall. He went to him and sat on the bed with its familiar sigh of rope netting. He placed his hand on his friend's thigh, then withdrew it with revulsion. It had been like that ever since the Duomo. There was nothing he could do about it. The bed also stank.

"Gianni, speak to me."

There was no reply, and he pulled him around. The boy's eyes were closed.

"Wake up. It's me . . . Nardo."

Gianni rose up on his elbow. His light gray eyes were covered with the opaque glaze of a dead fish.

"Oh my God!"

Gianni turned back to the wall.

"Go away, Nardo. Just go and leave me alone."

"For God's sake, Gianni . . . what's happened?"

"*Porco!* Can't you see?" He sat up again, opening his eyes, the pupils glazed. "I'm going blind, Nardo. Blind, you bastard!"

Leonardo stared with horror. Once, those eyes had opened to the entire universe—the world of nature and its wonders, the beauty of life in all its forms, the arching dome of the skies, the whirling of birds, the sun and the moon, the turning seasons. Once, in a most miraculous way, all of this had come to one point in those eyes. Now there was only the creeping darkness of a tomb. He cringed, feeling overwhelming sorrow for his friend.

"Can't you see anything?"

"What is it to you?"

"Stay calm, Gianni. Has a doctor seen you?"

"Stay calm, *cacca*. Where've you been? You promised to come every day. I waited with the dark creeping up on me, and every day I cursed you."

"I went to Pistoia with the master. It was urgent. Didn't Tommaso tell you?"

"In *culo* the master, and in your *culo*, you *pezzo di merda*. I counted on you, of all people, but I should have known better."

"Wait, Gianni. For Christ's sake, wait. I nearly killed myself saving you at the Duomo. Why wouldn't I come? This is a terrible thing, especially for an artist."

"Sure, your art. That's all that matters. Not me, not a human being." He began to sob. "Why didn't you see it when Verrocchio sent me home? You have eyes, you son of a bitch, but you see nothing. I'm blind, and I see everything now. You never loved me. You'll never love anybody except yourself and your *maladetto* art."

"That's not true."

It was true, however. He looked at the matted hair he had once caressed, at the delicate features ravaged by fear and terror, at the naked body he had known. Now there was only pity and a loathing in this stinking room. Gianni sat up and began to talk into space.

"'Let's draw each other,' you said. 'First, we'll draw ourselves nude. Then when we know the outside, we can go inside.' Well, you never went inside me, except into my *culo,* and even that wasn't very far. . . ."

That was a lie, of course. Gianni had loved all of it, every time. He was hurt and sad, and he didn't know what he was saying.

"To really love someone, you have to go to them blind, like I am now. You have to trust what you can't see and take it on faith. But not you, Nardo, because you're afraid to touch or love someone you can't see first in some cursed drawing."

Not always. He had drawn Albi because he loved her. Andrea had seen that immediately at Vinci. But Gianni was different. He had drawn him many times, every part of him, but nothing remained except himself.

Leonardo took his hand, but the boy pulled it away, flailing wildly at the vague form before him. Leonardo grabbed one arm—only to be struck on the mouth.

"Oh, Nardo! I hit you. . . . I'm sorry."

"It's nothing."

His lip was bleeding, and he rose to leave.

"I'm frightened, Nardo. Please stay with me."

Gianni extended his hands, as the blind do in their perpetual night. It was pitiful. Leonardo took the waiting hands, but without coming closer.

"Will you stay with me tonight?"

"I can't, Gianni. I'd like to, but I promised to help Andrea."

It was a lie, and Gianni knew it. Yet it was better than the truth. Better than arms pulling him into a dark tomb. He felt a chill and sudden fright. Maybe this creeping blindness was a first symptom of the plague. Maybe the Black Death was creeping into him through the bleeding lip. He withdrew his hands.

"I have to go, Gianni, but I'll come back in the morning . . . *va bene?*"

He waited while the face of broken beauty stared through shades of darkness. With guilt and anger, he went to the door. Staying longer would only make it worse.

"*A domani,* Gianni. We'll get a doctor for you, and I'll have Nannina clean this place and bring some food."

On the landing, he saw the air shaft used for shunting waste matter down to the side alley. You could have done that, he thought. At least have emptied that stinking pot for him. But then, Nannina probably had her own way of doing it. Perhaps she flushed it with water. That was what was needed— mixing water with this waste to drain it into the river. You could even make toilet seats with running water to take it away.

When he returned the next day, Nannina said Gianni was gone.

"His mother came for him."

"Did he leave a message for me?"

Her eyes shifted. "He said to tell you good-bye. He will miss you. . . . He said he will send you news of how he is."

She was lying, but not exactly. Though Gianni had not said it, she knew he felt that way. Deep within his pain and sorrow were the memories. Nothing could change them.

"Thank you, Nannina."

"Nothing."

In the courtyard, he again noted the air shaft that channeled palazzo sewage into the side alley. It was only fifteen feet from the well with rainwater. During heavy rains, the outside sewage could easily seep into the well. Here was a source of disease, perhaps even the plague. Why hadn't the Medici or the Signoria done something about it? Lorenzo certainly would agree to a conduit network to flush the city's waste into the Arno.

BAPTISM OF CHRIST

August — September 1471

IN EARLY AUGUST, Verrocchio received a letter from Padre Simone, abbot of the Vallombrosan monks at Montescalari. Their superior general, on passing through Florence, had heard the booming of the great bell that Maestro Verrocchio had cast for the Dominican convent of San Marco.

"Our father general," explained the abbot, "desires a bell for our monastery that is bigger than the one you did for the Dominicans. From our hilltop, he wants it to be heard all over Florence. Please come immediately, before the Father General leaves."

Delighted, Verrocchio showed the letter to Perugino.

"*Quanto bello!* A religious war with bells, and we're on the front line!"

His shop foreman was not amused. "Other bells are ringing for you. The abbot of San Salvi is screaming at us. He wants his *Baptism* this month or triple his money back."

"Pietro, calm down. There's only one angel left. You can finish it while I'm away."

"Away? You're going to stay up there?"

"A week or so . . . If they give me a monk's cell, maybe God will slip me some ideas for *Christ and Saint Thomas.*"

This was what he needed. Time to be alone, away from the shop. Pietro, however, was shaking his head with that upside-down mouth that never went up.

"That's not all. The predella panels for the Abbey of Camaldoli are due next week, when they expect a bishop from Rome. The *Nativity* is ready, but not the *Annunciation.*"

"I know that," snapped Verrocchio. "Leonardo can do it. He's already done a bigger one."

"Why not the *Baptism*?" Pietro suggested. "The underpainting is there. And for color, he has the other angel to guide him." He paused. "In that way, I'll be able to match the two predellas."

Verrocchio hesitated. Pietro's eyes had wavered. He probably feared Nardo's predella would shame his own. Also, there was little chance of doing anything with that *Baptism* angel.

"All right." He nodded. "Give Leonardo the *Baptism*. God knows, it's nothing to be proud of, thanks to those idiots."

The monks had insisted on a copy of a *Baptism* panel by Alesso Baldovinetti, itself a copy of Leonardo di Ser Giovanni's silver relief at the Baptistery altar, which, in turn, had been lifted from Andrea Pisano's version on the Baptistery's south doors of 1330. Verrocchio had agreed, despite his aversion to a concept originating some 140 years ago.

"I've never liked that panel, but maybe Nardo can improve it."

"He's at the market again, sketching faces of witches and monsters. I'll tell him when he returns."

"Do as you wish, but I want both works finished when I return. And no more trouble, you hear me?"

"You have my word, Andrea."

When Leonardo arrived, Perugino explained that the master had gone to the Montescalari monastery, where they wanted a bell bigger than the one at San Marco.

"He waited for you," he said. "He wants you to finish the *Baptism*."

Leonardo shook his head. "It's a mess, that painting. Copying Baldovinetti was a mistake. The Baptist is stiff, his extended arm is all wrong, and Christ looks like he's freezing to death in a puddle of water."

"So go ahead and fix it. He wants you to bring it to life in any way you see fit, even if you have to change what's already there."

"I doubt he wants me to change what he has done."

"I'm telling you: he doesn't care. He wants the picture improved by you and ready when he comes back."

"So I'll use oil colors. They go well over tempera. We shouldn't have any problems."

"Agreed," replied Perugino, delighted.

Now everything was finally in place. With his drive to be better than anyone else, the Vinci bastard would create a work that was not a Verrocchio and thus ruin himself. With the master squatting in a monk's cell, all that remained was to sit back and watch it happen.

Leonardo left early to walk along the river. He needed to think about Pietro's stupid plan. Clearly, he wanted a break with Andrea. Just go ahead and fix it, Nardo. Change it any way you want. After that, when the finished work makes a mockery of the master, you'll have no option other than to leave the workshop.

Pietro was an idiot. He didn't understand the art of Andrea. At thirty-six, the master was still young and constantly evolving. So it didn't matter what you did as long you remained within the given perimeters while extending his drawings or models toward their potentially higher level. The *Baptism* painting could be finished that way. Andrea would be delighted with it. And once again, Pietro would be a ridiculous figure, swinging at flies.

2.

Verrocchio returned ten days later, pleased with his trip. Besides an agreement on a great bell for the Vallombrosans, he had a spectacular solution for his *Christ and Saint Thomas*.

Entering the workshop, he sensed unease among his assistants. Then he saw the *Baptism* with its new angel, waiting for him on an easel in the light of the studio window. He stared at it, amid a hushed gathering of everyone in the shop. This was Leonardo. Only he could have created such an overwhelming work. It had happened before, but never like this.

He took a deep breath, trying to control himself. Then he looked for violations of his basic design and intent. There were none. Everything that was his had remained—large eyeballs, tight lids, hooked nose, folds in the neck—all Verrocchio. Yet as with the *Discord* relief, Nardo had taken his outer form and infused it with an inner life it had not possessed. As a result, this one angel, visible only from the back, its face upturned, was now the living center of the picture.

With mixed envy and wonder, he noted its structuring—the stepped folds of the blue robe, the bloodred gash of its lining, the snakelike strip of white linen to dry the feet of Christ—all of it rising upward toward the angel's face, which was framed by golden hair.

Within the old outline, a new face had appeared, unlike any of the workshop models'. It had the sudden, disconcerting beauty of a forest creature caught by surprise. It was pure and innocent, yet all-knowing. The lips were slightly parted in a mysterious smile, and the eyes contained both joy and sadness, as though the angel was aware of all that was to follow from this pivotal moment in the river Jordan. Before the haunting beauty and presence of this creature, the Baptist and his Savior were earthbound mortals. The angel alone had the grace of heaven.

Yet the stiff figure of Christ was also improved. He no longer stood in a stagnant puddle. A stream of crystal clarity, the waters of a new life, now swirled around him and the Baptist. The winding river flowed from distant mountains, bringing the promise of a new and loving intimacy with God.

Verrocchio stared for a moment at Leonardo. Then he saw the smirking face of Pietro. You son of a bitch, he thought, you'll pay for this. Then he left without a glance at the others.

Leonardo looked at his companions for some sign of support, but they avoided him, staring uneasily at Perugino, who was gloating in triumph. He was back in the school courtyard at Vinci. Pietro was Tonino, with the same sneer and glazed eyes of a bully.

"Well, Nardo, you've done it."

"That's right."

"The Master was furious . . . just as I expected."

"That's right."

This was not what Pietro wanted, and he lost control.

"'That's right.' 'That's right.' What else do you have to say?"

Leonardo left to find Andrea, who was in his private studio. His master was looking out of the window. When he turned, Leonardo saw a face torn by sorrow. It was in his eyes. There was an attempt at a smile, but it was a sad smile.

"Well, Nardo, it's happened . . . just as we expected."

"Don't say that. Please don't say that."

There was no reply. This was more difficult, more frightening than he had expected.

"I worked inside your lines. I used the same colors. I followed the other model."

Andrea waved his hand. "It's not that, and you know it."

Leonardo felt a sudden, plunging fear. He would soon be ready to join the Confraternity of Saint Luke. He was almost twenty now, and he could even open his own workshop. But this was his only home, and he loved this man. More than master, Andrea was the only father he had ever known. He began to tremble and tried to control himself. Then Andrea smiled again.

"You slept before it at night, like a lover."

He nodded.

"You made love to that angel. You gave it the wonder and beauty of your love."

He nodded again, unable to reply.

"I'm not angry, Nardo."

Leonardo fought back the tears, frightened and ashamed of his panic.

"How can I be angry? We knew it was going to happen. So now you've done it. . . ."

Andrea said no more, unable to continue. Leonardo sought to be as brave as possible.

"I'll go when you like. Just tell me when you want me—"

Andrea shook his head, suddenly angry.

"Leave me? You would leave me?"

He opened his arms. Leonardo hesitated. Then he went to him.

"*Figlio mio,*" Andrea sighed, holding him as a lost son.

"*Padre mio,*" murmured Leonardo.

PORTRAIT OF GINEVRA

FLORENCE

January – March 1475

E ARLY IN JANUARY 1475, the Venetian ambassador to the Florentine Republic came to see Verrocchio in his workshop. He requested a portrait of a Florentine lady—Ginevra de' Benci, the seventeen-year-old wife of a cloth merchant, Luigi de Bernardo Niccolini.

Verrocchio was intrigued. Of all the envoys to Florence, His Excellency Bernardo Bembo was the most notable—a cultured personal friend of Lorenzo de' Medici and a member of his intimate group of Platonic scholars. A tall, elegant signore in a dark blue cape trimmed with red fur, he had a virile face, dark hair graying at the temples, and the gray eyes of Venetians who knew the ways of the seas.

"It would be an honor," replied Verrocchio. "I have seen Donna Ginevra. She is most beautiful."

"It's a wedding present," Bembo explained.

"But wasn't the marriage some months ago?"

"That's why we want it done quickly. Every day makes it more embarrassing."

We want it? Verrocchio was further impressed. The Venetian Republic, with exquisite diplomacy, was honoring an important Florentine family. Luigi Niccolini had been a *gonfaloniere della giustizia*—the highest civic honor. Ginevra was a noted poet and also a friend of Lorenzo.

The diplomat spoke confidentially. "Donna Ginevra has weak lungs, and her doctors fear for her health if she remains in Florence during these cold, humid days. So you will do it at her country villa in the Mugello Valley, just an hour's ride."

Verrocchio couldn't spend two hours a day on the road. The shop was working overtime, and he still had not begun the bronze group, *Christ and Saint Thomas,* to replace Donatello's *Saint Louis of Toulouse* at Orsanmichele—another challenge from Donato's grave.

"I'm sorry. It would be an honor, but I cannot do it immediately."

"In that event, Il Magnifico wondered if your Leonardo would be free to do it?"

So Lorenzo de' Medici had suggested Leonardo, who had taken Lorenzo's life mask for a terra-cotta portrait and had worked on the marble bust of Giuliano's mistress, Fioretta Gorini. At twenty-two, he was a master in his own right in the painters' guild, under the Guild of Apothecaries and Doctors, and in the artists' Confraternity of Saint Luke. Perugino was in Perugia, turning out baby-faced Madonnas like sausages, while Nardo had remained as his assistant: *You have been like a father, and the shop has been my home.*

This would be Leonardo's first commission and the first step toward his eventual departure. For years, Verrocchio had feared this moment. Then he felt a surge of pride and joy.

"You are most fortunate, sire. Leonardo can do your portrait in a way that is beyond my powers . . . or those of anyone else. I will have him call on you."

Bernardo Bembo left the workshop pleased. He had obtained Leonardo, as Lorenzo had suggested. Verrocchio would never have fitted into this little adventure. Now all that remained was to get Ginevra's husband out of town. Luigi's business was in trouble. A letter from Venice, with a tempting proposal, would do the trick. The lovely Ginevra could move to her country villa for the portrait, and he would drop by to check on its progress.

Then her lingering hand would find what it desired. Her furtive glances would finally see what they could only imagine. And she would offer all that she had promised in her veiled poems of love:

> O, I pray thee take heed,
> You who wouldst pass my gates.
> Gentle mercy is my need,
> Though here a mountain tiger waits.

In the barren bed of her mountain lair, she wanted a tiger. And, *per bacco,* she was about to get one.

2.

In the living room of the villa, the winter sunlight came through muslin curtains in a warm, luminous glow. Sitting at an angle to the light facing Leonardo, she was dressed simply in a russet bodice trimmed with gold filigree.

Beneath the green lacing between her breasts, a transparent chemise lay over pale flesh. She wore neither jewels nor ornaments, other than a three-inch-wide black scarf band, which came over her bare shoulders and fell to her waist—a Florentine reminder of faith and mortality.

At first, it had not gone well. Her maid had sat near them, looking at his sketches as he worked. Finally, she had told the maid to go away, and now they were alone and she was more at ease.

"I thought portraits were done in profile. Do you want me to keep looking at you?"

"It would help. If you tire, tell me."

"You can still do it if I move?"

"I need you to be naturally yourself . . . not stiff or posed."

"That's not easy with you looking at me."

He smiled and continued to draw her hair—ringlets, like copper-bright coils, cut diagonally across her brow. The nose was delicate, but with flared nostrils. The mouth, modest in size, also had the rich, full lips of a passionate woman, and the wide cheekbones of a Tartar. Bembo had said the Benci family was of old, aristocratic stock, but a Tartar slave was in there somewhere. The almond cast of her eyes resembled that of Tara, his father's slave girl, and there was the innate pride of the Tartars, like the Circassians.

"Beauty comes and goes like the sun and clouds," she said. "How do you explain that?"

"Love helps, don't you agree?"

"Being loved?"

"Just feeling loved."

"It makes one more beautiful?"

"Anyone. Even horses."

"Really? Do I seem that way to you?"

"No, not like a horse."

She laughed for the first time, like a child dancing. He drew this, wondering if it pointed to something more.

"I don't know what you see . . . what you're looking for."

He didn't want to talk about it. Talking would get them nowhere. But she persisted.

"It would help if I knew what you see when you stare at me this way."

"It's not only the outside," he replied. "There's also the inside. They have to match up."

"And if they don't?"

"The picture will have no life."

"I don't know if I want people seeing my inside."

"Are there many who do?"

"O *Dio!* I hope not! You are a strange man, Messer Leonardo. May I call you Leonardo?"

He smiled and nodded.

"Tell me, Leonardo. How do you plan to enter my secret inside?"

"I'll wait for some sign from you."

She hesitated and lowered her eyes. With this, he imagined her body, the shape of her breasts, the waist and thighs. He had noted the way she walked, and how she turned her head to look at him, her eyes lifting as she laughed in a way he had known long ago.

No, he thought, this is not Albi from the dark night of dreams. This is a creature of early spring—pale, untouched, waiting for someone, yet also withdrawn. He noted the tenseness in her body, the legs pressed close together, a hand touching the lacing of her bodice, and he felt within himself the beating of her heart.

She looked at her hand upon her bodice.

"What do I do with my hands?"

"You could hold some of your budding almond blossoms. They're a symbol of the Virgin . . . and a promise of new life in the spring."

She smiled and closed her eyes. Clearly, her new life was about more than flowers or a risen Jesus. Maybe Andrea was right about Bembo. An elderly man with a black dog came in from the loggia. Ginevra waved to them.

"Welcome to the picture party!" she called. "Leonardo, this is my husband, Luigi Niccolini. And the dog is Argos. In an earlier life, he belonged to Ulysses."

Luigi resembled Leonardo's father—the hooked Florentine nose, broad cheekbones, bushy brows over gray eyes, and hairs bristling from his nose. He even wore a riding cape like Piero's dark forest green one.

"Signor Leonardo, I know your father, Ser Piero . . . also the Amadori," Luigi added, referring to Albi's parents.

Leonardo nodded. Luigi had rudely begun to examine some folios on an adjacent table—sketches of his wife's face and head, with details of eyes, nose, and lips.

"Well, Ginevra, he seems to have caught you perfectly . . . falling apart in bits and pieces."

"Let me see!" she cried, rising. "Oh, they're beautiful!"

She touched the drawings, tracing the lines of her face, her braided hair and lips.

"Look at this one, Luigi! One little squiggly line, and there's a living part of me!"

"When does he put all the pieces together?"

"When he understands me better."

"When he what?"

Leonardo saw in him Piero's eyes, which displayed neither belief nor trust.

"That's right, Signor Niccolini. . . ." He paused to relish the jealousy and fear. "From these sketches, I will choose the essential ones to portray your wife."

The maid appeared to say lunch was ready. Ginevra turned to her husband with a smile.

"*Caro mio,* I asked Leonardo to lunch before I knew you were coming. Is it all right?"

"Of course. I might as well get used to this. You and your Leonardo. Maybe we should have Bernardo Bembo keep you company while I'm away."

Ginevra was not the least amused. "Away? Where are you going?"

"A Venetian shipping firm is interested in a large consignment of our silks. Bernardo believes I should be there to close the deal personally."

3.

Ginevra de' Benci sat on the veranda of her villa, looking at the distant hills of the Mugello Valley in the golden light. During the night, she had dreamed of making love with Bernardo. He had been sweet and gentle, and it had felt like flying. Before the marriage, Aunt Bartolomea had said making love was like that. You rose up, higher and higher, with mounting delight, until it became so intense that you lost all sense of where you were, before falling into dreamy darkness like black velvet. That was how it was supposed to be, but it had never been like that with Luigino.

Maybe it would happen with Bernardo, but she didn't know, and each time she thought about it, she became confused. If it did happen, if it was really wonderful, what would she do when he returned to Venice or some other court in Italy? It was bad enough now, but then it would be unbearable. No, she thought, it is better to do nothing. Don't think about him. Yet she continued to think of his gray eyes, his virile face and hands, and how she trembled when he touched her.

Aunt Bartolomea knew all about affairs like this. She had had several men, and now she was Lorenzo's secret mistress. He came to her villa at night,

and he rode back at dawn. Bernardo wanted to visit her the same way while Luigi was in Venice. Leonardo would paint the portrait by day, and Bernardo would come to her in the evening. It was simple, he had said. No problems . . . Yet it wasn't that simple. Nothing that made your soul turn in dreams was simple. Nothing that filled you with wonder and awe and fear was simple. Or was it? Aunt Bartolomea's villa was only a short ride away in the Mugello.

Ginevra found her aunt dyeing her hair with the help of a Circassian slave girl. She wore a broad-brimmed straw hat with the crown cut away, so that her hair lay in yellow strands upon its brim like spaghetti made with too many country eggs. The slave girl, using a sponge, wet the strands with a dark, acrid tincture from a simmering copper pot—a secret formula for blond hair from the duchess of Milan, who claimed it had done wonders for the queen of Sheba and Byzantine courtesans.

As prepared for Donna Bartolomea by the pharmacist Luca Landucci, it was boiled Muscat rosewater and civet, into which had gone the juice of hickory roots gathered in May, lizard tallow, gray *succinum,* ox gall, saffron, burned bear claws, and the droppings of swallows. To speed its drying, the object of Lorenzo de' Medici's love wore a floppy white cotton chemise like a desert Arab while seated in the sunlight that came through an open window. To hasten it still further, three copper basins with glowing coals heated the room—so much so that both the lady and her slave girl were perspiring profusely. This imparted some urgency to the talk. Ginevra had hardly begun when her aunt interrupted her.

"My dear girl, you are in the middle of a garden of roses. What's your problem?"

"I'm frightened. If Luigino finds out, he'll kill me."

"He won't find a pin if you're careful. He might suspect something, because they can sense it the way we can. But no matter, you must never admit anything because he doesn't really want to know the truth."

"Oh? . . . Why?"

"Because it'll make it worse for him. A man can have more horns than a basketfull of snails, but if he thinks no one knows, he can live with it. Especially your Luigino, who's an old cock. With his wife still warm in the grave, he was lucky to get you at sixteen, poor child. So he's no problem."

Ginevra was relieved. In the heat of the room, she stared at her aunt's perspiring body—the seductive source of this sexual wisdom. The light cotton chemise clung to her in the heat, exposing her belly and loins as they sloped into firm alabaster thighs. Her breasts, under the thin wet cloth, seemed remarkably firm for a woman of . . . well, at least thirty-six. Yet more than this,

it was the way she moved—her legs open without shame, the arms languid and supple, her body like an animal's . . . a leopard maybe. You could understand why Lorenzo rode through the night for this. It would appeal to any man—or woman, for that matter. No wonder her mother had never been close to this sister. She was too much for her.

"Go and play with your Bernardino. But keep Leonardo near you, so Luigino will be jealous and make a fool of himself, since he prefers young boys."

"Leonardo?"

"He's in Lionardo Tornabuoni's circle of sodomists. . . . Are you surprised? My God, Ginevra! Half of Florence is that way. We're famous for it. To the Germans, Firenzuola means 'those who prefer the *culo.*'"

"How sad . . . I thought so much of him."

"And why not? Donatello and Brunelleschi were lovers. So were Masolino and Masaccio. Maybe Verrocchio is one, too. Leonardo still lives with him, even though he's now a master in his own right. The dowry system does it. Our young men can't marry when they should, so they put it into slave girls or into one another."

"Now I understand why Luigino likes it that way. . . ."

"Oh, my child! Florentine men will put it anywhere they can. If they could get it into your ear, they'd do that, too."

"I thought Leonardo really liked me."

"Of course he does. He probably loves you in his way. Especially a splendid creature like you. That kind of love from a man is very precious. Take care not to lose it, Ginevra. These men are closer to us than other men can ever be. And we are closer to them in the same way. Now go, girl . . . go and become a woman."

4.

After the third sitting with Ginevra, Leonardo returned to Florence to review his drawings and select those to be used in the composition of the portrait.

It was a first, crucial passage. At this point, many artists reverted to the manner and substance of previous work—usually one containing a core reflection of themselves. To avoid this, to separate himself from any prior concepts, Leonardo turned his sketches sideways and upside down, looking at them as one seeks unexpected forms in clouds or in natural stains on old walls. In this way, he recovered the freedom he had initially enjoyed with the *componimenti inculti,* or "loose, unmediated sketches."

He worked at a drafting table in the studio of Verrocchio's workshop assistant. To his right were shelves with tins of assorted colors, distilled nut oil and juniper, crushed mustard seed with linseed oil, turpentine, and a standing array of brushes. Opposite this, above a chest holding papers and tools, were treasured objects from Vinci—a piece of the buried whale's jawbone, a drawing of his little horse Pegasino, a copy of Masaccio's *Expulsion*, and a silverpoint drawing of Albi in the field of flowers.

A wall scroll contained the maxim taken from Leon Battista Alberti:

> All visible things have been brought forth by nature, and it is among these that painting is born. Since nature is truly the Daughter of God, the painter is the Grandson of God. To him is given the power to create all things in the universe through essence, presence, or imagination. . . .

He looked at the drawings of Ginevra in a mirror, checking their potential for spatial relief. Finally, he chose one with the light coming from above and slightly to the left, falling directly onto the broad plane of the brow, the ridge of the nose, part of the upper lip, and the delicate yet resolute chin. A soft shadow began on the pale fold of her cheek. From there, it descended into the dark hollow of her throat, to emerge again as a delicate veil on the white pillar of her neck.

The next passage contained greater danger and promise—the use of informed fantasia to recombine images or parts of images into new forms, which could be assembled into a single yet enduring instant of time. He returned to his sketches for clues on how to proceed. Here, for example, the eyes were languidly staring at the mountains beyond her home. On another page, they had drifted away in boredom. Yet further on, there was a dramatic change. In their amber depths, she appeared to see an approaching figure. Or was it someone leaving her?

Either way, this poet and sensitive woman, wearing the black scarf of her mortality, awaited her fate with courage and resolve, visible in her eyes and mouth, with its barely perceptible smile. It was an old smile, one from the beginning of time—the shadow smile of women aware of their destiny. He found the hands he needed in another sketch—fingers touching the blue lacing of her bodice and a transparent chemise over the pale rose color of her bosom. This was better—a timid gesture on the threshold of intimacy. That decided, he began to compose the cartoon on a large sheet of paper, which would be transferred to a wooden panel for the painting in oil.

Gradually, she emerged as he wanted her to appear: the broad forehead with intricate coils of burnished hair curving down over the temple, the dark,

brooding Tartar eyes, the delicate nose with its thick nostrils, and the firm yet sensuous mouth. Over the bare shoulders, he placed the black band of mourning—stark symbol of her faith and awareness of life's brief span.

The background came next. Beyond the parapet of a loggia, a silver-gray mist lay over distant blue lakes at the foot of the dark green Mugello hills. Yet this was an escape from the enclosed drama of the portrait. Something else was needed—some analogous symbol to justify all that was visible, yet also all that was not.

The next day, he received a note from Ginevra. She had come to Florence to see her husband off to Venice and was anxious to return to the country whenever her "young master" so desired. Meanwhile, there was to be a jousting tournament on Wednesday, January 25, in honor of Giuliano de' Medici. Would Messer Leonardo—"a most esteemed and precious friend"—give her the pleasure of his company with Ambassador Bembo in witnessing the great spectacle?

Leonardo was delighted. On a proud day six years ago, he had witnessed Lorenzo's famous joust for his chivalric mistress, Lucrezia Donati. Andrea had painted her portrait on Lorenzo's red-and-white banner. And he, Leonardo, had painted its rainbow with Lorenzo's motto in golden letters: *Le Temps Revient*. While painting lilies on Il Magnifico's shield, Andrea had explained the Medici had adopted the lilies of France with the gracious consent of His Majesty Charles VII. "There's a real royal court," he had said. "They don't haggle with artists or treat them like tinsmiths."

Upon seeing the invitation, Andrea smiled. "Where's her husband?"

"In Venice on business."

"Arranged by Bembo?"

"Yes. Did I tell you?"

"No, but it makes sense. Bembo must be crazy for her. They say he's borrowed money from Lorenzo, compromising his mission here. Maybe it's to pay you and give her Venetian pearls."

"That's stupid."

"You don't feel for her the way he does."

"Maybe I feel a lot more, as you would."

5.

Prior to the tourney, Ginevra took Leonardo and Ambassador Bembo to a luncheon at the Medici Palace on via Larga. As they climbed a broad staircase to the second floor, other guests stared at them. The noble lady was in a fur-lined *cioppa* of purple velvet and a sweeping dress of red silk, its brocade bodice

laced with gold loops across her pale bosom. The ambassador wore a heavy gold chain on a sea blue doublet and a billowing cape of red and gold. The artist, between the lady and the diplomat, had on a green doublet, an ivory silk shirt with lace cuffs and collar, and his singular knee-length rose-colored tunic.

Bembo looked forward to meeting many friends at the luncheon.

"Members of Lorenzo's Platonic Academy," he explained to Leonardo. "Do you speak Latin?"

Leonardo paused. This was not going well. He liked Lorenzo, but not the prospect of meeting the members of his academy. Toscanelli despised them. He had said, "Their ideal city-state is a closed society like ours, ruled by a king-philosopher, Il Magnifico Lorenzo, with his gaggle of Medici patriarchs."

"I neglected Latin for nature studies," Leonardo replied. "I know it's still alive, however, among notaries, priests, doctors—"

"Not exactly," said Bembo, interrupting him. "Those people buried it with a thousand stupid rules. Instead, the humanists have revived the living, classical Latin of Cicero, Virgil, Ovid. . . ." He paused, laughing. "The priests tremble at our delight with famous non-Christian ghosts. They also tell other idiots that humanism centered on ancient Rome cares nothing for today's humanity."

"In Horace," suggested Ginevra, "we find ourselves in Roman society of all classes. In Catullus, we're shown the arts of love and playful tenderness . . . and in Lucretius, a universe opens before us."

"In Leonardo Bruni," added Bembo, "you learn that Florentines, with their republic tradition, descend from the Etruscans, who also hated Rome. In Marsilio Ficino's Neoplatonic philosophy, the Mosaic revelation to the Jews prepared them for truths in Christianity today."

Leonardo enjoyed this. Had Toscanelli lingered too long among the stars? Plinio was also there, in ancient Rome, with art theories in *Naturalis historia.* And there were the Marcus Aurelius horse and rider on Monte Cavallo, the nude Dioscuri and their horses, the beautiful boy Camillus, the great head of Constantine. . . .

"I've also been there," he replied. "Indeed, it's far nobler to go to the ancients."

Ginevra laughed, relieved. "Welcome to the party, *caro maestro!*"

The dining room was filled with guests on both sides of a long U-shaped table. Ginevra saw many of her friends, and Bembo noted numerous members of the Platonic Academy—Cristoforo Landino, the literary theorist, and Alamanno Rinuccini with Donato and Piero Acciaiuoli, the scholar-aristocrats—but no seats were available for them.

Then she saw Lorenzo de' Medici pointing to three places near him at the head of the table. Nodding gratefully, she paused with her friends as they

washed their hands in silver basins at a sideboard—etiquette of the day, since people ate with their hands. The Medici prince rose to greet them.

"Giuliano and his knights are making ready," he explained. "We won't see them until they enter the field. . . . I'm delighted you can take their places."

Ginevra sat on Lorenzo's left, next to her friend, Marsilio Ficino, the Platonic scholar and priest-philosopher. Bembo, as ambassador and a friend of Lorenzo, sat on his right. Leonardo was opposite them, next to Angelo Poliziano, the refined poet and tutor of Lorenzo's children.

"He's doing my portrait," Ginevra explained upon introducing Leonardo to the intimate circle.

Lorenzo nodded. "We know and admire the young master. How is it coming?"

It wasn't coming. He had what he wanted, but not the background of the picture. That's how it was, but he wasn't going to discuss it. Nor was it necessary. Ginevra was already explaining it to Lorenzo.

"In a few lines, he captures all of me. At first, I felt exposed and frightened. Then I recalled Marsilio's telling me"— she smiled at the philosopher —"that artists and poets are earthly counterparts of the Creator, and I thought, Leonardo is doing what I would do with words. After that, I began to enjoy it."

Ficino nodded, pleased. Lorenzo smiled, and once again Leonardo saw a dark beauty in the brutal face of the poet and ruling Medici. The waiters arrived with silver trays of fried baby eel on lettuce with saffron, crushed almonds, and rose petals—arranged to resemble the Medici stem. Chilled trebbiano wine was poured into silver goblets by white-gloved servants while everyone ate with their hands and wiped them on the tablecloth. It was like anywhere else, Leonardo decided, except there were no dogs under the table.

A page brought Lorenzo a note, and he broke into a high, nasal laugh.

"Oh, signori! Listen to this. Our Giuliano has obtained a silk chemise of the lovely Simonetta. Not only will he dedicate his joust to her beauty and honor; he will ride into combat wearing her gown under his armor. Now tell me, has my brother broken the rules of the joust? Ginevra, dear and gentle lady, what do you say?"

"I would say it depends upon his thoughts at the moment he donned the garment."

"Also on whether she was present when he obtained it," suggested Bembo.

Amid the laughter, Marsilio Ficino gravely shook his head. Lorenzo nodded, as though the matter was now before the Platonic Academy.

"What do you say, Marsilio?"

The philosopher, Leonardo decided, resembled Giotto's fresco of Dante in the Bargello—the same high, straight nose, deep brow, and dark, brooding

eyes. His translations of Plato for Cosimo de' Medici had made him the leading spirit in Lorenzo's academy. Now a priest, under Lorenzo's patronage, he wore a scholar's flowing black robe with rich pleats and large sleeves, closed at the top by the narrow neckband of a cleric—the open robe and closed band vestigial outcroppings of a belief in a divinely predestined synthesis of Platonic philosophy within Jewish and Christian faiths.

"These jousts are inspired by Gothic chivalry," observed Ficino. "They are also quite dangerous and the rules are fixed. The knights enter the arena bearing standards for a lady of their heart who is beautiful, virtuous, yet, above all, unobtainable. This display of courtly love educates the heart of our noble youth and is acceptable, since such love must be hopeless—"

"Because of the lady, not the knight," said Lorenzo, interrupting Ficino. "Her icy scorn, her chastity protect her from the knight's heated passions, and, in theory at least, the loss of her chemise."

"That's the problem," replied Ficino. "Giuliano's mistress, Simonetta Cattaneo, is indeed virtuous . . . and her husband, Marco Vespucci, is so honored in this event. But if he knew his wife's undergarment lay upon the sweating body of Giuliano, he would feel insulted and dishonored. This was a serious blunder and quite dangerous, since Marco is sure to hear about it."

Lorenzo turned to Poliziano. "How does the poet see this?"

"It is not a problem," he replied. "Giuliano's standard shows her in the vestal gown of Pallas, which no warrior can pierce. To further honor her, he took the robe of her chastity, which no man can penetrate."

"And what says the painter?" asked Lorenzo, turning to Leonardo.

"If no man can penetrate her chemise, what's the knight doing inside it?"

This delighted everyone, except Poliziano, who glared at Leonardo.

"Bravo!" exclaimed Bembo, "I fear it's a Trojan horse."

Ginevra glanced fondly at her Venetian friend. When she saw Lorenzo watching her, she blushed and lowered her eyes. Then she raised them and stared at him—defiant, proud, and unashamed. In that moment, Leonardo saw confirmed the face he had chosen for his portrait. Now all that remained was the background.

6.

In early afternoon, Lorenzo and his guests strolled over to Piazza Santa Croce. The vast square had been turned into a field of combat for the tournament, with raised pavilions and bleachers along its sides.

It was a perfect day for a tourney, the air crisp, with a warm January sun in a clear sky. All of Florence was there—on the viewing stands, behind

barriers, and in the windows of adjacent palazzi, hung with tapestries and the fading standards of past tournaments. Other spectators perched like huddled owls on red-tiled rooftops. In the still air, there was the odor of fresh earth on the cobblestone square. The rumble of the crowd was pierced by the cries of children and the shouts of carnival vendors hawking their fortune charms, religious trinkets, toys, and sweetmeats.

A wooden barrier enclosed the field. An entry through two large wooden doors was on the right, in front of the church of Santa Croce. Eighteen flags of the combatants hung from poles on each side of the entry gate, their bright colors and fierce emblems waving sporadically before gray stone saints and martyrs on the facade of the Franciscan church. A wooden barrier ran down the middle of the field. Ginevra asked Bernardo its purpose.

"This is a dangerous game," he said. "The players can be wounded or even killed, especially if the horses meet head-on. So they run at one another on opposite sides of that barrier."

"It also refines the art," Leonardo added. "To do it well, you must remain firm in the saddle, yet also tilt toward your opponent for a direct thrust. That's why the barrier is called 'the tilt' and the sport is known as 'tilting.'"

"It's very exciting," Ginevra said. "But even with the tilt, as you call it, there's a danger of those spears getting past the armor, isn't there?"

"The duke of Montefeltro lost an eye and part of his nose that way," Leonardo replied.

"I hope it doesn't happen today."

"It's unlikely. The lances are blunted with a ferrule, a flat piece of iron."

"Leonardo, you amaze me. I didn't know you liked this sort of thing."

"It's the horses. They're usually magnificent."

The spectacle began with a peal of trumpets, a roll of drums, and a pair of leopards led by black slaves. This was followed by a procession of singing troubadours, jugglers, flamethrowers, giant men on walking sticks, and mock knights on little donkeys. Again the trumpets pealed, and the crowd fell silent.

Two horse-drawn floats appeared, bearing the reigning queens of the day—two women whose beauty and charm had won the hearts of the two reigning Medici brothers—Simonetta Cattaneo, Giuliano's lady of love and reigning Queen of Beauty, followed by Lucrezia Donati, Lorenzo's muse and former queen of his tournament. After circling the field amid cheers and applause, the two queens dismounted before the main pavilion to be led to their waiting thrones.

Simonetta came first and everyone rose to honor the young Queen of Beauty and get a closer look at the pale, consumptive woman who had become a legend. She wore a white gown embroidered with red and yellow roses. Her

golden hair was fixed by pearls, and as she turned in the sunlight, Leonardo noted the pale, ethereal features that Botticelli had derived from Filippo Lippi—a child's profile with a high, fair brow, languorous eyes, teenage breasts, slender shoulders, and arms with the grace of a swan.

"Helen of Troy looked like that," murmured Ginevra.

"And she'll cause as much trouble when Marco hears of the chemise," added Bernardo.

As the young woman passed them, the diplomat shook his head. "She would have them both," he whispered.

Ginevra was astonished. "Both her husband and Giuliano?"

"You can see it in her face. That's a woman who gets what she wants."

"You see that in her face?"

"And her hands. You can tell a lot from hands."

Ginevra looked at her hands. "And mine? What do you see?"

Bernardo glanced at Leonardo.

"He's my friend," she said. "He knows all about me. You can trust him."

The Venetian took her left hand. It lay, long and pale, in his dark, broad palm.

"No," she said, suddenly withdrawing it. "Not now . . . not here."

After a parade of competing knights, the trumpets sounded again and the crowd fell silent—then, amid cries of delight, two knights rode through the gates for the first contest of the day.

"Who are these two?" asked Ginevra.

"I know the one on the gray horse," replied Leonardo. "It's Giuliano's friend Giovanni di Papa Morelli."

"Lorenzo told me the other is Luciano di Martelli, from Ferrara," said Bernardo.

The fifes sounded a shrill warning, and the two knights took their positions at opposite ends of the field. After a count of five, a two-note trumpet blast launched the charge. The two knights dug into the flanks of their mounts, their steel-enveloped bodies bent forward in the saddle, their lances firm in the hilted seat between forearm and shoulder. In full gallop, with wild cries inside their helmets, they met in a clash of steel, a muffled scream of rage, and the thud of a wood ax. The Ferrara knight flipped backward and fell to the ground like an upturned beetle.

"What happened?" asked Ginevra. "It looked like both lances hit at the same time."

"They did," replied Bernardo. "But Giuliano's friend had greater strength in the saddle."

"And a better horse," added Leonardo. "Speed is vital, though a heavier lance can deliver a greater impact and win the day. . . . There's Giuliano!"

He had seen this Medici several times at the workshop. Yet only now, after lunch with Lorenzo, did he perceive their stark dissimilarity. Giuliano had a smaller mouth, and a simian brow that sloped backward, extending the arc of his nose. And where Lorenzo had a strong, determined chin, his brother's was weak and receding. Did this proud knight contain some interior flaw?

"He's on the duke of Urbino's Orso," explained Bernardo. "When soldiers in battle see the duke on him, they throw down their arms and run away."

The young Medici took his place at the far end of the tilt barrier—opposite another friend, Raimondo della Stufa. Orso was highly agitated, turning and prancing, until brought under control. Then with the trumpet's blast, the famous warhorse charged like a beast of fury, its hooves pounding the earth with running thunder . . . to splinter the great lance of Raimondo.

Other contestants followed. Some broke or lost their lances. Others were unhorsed or suffered torn muscles and severed ligaments. Finally, Giuliano and his friend Giovanni di Papa Morelli met in a tilt that was to determine the day.

Through the slit in his steel visor, Giuliano's adversary saw a demon coming at him with flashing black eyes and the flaring nostrils of a beast from hell. They clashed, and the blunted tip of Giovanni's lance slipped under Giuliano's egg-shaped basinet. It smashed onto the steel gorget covering his throat and chest, knocking him backward on his horse. For a moment, Giuliano appeared to fall. Then he rose up in the saddle while retaining his lance—still undefeated as Orso took him from the field.

Ginevra had cried with alarm at the fierce blow to her favorite knight.

"Is he hurt?" she asked.

"Who can tell?" replied Bernardo. "What do you think, Leonardo?"

"He stayed in the saddle."

"I'm praying for him," Ginevra announced.

A few minutes later, both knights returned for another tilt. Before lowering his visor, Giuliano could be seen talking to Orso, stroking him with his steel glove. At the trumpet signal, they began their charge. Giuliano's dappled gray steed raced with renewed fury—teeth bared, nostrils quivering on his final run for victory. Both men leaned dangerously over the tilt, drawing moans and cries from the crowd. At the moment of impact, Giuliano's lance struck first, unhorsing his friend, whose head snapped back as though severed by the saber of a Turkish stradiot.

Giuliano de' Medici had won the day. His standard was returned to the field, and the judges awarded him the victor's prize. The crowd cheered, and when Lorenzo appeared on the field to greet his victorious brother, they cheered again.

"This is what Lorenzo wanted," Bernardo said. "His last tourney cost him ten thousand ducats. This one exceeds that price, but it's worth it. Look at the crowd, how they love the glamour and power of the Medici brothers."

Leonardo studied the victor's banner, painted by Botticelli on fringed taffeta. Pallas, the goddess of wisdom, stood in a flowery meadow, her hair fluttering in the wind. As might be expected, the meadow lacked perspective, and the windblown hair held no hint of the wind. Sandro knew nothing of science or nature. The blue buskins on her feet rested upon two flames issuing from olive branches and a gathering of leaves.

There was the solution for his portrait—a dark cluster of spiky juniper leaves, with *junipro* implying *Ginevra*.

"You're smiling, Leonardo."

"I've located you, Ginevra."

"Where am I?"

"In a world that can never hold you."

"Now you're frightening me again," she replied, but with a smile.

They rose to leave with the other guests. It was late, and the first shadows of evening lay across the piazza.

"Beloved lady, when can we begin the painting?"

"Day after tomorrow, if you like."

He nodded, and she kissed him good-bye—an impulsive yet tender kiss near his mouth. As he watched her leave with Bernardo, the sensation of her lips lingered. He imagined her pale face, its mask of feline languor and buried passions, against an interlacing of dark juniper leaves—the Tartar eyes waiting, the mouth fixed in defiance. A soft shadow, emerging from copper ringlets of hair, would slope across her right cheek and her chin before descending to the throat, with a light veil upon the slope of her breasts.

They were similar to Albi's, and he enjoyed thinking about it. Yet this wasn't Albi. It was another woman, though parts of Albi had appeared at unexpected moments. This was surprising.

Perhaps invading memories were inevitable in seeking an essence within cognate forms. Impressions of one woman, in passing from the mind's *imprensiva* into its *senso commune,* would inevitably seek identifying particles of an earlier one. So Ginevra, with aspects of Albi, was destined to enter a future woman. In this way, successive portraits would build upon one another, cell upon cell,

until eventually one of them would render useless any further search. Could that be the unknown Maria with the face of a woman to contain all of humanity?

He left the next morning after packing a mule with the portrait panel, painting supplies, and a few personal belongings. The mule trailed his horse, and he arrived at the Benci villa in early afternoon. Coming up the drive from the gate, he saw the maid, Gelsomina, gathering winter greens in the field. She began to run toward him, but he motioned that he did not need her. At the villa, he dismounted quickly, anxious to see the juniper tree near the rear veranda.

Entering the *salotto,* he saw them together—a creature of four legs and arms, similar to Plato's concept of human life before the sexes were separated, to forever search for their missing half. In the delirium of their union, her lace chemise had somehow managed to encircle the ambassador's naked bottom—a rather original way to present a *culo.* Her eyes, closed in bliss, suddenly opened as he turned to leave.

At the villa entrance, he saw Gelsomina breathlessly hurrying up the front steps. Beyond her, at the far end of the drive, a horseman was riding through the gate. Madonna, he thought, that fool even rides like Piero—too far back on the kidneys. And like Piero, he's coming home just when no one wants him.

"Gelsomina, would you inform Donna Ginevra that I am ready to begin the portrait immediately . . . and that her husband will be delighted to see it under way?"

"*Sì, signore!*"

When Ginevra opened the door for him, he saw again the face he had captured for his painting—her eyes containing the pride of a woman who could love without shame and betray without any sign of remorse.

THE SODOMY TRIAL

AND *SAINT JEROME*

FLORENCE

April 1476

T HE LETTER FROM POPE SIXTUS IV to Lorenzo de' Medici was marked *cit, cit, citissimo,* for the most rapid delivery possible. Consigned on Wednesday afternoon to the Florentine ambassador, Pier Filippo Pandolfini, it was sped north along the via Flaminia by a relay of couriers with armed escorts to safeguard it from bandits and marauding mercenaries.

The last courier—one Remo Migli, who had begun life as a jockey—arrived at five o'clock Florentine time, or two hours after midnight. He delivered the diplomatic pouch with its papal message to the night guard at the Medici Palace on via Larga. His mission finished, he took leave of his escort and wearily turned his mount toward the commune's stables behind the Palazzo della Signoria. It had been a hard ride, and Remo looked forward to getting into bed with his young wife.

At the Piazza della Signoria, he paused before entering the vast square—empty and ghostly white in the moonlight. At dawn, corpses were found here, blue and cold on the cobblestones—honest, God-fearing citizens no longer asleep in their beds. Also, everyone said that the ghosts of exiled Florentines haunted this place at night.

The courier shuddered. Then he shook himself. This was nonsense—there were no corpses or any ghosts in the piazza. To make sure, however, he crossed himself before urging his mount over its cobblestones.

The Palazzo della Signoria, seat of the Florentine government, was ivory in the luminous light, its bell tower soaring upward against a nearly full moon. Midway across the piazza, bats darted around him, and from a nearby palazzo came the piercing cry of a woman. Moving on, he came to the Marzocco—the old stone lion seated before the palazzo. The moonlight lay upon it like white powder. One large paw held a shield bearing the Florentine lily, the beast's massive head turned as though aware of Remo's approach. At that instant, the beast appeared to move in the ghostly light. Then suddenly, it was leaping toward him.

"Aiii!" he shrieked, his horse rearing in panic before a cloaked figure running down the steps and into the dark cavern of via di Leone.

The courier felt like a fool. It had been someone putting a note in the Medici spy box at the base of the seated lion. It was before him now—shaped like a *tamburo*, or "drum." Its bronze was green, except for the opening slit, bright as gold from the furtive hands of Florentines who had scrawled accusations against one another. A fearful tool of the Medici political system, it allowed citizens to denounce criminals, and report plots against the Medici and the republic, without fear of being identified, especially if done at night.

Courier Migli claimed in later testimony to have seen a black gown under the cloak of the running fugitive. The investigating tribunal felt this was important. Gowns of this sort were common among the *popolo minuto*, the "ordinary people." They were also worn by others—students, seminarians, and priests. This appeared to be relevant, for the accusation was written in the cultivated hand of an educated person.

2.

Lorenzo awoke suddenly from a bad dream. Pope Sixtus IV was condemning his use of Italian vernacular in poetry. Despite Petrarch and Dante, the Pope demanded that poetry be in classical Latin. What did that mean? Lorenzo de' Medici stared at the triptych at the foot of his bed—Paolo Uccello's battle of men and horses, *Rout of San Romano*. More likely, what was at stake was the freedom of Florence, threatened by this treacherous, venial, and violent Holy Father.

Rome had seen corrupt Popes, but never one quite like this Franciscan with his endless supply of so-called nephews transformed into cardinals, prefects of the Church, or bridegrooms for royal houses of Italy. Cosimo had always said, "Never cross swords with the Holy Father; he's got the longer one. It's here and also in the hereafter." Yet now the long sword of this Pope, in a demonic drive to extend his dominions, was at every border of the Florentine Republic.

In the south, his nephew, Cardinal Giuliano della Rovere, had seized Todi and Spoleto, and laid siege to Città di Castello, a vital outpost of the republic. Then came Imola, in the north. Sixtus wanted to buy it from the duke of Milan to control Florentine access to the grain-rich fields of Romagna and the Adriatic ports—shifting the balance of power in northern Italy. When Florence refused him the purchase money, the treacherous Pazzi made the loan, and took over Medici banking for the Holy See. To seal the deal, Sixtus

made another nephew lord of Imola, and married him to the duke of Milan's bastard daughter, Caterina Sforza.

Finally, he turned his attention to the western shores of the republic. Without consulting Florence, Sixtus chose Francesco Salviati to be archbishop of Pisa—a cauldron of incessant revolt against Florentine rule. Salviati, steeped in every known vice, would make it worse. Once again, there was no choice. The archbishop was refused entry into Pisa, and the Pope was enraged.

Lorenzo sighed. What would Cosimo have done with this one? The old man was gone, and now it lay upon him alone. No one else in Florence had the vision or saw the dangers. When they should have been united, the Pazzi had sold them out. A treacherous tribe, those Pazzi. Dante had placed traitors of this sort in the lowest pit of hell, at the bottom of the City of Dis.

Another danger, greater than any Pope in Rome, lay buried in the heart of Florence itself. The mercantile system, which made it rich and powerful, contained the seeds of its own destruction in people like the Pazzi. Did this mean that the glory of their days—the cathedrals and palaces, the poetry and art, the banks and even their families—would eventually crumble like the Roman Empire?

He looked at his sleeping wife. Clarice was pregnant again and lay turned away on her side. After the two boys, Piero and Giovanni, she wanted a baby girl. Maybe that would help the marriage. God knows this union was only to unify the Medici in Florence with the powerful Orsini family in Rome. From the first moments seven years ago, he knew he could never love Clarice, as he had Lucrezia Donati since childhood, or enjoy her as he did Bartolomea de' Benci. Besides, she was a religious fanatic, crazy about Franciscans, with no interest in his friends or the arts and letters in Florence. Maybe, God willing, a baby girl would bring some joy into her life.

Rising from bed without nightclothes, as was the custom, he felt a sharp pain in his left leg and rubbed it with sudden fear. No, he thought, it's only a bruise from yesterday's hunt at Cafaggiolo, not the arthritis and gout that crippled and killed my father and grandfather. *Santo Dío,* not yet! He was only twenty-seven. Maybe it would never happen if he stayed lean and strong.

He dressed quickly in clothes arranged on a wardrobe chest with scenes from the life of John the Baptist—a small pair of drawers, russet stockings with leather soles, a white linen shirt, and an olive green doublet. Over this, he pulled a dark brown silk tunic with slit, loose-hanging sleeves.

He left for the family chapel, off the courtyard corridor of the palazzo's *piano nobile.* Padre Verona had begun Mass for the Medici family and their household servants. In the crowded, narrow room, Lorenzo stood behind his

sister, Nannina, and next to Giulia, the family cook, who smelled of fish—probably a *carciucco,* the Friday fish stew. *Che bestia!* She hadn't even washed her hands for the Lord. He wanted to move, but he knew it might offend her.

Beyond the altar, Filippo Lippi's painting *The Virgin Adoring the Child* glowed in candlelight. Along the side walls, kings and princes in Benozzo Gozzoli's *Procession of the Magi* moved in glorious procession toward the waiting Christ Child. As a boy, he had watched the painter create this resplendent fresco to include himself and the family. Even now, he often came here to write poetry or simply to be alone.

Padre Verona, holding the sacred Host, was striking his breast: "*Domine, non sum dignus, ut intres sub tectum meum . . .*"

As the small group knelt to repeat the prayer, Lorenzo heard the voice of Giulia beside him. Her words were like flowers being laid upon the altar: "O Lord, I am not worthy . . . but say only the word and my soul shall be healed."

Her face resembled a man's, but her voice was light and sweet and it rose with its faith as though on wings. She was trembling with joy, and it was most beautiful. The first citizen of Florence reached over to touch ever so lightly the fold of his cook's gray tunic.

3.

The *tamburo,* which contained the accusations, was opened that morning by police in charge of public morals—the Officers of the Night and Conservers of the Morality of Monasteries. A sergeant and a corporal took its contents to a registry office in the Palazzo del Bargello for review. The corporal opened each note, then passed it to the sergeant, who read it to a notary, Tommaso di Corsini, for any tenable charges of public corruption or potential plots against the republic.

The first accusations were of no relevance—two dealt with domestic squabbles; another reported a runaway pet monkey; then a woman claimed her neighbor's evil eye had rendered her sterile and driven her husband into the arms of a woman next door. With each reading, the notary shook his head and the sergeant threw away the accusation.

The notary was bored. "Come now, Sergeant, you're wasting our time."

"Here's one with a lot of names," replied the corporal.

The note was written in a neat hand on light gray paper of good quality, folded precisely in four parts. As it was read, the notary became alarmed.

"This is no ordinary accusation," he said. "It's a clever attempt to besmirch the Medici family and their sculptor, Andrea Verrocchio. On pain of your life, do not speak of this with anyone!"

4.

Entering his office, Lorenzo found a note from Angelo Poliziano, his son's tutor.

> *Magnifice Domine mi—*
> Your son Piero is a most intelligent and handsome boy, and I love him as my own. Yet I am compelled by your trust to report that he lacks discipline in his studies, aggravated by his loving mother, to whom he appeals whenever he wishes to avoid any task not pleasing to him. . . .

The father dropped the note with fear and loathing. That loving mother was a selfish bitch. When his time came, Piero would have to rule with discipline, maneuver the trade guilds, and control the Signoria through Medici allies. The family and its fortune were based on that. Without it, all would be lost. Clarice was not helping it to happen . . . or was it more than that? Besides the crippling family gout, was there a generational slippage, an insidious weakening of sinew and mind in their offspring? That was a greater danger than the treacherous Pazzi. . . .

"*Buongiorno!*"

It was Ser Piero Dovizi da Babbiena, his administrative chancellor, with a leather folder containing the mail, the day's schedule, and a parchment scroll with the red seal of the Holy See.

"Piero Filippo sent this, saying the Pope is very angry. He wants Salviati in Pisa."

"No, he wants Pisa. That's what he wants."

Lorenzo scanned his envoy's report, then the Latin text of the Pope's message.

> *Magnifice fili noster et affinis salutem ed Apostolicam benedictionem:*
> Despite the most unwarranted acts of your republic against this Holy See, We have sought to forgive you with Christian charity as befits Our Office. Yet you continue to inflict upon Us the most grievous wounds. We now inform your Signoria:
> When We chose Archbishop Salviati for the See of Florence, you asked Us to grant it to your brother-in-law, Cardinal Orsini. In the fullness of Our Heart, we complied with your request. With God's guidance, We then appointed Archbishop Salviati to Pisa.

Since then, one year and six months later, your Signoria has prevented this prelate from entering his diocese. In exercising your first refusal, you have no further choice in this matter. Our wish must now be obeyed as a command from the Throne of Saint Peter.... With confidence in your filial obedience, to Our Person and Our Lord Jesus Christ ...

Lorenzo smiled and passed the scroll to his chancellor. "Let's tell His Holiness we wish to satisfy him. However, our rights to Episcopal investiture are shared with Milan, Venice, Naples, France, and the Holy Roman Empire. Out of respect for these sovereign powers, we are constrained to determine if they concur in a revocation of their inherited rights.... That will hold him for a while."

"Perfect! ... Besides, what can he do? Send an army to get Salviati into Pisa?"

"Besides Pisa, he wants Siena and whatever else he can grab. But he'll need a better excuse than a corrupt cleric to declare war on us."

"War? He'd never go that far."

"He bought his throne with bribes and broken promises. Once you do that, you think you can do anything, especially if you're the Pope. Also, *caro* Piero, it's not just one greedy Franciscan. It's a danger inherent when so much power lies in the hands of one man. Thank God we don't face that risk. Florence would never tolerate a religious tyranny of any sort. . . ." He sighed. "Unless our noble citizens felt they could make more money that way. . . . What's that?"

He pointed to a yellow folder among his secretary's papers. Piero nodded.

"The Otto di Guardia. Another suspected plot against you. We can do it later."

"No, let's take care of all the plots now."

"It's scented," Piero told Lorenzo, who lacked a sense of smell.

"A woman's?"

"Maybe. Maybe not."

Lorenzo began to read the letter.

I notify you, *Signori Officiali,* concerning a true thing—namely, that Jacopo Saltarelli, blood brother of Giovanni Saltarelli, living with him in the house of the goldsmith on Vacchereccia, opposite the Buco; he dresses in black and is about seventeen years old.

This Jacopo has been a party to many wretched affairs and consents

to please those persons who exact certain evil pleasures from him. And in this way, he has had occasion to do many things—that is to say, he has served several dozen people about whom I know a great deal, and here I will name a few:

Bartholomeo di Pasquino, goldsmith, who lives on Vacchereccia.

Leonardo di Ser Piero da Vinci, who lives with Andrea del Verrocchio.

Baccino, tailor, who lives by Or San Michele in that street where there are two large cloth shearer's shops that lead to the Loggia de' Cierchi; he has recently opened a tailor's shop.

Lionardo Tornabuoni, called "Il Teri"; dresses in black. These committed sodomy with said Jacopo, and this I testify before you.

This was alarming. Among those charged, two were from his extended family—a distant nephew, and a Medici artist.

"Have they any clues about who wrote this?" he asked.

"I don't know."

"Well, we have a few right here."

Lorenzo pointed to the word *misserue,* meaning "miseries," but intended by the author to mean "sordid" or "wretched." Another word, *tristezza,* or "sadness," was used to indicate sinful or evil pleasures.

"There's a moral choice in those words. Also, this is good-quality paper. Maybe it's a priest, or a priest writing for someone."

"Or another homosexual. They can get very angry with their lovers."

"I know this Saltarelli poses in the nude for various painters. Verrocchio used him for our *David.* He probably gives his *culo* to the goldsmith for lodging, and to the tailor for clothes. Our problem concerns this Tornabuoni boy and Leonardo da Vinci. I'm told they also practice this vice. So it can be serious for us, depending on who's behind it."

"Your enemies on the hill?" asked Dovizi, referring to the anti-Medici group around Luca Pitti in his unfinished palace on a small hill across the Arno.

"They would expect me to save a relative, then claim we tolerate sodomy in our family, among our artists, and in our Platonic Academy. Florentines would love that. Even our friends would laugh, though Marsilio Ficino and Angelo Poliziano wouldn't find it amusing."

"I know. I've heard about them."

"Let's leave it at that. . . . Piero, we have no choice. This has to go to the magistrate."

"That's dangerous, sire. There's risk of exile or even burning at the stake,

like the Bologna coppersmith who buggered a ten-year-old boy."

"He confessed to it. An anonymous accusation, such as this, requires two witnesses who observed the crime, or four who speak from common knowledge. We have to make sure this does not occur, and that none of the accused confesses to the charges."

"My dear Lorenzo, the prison guards are most brutal, especially with sex deviates. They beat them with pleasure and say the prisoner revolted. For plots against the Medici, they get a bonus with every confession."

"Not this time. Tell them there's no bonus for anything."

"How old is this Tornabuoni boy?"

"About fifteen."

"People will say you've thrown an infant to the lions to save yourself."

Lorenzo grimaced. "All right. We'll send him to Rome as an apprentice in our bank. Explain this to Leonardo and the others on this list. After you've finished, we'll give this to the magistrate."

"I hope to God none of them breaks under questioning."

"Saltarelli will be most vulnerable. He must deny everything, no matter what the guards do or say. Tell him he risks exile or even burning at the stake if he admits one thing."

5.

Piero Dovizi went first to Saltarelli, then to the goldsmith and the tailor. After hearing their options, they all agreed to cooperate. If they fled Florence, they would be judged guilty and exiled for life. If they stayed and denied everything, nothing would happen to them.

At Verrocchio's workshop, however, he learned that Leonardo was at Vinci but would return that same evening. Verrocchio was infuriated by the charges.

"This is a monstrous lie. Leonardo would never touch Saltarelli."

"So he does play those games?"

"I didn't say that. Don't put words in my mouth."

"Stay calm, maestro. I meant no harm."

"Did Donatello and Brunelleschi? Or Masaccio and Masolino? Why don't you ask about them, or half the young men in Florence?"

Verrocchio took a deep breath. There was no use getting angry. Lorenzo had sent his chancellor to make sure this went no further.

"So we say nothing and that's the end of it?"

"No, it must go before the magistrate."

"Are you telling me that Leonardo will be arrested for questioning?"

"There's no other way."

"Why doesn't Lorenzo throw this into the toilet, where it belongs?"

"He's forced to do it," replied Dovizi. "But don't worry, it's under control. When Leonardo returns, make sure that he denies everything. If there's any problem, let me know."

VINCI

April 1476

LEONARDO HAD LEFT FOR VINCI after receiving an urgent note from Checco, his uncle. A run of crop failures had plunged Francesco into debt, and he faced foreclosure from the bank. Still worse, his own brother had betrayed him. Piero would pay the debt in exchange for Checco's share in the family home and its land. Otherwise, Piero would simply wait and buy it from the bank.

On the river road to Vinci, Leonardo paused to rest his mount and go over his uncle's letter:

> . . . It would break my heart to lose this land. I have put my entire life into it. Also, Sandra and I have no children. You are the only son we will ever have, and we want our share to go to you, not to my brother, who has become a stranger. I believe it's this greedy new woman who wants the entire property. . . .

His father was a monster. This would destroy Checco. It was Cain killing Abel. After Francesca's sudden death last winter, Piero, forty-nine and desperate for a legitimate son, had taken a third wife—the pinched-face daughter of another notary, Marguerita di Francesco di Jacopo di Guglielmo. Barely seventeen, she came with a handsome dowry and a young womb ready for progeny. Clearly, his father wanted the entire estate for his future children, without a bastard son or his own brother in the way.

At Vinci, Checco and Sandra insisted he was wrong.

"It's not Piero," Checco said. "The new wife is a fierce hawk."

"Your father loves you in his way," confirmed Sandra.

They were lying. It was in their eyes. They were trying to help as best they could.

"It doesn't matter," Checco said. "We have the better of him now. There's a bumper crop of silk and the rains have been good. At this rate, I can pay off most of the debt by fall, if we can hold off the bank."

The following day, they took the carriage to Pistoia, where they met Checco's sister, Violante, and her husband. At the bank, they jointly underwrote the debt, which saved Checco's land and home. It was late in the evening when they returned, and Leonardo spent another night in the room of his childhood. The next morning, refreshed and warmed by the love of his aunt and uncle, he left at dawn for Florence.

Three hours later, a young man appeared at Vinci with a letter from Verrocchio, warning Leonardo not to return. Checco told him he was too late. He invited the youth—a new apprentice whose name was Lorenzo di Credi— to take lunch with them and rest his horse. He had made a forced ride, and his mount was exhausted.

LA BADIA PRISON

April 1476

Leonardo entered Florence at midday, and rode directly to the stable. As he left, the attendant followed him to the door, and two men in the street came forward.

"You are Leonardo da Vinci, who lives with one Andrea del Verrocchio?" asked the first one.

He nodded.

"Then come with us," ordered the second, explaining they were Eight of the Guard.

"What do you want?"

"You'll know soon enough."

They took him in a closed black carriage of the republic to the Palazzo della Podestà—seat of the police and the judiciary. Here, he was led through an arcade courtyard and up a stone staircase into the office of the chief magistrate.

It was a spacious room with windows facing the Palazzo della Signoria, its walls lined with insignia of the subject cities of Florence. At the far side, the magistrate sat at a large desk beneath a fresco of Florence and its bow-shaped Arno. He wore a red robe and had the hooked nose and cheekbones of the Medici. A notary, seated at a side desk, read aloud the accusation found in the *tamburo.* Then the magistrate spoke.

"I now ask you, Leonardo da Vinci, is this true according to your knowledge?"

"No, it is not."

"Do you know this Jacopo Saltarelli?"

"Yes. He is a model for my master, Andrea del Verrocchio, and other artists."

"Have you had sexual relations with him?"

"No."

"Do you know these other people named here?"

"Lionardo Tornabuoni. I know him."

"Has he committed sexual acts with Saltarelli?"

"I doubt it."

"You doubt it? So he might have engaged in such act?"

"I didn't mean to say that. I just don't know."

The judge nodded. Then he looked at his papers and nodded again.

"You live with your master, Verrocchio, and he's not married?"

"What does that imply?"

"Please answer the question."

"No, he is not married, but that says nothing about how he is."

"You also studied with him for nine years?"

"Ten."

"Four years ago, at the age of twenty, you became a member of the Confraternity of Saint Luke, under the greater Guild of Apothecaries and Doctors. So you are now a master in your own right, and accept commissions on your own?"

"Occasionally."

"Yet you have remained as Verrocchio's assistant and continue to live in his home, rather than take a place of your own. Why is that?"

"Because I love him as my father. He has taught me all that I know, most especially to respect myself and my talents. That is the greatest gift a man can receive from anyone."

The magistrate nodded, a slight smile on his face.

"However, your real father is Ser Piero da Vinci, the well-known notary?"

"Yes."

"Yet you love this other man as a father. Why is that?"

"Sire, if you know my father, you know the answer."

The magistrate smiled again, as though pleased with the reply. He opened Leonardo's sketchbook.

"I see many drawings of nude men, but there are no women. Can you explain that?"

"They are sketches to illustrate elements of physics or anatomy. The male is used in such texts."

"Yes, but I cannot read your notes. . . . Wait a minute. They're written backward. Is this for secrecy?"

"With the left hand, it comes more easily."

"Yes, I've heard of that."

He nodded once more, as though satisfied.

"Very well, Messer Leonardo da Vinci. You will be held here, pending further interrogation and a possible trial. I must warn you, however, if it is determined that anything you have said is false, you will be expelled from your

guild, and forever forfeit all rights to practice under its banner. You will also be subject to lifetime exile from this republic. . . . In view of this, do you wish to alter anything you have said here?"

"I have nothing to alter. . . . If you please, sire, may I have my notebook?"

The magistrate shook his head and gave the book to the notary.

"We must first make certain that none of these drawings is of the people, or parts of people, whom you deny knowing in any way. . . . Take him away."

Two guards led him down a circular stone stairway to the lower prison. One guard went first—a bulky brute with an ugly scar across his left cheek. The second guard followed—a little man with the shifting eyes of a weasel. They wore gray uniforms and had belted stilettos and flexible leather whips filled with lead pellets.

At the bottom of the stairs, the air was cold and damp. In the dim light, Leonardo saw Jacopo Saltarelli with two other guards, waiting to climb upward.

"Nardo! Oh my God, Nardo!"

"Shut up, you cocksucker," said one guard, slapping the boy with the back of his hand.

Leonardo was shocked. The beautiful face was in ruins. Jacopo's nose, with its straight, delicate bridge, had been smashed. The nostrils were splayed and smeared with dried blood. Small dark eyes were barely visible within folds of swollen flesh and hair. Leonardo turned with fury to the guards.

"What in God's name have you done to this boy?"

One of Jacopo's guards spoke to those of Leonardo. "Who the hell is this one? Another ass lover?"

"It's the son of a famous notary," said the one with weasel eyes. "He hates his father and loves another man."

"And draws pictures of naked boys," said the guard with the scar.

Leonardo persisted. To accept this, would only make it worse.

"As a notary's son, I know it is a punishable crime to beat prisoners, and you both know it."

"Is that so?" sneered the guard, turning to the frightened Jacopo. "Tell this fucking notary's son what happened. . . . Go ahead."

The boy nodded, his eyes downcast. "I fell down. . . ."

"Bravo! Did the notary's asshole son hear that? This cocksucker slipped in his own shit and fell on the stone bench in his cell. You got that?"

Jacopo was nodding for him to agree.

"Of course," Leonardo replied. "I can see how that could happen."

"Good. The notary's son wasn't born on Sunday. He knows this could happen to anybody . . . especially to someone who can't remember real good."

"Happens all the time!" cried the weasel guard, bouncing with idiotic

glee. "After he fell down, our little man here asked to see the magistrate. He suddenly remembered all the cocks that went up his asshole. . . right, little one?"

Jacopo lowered his head, sobbing like a child.

"How beautiful," said the guard. "A weeping asshole. . . . Let's go."

In passing, Jacopo whispered to Leonardo, "Never you, nor the others."

"Shut up!" cried the guard, slapping him with such force that he fell at the foot of the stairs.

Swollen lips moved upon the stone. "No more. . . . Please, help me. . . ."

Leonardo shuddered. Those were Gianni's words, even his voice. Yet this was more than another broken heart. Here was the field of human grief. It lay without measure on stone steps, in the form of a body when its spirit is broken. This was what painters sought in depicting profound human sorrow, as in the death of Jesus or Mary. Giotto had done it better than anyone, using faces and hands and garment folds. Donatello had done it in many places, especially in his San Lorenzo pulpit.

When Saltarelli failed to rise, the big guard kicked him.

"Get up, cocksucker!"

"Stop it!" cried Leonardo, helping the boy to rise.

There was no difference here. He was just as guilty as this one. You took it in the ass, or you gave it. It was sodomy either way. He had never touched Jacopo. The boy smelled like a rat from rancid oils on his body when modeling. But now they were both in it together. With fear and fury, he turned on the guards.

"Kick this boy again, and Lorenzo de' Medici will throw you all out of here!"

"So the notary's asshole doesn't like us," sneered the big guard. "Let's see if he really does."

They entered a dark, sloping passage with the stifling odor of human excrement. This is all a terrible mistake, he told himself, a nightmare that will soon end. Andrea will come. Or my father will do something, if only to save his own name.

The first prison cells appeared—a row of iron-studded doors on the left. Each door had a grilled rectangular opening the size of a human head. On the opposite side of the corridors, air shaft windows allowed a gray nimbus of light into the passageway. Passing one cell, Leonardo heard a man barking like a dog—a tiny bark from an old man's throat, resembling the cry of a terrier, with intermittent howls of pain. Farther on, a deeper voice was giving orders: "One, two, three . . . advance! One, two, three . . . withdraw!"

What did that mean? Did the illusions of these poor souls interlock as they went insane? Separate cries of despair seemed to intermingle like colors from a palette, producing a single primal shriek.

The weasel-eyed guard, who was behind him, spoke to the big guard up front.

"Where we putting him, Berto?"

"In Tristezza."

"So he can play with the toys?"

"You don't want the notary's boy to fall down and bust his nose, do you?"

"God forbid, Berto."

The cell door swung open and the acrid stench of urine and human feces filled Leonardo's nostrils. It came from the walls and floor, and it rose from a wooden bucket next to some chains hanging from the wall. So those were the toys—wall chains and shackles, spread apart for the arms and legs of a prisoner.

Cristo! It's not for you, he told himself. It's for the wild ones barking like dogs or for the commanders of invisible troops, not for a new prisoner.

"He doesn't like it, Berto. You'd think any dark, stinking hole would make him happy."

"It will. . . . Get in there!" cried the guard, kicking him in the crotch.

Doubled over with pain, Leonardo lunged against the closing door.

"*Porco giuda!*"

"Berto, did you hear what he called you?"

"I heard it."

"Let's go back and hook him up right now."

"Later, after we make our report. After they know he's gone out of control . . ."

Their voices trailed off, and he remained leaning with pain against the door. So that was their game. They beat the lower classes with impunity—poor souls like Jacopo. The others, with high connections, were prodded into revolt, then placed in chains. The descent into madness was a slippery slope, amid the mounting filth of your own excrement.

He looked around his cell. With the door closed, the wall chains formed a dark skeletal figure beside the slop bucket. He reached for his sketchbook, only to recall it had been taken from him. Without it, especially here, he felt naked and defenseless. No, he told himself. If you panic, you're lost. Remember every part of it and draw it later. If you can do that, you'll survive this.

To the right, a marble slab extended from the wall—the prisoner's bed. He sat on it and felt its chill in his thighs in the heavy mantle of darkness. That was going to be the worst part—the perpetual night of a tomb. He closed his eyes, seeking to enlarge their pupils as owls do at night. He saw Gianni again— naked and white in his bed stench, the glazed eyes staring past him. *You have eyes, you son of a bitch, but you see nothing. I'm blind, and I see everything now. . . .*

Feeling an insect on his hand, he shook it off—only to find several more on his leggings. Standing up, he brushed them off. Stroking the stone slab, he found others. Madonna, the place was crawling with them. If he sat or slept on that slab, they would crawl under his clothing and into the crevices of his body. They were probably lice, which thrived in prisons.

Taking one between his fingers, he held it up in the dim light that came through the upper grille. Soft-bodied and legless, it was too large for a louse. Yellow or light brown, it lacked wings, suggesting it was a dipterous insect. He crushed it, and a dark juice spurted onto his fingers—a scaly pulp with the odor of the excrement in the cell. He shuddered. These maggots fed on decaying human flesh. A colony had been nourished by the last prisoner, probably as he died with festering wounds in those wall chains. And now they were crawling upon him with the ferocity of starving rats.

The light began to increase as the afternoon sun slanted through the corridor windows. Suddenly, it passed through the bars of the doorway grille and streaked across the cell and onto the wall with its hanging chains, creating an oblique rectangle of yellow light with criss-cross shadows of the iron bars. On the wall, there seemed to be a scrawled message. Coming closer, he tried to make it out: *aria . . . aspetto Tu lo sai*. What did that mean: "aria . . . I await You know it"? The letters, black-brown and yellow on the gray stone wall, contained maggot scales and were written in a descending arc between the chains and the slop bucket, which emitted a low humming.

Tilting the bucket into the light, he saw a mass of yellow-brown maggots in a putrefying pool of feces, urine, and blood. The insects, jammed together from rim to rim, had become a single devouring creature with thousands of piercing, bloodsucking mandibles. Its surface rose and fell as though pulled by a distant tide, and there was a sound as from a single lung. Some of them, foraging on the handle, crawled onto his hands, and he lowered the bucket to brush them away.

Moving into the orbit of chains, he lifted a wrist shackle and found it extended to the last letters on the wall—sufficient for a chained wrist to write a message by dipping into the bucket for a handful of maggots and then crushing them into a mix of blood and shit for binding onto the stone surface. The light increased and he was able to read the missing letters: *Maria ti aspetto Tu lo sai*. "Maria I await you You know it."

Know what? What in God's name could Maria know or do? Save this poor soul from the maggots and a slow death in chains, as she had saved Albi and her little boy, who never saw the light of the world? To hell with it. She could do nothing.

Some of the letters contained finger imprints where the sulfurous mix thinned out on the wall. He touched them gently, imagining a faint voice slowly spelling out each letter, until the prayer was complete and the prisoner ready for death in the company of the Virgin.

Yet even without her intervention, there was a divinity here. It was in this act of a man's reaching for her. More than any object of belief, it was the act of believing. It didn't matter if it was a moon goddess or Maria—or even Albi. Belief made visible the invisible object of veneration. So Maria had been here, in this flung cry of hope, this crude yet living credo of her presence.

Remember this, he thought, for an *Adoration*. More than kneeling Magi, more than simple shepherds, there should be a mass of humanity, swirling about her as though brought to the sacred moment by a spiraling vector of unseen winds. More than Jesus or God, they sought this woman—this one last hope of the forgotten ones, calling to her through blood and shit on prison walls of the world. . . .

"Here we are, the notary's son."

It was the big scar-faced guard. The door opened and his large figure appeared against the light. This was how it had begun and would be forever—another Tonino against the blazing sun: . . . *you're a mongrel bastard and son of a slave* . . . He backed away against the wall chains with the call for Maria. But never with her. He had asked her once, for one life only, and she had turned away.

Ave Maria, full of grace, in this hour of death, I expect nothing from you. There is only one, in the dark night of my soul. She is all that I have, but she is enough. With maggots and shit, I will draw the sweet, immortal lines of her face on this wall . . . for the next poor bastard dying in these chains to touch her and whisper, "Albi, *ti aspetto* . . ."

Another figure appeared in the light: Andrea Verrocchio.

"Leonardo, I've come to take you home."

FLORENCE

April – July 1476

T HEY WALKED ALONG VIA DEI CIMATORI, and he breathed the crisp air with an acute sense of being alive.

"Don't blame Lorenzo," said Andrea. "He didn't want this to happen."

"So why didn't he tell them to go to hell? Cosimo or Piero would have done that. Instead, the great poet and philosopher let them torture and beat us."

"With the Lionardo Tornabuoni boy, he suspected an anti-Medici plot."

Leonardo nodded. Lionardino was one of the boys.

"He also warned the prison guards, but when I saw Saltarelli before the magistrate, I knew I had come just in time with Lorenzo's note to take you away."

"Away to where? You say I can be imprisoned again if there are more charges."

"That's right. *Absoluti cum conditione ut retumburentur* —on condition that you are not returned to the drum."

"So why won't they do it, using the same Medici bait?"

"Because the bait, as you aptly phrase it, has been sent to Rome to work in the Medici bank."

Leonardo imagined Lionardino in a bank open to the street, similar to one they were passing. In the short black tunic of an apprentice, he would flounce his little Medici ass with no fear of arrest as he brought account ledgers to customers and agents from Europe and exotic ones from the East. Their turbans and robes, their amulets of jade and topaz would catapult that boy into an erotic frenzy. Or perhaps he was in a loggia, like this one next to the bank, with agents bargaining stock shares at thirty florins in the Monte, the state pawn office, while Lionardino pranced about with *lettere di cambio,* the Florentine letters of credit that had made it the financial capital of the world.

"The boy was too young," replied Andrea. "He would have broken under questioning."

"What about the rest of us?" Leonardo demanded. "The dirty truth is that the Medici protect their own, and to hell with everyone else."

"So finally you've got it, Nardo. For years, I've told you the Medici are ruthless. They use us in order to appear grand and immortal. We use them to create work we hope will endure. That's the game. You can take it or leave it, but you can't change the rules or expect them to save your neck before their own . . . except we now share Lorenzo's need to know who started this."

"I thought of Perugino. He's in Umbria, but maybe he had someone do it."

Andrea shook his head. "Pietro would never do that to me."

"What if it happens again, without naming the Medici boy?"

"We'll need ten people to testify to your innocence."

Leonardo realized this was impossible. He was innocent as charged, but not really. Andrea knew it. At Landucci's, gossiping Florentines also knew it. Andrea smiled, as though aware of the problem.

"It's like Saint Jerome," he said. "He also faced grave moral charges in the court of the Lord."

"He was also that way?"

"Not exactly . . . His mind was filled with dancing girls who wouldn't go away. So he became a hermit in the desert of Chalcis, but the girls followed him. In despair, he beat himself with a rock. 'Why me?' he cried out. 'I'm prematurely dead in the flesh, so why these raging fires of lust?' Finally, to control himself, he began to study Hebrew and eventually translated the Bible we use today. So who is to say those dancing girls were not angels?"

"Did they tell him to do this?"

"Of course not! That's not in their nature. They simply turned him in the right direction."

"How did he know it was right?" asked Leonardo.

"The girls vanished."

Leonardo laughed. "Maybe they were boys who looked like angels."

"Does it matter? To justify it in the court of our Lord, he translated the Bible. . . . What do you have in mind?"

"Something close to that," he replied, recalling the *Adoration* he had found with Maria waiting for him in the blood and squashed maggots on the wall of the prison cell.

2.

Days and weeks slowly passed without renewed charges in the *tamburo*. This, of course, increased the gossip of Florentines at Landucci's. What would the Magnifico Lorenzo do if the next *tamburo* list revealed that Rinaldo Orsini, his brother-in-law and cardinal of Florence, buggered choirboys? Make him director of the Rome bank, or send him to their office in Antwerp?

Two months after the original accusation—June 7, 1476—Piero Dovizi suddenly appeared at the workshop. Verrocchio knew immediately it had happened.

"There's been a new charge?"

"It's been levied by a Franciscan friar—Mariani."

"How do you know?"

"This time, it's in Latin, but the calligraphy matches a letter he sent to Lorenzo, calling you a heretic for your *Saint Thomas,* and it's on the same scented paper."

"Thank God." Leonardo sighed. "We finally have the monster. Now Lorenzo can give him what he deserves."

"That's the problem," replied Dovizi. "Lorenzo is taking the waters at Porretta. I sent him word of this, but even if he started back tomorrow, the magistrate already has these charges. I informed the magistrate of the match in handwriting, and that Lorenzo would resolve it when he returns, but you never know with these people."

"They'll never get me," declared Leonardo. "Never again!"

The chancellor nodded, eyes closed. "I was about to suggest you leave Florence immediately, until this is cleared up."

"*Cristo!*" cried Andrea. "Nardo, go upstairs and get ready. I'll send for the horse and mule."

When Leonardo descended with his bag and notebooks, he saw Ion in front of the workshop. The black Barbary stallion, a gift from Ginevra de' Benci, was named after Apollo's natural son, grandson of Helen, and father of the Ionian race. Next to the mount was old Jupiter, the workshop mule.

Lorenzo di Credi, the new apprentice, was strapping onto the mule rack a large panel and assorted painting supplies. Andrea emerged from the workshop to say good-bye.

"Why the panel?" asked Leonardo.

"For a flight into yourself," replied Andrea. "Start a new painting. It doesn't matter what it is; just do it. . . . And also take this, should a sculpture come to mind."

He extended a serrated lime-wood spatula for working in clay—worn and dark from use.

"It was Donato's. After the San Lorenzo pulpits, he gave it to me. Now it belongs to you."

Leonardo looked at the old tool in his master's large hands, then at the man who was now his father—the broad face, the winged eyebrows rising in an attempt at good cheer. He took the spatula and ran his hands over it, the wood curved and worn from the hand of Donatello. Its small wooden teeth contained ingrained traces of gray clay.

"I can't . . ." He paused, unable to speak. "I can't take this. . . . It's a living link between you and the man you loved."

"That now includes you."

"*Andrea mia,*" he murmured, taking his master into his arms.

He put the spatula in his saddle pouch, tied the mule's lead to a saddle cinch, and mounted his horse. Andrea stood below him in the street. He looked small and sad.

"May God be with you, Nardo."

There were tears in Andrea's eyes. His pupil did not want to see this, or even think about it. Taking the reins of his mount, he left with the mule in tow. Andrea waved good-bye. Leonardo rode on without looking back.

3.

Four days later, after the return of Lorenzo de' Medici, Padre Mariano was arrested. He confessed to fabricating half-truths from secrets of the confessional—a most grievous sin for a man of God. His superiors placed him on probation, warning him that he would be excommunicated if there were any further violation of his vows. Lorenzo de' Medici also warned his prior that any similar accusations in the *tamburo* would be taken as inspired by the friar himself, and result in criminal charges and exile from the republic. Verrocchio sent Lorenzo di Credi to Vinci with news of their victory. He returned with a note.

> *Carissimo Andrea, Maestro Mio:*
> Thank you for sending Renzo. Finally! Finally free! I've taken your advice to go inside. Unless you need me, I will stay here until I come out again. May it be soon, for I long to return to you.
> *Figlio tuo,*
> Leonardo

Six weeks later, Verrocchio returned to the workshop in triumph. The Mercanzia had finally accepted his portrayal of *Christ and Saint Thomas,* without the apostle touching Christ's wound. As he entered, Lorenzo di Credi said Leonardo was back from Vinci with the mule and a load of food.

"He brought fresh vegetables, cheese, and some wine."

When Leonardo appeared, they embraced, and then stared at each other. For Verrocchio, so much had changed. The boy, now a man and a master of great promise, had grown a beard—a russet outcrop, lighter than the auburn hair that fell to his shoulders.

"You seem renewed, Nardo . . . or is it the beard?"

"You like it?"

"It looks like it belongs on someone else."

"Actually, it does. Come to my studio."

As they entered, Verrocchio saw two unfinished portraits of the Virgin, untouched during the absence. Beyond them, a panel on an easel was turned toward the window light.

"So it's a self-portrait?"

"How do you know? . . . *Caro maestro,* take your time. I'll return shortly."

Approaching the painting, Andrea expected the traditional picture of an artist, his gaze directed at the viewer. Instead, he found himself before a naked man in a desert with an immense lion. It was Saint Jerome. When you saw the lion, it was always that saint. Usually, he was in his library—a heavy monk in a black robe, translating the Bible with a quill in hand, a human skull on his desk, and the lion at his feet, like a big, sleepy dog.

This was the saint they had talked about—a desperate soul in the desert, beating himself with a rock to expunge his dreams of dancing girls. It was a sinopia in sepia and ink for an eventual painting. Yet it was all there, and there had never been a Jerome with this alarming despair and his awesome cry to God.

Structured with the solidarity of a rock, the saint was kneeling before his desert cave, his emaciated face a skull, his hallucinating eyes and shriveled body calling for release from sinful visions—the rock in one hand crashing onto his shrunken chest, his other hand extended toward an overcast sky: *Why me? . . . My flesh is dead, thus from whence these raging fires of lust?*

The lion lay in the foreground, completing the circle of damnation and hope—an immense reservoir of the blind, bone-crushing forces of nature, which the saint desperately sought to expel from his body. The beast's long, virile tail curled across the ground toward him—a whip to further flagellate the lusting flesh with its haunting dreams.

The entrance to the rocky cave opened behind him—its dark interior mute witness to endless nights of carnal visitations. In the distance, the stark plain of the desert gave way to a river flowing toward mountains veiled in a soft haze—calmer shores, perhaps, for a desperate soul. . . .

"Well, what do you say?"

Leonardo had returned.

"I'm overwhelmed, Nardo. Within the terror, you see his naked faith. It's frightening, but also beautiful. No one has ever seen a Jerome like this, nor will they ever forget him." He paused and smiled. "As a self-portrait, I assume you are both victims of sex and forbidden dreams?"

"Exactly. At first, I thought of having him beat his *verga*."

Andrea laughed. "He escaped into the Hebrew Bible. Where can you go?"

"I have an idea for an *Adoration*. But after all of this, I have to leave Florence."

Andrea shuddered. Not yet, he told himself. It was too soon.

"This will pass, Nardo. People will see you in a different way. You'll be getting many commissions. Besides, where would you go?"

"To a royal patron who doesn't destroy artists or throw them into prison to save a Medici."

THE PAZZI CONSPIRACY

AND MEDICI REVENGE

THE VATICAN

April – June 1477

SHORTLY BEFORE EASTER IN 1477, Lorenzo de' Medici again defied Pope Sixtus IV. The condottiere Carlo Fortebraccio led a small army through Florentine territory to free his native Perugia from papal bondage. Lorenzo had warned against the attempt, but when the mercenary refused to listen, he reluctantly acceded. Papal dominion in central Italy was an increasing threat.

Sixtus was enraged. He hated the Fortebracci even more than the Medici. They had ruled Perugia in arrogant defiance of three Popes. Braccio—father of this upstart Carlo— had even threatened to make Pope Martin say twenty Masses for a pittance. Now his son was still at it. With imperial fury, he ordered a division of his army to prepare for war. Then he dispatched the famed condottiere, Duke Federico da Montefeltro of Urbino—formerly with Florence, now captain general of the papal army—to destroy every remnant of the Fortebracci in Umbria, including their castle at Montone.

In the midst of this crisis, he was surprised to discover Archbishop Salviati in a Vatican corridor. After two years as archbishop of Pisa, this idiot was still sneaking around the holy palace like one of the rats beneath the basilica, scuttling among the lost bones of Saint Peter.

"What are you doing here?" he demanded.

"Waiting to go to Pisa, Holy Father."

"Count Girolamo hasn't fixed that yet?"

"No, Your Holiness."

"Get out of my sight!"

Sixtus angrily summoned Girolamo Riario. His nephew assumed it was for the Visitation of the Blessed Maria on the second of July. Upon arrival, he found his uncle angrily tapping the armrest of his throne. Clearly, this was not about Maria's visitation.

"Archbishop Salviati is still here," said Sixtus.

"Yes, sire, I know."

"He's sneaking around here like a rat."

"I know."

"'I know.' 'I know.' You know nothing! That's what you know . . . nothing! Pietro would have fixed that perfidious Medici long ago."

After the death of Cardinal Pietro Riario, Girolamo had assumed his brother's role in papal affairs. As a nephew, or, more likely, the natural son, of His Holiness, he was also invested with the Principality of Forlì and Imola—a nascent kingdom after Sixtus had purchased Imola with funds he obtained from the ruthless Pazzi, thus enabling them to wrest control of the lucrative papal banking from the Medici.

"Trust me, Holy Father, I'm doing all I can."

"So what in God's name have you done?"

As lord of Forlì and Imola, Count Girolamo Riario had written to Lorenzo de' Medici, professing the friendship and loyalty of a neighboring principality, hoping to calm matters and allow Salviati to enter Pisa—only to discover the Medici letters were as deceitful as his own.

"Are you deaf? What does the Medici say?"

"He keeps promising to review the matter."

"Review what matter? My archbishop? My divine right to rule this Holy Roman Church?"

Sixtus rose from his throne, his face flushed, hands waving as though warding off a swarm of flies. Girolamo, trembling with fright, noticed a wart on the lobe of his uncle's right ear. He had never seen it before—a pink wart sprouting from a lump of white fat like an overnight mushroom.

"Are you captain general and commander of the forces at Castel Sant'Angelo?"

"Yes, sire! At your command!"

"No, you're not. You're not even a pimple on the ass of one of your soldiers. . . . Do you know that?"

This was too much. To be humiliated this way in front of the chamberlain and papal attendants . . .

"By God! Answer me!"

"Yes, Holy Father."

"Now listen to me. I want you to fix this. I don't care how you do it; just do it. Otherwise, Signor Conte, you'll be peddling oranges again on the streets of Savona. Now get out of my sight!"

ROME

S HAKEN BY THE POPE'S CONTEMPT, and aware that he could never fix anything with the powerful Medici, Girolamo walked home to his palazzo on the banks of the Tiber. His wife, Caterina, saw it immediately. "My lord, you come home very sad and upset. What is it?"

"It's nothing, really."

Caterina, a natural-born daughter of the duke of Milan, Galeazzo Maria Sforza, had the pride and cunning of her father, infused with a bastard's drive for social redemption. Aware of her husband's distress, she led him to their vine-covered terrace overlooking the river. A few minutes later, she returned in a transparent gown, bringing wine and almond cakes.

Girolamo, seeing her legs against the light, recalled the first time he had touched them, four years ago. She had been a child of ten, and on the night they were engaged, they had slept together, though forbidden to enter her "cupola"—the dome of her maidenhood. Yet now the cupola was open, and at fourteen, she had become a woman in every way. Her forehead was too large, and she had that parrot's nose. But those tiger eyes, the long blond hair, and the ravishing body—all of it was coming together in a way that made her more exciting every day. The lovemaking was also doing it. She never had enough. At this rate, their first child would be in the oven before she was fifteen, on Saint Catherine's day in November.

"Momma," she said, "tell me what it is."

Momma shook his head. She sat next to him, placing her hand on his thigh.

"*Amore,* I can feel it," she began. "If I feel all else of you, how can I not feel this, as well?"

"Papa Francesco insulted me today in front of the whole court."

"What did he say?"

"He said I was worth nothing," he replied, hoping she would never hear about the pimple on a soldier's ass.

"He doesn't mean it, Momma. He loves you. He wants you to have more than Imola . . . much more, with Forlî and Faenza and a large kingdom in Romagna."

"Pesaro . . . we also need Pesaro."

"No, my cousin Costanzo is lord of Pesaro. We can't do that to him."

"*We?* Who is this 'we'?"

"We Sforzas. You wouldn't want to upset my uncle, Duke Lodovico, would you?"

When he said nothing, she sat in his lap and kissed him in the ear.

"What made Papa Francesco so angry?"

"Lorenzo de' Medici. He refuses to let Archbishop Salviati enter Pisa."

"So what does he want from you?"

"He wants me to get rid of that Medici dog. That's what he wants."

"The way they got rid of my father?"

He shuddered. The corpse of Duke Galeazzo now lay between them. As foreseen by Lorenzo de' Medici and many others, Duke Galeazzo had been assassinated upon entering a Milan church on the day after Christmas—Saint Stephen's Day, 1476. Caterina kissed Momma again in the ear.

"Your uncle, the Pope, won't live forever. For now, you can do anything."

"But not that. He would never agree to that."

"Of course he would. If there's no other way, he'd expect you to do it for him."

"He'd never give his blessings for such a thing."

"No, but he'd bless you and look the other way while you proved yourself to him . . . and to me."

He looked at her. A smile appeared on her lips.

"My God, you have no limits."

"Yes, I do. . . . Try to find them," she said, pulling him to her.

2.

Three months later, Count Girolamo Riario stood on the terrace of his palazzo and looked across the Tiber toward St. Peter's Basilica. In a few hours, he would meet with the Pope and finalize the plot to kill the Medici brothers. It wasn't going to be easy. Papa Francesco knew they had to do it, but he had never explicitly admitted it.

"Where is everyone?" asked Francesco Salviati, entering in archbishop's robes. This was stupid. They had agreed to meet in secret this morning. Now everyone in the street would know that a high prelate had come to the home of Count Riario.

"The others are coming."

Wrapping himself in his red cape, His Excellency sank into a chair with a sigh.

"They don't have as much to lose as I do," replied Francesco, waving his hand with its episcopal ring as though finally on his throne at Pisa.

Girolamo looked at the pinched face, the long nose and the tiny darting eyes, and decided that His Excellency, the archbishop, resembled a rat emerging from its hole.

"Forgive me, Franco," he said with loathing. "What do you have to lose? You can't even shit in Pisa."

"What a vulgar unit of measure." The archbishop sighed, wrinkling his nose. "But if we must use it, you can't fart in Rome without your uncle, the Pope."

Caterina appeared with the second arrival, the house servants having been sent away for this occasion. A short man of indeterminate gender, he had yellow hair and a puffed and powdered face. He was elegantly attired in a tunic of dark blue silk with gold piping. On the terrace, the archbishop rose to greet the new arrival.

"Cavaliere Franceschino!" he said, extending the limp hand with its episcopal ring.

Francesco de' Pazzi, manager of the Pazzi bank in Rome, did not enjoy being called "Little Francis the Knight." Applying his nickname to his brand-new papal knighthood made it appear ridiculous—clearly, the precise intention of this asshole archbishop. He left the hand in midair and turned to his fellow knight and lordship, Count Girolamo Riario.

"Where's our *imperator*?" he asked, using the Latin word for a condottiere, the commander of mercenary troops.

"I expect him any minute. He's making a forced ride from Romagna."

"Mercenaries," scoffed the banker. "They all go for the highest price, like courtesans. You can't trust any of them."

Girolamo suppressed a smile. Talk about courtesans. This conceited little Pazzi resembled one—puffed and powdered and possessing the voice of a soprano or a eunuch.

"Montesecco serves me, as well as the Pope," he replied.

"But he doesn't believe the Holy Father is with us. If your uncle doesn't tell this mercenary to do it, he'll go elsewhere, and the Medici will hear of it."

Girolamo watched the little banker twitch at the thought of such a danger—the darting tip of a tongue, a fleck of saliva at the corner of the mouth. It was disgusting.

"My poor *cavaliere*, you fear the Medici before we even start."

"Damn you, Girolamo! I fear none of them! They were milking cows when we were great signori. It's your Montesecco who said, 'My lords, I'll kill in battle, but I'm not a cutthroat.' That's why he trembles and needs the blessing of the Holy Father."

"My lords, I also tremble at the threshold."

Caterina was at the terrace entrance with Count Giovanni Battista da Montesecco. *Porco cane,* Girolamo thought. Had this warlord overheard them? Caterina showed no concern. Nor did Montesecco—an immense figure in a dark green riding cape, with long dark hair and a face that seemed carved from rock. It was the face of a warrior. You could see it in the forehead and cheekbones, the deep-set dark eyes under a massive brow, and the high broken-arch nose. The mouth had full, sensual lips, but there was no trace of warmth as the mercenary surveyed those before him.

Caterina was near him, radiant in a golden tunic with a necklace of green emeralds.

"His Excellency desires only water," she said, purring with pleasure. "Do you knights wish something more?"

Girolamo cringed with embarrassment. The bitch wanted him. Could the others see it? It was there—in her eyes and the way she moved before him.

"No one?" repeated Caterina.

There was no reply. She looked up at the tall warlord and smiled as if they had known each other forever.

"You're the only one."

There was the short cry of a child, and Montesecco turned to a passing Tartar slave girl with an infant. He looked again at Caterina.

"Is that your new son?"

"No, it's only a niece," grumbled Girolamo. "She's produced nothing yet."

Caterina smiled, feigning surprise. "My lord, the day is young, we're fresh in the saddle, and the stag has yet to hear the yelps of the anxious bitches."

Montesecco was delighted. "That's an old saying from Romagna."

"Also Imola, where our roots are entwined with yours."

"Praise the Lord," Montesecco replied. "And bless Your Ladyship with many children."

"Thank you, my dear captain. So it shall be."

Girolamo couldn't believe it—the whore and her soldier brazenly planning their fornication in his presence.

"That remains to be seen!" he blurted.

His bastard child bride smiled as though aware that she would eventually take a Florentine Medici as a lover and launch a dynasty, beginning with

Giovanni dalle Bande Nero, the greatest condottiere of the sixteenth century, followed by seven grand dukes of Tuscany, King Louis XIII of France, a queen for King Charles of England, another queen for King Philip IV of Spain, and a galaxy of other men and women who would shape the destiny of Europe.

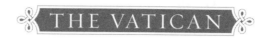

September 1477

COUNT RIARIO AND ARCHBISHOP SALVIATI, without the portentous Pazzi, accompanied Montesecco to the Vatican. They rode in a closed carriage, and as it crossed the Tiber, the condottiere expressed his concern to Riario.

"I overheard you say the Pope cannot reveal that he agrees with us."

"I didn't say that."

"Don't play games with me, sire. You said his true intent would be hidden under his tongue. If it remains there, how am I to know he's really behind us?"

"You'll hear him. . . . He's waiting to tell us now!" shouted Girolamo above the rumble of the carriage on cobblestones.

At the Apostolic Chamber, however, they found the Pope was gone.

"This is not possible," protested Count Riario. "He personally asked me to come at this hour."

"He went to the library," replied the chamberlain.

"What about our appointment?"

"He said to take you there."

"Idiot! Why didn't you say so?"

"You didn't give me a chance, Signor Conte."

As they walked through gilded corridors, Montesecco's fears increased. This Riario was an obnoxious weasel. He had been mean to his wife, and he had insulted a papal chamberlain. A man like that was a danger in battle. In a conspiracy of this sort, it could get them all killed. And that ridiculous Pazzi was even more dangerous, blurting that the Medici were as good as dead.

It had been a mistake to come here. Somehow, he had to retreat, but without angering the Pope. It wasn't easy to get a paid *condotta,* and they still owed him two thousand ducats from the Niccolò Vitelli campaign. The only maneuver was to outflank Riario by insisting on clarity. Tell the Pope they would have to murder two men, then ask for the impossible—a blessing for doing it.

"Here we are," Girolamo announced. "The greatest library in the world."

"Pope Nicholas started it," explained Archbishop Salviati. "But our Holy Father is bringing in more books from everywhere in the civilized world."

They were in the first hall of the library, where the Greek manuscripts were kept. To their left, a large glass window glowed with the arms of the Rovere family. At the far end, in a second hall, this one reserved for texts in Latin and secret documents of the Holy See, the Pope was talking with his librarian, Platina, the Lombard humanist and papal historian. As they approached, Platina withdrew and Sixtus summoned his chamberlain.

"Please leave us," he commanded. "Close the doors, and allow no one to enter here until you see us again."

He sat down at a reading table and waved for the others to sit opposite him. Montesecco, in taking his place, saw two books in a slot beneath the table—the *Council of Nicea,* and the *Commentaries* of Saint Ambrose.

"Ah!" he exclaimed. "The homoousian solution and the making of saints."

The Pope was amazed at the warrior's familiarity with the Nicean decree on divinity and equality of Christ in the Holy Trinity, as well as Saint Ambrose's conversion of Augustine of Hippo.

"Gian Battista, you appear to rival the duke of Montefeltro in both courage and learning."

"You honor me, Your Holiness. I accept this as a sign of affection, if not of truth."

"Ha! Also formidable of tongue . . . Now, what do you want to know from me?"

Girolamo spoke first. "It's the matter of Florence, Your Holiness."

Sixtus sighed and looked at Captain Montesecco.

"Yes, I want you to take it in hand."

It was the condottiere's moment, and he seized it.

"This matter, Your Holiness, cannot be done without the death of Lorenzo and Giuliano, and inevitably others with them."

The pontiff shook his head, eyes closed.

"I do not want the death of anyone, for that is contrary to our Holy Office."

There was the sharp odor of pine oil. Montesecco realized it was coming from the Pope, who was speaking toward the gilded ceiling as a witness before God.

"Lorenzo is a despicable villain who has treated us shamefully, but we have no desire for his death . . . only a change in government."

Montesecco decided he had what he wanted. The Pope was not with them, but Girolamo persisted.

"We understand your wishes," he said, staring at his uncle. "We'll do everything possible to see that Lorenzo does not die. But should he die, will Your Holiness pardon the one who did it?"

"Don't be stupid!" cried the Pope. Then he spoke to his nephew as to a child. "I repeat that I do not want anyone killed, just a change in government."

He turned to Montesecco. "Both Medici are enemies of the Holy See. They must be removed from power in Florence."

Montesecco looked at the Pope's eyes—dark brown with yellow streaks. Like a squirrel, he thought. His flesh was yellow as parchment, and those huge ears, emerging from under the red *camauro,* were white as turnips, and from the right one sprouted a pink wart. The odor of pine oil came from his yellow hands, and the red ruby on his left index finger had the glow of fresh blood.

"You understand me?"

"Yes, Your Holiness," replied Montesecco, aware he could go no further without risking the Pope's anger and dismissal—including the loss of two thousand ducats.

"Good," replied the pontiff. "Lorenzo is a villain who consistently defies us. Once he is removed, it would be most pleasing for us."

He paused until Montesecco felt compelled to nod once more. Girolamo saw this and sought to clinch the agreement.

"Are you content, Holy Father, that we do everything necessary to steer this vessel safely into port?"

Sixtus nodded, looking at each one as though he understood the consequences and was with them in every way. Then he doubled back and repeated his earlier warning.

"I'm content, but take heed that the honor of the Holy See is not compromised."

He rose to dismiss them, speaking to Montesecco in a barely audible voice. "Let me know your needs—men at arms, or whatever else might be necessary."

"Yes, Your Holiness," replied the warrior, kneeling to kiss the Fisherman's ring.

As they left the library, Girolamo claimed they had won a victory.

"You heard him, Gian Battista. At the last minute, he told you what you wanted to hear, just as I said he would."

"He said he wanted no bloodshed, but then he offered armed troops."

"Exactly . . . you can't drown someone without water. You can't seize a city and drive out its rulers without bloodshed. He knows that. Did you see him smile when I promised to do everything to remove the Medici?"

"What did that mean?"

"He'll pardon whatever we do for him. Don't you believe in the Holy Father?"

That was the problem, Montesecco realized. There was the Holy Father, and there was this angry old man smelling of pine oil, with a pink wart on a turnip ear.

"I suppose so."

"Good!" exclaimed Archbishop Salviati, twisting his episcopal ring. "Now we can get rid of the bastards."

"It won't be easy," replied Montesecco.

"What is this?" demanded Girolamo. "You're still not with us?"

"I'm saying that this requires great care. You have to kill both Medici at the same time. If one escapes, you will have lost the day."

"That won't be difficult."

The condottiere nodded gravely. "Two birds in one sweep of a hawk. How many times have you tried it?"

FLORENCE

April – June 1478

IN THE SPRING OF 1478, Andrea Verrocchio's dream of a lifetime suddenly appeared within his grasp. The news came in a letter to Leonardo from Ser Piero, finally notary for the Signoria of Florence.

Bartolomeo Colleoni of Bergamo, the legendary condottiere,. had bequeathed the bulk of his fortune to Venice for an equestrian statue of himself, to be erected in Piazza San Marco of the republic, which he had served with honor and glory. Andrea Verrocchio had been chosen as one of three contestants to create the horse and rider.

The sculptor was overwhelmed. After the duke of Milan's assassination, he had lost all hope of realizing a monumental horse and rider. Yet here it was again—a chance to realize the dream and face the challenge of Donatello's equestrian monument to the condottiere Gattamelata in Padua.

"I can't believe this," he said.

"I believe it," replied Leonardo. "You are destined to surpass Donatello."

"I'm not sure. There are two others," noted Andrea, turning to the letter:

> The Venetian Senate will choose the artist for this work from models in a competition with three masters in bronze—Bartolomeo Bellano of Padua, Alessandro Leopardi of Venice, and our own Andrea Verrocchio, who is considered their only possible equal. . . .

"They are there, in the piazza," he said. "I'm very far away."

"So what? You'll overtake them with your model," Leonardo replied.

"They'll corrupt the judges. It's an old story."

"We'll have Lorenzo behind us, and two ambassadors. Listen to this," he said, reading from the letter:

> "The Venetian ambassador to the Kingdom of Naples informed the Venetian Senate that Andrea's bronze head of a warhorse, which our

Lorenzo de' Medici gave to Don Diomede Carafa, count of Maddaloni, rivals the greatest works of ancient Greece and Rome. And Bernardo Bembo, Venetian envoy to our republic, told them that no human figure in bronze could equal Andrea's *Christ and Saint Thomas*. . . . So with their support, and that of our Magnificent Lorenzo, Messer Andrea should carry the day. . . ."

"You believe that, Nardo?"

"I believe it, even though it's from my father."

They were in Leonardo's studio. His *Saint Jerome* stood on a nearby easel. Andrea glanced at the saint; then he nodded and took a deep breath.

"The two elements, horse and rider, must extend into each other. That's where Donato failed. The tension in the enraged beast, the muscles in his legs, the fury of his tossing head, the open mouth, the wild eyes—all of it must be in the warrior's face and body, as though part of the animal beneath him."

"Horse and rider," added Leonardo. "Fused in the heat of combat . . . a single moment that contains the entire battle."

"Also, the proportions are vital. The man must be scaled with the horse. Not like Uccello's little John Hawkwood in the Duomo."

"Castagno, next to him in the Duomo, is not much better, though his Niccolò da Tolentino is more powerful in the saddle."

"Yes, but on a plow horse," replied Andrea. "My charger will be immense yet moving, free of gravity. . . . Let's go and look at them both."

"But they're not what you want."

"Sometimes, Nardo, you find what you seek in the failure of others. . . . Let's go."

"It's Sunday. The Duomo will be crowded. And I hear the Medici will be there with a houseguest. Another one of the Pope's relatives, a new boy cardinal."

"Good. We'll talk about horses, and look at horses' asses."

2.

After six months of intrigue, the assassination of the Medici brothers was to take place that morning during Mass in the Duomo. It was April 26, the feast day of Saints Cletus and Marcellinus—two Popes martyred, respectively, by the Roman emperors Domitian and Diocletian. Times having changed, Popes were only rarely murdered. Yet, in the manner of Sixtus IV, they still ordained the murder of others.

The plot against the Medici depended on Captain Montesecco's military seizure of Florence after the suppression of both brothers. It had taken shape on the day after the meeting with Pope Sixtus, when the mercenary captain left Rome with papal letters authorizing him to raise an army.

He rode first to Imola, where he engaged Giovanni Francesco da Tolentino, a papal condottiere. At Città di Castello, he charged Lorenzo Giustini, vicar of the Pope, to raise another force. From Todi and Perugia, he summoned troops of Napoleone Orsini. With this, he had a reserve army of two thousand foot soldiers and five hundred cavalry, to be briefed on their secret mission only at the final hour.

He then rode across the Apennines toward Florence. All was in order, but it would not be simple. On a battlefield, the rules were different. You killed to survive. You seized cattle and grain from peasants to feed the men and horses. And you sometimes allowed the rape and pillage of towns to satisfy the troops. But stabbing a man in the back was something else. This was Judas money, the work of thieves and cutthroats. Federico of Montefeltro, or any honorable condottiere, would refuse. Yet now there was no turning back. He had raised an army and given his word. To betray them, especially the Pope, would mean his ruin and even his own assassination.

He sighed and slowed his horse to a walk. In the field beside the road, the winter wheat was already up five inches. In Romagna now, in mid-November, it would be a little less, but the fields would also be green and yellow in slanting sunlight.

Florence appeared below him—a dense, spindle-shaped carpet of red rooftops, church domes, and bristling towers within its walls. A river wound through it, and the sound of Vesper bells arrived on the evening breeze. With it, there was the low rumble of the streets and piazzas, like the breathing of a lion in the cages behind Palazzo della Signoria. Indeed, the City of the Flower was like a sleeping lion and the river was its tail. Two thousand men and cavalry could never take it. The narrow streets, defended by the furious inhabitants of the city, would become a death trap. Florence could only be taken by stealth. To achieve this, however, you would need riots in the streets, thereby dividing the populace and its will to resist. And for that, there was one man: Jacopo de' Pazzi, Francesco's uncle and head of the Pazzi clan.

He spurred his horse and began the descent. This was going to be difficult. Old Jacopo was an embittered autocrat, and an avaricious gambler, who flattered Lorenzo while despising him. He had also told his nephew, Franceschino, that he wanted nothing to do with their crazy scheme. Now it was crucial to change his mind. Only Jacopo could rally the family and the

support needed to avoid street fighting during the takeover. Without him, there was no chance to succeed.

3.

The Pazzi lord immediately made it clear that he wanted nothing to do with his nephew or any lunatic plan to murder the Medici brothers.

"They are going to break their necks," he said. "I know what's involved here better than they do. I don't want to listen to you, or hear any more about it."

"The Pope does not agree with you."

"The *who?*"

They were in Montesecco's room at the Albergo della Campagna. Jacopo looked around as though expecting to see someone else.

"The Holy Father," replied Montesecco. "He has promised to supply whatever troops we need."

The old gambler squinted his gray eyes as though trying to read the condottiere's cards.

"How do I know you're telling the truth?"

Montesecco shrugged. "Ask your nephew, Francesco. Or ask the Pope. What makes you think I would risk my life without his support?"

Jacopo blinked, then nodded. "Yes, of course. But you must understand my concern. This is an immense undertaking, and"— he lowered his voice— "they have spies everywhere." He wet his lips. "But they also have many enemies. More than you know."

The condottiere nodded and waited.

"When the people know it's over," mused Jacopo, "they will run into the streets."

"Hailing you as the new Medici!"

"You think so? Just like that?"

"Of course . . . while you ride through the streets with your followers, calling for liberty and freedom."

"Long live liberty! Down with the balls!" cried old Jacopo as though already on horse—balls being a symbol from the Medici crest.

Gian Battista smiled. The old man had taken the bait.

"So maybe we could invite Lorenzo to the Vatican. That would separate them, and make it easier here."

Gian Battista agreed. "Count Riario will arrange that. The brother will be yours."

Lorenzo, however, refused to go to Rome, and the conspirators became concerned. With so many people involved, the danger of the plot being discovered increased daily. It had to be done in Florence as soon as possible, and Girolamo quickly devised another trap for the Medici. It began with a letter to Raffaele Riario, the Pope's seventeen-year-old great-nephew, recently made a cardinal and currently studying canon law at the University of Pisa.

The Holy Father, he explained, desired that His Eminence visit Perugia as papal legate. On the way, he could stop in Florence, where he would be royally entertained at the Montughi villa of Jacopo de' Pazzi. The teenage cardinal obediently agreed—an unwitting pawn in the deadly game.

As expected, Lorenzo offered a banquet for the Pope's cardinal nephew at his Fiesole villa overlooking Florence. Girolamo covertly inserted three cutthroat Spanish bravos into the retinue of the adolescent cardinal. Together with Jacopo and Francesco Pazzi, Archbishop Salviati, and Captain Montesecco, there were now seven assassins to kill the two Medici at dinner. The stage was set for a double murder.

At his villa, Lorenzo graciously greeted everyone, including Francesco Pazzi, despite their betrayal in giving Imola to the Pope and taking over the Medici account as papal bankers.

"I am pleased and honored," he said. "Yet sad to report that Giuliano is ill and cannot be with us today. He hurt his leg while hunting. But he'll be up again in a few days."

"I'm glad to hear that," replied Francesco.

At the dinner, glasses of trebbiano were raised to Giuliano's speedy recovery.

Lorenzo, moved by their concern, expressed his thanks. Francesco Pazzi then advanced his cardinal pawn.

"His Eminence will attend High Mass in the Duomo next Sunday."

"Good," replied Lorenzo. "After that, we'll have a feast of honor at via Larga for His Eminence."

With this prospect, the ringleaders gathered the following day at Jacopo de' Pazzi's Montughi villa. The total group now consisted of ten men from the Pazzi and Salviati families, eight anti-Medici Florentines, ten others from exile in Perugia, and three Spanish cutthroats. With such a number, it was urgent they act before being discovered.

There was little choice. If Giuliano went to the Mass, he might withdraw again from the banquet. That left the cathedral, which was probably the better way. The duke of Milan had been an easy target, assassinated upon entering his church. This would be more difficult, however, since they had to dispatch both Medici at the same moment. Archbishop Salviati suggested it occur

during the Credo, while everyone knelt in the belief of salvation descending from heaven.

"*Nostram salutem descendit de caelis,*" he intoned. "Once you say that, everyone goes down."

"That's stupid," replied Francesco Pazzi. "Everyone kneels and we stand there so the whole place can see us."

As the two men glowered, old Jacopo suggested it occur when the sanctuary bell rang at the first elevation of the consecrated Host.

"It's a perfect moment," he said. "The priest genuflects, and everybody bows in prayer."

They all agreed, and details of the plot were complete. Francesco Pazzi and his retainers would cut down Giuliano. Captain Montesecco, with his professional skill, would quickly dispose of Lorenzo. After this, the seizure of Florence would follow in three phases.

Montesecco's military forces would move on Florence. Archbishop Salviati, bearing a spurious message from the Pope, would enter the Palazzo della Signoria with an armed group to kill anyone resisting them. Finally, Jacopo de' Pazzi would rouse the people by riding through the streets with retainers, calling for liberty and death to the Medici.

Jacopo poured wine and they all raised their glasses—except Montesecco.

"Come on, Gian Battista," urged Francesco. "One glass for victory."

The condottiere shook his head. The wineglasses were lowered.

"What's the matter with you?" demanded Jacopo, suddenly suspicious.

Captain Montesecco could go no further. More than ever, he believed this would bring death to all of them. Yet that was not all. He had seen many men die. He had been wounded six times and a dozen horses had been destroyed under him—four of them in battles against Roberto Malatesta for Paul II. This was something else, and of far graver consequence.

"God help us," moaned Francesco. "He's lost his courage again."

The condottiere turned with fury. "Courage, you fool, what do you know about it?"

"Stop it!" cried Jacopo. "We don't need any more trouble." He turned to the condottiere. "So what's wrong now?"

"I'm sorry . . ." The warlord spoke slowly. "When we began, no one mentioned a sacrilege in a church. This is not possible for me. I cannot kill anyone in the house of God, where the Lord and the Virgin Mother are watching me."

To everyone's relief, two priests volunteered to replace the superstitious soldier. One was Padre Antonio Maffei of Volterra, a scribe in the Apostolic

Chamber, whom the Pope had sent with a cardinal's hat for his great-nephew. Maffei hated Lorenzo for the sacking of Volterra, even though Lorenzo had not been responsible. The second volunteer, Padre Stefano da Bagnone, was parish priest for the Pazzi family, Jacopo's secretary, and tutor of his natural daughter, Caterina. This arrangement freed Montesecco to be with his troops at the moment the two Medici were put down.

"It's better this way," Jacopo decided. "No one will suspect two priests standing behind Lorenzo, especially if he's near the altar."

"Maybe," agreed Francesco. "But they'd better get some practice with the knives . . . like sticking pigs."

Everyone laughed—including the two priests, who had no fear of the eyes of God, nor shame in adding to the sorrows of the Virgin Mother.

4.

When Leonardo and Verrocchio arrived at the Duomo, the piazza was deserted, except for four men coming toward the cathedral. Leonardo recognized Giuliano de' Medici, who was accompanied by a liveried servant, and Francesco de' Pazzi, helping Giuliano to walk on his injured leg.

"There's Giuliano," he said. "That little Pazzi banker with yellow hair wants a marble bust in a Roman toga like yours of the Medici banker Francesco Sassetti."

"The other one is Bernardo Bandini de' Baroncelli," replied Andrea. "He threw away a fortune and is in debt to the Pazzi. You did a death mask of his aunt."

Leonardo and Andrea followed them into the crowded cathedral. Archbishop Rinaldo Orsini was at the altar in a chasuble of gold and silver with images of the Lord's Passion. The young Cardinal Riario, seated in the episcopal throne chair, wore a blue-and-silver vestment adorned by flying doves and angels with images of the Virgin Mary. It was too big for him and, sitting on the ornate throne, he resembled a child in a charade.

They were into the Canon, with the archbishop's prayer for the Church triumphant in heaven.

Memoriam venerantes, in primis gloriosae semper Virginis Mariae, Genitricis Dei et Domini . . . ("Mary ever a Virgin, Mother of our God and Lord Jesus Christ . . .")

Giuliano's companions led him down the left aisle. Andrea and Leonardo followed, until they came to two equestrian frescoes—Paolo Uccello's cenotaph of the mercenary captain Sir John Hawkwood, and Andrea del Castagno's mural of another warlord, Niccolò da Tolentino.

"It makes no sense," Leonardo said.

"Paolo's copper green colors? It's supposed to resemble a bronze monument."

"I mean Francesco de' Pazzi," replied Leonardo. "He hates the Medici. So why is he helping Giuliano this way?"

"Who says he hates them?"

"When he came for a marble bust, he said, 'The Medici are finished. My family will soon replace them.'"

"So now he wants something from him, or maybe from Lorenzo."

"He doesn't need Giuliano for that. His brother, Guglielmo, is married to Lorenzo's sister, Bianca. Did you notice his face when he saw us?"

At the altar, the archbishop had begun the narrative.

"... *Pridie quam pateretur, accepit panem in sanctas ac venerabiles manus suas, et elevatis oculis in caelum ...*" ("... On the day before he suffered, he took bread into his holy and venerable hands, and having lifted up his eyes to heaven ...")

Leonardo persisted. "I think we should go to Giuliano."

Farther down the aisle, Francesco de' Pazzi paused before the side entrance to via dei Servi.

"Perhaps it's better here," he told Giuliano, indicating the exit.

"With your leg, it'll be easier," added Bandini.

Giuliano hesitated, looking over the crowd toward the distant altar, where he had an assigned seat.

"I don't see Lorenzo," he said.

"He's up front, to the right of the choir," Francesco said. "You want to join him?"

"Not through this mob."

Francesco turned to Giuliano's servant. "Go get your master a chair. . . . Get one from the sacristy."

He then put his arm around Giuliano's waist, as if to support him until a chair arrived. There was no breastplate or mail shirt, nor hunting knife to chafe his thigh. The victim was disarmed, and his servant was gone.

The sanctuary bell rang at the moment of Consecration—the moment of eternal mystery, with bread changing into the Body of Christ. With his back to the congregation, the priest raised the sacred Host above his head for everyone to witness the miracle of faith. It was the moment for conspirators on both sides of the church to act.

"Take that, you traitor!" cried Bandini, his saber piercing Giuliano's chest.

"And that!" screamed Francesco, driving a stiletto into the young man's back.

"*O Dio!*" exclaimed Giuliano, staggering from his wounds.

Francesco stabbed him again, and the Medici heir sank to his knees before the Chapel of the Cross. He looked at his two assailants with trembling lips.

"Why? Francesco, why did you . . ."

"This is why!" cried Bandini, driving his saber again into the bleeding chest.

He withdrew the blade and turned to face the screaming crowd as the congregation scrambled for safety. A few men remained, however, but when he brandished his saber, they also ran away. Giuliano now lay on his side, his red tunic turning purple with blood, as he slowly closed his eyes.

"Maria, Maria . . ." he whispered, his lips near the marble floor. "Santa Maria, come to me . . . in this hour . . ."

His chest began to heave as he struggled for air, and in a final gasp, he projected a mouthful of blood onto Francesco's green stocking. The banker screamed as though run through by a sword.

"Oooh . . . son of a whore!"

The enraged Pazzi stabbed him again—this time through the temple. The blade drove through bone and brain to the marble floor of the cathedral. With the last thrust, Giuliano's left eye popped out—dangling by its tendon across the bridge of his nose. In rage, Pazzi struck again and missed, plunging the blade into his own right thigh.

"*O Dio . . . o Dio,*" he moaned.

Hysterical at the sight of his own blood, he began to stab the inert corpse with blind fury.

"Enough, enough! . . . We've done it!" cried Bandini.

They were alone in the aisle, everyone having fled the ghastly scene. Elsewhere in the church, people were running back and forth, saying both Medici brothers were dead. Others were screaming that the cathedral dome was about to fall on them. Bandini saw a sword flash up near the altar.

"They missed Lorenzo!"

At that moment, Leonardo and Andrea came into the clearing.

"Assassins!" screamed Andrea.

"Don't go near them!" cried Leonardo, holding him back.

"Come on, Francesco!" urged Bandini, running with his bloody saber to kill Lorenzo.

Francesco remained beside Giuliano, stiletto raised against Andrea. For a moment, he stood there—mouth open, eyes wild with fear. Then, dropping the dagger, he fled through the side exit. Andrea rushed to the side of Giuliano as Leonardo ran after Bandini.

5.

Lorenzo's fate turned on an act of courtesy for Cardinal Riario. Since the young prelate was to be a luncheon guest after Mass, he had accompanied him to the high altar and remained nearby, standing in the right ambulatory. Angelo Poliziano was beside him, along with four other friends—Antonio Ridolfi, Lorenzo Cavalcanti, Filippo Strozzi, and Francesco Nori, former manager of the Medici bank in Lyon.

The two priests, Maffei and Stefano, waited with concealed daggers at the adjacent altar of Saint Zenobius. Behind them were four Florentine cutthroats and the three Spanish bravos from the cardinal's entourage—ready to finish off Lorenzo if the priests failed.

Lorenzo's friends, however, had created a problem by encircling him. As the Mass progressed, the two priests slowly entered the ambulatory. Mistaking fright in their faces for pious ecstasy, Lorenzo's companions allowed them to stand directly behind him at the chancel rail. The mercenaries sought to follow, but Filippo Strozzi and Francesco Nori instinctively closed ranks, preventing them from entering the ambulatory.

At the tinkling of the sanctuary bell, both priests stealthily drew their daggers. Padre Maffei placed his hand on Lorenzo's shoulder, expecting him to turn for a direct thrust into the heart. Seeing the weapon, Strozzi shouted his alarm.

"Lorenzo, look out!"

"The priests!" cried Nori, sinking Padre Stefano to his knees with a kick to the crotch.

Lorenzo whirled, throwing his cloak over his left arm to free his sword, causing Maffei's dagger to miss and pierce the left tendon of his neck.

"Traitors!" he cried, drawing his sword. "Come, swine in God's clothes!"

As the terrified priests escaped, Poliziano saw the Florentine and Spanish assassins emerging from the crowd with drawn swords and daggers.

"Renzo! . . . Run to the sacristy!"

Lorenzo turned and leaped over the altar rail. Bandini came after him, but he was blocked by Francesco Nori, who fell, mortally wounded. Lorenzo Cavalcanti charged Bandini and knocked him over, the assassin's sword piercing his shoulder. Lorenzo entered the sacristy, followed by his friends. Poliziano closed the bronze doors just as the wounded Cavalcanti hurled himself inside. They were secure for the moment, with Bandini and the mercenaries beating vainly upon Luca della Robbia's massive portals.

"Giuliano . . . where is Giuliano?" asked Lorenzo.

Fearing the dagger poisoned, Antonio Ridolfi sucked Lorenzo's neck wound as he continued to ask for his brother.

"Giuliano . . . *Santo Dío,* has anyone seen him?"

The pounding on the doors ceased, followed by friendly voices calling for Lorenzo. To make certain, Sigismondo della Stufa climbed into the choir loft for a view of the church's interior. Bandini and the mercenaries had fled. A group of friends were knocking on the doors. Beyond them, at the altar, the little Cardinal Riario was on his knees, sobbing in a silver-blue vestment with crumpled images of the Virgin Mary. Two cathedral canons were at his side, urging him to stand up.

Closer to hand, Francesco Nori lay dying on the black-and-white marble floor, attended by a woman and a priest. His tunic and doublet were dark with blood, which was draining onto the cathedral floor and its bronze meridian marker.

6.

Leonardo paused before the dying Francesco Nori. A priest was mumbling Last Rites, and a woman held the youth's head against her breast. Backing away, he sketched them and noted, "For a Lamentation, the Madonna does not pray. She draws her son to where she first nursed His life."

Returning to Andrea, he found his master kneeling with a small group beside the corpse of Giuliano. Among them, he recognized Fioretta Gorini, Giuliano's mistress and mother of his one-year-old child, Giulio. For Andrea's marble portrait, he had carved primroses pressed against her bosom. In their place, she now held the head of her lover.

Andrea's face was torn with grief. When he saw Leonardo, he closed his eyes and shook his head.

"You said to follow him. Why didn't I listen to you. . . . Why?"

Tears coursed over sagging jowls. Fioretta had no tears. Her face was dark with anger.

"Why this?" she charged. "Tell me, why this, too?"

She held Giuliano's head with her hand, covering his eyes.

"Monsters," sobbed Andrea.

Fioretta lifted her hand to console him, and Giuliano's replaced eye dropped out, hanging by its optic tendon on his cheek—the brown pupil cocked toward a gay sprig of blue ribbons in the white lace of her chemise.

From the street outside, there were the sounds of running crowds and the distant tolling of the *vacca*—the Palazzo dei Signori bell—calling citizens to defend their republic.

"Go, Nardo!" cried Andrea. "For God's sake, go! Put it all down, every bit of it . . . the horror of this day!"

7.

Leonardo joined the crowd rushing toward Piazza della Signoria. Some men carried swords and lances. Others had pitchforks or long kitchen knives. A boy near him was beating a drum, a housewife held a stew fork, and an old man in a red jacket bore a curved Turkish sword. Here was the heart of Florence, with the weapons of their fathers and the tools of the hearthside. There was much shouting. Many thought both Medici were dead.

On via dei Pittori, Jacopo de' Pazzi appeared on horseback, followed by a band of mounted supporters, waving swords and shouting, "Liberty! Liberty! Down with the Medici! . . . Down with the balls!"

A wool worker picked up the cry. "Bravo! Down with the balls!"

The enraged crowd turned upon him. "Down with yours!" they yelled, and a pitchfork handle bounced off his head.

Elsewhere, the conspiracy was proceding as planned. After witnessing the murder of Giuliano and hearing that Lorenzo was also dead, a courier raced from the cathedral, reporting the death of both Medici, which had sent Jacopo and his retainers into the streets. Montesecco followed suit. Stationed at the Santa Croce gate with thirty crossbowmen and fifty infantry—ostensibly an escort for Cardinal Riario—he called for his troops, massed on the borders of the republic, to advance on Florence.

At the same time—and crucial to the seizure of Florence—Archbishop Salviati hurried to the Palazzo della Signoria with a fictitious message from Pope Sixtus. As a presumed papal legate, he had retainers and an armed escort—actually, a band of eighteen anti-Medici Florentines and exiles, ten Pazzi and Salviati family adherents, and three Spanish cutthroats. Among them was Jacopo Bracciolini, son of Poggio, the famous scholar and friend of Cosimo. Jacopo, a typical turncoat Florentine, was a member of the Platonic Academy and friend of Ficino. He had joined the conspiracy after writing a commentary on Petrarch, profusely dedicated to Lorenzo de' Medici, whose death he now desired.

Entering the palazzo, Salviati sent word to the ruling *gonfaloniere,* Cesare Petrucci, that he had arrived with an urgent message from the Pope. The supreme magistrate of Florence, after attending Mass in the palazzo, was dining with his eight priors. During their two-month term in office, the priors slept in a common room and never left the palazzo on private business. They lived regally, however. When Salviati arrived, country singers from

the Mugello and a buffoon dwarf from Mantua were entertaining them.

Irritated by this sudden intrusion, Petrucci gave orders for the archbishop to wait in a reception room. His retainers and Jacopo Bracciolini were to remain in the corridor. The anti-Medici Florentines and exiles from Perugia were led to nearby offices. This left Salviati alone, unarmed, and desperate. Bracciolini and his other retainers were still in the corridor. If he called them in now, Petrucci would comprehend the plot. At that moment, the *gonfaloniere* arrived, wearing the red cape and golden chain of his office.

"Good day, Your Excellency. What can I do for you?"

Archbishop Salviati had rehearsed his speech, but now he could hardly recall it.

"I bring good news from . . ."

His throat was dry, and he had trouble talking.

"Go on; I'm listening."

"The Holy Father intends to favor your son . . ." He was trembling and sought to control himself. He coughed and glanced toward the corridor. Somehow, he had to get Jacopo and the others in here to help him. Petrucci had seen enough. As mayor of Prato, anti-Medici conspirators had imprisoned him. Here he sensed it once again.

"Excuse me a moment," he said, bowing politely.

At the door, he quietly summoned Marco Landini, sergeant of the guards. Seeing his chance, Salviati rushed from the room, calling for support. Petrucci ran after him—only to bump into Jacopo Bracciolini with a drawn sword.

A former back hitter, or fullback, in the rough game of Florentine football, Petrucci resorted to dirty tricks of the playing field. Holding Jacopo close by his hair, he drove a knee into his crotch, doubling him over. A neck blow dropped him to his knees, and a head kick left him senseless on the floor. Seizing an iron roasting spit, the formidable magistrate beat off the archbishop's other retainers until the guards rushed upon them. Seeing the guards, and hearing shouts of the Florentines trapped behind self-locking doors, Archbishop Salviati and his disarmed retainers surrendered.

The palazzo doors onto the piazza were bolted, and the great bell of the republic continued to toll, summoning all of Florence to the palace, where Archbishop Salviati and his accomplices were now Petrucci's prisoners. At the top of the stairs, the *gonfaloniere* met Ser Piero da Vinci. The notary was gasping, his face gray with fright, and Petrucci saw his worst fears confirmed. The republic had suffered a most grave tragedy, and he was about to hear it from this pompous, text-creeping mole.

"I come from below . . . from talking with people outside."

"So what is it?"

"They . . . they killed Giuliano de' Medici in the Duomo. They butchered him. . . ."

"What about Lorenzo?"

"He escaped with only a small wound."

"Sons of whores. By God, they'll answer for this."

Calling the priors into conference, along with their notary and chancellor, Petrucci quickly presented the case. In the Prato revolt eight years previous, all conspirators had been executed by order of the republic. Now, as its ruling magistrate, he proposed the same fate for every prisoner in hand, and all others involved in the death of Giuliano de' Medici, and the assault on his brother, Lorenzo. The priors quickly agreed, and Petrucci turned to his notary.

"Ser Piero, keep your wits sharp. Besides making full notes on these proceedings, I want you and the chancellor to record all that is about to occur inside this palazzo."

He then called Sergeant Landucci.

"Open the doors and admit fifty armed citizens. Make sure they are all young and strong—and with sufficient balls to help us dispose of everyone, including the archbishop."

"Dispose, my lord?"

"Execute every one of them."

"The ones in the locked rooms?"

"Every cursed one of them . . . Get going, Sergeant, and do it fast!"

8.

Entering the piazza, Leonardo found it filled with armed Florentines seething with fury. Upraised lances, swords, pitchforks, and the iron prongs of wool dyers appeared to float on the surface of a surging sea. Many were shouting at one another or at the distant Palazzo della Signoria. Working his way through the mob, he arrived at the palazzo. Five guards with lances were holding the crowd back from the *aringhiera,* the stone rostrum skirting its front and north side.

At that moment, a corpse was flung from a mullioned window on the second floor. It seemed to fly on its own—a tall figure with a gray beard and a gray cloak billowing out like sprouting wings as it turned in midair, then landed with the hollow thump of an empty wine vat. From beneath the gray cloak, now covering the victim's head, a red-and-yellow liquid streamed out toward the Marzocco, the sitting marble lion and symbol of Florentine valor.

The crowd pressed forward, but the guards' lances drove them back as a second corpse came through the upper window—a blond youth, naked to the

waist, his chest split open by an ax. It was a clean cut, as though made by Nando's new saw. In landing next to the gray cloak, the severed chest sprung apart like a mute scream. In his notebook, Leonardo recalled the Greek physician: "Galen had gladiator games of bloodthirsty Greeks for his anatomical studies. We have assassins and blood-crazed Florentines. . . ."

The crowd cheered again as a third corpse sailed out of the window—a small figure in green with a fluttering yellow cape, the colors like a parrot's plumage. Leonardo noted: "For cloth in flight, as the robes of Gabriel, the air forms another body in reverse. . . . Remember how Greeks and Romans revealed the draped body with wind pressing upon it. . . ."

A second window to the left was flung open to increase the exodus. The first ones hit the bare pavement with the thud of an ax cutting into a tree. Others landed on their companions with short, muffled sounds similar to the cough of a sick horse. Gradually, the weight of the upper bodies caused those below to expel wind from their lungs and intestines, resembling a prolonged sigh. Their blood began to intermingle, streaming out as from a single giant body to collect in dark red puddles, then trickle down the rostrum's five stone steps toward the crowd, driving them back more effectively than the spiked lances of the guards.

The accelerated flight of bodies from two windows soon turned into a spectacle of competing players, the crowd judging one or another corpse according to its dress and manner of flight. Some were cheered for appearing to fly. Others, like clowns, brought laughter. Another one, top-heavy with armor, fell short of the pile, landing on its head, its legs opening in an acrobatic split, to the delight of everyone.

To escape the press and stench of the crowd, Leonardo climbed upon the Loggia dei Lanzi. The crowd had fallen silent, and he looked up, to see Jacopo Bracciolini sitting on the windowsill with his hands bound behind his back and a rope around his neck. Then he was shoved off, and he fell, with legs kicking, until the rope jerked him in midair. This snapped his neck and cocked his head at an angle, like a child tweaked by its ear. The legs hung still, but the body continued to turn slowly, as though its soul was curling out and away. The crowd's first murmur of approval, like approaching rain, broke into a storm of cheers with screams of joy at this first hanging.

More shouting came from the far side of the piazza. From his loggia pedestal, Leonardo saw a distant flashing of swords and lances, the joggling of heads and raised fists greeting the latest player in the grim drama of death's revenge. Francesco de' Pazzi, found in bed at his uncle Jacopo's house, was now being driven naked through the crowd toward the palazzo.

Leonardo drew the approaching figure, bent and sobbing, yellow hair matted on his face, fat belly glistening with sweat. As the prisoner drew near, Leonardo noted sweat dripping from the tip of his little penis. Blood from a bound wound in his right thigh coursed down his leg to the foot and toes, where its dark red became orange and yellow in the dust of shuffling feet.

In front of the palazzo, the screaming crowd sought to seize him.

"Kill him! . . . Kill him now!"

"Get back, idiots . . . pigs . . . scumheads!" screamed the guards, driving them back with lances, swords, and spiked maces. The mob then focused its rage on the prisoner's small penis—an immutable verdict of nature, all but hidden under a fat belly.

"Big banker, little rod!" cried one man in a red cap.

"That peg couldn't stick a roped goat!" shouted another, a gaunt man with the stained hands of a wool dyer.

The palazzo doors opened for the naked Pazzi, his back and buttocks red with purple welts like encircling snakes. The doors closed and the crowd surged forward again, shouting for their victim. Then he reappeared, sitting in the second death window—one bloodred leg and a white one dangling over its edge, hands bound behind his back, a noose around his neck.

From his window ledge, Cavaliere Francesco de' Pazzi saw his destiny—Bracciolini hanging on a rope from the next window, and, below that, the jeering mob demanding his death. Suddenly, he was shoved off the ledge, his legs in a frantic midair dance until the halter closed on his neck. At that moment, with the mortal jerk of his spinal cord, his penis sprung up in an erection.

The crowd roared with delight and hurled insults at the pendant corpse.

"To get it up, they had to hang him!"

"Even his rod is crooked!"

Archbishop Salviati appeared next in the window, hands bound in back and a noose about his neck. All in the piazza fell silent. This was a Roman Catholic archbishop—maximum guardian of their souls, ultimate judge of their sins, and a favorite of the Pope in Rome. Yet there he was, perched on the window ledge in a robe of red, black, and gold like an exotic creature from an African jungle—to be strung up, prime trophy of the day, alongside a naked man on a rope from the same window.

He remained there, however, delaying his fate by talking to someone behind him. Leonardo saw the russet gown of a notary and recognized his father taking notes. Then Piero withdrew, and the archbishop peered at the corpse hanging below him. Its rope ran alongside his thigh and, in a desperate gamble, he hooked both legs around it as he was pushed off the ledge.

With the rope between his legs, the archbishop's slide to death was halted when his crotch jammed onto the twisted head of his fellow conspirator, Cavaliere Francesco de' Pazzi. From the piazza, the crowd stared in wonder. The archbishop was perched like a jungle bird atop the fat Pazzi, his red robe with its gold hem now skirting the swollen belly and its erection. This ridiculous coupling appealed to the Florentine sense of humor, and those watching began to laugh and then applaud. It was the best feat of the day. With his chin hooked around the rope in an attempt not to topple over, the archbishop had saved himself in a most spectacular manner—yet not for long.

From the window above, two guards jerked his rope until the archbishop lost balance and fell from his perch toward his fate—only to halt himself once more by sinking his teeth into the shoulder of the Pazzi banker who had led him to this end. For a moment, he held on, moaning like a whipped dog. Finally, the flesh gave way and he fell, kicking and cursing. The noose snapped his neck, and his head flipped to the side. This left him facing the naked Pazzi, whose erection was now buried somewhere within the folds of the archbishop's robe.

The crowd urged the dead banker to make the most of a rare opportunity.

"Bravo, *Eccellenza!* Now grab his rod!"

"Open your *culo* for the *cavaliere!*"

After this, the windows remained empty. A guard detachment emerged from the palazzo to separate the piled-up corpses, placing them in three rows along the stone terrace.

The show was over, and the crowd began to disperse, except for an agitated group seeking to get past the cordon of guards. One woman ducked under a spiked lance and ran up the steps, calling for her son. She hopped from one body to the next like a wounded bird trying to fly. A guard seized her, but she bit his hand and broke away. With his bleeding hand, the guard dragged her screaming by her hair and threw her into the mob. In the confusion, a young woman broke through but was caught on the steps by another guard, who cut her skirt open, exposing dirty white underpants. Amid laughter, she ran away in shame. A man darted up but was struck by the flat side of a lance and left senseless on the steps.

Leonardo saw the corpses, many with exposed chests and stomachs, as a remarkable landscape of human anatomy—to be viewed quickly before death altered their true state. Skirting the crowd, he came to the far side, where a single guard stopped him. He held up his notebook with its drawings.

"These are for the Santa Maria Novella hospital. I must now determine if any remain alive."

The guard, a youth with a scraggly brown beard smelling of garlic, stared in wonder at drawings of bodies flying through the air, the archbishop sliding down the rope, and then a detail of his teeth in the shoulder of the banker.

"That was the best part." He grinned. "I saw it myself . . . and I can tell you, none of them are alive."

"I'll let you know," replied Leonardo, shoving past him.

Amid the corpses, he knelt first beside the blond youth with the cloven chest. The heart autopsy in the morgue had been without blood. Here there would be clues to its actual flow within the heart. But upon pulling open the rib cage, he found that a pool of blood had filled the chest cavity. Lacking towels or any means to remove it, he rolled the body over. The blood gurgled out and ran down the steps. As he rolled it back, one of the guards stopped counting the corpses.

"What are you doing here?"

"He's a doctor," said another guard. "He's making sure they're dead."

"And this one isn't dead?"

"Leave me alone," Leonardo replied. "This is for Santa Maria Novella. They need it as soon as possible."

"*Signore, sì!*"

With the cavity cleared, he noted a saber or an ax had sliced the chest along the right side of the heart. Peering among the severed arteries and veins, he saw a break in the pulmonary artery that ran from the right ventricle to both lungs. This would give him a window into cardiac behavior, and he pressed the heart. Dark blood emerged from the stump of its artery. How could that be? Professor Fico had said this vessel carried vapor impurities from the furnace of the heart to the lungs—not blood. To check it further, he reached under the rib cage and compressed the right lung. More blood emerged from the upper branch of the severed artery.

Was it possible that the accepted concept of the working heart was in error? Unable to believe it, he sought the other conduit between the lungs and the heart—the pulmonary veins. He found one of them—a severed right branch. Fico had said these veins brought an air spirit from the lungs into the left ventricle, where its internal furnace produced the vital spirit of man. Yet this vein also contained dark red blood. Did that mean the air spirit was mixed with blood? If so, blood was refined in the lung, and not by passing through a porous septum between the ventricles. Could Fico and a thousand years of the Greek, Arab, and Italian anatomists all be wrong?

"How many have you counted?"

It was his father's voice. He looked up to see him; holding a notary's

ledger, he was talking to a guard. Gray strands of his hair had fallen over his ear.

"I got thirty," replied the guard.

"That's what I got," said another.

Then he spoke to Leonardo, who was drawing the pulmonary vein, with its startling flow of blood.

"How repulsive. I saw you roll that cadaver over, and now you're inside it. That's really disgusting."

"Good day, sire. An artist must know human anatomy. It's a form of record, just as you make records for the commune."

"I do the living. You do the dead."

"I would say just the opposite. You record words of the dying and the dead. I go the other way, in recording a life. It's a different road."

"No, you've always done this, like a vulture feeding on carrion."

Leonardo looked up, surprised. His father's mouth was tight with anger, his eyes narrowed with disgust. This wasn't an old man's fear of death. It was a father's hatred of his son.

"Don't say that. You don't mean it, so don't say it."

"Of course I mean it. You've always done this, stinking up the place with dead fish and birds and rotting snakes. You dug up a corpse in the graveyard and even went into that putrid underground of dead people to find your stepmother. . . . You always wanted her for yourself. That's why you, with your filthy lust, drew her naked body."

Leonardo sprang to his feet with fury, his bloodred hand raised against his father. Piero stepped back from the bloody hand, a fleck of spittle at the corner of his mouth.

"Go away," Leonardo said. "Leave us alone."

He watched his father turn, noting the scraggly gray hair on his ear, the bent back, the notary pad under his arm, and felt profoundly sad. No, he told himself, it's not him. It's for Albi. . . . Nothing else matters.

9.

Excited by events in the piazza, the crowd ran toward the Medici Palace on via Larga. Many said Il Magnifico Lorenzo was dead, others that he was dying. They wanted revenge, and they gathered before the palace, calling for the surviving Medici until he appeared at the corner window in his bloodstained doublet and shirt, a white bandage around his neck. He spoke slowly, trying to appear calm, but his high-pitched voice broke under intense emotion.

"My people . . . dear friends . . . I am deeply moved by your concern for me. As you can see, my wound is not serious, *grazie a Dío* . . . but my brother is gone forever. . . ." His voice faltered. "A heavy stone lies on my heart, as it does on yours. We will punish the guilty, every one of them. Yet I pray you, let justice take its course. Control yourselves. Do not harm the innocent, for this will only add to our sorrows. . . ."

This brought cheers and shouts of affection, and it overwhelmed him. He was alone now, but these people, these beloved Florentines, were with him. To hide his tears, he waved farewell and turned away from the window. His Florentines, however, had tasted blood. Heedless of his warning, they raced through the streets in search of conspirators, or simply to settle old accounts with a hated neighbor. Victims, hiding in closets and cellars, or running through the streets as they sought to flee, were slaughtered on sight. Soon it was like the plague. Corpses lay everywhere, and from dark alleys came the stench of spilled viscera and human feces.

Dark clouds appeared to hide the sun, and in a gray light without shadows, strange things happened. Men screamed like hysterical women, and women cursed like men. Children playing grown-ups ran about in clothes of the dead. Severed heads were held aloft on lances or broomsticks. Eyes were gouged out, ears and noses cut off, penises uprooted. Testicles, hearts, and livers went into cooking pots, especially those of the growing slave population.

As Lorenzo had feared, the innocent were yoked to the guilty. Renato de' Pazzi, who had opposed the conspiracy, was found in his country house—hanged. Two of his brothers, equally innocent, were thrown into dungeons. Guglielmo de' Pazzi, married to Lorenzo's sister, Bianca, barely escaped to a Medici villa. Cardinal Riario, sought by the mob, was saved by Lorenzo and retained as a pawn in his palazzo.

The guilty ones were also caught. After failing to arouse the citizenry, Jacopo de' Pazzi had retreated to his palace, where he learned that Lorenzo was still alive. Overwhelmed, he fell to his knees and beat the floor in rage. Then he recalled that Montesecco's papal troops would be advancing on Florence, and he hastily rode to the Santa Croce gate, where he found the condottiere with his detachment of soldiers.

Montesecco was dark with anger and an awareness of his impending death. This frightened Jacopo.

"Where are your troops?" he demanded. "You said the Pope promised them."

"When they heard Lorenzo was alive, they turned back."

"So what now?"

"We leave, as fast as we can . . . and may God help us."

Montesecco's retreat, limited to the pace of his foot soldiers, was too slow for the frightened Jacopo. A gambler to the end, he galloped away on his own—only to be seized by peasants in the village of Catagno. He offered gold for his release, but they refused. He was a traitor, and they prepared to take him to Florence. Jacopo realized the game was almost over.

"I'll save you the trouble," he said, using the bravura of the gaming table. They waited for his bid.

"You can have all my gold if you kill me now."

"Where is it?"

He offered his pouch. They took it, then beat him so badly that he had to be carried by litter to Florence, where they were paid again—a ransom of fifty gold ducats. The examining magistrate asked Jacopo what had led him to believe he could destroy the Medici.

"Francesco," he replied. "I counted on his support from the Pope."

"The Holy Father was also involved in this?"

"Montesecco said so. . . . I should have never listened to him."

"You can tell him that when he joins you."

Jacopo, wearing a purple tunic with black stockings, was hanged from the same window with Francesco and the archbishop. As the rope seized him, he cursed his nephew and his fate, then consigned his soul to the devil.

Following his burial, constant rains lashed Florence. Ghostly cries were heard at night near his grave at Santa Croce. Terrified citizens, believing the devil had been called forth, disinterred Jacopo's body from sacred soil and reburied it near the city wall. At that point, the weather cleared. Two days later, some boys dug up the corpse and dragged it through the streets by the hangman's rope still about its neck. A mob followed, shouting, "Make way for the great knight!" When they arrived at Pazzi's palazzo, the decomposing old man was propped up against his front door. Banging his head as a knocker, the crowd cried, "Open the door! The master has returned!"

That evening, the putrefying corpse was thrown into the Arno, and crowds gathered to watch it floating down the river. The next day, some boys near the village of Brozzi pulled it from the water, and hung it on a willow. They took turns beating it, then threw it back into the river. The next day, people in Pisa said they saw it floating out to sea.

Montesecco was captured and, after being tortured, signed a confession, which included a verbatim account of his meeting with Pope Sixtus. His refusal to murder Lorenzo in the cathedral was of no help in weighing his role in the conspiracy. As a soldier, he was beheaded by sword in the courtyard of the Bargello.

So it went for three days, until over one hundred people had been executed in the eyes of justice or in blind acts of revenge in the streets and inside their homes.

IO.

Lorenzo's friends, desiring to commemorate his survival, commissioned three life-size figures of himself from Verrocchio and the wax modeler Orsini. To obtain a living image, they used Leonardo's mask of the surviving Medici. Two of these were displayed in Florentine churches. The third was sent to Santa Maria degli Angeli in Assisi, the shrine church of Saint Francis. In the tradition of painting defamatory images of criminals and political adversaries on public buildings, Sandro Botticelli was asked to depict the conspirators on the walls of the Bargello, seat of public justice.

When Leonardo saw his rival at work on the wall above the door to the Customs Office, eight figures were already finished, including those of Jacopo de' Pazzi, his nephew Francesco, and Archbishop Salviati all with ropes about their necks. Bernardo Bandini, who had escaped, was shown in the traditional manner of hanging by one foot.

Leonardo knew why Sandro had been chosen. Poliziano had convinced Lorenzo. "Leonardo," he said, "seldom works in tempura and takes a long time to finish anything. This is in fresco, our Sandro is a fresco master, and he works fast. That's why we need him. So people can see this as soon as possible."

Leonardo paused to watch his rival on the scaffold. Sandro did work well and fast, but he had no idea of how to portray a dead man on a rope, with broken spine and crooked neck. There was no grasp of human anatomy. Yet it wasn't only his lack of knowledge regarding anatomy. Giotto, with cloaked figures amid formalized rocks, had been able to create human beings in the stark reality of their lives . . . as had Masaccio and Donatello, the masters who had taught Verrocchio. Sandro had worked briefly with Andrea but had employed only shop techniques to embellish his lyrical style of harmonic color and graceful form.

Also, his people stared into space as if they were lost. In his portrayals of the Adoration, baby-faced Madonnas looked at the newborn Christ Child as though He had been discovered on a doorstep. Or they were half-asleep, with Fra Filippo faces—the small pointed chin, tiny petulant mouth, high forehead, and eyes of a munching cow. Faces surfaced above a crowd as though gasping for air, some with the blank look of deaf-mutes, others with acute pain.

Leonardo smiled. One day, he would show Botticelli and Lorenzo's gaggle of Platonic Humanists the immensity of an *Adoration*. Beyond the

powers of Sandro, it would contain the aura of the moment, with people who saw and heard and smelled one another, their words interlinked in a sudden, unexpected brotherhood before a mystical occurrence, a spontaneous offering and acceptance of one another without number.

Sandro was staring at him from the scaffold, his work tunic splashed with color, his hair yellow in the sunlight. He nodded, as if to say, Go ahead, copy me if you like. That's all you can do now, because you can't work this way, or as fast.

Leonardo also nodded, accepting the challenge. Wait, just wait, he thought. You are seven years older, but I'm far ahead of you. My turn is next, and where I go, you will never be able to follow.

POPE SIXTUS AND THE FLORENTINE WAR

❧ THE VATICAN AND FLORENCE ❧

April – July 1478

FROM THE FIRST DAYS OF HIS REIGN, the court of Pope Sixtus IV had been accustomed to his fits of anger—the fat face purple with rage, darting dark eyes infused with fear, a scream from the brink of hell while hurling the anathema of damnation.

No one, however, had ever witnessed the frenzy that seized the Holy Father after the disaster of his nephew's attempt to murder the Medici. Nothing could assuage his fury, not even the solace of his Black Madonna, who had spoken to him from her wooden panel during the conclave: *Francesco, be of good heart. The Lord has chosen you to save the Church. Tomorrow you will be made Pope.*

Sixtus IV proclaimed to the world that everyone was lying. The banker, the condottiere, and the archbishop were all despicable traitors. God was his witness. He had been perfectly clear. No bloodshed was to dishonor the Holy See. Yet they hadn't listened. And for this, their souls would burn in hell.

So would that despicable son of iniquity, Lorenzo de' Medici, for committing acts of villainy against numerous servants of the Lord. An archbishop had been hanged without trial, and priests slaughtered like hogs. A cardinal and great-nephew of the Holy Father was being held hostage. This was against all rules of law—a mortal sin against Almighty God, and the reigning Vicar of Christ.

Girolamo Riario soon made it worse. Leading two hundred soldiers, he seized the old and respected Florentine ambassador, Donato Acciaiuoli, and imprisoned him in Castel Sant'Angelo. Alarmed at this violation of diplomatic immunity, the Venetian and Milanese ambassadors demanded their colleague's release—or the Holy Father could expect similar actions against his papal envoys elsewhere in Italy and Europe. This meant that Cardinal Riario, in house custody with the Medici, would also be placed in a dungeon. Sixtus quickly released the Florentine envoy, vowing he knew nothing of Count Riario's stupid act. Then he sent for his nephew.

"You are an idiot," he shouted. "Go home to your Caterina and stay there!"

Girolamo decided his only defense was to enflame the Pope further.

"*Santità,* they're laughing at you, all of them."

"Who's laughing?"

"In Florence and here in Rome. The Medici bankers, especially. They say you've made a fool of yourself."

"A what? How do you know this?"

"Also you're too old to be Pope, you make stupid mistakes."

"Old, you say? Stupid? Leave me! Get out of here!"

Girolamo's heart sang, but he showed a sad face. "*Santità,* I was only trying to help."

"Leave me, you idiot . . . you and the Medici dogs!"

Sixtus knew his nephew had manipulated him. It was partly why he was so furious. Who could protect him from the stupidity of a Girolamo? Or his insolence? *Too old, too stupid to govern? Santo Dio,* he would show them.

First, he had to deal with the treacherous Florentines in Rome. Unable to arrest them while Florence held Cardinal Riario, he sequestered the assets of the Medici bank, repudiated all debts to it, and seized all of its properties. Next, he sought to isolate Lorenzo from his people. In a bull of excommunication—June 1, 1478—he demanded that Lorenzo de' Medici "son of iniquity and foster-child of perdition" be handed over to papal justice. When this failed, he issued a scathing interdict. Lorenzo and all his accomplices were excommunicated and anathematized as "sacrilegious, infamous, unworthy of trust. . . . All their property is to revert to the Church; their houses are to be leveled to the ground. . . . Let everlasting ruin witness their eternal disgrace."

Obtaining no satisfaction, the exasperated pontiff declared war on the Florentine Republic, July 7, 1478. His ally, King Ferrante of Naples, joined him to extend the House of Aragon into Tuscany. The king's son, Alfonso, duke of Calabria, struck immediately. Two weeks after the onset of war, he had invaded Florentine territory and stationed his troops near Montepulciano.

Confident of victory, Alfonso sent King Ferrante's herald to Florence with a grim warning: "Render to the Pope or be destroyed." With this came a final ultimatum from Sixtus to deliver Lorenzo to the justice of the Holy See, or face total destruction and eternal damnation.

FLORENCE

August 1478 — November 1479

IN FLORENCE, THE STARK REALITY of an advancing army and the Pope's dire warning was abundantly clear. The fate of the republic hung in balance between the person of Lorenzo and a war against a superior army, already within its borders.

Lorenzo summoned the leading citizens to the Palazzo della Signoria, and in his high-pitched voice, he spoke to them as an extended family. The death of his brother, and the attempt upon his own life, had taught him that he had more enemies than he realized—yet many more devoted friends.

"The Pope says I am the cause of this conflict. So it is up to you, the people of Florence, to decide. I place myself, without reserve, in your hands. Know it well: I will suffer exile or death if this will serve the good of our beloved republic and its people as my brothers and sisters."

To free himself for the task ahead, he had sent his wife and children to a place of safety outside of Florence. Yet they deserved no more privilege than anyone else.

"If need be, I will sacrifice even those dearest to me to the common cause."

Overwhelmed, Jacopo de' Alessandri rose to speak for everyone. They were all aware of what the Magnificent Lorenzo had done for them. To a man, they stood behind him. He was given a twelve-man guard, and made a member of the War Council of Ten. The city then girded itself for war, and the Signoria sent a remarkably stern rebuke to the Pope:

> You say Lorenzo is a tyrant and command us to expel him. With one voice, we acclaim him the defender of our liberties. . . . Had he permitted himself to be slaughtered by those most atrocious satellites whom you sent here . . . there would be no cause for contention between us. . . .

Remember your high office as Vicar of Christ. The Keys of Saint Peter were not given to you to abuse them in such a way. Florence will resolutely defend her liberties, trusting in Christ who knows the justice of her cause . . . and trusting in her allies, especially the most Christian King Louis of France, ever the patron and protector of the Florentine State.

Euphoria swept through the city. The fiercely independent spirit of the Florentines, a source of endless and bitter quarrels, bound them now in union against a common enemy. Lorenzo urged them to lay in supplies for a long siege. The Signoria levied war taxes, and they paid them. Florence had defeated Pope Gregory XII a hundred years ago in a war that broke papal tyranny in states surrounding its borders. They would do it again against this bloodthirsty Pope, for God was on their side.

So were the Tuscan bishops. Reacting to the interdict against them, they excommunicated the Pope himself. Printed on the press of Bernardo Cennini, the first in Florence, the historic document was circulated throughout Europe.

2.

Florence entered the war with calls to her allies, Milan and Venice, and an appeal to King Louis XI of France, a professed ally. Mercenary troops were hired. Other support was sought from the Medici's Orsini relatives in Rome, and from an old friend and papal foe, Giovanni Bentivoglio of Bologna.

The Signoria then chose Ercole d'Este, duke of Ferrara, to command its gathering forces. This surprised many Florentines, since the duke was married to the daughter of the King of Naples, Leonora of Aragon. That made him a son-in-law of a king who wanted to seize Florence, and brother-in-law of the king's son, Duke Alfonso, who led the king's army. How could this *capitano* fight with any resolve against his own family?

Leonardo and his friends watched the duke enter Florence on his white charger, accompanied by a force of one hundred pikemen and a cavalry of fifty lance squadrons bearing crossbows and arquebuses, or hook guns, with a baggage train of fifty mules. This was an impressive prince.

"We need someone who knows him," suggested Atalante Migliorotti, thinking of ducal patronage.

"No, we need something *he* needs," replied Leonardo.

"And what is that?"

"Weapons . . . weapons no one has ever seen. His handguns are too heavy

and require six minutes to load and fire. In the same time, a crossbow can get off a dozen steel-tipped armor-piercing arrows. Also, mounted cannons for a fast-moving artillery."

"I don't see any cannons," Tommaso said.

"Of course you don't. To move them, you need massed ox teams. They should be light and mounted on horse-drawn carriages to keep up with the infantry. Then they can launch exploding fireballs that will send terrified soldiers into flight."

Atalante laughed. "The duke doesn't know what he's missing."

"Neither did I," said Tommaso. "You'll be the savior of Florence."

3.

Leonardo was, by nature, opposed to violence. As a vegetarian, he refused to eat any form of life subject to pain. To the amazement of Florentines, he often bought caged birds in the market to set them free. He also believed that war was a "beastly madness." To kill a man was an abominable, unforgivable act.

> O man . . . if you consider it atrocious to destroy the admirable works of nature, reflect how it is altogether atrocious to take the life of a man. If the organization (of his body) appears to you like a marvelous creation of art, remember that it is nothing compared to the soul that inhabits this structure . . . let not your rage or malice destroy such a life. For truly, he who does not value it, does not deserve it . . .

Despite this, he joined the Florentine war effort as a self-appointed military engineer. In this, he saw no betrayal of principle. A reverence for life also called for extreme efforts to preserve it. In the incessant warfare of fifteenth-century Italy, this meant walled cities, mercenary armies, and evolving military weapons in a period of transition, during which gunpowder was used alongside the crossbow, the pike, and the catapult.

Fireworks, to the delight of everyone, had arrived in Italy in the thirteenth century. Gunpowder came in the fourteenth, with bamboo tubes serving as gun barrels, followed by hand grenades. Then metal guns appeared, which fired stones, broken porcelain, and, finally, metal bullets.

Leonardo was prepared for this. Many years before the war, his search for universal laws in basic machine elements had led him to the mechanical and engineering challenge of military weapons. It began in the Verrocchio workshop with the making of guns. At this time—in the 1470s—guns weighing

up to six hundred pounds were still made in a rudimentary way by welding a series of wrought-iron bars around a core. After the core was removed, the resultant barrel was strengthened with iron hoops, then mounted on a wooden stock, with one end blocked. Depending on size, this primitive muzzle-loading gun was either hand-carried or moved on wheels.

Leonardo decided bronze would provide a stronger gun barrel, as would a solid casting. Lighter guns could have longer barrels in relation to the bore. And flint could ignite gunpowder better than saltpeter in the clumsy matchlock mechanism, which often failed in wind and rain.

From the ancient texts of Archimedes, Plinio, and Vitruvius, he learned of great catapults used by the Greeks and Romans. Their power was immense. Vitruvius had given dimensions for the greatest catapult of all time, capable of firing stones weighing just under a ton. Many of these ancient weapons were described, with eighty-two woodcut illustrations, in Roberto Valturio's twelve books on the art of war, *De re militari*. Leonardo, looking for ways to innovate, adapted some of these ancient weapons in drawings of guns and ballistas, or catapults, delivering immense arrows or stones—drawings with meticulous attention to the smallest details of mechanical engineering: bearings, screws, wheels (friction, toothed, click-and-fly), crank ratchets, pinions, and couplings.

So the imaginary grandson of God and a real Circassian warlord began to devise weapons and machines of mass destruction. None of them, however, was accepted or even considered by the War Council, whose Florentine League commander was not even using conventional weapons. Incredibly, Duke Ercole was waiting for his stars to be right—lingering in Florence or sitting in camp at Poggio Imperiale.

While he waited, the enemy swept through the land. Employing the tactics of mercenary warfare, they cut lifelines to Florence—burning crops and farms, destroying orchards and vines while seizing provisions for themselves. After seizing a key fortress near Arezzo, the enemy sacked every town in its path—Radda, Panzano, Brolio, and Rovezzano. People from the outlying areas of the republic poured into Florence with frightening tales of women who had been raped before the eyes of their men.

And along with them came the plague. A stable boy was the first to go, followed by a wool dyer. After that, it swept through Florence without regard for the age, sex, or defense of its victims. Nothing helped—cotton veils, bathing in vinegar, perfume to the nose, prayers to the Virgin, or joining the devil in drunken orgies. Church bells rang all day. Carts piled high with corpses rumbled through the streets, and the hospital of La Scala disgorged corpses day and night.

The rains came in a deluge, and the swollen Arno entered Florence. Its waters, dark brown with human refuse and rotting garbage, drained into cellars and into low-lying areas such as Piazza Santa Croce. With this, the plague spread to those hiding in convents or in the back rooms of boarded-up palaces. Yet Florentines, like Job in his darkest hour, refused to believe God had abandoned them. The Virgin and Saint John would bring them through any personal danger or defeat—including the treachery of Duke Ercole d'Este.

No one could believe it. The commander of the Florentine League kept a two-mile distance between himself and the enemy. Even worse, in his first major skirmish near Pisa, he had withdrawn when close to victory. In the piazzas and taverns, people began to call for a new *capitano*. This one should have his tongue pulled out by his neck.

From reports to the War Council, everyone knew the enemy's one hundred cavalry squadrons and five thousand infantry outnumbered their Florentine League by four to three. Without a commander equal to the formidable Federico da Montefeltro, Florence had little chance. After visiting both camps, Philippe de Commines, the veteran French envoy, advised King Louis that Florence would soon be lost—unless His Majesty could persuade Pope Sixtus to abandon his war of revenge. Yet nothing altered the Pope's fury, or the devastating advance of invading forces approaching Colle, a Tuscan fortress in the Val d'Elsa—the last bastion before Florence.

The siege of Colle and its defense dramatically revealed the art of warfare at this time. The walls of the hilltop fortress, immense and deep at their base, rose up to fringelike turret openings encircling the upper embattlements. The need for a wide-angle view, when firing through these openings, mandated narrower walls—more vulnerable to cannon fire and catapults.

Indeed, Federico's cannons soon blasted the turrets, exposing the fort's defenders and allowing enemy troops to close in on it. For entry, however, the base walls had to be breached by immense cannons, or bombards. At Colle, an unusual number of bombards were used—three in defense, five in attack—making it one of the first Renaissance battles determined by these giant weapons. Their names suggested evil horsemen of the Apocalypse—"The Cruel," "The Desperate," "The Ruin," "The Victory," and "None of Your Jaw."

During this siege, Leonardo plunged onward. On page after page, new weapons appeared, exquisitely drawn, along with notes on their usage and the methods for assaulting and defending a besieged city. Men were shown on scaling ladders with grappling irons to hook over the wall's top, pitons to secure their climb, and rope ladders to bridge moats, similar to ratlines on sailing ships. To defend battlements against such tactics, a horizontal beam, driven by

a giant cogwheel with horizontal sails, toppled scaling ladders and swept invaders off the wall like ants.

None of it helped, however. After a six-week siege and an exchange of 1,024 cannonballs, Colle fell in mid-November, with the Florentine forces in full retreat. The papal army pursued them to within eight miles of Florence. Though winter was near, Duke Alfonso rallied his troops to seize Florence. Pope Sixtus would reward them. The arrogant Florentines and their Medici tyrants, excommunicated and anathematized by the Holy Father, would finally suffer defeat. His bone-weary soldiers cheered, dreaming of plundering the city and its women.

Duke Federico opposed the siege. His leg wound had never healed. His troops were tired and ravaged by disease, and the veteran warrior had no wish to expose them in the cold months ahead. Above all, there was Duke Alfonso. His mercenaries had sacked Monte San Savino in an outrageous breach of surrender terms. The honor of Urbino's famous condottiere had been violated once before, in the sack of Volterra, when employed by Florence. That still haunted him. He was not prepared to risk it again with this hot-tempered, vicious Neapolitan.

At the last hour—November 24, 1479—Florence was saved by the supreme commander of armies at its gates. Federico da Montefeltro called for a three-month truce and a general retreat to winter quarters.

December 1479 – March 1480

LORENZO DE' MEDICI KNEW THEY HAD LOST THE WAR. Florence could not take another year of increased taxes, the mounting costs of mercenaries, and further damage to the economy. Foreign trade was in decline, banks were closing almost daily, and hundreds of workers were locked out of idle factories. Food was increasingly scarce, and the city was being ravaged by the plague. In this weakened state, it could neither continue the war nor long endure a siege of its walls.

There was only one way to avoid abject surrender to the bloodthirsty Pope and the duke of Calabria, who now claimed southern Tuscany for the House of Aragon. Lorenzo would personally go to Naples, present himself before King Ferdinand, and seek a separate peace. Without the king, the Pope could not have launched the war. His withdrawal would end it.

To prepare for this venture, Lorenzo turned to Lodovico Sforza in Milan. After the assassination of the reigning Duke Galeazzo, his brother was ruling Milan as regent for its rightful heir, ten-year-old Gian Galeazzo. Lorenzo de' Medici instructed an envoy, Girolamo Morelli, to play on the ambitions of Lodovico, also known as "Il Moro," or "the Moor."

"Impress this truth on Lord Lodovico, that our position here will be strong or weak at His Lordship's will. If he should do nothing, he will place the reins of Italy into the hands of others, while now they are in his own," Morelli was instructed.

With the innate cunning and the political skills of a supreme prince of the Renaissance, the Moor wrote to his sister Ippolita, wife of Duke Alfonso and a favorite of King Ferdinand. She was to warn the king that France had renewed its Anjou claim to Naples. Also, after the war, the Pope would claim all territories conquered by Duke Alfonso as papal domain. As a result, they urgently needed to revive the Milan-Florence-Naples triple alliance. Duchess Ippolita replied by return courier. His Majesty would listen to a peace proposal

from Lorenzo de' Medici—indeed, he was sending two galleys to bring him safely to Naples. Ippolita was an old and trusted friend. But could he trust her father-in-law?

Ferdinand, known also as "Ferrante," was a vengeful monarch without a shred of honor. He invited the famed condottiere Jacopo Piccinino to visit Naples with his bride, entertained him royally for three weeks, then had him murdered. And like Pope Sixtus, he trafficked in the hunger of his subjects, making corn a royal monopoly.

Yet Lorenzo had no choice. Revealing his plan to forty leading Florentines, he placed the city in charge of its *gonfaloniere,* Tommaso Soderini, and left in secret for promised ships waiting off the coast of the Maremma. Everyone knew that Il Magnifico was not always magnificent. Indeed, he could be petty and even cruel in caring for his family and in holding the reins of power. Yet here he had met the challenge in a manner befitting the greatest and most magnificent of the Medici. Before he embarked at the port of Vada, near Pisa, on December 11, 1479, the Signoria bestowed on him plenary powers to negotiate with the king.

Count Diomede Carafa sent his son to meet Lorenzo, with a note pledging his support as an adviser to the king. Federico, the king's second son, whom Lorenzo had known since boyhood, also met him at the dock with good news: His sister-in-law—Ippolita Sforza, wife of Duke Alfonso—would be pleased to offer her seaside villa to Il Magnifico.

FLORENCE

March — August 1480

O N A SUNNY DAY IN MID-MARCH, three months after his perilous departure, Lorenzo de' Medici returned home in triumph. He bore a peace treaty and rode a white stallion from King Ferdinand, who had agreed to quit the war and return to the triple alliance between Milan, Florence, and Naples.

Florentines cheered him, as they had his grandfather Cosimo on his return from exile in 1434. Their joy faded, however, upon learning the terms of the treaty. Duke Alfonso was to retain Siena, as well as other towns in southern Tuscany, and receive an annual indemnity. The hated Pazzi prisoners in Volterra were to be freed. Even more humiliating, Florence would submit to the Pope in Rome and request his pardon.

The treaty also infuriated Pope Sixtus. In a fit of rage, similar to the one that would eventually kill him, he demanded Lorenzo de' Medici come to Rome and beg forgiveness on his knees before the holy throne. Until then, Florence would continue to drift toward hell under his interdict and bull of excommunication.

The infidel Turks of Sultan Mahomet II soon changed the Holy Father's mind. Seven thousand of them under Keduk Achmet landed at Otranto in July. They massacred twelve thousand people and took ten thousand prisoners. In scenes of horror never seen in Italian warfare, the archbishop and local commander were brought to the main square and sawed in half. Others, refusing to embrace Islam, were thrown off a cliff and left for the dogs.

With a beachhead secured, the conquering Turks prepared to march north toward Naples and Rome. Duke Alfonso raced back to Naples to save his father's kingdom. As Lorenzo had foretold in peace talks with King Ferdinand, the House of Aragon now needed the Florentine Republic. Before committing itself, the Signoria requested the return of its losses in southern Tuscany. Alfonso, desperate for aid and men, ordered his lieutenants to comply,

and Florence recovered its territories from Neapolitan forces. Lorenzo responded with a gift of ten thousand ducats to Alfonso, and the two men became lifelong friends.

THE VATICAN

A TERROR-STRICKEN POPE SIXTUS, fearing the Turks would seize Naples, prepared to flee Rome for Avignon. Desperate, he promised to pardon the sins of all Christians who fought the godless Turks. The pontiff had no choice but to make peace with Florence. He summoned its envoy, Guidantonio Vespucci, and they agreed on a mock show of repentance before the Holy Father.

Six leading Florentines—notably without Lorenzo—came to Rome to enact the charade. Sixtus received them on Sunday, December 3, 1480, while surrounded by his cardinals and seated on a canopied throne outside St. Peter's. The delegation knelt as their spokesman, Luigi Guicciardini, mumbled an apology, which was barely audible above the chattering crowd. The Holy Father's reprimand was no more audible as he tapped each Florentine on the shoulder with the penitent's staff to formally withdraw his interdict. To the chanting of Miserere, the gates of St. Peter's were opened. The penitents, in a ritual of return to the Mother Church, followed the papal procession into the cathedral to attend High Mass.

Prior to the ceremony, Florence had agreed to the Pope's request for fifteen galleys to fight the Sultan. They were never delivered. Mohamet the Conqueror died suddenly at fifty-one, while marching on Byzantine Scutari, May 3, 1481. Four months later, his Otranto garrison of eight thousand men capitulated to the duke of Calabria. Another promise, made at the same time, would result in a singular glory of Pope Sixtus's turbulent reign—and a bitter blow to Leonardo da Vinci.

After the peace ceremony, Sixtus led the Florentine envoy, Messer Vespucci, to his newly completed chapel, which would eventually bear his name: the Cappella Sistina, or Sistine Chapel.

"This will be the greatest, most spectacular chapel in all of Christendom," he said with a sweep of his right hand and a flash of its red ruby.

"I'm sure it will be," replied the envoy.

"How can you be sure? You don't know what I want."

The veteran diplomat knew exactly what the Pope wanted, and how it could further mend relations between Florence and the Holy See.

"If you will pardon me, Your Holiness, I can see these walls filled with frescoes."

"Exactly! On the left wall, we'll have the history of Moses. On the right, that of Christ. So Moses will bring the Chosen People to the feet of Christ. Then we'll follow our Lord until He gives the keys of salvation to Peter, who lives today in Our Person as a Vicar of Christ. . . ." He paused to savor this vision. "Can't you see it? The entire story of Christianity across the walls of this room?"

"Oh yes, Your Holiness! And our republic would be honored to help bring this glory to you and to the Church."

The Pope paused, his eyes narrowing in a return to practical matters.

"And just how would you do this?"

"As you know, sire, Florence has the greatest painters in all of Italy. We can send you one or two of the best ones."

"Send me five. I want this done in a hurry. Who knows how much longer I will live, with that Judas king in Naples, the infidel Turks, and my stupid nephews."

Ambassador Vespucci promised to deliver his painters like so many bales of Florentine wool.

"Five great ones, Your Holiness. I'll ship them off as soon as possible."

"Only the best ones, and they have to work fast. There's a lot of wall to cover here."

THE ADORATION AND A
FAREWELL TO FLORENCE

FLORENCE

December 1480 – February 1482

BEFORE ANYONE IN FLORENCE HEARD of the Pope's five fresco painters, Leonardo was offered a new commission. The Augustinians of San Donato desired a large *Adoration*. Ser Piero, as their notary, claimed to have arranged this, but Leonardo suspected his father simply wanted a large fee for drawing up the contract. Regardless, he finally had a chance to do the painting, which had haunted him for many years.

On the appointed day, he rode to the Augustinian monastery at Scopeto, a small hilltop village beyond the Prato Gate. Upon arrival, a lay brother led him into a courtyard similar to that of San Marco, with rosebushes around a splashing fountain. From there they entered the convent's refectory. Glancing toward its far end, he saw the prior, a tall figure in a black robe, seated at his refectory table.

He motioned for Leonardo to sit before him. He was a gaunt man with dark, sunken eyes and a bent nose over a grim mouth. Below this, he resembled a goat with two gray whisker tufts.

"So you are Piero da Vinci's son?"

Leonardo nodded.

"I'm the prior, Padre Battista. You are here for our *Adoration*?"

"If it so pleases you."

"Your father says you're doing one for the Saint Bernard chapel in the Signoria."

"I planned an *Adoration of the Shepherds,* but the Cistercians wanted it to include Saints John and Bernard. The space is too small for all that."

"Ours is big. Eight square feet."

"That's what I need."

"You sound like you know what you want."

"I've made many studies for this."

The prior nodded and began to detail what he wanted, as though speaking to a servant. Leonardo cringed. This man still believed a painter, even a master, was the same as a saddle maker or a carpenter.

"We want the Magi, not the shepherds," he said. "Kings carry more weight with people. Their gifts reveal the Virgin as the first altar of the Church, and we'll have gold leaf for their crowns."

"I doubt they will have them."

The prior sat back, startled. Besides the goat whiskers, he had the ears of a bat.

"Kings have crowns," he insisted. "That's what they wear."

"Do they, before a superior king?"

Annoyed, the friar closed his eyes. The bat ears appeared to listen for sounds beyond human range. Then he nodded and opened his eyes.

"Of course they don't wear them before our Lord. But that doesn't mean we can't see the crowns."

"Where? On the ground?"

"Of course not. They can be holding them."

"With their gifts on the ground?"

The prior stiffened, the goat beard quivered, and the dark eyes narrowed.

"What are you trying to say?"

"Padre, it's very simple. You will know the kings by their bearing, not by their crowns. You will know others in the same way. With all due respect, I must have the freedom to compose this work. Otherwise, you should get someone else."

"All right." The prior sighed. "We'll give you some land for this, productive land at Val d'Elsa, while you pledge to pay one hundred and fifty florins for the dowry of the granddaughter of a lay brother. . . . Also, you will pay for the colors, the gold, and all expenses in making the picture."

Leonardo did not have the sum, nor did he expect to have it. All that mattered now was to begin the painting. Piero, who had said nothing of this, would have to pick up the pieces.

"Do you agree to these conditions?"

"My father can make the contract."

"Good. Now Brother Bruno will show you out."

It was like a master dismissing a servant. Clearly, this was not going to be easy. No matter, he knew what he wanted, and that prior would have nothing to say about it.

2.

Two weeks later, Piero Dovizi appeared at the workshop. The Magnificent Lorenzo had entrusted his secretary-chancellor with the delicate mission of bearing both good and bad news for his two artist friends.

He found them at work on a life-size model of the Colleoni horse, to compete with those of two Venetian sculptors. The network of metal rods revealed the entire form of the horse in minute detail—from the sweep of the tail to the head reared in fury, its ears pointing in alarm. The intensity and power of the beast was visible within its metal webbing, much as an artist's sketch might convey the power and life of a final work. Andrea greeted him as a humanist scholar with a vast knowledge of Roman art.

"*Salve, Professore!* How do you like the bones of our great beast?"

"Beautiful . . . What a pity to lose all of this in clay."

"It'll be in wax—green wax, to resemble weathered bronze."

The sculptor was welding a structural rod, which ran from the horse's left interior flank to its right wither. Leonardo held it in place at the front end.

"How does this differ from Donatello's in Padua?"

Andrea placed the welding iron in its brazier and, with a foot pedal, began to pump air through glowing coals.

"There are many differences," he said. "The first bronze horse since the Romans was that of Niccolò d'Este in Ferrara. Donato's, two years later, was much larger, but he had trouble distributing its weight, and the anatomy suffers from that."

With the iron glowing orange-red, he began to weld a second cross rod within the internal armature. Leonardo spoke while holding the heated end with tongs.

"The legs of Donato's horse are too short and thick," he said. "They're spread apart, as if about to collapse under the beast's massive carcass and rider."

"Our Colleoni will also differ," added Verrocchio, replacing the iron in its brazier. "In the middle of battle, he stands upright in his stirrups, hurling a curse at the enemy. . . . The model is over there."

Our Colleoni . . . Just as Dovizi suspected, Leonardo had contributed to creating the magnificent beast. Lorenzo would be delighted to know that. The humanist turned to a two-foot clay model of horse and rider.

"Your Colleoni resembles Dante Alighieri."

Andrea smiled. "Great warriors are all intelligent. That's how they survive."

"You'll win in Venice. . . . Then it'll be Leonardo's turn to do a great horse."

"I told him that. Now that Lodovico Sforza is ruling Milan, he'll want a monument to his father, Francesco Sforza."

The chancellor had the opening he needed.

"How strange," he said. "Lorenzo expects Sforza to ask us for the sculptor, now that the Pope wants five artists to fresco the walls of his new chapel."

Leonardo stared through the cross webbing of the horse.

"So that's why you came to see us?"

Dovizi nodded. "To say you're up front to do a great horse in Milan and . . ."

"Lorenzo picked five painters without including either of us?"

There was another nod.

"Who are they?"

"Sandro Botticelli, Luca Signorelli, Cosimo Rosselli, and Domenico Ghirlandaio."

"That's only four," replied Andrea. "Who's the fifth?"

"Perugino," said Leonardo. "It can only be him. Poliziano did his dirty work again."

"Just a minute," protested Dovizi.

"No sire, we know how it went. Lorenzo omitted Andrea because he can't leave this horse. As for me, Poliziano told him, 'Leonardo doesn't work in fresco, and he takes forever to finish even a little picture of the Virgin.' That's why they gave the Pazzi frescoes to Botticelli."

"Listen to me," instructed Dovizi. "The Pope wants his chapel frescoed in three months. That's why he needs five artists, and Lorenzo must be sure of its being finished on time. He's just made peace with that crazy Franciscan, and the last thing he wants is more trouble. Also, if you're working in Rome for the Pope, Lorenzo could only send Pollaiuolo to Milan. You want that to happen?"

"He'd send him anyway. He's better known as a sculptor."

"Forget it, Nardo," said Verrocchio. "You have greater powers, and Lorenzo knows it. When the time comes, you'll do the Sforza monument. That's your future. Rome is but a few months. Milan can be a lifetime, as it was for Piero della Francesca at Urbino, or Mantegna in Mantua." He turned with pride to Dovizi. "And now he's doing an *Adoration* for the San Donato Augustinians."

Leonardo did not want to discuss it, but the chancellor persisted.

"There are *Adorations* all over Florence. Pray tell, how will yours differ from any of them?"

"Sire, in Florence, there are many Madonnas grieving at the cross, done by most of those painters. How do they differ from Masaccio's in Santa Maria Novella?"

The humanist scholar smiled as though recalling a beloved friend. "She's a living presence in that Trinity . . . a real woman with the deep, universal sorrow of all women. You see it and feel it, as you do with all of his people."

"Exactly, but you don't find that in any of the others, except Giotto's universal Madonna at Ognissanti. Masaccio learned from him, unlike the others."

"Are you saying you will go beyond Masaccio and Giotto?"
"You can tell me, sire, after you see it."

3.

Leonardo left the workshop in late afternoon to enter his own studio. Taking some notebooks, he leafed through preliminary drawings until he came to one of the Virgin, with her infant extending a hand to a kneeling Magus. It was Albi, a little older now. She was seated, turning slightly at the waist, her head bowed like a flower over her child. This was the pulsating heart of the event. People flowing around her would be its living body.

He opened a notebook with sketches of men and women at Vinci, witnessing Don Piero's Resurrection of a puppet Christ at Easter. Many of these could be used. In Bethlehem, as in Vinci, there would be the early arrivals, like Olga, Monna Pippa, and Luisa, who came to witness a living Christ. Others, like Dario the beekeeper or one-eyed Giggeto, simply thought it was a good show.

To place this immense drama in perspective, he prepared his panel with Alberti's grid system of vertical lines converging in a distant background. That night, however, the grid lines kept him awake. They imprisoned the Virgin and the people of Vinci. He sat up and stared at the bed lamp. Many years ago, when he first saw Masaccio's frescoes with Albi, a student had vainly tried to capture the shadow of Saint Peter in a network of lines. How had Masaccio done it?

The next morning, he arose early. Crossing the Arno at Ponte Santa Trinità, he walked upstream to Santa Maria del Carmine and its Brancacci Chapel. Here were the headwaters of his soul. Here, he had found himself as an artist. Here, he had found Eve. And here, Tommaso the Florentine, nicknamed "Masaccio," was his friend and teacher.

Entering the chapel, he saw the solution in the upper fresco of Saint Peter paying tribute money to a tax collector. It was in an oval gathering of figures around Christ's disciples in heavy togalike robes—bearded or unshaven faces filled with mixed ferocity and wonder as Christ ordered Peter to fetch a silver shekel from the mouth of a waiting fish. They were a magnificent tribe, with the power of sculptured figures. Indeed, Masaccio had encountered them in the sculptures of Ghiberti, Donatello, and Nanni di Banco at Orsanmichele.

Depth was shown in changing tonality across broad planes. Also, objects became less distinct, and colors mutated toward blue-gray as they receded from the eye. That was pure Alberti. His third rule of linear structuring,

however, was unknown to Masaccio. Yet it was just this absence that served to invest this fresco with its strength and reality. Instead of a perspective leading to a group of figures, the volume of the figures created its own dynamic in space.

He turned to the other scenes. In those portraying Saint Peter as he gave money to the poor, baptized converts, or healed with his shadow, depth was obtained again through the volume of figures on a vast landscape, or in groups along Florentine streets. And in all of them, a narrow range of earth colors determined the flesh and clothing of the *popolo minuto,* who had put down tools and kitchen pots to witness the healing passage of the saint.

This was what he needed for his *Adoration*—the volumetric perspective of Masaccio. And together with the people of Vinci, there would be others from the streets of Florence, unlike Botticelli's parade of rich princes, fish-eyed merchants, or a Medici kissing the foot of baby Jesus. This was not an event for parading aristocrats. It was the defining experience of people staring at one of the most common sights in the world—a woman holding a baby in her lap.

What they saw in her at that moment would be visible in their faces—a reflection of man's eternal search for faith, which, in turn, made the faith itself eternal. That was the heart of it. If he could show this, or even come close to it, he would have a universal picture to silence entrenched humanists like Dovizi.

4.

He closed himself in his studio, and time collapsed into an endless spiral of days and nights. Within its passage, concepts came and went—some like sudden winds, others as barely audible whispers. Each figure, in passing from sketchbook onto the panel, became an intimate part of an extended family taken from Vinci or the Florence of Masaccio. Occasionally, Andrea would enter and look at the panel, as though it was already above the high altar at San Donato. Then he would leave, saying: "Keep going, Nardo. You're doing fine."

To structure the underpainting, he used a range of lamp black with luminous shades. The lines varied in width, with sweeping curves and subtle changes of pace, investing every figure or object with a singular identity. To obtain depth in the unfolding drama, he used Masaccio's volumetric perspective, Alberti's tonal modeling, and Donato's sculptural play of light and shade. This gave it a spectral unity, with the smallest details in the distant background integral to the foreground of the swirling crowd around the Virgin and Child.

In this way, his people increased in number, until one day, arising at dawn, he looked at them and realized he had created a great chain of being. It

was all men and women, and it went back to the first man and woman—Adam and Eve. Now, their descendants were witnessing another creation, configuring remote ancestors—Eve recast in the purity of Mary, with her Holy Child a sinless Adam for a new paradise.

Finally it was ready, in early August, 1481. To further fix the volatile lamp black, he applied a light wash of white lead over the entire panel. This altered it dramatically, plunging the dark figures into the gray light of a world at the dawn of time. There were no colors other than shades of black and gray, yet the entire painting was vibrant in the smallest detail, ready for the application of color . . . and ready for the Augustinians at San Donato to see their basic painting.*

5.

At the San Donato convent, Leonardo placed the *Adoration* panel on an easel in the arcade of the interior courtyard. Then he asked for the prior, Padre Battista. While he waited, young friars began to gather. Here was the secret *Adoration* of Leonardo!

They stood in silence before it, filled with awe and wonder. Clearly, this was not the usual teenage Madonna. Here, the mystery of the holy seed becoming flesh was visible in a real woman—her mystical union projected beyond ordinary reality into the realm of prophetic truth.

Gradually, they drew closer, until they felt they had entered the picture and joined the crowd near this woman nursing her child. She was seated on a grassy knoll, and all of humanity was there, swirling around her in waves, testifying to her universal presence in the lives of millions—including two reckless youths riding a wild horse within a few feet of the Holy Lady. In many faces, there was bewilderment and doubt, even incredulity. Such was the fixed reality of the world—even here, at the dawn of Christianity.

The three Magi were nearby, old men like other old men. In the epiphany of Christ's self-revelation, one king near the Virgin held the gift of gold. Another, bearing frankincense, kissed the ground near the Holy Mother's bare feet. The third one knelt before the Holy Child, offering a chalice of myrrh.

Maria, however, seems oblivious to the swirling tempest around her and the mumbling kings at her feet. Within the sweeping lines and shadings, there

* For over 139 years, there was no trace of Leonardo's *Adoration*. When returned to the Uffizi in Florence, a brown wash had been laid over it, resulting in its current sepia hue. The fact that this wash penetrated the surface cracks has made restoration impossible.

was the flesh and blood of this woman of many dreams. A pool of warmth flooded her arms as she held the infant, and her lowered eyes appeared to see beyond this moment—across the tragic landscape of their destiny. Her lips were drawn in a faint smile, as though murmuring, *Son, my son, with the dancing eyes, we have so little time.* Then, like any mother, she warns her baby, who is reaching for the gift of myrrh. *Gesù! Calm down! You're going to fall on your face!*

Brother Bruno was the first to find himself in the crowd.

"There I am!" he exclaimed, pointing to an image between a turbaned figure being run over by a galloping horse and a robed figure who appeared to be a philosopher delivering an opinion on the holy scene.

"And that's me next to you!" cried another brother, indicating a tilted face above the crowd, speaking to the image of Brother Bruno.

"Yes indeed, it's you, Brother Simone," confirmed Bruno. He turned to Leonardo, who was waiting nearby. "Maestro, it's both us, isn't it?"

The maestro nodded. All of humanity was supposed to be gathered around the Virgin. If people saw themselves in it, so much the better.

"There's our Reverend Father!" exclaimed a third brother, pointing to the king holding the gift of gold.

"Are you blind?" jeered Brother Bruno.

He indicated the king on his knees, offering a chalice of myrrh to the Holy Child.

"That's our Reverend Father . . . his mirror image."

"You're both crazy," replied a fourth one. "Neither one has his beard."

He pointed to the third king, who was kissing the ground near the Virgin's bare feet.

"That's our prior, paying his profound respects to Our Lady."

Padre Battista arrived, and everyone made room for him to look at the three kings, all of whom looked very much alike, though only one had his beard.

"The maestro says everybody's in this," reported Brother Bruno.

The tall Augustinian turned to Leonardo. "Is that true?"

It wasn't exactly true. But if old Goat Whiskers believed he was one of the kings, the painting would be an instant icon. And he, the painter, would obtain instant payment.

"If it so pleases, you are there."

The prior looked at the three kings. He shook his head at the one with the gold, and at the king offering a chalice of myrrh. Then he stared at the bearded king kissing the ground in homage to the Queen of Heaven. After a few moments, he knelt to make the sign of the cross before the Mother and Child—and his own image. Everyone else did the same, relieved that the Reverend Father had found himself in this holy picture.

Padre Battista felt compelled, however, to make a proper show of humility before his brethren and the painter.

"I'm only a poor friar," he demurred. "This is a wise man and a king."

"The patron is usually shown," observed Leonardo. "All around Florence, the Medici, Strozzi, and Tornabuoni are in paintings with Jesus and the Holy Mother."

That settled it. The prior shrugged and smiled to indicate this was beyond his control. His black-robed brothers pressed around him, laughing happily. Everyone agreed it was a miraculous painting. The gray figures lacked their final colors, but they were there anyway, with flesh and blood, to witness the first revelation of the Lord—to the glory of San Donato, with their Reverend Padre humbly at the feet of the Virgin.

The bell rang for dinner, and Leonardo was invited to join them. Entering the refectory, he felt greatly relieved. The monks were overwhelmed, and old Goat Whiskers no longer addressed him as a servant.

News about the extraordinary picture spread throughout Florence. At the San Donato convent, all sorts of people could find themselves portrayed in company with the Holy Virgin Mary and the Christ Child. Overnight, the Augustinians were inundated with a flow of visitors, who arrived, hour after hour, to see the miracle.

6.

The presumed presence of so many Florentines in the picture inevitably incurred local hatreds and rivalries. Where some were enraptured by the work, others saw themselves portrayed in an unflattering manner, or, worse, in the presence of mortal enemies. Vicious accusations spread through the city. The San Donato painting contained a scandalous collection of people—heretics, prostitutes, thieves, beggars, and even an astrologer pointing to the stars instead of to the Holy Virgin and her Child.

That evening, after the crowds had left, an angry delegation of men and women called on Padre Battista. They gathered before the painting, which the friars believed would fill their church with worshipers and their collection boxes with gold. The abbot knew them from the village of Scopeto and the surrounding villas of rich Florentines who attended the convent church. Gino Domenici, a thin man with a hooked nose, spoke for the group.

"Reverend Padre, these people don't belong in the company of our Holy Mother."

He pointed to two youths who had turned away from the Virgin to listen to an old man in a dark robe.

"Those two boys are heretics. We know them personally. It's Tommaso and Ugo from Borgo San Jacopo. They don't believe in the Virgin Birth of our Lord."

The prior looked at the painting. The two youths resembled Brothers Bruno and Simone, who certainly were not heretics. They seemed perplexed, even puzzled, but those two brothers were that way all the time.

"Tell him, Gino," said a fat woman. "There's no awe or respect."

That was Signora Rosa, a constant troublemaker, who had promised to bequeath her fortune for poor girls, and her villa and farmlands for old priests.

Gino read a long bill of indictment. Shadowy figures in the background were whores from San Frediano. Mimmo of Parma, a heretic who believed in the stars and not the Lord, sat under the carob tree above the Holy Mother.... On and on it went. Padre Battista was disgusted. A holy picture was under attack by a gaggle of idiots. It had to be stopped. He stroked his whiskers, then spoke as a pastor to his flock.

"Dear children," he said. "I am moved by your holy concern, but you are confused. These aren't real people. They don't live in Florence. They come from the painter's mind, and he used them to describe this sacred event. That's all there is to it."

Signora Rosa glared at him. Her index finger, adorned with a ruby ring, pointed to the king kissing the ground before the Holy Child.

"That's you, isn't it?"

"My image," he replied, correcting her. "Patrons appear in works like this."

"How many other monks are in here?"

The prior smiled. He had what he needed to shut her up.

"I'm glad you asked that. Two of them are the same as your two heretics. So you see, you're imagining what's not there. That's the gift of this painting. Everybody sees what they want to see."

"Imaginary or not, we see heretics, whores, and a pagan stargazer in the company of our Blessed Virgin."

"Madonna Rosa..."

"Don't Madonna me," she snapped. "Do something for this Madonna, or we'll go somewhere else."

There was a nodding of heads and mumbled agreement.

"That's right," Gino declared. "We'll go somewhere else."

The Augustinian looked at his image as a king prostrate before the Christ Child. It was a shame to touch any of this. But no picture could equal a fortune for poor girls, a villa with farmlands for old monks, and other uncounted legacies from San Donato's little flock.

"All right." He sighed. "I'll speak to the painter."

7.

The next morning, Leonardo took the San Donato contract to the Signoria. After a long wait, his father appeared in the fur-trimmed red robe of a notary to the republic—visibly upset at being disturbed.

"I'm in a meeting with the prior. What is it?"

"The monks sent my *Adoration* back, saying I have to change it, but they have no right. It's clear in the contract."

He offered the document, but his father pushed it aside on the table.

"I know what's in it. I wrote it, and there's nothing you can do about it. Padre Battista came here, very upset. He says you must alter it, or it'll drive people from his church and cost him a fortune in canceled testaments."

"I can't alter anything. I will give it to the Dominicans at San Marco."

"Don't try it, Nardo. You don't own it. They can put you back in prison."

"I expected you to help me."

"Help you? I got you the commission, but you fouled it up. What more do you want?"

Leonardo then sent an appeal to Lorenzo de' Medici. They heard nothing for a week. Then late one afternoon, he appeared at Leonardo's studio, accompanied by the poet Angelo Poliziano, and two hulking bodyguards. The ruling Medici could no longer roam the streets unarmed as had his father and grandfather. His guards, decreed by the Signoria during the war with the Pope, had been retained after a second murder attempt instigated by Girolamo Riario from Imola.

"Ah, Maestro Leonardo!" he exclaimed, with a nod to Leonardo's friend, Atalante Migliorotti. "Where is your *Adoration*?"

Leonardo led him to the rear of the studio, where the Medici ruler stood for several minutes before the painting. Then he turned to Leonardo.

"There's no doubt about it. This is a masterwork, an honor for Florence, and for you, *caro maestro*."

"What can I do about those friars?"

"It's been done for you by l'Arte dei Giudici e Notai," he replied, meaning the Guild of Judges and Notaries. "They've ruled that intellectual property is as real as a bale of wool. The San Donato friars accepted your painting as merchandise, made money from it, but then demanded it be altered into another product. They have no right, other than to accept it as it is . . . but since

they can't do that without losing other riches, the painting reverts to you. You owe nothing, other than a return of the property they gave you. . . ."

He paused, seeing a silver lute on a shelf, together with a flute and some musical scores.

"A lute in a horse skull! . . . Does it play?"

The Medici tried several chords, the animal's teeth serving as frets for twelve strings. It had a deep, warm resonance and a limpid clarity.

"Very beautiful."

He began to sing a popular country ballad in his high-pitched voice:

> Haste to the garden now
> Thou bright and merry maiden,
> Cull there an olive bow,
> With black olives laden.
> Black as the maiden's eyes of night,
> Oh, maiden mine, snow-white,
> Maiden, my heart's delight . . .

As the chord lingered, he turned to Leonardo. "Can you do another one for me?"

"Take this one."

"I'd like to send it to Duke Lodovico Sforza in Milan. He thinks he has everything, including us. He doesn't, of course . . . nor will he ever."

There was light laughter. Leonardo saw his chance.

"If it's that important, sire, may I take it to him?"

"Excellent! I'll send you as my personal envoy."

"My friend Atalante Migliorotti di Manetto is a composer with a golden voice. If I take him along, your silver gift will be alloyed with gold."

Lorenzo laughed. "Did you hear that, Angelo? How music flowers on the tongues of artists?"

Poliziano was disgusted. "Painted panels have neither music nor lyrics."

Leonardo suppressed a smile. Lorenzo de' Medici was in a russet tunic, split down the side, with a deep green doublet. Poliziano wore the same, but with the colors reversed.

"How strange," he remarked. "A gifted poet who cannot discern a Greek ode in a marble Apollo, or a psalm in a painted Virgin."

"Ah, Angelo!" exclaimed Lorenzo. "He's run you through!"

The poet glared, speechless with rage. You, too, Leonardo thought. You are part of the ruin of Florence. It is your vanity and venom that is driving us away. Sooner or later, it will totally destroy the Tuscan promise.

8.

In the following week, Andrea learned he had finally won the commission to create his great horse and rider—the equestrian monument to the famed Venetian condottiere Bartolomeo Colleoni. Upon departing for Venice, he planned to leave the workshop temporarily in the hands of Lorenzo di Credi.

First of all, however, they had to prepare for Leonardo's departure, including a personal letter to Lodovico Sforza, duke of Bari and regent for his nephew, Gian Galeazzo Sforza, the legitimate duke of Milan.

Andrea insisted it take into account a new war of Pope Sixtus. With the help of Venice, the Vicar of Christ now wanted to seize Ferrara. The troops of Milan, Florence, and Naples were fighting to save the city and the balance of power in northern Italy.

"Duke Lodovico wants out of this mess as soon as possible," he explained. "Venice is urging the French to cross the Alps and take Milan. . . . Where are those drawings of war machines you did during the Pazzi war? Structure your letter around them."

"And the great horse?"

"The monument to Francesco Sforza? Put it last. The first part will keep him reading. The horse will clinch it."

"And myself as an artist?"

"Keep it last, too. You are without equal. But don't labor it. Lorenzo will tell him, as I will in a separate letter."

Leonardo agreed. Artist-engineers were in every court of Italy. In Florence, Giotto had engineered its fortifications and the bell tower of the Duomo. Filippo Brunelleschi had erected the great dome on its cathedral. Taccola and Francesco di Giorgio had fortified Siena.

The next morning, Andrea saw the letter beside a notebook with drawings of military weapons and machines. He scanned the opening on Leonardo's military engineering, including techniques for assaulting fortresses and overcoming their defenders, destroying vessels at sea, tunneling under rivers, tank vehicles impervious to gunfire, flamethrowers to terrorize the enemy, giant catapults and blunderbusses of demonic power:

> In peacetime, I think I can give perfect satisfaction and be the equal of any man in architecture, in the design of public or private buildings, and in conducting water from one place to the other.
> *Item:* I can carry out sculpture in marble, bronze and clay; and in painting, I can do any kind of work as well as any man, whoever he may be. Moreover, a bronze horse could be made that will be to the immortal

glory and eternal honor of the lord your father of blessed memory and the illustrious house of Sforza.

Item: I was trained in the workshop of Andrea del Verrocchio, the most illustrious master of our time. He taught me all the elements of art and sculpture, as well as the art of bronze casting, which we used in erecting the great ball above the cathedral of Florence, and which I will use in realizing for you the above-mentioned weapons of war and the equestrian monument to honor your illustrious father, Duke Francesco Sforza. . . .

The master looked up from the paper. "Very impressive. But if you say I am the most illustrious master of our time, the duke will say, 'Why take the pupil when I can have his master?'"

Leonardo looked at the paragraph. It was only a summary, a pathetic reference to how it had been. Impulsively, he crossed it out. Andrea nodded approval.

"You'll have a great future in Milan."

"As you will, *maestro mio,* in Venice."

9.

He rose shortly before dawn on the day of his departure, February 21, 1482. At the stable, his black stallion turned in the stall with unusual agitation.

"*Buongiorno,* Ion. So you're ready for the long ride?"

Ion snorted and kicked the wooden stall.

"Ion, Ion . . ." he whispered.

Placing his mouth on the horse's nostrils, he took its breath and exchanged it with his own. With this, the stallion lifted its head and waited to be saddled. At the workshop, he found Andrea working on a silver panel of Saint John the Baptist. When he entered, his master looked up, feigning surprise.

"Oh! So you're ready, Nardo?"

"Atalante is waiting at Ponte Santa Trinità, and I'm already late."

"And you'll be staying with Ambassador Alemanni?"

Leonardo nodded impatiently. Lorenzo de' Medici had arranged for them to stay with the Florentine envoy in the palazzo Francesco Sforza had given to his grandfather, Cosimo de' Medici. He had left his *Adoration* with his friend Giovanni de' Benci, brother of Ginevra. His clothes, personal possessions, and works of art, including *Saint Jerome,* a portrait of Atalante, and two of the Madonna, had been sent ahead by mule train.

He paused before Andrea's silver *Saint John*. The Baptist was on his knees, his head bowed, expecting the executioner's sword. The gold halo surprised him.

"What's this?" he asked. "You always hated halos. Maybe I shouldn't go after all."

Andrea smiled. "I knew you'd say that. The Calimala guild wants it, so I made the executioner's sword also in gold."

"A mystical chord between martyrdom and glory of the altars . . . bravo!"

There was a sad smile. The eyebrows lifted, but they didn't seem to fly anymore. The amber eyes were still young, but the face was aging, the jowls sagging, the hair turning gray.

"From the first day," he said, "I thought that I could manage this . . . but it's more than I expected."

He began to blink back the tears. Leonardo felt his heart breaking.

"Andrea, *Andrea mio*," he said, taking him into his arms.

In the street, they embraced again. Weeping silently, the master held the youth he had loved as a son. Then Leonardo mounted Ion and rode away without looking back.

MILAN:

THE MOOR AND CECILIA

MILAN

February 1482

AFTER A SEVEN-DAY RIDE OVER THE APENNINES to Bologna and across the vast plains of the Po River, Leonardo and Atalante Migliorotti entered Milan through Porta Romano in the retinue of a Rucellai–San Miniato Florentine delegation. A priest emerging from the church of San Lorenzo gave them directions, and they rode through a maze of crowded streets, past the old Corte Vecchio, to finally reach the residence of Pietro Alemanni, the Florentine ambassador.

The tall, gray-haired Tuscan was delighted to receive the two envoys from Lorenzo de' Medici. His usual guests, bankers and merchants, made Florence rich and helped to pay his salary. But these young men made the republic famous for its arts and letters.

"You took a death mask of my uncle Amerigo," he told Leonardo. "I've seen your portrait of Ginevra de' Benci, and heard about an *Adoration*." Turning to Atalante, he said, "I gather you have brought a rare lute for the duke. . . . May I see it?"

The youth opened its leather case and the ambassador saw the silver horse skull in a nest of purple velvet.

"*O Santo Dio*," he murmured. "The Moor will go crazy with this. Lorenzo was right: You are most welcome."

Two nights later, he took them to meet Lodovico Sforza at a reception where the two Florentines were to play their strange musical instrument. From the window of the embassy carriage, Leonardo saw the great Sforza castle before them, with flaming braziers on its upper ramparts and a wide moat with gliding swans.

"Inside these walls," explained Alemanni, "the ducal palace and its royal court is the most magnificent in Italy, if not in all of Europe. Here you meet scholars and poets, painters and architects, musicians and astrologers. There are pageants, elegant balls, major tournaments, and banquets that go on forever.

Eight hundred courtiers and servants swarm the place like rats, with five hundred horses and mules in the stables. . . ."

"This duke must be rich as a king," observed Atalante.

"Richer than the king of England, or even the Holy Roman Emperor. He gets seven hundred thousand ducats in taxes alone. Milan is twice the size of Florence, with over a hundred thousand people, and another million in the subject cities of Pavia, Piacenza, Parma, Como, and Genoa."

Crossing the drawbridge, they were stopped at a battle station of archers. The guards recognized the diplomat and allowed his carriage to pass through the castle gate beneath Filarete's soaring tower and enter a vast parade ground—the Piazza of Arms.

"*Madonna mía*," whispered Atalante.

"On this field," explained Alemanni, "the Moor can assemble three thousand five hundred soldiers. . . . During the day it's a busy place with food and suppliers."

"Is the duke also a Moor?"

"He's dark-skinned, and in childhood, he was nicknamed 'Il Moro,' from his given name, Mauro. He has a Moor's head and a *moro,* the mulberry tree, on his coat of arms. Our fellow Florentine, Bernardo Bellincioni, has a poem praising the Italian Moor, a white ermine. But the title he really wants is duke of Milan."

"If he's not a duke, how can he rule this place?"

"He's the duke of Bari and regent for his nephew, Gian Galeazzo, who is only twelve. In six or seven years, the boy will be ready to take over . . . unless something happens to him."

"What do you mean?" asked Leonardo.

"Eighteen months ago, this man was exiled from Milan for conspiring to take the throne following the murder of his brother, Duke Galeazzo Maria. Then he secretly returned and entered the castle through the rear Garland Gate. Once inside, he convinced his widowed sister-in-law, the Duchess Bona of Savoy, to make him regent for her son and heir, Gian Galeazzo. She soon regretted it. Her trusted chancellor, Cecco Simonetta, was beheaded, her lover exiled, and the Moor seized control of the Secret Council governing Milan. His astrologer says he's destined to become duke of Milan, and one day he might succeed."

"In place of his nephew?"

"This close to the throne, anything can happen, especially with this man. . . ."

The diplomat paused, then continued in a whisper within the carriage.

"You come from Lorenzo, so I will speak frankly. This Moor is ruthless and very smart. At eleven, he wrote Latin speeches. From his tutor, the treacherous Francesco Filelfo, he learned dialectics and sophistry, which he uses to mask his feelings. He's cynical and, like most tyrants, vain and subject to flattery. But he can also be eloquent and charming, and women love him. Bellincioni limns the Moor with the cunning of a fox and the courage of a lion. But there's no lion, only cunning and deceit and an ambition that stops at nothing. So remember, sleep like a Tuscan, with one eye open."

They were stopped again by more guards at the far side of the courtyard, then allowed to cross the inner drawbridge over the Trench of Death. Alemanni sighed.

"There are eight hundred guards here, and they stop you every two feet. It's to protect the Moor. Three Visconti dukes were assassinated, his brother was also killed, and there are constant plots to do away with this one, as well."

In the palace courtyard, there was a lineup of other carriages. While waiting, the envoy pointed to another palace on their left—the Rochetta, an inner fortress within the castle. In the flickering light of courtyard lamps, it rose above them, the color of dried blood.

"There's the heart of the Sforza dynasty. It has the private quarters of the duke, with gold and jewels beyond all counting, and a pile of ducats so high that not even a stag could leap over it."

"Madonna," murmured Atalante. "We've come to the right place."

"And I've brought the right letter," Leonardo replied. "For such wealth needs to be defended."

"Not now, not tonight," warned Alemanni. "When I told him you had come with a horse-skull lute from Lorenzo, he was delighted and invited his friends to hear you play it. He knows nothing of your letter."

"When do I give it to him?"

"Another day, after he hears you tonight."

"I'm not just a singer."

"He knows that. Lorenzo told him you were a painter and sculptor without rival, who could also create the great monument of Duke Francesco on a warhorse."

"That's better."

"Better than a singer? This duke pays his singers and lute players fifteen ducats a month, but he treats painters and architects like beggars. There's a man here named Donato Bramante, from Urbino, who's a brilliant illusionist painter and architect. He gets only five ducats a month and often has to beg for that pittance."

Their carriage halted before the palace. Servants in green velvet helped them descend. Passing between more guards, they began to climb the broad palazzo stairs to the reception hall.

"Why does he pay painters so little?" asked Leonardo.

"They are like tailors for him," replied the envoy. "He uses them to dress up his court. So there are only mediocre ones in Milan. Also, my dear Leonardo, they will fiercely resent the arrival of a master like yourself." He paused. "So we'll have to find you an ally among them."

"I thought my letter would help me as a military engineer, especially since Milan joined the Ferrara war against Venice."

"Wait until he knows you. Otherwise, your startling list of war machines will make him think you're a madman or a fool. Take my word for it. I've been here longer than I care to remember."

2.

The ballroom above the courtyard was filled with lords and ladies of Milan, court councilors, diplomats, and a scattering of poets and humanists. Upon entering, Atalante was soon surrounded by musicians asking to see the horse-head lute. As he opened the case, Alemanni introduced Leonardo to Giacomo Trotti, the veteran ambassador from Ferrara.

Trotti bowed graciously. Short, with gray hair and deep blue eyes, he was an imposing figure in a purple doublet with the insignia of knighthood from the Duchy of Milan. He spoke with an accent of the Paduan plains.

"Who hasn't heard of the young master coming to us from the Magnificent Lorenzo?"

Leonardo nodded, pleased. At least someone knew he was more than a singer with a strange lute.

Trotti turned to Alemanni and launched a starling conjecture.

"Girolamo Riario has escaped three assassination attempts. In Ferrara, we understand that a fourth one is underway. Could it be that your Magnificent Lorenzo is preparing to finally avenge the murder of his brother, Giuliano?"

Caught off guard, the Florentine envoy dissembled. "Lorenzo would never bloody his hands . . ." He paused, giving a slow smile. "But as you note, Girolamo has escaped it three times. I would be surprised if he managed to escape the next time."

There was a stirring in the crowd, and Alemanni drew Leonardo aside.

"It's the Moor's mistress, Cecilia Gallerani," he whispered. "He's engaged to Beatrice d'Este, but she's in Ferrara and only six years old. So there's time to play with this delightful creature. She speaks Latin, writes poems, and the

courtiers call her 'the modern Sappho,' but she's neither a sexual libertine nor a courtesan. The Moor took her at fifteen, and at nineteen she's his wife in everything but name."

She came toward him in the glow of burning lamps and amid wall frescoes of dancing nymphs and satyrs playing flutes under spreading trees for courtesans and their paramours. In a purple gown of voided velvet, a brocade of golden lilies on its sleeves, she moved with the grace of a swan through an inlet of bowing courtiers and nodding nobles. Then she was before him, a pendant pearl upon her forehead, next to the man known as the Moor— Lodovico Sforza, duke of Bari and regent of Milan.

"Maestro Leonardo da Vinci has brought us a silver lute from Lorenzo de' Medici," he explained. "It's shaped like a horse's skull, but he says it has the voice of an angel. We'll soon hear the truth of it."

"We've heard of you," she replied. "They say you are without equal in portraying the beauty of women, especially the Virgin."

Her voice was lower than expected, and the eyes were old beyond their years.

"Also for those who are no longer virgins," observed the duke. "He gives it back to them."

Leonardo wondered if this referred to Ginevra de' Benci. Or had Alemanni told him about Giuliano's mistress, Fioretta Gorini, holding the primroses?

"A recovered virginity?" asked Cecilia, delighted. "How do you do that, Maestro Leonardo?"

It wasn't like that, but the duke wanted to play this game.

"If there's proper space in the picture, the viewer will find what he seeks."

The ruler of Milan frowned, his eyes narrowing. A plump forefinger, raised in doubt, had a ruby ring incised with Caesar's head.

"What sort of space is that?" he demanded.

Leonardo had waited many years for a chance to enter a royal court. Now it lay before him—as he observed the ducal usurper, who had small, dark eyes, a pointed head, jet black hair cut like a helmet across the brow, and a small mouth with red lips between flabby jowls. A heavy gold chain on his crimson robe of velvet held a pearl-encrusted device of two clasped hands, inscribed with a blunt warning: *Tale a ti quale ad mi* ("As thou dost to me, so shall I to thee").

"Yes, do tell us," prompted Cecilia with an expectant smile.

"It's a free space," he replied, relieved by her bidding. "A space where you move without the barrier of thought, as in a dream where you may encounter yourself at any turn."

"Of course." She nodded. "I've heard that everyone in Florence found themselves in your *Adoration of the Magi*."

There was a murmur in the lower register of that voice, as from the depths of the seas, which had nurtured her pendant pearl. It trembled on her forehead, and he saw blue, ochre and terra-verte—the basic colors of the flesh on which it rested.

"He's staring at my pearl," she remarked. "Do you see another kind of space?"

"Illustrious lady, spaces in nature, even of a single dot, are infinite."

"How beautiful! Our poet Bellincioni says Muslims believe a pearl of this size could contain both a blessed warrior and a virgin who had waited for him in paradise."

"How fortunate, my lady, that you have no need to alter your faith, nor endure confinement, to enjoy such a paradise."

The duke laughed, delighted. "Bravo! Lorenzo de' Medici said your tongue rivaled your brush. But you have not answered my question. . . . A virgin may be enjoyed forever in a Muslim's pearl, or maybe in your secret dream spaces, but for us, alas, it's only once. . . ." He glanced at Cecilia, who lowered her eyes. "So how can you portray it when it's gone?"

"Yes, tell us," she urged. "How do you manage such a miracle?"

She knew the answer. It was in her eyes and in her smile. He spoke to the duke.

"If it exists in memory, it may well reappear in moments of love. Would you not agree, my lord?"

The Moor nodded, pleased. "Yes, I would say so." He turned again to his lady. "Do you not agree?"

Cecilia smiled with proud defiance. It was Ginevra opening the door for him. Then she waited until her lord nodded.

"Welcome to Milan, Messer Leonardo. Would you do a portrait of Lady Cecilia, leaving space for me to enter at any time of day or night?"

There it was—his entry into the royal court of Milan. He would begin sketching her at relaxed, informal sittings until he found what he needed. The duke was speaking.

"You seem to hesitate, Messer Leonardo."

"My lord, I would be honored to please you in any way."

"Good, you can start tomorrow."

She was staring at him from shades of memory. A new love had entered his life.

CASTELLO
CECILIA'S APARTMENT

February 1482 – April 1483

THE NEXT MORNING, Leonardo packed his drawing kit and began to walk from the Florentine embassy across Milan to the Sforza castle at Porta Giovio. He walked into the rising sun, feeling its warmth on his face, the air crisp in his lungs. This was more than a new day. It was a new world. The doors to the court had opened, and Cecilia was waiting for him.

Turning into via degli Armorai, he encountered a phantom army stretching along each side of the street—a display by workshops of Milan's arms industry for clients from all of Europe.

Walking down the street, he nodded to headless knights in shining armor, wooden horses sheathed in steel, and dummy foot soldiers in battle mail with engraved swords and shields amid a forest of lances, pikes, and halberds. It was a restless array of a ghostly legion, waiting for a call to battle. Yet they could be easily defeated, he decided, with weapons he would propose to Duke Lodovico. Pausing in the street, he envisaged his weapons decimating the forces around him: a self-propelling fireball searing faces and eyes of foot soldiers . . . another fireball spurting sulfur fumes, which blinded combatants and poisoned their lungs . . . ballista-projected shells exploding into fragments, eviscerating men and horses . . . thrown javelin, breaking into flames, terrorizing a mounted cavalry charge . . . hurled disk with an ignited fuse, bursting into fragments, crippling horses and ground troops . . . armored tortoise-shaped vehicle with sharpshooter fire through loopholes, its wheels crushing the fallen foe.

Leaving the street, he eventually came to the Milan cathedral, Santa Maria Nascente, or the Duomo—a hybrid structure with a French Gothic roofline and Roman arched portals. A gallery of fourteen marble saints lined its red-and-white facade—stiff figures with startled faces from Germany or

some northern realm. He looked at his sundial watch. It was the twenty-third hour—eight o'clock. There was still time to explore this strange cathedral before meeting Atalante at the Sforza castle.

Upon entering, he was surprised to see no works of art on its bare walls. In the vast nave, however, pillars rose up like immense trees into misty regions under the vaulted roof. A piece of heaven seemed to float somewhere up there. In a Florentine church, sculpture and painting provided another pathway to prayer. Here, space of cosmic dimensions took you through the veil of time into the infinite regions of the spirit. And for those who faltered, Christ and the Holy Virgin were waiting in stained-glass windows, casting the spirit of their forms in shifting colors on the marble walls and pillars of the great nave.

Next to the chancel, he found stone steps leading to the raised choir. From there, wooden stairs took him to the roof. Four workmen were installing two stone saints into niches on the facade, using a fixed-line trolley, instead of a revolving crane with transmission gear. The foreman shouted in a thick German accent. The Italians spoke to one another and continued to work as though the German wasn't there.

Leonardo smiled. That was how Italy survived its tyrants and invaders. Working at this rate would take them forever. It was a sick structure, in need of a physician-architect. He would mention it in his next letter to Duke Lodovico.

At the north edge of the terrace, he climbed onto a raised pediment for a view of Milan. It spread out below him like Florence from Bellosguardo, except this city had a different shape. Florence had walls shaped like a spindle. Here the encircling ramparts were round like a buckler, with fifteen towers. And where Florence had a river running through it, Milan was surrounded by a moat. Inside its walls, a network of canals, similar to coronary arteries of the human heart, served as its six aortas—portal gates for the flow of food and supplies into the living city.

You could see the gates easily. Each one had a drawbridge across the moat. And within the walls, each had its own district shaped like a slice of pie—exactly as Alemanni had described them the previous night at dinner with Donato Bramante.

Looking southwest, Leonardo saw bits of glistening steel on the street of the armorers. Beyond this, there were numerous redbrick buildings with small windows—probably the silk factories Alemanni said employed fifteen thousand workers. You could also identify palaces of the nobility. They were near the portal gates, around the cathedral, and to the south near the Italian embassy and the old Arengo Palazzo of the Visconti—square buildings with grim

battlements and squat towers, ringed with forked merlons like the broken teeth of entrenched Ghibellines.

The Sforza castle lay to the north, surrounded by a wide moat with floating swans and a green park leading to distant woodlands. The red brick of the castle had faded to pink, the Sforza flag and the Moor's coat of arms waving from its rounded turrets. He could see the Rochetta tower inside the castle walls, and the roof of the ducal palace, where Cecilia was probably preparing herself to sit for the portrait.

To the right of this, separated by a small wood, was the Dominican convent of Santa Maria delle Grazie, where he hoped to create a *Last Supper* after Donato Bramante had restored its church. From the castle and convent, a large street with oak trees ran through Milan, toward him at the cathedral. It was filled with pedestrians, carriages, and market wagons.

There was sudden thunder from below. Logs were being dumped from a wagon, but the sound arrived a full second after he saw it occur. Sound traveled that way, rippling outward into circles in the air, as from a stone thrown into a pond. With a sensitive timepiece at each end, its speed could be easily calculated.

The speed of light, however, was apparently instantaneous. So were the rays, which emanated from the eye, then returned with an image of a scene, such as this one with its rolling logs. Yet how was this possible? Could the eye actually send out from itself visual rays, which structured the faculty of vision? Plato had said so. So had Euclid and Ptolemy, and even Toscanelli. Perhaps it was simpler than that—the object, with rays of its image, arriving unbidden to the waiting eye.

He looked at his sundial watch. In half an hour, he was due at the castle. He could not be late for the first session with Cecilia, especially if the Moor was there, waiting for his mistress to regain her virginity in private places within the painting.

2.

He began to sketch her seated before a window of her castle apartment. Atalante played the silver lute, performing songs from the previous night, which had delighted Duke Lodovico and his guests.

"Please," she said. "I so enjoyed Leonardo's song of the maiden in the garden. Do you also know it?"

"Of course, my lady."

A smile appeared, and in her eyes there was the delight of a child. The next song from Umbria was a favorite of women without their men, and of

soldiers around campfires. She turned her head, her lips in the hesitant half smile of other women he had loved—Albi with child, Ginevra waiting for Bembo, and something more. All of nature was in constant transformation, and here there were lingering moments of a childhood. Somehow, he had to retain this evolving human ambiguity.

He kept at it for a week, and each day brought him closer. Finally, in the first shadows of late afternoon, it came together. Every part he had drawn in detail took him into the most intimate recesses of her being. With this, he saw the composite portrait. It was close and familiar, as though it had existed forever in memory.

As promised, Alemanni had found him a studio near Porta Ticinese. It was the studio of Ambrogio de Predis and his three brothers—a family of Milanese artists, who gave Leonardo a large room with north light, overlooking a garden. Here he worked quickly and well on Cecilia's portrait.

She was seated near the window, with its light falling upon her pale oval face. A russet veil edged with lace was modestly drawn across her cheek. A thin black headband with a golden frontlet encircled the pearl white forehead. She had turned once again, and amber eyes appeared to hesitate before an approaching figure. Yet the lips said otherwise, with their half smile of anticipation.

Other ambiguities suggested this duality. Over her long, sloping shoulders, the blue gown of the Virgin was split at the sleeves to expose a courtesan's flowered chemise with capricious ribbons. The black pearls of her entwined necklace descended like prayer beads toward the first slope of her breasts. From there they entered a dark cove beneath her hand, its long fingers curving erotically on the white fur of an ermine in her lap. The alert eyes of the semiwild creature reflected those of its mistress, its tense body and acute snout projecting kindred instincts and passions.

Leonardo noted the animal's innate pride: "Rather than stain its purity in a muddy den, the ermine . . . will rather let itself be captured by hunters." It was also a symbol of her lover. Sforza, as a royal ermine knight, guarded his mistress against any intruder, while a clawed paw shamelessly exposed the red carnal interior of her virginal blue gown.

He had the image he wanted, but Cecilia wasn't entirely there. Deeply concerned, he went over the work in detail, much as one would go back on a trail to find where one had taken the wrong turn. There were apparent anatomical deformities—a girl's head on a woman's body, an abnormally long left shoulder, the extended skeletal hand holding the ermine. All of these fused well, projecting remnants of childhood on the shores of a woman. The trouble was somewhere else.

That night in bed, the portrait haunted him. Relief was the soul of painting, and this picture was in full relief, created by light from a window. Was that the problem? Since the first days in Florence, he had used windows as a defining source of light. Yet now, with a technique of progressive light and shade creating tonal unity, was this an invasive element?

He rose from bed and took an oil lamp into his studio. Placing his hand over the window, the portrait assumed another life. That was it. Working by lamplight, he removed it, and Cecilia suddenly appeared intensely alive. Now she herself was the source of light, with the hesitant smile of a returning dream—her own window into the ambiguous depths of her being and into those of anyone looking at her. So it had been, he realized, with his other works—*Ginevra de' Benci, Saint Jerome,* and the *Adoration.*

Ambiguity allowed the viewer to enter the work, imagine its missing parts, and, in effect, project a singular experience beyond whatever was visible or understood. There was another law of painting. Perhaps it was the heart of it—the secret heart, born of instinct and beyond the range of textbooks.

The portrait overwhelmed Duke Lodovico. He stared in silence, as though facing a landscape of many rivers and unseen swamps. Finally, he nodded, ready for the crossing.

"Bravo, maestro. I'm her protective ermine, and you've returned her virginity . . . or some of it."

Cecilia laughed. "That makes no sense. There's no such thing as half a virgin. You have it or you don't."

"All right, but it looks like you're ready to give it away again."

"If so, it's only for you, *caro mio.*"

"How do I know that?" The Moor turned to Leonardo. "You made space for me to enter into this. But, *signore mio,* so can other men."

It was another word game. Leonardo sought to please him.

"You have the advantage, sire. You enter with your knowledge of her. The others must imagine someone else."

"Except you, Messer Leonardo. Since you created this, you can come and go as you please."

The duke's eyes darted from his mistress to her artist. Leonardo waited. Was the game suddenly serious? Or had there been any game at all? Either way, this was dangerous. This man, having seized a dukedom by guile, now feared the loss of his woman in a painting. Cecilia laughed and took his arm.

"Don't be silly," she said. "The picture is finished. He doesn't want me anymore . . . certainly not in any way that would interest you."

She smiled at Leonardo, and he realized she knew how it was. As a woman, she had sensed it. His heart was pounding. She was offering him her love, and he was ready to accept it.

3.

Cecilia hung her portrait over the fireplace in her castle apartment. The Moor enjoyed it more each day and proudly showed it to many visitors, including the archbishop, Milanese nobles, diplomats, and ministers of his court. With a regal wave of his hand, he explained it in terms used by its creator.

"Maestro Leonardo gives women the look of virgins and then provides secret spaces for you to enter into them."

Anyone could see secret or hidden places in the portrait. Cecilia was looking beyond the frame at one of them. So was the ermine. It was in both their eyes, and in her emerging smile. In fact, the more you looked for these secret places, the more you found.

Portrait commissions began to arrive for Leonardo at the Predis studio. Ambrogio de Predis, also well known for portraiture, accepted this as advancing his own career. It increased the fame of his studio and offered him a chance to work with this wizard from Vinci and learn the secrets of his art. So began a collaboration that resulted in a series of borderline paintings containing the genius of Leonardo and the mediocrity of Ambrogio. It was further complicated by the Lombard painter rising to the challenge with the best work of his career. After the departure of his lodger, his talent declined into a trail of uninspired portraits, notably with white eyelids.

Meanwhile, Leonardo expected a call from the Moor. He had sent him a message through the duke's private secretary, Bartolommeo Calco: "Maestro Leonardo holds himself at your disposal at all times in case he should be needed."

Months passed without a reply. From Ambrogio, he learned his letter to Duke Lodovico had alarmed the duchy's new military engineer, Ambrogio Ferrari. Viewing it as a serious threat to his position, he dismissed the Florentine's revolutionary weapons as the work of a charlatan, shamelessly lifted from Roberto Valturio's *De re militari*. Similarly, Leonardo's messages to Cecilia had gone unanswered—intercepted by the Moor, who was irritated by her open fondness for this strange Florentine.

Cecilia soon discovered this, however, and appeared one morning at the Predis studio—a sudden flower of spring in a pink tunic over a light green silk dress with brocade of white lilies.

"I brought my friend," she said, smiling brightly.

It was Count Galeazzo da Sanseverino, commander of the ducal troops and a close friend of Duke Lodovico—a regal figure in tunic of white satin embroidered with red velvet shields bearing the Sforza coat of arms.

Leonardo had met him at the reception upon his arrival—a jousting knight with the beauty of a Saint George, whose strength and quick mind made him the ideal of heroic youth, and a legendary victor at jousts, where he toppled adversaries like toy soldiers.

"I've met Lord Galeazzo," he replied. "The gallant knight and most formidable lance in Europe."

Galeazzo shook his head, smiling. "And Maestro Leonardo, without equal in the arts, who would do the monument of Duke Francesco Sforza."

Cecilia had begun to leaf through an open notebook on the desk.

"Here!" she exclaimed, showing Galeazzo a drawing of a rearing horse with a naked rider brandishing a baton.

As Galeazzo studied the drawing, Cecilia smiled at him. Clearly, she had come to help with the equestrian monument.

"Whose horse will you use?" she asked. "Lord Galeazzo has some magnificent Arabians with short heads and long bodies, and legs so thin, I always wonder how they can run on them. The most famous and beautiful mounts in Milan—no, in the whole world."

Galeazzo laughed. "Yes, please come to see me," he said, turning to Cecilia. "Yet we came for something else, did we not?"

She was looking at a large sepia cartoon of Saint Sebastian on the studio wall.

"Why don't you tell him?" persisted Galeazzo.

Cecilia continued to stare at the picture of the saint. Pierced with arrows, he lay in the lap of the widow Irene, who would nurse him back to life.

"She wants a picture of the Virgin Mary," explained Galeazzo.

"O Dio mio," murmured Cecilia. "How beautiful. I want to hold him."

She approached the drawing, touching an arrow in the shoulder of the fallen knight, then another in the groin, just above his genitals.

"My dear friend, may I have him? I'll pay whatever you like."

"Of course, my lady. He's yours."

"Just a minute," interrupted Galeazzo. "You came here for a Virgin, and you're leaving with a nude youth lacking a loincloth."

"No matter," replied Cecilia. "The Greeks and Romans showed themselves this way. Why can't we?"

"I fear our Lodovico will be uneasy with it."

"My lord, look more closely. His own lance is at rest. Besides, what is there to fear? He's a saint with honor, which you, of all people, know and respect. . . ." She paused. "It takes so little to make one feel like a mother."

Galeazzo stared in wonder. "You would make a beautiful Virgin with Child."

Cecilia laughed. "Nobody would believe it. Not in Milan anyway." Then to Leonardo: "That reminds me. Some Franciscans want a big painting of the Virgin of the Immaculate Conception. I told them that only you could do it to perfection."

"My lady, how can you know this?"

"If you can find me, you can find anybody . . . even the Virgin Mary, whom no one understands, especially our men."

CONFRATERNITY OF THE IMMACULATE CONCEPTION OF THE BLESSED VIRGIN AND THE DE PREDIS STUDIO

April 1483 – April 1485

A WEEK LATER, LEONARDO RECEIVED A NOTE from the Confraternity of the Immaculate Conception of the Blessed Virgin, requesting he come to their convent to discuss an altarpiece of the Conception of the Glorious Virgin Mary for the Church of San Francesco Grande.

At first, he hesitated. Here were the San Donato friars again, with all the inevitable trouble—a pious fraternity of wealthy Milanese run by Franciscans. Yet there was no choice. It was a major work, his first in Milan. Cecilia had proposed him, and her Moor would see it. It would also advance his career and chances at the court.

The Franciscans presented a contract describing the painting in detail. The Virgin Mary, flanked by two prophets, was to have a cloak of ultramarine blue with gold brocade, and a gown of crimson with gold brocade—all of it painted in oil. God the father, clad in blue and gold, would soar overhead among angels, to be painted by Leonardo, the Florentine master, "in the Greek style." Ambrogio de Predis would do the side panels with four angels, and his brother, Evangelista, the gilding.

Leonardo had no intention of painting such a monstrosity. Nevertheless, he signed the contract, April 25, 1483, in the presence of the prior, Bartolommeo degli Scarlione, and eight brothers.

2.

In the spring of 1484, the bubonic plague returned to Europe. Sweeping southward, the Black Death arrived in Italy, where it would remain for two

❀ 277 ❀

years. Milan would suffer especially in 1485, with the disease carrying off one person in six from a city of half a million.

Believing the sickness was caused by "foul vapors, the enemy of the heart," doctors held perfumed handkerchiefs or posies to their noses upon entering the homes of victims. Their prescriptions, varying from herbal baths to bloodletting, were useless. From its first symptoms of chills and aches in the upper leg and groin, the disease pursued its hideous course—vomiting, yellow fur on the tongue, purple blotches spreading over the body, egglike swellings that ruptured with yellow pus, the face turning dark, then black with death.

The Moor lived in terror behind the walls of his castle, never daring to enter his stricken city. Each morning he looked at himself in the mirror, sticking out his tongue to see if it was furry, then examining his body for a blemish or swelling that would indicate the fearful disease had taken root. Finding nothing, he became convinced it was going to sneak up from behind, where he couldn't see it. Fearing contagion, he canceled all contacts with the outside, except for crucial meetings with members of his government. His court astrologer, Ambrogio da Rosate, brought a daily astrological reading, and a glass of "astral spirits"—a bittersweet concoction of herbs with powdered ox blood, which had been exposed to favorable star constellations.

To stem the fearful tide, he employed the tactics of his father, Francesco, during the plague of 1450, which had claimed thirty thousand lives. Town criers were sent into Milan's six districts with orders to board up infected families, isolate sufferers in hospitals, burn the clothes and beds of victims—or face imprisonment. Each district was subject to heavy fines for any corpse left in the streets for more than twenty-four hours. Grave diggers striking for higher pay were thrown into prison and told plague victims would join them in their cells—a prospect that swiftly brought them back to work. Yet nothing stemmed the swelling toll. Five deep lime pits were added to the municipal graveyard, while cries of despair and animal moans could be heard from within the boarded-up homes of victims. Church bells rang from dawn to dusk, garbage piled up in the streets, and a blue slime glistened in the gutters.

One day—March 16, 1485—the sun itself disappeared. Milan's terrified population watched it slide behind the moon, forming an eerie ring of light. Then this also vanished, plunging the city into the darkness of a total eclipse. Clearly, the Day of Judgment had come. People ran for shelter; churches rang their bells. Almost everyone, convinced the earth was about to open up and swallow them, prayed to God, the Virgin, and Milan's patron, Saint Ambrose.

During this blackout, the Moor hid in a closet. When the sun emerged again, he angrily sent for his astrologer, who had failed to predict the event. With the slippery ease of his profession, Ambrogio da Rosate claimed it was an

act of God, not the stars—and so beyond mortal reckoning. This increased the fears of the terrified ruler of Milan. Since God had sent this plague, His removal of the sun was a sure sign that nobody was safe.

A week later, the duke's fears were confirmed. The plague leaped the walls of his castle, with four cases appearing in the stables. Then six guards at the moats were taken ill. The Moor decided he had done his best for Milan. Now he had to save himself as its ruler by escaping to the castle at Pavia. The air was purer there. Wind sweeping through the forests purified its passage.

3.

On the eve of his departure with Cecilia, the Moor called a meeting of his Council of Ministers. They had received alarming news. Florence was about to capture Sarzana, a strategic fortress on the Ligurian coast leading to Genoa and Milan. At the table with his ministers, the regent of Milan cupped his chin in his hand, the ruby ring with Caesar's head under his nose. Then he nodded as though moving a chess pawn.

"When they seize Sarzana, Genoa will be next," he said. "Before that happens, we'll have Archbishop Fregoso tell his people that Genoa will be safer under a Sforza protectorate. The city will then fall into our hands, and twenty thousand ducats will fall into the hands of the archbishop."

Bartolommeo Calco, his foreign affairs secretary, and four other ministers nodded with relief. This Moor was a grand master at intrigue. In secret talks with Venice, he had ended the Ferrara war in a treaty at Bagnolo. Venice obtained what she had sought—Ferrara's rich farmlands in the Po Valley. Lodovico Sforza privately received sixty thousand ducats for brokering the agreement, while Pope Sixtus and Girolamo Riario received nothing. Hearing of this, the Pope had raged, "Oh, that treacherous Moor!" Four days later, he died of apoplexy, leaving Lodovico Sforza—duke of Bari and regent of Milan—the triumphant arbiter of peace in Italy.

Giacomo Trotti appeared next with an urgent letter from Duke Ercole d'Este. Beatrice d'Este, his betrothed, had returned home from the court of Naples. She was not quite ten, but already a princess from the court of her adoring grandfather King Ferdinand. So it was the ideal moment for the Most Illustrious Duke Lodovico to leave the plague in Milan.

Lodovico shuddered. At this age, that girl was only two years short of an acceptable marriage age. Maybe he would marry her, but maybe not. She certainly wasn't beautiful, and in no way was he ready to leave Cecilia.

"There's no plague in Ferrara," urged Trotti. "You could obtain two things at once—ensure your future life, and see your future bride."

"I am moved by the concern of your valiant Duke Ercole," replied the regent. "But I cannot leave my subjects at this critical time."

"Of course, my lord," replied the envoy, knowing the Moor's most critical time was spent with Cecilia Gallerani.

Giovanni da Bellinzona, secretary of justice, was next, with reports on a breakdown in public order and the plague deaths of doctors and nuns in the hospitals. He paused, and the Moor became impatient.

"What is it? We have little time left."

"Sire, you should know that the new portrait of the most esteemed and illustrious Lady Cecilia by Maestro Leonardo da Vinci is being contested by some friars of the Immaculate Conception."

"I gave no permission for this. It must be a copy of the one we have."

"No, my lord, this is different. She's an angel with the Virgin, while Jesus and Saint John are babies. . . . Also, this one has many more secret places than the first picture."

"How do you know?"

"They're in a cave, my lord. "

"*Porco Giuda,* where is this painting?"

"With Maestro Leonardo at the Predis workshop near the Ticino Gate."

The Moor hesitated. To get there, he would have to traverse Milan, through the worst part of the plague. The secretary quickly saw the problem.

"You could exit here at Porta Vercellina and go around the walls."

"Yes, of course. Tell Messer Leonardo to expect us tomorrow morning. I want him there with those friars. If they're not there, they can expect my extreme displeasure."

4.

In the midst of Milan's harvest of death, Leonardo had finished his painting *Madonna and Child with Infant Saint John.** Informed of this, the friars of the Confraternity of the Immaculate Conception of the Blessed Virgin hurried to the Predis workshop to see their long-overdue painting. Ambrogio met them, saying Maestro Leonardo would soon arrive, then led them to the studio where the painting was waiting on an easel.

They saw four figures within a rocky cave—the Virgin, an angel with wings, the Christ Child, and an infant Saint John. This wasn't what they had expected. Yet it was very beautiful and mysterious, and they stood before it, trying to decide what they were seeing.

* This painting eventually became known as *Virgin of the Rocks.*

At first glance, it seemed simple enough. The Blessed Virgin had fallen to her knees, with her arms outstretched to protect the playing children—as yet untouched by their awesome destiny. A stream of light with the radiance of springtime had penetrated the cave, falling on the Virgin's head. She was looking at the infant Baptist, who knelt with one chubby knee on a cluster of flowers and grass.

His fat little hands were clasped before his playmate, the Christ Child, seated before him on a flowery ledge above a stream of water, his tiny right hand raised in benediction.

The Virgin's right arm supported John. Her left arm was thrust forward, its hand hovering above the head of her child. The angel, seated behind the Christ Child, pointed a finger toward the infant Baptist. His long finger and hand, extending below the Virgin's hand, formed a cross of light above the infant Savior.

Bartolommeo degli Scarlione, the prior, was drawn to the picture, yet also repulsed by it. He shook his head.

"This is not what we ordered. We asked for two prophets."

"There's one anyway," said one friar.

"He's a baby prophet, but still a prophet in the making," agreed a second one.

"And that angel is pointing her finger. So she's a prophet, too," affirmed a third.

"Her? That's Uriel," replied the first friar.

"Well, it looks like a woman, with those eyes and lips."

Uriel, in the apocryphal story of this desert encounter, was a male angel. Yet this creature with its rich lips, delicate nose and chin, seductive eyes, and graceful pointing hand clearly belonged to a woman.

"That's just it," warned the prior, feeling suddenly trapped in a pagan cave of indeterminate pleasures.

"What is it, Reverend Father?"

"You don't know where you are here, especially with that man or woman's finger pointing to a baby Baptist instead of to Jesus. How can we put that above our altar?"

Leonardo arrived, and the prior told him the painting had to be altered to conform to the contract. Here it was, as expected—the text-creeping San Donato friars.

"You have what you wanted in clear symbols," he replied.

"We don't want symbols. We want flesh and bones."

Leonardo shook his head. "This is how it is. I'm sorry, I can't change it. . . ."

"Then we refuse it as worthless for our purposes," replied the prior.

They left, demanding a return of eight hundred ducats in advance. Leonardo refused and asked for another four hundred ducats, claiming the advance payment would hardly cover the expense of the ornate frame. Both sides then applied to the magistracy of the Twelve of Provision, responsible for setting the prices of foodstuffs and luxury items. Its vicar, Giovanni da Bellinzona, looked at the picture and, noting the angel's striking resemblance to Cecilia Gallerani, realized he had to refer the dispute to the ruler of Milan.

That was were matters stood when Lodovico Sforza, shocked to learn Cecilia was now an angel in a new Leonardo painting, directed his black-and-gold coach around the walls of Milan to the Predis workshop.

He descended quickly, wearing a hunting cloak and a cap with a pheasant feather. Lady Cecilia, similarly attired for the trip to Pavia, wore a green tweed jacket and an innovative split in her riding skirt. Entering the workshop, they found the Franciscans standing to the left of the painting, with Leonardo and Ambrogio on the right. In between, the painting glowed with light from the garden window.

When the friars began to talk, the Moor growled at them to be quiet. He looked at the picture in the silence and seemed to have trouble breathing. He had never seen anything like this, nor had anyone else in Italy, or in the entire world, for that matter.

Leonardo had taken Masaccio's tonal painting to greater depths. A mutation in color, distance, and a blurring of form in the atmosphere created a "perspective of disappearance." Its unity was determined by the primacy of shadow, as in the portrait of Cecilia. Within this darkness, colors were veiled or released in varying degrees of brilliance according to the illumination of the area. Streaks of light fell upon each of the separate participants, while their collective destiny appeared in symbols around Mary and the two children— the waiting waters of Baptism, the sharp leaves of the iris as her sword of sorrow, and the palm fronds, a Marian symbol of ultimate victory, which Leonardo had used in his *Adoration*.

The Moor wondered what was happening to him. This picture had a lot of secret places, but there was something more—some mysterious power. It drew you on and on, until you wanted to stay there without coming out. Maybe it was Cecilia's face near the Christ Child. Or perhaps the beauty of the Virgin opening her arms. He shook himself and turned to the woman he loved.

"Did you know about this?"

"About what?" she asked demurely.

"You know exactly what I mean—you as this angel."

"Is that really me?"

"It's more you than not you."

"All right." She smiled. "I'm just as surprised as you are."

"I don't believe that. You came here. He did it with you here."

"Why don't you ask him?"

The duke hesitated. He hated this scene taking place in the presence of these smirking Franciscans. But he had to know, and he turned to Leonardo.

"How did this occur?"

"Sire, if you are unable to forget Lady Cecilia in her absence, how can you doubt this occurring to one who has portrayed every detail of her beauty?"

"You see?" replied Cecilia. "Besides, what does it matter? You know how he's my friend."

That could have meant almost anything, but Leonardo understood what she meant. They had never spoken about it, yet she knew how he was, and she must have told the duke.

"*Mio caro,* why don't you look at the Virgin? She's much more beautiful."

"No, she's not, and you know it," he replied, again in command.

"How much is owed to the artist?" he asked the prior.

"We gave him and de Predis eight hundred ducats. They want four hundred more."

"Good. I'll pay the total amount." He looked at each one of the Franciscans. "This will now enrich the chapel of Maximilian, Most Christian King of the Romans."

"What will we have?" asked the prior, suddenly aware of losing a treasure.

"Nothing. Get another artist. You don't know a masterwork when you see one."

The prior huddled with his brethren. Then he said, "You haven't understood us. We also see the worth of this portrayal of the Virgin and the infant Jesus. But that hand pointing at Saint John will confuse people."

The Moor turned to Leonardo. "Would you do another one without the hand?"

Ambrogio nodded, and Leonardo agreed. "My lord, we shall do as you suggest."

"Good. Send this one to the palace . . . and my compliments, Signor Maestro."

Leaving, he paused at the door. "Lord Galeazzo says you've made some splendid drawings for the monument to my father, Duke Francesco. Let me see them. Perhaps we can discuss what you have in mind."

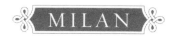

May – June 1485

THE NEXT MORNING, LEONARDO SENT a portfolio of drawings for the Sforza monument to the palace. A week later, he received a note from the Moor's secretary, who had given them to the duke in Pavia.

Esteemed Maestro Leonardo da Vinci,

Your drawings for the monument to the Most Illustrious Francesco Sforza have arrived. His Lordship Duke Lodovico enjoyed seeing them. He finds the horses most beautiful while possessing strength and fearful force (*terríbilità*) of an ideal warhorse. We will be in touch with you upon our return to Milan.

Her Ladyship Cecilia asks me to relay the extreme pleasure she also derives from these drawings, and sends her fond regards.

Bartolommeo Calco Pavia, May 6, 1485

He wondered where this left him. Nothing was certain with the devious Moor. He might have sent this to please Cecilia. She had a way of getting what she wanted, as in using his secretary to send her fond regards, when a private note could be misread. Perhaps the duke had accepted their friendship. Yet how much of this was the Moor, and how much Cecilia?

While waiting their return, he walked the streets of the plague-stricken city. As an urban anatomist, he noted stagnant pools of slime in the gutters, yellow offal thrown from windows, garbage heaps with dead cats and dogs and an occasional hen or rooster. He also noticed people hurrying by, holding perfume-drenched cloths to their faces—another useless panacea from their doctors.

But were they right? If a heavy odor bore the cause of this disease, how could the light scent of perfume or a flower block it? No force came to rest without encountering its equal. Also, precisely what odor brought the

contagion? Men working outdoors, even those handling graveyard cadavers, appeared to suffer less than others. Was it because they labored in the open air? The wealthy sought fresh country air in fleeing Milan, as they had in Florence at the time described in Boccaccio's *Decameron*.

There was a clue. Did stagnant air, taken into the lungs, remain to contaminate the blood and the heart? If so, the city sowed its own seeds of death. There was only one solution, which he had conceived in Florence. Build peripheral cities around Milan—ten of them, each with five thousand houses for thirty thousand inhabitants.

"In this way," he wrote later, "you will disperse the masses of people who live crowded together like goats, filling the air with stench, spreading the seeds of plague and death."

Satellite cities would be located along a river, such as the Ticino, to provide water and a sewage outlet. A network of canals would serve for transport. Also, by means of locks, canal water could wash the streets and stables before returning to the river through underground conduits.

"Each city," he noted in a proposal to Duke Lodovico, "will be of beauty and financial worth to you, adding to your everlasting fame."

His mind raced on, devising elements for the new cities: smoke driven from chimneys by a wind cowl; municipal privies with "holes for vapors to escape"; a latrine seat that closed itself like a "little window in a monastery"; stables having three compartments, one for the groom, and automatic conduits for manure removal; a brothel with three entrances, allowing respectable clients to enter and leave unseen.

Amenities of life included a roasting spit operated by heated air; a variable-intensity table lamp; a therapeutic armchair; a combined violin and harpsichord, which he called "viola organista"; a mechanized drum on a wheeled trestle; purifying sunlight in the communal bathhouse; and a variable crane for cleaning sewage drains.

Ideal health in the ideal city also depended upon body harmony: "Medicine is the restoration of harmony between unbalanced elements; illness is the disharmony of elements present in a single living body." His own meals, without meat, consisted primarily of vegetables, pasta, cereals, salad, mushrooms, and soup—especially minestrone. His rules for a daily regime were from a popular verse at the time:

> If you would be healthy, observe this advice:
> Eat only when hungry, and let light fare suffice.
> Chew your food well is the prime rule to follow;

Well-cooked and simple be all that you swallow.
On leaving the table, a good posture keep;
And after your luncheon, yield not to sleep.
Let little and often be your rule for wine,
But not between meals or when waiting to dine.
With a regular diet, perfect digestion is made,
And visits to the toilet should not be delayed.
Avoid fits of rage and the anguish of tears,
To ensure good health and extend your years.

Wine and sleep also robbed one's chances for immortality: In a *Strategy for Sleep Reduction,* he theorized that sleeping fifteen minutes every four hours, totaling one and a half hours a day, was all one needed. This would allow more time "for your work to be such that after death you become an image of immortality."

June 1485 — April 1488

FTER FOUR WEEKS IN PAVIA, the Moor returned without Cecilia, who was ill with a fever. Her doctors had advised her not to travel, especially to Milan, where the subsiding plague still remained a danger. Despite this, she wanted to leave with him when he came to say good-bye. She was sitting upright in bed in a light blue gown with embroidered pink primroses.

"You'll need me," she said. "I know you will."

"I'll be fine," he said. "And you're in good hands. These are the best doctors in Italy. They teach at the university."

"You're my doctor. You're the best doctor I know. You make me feel wonderful."

He laughed and kissed her on the nose.

"I'll have you before me at night in the painting of your Leonardo."

"My Leonardo? I told you how he is."

"I know that, and he was arrested for it in Florence. I'm only saying he's your close friend. Why don't you admit it?"

"He's your friend, too. He can do a lot for you if you let him. Besides that monument to your father, he can decorate the castle and arrange amusing court spectacles for us."

"I doubt he can do the monument."

"You said you liked his drawings and wanted to talk to him about it."

"Before we're involved, I have to be sure he can do it."

Back in Milan, the Moor met Calco, who carried a letter from Leonardo da Vinci.

"It's about the monument?"

"Not only that. He now wants to renovate Milan with some satellite cities. He says it will stop the plague and bring you a lot of money."

The duke laughed. "How do you see him, Barto?"

"Other than his paintings? He's a dreamer, but also a practical architect and engineer. He could be valuable if used in the right way."

"Cecilia believes he could produce beautiful court spectacles."

"With his painter's eye and knowledge of machines? She's probably right . . . but we also have his drawings for the monument to your father."

"Forget it," replied the Moor. "If you want something done well, get a specialist. His master, the sculptor Verrocchio, is doing the Colleoni monument in Venice. That's the man for us. After he's finished, he can come here."

"So how shall I reply? We told him you wanted to talk about it."

"Put it off. Tell him we need more time. . . . No, wait. He wants to build cities for me. Let's see if he can make a dome for our cathedral. Enter him in the competition for that. That'll give us some idea of what he can do without a paintbrush."

2.

Calco's letter surprised Leonardo. His Excellency, the regent of Milan, had decided to postpone the Francesco Sforza monument to a later date. In the meantime, it was a pleasure to inform Maestro Leonardo da Vinci that he had been chosen to submit plans for erecting a new dome on the cathedral.

This was disappointing. A dome for the cathedral instead of the great horse. But even so, it was a great honor. Brunelleschi had given Florence a dome for its Duomo. Now another Florentine was up for the crown of Milan. So were Donato Bramante and Francesco di Giorgio Martini, Siena's brilliant civil and military engineer. There were others, but none equal to Donato, Francesco—or himself.

It was also a formidable challenge. A crossing dome, or *tiburio,* was to be placed over the meeting of the cathedral's transepts, replacing a temporary one, which threatened to collapse. It defied any solution, short of a drastic intervention. Leonardo said as much in a letter to the authorities:

> Just as it is necessary for physicians, nurses, and healers of the sick to know the nature of man, of life and health, and to know how the balance and harmony of elements preserves them, and how their disharmony endangers and destroys them . . . this sick cathedral needs a physician-architect, who understands the nature of building, the rules from which a correct method of building proceeds . . . and the causes which hold a building together and give it permanence. . . .

I shall be at pains to offer no criticism of anyone and to bring no charge against anyone.

Such confidence bordering on arrogance, the caveat to let sleeping dogs lie, and the metaphysical concept of the Duomo as a living organism must have impressed the judges. They asked for a model, and Leonardo began to seek a solution.

His notebooks, some with pages from the Duomo's registry, revealed his search to harmonize Gothic elements of the cathedral with a Romanesque dome. Among the drawings were sketches of flying buttresses, soaring pillars, and dovetailed stonework for melon-shaped domes. Even Brunelleschi's dome suddenly surfaced like a haunting dream.

His eventual solution, beginning with rectangular, diagonal, and circular elements, gradually coalesced into an octagonal design supported by eight buttresses and eight pillars. Leonardo had studied a similar one near Milan—that of Santa Maria in Pertica at Pavia. Renaissance architects occasionally adapted this concept from Roman temples, and Brunelleschi had used it for Santa Maria degli Angeli in Florence.

He presented his final model to the cathedral authorities—with drawings of ground plans, elevation, and engineering details—in January 1488—receiving in payment forty imperial lire. The other contestants also delivered their models, but the judges, pressured by Ghibelline interests and entrenched Milanese masons, were unable to make a choice.

On June 27, 1490, Duke Lodovico intervened, and in September the archbishop laid the foundation stone of the dome. A Lombard, Giovanni Antonio Amadeo, then discarded the approved models—this, and other blunders, delaying the dome's completion for another hundred years.

Leonardo had long since withdrawn from the competition. His model had been equal, if not superior, to those of top architects of the day. That was enough for him. He had no desire to encounter the inevitable treachery of local guilds in managing the building site.

August 1488

S HORTLY AFTER THE MID-AUGUST HOLIDAY, Leonardo returned to his studio, expecting to help Ambrogio with the second version of the Madonna picture. He found his friend visibly disturbed.

"I've just been to the palace," Ambrogio said.

"The Moor wants Cecilia as the Virgin in the new painting."

"Worse than that . . . far worse. A priest named Padre Vincenzo came to say that Verrocchio had died in Venice."

"Bandello was prior of the Dominican convent in Florence. . . . Where did he go?"

"Santa Maria delle Grazie, their convent in Milan."

Leonardo began to run across Milan, knowing it was the horse that did it. It had to be that. The horse took him into the Great Sea. He knew it without knowing how. At the convent, the portal brother said Padre Vincenzo was in Milan for the Lombard Congregation. When Leonardo gave his name, the brother nodded.

"He left word for you to wait. He'll be back shortly."

"Where is he?"

"After Mass, he went to the palace with the duke and Lady Cecilia."

"I'll be in the church."

He sat near the altar and closed his eyes, but it didn't help. The memories kept coming back: Andrea's hands like bird wings shaping the face of David, entering the wound of Christ, opening the doubting eyes of Saint Thomas, carving the head of the model for his great horse . . . then blinking back tears as he, Leonardo, left for Milan, Andrea saying, *"Figlio, figlio mio . . ."*

It was too much. He left the church, crossed the cloister garden, and entered the convent refectory. If he ever did a *Last Supper,* this would be the

perfect place—at the end of the long dining hall, with its rows of tables set with pewter mugs and plates. The table with Christ and his disciples would be identical to these tables, done in perspective as an extension of the room. In this way, the Savior would appear to be also at supper with the Dominican friars. . . .

"There you are. I thought you were in the chapel."

It was Padre Vincenzo—an immense man, with the rugged features of a commander of armies, wearing the white tunic and black cloak of the Dominicans. His brow was furrowed now, and there were gray hairs at his temples.

"Thank you, Padre," he replied. "What happened to Andrea?"

"I'll tell you what I heard from Florence. The lagoon fever got into his lungs, and it became worse, until he could not rise from bed. So he wrote his last will, and they sent for a priest. But when he arrived, Andrea was gone. They found him in his studio, beneath his great horse and rider. The work was finished, but there was a piece of clay in his hand. I don't know why or even if it mattered. . . . Both horse and rider were ready for casting."

So it was true. The horse had taken him into the Great Sea.

"Only a small piece of clay," said Vincenzo.

"A particle of a dream has no measure."

"They say he seemed to be asleep and at peace, even though he had departed without a priest for his soul."

"The horse took care of that. Andrea created it with the help of God. That's why he was there when it happened . . . to be close to both of them."

The Dominican sighed. "The corpse is being sent to Florence for a memorial service in three days. Will you go with me?"

"Of course. . . . He was the father I never had."

He would take Donatello's old wooden spatula and put it in Andrea's hands. His master should have it now that he had gone into the Great Sea.

"We can leave tomorrow," said Vincenzo. "Also, Lodovico wants to see you. It's amazing how a man of his position believes in magic and evil omens."

"What omens?"

"When I told him about Verrocchio, he saw it as an omen to start the big horse for his father before it also kills somebody. . . . Why are you smiling?"

"That's no omen. It's what Andrea expected."

August – September 1488

I N THE LONG, VAULTED ROOM WITH FRESCOES of his father's military victories, Lodovico Sforza was entranced with a report from Forlî on the military brilliance and bravery of Caterina Sforza after the assassination of her husband, Girolamo Riario. He read it aloud to Bartolommeo Calco, who was sitting at the far end of the long desk.

> ". . . From the top of the Rocca fortress, she looked at the Orsi rebels who had murdered her husband and now threatened to slice her children's throats if she did not open the gates. She laughed at them and lifted up her gown, showing herself to them, saying, 'Take a good look, you idiots. From this oven, I can make many more.'"

The Moor laughed, a high-pitched snort. "*Per Dio!* There's a Sforza for you. She has no fear. And now she's turned the Rocca cannons on Forlî, should the rebels dare to harm her children."

Calco grimaced with displeasure. A tall Lombard with a long nose, blue eyes, and receding blond hair, he was a humanist scholar and founder of a school for poor students who wished to master Greek and Latin.

"Seeing their mother that way must have terrorized those poor children."

"No matter, they're safe now," replied the Moor, who had sent Galeazzo da Sanseverino with twelve thousand troops to rescue his natural niece. "After Galeazzo drives the Orsi into exile, she'll rule without a husband. . . . And here's how Lorenzo finally avenged the murder of his brother."

> "Checco Orsi, a family friend betrayed by Count Riario, entered the living room while the count was leaning out the window, talking to

friends in the street. He stabbed him but missed his mark, and Riario crawled under the table, seeking his wife's room. . . ."

Lodovico looked up with a grim smile. "She had balls for both of them," he said, turning back to the report:

> "Then Lodovico Panesechi, the Florentine, rushed into the room, stabbed Riario through the heart, and threw the body out the window into the piazza. . . ."

"Just a minute," said Calco. "Wasn't Panesechi an accomplice in the Pazzi conspiracy?"

"Exactly, and now he can return to Florence from exile. There you have the invisible hand of the Medici that will never appear in history books, while Caterina, with her attractive person and fertile oven, will find new lovers and extend the Sforza seed into other royal houses." The duke smiled. "She reminds me of my great-grandmother Elisa, who could fight like a man, had nine children, and sent all her sons off to war, beginning with my grandfather Muzio, the first to be called Sforza. . . ." He paused and glanced at papers on his desk. "Enough of this. . . . What's left for today?"

"Leonardo da Vinci, who has come to discuss the Sforza monument."

"This has been put off long enough—send him in."

With a sigh, the Moor turned toward a wall fresco of Francesco Sforza entering Milan amid cheering crowds. How had he managed it? Running this duchy was exhausting. Every day, something else. And now, on top of it all, there was Cecilia and her Leonardo. In their bedroom the night before, she had stared at his Madonna in a cave with little Jesus and baby John. It was as if the Virgin were speaking to her.

"I want one of them," she said suddenly.

So it was a baby. He tried to make light of it.

"You prefer little Jesus or baby John?"

"You . . . I want your son. I don't care what anyone says."

When he said nothing, she looked into his eyes.

"Say something, *amore*. Tell me now. . . ."

He kissed her on the brow, then on the cheek.

"Yes, little one, yes," he said, holding her close.

"My lord . . . here I am."

Except she was looking at the Madonna and the infant Jesus and baby John. Leonardo had created them. So was he with them now, as well? The

mind played dirty tricks. Maybe this man's babies were being seeded into his own little Lodovico. *Porco Giuda.* Horns from that son of a bitch. . .

"*Buongiorno, signore.*"

There he was again with Calco before his desk. Nodding glumly, he began to sift through a sheaf of drawings Calco had placed on his desk.

"Where's the one I want? It's not here."

He shoved them angrily toward his secretary and looked at Leonardo.

"You're a painter, not a sculptor. How do I know that you can do a monumental horse and rider?"

"I worked with Verrocchio on his horse. I can do a better one."

"Better than your master's?"

Leonardo wondered what was wrong. The duke was glaring at him, his hair like a black helmet, the eyes dark as chestnuts. To hell with you, he thought. You wanted Verrocchio, but now he's dead. So now it's me again. You don't know how lucky you are. . . .

"I asked you, how could you be better than your master?"

"It's to be expected, sire. Have you not surpassed your father in the rule of Milan?"

The duke grunted. "And how would you surpass the great Verrocchio?"

"With a monument to your father that would also be a tribute to you as the ruling Sforza."

There was a slight nod. "Very good. You understand that much quite well."

Calco gave him a drawing, and the duke flicked it across the desk—a sketch of a rearing horse with the rider brandishing a baton.

"I like this one. Can you do it with both hooves in the air?"

"Not in the size you want."

"The size I want? You also know that?"

"If you wish to surpass the ancients, it should be larger than anything ever done."

"How big is Donatello's *Gattamelata*?"

"Almost eleven feet. Verrocchio's is thirteen. The one of Marcus Aurelius in Rome is fourteen. Yours will be at least sixteen feet."

"You can do it rearing up?"

"With one hoof on a fallen warrior, or some object for triangular support."

"Good, have its hoof crushing a Swiss mercenary." He smiled reflectively. "My father called his great warhorse Ton . . . or 'Thunder' in Romagnolo. He'd ride into battle crying 'Ton! . . . Ton!' with the ground shaking and soldiers fleeing for their lives."

"Ton . . . Ton," replied Leonardo, making it rhyme with *Tun.* "I can hear it as a battle cry."

The Moor nodded, pleased. "Now, I have another request. The duke of Milan is to marry Isabella of Aragon. It must be a special event. Have you any ideas?"

"I presume you wish to make the duke and duchess appear as the center of the universe?"

"Center of the universe? How can you do that?"

"In a model of the heavens, I'll place them in the midst of its constellations."

The Moor turned to Calco. "You heard him. Do you believe it?"

"Brunelleschi did something like that in Florence."

"This will be much larger, with more constellations and stars. Also, planets will move as they do in the heavens."

"You can do that?"

"If you give me the means, sire. It will require special engineering elements, and skilled workmen."

The Moor's dark, unblinking eyes stared at the Florentine. Then he nodded.

"All right. Both Lady Cecilia and Count Calco believe in you. Let's see if they're right and you make good on your promises." He turned to Calco. "Let him have all he needs to do this."

"How shall we list him for the court? *Leonardus ingeniarius ducalis?*"

The Moor hesitated. "*Va bene.* . . . Since he's not God, he'll need some authority to create another universe."

He laughed at this, and Calco smiled. Leonardo waited. Lorenzo would never have kept him standing.

"You also want to build new cities for me," the duke was saying. "Let's start with renewing an old one. I want you and Francesco di Giorgio Martino to go to Pavia and see how we can rebuild the cathedral."

"It will be a pleasure, sire."

"Good. You can leave tomorrow with him."

Leonardo hesitated. He would need a week to attend Verrocchio's funeral in Florence.

"I'll need more time, my lord."

There was a flicker of anger in the black eyes, then a wave of the plump hand and ruby ring.

"Forget it. We'll send Bramante."

In that moment, Leonardo saw his future in Milan. It depended upon a man who did not know what he wanted, unless obtained by force or intrigue.

That was how it was going to be. As with the Medici, you could either accept it or leave it.

"That won't be necessary, my lord."

Andrea would understand. So would Vincenzo. If the padre didn't, there was nothing he could do about it.

"So what do you say?"

"I'll go with Francesco tomorrow."

2.

Leonardo expected his superspectacle of celestial planets to lead to other shows, ensuring his future at the court. Indeed, it was already under way. The duke had agreed to a monthly salary of one thousand ducats, with a studio and living quarters in the Corte Vecchio.

The twelfth-century palace, facing Milan's central piazza with its soaring cathedral, delighted him. As the Corte d' Arengo, it had served the 130-year reign of the Visconti family. After seizing Milan, Francesco Sforza had also lived there while renovating Castello San Giovio on the northwest side of the city.

Its right wing was retained for visiting diplomats, or those who did not warrant staying at the castle. The artist occupied the left wing. It was large enough for him to lay out a workshop with separate units, similar to Verrocchio's. The sculpture studio and metal workshop were on the ground floor, which opened onto a courtyard with an elegant arcade of Ionic columns—ideal space for creating the great horse. The painting studio was installed in the large courtroom on the first floor. Adjacent to it, three rooms overlooking the cathedral square became his living quarters. One of them, his private studio, had direct access to the painting shop—again similar to the Verrocchio bottega of his youth.

With everything in place, he turned to three wax models of a rearing horse, its right foreleg on a fallen warrior, as desired by the Moor. Their projected weight in bronze at sixteen feet came to 17,500 pounds. The bronze rider would add another 2,500, for a total of 20,000 pounds, or ten tons, to be supported by one front and two rear legs.

This was valid for a walking horse. Yet one rearing at a thirty-five degree angle, with the rider's extended right arm and staff in counterthrust, would shift one-tenth of the frontal weight to the rear legs, bent in a fifty-degree angle. Adding 10 percent as a safety margin, could both legs support 14,600 pounds, or more than seven tons? At the foundry, he hollow-cast two bent legs

and found their joint tolerance was only 3.3 tons. He recast them in solid bronze, but this gave way at 6.8 tons.

Bramante agreed with his calculations. Clearly, it couldn't be done.

"You have to solve this, Nardo. The Moor might turn to someone else."

January – February 1489

THE ROYAL WEDDING OF DUKE GIAN GALEAZZO and Isabella of Aragon, granddaughter of the king of Naples, began with a startling display of Milanese wealth and heraldry. Three weeks before the event, the duke's brother, Hermes, arrived in Naples with 450 nobles dressed like kings. The court of King Ferdinand stared in awe. Some of these Lombards wore jewels worth seven thousand ducats. The curtain had risen on a singular drama of Milan during the years of its Renaissance glory.

Duke Gian Galeazzo, along with his regent uncle, Lodovico, met his bride, Isabella of Aragon, in a rainstorm at Tortona. After an exhausting feast, they galloped on to Milan to meet her barge as it arrived at the Porta Ticino dock. Amid a blare of trumpets, salvos of artillery, and bells ringing throughout the city, the dark princess walked hand in hand with her pale, blond duke to an open carriage. It had been a difficult midwinter trip for Isabella. The rough seas and an illness had forced her to bed at Genoa. Yet now her future husband's hand and the cheering crowds revived her.

At the castle, her spirits soared even more. Upon crossing the castle drawbridge with her bridegroom, she entered a wondrous world. The immense, barren courtyard had been transformed by Leonardo into an antechamber of Paradise—its grim walls covered with streamers of sky blue linen bearing the ducal coat of arms and decked with boughs of laurel and ivy, amid paintings of lovemaking centaurs. A colonnade for strolling pagan gods rose up before the princess, its pillars soaring in spirals of mistletoe, its arched roofing gleaming with woven leaves of gold.

Bianca Maria Sforza, her sister-in-law and the future bride of Emperor Maximilian, awaited her under a seven-column portico draped in crimson and gold, her arms open with delight.

"Dear sister, God has answered my prayers. You have arrived. Come, I'll take you to your chamber in the Camera della Torre."

Shortly before noon on Sunday, February 1, 1489, the bridegroom and his uncle Lodovico, with other nobles and signori of the court, arrived to escort the bride from her room. Leaving the castle in pairs on horseback, they entered another fairyland created by Leonardo.

The bridal pair rode under a large canopy of white damask embroidered with ducal arms of the lord, and borne by forty doctors dressed in crimson satin with matching hats. The street to the cathedral, via Monte di Pietà—seventeen hundred paces, or nearly a mile—had been carpeted during the night with white cloth. Along the way, they passed walls on each side that were draped with tapestries and festooned with juniper and orange.

A Florentine envoy reported the event to Lorenzo de' Medici:

> Nothing better was ever seen . . . thirty-six priests went in front of the whole court (followed by) sixty knights all in dresses of gold brocade with pearls and jewels and a number of chains, plus sixty-two trumpeters and twelve pipers.
>
> The Most Excellent Duke wore a vest of the richest brocade. In his cap was a diamond with a pearl larger than a round nut. . . . At his neck, he had a pendant with a Balas ruby and above it a wonderful diamond. Her Excellency, Madonna the Duchess, was also dressed in gold brocade and had a rope of pearls on her head with some very beautiful jewels. . . .
>
> Signor Lodovico with all the other Sforza men were also dressed in gold brocade, and most people agree there was enough silver and gold to dress three hundred persons. Of velvet and satin I say nothing, because even the cooks wore it!

Leonardo rode with other members of the court behind the bridal couple, the blaring trumpeters, and the swaying column of priests chanting the glory of "Blessed Maria, forever Virgin." Inside the cathedral during the service, Leonardo could see Isabella's face at the altar when she turned to Gian Galeazzo.

At fifteen, and clad in white, she was another child to be ravished in royal wedlock. Yet when the bishop of Piacenza pronounced them man and wife, the duke seemed startled and lost. The child bride, however, appeared to know the way—kissing her lord and whispering in his ear. Startled, the groom turned away from her moving lips.

As duke of Milan and tool of his uncle, he was given a golden sword to bestow knighthood upon Pietro Alemanni and Bartolommeo Calco. Leonardo observed this with pleasure. Alemanni had been a close friend and adviser, as had Calco in dealing with the mercurial Moor.

Afterward, the bride and groom were escorted to the Rocca stronghold within the castle. In the fashion of the day, their rooms were hung with pure white satin. The ducal arms were embroidered on the soft linen sheets where the child princess was to arrive on the shores of womanhood. The next morning, however, the private chamberlain found the sheets white as snow. Somehow, the princess had remained offshore. Her duke had failed to manage a landing.

The wedding had also been marred by the prior death of the bride's mother, Duchess Ippolita Sforza. As a result, the Feast of Paradise, which Leonardo had expected to draw praise and ensure his presence at the court, was postponed for the customary year of mourning.

The bridal couple prepared to withdraw to Vigevano, the Visconti castle at Pavia—a favorite royal retreat with four spectacular towers, a courtyard of exquisite arcades, an indoor swimming pool, an immense library of rare books, and a hunting park covering thirteen square miles. Before departing, the bride was shocked to discover that Lodovico, as regent of the duchy and uncle of both the bride and the groom, had cut her allowance from eighteen thousand to fifteen thousand ducats, to be paid through a steward appointed by him. He had also sent her ladies-in-waiting back to Naples.

Greatly alarmed, the new duchess appealed to her husband, only to be told that Uncle Lodovico ruled the duchy and that she had no business making trouble. In despair, she wrote to her father, Duke Alfonso of Calabria. Uncle Lodovico was a tyrant who had sent away her ladies-in-waiting, cut her allowance, and had exiled them to Pavia so he could rule like the real duke. She was helpless and had nowhere to turn. Gian Galeazzo was afraid of his uncle, and she was the most unhappily married woman in the world. Her reluctant duke had left her as pure as she was on the day of her birth.

2.

The Duke of Milan's inability to make love to his wife soon became the talk of every court in Europe. Nothing seemed to help. Lodovico spoke to his nephew man-to-man. He chastised him with jokes before members of the court, which drove the youth into the arms of less demanding companions—in particular, his favorite boy, Bozzone.

King Ferdinand of Naples, disgusted and offended, sent a stark warning to Duke Lodovico. The last installment of Isabella's dowry, a princely twenty thousand ducats, was being withheld. Unless Gian Galeazzo proved he was a man, the bride would be recalled to Naples, along with the dowry's first payment, as agreed in the marriage contract.

After Isabella desperately appealed to her father, saying death was far better than her disgrace, Trotti warned Lodovico that the violent duke of Calabria might take revenge.

"Sire, that man is capable of anything, including a declaration of war to redeem his honor and dry his daughter's tears."

"Ferdinand would never allow it."

"The king is old, sire. What if he dies?"

Lodovico waved his hand, "With our allies, we can handle any acts of madness."

Trotti realized he could go no further. The Moor believed he was invincible in manipulating the weakness of men, including the mad king of Naples. The old diplomat knew otherwise. Here was the inherent weakness of tyrants. It structured their dark destinies and toppled them overnight from their thrones.

A few days later, Lodovico received a message from Isabella. At Vigevano, they had no water. The castle pipes were frozen, and no one could fix them. "My lord, the duke requests you send us immediate help," she wrote. The Moor, aware he had to placate the enraged princess, summoned Leonardo.

"Try to please her," he said. "She's a difficult, demanding lady, but you know how to charm women."

"Thank you, sire. I presume, however, that a woman without water will be charmed more by open drains."

The Moor snorted with delight. "Bravo! You know how they are. Also, you can inform the princess we are always concerned for her comfort, and inform the duke I'm sending him two magnificent Arabian steeds. . . . By the way, when do I see our great Sforza horse?"

"I am working on several models, sire, and a method of casting in bronze that will give us the great horse you desire."

October — November 1488

FROM THEIR HORSES, THEY WATCHED the duchess in the middle of the moor field, her right arm swinging a long feed line with its lure of red meat, while a great hawk circled high above her in the gray winter sky. She looked like a man, but it was Isabella of Aragon, the duchess of Milan, in her husband's dark green leggings, matching doublet, and peaked cap with feathers of maroon and gold—royal colors of the Sforzas.

Bucchino, the court dwarf, explained his mistress's purpose to Maestro Leonardo da Vinci.

"The bird flew away two days ago, but now she's back looking for her master. Since the duke can't rise from his bed today, the duchess is wearing his clothes."

"Who are those two men under that oak at the far side of the field?"

"That's Goffredo, the castle falconer, and his assistant. They're giving the duchess clear ground."

Leonardo looked at the dwarf, who was astride a Gaston pony that resembled Pegasino, his boyhood horse. Bucchino had the usual large head with a pug nose and a wrinkled face that was old at birth. You never knew the true age of dwarfs, but from neck wrinkles and the small square hands, this one was about thirty-five. His saddle had high stirrups for his short legs, clad in maroon-and-green stockings, and he wore the gold-trimmed maroon tunic of a royal courtier.

"Din-amah . . . Din-aaah!"

Isabella's call came to them on the wind like a high moan across the moors.

"It also hears the voice of a woman, not a man."

"That doesn't matter," persisted Bucchino. "Dina trusts the duchess since her first days of training. Maybe she'll do it. What do you say, maestro?"

Leonardo watched the bird. It was a splendid female goshawk from the accipitrine family, a fierce and powerful short-winged bird of prey. In circling

the field, it was now flying over a group of green-and-yellow Piedmont poplars, its right wing lowered as it turned southward toward the dark moor ringed with brown-and-yellow cattails.

Delighted with the beauty of this bird, Leonardo took out a notebook to draw it heading south—the wing edge and elbows set above the wind, which lifted it upward. Below this, he noted: "Facing and upon the wind, the bird will rise much more than its natural impetus requires, since it is also helped by the wind, which plays the part of a wedge."

He drew the hawk again, its right wing lowered toward its tail as it slanted against the wind in turning eastward, the center of gravity shifting into the wind, the head pointed north to prevent flipping over. At that moment, the bird turned back into the wind and, with a beating of outspread wings, rose still higher into the distant eastern sky. "When the bird desires to rise by beating its wings, it raises its shoulders and beats the tips of the wings against itself . . . the pressure of the condensed air, interposed between the points of the wings and the breast of the bird, causes it to rise upward."

"She's gone." Bucchino sighed.

"Maybe not," Leonardo replied. "She could be coming in."

"How do you know that?"

He had begun a *Treatise on Birds,* to be divided into four books. One would deal with flight by the beating of wings, another of flight with force from the wind. The third concerned flight in general, such as that of birds, bats, fishes, animals, and insects, while the fourth book examined the mechanics of flight movement.

"How do you know what she's doing?" insisted Bucchino.

"You watch the position of the head, the wings, the tail, and the center of gravity."

"All of that at once? How is it possible?"

Leonardo showed him the notebook, and the dwarf's eyes widened.

"You must have the eyes of a cat, or even a hawk." The dwarf paused and then said, "I hear you built a flying machine for yourself."

"Where did you hear that?"

"Everyone knows it," replied Bucchino. "And in the market, you buy birds to set them free. People say you expect to find them waiting for you in the sky."

Leonardo smiled. The dwarf's jesting ridicule, seeded with flattery, had made him famous in the court of Naples. He was probably lonely in this remote castle with his unhappy duchess.

Suddenly, the goshawk appeared, cutting southwest across the wind to speed its curving descent. Leonardo sketched it gathering speed—the head

pressed close to its body, the tail straight and wide, the wings beating to increase its velocity under the wind. In a flash of brown and gold, it streaked across the field to seize the swinging meat in its talons, and in a blur of semivertical wings, it landed at the end of the falconer's line.

Leaving their mounts at the field's edge, the two men walked toward the duchess. When they came to her side, the tethered hawk was on her shoulder, tearing remnants of liver from her gloved right hand. For a moment, the bird paused, a strip of liver dangling from its hooked beak, yellow eyes glaring fiercely. The duchess turned to her visitor. Her brown eyes were flecked the yellow of her hawk, and she had a slight bend in her noble nose, a broad, generous mouth, and a pleasant smile.

"Maestro Leonardo, thank you for coming. Was it for the frozen pipes? They're open again."

"It was Duke Lodovico. He says he cares for your well-being, and that of his lordship, the duke."

Isabella stiffened. "*Caro maestro,* the duke of Bari cares only for himself and prevents my husband from ruling as the duke of Milan."

She gave the hooded bird to the ducal falconer, who complimented her. As he left with Bucchino, she turned to Leonardo with a proud, bitter smile. He recalled softer, gentler smiles of a month ago, when she and her handsome duke arrived at the castle, small girls dancing in their path. He nodded gravely to indicate sympathy.

"My dear duchess, I merely repeated what Duke Lodovico asked me to tell you."

"I understand. So now we may speak without shadings. Or is that possible, since you are in his service?"

He resented that. He was no servile courtier, and she certainly knew it. Her anger had blinded her. But it also revealed she was far older than sixteen. Overnight, she had become a woman wearing her husband's clothes, a duchess with the blood of Aragon and the fierce pride of a princess. The Moor was right to fear her.

"I'll leave the clarity and truth of our words to the judgment of your ladyship."

She hesitated, then smiled and gave her judgment.

"Thank you, Leonardo," she said, using his name for the first time. "Of course you will stay with us at the castle. If the duke feels better, we'll leave for Milan early tomorrow. My father has returned two ladies-in-waiting taken from me by that terrible Moor. So you will have time to yourself—and perhaps frequent our famous library."

2.

The resident artist-engineer was given a corner apartment in the castle with a splendid view of Pavia's brown-and-yellow rooftops huddled around the cathedral and along the banks of the Ticino River. After the departure of Isabella and her duke, he sought the renowned castle library.

Climbing a marble staircase in one of four terminal towers, he entered a vast hall. There was a musty smell and small shafts of sunlight through high ogive windows. Endless shelves held yellowed incunabula tied by goatskin thongs, and handwritten books bound in leather, velvet damask, or gold brocade. Perhaps here he would find what he needed. Beyond the science of sight, the physical properties of light and color, he needed to determine the structure and properties of the human eye and its vision.

"In Vitelone, there are 805 conclusions on perspective," he wrote, clearly excited upon finding Witelo's *Perspective.*

The thirteenth-century Pole, exploring the psychology of perception, described two ways of seeing the world. One was *aspectus simplex,* where "the shape of the object is simply imprinted on the surface of the eye." The other was *intuito diligens,* where "sight diligently examines and acquires a true understanding of the shape of the object."

Leonardo already knew this. More than a mirror of nature, a painter had to be a thinking mirror. Beyond *saper vedere,* to know how to see, you had to *saper aude,* or dare to think and determine "the scientific and true principles of painting comprehended by the mind." That was why painting was a science, not a mechanical art.

So it went for him, day after day in the library. One morning, he left the castle to walk along the banks of the Ticino. There he found four men repairing the embankment. After questioning them and taking notes, he headed for the cathedral in Pavia to see what had happened to it since he was there a year ago with Francesco di Giorgio Martino.

They had both submitted plans for a new church in the shape of a Greek cross. Leonardo had projected a cupola with quartering pillars on a square substructure with apses on all four sides and four corner towers. Cardinal Ascanio Sforza, the Moor's brother and bishop of Pavia, had his own ideas. Most likely, nothing had been done. Emerging from dark, narrow streets into the piazza, Leonardo found he was right. The old cathedral was still there—a venerable duchess in the glory of a setting sun.

At that moment, he saw an ancient bronze monument in the piazza. Odoacer, king of the Goths, known as "Regisole," or "Sun King," was mounted

on a striding horse. Leonardo walked around it, holding his breath. This was what he wanted—a horse with the flowing freedom of the Marcus Aurelius warhorse in Rome. Or the mount in Paolo Uccello's fresco in Florence. It was what Donatello and Verrocchio had sought—a moving horse and rider fused into the union of a centaur. Why hadn't he seen this before offering the duke a rearing horse? How many other wonders in the world did one miss in this manner? He began to sketch it and noted, "You take from nature, the daughter of God, as a source of life in painting. You also take what you want from others and, in doing so, the imitation of ancient objects is more praiseworthy than modern ones."

Now he would create a horse moving with the grace and mystery of a free animal. Suddenly, he felt Verrocchio's spirit near him. He saw his hands moving over clay like birds in flight . . . the brown eyes with the glow of sunrise from shades of night. Andrea would be with him when he began this colossus, as he often was in dreams.

MILAN
CASTELLO DUCALE

July 1489

D URING A JULY HEAT WAVE, Ambrogio da Rosate informed Duke
Lodovico that his gifted painter was incapable of sculpting any Sforza
monument. He placed Leonardo's natal chart before the regent of
Milan at the ducal castle. The date, time, and place of birth were inscribed in
ornate letters:

> LEONARDO DA VINCI
> Apr 15, 1452 OS
> 9:52 P.M. LMT—0:45
> Vinci—Firenza

The duke looked at an intersection of lines and plotted angles between
symbols of the planets, revealing their position at the time of Leonardo's birth.
Along the edges were other signs showing the celestial circle's division of
houses at that moment. He sought a clue in further data under the astral
heading:

> 43oN46'0110E15"
> Geocentric—Tropical
> Regiomantanus—True Node

At a loss, the Moor shook his head. The astral symbols resembled ants
streaming across the page. Then he saw Latin names next to them.

"*Media pleiorum* . . . that must be Pleione, mother by Atlas of the Pleiades,
who became a constellation," he said with measured authority. "But I see
nothing about my monument or Leonardo."

"There's a great deal," affirmed Ambrogio. "But since it could upset Your Excellency, I have hesitated showing it to you."

"So what is it?" demanded the duke. Impatiently, he moved his plump forefinger, with its ruby image of Caesar, from MC (*medium coeli,* mid-heaven) down to IC (*imum coeli,* lower heaven), the lowest point on the chart. He was lost, and tried to make a joke of it. "Looks like Leonardo's moving with the speed of Apollo."

"It's actually Mercury, my lord. But he's not going anywhere. He's a creature of crossed stars. You need only to look at the indications of these stars."

The astrologer pointed to a little circle with a cross beneath it.

"Venus is surpassingly strong in this chart. She rejoices in her domicile of Taurus, along with the sun. That's a feminine sign, and so is his moon in Pisces. As the ancients have written, when Venus and the sun and moon are feminine signs in the chart of a man, it makes him effeminate and unsound."

"How can you know that?"

"Ptolemy confirms it. Mercury, in opposing Saturn, the Great Malefic, increases notoriety and instability . . . and when the Pleiades are setting with Venus, as in this chart, they excite venereal passions and dissolute behavior in an alarming manner. . . ." He paused for effect. "These and other indications make it clear that Leonardo has an unnatural love for his own sex, especially boys."

"Oh, Ambrogio!" The Moor laughed. "Everyone knows Leonardo likes boys. So did Socrates and some of our greatest painters . . . Donatello, Brunelleschi, and Botticelli. Even the Popes do it. Sixtus took boys and women, and so does Pope Innocent."

"This is different, Your Excellency. For here the stars also speak of how it relates to the Sforza monument."

"What do they say?"

"Leonardo is no sculptor." Ambrogio continued to explain how the stars clearly stated that Leonardo's talents did not include sculpture. "It's already evident in his inability to cast the monument to your illustrious father."

"He said he was solving the casting problem."

"At the foundry, they say it's impossible. The rear legs of his horse bend and crumble each time he tries to fuse them. Have you not heard of this, my lord?"

With fury, Lodovico summoned the Florentine envoy, Pietro Alemanni, whom he had knighted during the wedding of Gian Galeazzo.

"I want my father on a rearing horse, but your Leonardo is unable to make it."

"Are you sure, my lord?"

"*Per Dio,* he can't even cast it. Ask him yourself. No, don't bother. Ask your Magnificent Lorenzo to send me one or two masters from Florence to replace this man."

2.

Alemanni left the castle deeply disturbed. This was an ongoing tragedy and an insult to Florence. From the time of Cosimo de' Medici and Francesco Sforza, Milan's mediocre painters, architects, and stonemasons had exiled Florentines of great talent. And now they were out to destroy Leonardo da Vinci.

It had to stop. He had known of Leonardo since the Verrocchio days, when he had made a death mask of Uncle Amerigo. And with hundreds of Florentines, he had climbed the San Donato hill to see his *Adoration.* Everyone, including Lorenzo, said he was a great master. No, signore, Leonardo could cast any bronze horse, rearing up or standing on its head. A jealous rival, wanting the horse for himself, had fed the Moor nonsense.

At the Corte d'Arengo, as Alemanni knew the old palace, Leonardo was delighted to see him.

"*Caro Pietro!*" he exclaimed, admitting his friend into the studio.

Leonardo must have been at work on a painting. He was in a brown workshop tunic, spotted with paint, including a fleck of green on his dark brown beard. There were dark pockets under his strange gray-green eyes—probably from lack of sleep. He was about thirty-seven now.

"I heard you were in Pavia to see about the frozen pipes of the duchess."

Leonardo nodded. "She's an extraordinary woman. When I arrived, she was in a field, bringing in an errant falcon. She did it like a man, but she's a woman in every way. She danced for us one evening—a very seductive Neapolitan dance."

"So she's finally captured the duke, as well?"

"I doubt it. He has a boyfriend called Bozzone."

It was the moment to inquire about the horse. Alemanni used a diplomatic ruse.

"*Caro Leonardo,* I bear a message from our Lorenzo de' Medici. He would like to know about your projects under way."

"Come," Leonardo said, leading his friend up winding stairs to a large hall on the second floor, where the envoy saw two long work banks on opposite sides of a vast room, their surfaces laden with machine tools, models, and scattered drawings.

With a shock, he realized these were not art projects. He had been admitted into the secret world of Leonardo's mechanical inventions. At the first bench, they paused before an assembly of interlocking cogwheels while the artist-engineer described their ability to release, augment, and transfer power. He spoke as a lover when describing their beauty and practicality.

"In revolving, they glisten and hum with systematic automation, which will one day change the world." Then he said, "This comes next after printing. It's no less useful, and its also more profitable, a most beautiful and subtle invention."

There was more for the astonished envoy: an olive oil press driven by interlocking gears; a rope-making machine; geared and automated textile looms; a cloth-warping machine using four warping banks; and cutters to trim uneven cloth in winding onto broad rollers—practical, labor-saving devices for Milan's textile industry. Perhaps the most startling was a horseless vehicle driven by a linked system of steel springs.

"What happens here?" Alemanni asked.

"The rotating teeth of the crown wheel turn the cogwheels at varying rates to compensate for different wheel speeds on the curves. This can be critical for battle wagons, or for carts and carriages in our crowded cities."

Alemanni caught sight of a child's toy parachute. By pulling a spring, it was sent upward like a weighted arrow before opening up to float earthward.

"I remember these!" he exclaimed, touching it with delight.

"It spins around a screw," explained Leonardo. "This creates a helix in the air, sending it upward. In this way, with proper gears and power, you can send a man into the air and keep him there."

"Until it stops and he breaks his neck."

Leonardo smiled. "Using a tent made of well-primed canvas, about twelve *braccia* across and twelve high, you should be able to drop to earth from any height without harming yourself."

Alemanni lingered, seeing an extended pair of eagle wings. Next to them were several folios containing mathematical calculations and drawings of wingspans, and one showing a man in flight.

"So you plan to fly with this bird?"

Leonardo stroked the eagle wings, which were pinioned to a wooden base.

"First, you have to understand the nature of air itself as a sort of liquid with varying weight, through which a man with sufficiently broad wings, and the power to move them, can fly." He smiled at an old dream. "*Sì, caro Pietro,* he could one day join the eagle."

The envoy had more than needed to confirm the Florentine's mechanical genius. It was time to clarify the Moor's charges.

"Where are you with the Sforza horse?"

"Come, I'll show you."

They descended the steps again and, passing through a large painting studio, entered the master's private studio. Alemanni saw a workbench with a bronze model of a rearing horse cut into three parts.

"O Dio!" he bantered. "Another dismembered creature."

Leonardo nodded, and the diplomat wondered if the duke was right.

"You were unable to cast this into bronze?"

"I found a better solution."

He opened a notebook with drawings of the Sun King's striding horse in Pavia, followed by sketches of parts of other horses—flaring eyes with forelock and alert ears, the chest with high-stepping forearm and cannon, a driving gaskin with hock and shank.

"It's no longer rearing?"

"A rearing horse is but a second of time," explained Leonardo. "This one will be timeless and twice the size of the other . . . a mythical creature, bigger than life."

The ambassador shook his head. "If the other horse was almost impossible to cast, how can you manage a giant one?"

"It will be walking, not rearing."

"Does the duke know this?"

"Not yet. Have you any suggestions?"

Alemanni searched the face of the proud artist. Gazing into the depths of the gray eyes, he saw once again the miraculous machines with their glistening gears, the spectacle of man in flight, then the first drawings of a striding colossus. All of it appeared before him, and he felt humbled before this man and his searching mind. He took Leonardo's arm.

"Caro amico, I will speak to the duke. He's set on having power. A giant horse striding over the heads of his subjects will celebrate his rule far more than a smaller mount on two rear legs. Believe me, you can make your colossus."

MILAN
CASTELLO DUCALE

January – April 1490

FTER A YEAR OF MOURNING FOR Duchess Isabella's mother, the sister of Duke Lodovico, the day arrived to celebrate the royal wedding with Leonardo's *Masque of Planets*, containing Bernardo Bellincioni's libretto. In the midst of the final preparations, he received an urgent note from Pietro Alemanni.

> *Carissimo* Leonardo,
> Last night I dreamed I was on horseback, riding to see your Paradise spectacle. Oddly, it was the road from Careggi to Florence. Suddenly, I was forced to turn back and take a secondary road. Dear friend, can you explain this to me before your show starts tonight?
>
> In haste, Pietro

This was a cryptic warning of danger. Lorenzo de' Medici, en route from Careggi to Florence, had encountered a band of cutthroats waiting to seize his father, Piero de' Medici. Clearly, Pietro believed someone intended to sabotage the show—probably the treacherous Ambrogio da Rosate. Alarmed, he summoned his two assistants, Marco d'Oggioni and Giovanni Antonio Boltraffio.

"Go immediately to the castle. Until I arrive, don't allow anyone near our mechanism, nor inside the back room of the stage. No one, you hear me?"

"Someone wishes you ill?" asked Marco, a tall blond youth.

"What else?" replied Giovanni Antonio, a short and stocky Lombard. "Let's go!"

When Leonardo arrived, his assistants reported that all seemed in order. No one had entered the stage or approached the aerial mechanism. The show's seven actors, who would impersonate the planets, and two bargemen for the spring-driven mechanism had been detained in the dressing room.

"Two palace guards came, but we sent them away," reported Marco.

"One of them was angry," explained Giovanni Antonio. "He said he was from the duke and would return."

"I doubt it," replied Leonardo, smiling. "Let's go over everything, piece by piece, to make sure nothing has been touched."

Marco d'Oggiono brought onstage the actors dressed as planetary gods, as well as the two muscular bargemen. Leonardo took a deep breath and pulled the power lever. The planets began to orbit slowly beyond the moon. He allowed them to rotate for several minutes while the two men, who normally dragged barges through Milan's canals, cranked the springs that powered the machine. After halting it at intervals without incident, he sighed with relief. Apparently, no one had sabotaged the mechanism.

Glancing through a through a gap in the curtain, he noted the lords and ladies of Milan settled on cushioned bleachers along opposite sides of the hall, which he had transformed for the occasion. Its domed roof was now a cupola of woven green laurel, its walls lined with paintings of Francesco Sforza's military victories.

Duke Gian Galeazzo and Duchess Isabella, along with their guests of honor, were there, seated on a central dais before the stage. Isabella was radiant in a robe of ducal white trimmed with gold and covered with jewels, her face flushed with excitement. Duke Gian Galeazzo, in white satin with golden insignia, seemed pale and apprehensive.

Little wonder. Everyone was staring at him and his duchess as if they were animals in a cage, the ladies gossiping in loud whispers, interspersed with screams of laughter: Cara mia, *nothing has changed! That poor Neapolitan is still as chaste as snow. What do you expect? Her duke has nothing but a floppy oyster!* They also laughed at the Moor, who wore a Spanish-style costume to honor the bride: Povero uomo! *It's his confused idea of what's worn at the court of Naples . . .* Signora mia, *don't fool yourself. He knows what he wants. Look at him sitting behind the duke of Milan, ready to shove that poor boy without balls off the throne!*

The men, Leonardo noted, were staring at Isabella with sly smiles: Signori, *she's got the Spanish blood of Aragon. Women like that go wild in bed, like runaway horses. . . . Madonna, why doesn't the Moor give it to her? He's taking the duchy from his nephew, so why not his woman? . . . Are you crazy? Spoil that delicious* fica *with the Moor's little rod?*

The treatment of Isabella as a royal broodmare disgusted Leonardo. Women were one of the divine mysteries of Creation. Especially one with the spirit and beauty of Isabella. Those grunting pigs, imagining their snouts upon her, would never know the wonder and beauty of her inner being.

A sudden blare of trumpets and roll of drums startled him. The show, featuring Isabella, was about to begin. Yet she was still seated with the duke. Had she changed her mind at the last minute? At Pavia, he had refused for her to appear onstage before his Milanese subjects, then relented when she had insisted.

Through the gap in the curtain, Leonardo urged her on. "Go on, Isabella! Let them see you!"

Five young women in bright floral dresses beckoned her from the stage, clicking castanets and striking their heels to music supplied by three guitarists seated in chairs. Then the music ceased, and the dancers sank to their knees for her to join them.

"*Vai!*" he shouted through the curtain, without thought or care that the intimate verb form, which meant "Go," was for dogs, pupils, and servants—certainly never for a princess.

Isabella smiled and nodded. Had his cry of anguish entered her own? No matter, she rose to walk toward the stage. In the hushed silence of the great hall, the nobility of Milan stared at their new duchess from Naples—a proud creature of sixteen with the dark features of Aragon and the allure of a courtesan in a gown of gold brocade and jewels. There were excited murmurs in the hall, and in the royal box, her spineless duke smiled, as though seeing her for the first time.

"We've got him," Leonardo murmured. "And he hasn't seen anything yet."

Masked dancers of many nations—Spain, Hungary, Germany, Poland—began to pay homage to the seated duchess, until a little boy with angel's wings appeared before a satin curtain stretched across the full length of the hall.

In a tiny voice, the angel informed the most noble and illustrious lords and ladies they were about to witness an event never seen on this planet. Sudden shouts from the audience, with piercing cries from the women, sent him scurrying from the stage.

The curtain had risen, revealing an overwhelming vision of the heavens. The audience saw the Paradise that might be there for them—God willing!—at the close of their sinful days. On a distant horizon, torches illuminated twelve signs of the zodiac, which governed the lives of those in the hall, before they rose to heaven or sank into pits of sulfur.

In the midst of this glory, the seven planets circled around the sleepy face of the moon. Each one contained a glowing light while orbiting in the night sky within an immense egg-shaped shell—the heavenly sphere. Various melodies with harmonious songs hid the sound of the aerial mechanism, increasing the impression of the spectacle occurring in the vast silence of the heavens.

As one or other planet passed near the earth, a god would appear onstage to pay tribute to Duchess Isabella on her throne. One after another, with rival songs and poems, they confessed wonder and love for Duchess Isabella's virtue and beauty. Jupiter rushed forward to save her from Apollo's jealousy. Mercury brought three pagan Graces and seven Christian Virtues to protect her from jealous gods and scheming mortals. Dancing nymphs crowned her within a suspended circle of blinking Chinese lanterns.

Finally, the three Graces and seven Virtues led Isabella to her royal bedchamber—her face "shining like the sun" as the curtain came down. The audience cheered. Duke Gian Galeazzo, rising with excitement, seemed aware of losing his woman—if only to the hearts of the Milanese. Leonardo nodded with delight.

"*Brava, donna,*" he whispered. "Now make him beg for it."

Three months later, Trotti was pleased to inform his mistress, Duchess Leonora of Ferrara, that her illustrious niece, Duchess Isabella, was finally pregnant. Her duke, however, he added, "is sick to the stomach from having overtilled the ground. Where before spurs were needed, he now requires the bridle!"

2.

The Paradise spectacle was a turning point in Leonardo's career at the court of Milan. Lodovico Sforza made him a permanent *ingeniarius ducalis* and confirmed his commission to create the equestrian monument. The regent finally realized that the diverse disciplines and creative power of this Maestro Leonardo could glorify the Sforza dynasty and spread its fame to all of Europe.

It was no longer necessary for Lorenzo de' Medici to send another sculptor from Florence. Leonardo would create Ton, the magnificent Sforza warhorse, a bigger beast than had ever been known, in any way he desired. No doubt about it. Even Ambrogio agreed, after claiming Leonardo's astral chart had been structured on false data from Florentine records.

The spectacle also changed the life of the Moor. Cecilia saw it coming.

"In one show, Isabella conquered Milan," she said.

"I know that," he replied.

"She even woke up the sleepy duke."

"What are you saying?" he asked, irritated.

They had made love and were now talking in bed. Usually, this was the wonderful part. It gave meaning to the first part. But not this kind of talk.

"She wants to be the real duchess now, and Milan is waiting for that to happen."

"*Porco cane!* What can I do about it?"

"I can't say it," she replied, rolling away.

He looked at the red and yellow lilies on the embroidered bed canopy. She couldn't say it, but he knew what she meant. The only way to block Isabella was for him to marry Beatrice d'Este. He had postponed doing this three times, sending her jewels and the Roman sculptor, Gian Cristoforo Romano, to do her bust in marble. He didn't want her, but he needed her father, Duke Ercole of Ferrara, as an ally of Milan. And a royal marriage would help him to finally rule as the actual duke of Milan.

Cecilia stared at the Virgin with Jesus and the infant Saint John in their cave.

"We have no choice," she said suddenly.

He knew it was true. He had to do it. But that girl from Ferrara would never replace a woman like Cecilia. Never. And she knew it, too . . . or did she? He pulled her over, and she was weeping.

"It's not the end," he said, kissing the tears.

"Except for this," she said, pulling him close.

"Don't say that. You're staying here with me. I'll put her in the Rochetta," he promised, referring to the fortress within the castle walls.

"You're crazy!" She laughed.

"I need you here. You're my compass in a crazy world."

"Hold your compass," she whispered. "Hold her tight, my lord."

MILAN
CASTELLO DUCALE

April — May 1490

Two WEEKS LATER, LEONARDO opened a large notebook devoted to the studies of light and shadow. On the fifteenth folio, he wrote: "23 April 1490, I began this book and began again the *cavallo*," meaning the bronze horse.

He began as he did with portraits of women—sketching movements of the mind. From these drawings, and with knowledge of anatomy, he eventually experienced a sense of entry, a transcendent fusion of self into primal elements of a woman—or a horse, for they also possessed buried secrets and dreams. In this manner, with precise calculations by compass and calibrated staff, he configured the greatest war mounts in the stables of Milan.

One morning, while studying dimensions of Sicilian, Sanseverino's famous horse, his housekeeper brought a letter left by a palace courier. It was from Calco, written without the secretary's habitual informality:

> *Ill.mo Maestro,*
>
> His Excellency, Duca Lodovico Sforza, regent of the Duchy of Milan, requests your presence this day at the fifteenth hour on a matter of extreme importance . . .

At the castle, Calco led him into the royal office of government, decorated with frescoes of Francesco Sforza's military victories. The regent of Milan was seated in a golden throne chair, his long desk piled high with papers.

"Sire, your great horse is well under way," he said. "I'll soon have a model for you. Here are some drawings."

With Calco's help, he spread the ink renderings across the end of the desk. Lodovico stood up to inspect them. He paused at one drawing of the

horse striding forward with his left leg raised, his proud head arched in full alert. After a moment, the duke touched the head with a plump index finger. Then he slid it along the back of the mount with a flashing of his ruby ring.

"Very beautiful. May I have this one?"

"Of course, my lord. Take what you desire."

"I can see my father on this beast, reviewing his troops before battle. . . . You will name him Ton?"

"Big Ton. He'll be over twenty feet high."

"*Santo Dío,*" murmured Calco. "Has anyone ever made a horse that big?"

"Never, but I can do it," Leonardo asserted. "We'll cast it upside down in great pits with four furnaces."

He could cast a horse of any size. If they doubted it, to hell with them.

"*Va bene,*" replied the Moor. "Maybe he'll do it."

Calco nodded agreement and the regent sank back into his throne chair. Grasping the golden armrest with its carved heads of reclining lions, he said he was going to marry Beatrice d'Este.

"Let's get to the wedding," he grumbled, pushing aside the drawing. "In your *Feast of Paradise,* you made Isabella of Aragon a mythical diva. I want something more for Beatrice d'Este. Everyone must realize that the wife of the regent is a princess from the house of Este as well as my duchess of Bari."

"It's crucial," Leonardo agreed. "Her image is vital for your lordship."

"My enemies will do everything possible to prevent this. That's why I want her wedding to be more spectacular than Isabella's, with a six-day festival for everyone in this crazy duchy."

"It'll be a pleasure, sire," replied his artist-engineer. "If your brother, Cardinal Ascanio, finds a new relic of Saint Ambrose on the day of your lordship's wedding, people will believe their patron saint has chosen Duke Lodovico and his duchess to rule Milan."

"What an extraordinary idea!" exclaimed the Moor. "Messer Leonardo, you would make a remarkable diplomat."

Calco nodded, and Leonardo felt he was no longer an outsider. Nor was he the usual signore of the court. He was Maestro Leonardo, a mythical *mago* and valued counselor in the Moor's rule of Milan.

"If we don't have the relic"— he paused, certain this would also please them—"maybe Saint Ambrose could work another of his miracles on the day of her arrival."

"That'd be easier to arrange than a relic," mused the Moor. "Yes, we'll do it. Also, there'll be a three-day tourney in front of the castle, with knights from all of Europe. What can you do with that, maestro?"

"We could put the knights in costumes, with mythical gods entering the listings."

"Bravo! And for a ball at the end of the tourney?"

"Decorate the Sala della Palla with paintings displaying the glory of Francesco Sforza and your rule of Milan."

The Moor nodded. This was exactly what he wanted. Leonardo seemed to speak his mind before he knew it himself.

"We need a bridal suite in the Rochetta," he said. "Private rooms for the duchess, her ladies-in-waiting. . . ." He pursed his lips. "I have an idea. In your proposal for satellite cities, you offered baths with running water. Let's install one for the duchess."

This surprised Leonardo, He had never heard from the Moor or Calco on the proposal.

"And your quarters, sire?"

"Adjacent to the passageway."

Leonardo had expected this. A secret passage, with gates and guards at each end, ran through the walls from the fortified Rocca to the castle, where Cecilia lived. So she would stay on—or would she?

"With Donna Cecilia expecting your heir, my lord, shall we install running water in her bath also?"

Lodovico seemed surprised, then suddenly angry. "Does Cecilia remain in the castle? That's what you're asking, right?"

"Not exactly."

"*Per bacco,* you think I would send her away while she's with my child?"

"No, sire."

"So there's your answer. Give her a silver bath with a river of running water . . . Is that clear?"

"Yes, my lord."

"Good-day, signore."

May – June 1490

THE DAY FOLLOWING HIS HUMILIATING DISMISSAL, Leonardo received a note from Calco, confirming his proposals for the marriage: "His Excellency also approves your considerate suggestion for a second new bath in the castle."

That was how it was with the Moor. Nothing was certain. Nor was it anywhere else. People betrayed one another in *tamburo* drums all over the world. Only in nature and mathematics was there any certainty, structured on logic and order. And now it lay before him, in the head of a decapitated criminal—sent by an anatomy professor at the Collegio dei Nobili Fisici, Milan's medical school, who feared his students would stare at the dead man's face, rather than follow the day's discourse on vital life forces rising upward from the liver to the furnace of the heart.

Leonardo received it in the dissection room at the college. Belonging to a dark-skinned male, it had been severed by an executioner's ax. Dried blood matted its curly black hair and drooping mustache. He approached it with awe and wonder. Here lay the unexplored world of man—the universe of his intellect, the dwelling of his soul. Here lay secret channels to the origin of human doubt. Here lay the genesis for every form of life in nature, immortal daughter of God.

He removed the scalp and drew the skull from four sides. These ink renderings allowed the viewer to effectively walk into the house of the mind—a technique from twenty years ago in Florence, upon dissecting the human heart. Next, he split the skull in half for a cross-sectional view of its interior structure—unrivaled for two centuries and never equaled in its stark and haunting beauty.

From this osteology of the skull, he turned to its inner life and nervous system. A notebook entry, charged with awe and excitement, offered a rare cross section of his searching mind:

> Represent whence catarrh is derived. Tears, Sneezing. Yawning, Trembling. The falling sickness [epilepsy]. Madness. Sleep. Hunger. Sensuality. Anger, where it acts in the body. Fear, likewise. Fever. Sickness. Where poison injures . . .
>
> Why lightning kills man and does not wound him, and when a man blows his nose, why he does not die of lung injury. Write what the soul is. . . . How necessity is the companion of Nature. Illustrate whence comes the sperm. Whence the urine. Whence the milk. How nourishment proceeds to distribute itself through the veins. Whence comes intoxication. Whence vomit . . .
>
> Whence dreams. Whence frenzy resulting from sickness. Whence it happens that by compressing the arteries a man falls asleep. Whence when pierced in the neck, the man falls dead. Whence come tears. Whence the turning of the eyes so that one draws the other after it . . .

These mysteries within the brain were served by a primal pathway—human vision. Indeed, the primacy of vision was identical with intellectual activity. To explore this, he boiled the criminal's eye in egg white. This created a firm coagulum, allowing him to dissect its tissue, isolate its lens, or crystalline humor, and detach the iris. Finally, he drew the optic nerve of the eye entering three egg-shaped cavities, or ventricles, of the brain.

In his reverse script, he carefully described the brain's first, or anterior, chamber as containing the *sensus communis,* capable of fantasy and imagination. The middle chamber was the seat of *cogitato,* the faculty of judgment. In the final, or posterior, chamber lay *memoria,* with the power of remembrance and voluntary movement.

The eye, in transmitting images to these chambers, converted them into visual form through a *virtù visiva,* or "seat of vision." In this way, the brain created its own interior pictures. The painter, working on the outside, had to know this.

> The painter is concerned with all ten functions of the eye, that is, shadows, light, volume and color, figure and placement, distance and proximity, movement and rest. . . .

The eye embraces the beauties of the whole world. It is the master of astronomy, the author of cosmography, the advisor and corrector of the human arts. It carries men to different parts of the world; it is the prince of mathematics . . . the window of the human body through which the soul observes the beauties of the world and . . . therefore accepts the prison of the body, which would otherwise be a place of torment. . . .

So it seemed. Yet not even Leonardo's remarkable eye, capable of perceiving the unknown in nature and science, could discern inherent dangers within himself.

July 1490 – February 1491

UNDER LEONARDO'S DIRECTION, a score of painters, goldsmiths, and artisans prepared the bridal suite in the Rochetta, with separate quarters for the Moor. Virtually every painter in the duke's domain was also employed in covering the walls of the Sala della Palla, a 160-foot sporting arena, with paintings of Francesco Sforza's military victories, and in turning its vaulted roof into a sky blue heaven with golden stars. Meanwhile, palaces and outlying castles were prepared for retinues of noble lords and foreign princes linked to the Sforza and Este families.

Milan buzzed with excitement in anticipation of a week of masques and plays, fancy balls, and the three-day tournament featuring the greatest lances of Europe in disguise—including the formidable Galeazzo da Sanseverino, whose costumes were being designed by the Florentine artist Leonardo da Vinci. In the midst of this, Giovanni Antonio Boltraffio entered his master's private study in the Corte Vecchia.

"Forgive me, maestro. There's a farmer outside with a boy named Giacomo, who says he has an appointment with you."

"I don't know any such boy. What does he want?"

"I believe he wants to apprentice him with you. He gave me these."

Boltraffio placed a sheaf of papers on the desk—childish drawings of a horse copied from posters proclaiming a special tax for two simultaneous marriages:

> +Anna Sforza, sister of the Duke of Milan to Alfonso d'Este of the royal house of Ferrara,
> +Lodovico Sforza, Duke of Bari, Regent of Milan, to Beatrice d'Este, daughter of Duke Ercole d'Este of Ferrara.

The master laughed, shaking his head. "That boy has no talent, but also no fear. These posters are intended for the public, not a schoolchild. How old is he?"

"I don't know. Maybe eleven. He says he's here to help you make a big horse."

"Make a horse?"

"That's how he put it. They also have a large ham and some cheese for you."

He laughed again. "Giovanni! Why didn't you say that right away? Maybe we have a rich benefactor. Send them in."

"Rich they are not," warned Giovanni.

The farmer entered with his young boy. Giovanni was right. This was a poor *contadino* in a tattered cloak, carrying a ham and a cheese drum. The boy was in rags. But he had the poise of a little prince and a face of remarkable beauty—a high noble nose, a broad brow over dark, dreamy eyes with lowered lids, a petulant mouth with a full upper lip, and, crowning it all, a luxurious tangle of blond hair. The boy smiled and extended his hand as though they knew each other and had an appointment.

"*Buongiorno,* maestro."

"*Buongiorno,*" replied Leonardo, taking the hand and holding it with sudden awareness that he would miss its withdrawal.

"Messer Maestro," said the farmer. "If it pleases you, I will leave Giacomo with you for instruction."

The maestro withdrew his hand, but Giacomo continued to stare at him. With a shudder, Leonardo recalled the cold, uncaring farewell of Donatello's *David*—the lascivious lover standing in triumph over its shrunken, lifeless creator.

Not having a reply, the farmer spoke to Boltraffio.

"So may I leave Giacomo with the Signor Maestro?"

"You have to pay six lire each month," he snapped. "We don't feed people for nothing."

This startled Leonardo. Giovanni wanted no part of this new apprentice.

"Lire, I have not," replied the farmer.

He turned to the maestro, saying he was Giovanni Pietro Caprotti of nearby Oreno, a poor but honest *contadino*.

"Food, yes, I can send to you," he said, placing the ham and cheese on top of his boy's crude drawings. Leonardo nodded.

"I'll think about it."

"*Signore mio!*" cried the boy, kneeling to kiss the master's hand.

"All right, Giacomo. Come back next week." He turned to the farmer. "We'll give this a try. Start sending your food and vegetables."

Giovanni showed them out. When he returned, his head was tilted to the left, as though trying to determine what was wrong with a painting.

"You said he had no talent."

"Maybe it's there but not developed. He's bright and quick. With discipline, he might become an unusual painter."

Giovanni straightened his head. "If he doesn't listen to you, we'll have a wild fox running around here. Then what'll you do?"

"I'll send him away," Leonardo replied, feeling a sudden sadness.

A week later, Giacomo's arrival was recorded among notes on light and shadow. Beneath an exultant entry in April on the horse could be found a similar note of triumph for the boy: "Giacomo came to live with me on the feast day of Saint Mary Magdalene (22 July) of the year 1490. He is ten years old."

It was a short-lived triumph. The master soon found his pupil was worse than a wild fox. With surprise and anger, he noted: "On the second day, I had tailored for him two shirts, a pair of hose and a jerkin; but when I put aside the money to pay for them, he stole the money from the purse. Though it was impossible to wring a confession from him, I am absolutely sure that he did." A cost was entered: four lire. He described the boy as a "thief, liar, obstinate, and greedy."

Despite his promise, Leonardo did not send the child away. He secretly relished the little devil and called him "Salai"—a Tuscan word meaning "demon," or "limb of Satan." Boltraffio and the others in the workshop had to accept the master's decision. He was human, like anyone else.

2.

Lodovico Sforza was similarly surprised to discover that he could rule a duchy but not a child bride of only fifteen. Overnight, Beatrice d'Este emerged as a woman of fierce ambition, insatiable pride, and capricious willfulness.

It began shortly after their first encounter, January 15, 1491, when he climbed aboard the buccaneer that had brought her, along with the Ferrara party of fifty people, up the Po and Ticino rivers to Pavia. She knelt before him, her red velvet robe spread out on the deck of the royal barge.

"My lord," she murmured, her eyes modestly lowered.

"My lady," he replied, kissing her hand as she rose.

It was the hand of a little girl. The face was also that of a child—a moon face with the sullen mouth of a petulant teenager. He imagined it under him, looking up, or lying on a pillow as he stared across at it in the morning. Not for a night, nor a few days. This would be across the years, with that mouth and the moon face. *Madonna mia!* . . . Yet there was something more, suggesting surprise, even danger. It was in her eyes—dark and flecked with yellow, staring like a cat as she waited for his first move.

On the boat deck, two women suddenly appeared. The one on the right had the pure face of Aragon, its beauty framed by the cowl of a purple cloak.

This was Duchess Leonora, wife of Ercole d'Este, mother of the bride, and aunt of the rebellious Isabella. He took her jeweled hand, performing the ritualized kiss of hovering lips.

"My dear duchess, the honor and joy of having you cannot be surpassed by any earthly delight."

"Most illustrious lord, your gallant words encircle my heart."

He turned to the second woman, who was wearing a sky blue cloak embroidered with golden prancing lions. Isabella, the marchioness of Mantua. This sister of Beatrice had shades of her mother's dark beauty. She had been his first choice when she was only six, but Duke Ercole had promised her to Francesco Gonzaga, son of the Marquis of Mantua. Would her five-year-old sister, Beatrice, suit him as well? he'd wondered. Indeed, she would. Marriage into a royal family would bring him closer to the throne of Milan.

Isabella extended her hand with the guile of a courtesan.

"My lord, after two weeks in freezing snows, may I presume that your castle in Pavia has a roaring fireplace?"

"It has many, my lady."

"Then let's be off!" said Beatrice, taking the arm of her new lord and future husband.

Leaving for their waiting mounts, the bridal couple encountered a youth in a russet doublet trimmed with gold—Alfonso d'Este, brother of Beatrice and heir to the throne of Ferrara.

"Your Excellency," he said, bowing to Lodovico. "Anna and I are deeply grateful for the honor of celebrating our wedding, together with your illustrious marriage to my sister."

"My dear Alfonso, it is you who will make it memorable for us."

Indeed, it was just that. The coupling of his own wedding with that of Alfonso and Anna Sforza, sister of the duke of Milan, allowed him to decree a week of festivities in honor of the ducal houses of Milan and Ferrara while investing his own wedding with a pomp and glory exceeding his lesser role as duke of Bari and regent of Milan.

With Beatrice at his side, he led the royal cortege through the streets of Pavia in the fading light of a January afternoon. They rode through crowds along the Strada Nuova, passing marble palaces and loggias with flags and tapestries, the famed Ateneo university, and the cathedral with its sun-god monument, which had inspired Leonardo.

Along the way, the people shouted their joy: "*Il Moro! Il Moro!*" He nodded to them. Beatrice also bowed and smiled, as though she were already their duchess. What's more, she did it with gravitas, as though she believed it. Good,

he thought. They shared the same dream, and, apparently, the same resolve. That viper Isabella was about to meet her match in her arrogant cousin. They had played together as children at the court of Naples. At the court of Milan, the game would have far higher stakes.

At the castle, prior to an intimate chapel wedding, Beatrice began the game ahead of time.

"I thought we would do this in Milan, like Isabella and Gian Galeazzo, with a gorgeous parade."

The little bitch hadn't the slightest clue of how it worked. His enemies were waiting for a mistake like that. A wedding in a family chapel would cast no shadows.

"I had hoped for something like they had."

"Be quiet, donna!" He paused to control his anger. "Let's get this straight from the start. When I need your counsel, I'll ask for it. Is that clear?"

"Yes, my lord."

"Besides, you're getting a lot more than a passing parade. All of Milan is waiting to cheer you. There'll be a week of spectacles created by a Florentine genius, Leonardo da Vinci, then a three-day tournament with knights from all of Europe, and a wedding ball where you can dance with gallant knights to make me jealous."

"My Lord, when you discover how I feel about you, you'll realize that's impossible."

That was better. Or was it? She had phrased it like a room of mirrors where you saw only parts of yourself—a lovely bit of subterfuge. He smiled with delight. This woman would have no trouble with fork-tongued courtiers or diplomats in the ink clouds of scuttling squid.

His joy faded, however, amid the grim circle of royal relatives during the wedding in the ancient chapel. He now faced his betrayal of Cecilia, pregnant with their child. Ambrogio said the stars promised a boy, so he was also betraying his son. Entering the bedchamber, he expected the usual fright of a virgin—covers under the chin, the mouth in a pathetic little smile. Instead, this one was sitting upright on the immense four-poster bed, her arms around her knees, wearing a transparent blue gown.

"There he is! My lord has arrived!"

She laughed and threw her gown onto the floor. Her breasts were small but firm, with a virgin's pink nipples. In bed together, she began to kiss his breasts, then gently bite them. He pushed her away.

"Where did that come from?" he demanded.

"What?"

"You know what. Who taught you that?"

"No one," she replied, her eyes closed.

"Nonsense. You have slept with another man."

He sat up, disgusted. She laughed again and pulled him back.

"Don't be afraid, my lord. Isabella taught me everything to please you. Don't you like it?"

For the love of God, he thought. Their sex life programmed by Isabella! At this moment, her ladies would be tittering over the thought of Beatrice sucking his nipples . . . and what else? He had trouble breathing, and his erection collapsed.

"What else did she tell you?"

"This," she said, taking him in her little hand. As his penis rose again, she whispered, "I must comfort it with my mouth. But if it gets any bigger, I won't be able—do I have to do all of it now?"

"No, I'll do everything for you."

"Then do it, my lord, so that we can become one together."

The following day—January 18, 1491—an official proclamation was posted in Milan, and in every city of the duchy, with dispatches to its ambassadors in foreign courts. It made clear that the regent of Milan had triumphed where its titular duke, Gian Galeazzo, had failed: "The nuptial benediction was pronounced, the act of espousal confirmed by the ring which Signor Lodovico placed on the bride's finger, and that night the marriage was consummated."

3.

Leonardo's difficulty in controlling his young pupil was further compounded by his own desire for the boy. He didn't want it to go that far. Andrea had never done it with his apprentices. They had often embraced with warmth and love, but always as father and son.

Now he was the master, and his eyes had to look elsewhere. So he told himself, only to fail the first test. When fine linen shirts and leg stockings arrived, Giacomo was too filthy to wear them. Boltraffio and Marco d'Oggiono had left for the day. Caterina, the housekeeper, was at the Ospedale Nuovo with an ailing aunt. So the boy was allowed to use his master's bath.

Leonardo watched him undress—noticing the slender body, the budding breasts, the tight little hips, the languorous penis over its sac, the rich lips and open mouth, the tangled waves of blond hair—all of it sinking with a sigh into the hot tub.

"Here," he said, throwing the boy a bar of soap.

"Thank you, master. I love being with you."

He turned to leave, only to pause as the boy began to soap himself.

"I can't reach my back," he said, offering the soap with both hands.

"All right, give it to me."

"Oh yes!"

He began on the neck and shoulders, then washed down to the water's edge. This would do it. As he paused, however, the boy stood up in the tub. So he continued, descending to the top of his buttocks. That was it. He could go no further. Yet he could if he wanted it, and suddenly he wanted it, and he slid his hand into the lovely narrow valley.

"Yes, yes!" cried the boy, grabbing his little mounds.

"No . . . that's all," stammered Leonardo, dropping the soap to rush from the bath.

Shaking with fury and shame, he sat at his desk and stared into the darkness of his palms to block it out—the glistening body, the little penis, the delicious lips, the spreading buttocks, the child's voice as he said, "Oh, yes!"

Saint Jerome appeared, beating himself with a rock while the lion waited for the arrival of night and the return of erotic dreams. Cennini had warned against this. Sex could make your hand shake like a leaf, and drain your creative powers. But then Andrea had said, "Your daemon can lead you to a new sanctuary in the creative mind."

He sighed and opened his eyes. The notebook concerning his study of light and shadow lay open on the desk with his notes for a *Treatise on Painting*:

> I state that every opaque body is surrounded, and on its surface is clothed with shadows and lights . . . and from these primary shadows, there issue rays of shadow, which are diffused in the air . . .

This was a primal problem in painting—the diffusion of a clear outline in reflected rays of light. *Per bacco,* he thought, there you are. As light and shadow are fused, your visible self is fused in a shadow world of sex and dreams. Startled by this insight, he read on:

> . . . when these derived shadows fall on an obstacle, they produce effects as varied as the different types of places they strike [while] numerous varieties of reflected rays will modify the primary shadows by as many varieties of colors . . . from which these luminous rays issue . . .

There it was again. You could determine fixed laws governing reflected lights and the shadings of shadows. Yet nothing could alter the visual ambiguity resulting from their intermingling. And since this was innate in nature, was it not the source of ambiguities of the human mind and spirit?

Shadow is of the nature of darkness, light of the nature of brilliance. One conceals, the other reveals. . . . Yet shadow is always more powerful than light, for it can entirely deprive bodies of it, while light can never dispel all shadow from a body . . .

So the painter, in describing man and the motions of his mind, had to model forms across a tonal range from white to black, or through the color spectrum, with the latent ambiguity of shadow conveyed through a mix of *chiaro et scuro*—a *chiaroscuro* of lights and darks within the colors. Yet within this, the primacy of a shadow world gave it life.

From his studio, he looked across the square at the stone saints on the cathedral. There you could see it happening—the world of moving shadows bringing life to these men as they emerged from a history of human faith. This was what he needed for a *Last Supper* at Santa Maria delle Grazie—the ambiguities of light and shadow in a portrayal of the human experience across the landscape of time. It would have to be structured on diverse elements—the transepts of reason, the purity of mathematics, the ambiguity of beauty, the anarchy of love, the dream of eternal life, and, inevitably, the tragedy of betrayal and death.

Only then would it encompass his dreams. It would have to wait, however, until Bramante found some compromise to satisfy the Moor, who was stubbornly demanding that the new tribune replicate Brunelleschi's Old Sacristy at San Lorenzo, where God had saved Lorenzo de' Medici from assassination during the Pazzi conspiracy.

4.

Upon approaching Milan with her royal escort—Sunday, January 21, 1491—Beatrice d'Este found her old playmate and cousin, Isabella of Aragon, waiting before the suburban church of Sant' Eustorgio. The two duchesses, soon to become fierce enemies, embraced and proceeded to the city gates, where their two dukes and a company of Milanese nobles met them.

Lodovico, in a mantle of gold brocade, rode through the streets with his bride, preceded by forty-six pair of trumpets, sending birds and pigeons into

frantic flight. Around them lay another paradise created by Leonardo. Tapestries, flags, and costly brocades festooned windows and balconies; wreaths of ivy entwined columns and doorways. Along the via degli Armorai, headless knights in shining armor waited with lowered visors over faceless stumps, glittering swords and lances at rest in mailed gloves. From these ghostly figures in gray winter light, Beatrice arrived at Castello Sforzesco.

With a final trumpet blast, Bona of Savoy received her under the castle portal. The duchess, back from exile, embraced her two daughters, Bianca Maria and Anna Sforza. Anna's marriage to Alfonso d'Este was to be performed privately in the ducal chapel, with royal celebrations upon their return to Ferrara.

Duchess Beatrice was delighted with her bridal suite. In a bedroom of red damask, angels and doves frolicked across a frescoed heaven above her four-poster marital bed. In addition, she discovered a book-lined study and writing room, two dressing rooms, four wardrobes, Leonardo's miraculous bath with running water, two wardrobe mistresses, four ladies-in-waiting, and an adjacent lounge for informal encounters with visitors.

As her lord had promised, their marriage was more than a passing parade. At Isabella's one-day *giostra* in Pavia, her knights at arms had worn ordinary attire. For Beatrice's three-day tourney in the vast piazza of the castle, her knights appeared in exciting costumes with exotic symbols.

During the three-day tilting matches, a disguised knight entered the lists. Francesco Gonzaga, marquis of Mantua, had shunned the wedding in deference to his Venetian allies, who distrusted this marital bonding of Ferrara with Milan. Yet he could not resist a *giostra* with the greatest lances of the day. His red lips, bulging eyes, and ape's nostrils were hidden from view, but Isabella d'Este proudly knew her husband from the fury of his charges on Pluto, his favorite Andalusian black stallion.

In a din of clashing armor and muffled screams, huge lances of great weight were broken like straws. Powerful knights, their mounts charging with the sound of thunder, crashed and fell like giant oaks. Many were wounded and left the field. One lance ripped into the hand of Annibale Bentivoglio, but he remained in his saddle and fought on, toppling six more rivals. Finally, on this ritualized battlefield of splintered lances, broken bones, and fallen knights, Galeazzo da Sanseverino was crowned victor. Beatrice was delighted and gave him the palium of gold brocade as if she were victor of the day.

There remained, however, the victory ball of that evening, with its own upsets and triumphs on an equally fierce battlefield of the human heart.

February – March 1491

ALMOST EVERYONE AT THE VICTORY BALL expected some royal skirmishes. All of Milan knew Gian Galeazzo's Neapolitan princess hated the Moor and her awful cousin Beatrice, and that she wanted her grandfather, the king of Naples, to send an army to put her duke on his throne, even though he didn't want it. Also, *cara mia*, the Moor's mistress, Cecilia Gallerani, was still in the castle. . . . Did Beatrice know this? they wondered. *Signori miei*, a spectacular evening!

Indeed, the titular joust began immediately. Protocol required that the regent of Milan, Duke Lodovico, and his duchess, Beatrice, give precedence of entry to the reigning duke, Gian Galeazzo, and his wife, Duchess Isabella. They were delayed, however, which left the Moor and his Beatrice fuming with anger under Leonardo's outside arch of triumph.

When the royal couple did arrive, Isabella swept past them with the air of a reigning duchess, wearing a flowing cape embroidered with the ducal coat of arms, underneath which was a jeweled gown of white silk. Duke Gian Galeazzo followed as though late for school—a slight, pale figure in a cream-colored ducal uniform with golden tassels and his ducal insignia on a crooked gold chain.

Then Isabella saw Leonardo—at thirty-eight a handsome figure with a short auburn beard, dressed in a forest-green doublet with silver buttons, russet leggings, a pale yellow shirt trimmed with lace, and his scalloped knee-length tunic of rose-colored silk.

"*Caro Leonardo, che bella!*" she exclaimed, indicating the Sala della Palla sports arena, which he had transformed into a spacious ballroom with blue vaulting and scattered stars.

"*Duchessa mia,*" he murmured, giving a short bow.

The Moor followed without looking at him—his face dark and distant, a

huge pearl dangling from the gold letter M on his *berretto,* his double chin drooping over the white collar of a maroon tunic embroidered in gold with Ambrosio's signs of the zodiac. Had Lodovico overheard the words *Duchessa mia* as he'd bowed to Isabella? Even so, the Moor surely knew this was court etiquette. Beatrice was opposite him now—glowing in a pink gown embroidered with the French fleur-de-lis and a startling vest of woven gold. He nodded and smiled, but she also stared past him, her tiny eyes cold and distant. You bitch, he thought. I've moved mountains for you. The devil take you.

"There he is . . . Nardo!"

It was Cecilia, with Bernardo Bellincioni.

"Come along with us!"

He nodded and started to join them. She was older now. Yet there was still the smile and those eyes, filled with wonder, waiting for an unseen event. As always, she was exquisitely dressed. A pendant ruby lay upon her brow, and, over her gown, she wore a transparent sleeveless tunic of purple silk embroidered with lilies—a loose *guarnello* worn by pregnant women. Cecilia, he recalled, was now five months with child. Beneath the sfumato veil of her tunic—*santo cielo!* —there was a vest of woven gold exactly like that of Beatrice.

"Are you coming?" asked Cecilia.

"Not yet, *cara mia.* I'm waiting for someone."

Inside the hall, Beatrice looked forward to dancing with the handsome Galeazzo, who had entertained them in Pavia. Then she saw a woman surrounded by courtiers. Under her silk *guarnello,* the woman wore a vest similar to her own. At least, it seemed that way. Coming closer, she realized they both wore vests of the same woven gold. In disbelief, she looked across the floor at her sister and mother. They were also staring at the woman.

Storming through the dancers, she found her husband with ambassadors from Naples and the Holy See. She waited, eyes blazing—only to be waved away by the Moor, who had just learned that Pope Innocent VIII had invited Charles VIII to invade Italy and seize Naples, which would result in the inevitable renewal of French claims on Milan.

Turning away with fury, she encountered her mother and sister, accompanied by their Ferrara ambassador, Giacomo Trotti. Of all people, he should have warned her.

"Who is that bitch?" she demanded.

Trotti had no choice. She would learn the truth from someone else at the ball.

"She was the mistress of Lord Lodovico," he replied, seeking to lessen the shock.

"*Cara Trice,*" said Isabella. "It's Cecilia Gallerani. We told you all about her."

"You said it was over. Finished. What's she doing wearing my vest of woven gold? Tell her to leave. I don't want her here a minute longer."

"I'm afraid we can't do that." Trotti sighed, knowing she would discover this, as well. "She lives here in the palace."

"Here . . . in the palace with me? Throw her out!"

"*Cara figliola,*" replied the diplomat, who had known her since childhood. "Let it alone. Time has a way of solving these problems."

"*Time?* I have no time!" she cried.

"Be quiet. Everybody can hear you," warned her mother, Duchess Leonora.

The Moor appeared, visibly furious. He growled into his wife's ear.

"Be quiet! You're making a fool of yourself and me, as well. If you want to be duchess, then act like one."

"That woman is wearing my vest of woven gold."

"It's not the same. You're imagining it."

"Yes it is. . . . I'm leaving."

"Impossible. I forbid it."

"If you leave," added her sister, "she'll have defeated you before all of Milan. You want that?"

Leonora took her daughter's hand. "*Cara mia,* listen to our dear Trotti. Time is on your side, and there's a lot you can do to speed it up."

Beatrice threw herself into dance as if there was no time left—first with Lodovico, who sought to calm her, then with the gallant Galeazzo, followed by a dozen others. Her husband followed this with alarm. She was still screaming— this time with her body. He would take care of her later. Now Cecilia needed him. He found her dancing with Galeazzo's brother, Gaspare. When they were alone, he began to apologize.

"I don't know how it happened. . . ."

"*Povero Cocco!*" she laughed. "How could you know we'd both make vests from the same *braccio* of cloth from King Louis?" Amused, she touched her vest. "You can tell your wife that mine is Parisian. . . . Now you'd better leave me. They're all watching."

"Later, then."

"No, *amore,* not tonight."

After the ball, Beatrice brought the frenzy of her dance into their bed.

"That woman, your Cecilia, is pregnant with your child."

"Who told you that?"

"For the love of God, you can see it and everybody knows it. I don't want her or that child in this place."

"She's not here. We're in the Rocca. She's over there," he replied, meaning the palace.

"I don't care. She has to leave or I'm leaving."

"Not just yet. Maybe after my son is born."

"Your son! Your son! What about me?"

She began to beat him with her tiny fists. Jesus, he thought, another woman with the blood of Aragon. Before he could reply, she was gone—closing the door to her private chambers.

2.

Lodovico had no intention of giving up Cecilia. Surely, this was nothing new for the Este family. They kept mistresses and had bastards all over the place. Beatrice's father, Duke Ercole, had inherited the throne from a bastard, his brother, Duke Borso. Their brother, Ugo, another bastard, had been beheaded for sleeping with his mother. He summoned Trotti, the ambassador from Ferrara, who had known this stubborn bitch since childhood.

"All the Este men have had mistresses and bastards," he told the envoy. "So Madonna Beatrice should not be surprised. I'm no different from them."

"There is one difference. They are reigning dukes."

The Ferrara diplomat, seeing he had scored, was ready with a solution.

"My lord, if you moved Madonna Cecilia into her own palace, you could tell them it's all over. That's all they want to hear. Indeed, you would be praised as a real signore, worthy of ruling the duchy . . . and your love, free of any reins, could proceed at whatever gate it desires."

"Ah, Trotti! You know me so well."

Lodovico acted immediately. The same day—February 6, 1491—he called in Count Lodovico Bergamini. The count had been with Cecilia when she saved his life by discerning a dagger under the cloak of an assassin. With customary grace, the count agreed to marry Cecilia. He was thirty years older than she, and he resembled old Cosimo de' Medici, having high cheekbones, a bent nose, and a banker's curved spine. Sex was no problem, either, since he preferred boys. Nor would he attempt, in some aberrant moment, any sort of conjugal intimacy without permission from the bride's lord, Messer Lodovico.

That being settled, Cecilia needed a private residence, closer than the Bergamini estate at Cremona. To install her as a noble lady in Milan society, Lodovico deeded her the famed Palazzo del Verme on Piazza del Duomo. Cecilia was delighted. She could begin a new life with Lodovico, free of spying courtiers or the indignity of sneaking through corridors.

MILAN

July – November 1493

LODOVICO SFORZA HAD COME TO POWER with an innate gift for discerning the weakness in men—their venial, frantic, grasping natures. He could smell it like a wild animal, and, like any beast, he had no pity in dismembering his victims, or turning them into pawns for his own ends—as he proceeded to do in the most brilliant and daring scheme of his career.

The dark plot unfolded with the trappings of an Italian opera. Maximilian, heir to the Hapsburg Austro-German Empire, would soon succeed his gravely ill father, Emperor Frederick III. The Milan ambassador, Erasmo Brasca, placed two proposals before him.

First, he was offered the hand of Bianca Maria Sforza—the duke of Milan's sister and Lodovico's niece—with an astonishing dowry of 300,000 ducats. The second proposal turned on Milan's being an imperial fief, as Naples was a papal fief.

Maximilian, upon becoming emperor, would renew the imperial investiture of Milan, formerly granted to the Visconti dukes, but never bestowed on Francesco Sforza. With this, Francesco's first son would be his legitimate heir—Lodovico Sforza, seventeen years older than Gian Galeazzo. To give "more solemnity and luster to the deed" another 100,000 ducats would be paid upon Lodovico's receiving the imperial diploma.

Maximilian had no interest in Bianca. But so much money was most attractive—indeed, urgently needed after driving the Hungarians from Austria, regaining Vienna, and girding his spurs for a war of revenge on France. Finally, when his father died in August, the new Holy Roman Emperor-elect consented to all of the Moor's conditions, provided the investiture be kept secret until the proper time—to wit, the death of Duke Gian Galeazzo.

Leonardo was charged with preparing for the historic wedding, to be held on November 30, 1493. Doors and windows were again wreathed with

laurel, ivy, and myrtle boughs, giving Milan the verdant face of May in gray November. To burnish the Sforza image, balconies were hung with tapestries and armorial emblems of royal houses related to this violent race descended from Romagna peasantry. The adder of the Visconti, the cross of Savoy, and the Hapsburg imperial eagle were shown alongside the mulberry tree, and other fantasy devices of the Moor. Strange emblems also appeared on the houses of new merchant barons, including a crocodile, which a startled historian described as a creature never before seen in the Lombard capital.

2.

On the eve of the imperial wedding, Leonardo entered the courtyard of his palace to speak to his heroic horse. Every element of nature, including rocks and raindrops, contained an interior life. If you listened carefully, they would speak to you . . . especially this horse of clay.

"Tomorrow the whole world will see you," he said. "I want the bronze just as much as you do, but we have to wait for it later."

He ran his hand along the right shank, feeling its dampness and inhaling the musky smell of clay. That was how it should be. Ton needed water, like any other horse. Without it, his clay would crack and crumble. He climbed a ladder and ran his hands over the mount's broad forehead and the swollen veins running from the left eye onto the cheek.

"We'll keep you wet. . . ." He paused and whispered, "God knows, I don't want to lose you."

It was more than the years of planning, sketching the greatest war mounts in the stables of Milan, noting their movement and gaits, and exploring their anatomy in autopsies. Here was a colossus that could stand with honor and glory before the ancient temples of Greece or Rome. You sensed it as you walked into the courtyard. When close, you felt the surging strength in his body, the power of his lungs, the heat of the great heart, and in those fierce eyes there was a *terribilità* that feared nothing, not even death—for death was buried within him. Heroic sculpture had that innate duality. Its daemonic charge of life contained the threat of death.

He looked into the left eye. It stared back, as it had when he'd created its dark pupil—a half-inch hole set within an eight-inch ocular sphere—releasing a sudden surge of power from beneath its hooded brow. Then, upon opening the second eye, the great beast had surged to life, both eyes staring beyond their creator toward the freedom of unseen plains and mountains. At that moment, the great horse, nurtured by dreams and shaped by mortal hand,

appeared to be immortal—though still in clay, without the bronze to ensure its continued existence.

3.

The night people of Milan—curfew police, bakers, canal dredgers, doctors, and priests for the dying—were the first ones to witness the weird event. In the light of burning torches, a huge figure was moving toward the Sforza castle on an immense wagon drawn by four black mules. The vehicle was stabilized by spring-wheels that bobbed up and down over the cobblestones like running squirrels. Two young men wearing tan work tunics stood on each side, holding on to the rope stays, while a hooded monk in brown robes sat up front next to the muleteer.

Everyone stared in wonder. Surely this was the horse made by that Florentine who lived in the Corte Vecchia palace—the colossal horse for a monument to Francesco Sforza. It would be the same horse, only much bigger than the one Francesco Sforza had ridden into the cathedral on the day he conquered Milan. Also, there was a triumphal pedestal waiting for it in front of the castle at Porta Giovio. You couldn't be sure, though. The huge beast was covered with a hemp shroud, gray and streaked with yellow in the torchlight.

People began to follow the wagon. In the piazza before the castle, other workers appeared as the monk directed them in raising the shrouded beast on the slings of a crane, which lowered it onto its stone pedestal. When it was in place, two youths in work tunics climbed ladders to release the slings, and then the crane withdrew. They poured buckets of water upon the hemp covering of the horse's head, back, and tail and splashed it onto the leg and hoof wrappings. Then they removed the shroud from the three standing legs and then from the fourth one, which was raised in a high-stepping gait. Finally, they pulled off the top covering and the great beast's arching neck and head appeared, raised in pride and fury.

The crowd sensed the body heat and pounding heart of the great animal. Its immense eyes seemed to follow them, and they were humbled and frightened. Yet when they looked beyond it at the red castle with its drawbridge and the moat with its floating white swans, they felt a strange relief and joy. The living horse spoke to them. It said, You are safe here with me. You don't need to be within castle walls. So it seemed to them, and strangers began to smile at other strangers. Something touched by God had entered their lives. Women crossed themselves. Their men nodded and said nothing.

The two youths in work tunics mounted the wagon drawn by the four

mules and rode away, the monk still sitting next to the muleteer up front. When they were again on the Corso, returning to the workshop, Leonardo threw off his hood and turned to Boltraffio and Marco d'Oggiono, who burst into laughter.

"You were a funny monk," said Boltraffio. "People asked if it's a holy horse."

"An old woman expected you to bless it," replied Marco.

Leonardo smiled. "If the day is hot, we'll have to wet him again at midday tomorrow . . . or in the afternoon."

"Master, why didn't you talk to people about Ton?"

"He can talk to them. I have nothing more to say."

4.

Galeazzo da Sanseverino was the first to honor the great horse the following morning as he emerged from the castle with mounted guards to hold back surging crowds. Approaching Ton on its pedestal, the captain general of the ducal armies paused to raise his sword in honor, as though the legendary Francesco Sforza were sitting in the saddle on his horse. This brought a roaring cheer from the mob.

The bridal carriage appeared next. Black and gold and drawn by six white horses, it rumbled across the castle drawbridge. Bianca Maria Sforza nascent queen of the Romans, sat between Isabella, duchess of Milan, and Beatrice, duchess of Bari. At the cathedral, two imperial ambassadors would legalize the marriage for Maximilian in Innsbruck.

As they entered the piazza, the crowd surrounded the open carriage, and the future queen simply giggled with joy. Above the roar, Beatrice shouted into her ear.

"Wave to them, Bianca! They're cheering you!"

At that moment, Ton appeared above them. The magnificent beast seemed to ride across the sky.

"Oh my God!" cried Isabella.

"What is it?" asked Bianca.

"It's a monument to your grandfather, Francesco Sforza."

"Oh yes!" Bianca cried, and waved to the horse. Then she giggled again. "How silly. It has no rider."

Beatrice shook her head. God help us, she thought. Her mother, Duchess Leanora, had died in October. Despite this, she had put aside her mourning to assist at this wedding. Poor Maximilian—his queen, at twenty-one, had the brain of a child. The sorry thing, with those bland eyes, parrot nose, tight little

mouth, and receding chin, could never be an empress. She was a disaster, like her brother, the dissolute duke.

Foreign ambassadors riding behind the bridal carriage also paused to admire the great horse. Then the two dukes, Lodovico and Gian Galeazzo, proudly saluted the monument. Along via Monte di Pietà, which led to the cathedral, the stores were decorated with laurel and green myrtle, and the palaces were hung with tapestries and flags. The clergy of Milan lined the way—a thin black line of somber faces in front of bobbing and cheering throngs. Some cried, "*Duca! Duca!*" for Gian Galeazzo, who was riding alongside his regent. Many more cried, "*Moro! Moro!*" In the bridal carriage, Isabella turned angrily to Beatrice.

"You hear that?" she demanded. "They're shouting for your Moor!"

"Why not? Is he not their regent?"

"My husband, the duke, is also there. . . . You're smiling! This isn't funny!"

Beatrice looked at the crowd. No, it wasn't funny. If anything, it was tragic. That bitch was about to start a war. Her letters, claiming she would kill herself rather than submit to Lodovico's tyranny, had enraged her father, Duke Alfonso, in Naples. Only King Ferdinand had kept him from starting north with his army. And now the birth of Massimiliano, their son and Lodovico's heir, had made Isabella even more desperate. Her little Francesco might never be duke. Poor girl, she had always been a bad loser.

5.

The great horse brought its creator overnight fame throughout Italy and Europe. A Roman poet, in a play on the artist's presumed surname, claimed Jupiter had to abandon the field to this immortal creator: *Vittoria vince e vinci tu vittore* ("Victory is victor and thou, O victor, hast the victory").

The man from Vinci had reached a turning point in his life. No longer would he have to humble himself for commissions or prove his worth to a mercurial Moor. It was a farewell to all of that—and to his old friend, Ambrogio de Predis, who joined the queen's cavalcade as it left for Innsbruck, where she would at last actually embrace her spouse, the Holy Roman Emperor, Maximilian.

August 1494

TON WAS FINALLY READY for his bronze casting, and Leonardo moved him to the Giscardo Foundry on the banks of the Ticino canal—a short walk from the Corte d'Arengo through the Ticino Gate. The heroic beast was housed in a separate shed, where Leonardo, with the help of assistants, would create the molds and casting kilns.

The foundry foreman, Dino Falconi, was astounded by the project.

"You want this in one casting?" he asked.

"One casting."

"It can't be done, maestro. I've been here twenty-three years, and we've never done a work half that size in one piece."

Dino resembled Zeno, their farmer at Vinci—a short, lean Tuscan from Siena, with leather-thick hands and a furrowed face from the furnace heat.

"Large works are cut apart," he explained, "then cast into smaller pieces and welded back together."

"Caro Dino, Big Ton will not be dismembered."

The little man walked around the horse, shaking his head. Then he stopped and ran his hand across the raised foreleg.

"All right." He sighed. "If you can create this colossus, what's your plan for it?"

"Upside down in a deep pit using four furnaces."

"Four feet is the limit. At six feet, there's water. We'll have to raise the ground level for kilns and furnaces."

With this agreed, they began to prepare for the casting. Afternoon sunlight filtered through the garden windows, and the first day went well. He had solved the casting process after consulting with Giuliano da Sangallo, the forty-nine-year-old Medici engineer and architect of the Gondi palace—his

father's home in Florence. In a notebook, he described every step in a new process that would allow him to cast the immense horse in one piece.

It began in a trial run "with a smaller piece and smaller furnaces, using a plaster mother mold of the entire figure." He then coated the mold with a two-inch layer of clay and wax, called *grossezza*, or "thickness," and placed it in a heat-resistant core of fired clay with its male, or convex, mold. To obtain a hollow center, he stuffed the core with a disposable "mixture of coarse river sand, ash, crushed brick, egg white, and vinegar [bound] together with clay."

After a trial firing, he removed the clay-wax impression from its plaster mother mold, checked it for accuracy, then used its volume to determine that they would need sixty-eight tons of bronze for the heroic horse.

At a drafting table, he showed Gino his drawings and notes for the actual casting:

> Let there be four furnaces built between pillars resting on solid bases . . . for casting let every man keep his furnace closed with a red-hot iron bar. Let all furnaces open simultaneously, and let fine iron rods be used to stop any of the holes becoming blocked by a piece of metal; and let there be four rods kept in reserve at red heat to replace one of the others if they should be broken. . . .

Gino nodded approval. He was especially delighted with drawings of the mold for casting the horse's head.

"This is beautiful," he murmured. "It's another sculpture."

He ran his rough hand over the drawing and sighed. "With you, we will be able to do the impossible. At first, I did not believe it, but now I do."

He smiled—a beautiful smile—and Leonardo realized he had found the perfect collaborator. Once in bronze, Ton would join other immortal war mounts and gods of ancient Greece.

PART NINE

KING CHARLES

INVADES ITALY

September 1494

IN SEPTEMBER 1494, CHARLES VIII OF FRANCE crossed the Alps with an army that would dramatically alter the lives of princes, Popes, the men and women who had contributed to the golden age of the Italian Renaissance—and the world of Leonardo da Vinci.

The Most Christian King came with dreams of conquest—beginning with the Kingdom of Naples. He also came with the greatest army in Europe since the Roman Empire. Descending from the Montgenèvre Pass onto the plains of Lombardy, it presented a frightening spectacle of gleaming armor, giant cannons, and great horses of war with flashing pikes and flying pennants. Crowds lined the country roads and streets of passing towns as it made its way toward Asti—a French outpost town near the Italian border and the Duchy of Milan.

Before the gates of Asti, Lodovico Sforza, regent of Milan, waited for his royal guest under a floral arch of triumph. Duke Ercole d'Este, his father-in-law, was beside him with the governor of Asti, along with other French notables. A wooden tribune held Milanese patriarchs, members of the royal court, and foreign diplomats, including Pietro Alemanni, the Florentine ambassador, Leonardo da Vinci, and Donato Bramante.

In the distance, the sound of great drums came across the Lombard plain on a September wind: *Arr-rrumph! Arr-rrumph!* As the army drew nearer, the waiting horses turned nervously, stomping hooves and tossing their reins. The Florentine envoy shook his head.

"We've opened Pandora's box. This will be a disaster for all of Italy."

"Isn't the Moor the king's ally?" asked Leonardo.

"He had no choice," replied Alemanni. "He tried to form a league of Italian states and Venice was vital, but she refused. Still, he's not the first one. Others have asked the French to come for them, including Dante, Pope Innocent, and even the arrogant Venetians."

"So he saw this coming?"

"For years he's seen it coming. I'm amazed, Nardo; don't you follow these things? After Ferdinand died in January, Alfonso, as the new king, started his war with Milan to avenge his daughter Isabella."

"We all know that," Bramante interjected.

"I'm trying to answer his question," replied Alemanni. "The Moor needed French troops to stop the Neapolitans in Romagna. That was in April, and last week a French fleet under Louis d'Orléans kept the Neapolitans from seizing Genoa. So they saved the Moor at his back door, but now his front door is wide open."

"For the French king?"

"Also his cousin, Louis d'Orléans. After Charles captures Naples for the house of Anjou, Louis will claim Milan as a Visconti, using his cousin's army. He calls himself 'Dux Mediolano,' as if he's already duke of Milan. So the Moor, who welcomes the king today, will have to betray him before it's over."

"There they are!" cried a woman behind them, amid cries and cheers from the crowd.

A yellow cloud of dust rose above the army on the Triversa river road. It swirled like smoke above white silk banners of France, claiming God had sent them: VOLUNTAS DEI and MISSUS A DE. The infantry arrived first before the awed French and Italian welcoming party. Seventeen thousand Gascons and Picards marched by in a thickening cloud of dust—archers and crossbowmen, spearmen and halberdiers in short doublets with the royal colors, followed by two thousand Swiss foot soldiers bearing partisan spears.

They circled the town, its streets being too narrow for their formation, followed by the heavy cavalry in an earth-shaking roar—seven thousand troopers with lances and flying pennants, sweating necks and flanks of foam-speckled mounts gleaming in the sunlight. The artillery was even more alarming: thirty-six bronze cannons, eight feet long, each drawn by twelve horses. No one had seen such weapons of siege warfare, nor imagined that a wagon train of this size could cross the Alps. The earthshaking rumble of the cannons, the massed fury of the horse teams, the lashing whips and wild cries of their drivers petrified the crowd. These were weapons forged in hell.

Alemanni was surprised by Leonardo's rapid sketching of the mobile guns.

"You know these cannons?"

"I invented them during our war with Naples and the Pope. Lorenzo sent them to the Signoria—which did nothing."

"It might have made a difference."

"Not with that coward as our captain," replied Leonardo, meaning Ercole d'Este.

"Who can forget it?" replied Alemanni. "Now he seems ready to betray us again."

Under the floral arch, Ercole d'Este, as a military veteran, realized the Italian art of warfare would never be the same.

"It's all over," he told Lodovico. "With these guns, nobody can stop that Frenchman."

"Galeazzo told me about them. They fire lead balls as big as a man's head, and they can breach any castle in a few hours."

Lodovico had sent Galeazzo da Sanseverino, as commander of Milan's armed forces, to advise King Charles on the "Italian enterprise." The mission had been crowned by introducing the famous knight to the queen of France, then to the king's mistresses—to the delight of the Moor, whose twelve-year-old natural daughter, Bianca, was married to Galeazzo.

As the cannons rumbled away, the crowd was relieved to see the king's royal guards—French nobles and descendants of mailed knights from the Middle Ages. Their commander rode a white stallion. With the piping of flutes, they seemed to emerge from a medieval tapestry—eight hundred horsemen in armor of steel or gilded bronze, ostrich feathers waving from shining helmets. Upon approaching the Milanese royalty, the cavalry commander raised a flashing saber, and with a peal of trumpets, the knights opened ranks.

King Charles appeared on Savoia, his famous black stallion, under a golden canopy held aloft by two rows of mounted pages in blue velvet trimmed with gold. On either side, his royal bodyguards—giant men, nearly seven feet tall—beat back the crowd with the flat sides of their halberds.

The monarch's crown of golden spikes and glittering jewels was strapped to a white hat with trembling black ostrich feathers. This splendor dazzled the crowd, unaware that beneath it was a pathetic little man. The flowing blue velvet cape covered dwarfish bowlegs. The breastplate under a doublet of gold brocade concealed a humped back and shoulders. Yet nothing could disguise the abnormally large head or ugly features of the twenty-four-year-old king of France—a parrot's nose, a frog's popped eyes, a scraggly red beard, and mucus-wet lips fixed in a rapturous smile.

Leonardo began to sketch him while Bramante shook his head in disbelief.

"Madonna," he murmured. "You call that a king?"

"A king with the heart of a knight errant and the brain of a semiliterate fool," replied the envoy.

Bramante laughed. "What happened? Did he run away from school like Leonardo?"

"Louis XI, the Spider King, who united France and created this great army, took one look at his deformed son and knew the child could never cope with Latin or the studies of a dauphin. They gave him stories of gallant knights and medieval chivalry, so now he can hardly sign his name, but his head is full of crazy conquests. After Naples, he wants to drive the Turks from Greece, seize Constantinople, and fly the fleur-de-lis from the turrets of a redeemed Jerusalem."

"Maybe Louis overlooked his son's balls," suggested Leonardo.

"Exactly!" replied Alemanni. "When he moved his court to Avignon, his advisers told him he was gambling his throne and the prestige of France on illusions. Phillip de Commines, lord of Argenton and Louis XI's veteran envoy, warned Charles he lacked the money, experience, and preparation for such a crusade. But the young lords of the war party wanted their sovereign to cross the Alps like Charlemagne."

The young lords, passing before them now, included Neapolitan exiles and an immense man on a gray stallion—Giuliano della Rovere, the violent-tempered cardinal of San Pietro in Vincula.

"There's a ruthless cardinal," explained Alemanni. "He fled to Lyons after losing the papacy to the Borgia, Pope Alexander, whom he hates and feared would poison him. He wants Charles to seize Naples, then call a General Council of the Church to depose Alexander for having bought his election—an outrage, he says, without noting that his uncle, Sixtus IV, also bought his tiara."

"Charles may be a royal frog," replied Bramante, "but Leonardo's made him look like a king."

Alemanni glanced at the sketch of Charles on his horse beneath the golden canopy, surrounded by giant bodyguards with flashing halberds.

"That's why they need artists," noted the envoy. "To turn a frog into a king."

Under the royal arch, the Moor was astonished at the French army—especially its cannons. He had to have them at all costs. Otherwise, he was at the mercy of this slobbering king. He turned to Ercole.

"Can your Giannino make cannons like these?" he asked, meaning the Este cannon founder, Giannino Alberghetti.

"Of course. . . . Send me the bronze and you'll get them."

❧ PAVIA AND MILAN ❧

October 1494

DUKE GIAN GALEAZZO NOW REALIZED he was dying. After receiving Last Rites, he asked to see two horses he loved—gifts of Lodovico. They were brought into his bedchamber, followed by his greyhounds, who pressed their wet noses into his lifeless pale hands. As he lay dying, he asked if his uncle loved him and excused him for being away with the king. After that, he died in the arms of Isabella on the morning of October 21, 1494.

Lodovico, leaving King Charles in Piacenza, raced back to Castello Vigevano at Pavia to have the deceased duke sent to Milan for a public viewing. He then summoned the magistrates, councilors, and leading citizens to the Sforza castle. With false modesty, he proposed that the legitimate duke the three-year-old Francesco, known as "Il Duchetto"—succeed his father. As planned, his friends protested. The times were too perilous for a child on the throne. Antonio da Landriano, secretary of the treasury, asserted that Duke Lodovico, "alone among our princes, can grasp the ducal scepter with a firm hand." Others agreed, and the duke of Bari was proclaimed duke of Milan. Wearing a mantle cloth of gold, he rode through the streets. Bells were rung, trumpets blared, and the people cried, "*Duca! Duca! Moro! Moro!*"

With the approval of the magistrates, the nobility, popular acclaim in the streets, and Maximilian's promised investiture, the Moor finally had what he wanted. Yet something else came with it. He found it in the Duomo.

Gian Galeazzo, six days after his death, lay in state before the high altar, dressed in ducal cap and robes, with sword and scepter at his side. Two anonymous epigrams, tucked under the scepter, accused the regent of poisoning his nephew. The Moor shuddered. His father had been killed in a church. He had barely escaped assassination in the same church. And now this threat in the cathedral.

As his aide pocketed the notes, he bowed in prayer. His nephew, white as marble, appeared to be sleeping. Indeed, the pale lips contained a suppressed smile. He looked again. They were about to speak. The new duke of Milan ceased praying and abruptly left the cathedral.

MILAN
GISCARDO FOUNDRY

November 1494

L EONARDO GAVE SALAI A LETTER for Bartolommeo Calco, informing the Moor that they were under way and would need sixty-eight tons of bronze within three weeks. The boy, in pink-and-green leggings, with a green doublet and sprouting lace at the sleeves, was perfectly attired as his courier. They walked from the workshop into a courtyard filled with plaster models of sculptures, which had departed for palaces, churches, and estate gardens.

"Deliver this to Calco personally," he said. "Bring the reply as soon as possible."

"Yes, master."

After the foundry closed in late afternoon, he walked back to the workshop with Marco d'Oggiono and Giovanni Antonio Boltraffio. Salai was waiting for them when they arrived.

"Where've you been?" he demanded. "We expected you at the foundry."

"Your friend Calco was away. They sent me to someone else. Here's what they gave me."

The cream-colored envelope, addressed to *"Ill.mo Ingeniarius Camerarias, Leonardo da Vinci,"* bore the usual red ducal seal. He tore it open and, in a flash, he saw it all. The words swarmed before him. The Moor had betrayed him again. As usual, he had done it in secret—this time through the ducal treasurer, Messer Giovanni Gualtieri.

Illustrissimo Ed Onorevole Maestro,

Thank you for advising us of your readiness to finally cast your magnificent *cavallo* of Duke Francesco Sforza. At the moment, however, it will have to be postponed.

The entire supply of bronze available for this undertaking has been sent to Ferrara for casting into cannons—an urgent matter following the barbaric French invasion into Italy, and our need to be ready for any subsequent return.

Rest assured that His Excellency, the duke of Milan, wants to see you complete the monument to his illustrious father, and he will provide you with the needed bronze when it becomes available. . . .

Leaving the workshop, he began to run toward the foundry. The sun was setting, and he had to be with Ton before nightfall. There was nothing he could do about this, but he had to be there. He had promised it would never happen. He always said it in the evening, when he spoke to the *cavallo* in the studio courtyard.

At the foundry, Ton was waiting in the gray shadows of nightfall. Ton's eyes were on him as he entered, dark half-inch pupils under the heavy cliff of its brow, the ears in full alert. He recalled the moment he had opened those eyes in gray-blue clay. As if waiting for the moment, they stared beyond their creator toward distant plains, where a trot was the natural gate of a free horse.

Climbing up a ladder, he looked into Ton's immense eyes, stroked his brow, the tuft of hair between his ears, and spoke as he did every evening at the studio.

"It won't happen," he promised. "We'll get the bronze again. We just have to wait a little bit more."

He stopped, unable to go on. Descending the ladder, he ran his hand over the animal's withers.

"I'll come tomorrow. Every day we'll bring you water and be with you."

At the gate, he looked back. Ton was alone now, waiting for his return. He turned homeward, and tears blurred his vision. Memories returned of the schoolyard, rocks scudding around him, the tears, and stumbling over cobblestones—alone in the world, except for Donna, the mare in the stable with her colt, and Albi's tears upon his hands.

MILAN
SANTA MARIA DELLE GRAZIE

June 1495

He often came to the convent at early dawn to work on his wall painting of the Last Supper. Hastily mounting the scaffold, he worked diligently until the shades of evening compelled him to cease, never thinking to take food at all, so absorbed was he in his work.

As the great painting neared completion, sometimes he would remain there, gazing at his work with folded arms. Then he would walk back and forth, pausing momentarily before one or another of the seated disciples as though seeking their opinions on how well he had conceived them—or, more likely, how he should represent the faces of their Lord and that of Judas, which were still to be painted.

S O IT WAS RECALLED YEARS LATER by a boy who had watched Leonardo da Vinci from a hiding place under a table in the convent's refectory. In this final stage of his great wall painting, the master had wanted no one present. Yet this had never prevented the youngster from going there. Quiet as a cat, he'd crept in on all fours, passing under one dining table to another until he was close enough to see Master Leonardo and everything he did.

The little spy was Matteo Bandello, the fifteen-year-old nephew of the convent's new prior, Padre Vincenzo Bandello. A seminary student with a spirit of adventure, he was at the onset of an extraordinary career as a Dominican friar, a bishop, a soldier, a diplomat, and author of 230 novellas, including *Romeo and Juliet,* which Shakespeare would adapt—but with an altered, less dramatic ending. Even now, at this early age, his innate curiosity had led him to a hidden crisis in Leonardo's attempts to finish his *Last Supper* at Santa Maria delle Grazie, the Dominican convent in Milan.

Matteo soon discovered that wherever he crept within the forest of table legs, he seemed to be in the middle of the picture. It stretched across the entire

end wall and appeared to be an extension of the dining room. This in itself was a kind of miracle, since the friars would feel as if their Lord and his apostles were eating at a table in front of them—a table with the same blue-embroidered tablecloths as those around him.

Christ was seated at the center of a Passover meal. He wore a red tunic and blue cloak and had his arms extended upon the table. Above the neckline of the red tunic, there was an empty space for his missing head. His apostles were very excited—some rising up in anger, others turning to one another in shock and disbelief. At first, Matteo thought it was the moment when Jesus revealed that one of them was about to betray him. Yet somehow this wasn't right. The apostles on each side of the table were reacting differently.

Those on his left were clearly amazed at being told that their Lord would soon go away, yet also remain with them. From his Bible class, Matteo knew all three synoptic versions of the Passover supper by heart, and Matthew's came to mind:

> Now as they were eating, Jesus took some bread, and when he had said the blessing, he broke it and gave it to his Disciples. "Take it and eat," he said. "This is my body." Then he took a cup and . . . gave it to them. "Drink all of you from this," he said. "For this is my blood, the blood of the covenant, which is to be poured out for many for the forgiveness of sins."

Yes, he decided, they were reacting to news of the Eucharist. Their father was leaving them, as his own father had left him. He knew how they felt, and their words of love and loss and confusion.

One of them, his arms wide with amazement, was staring at a piece of bread and a glass of wine, wondering how this could become the body and blood of Jesus. Another was pointing his finger to the sky—most likely, Doubting Thomas. Leaning over them, a third disciple was bent in grief, his hands upon his chest. To the right of these, at the end of the table, the faces and gestures of three other disciples revealed their difficulty in understanding the mysterious words of their Master.

Surely that was it, for Jesus himself indicated the difference between the two ends of the table. His left arm, wrapped in a blue cloak like the Virgin's mantle, was extended toward those grappling with the mystery of the Eucharist. It lay with its palm open, as if to lift their spirits toward the vision of eternal life.

His right arm, however, was clothed in a bloodred tunic and extended toward six apostles on the other side of the table. Here his hand was turned

downward, its fingers spread wide in a gesture of sudden alert. Near it, the dark hand of another disciple was fixed in a similar clawlike gesture. He was holding a money bag and had knocked over a salt cellar. That was Judas, of course. He also lacked a head on his dark torso and was leaning back in sudden fright. So here, too, the Master had just spoken, but this time it was of a traitor in their midst. Matteo again recalled Matthew:

> And while they were eating, he said, "I tell you solemnly, one of you is about to betray me." They were greatly distressed and started asking him in turn, "Not I, Lord, surely?" He answered, "Someone who has dipped his hand into the dish with me, he will betray me." . . . Judas, who was to betray him, asked in his turn, "Not I, Rabbi, surely?" "They are your own words," answered Jesus.

An angry disciple had risen behind Judas. He had white hair, a fierce look in his eyes, and he held a dagger. So this was Peter, always quick to anger. In his fury, he was speaking to a dreamy disciple, seated next to Christ. Clearly, this was the beloved John, in a tunic and cloak like Christ's, but with the colors reversed. To the left of them, at the end of the table, three other disciples stared at their Master with alarm, two with hands raised in denial, while the third one had sprung to his feet, ready to leap upon the unknown traitor in their midst.

So it seemed to Matteo on this particular morning when, for the first time, he saw Master Leonardo pick up an ink brush and approach the blank face of Christ. From his hiding place under the table, the boy held his breath. This was a great moment. He was about to witness a man, a human being, revealing the Son of God.

It happened in a twinkle of the eye. With a few rapid strokes, the face of Christ emerged as from a morning mist. The artist then stood back to survey what he had done. It wasn't right, however, for he began to walk back and forth, pausing before one or another apostle as though they had something to say about it. Suddenly, he glanced at the refectory, and Matteo slid back under the table, hoping he had not been seen. When he heard the footsteps again on the wooden platform, he looked up—and the face was gone!

This explained why Master Leonardo wanted to be alone. He was having a private struggle with Christ and the archtraitor, Judas. So spying on him was a grave sin of some sort. Whatever it was, Matteo knew he should look no more and crawl away. Yet he remained crouched under the table, sadly aware that he was going to be a sinner all his life.

SOUTH ITALY
FRENCH INVASION

November 1494 – January 1495

KING CHARLES HEADED SOUTH FROM MILAN, crushing every obstacle in his path. At the Florentine border, he sent envoys requesting safe passage across its territory. Piero de' Medici kept them waiting.

The latest ruling Medici, son of the Magnificent Lorenzo, had foolishly exchanged Florence's alliance with France for a worthless pact with Naples. Now he didn't know what to do. As feared by his father, this Medici was arrogant, brutal, and tactless. He ruled like a tyrant, rather than by sufferance. Their political machine, created by Cosimo, was on the verge of collapse.

After waiting five days, the envoys returned to an enraged Charles. His army crossed the border, turned its cannons on the Florentine fortress of Fivizzano, and killed everyone. In panic, Piero hurried to the French camp. He groveled before Charles and gave the French six key fortresses, including Genoa and Pisa, with permission to occupy Florence. When he left, the French laughed at him as a coward and a fool.

Florence rose in revolt. The Signoria closed its doors to Piero, and he fled for his life, to spend the rest of his days as Piero the Exile. His two brothers, Guiliano and Giovanni, escaped with him. So ended, on November 19, 1494, the glorious sixty-year rule of the first Medici.

The French king, after the departure of Piero, received an unusual Florentine envoy: Fra Savonarola. The fiery Dominican prophet and reformer hailed and harangued Charles in perfect French.

"Most Christian King, you are an instrument in the hands of the Lord, who sends you to relieve the afflictions of Italy, as I have for years foretold, to reform the Church, which lies prostrate in the dust. But if you are not merciful, if you fail to respect Florence, its women and citizens, and its freedom, if you forget the mission that God gives you, He will choose another to fulfill it. He

will harden his hand and chastise you with terrible afflictions. These things I say in the name of the Lord."

Despite the prophecy, Charles entered Florence as a conqueror with lance in hand. After moving into the Medici Palace, he demanded that Florence cede everything Piero had promised, as well as forgoing a restoration of Medici rule. This was too much. Commissioner Piero Capponi, speaking for the Signoria, adamantly refused.

Impatient, Charles threatened to call his men to arms: "We will blow our trumpets." To this, Capponi cried, "And we will ring our bells!"—which would bring an enraged populace into the narrow streets. The king relented on a return of the Medici, agreed to restore Pisa to Florence in exchange for a large subsidy, and accepted a title crafted with Tuscan wit: "Protector of Florentine Liberties."

Charles rolled on toward Rome. At Viterbo, sixty miles from the Eternal City, Pope Alexander learned a French cavalry had captured his nineteen-year-old mistress, Giulia Farnese, and his daughter, Lucrezia Borgia, who was fourteen. Charles, in chronic need of funds, demanded a ransom of three thousand ducats. The Borgia Pope worshiped Giulia. No papal document ever left the Vatican with greater speed than the ransom payment.

At that point, Alfonso withdrew his allied troops to Naples. Suddenly alone, without forces to defend himself, the Pope panicked. In haste, he moved his bed and breviary across the enclosed passageway from the Vatican to the fortress of Castel Sant' Angelo.

Charles entered Rome through the Flaminia Gate, riding in triumph with Cardinals Giuliano della Rovere and Ascanio Sforza by his side. Both prelates hated each other, but they hated the Borgia Pope more. Their rivalry at the last conclave had put the Spaniard on the throne.

From his fortress castle, Alexander—at sixty-three, a seasoned power broker for five Popes, and steeped in every known intrigue of the Roman Curia opened a "charm offensive" by inviting Charles, who was in Palazzo San Marco, to visit the Apostolic Palace. At a lavish banquet, Giulia and Lucrezia enchanted the lascivious monarch.

A few days later, Alexander said Mass in St. Peter's Square, with Charles as the Pope's server before twenty thousand startled French soldiers. The Vicar of Christ, and father of seven children, then embraced the little king as the eldest son of the Church.

On January 16, 1495, two weeks after entering Rome, Charles returned control of Rome to the Holy See. He swore obedience and loyalty to Alexander VI as Supreme Pontiff. In return, the French army had the Pope's blessing to

march through the Papal States toward Naples. Charles left believing he had a new friend and ally. Alexander had no intention of being either—nor of granting Charles his expected papal investiture as king of Naples.

Approaching Naples, two envoys were sent to demand the surrender of the Monte San Giovanni fortress and its food supplies. Its arrogant commander, believing he was safe within the massive fort, cut off their ears and noses. Enraged, Charles called up his cannons, and soon breached the great walls. His troops then massacred the entire garrison—some nine hundred men killed by sword or thrown alive from the high ramparts.

With this display, the Neapolitan army vanished. So did the monarchy. King Alfonso, who had sworn to defend the crown with his life, abdicated in favor of his son and fled to Ischia. Ferdinand II, the young king, then ran away to join his father. Charles rode into Naples with pomp and majesty. Crowds cheered him along the way. They rejoiced again when he was crowned king of the Two Sicilies in the cathedral. Elsewhere, the kings and princes of Europe followed this capitulation with growing fear. At this rate, France would soon seize all of Italy.

MILAN

January – October 1495

AMBASSADOR PIETRO ALEMANNI found Leonardo on the scaffolding of his *Last Supper*, sketching the heads of Christ and Judas in large foolscap notebooks.

He had come to warn his friend. All of Milan was talking about the French invasion. After King Charles seized Naples, his cousin, Louis, the duke of Orléans, would claim Milan as heir to the Visconti throne. If the Moor defied him, like Hector of Troy besieged by Achilles, no wooden horse would be needed. Everyone knew the French cannons could topple the walls of Milan. The Florentine envoy mounted the platform.

"*Caro Leonardo*, you're like a hermit in here, while outside, all hell is on its way."

"The French invasion? You said Italy would never be the same."

"It's not only King Charles. His cousin, the duke of Orléans, expects to claim Milan as a Visconti heir."

"You said that, too," Leonardo replied, returning to his drawing.

"*Santo Dío*, doesn't this mean anything to you? Look at me, for Christ's sake! . . . If the Moor doesn't assemble an anti-French league, you'll soon need the favor of a French patron. So finish this great painting before they get here."

"Thank you, Pietro; I'm also aware of that."

"Then what's your trouble . . . the face of Christ?"

"Judas," he replied. "When I get him, Christ will follow."

2.

Judas haunted Leonardo. The headless man was somehow speaking to him in words without sound. There had to be some reality to this, but he had no idea of where to find it. All he had, in seeking to portray the face, imbued with its base betrayal, were incessant betrayals in his own life.

Since childhood, they returned in dreams at night—old episodes of sorrow and shame. They usually ended with Pegasino taking him up the slopes of Mont' Albano—to the world of nature, daughter of God, where he was God's grandson. Despite this, jumbled fragments of human betrayal continued to pursue him, even in sudden moments during the day.

The slammed fist, the voice of rage: . . . *Cristo! He's a slave boy, you want him before our own sons?* . . . His father seeing the drawing of Albi with the dead baby: . . . *He was my son, my true son. He would have been a great notary . . . know what I mean?* Stones flying past him, classmates yelling: *Bastard of a slave!* . . . *Fucking like dogs stuck in their assholes!* . . . His father's sneer, gray hairs sprouting from the nose: *Not even death stopped you from drawing Albi's naked body with your filthy lust.* . . . Father Mariani stuffing lies into the *tamburo: I testify, Signori Officiali, that Leonardo di Ser Piero da Vinci committed sodomy with said Jacopo.* . . . Prison cell wall chains encircled by a yellow-brown scrawl of maggots from the prisoner's bucket of feces, urine, and blood: *Maria . . . I await You know it.* . . .

Maria you know it. . . . What did she know? That human betrayal of her son was forever a part of life? Was this what the headless Judas was trying to tell him? Padre Mariani, a betrayer of Christ's purity, was but a common man—without love or pride or honor in also betraying his companions for a few gold shekels.

Dante had encountered such men in the Ninth Circle of Hell—the realm of treachery for betraying the sacred bonds of love and trust and faith: "One whom I saw ripping himself in half, from his chin to where we fart, his bowels hanging between his legs with his vitals and the miserable sack that turns what we swallow into excrement."

There was the destiny of Friar Mariano. And there was the face of Judas, who had betrayed both man and God for a pitiful handful of gold. Now all that remained was to find the face of Christ.

3.

Lodovico Sforza had no time left. Louis of Orléans was waiting at Asti to claim Milan when Charles returned with his cannons. Equally concerned, Venice and Emperor Maximilian were finally ready for an alliance to drive the French from Italy. With this, Lodovico conjoined a formidable league in Venice, which included Maximilian; Pope Alexander VI; Ferdinand, king of Spain; the Republic of Venice—and himself, duke of Milan. Florence abstained, fearing the return of Charles.

The monarch had no intention of bowing to any league. Nor was he concerned about the return home. He rode through Naples holding a golden

ball and a scepter signifying he was king of France, Naples, and Jerusalem. He ruled through corrupt, incompetent bureaucrats. Land grants and jobs went to French favorites, infuriating Neapolitan exiles who had come with him from Lyons. The people were also driven to despair by the soldiers' looting, drunken brawls, and rape of women. Hailed a few weeks previous, the French were now detested.

The monarch began his retreat on May 20, 1495, four months after entering Naples. At Rome, he learned that the Pope, now a member of the league, had fled in panic to Orvieto with his court and twenty cardinals. At Pisa, the tears and laments of barefoot women in black drove him to break his promise of returning the city to Florence, a vital port for its far-flung merchant empire.

Farther north, at Pontremoli, his army, with its cannons and wagon trains laden with Neapolitan loot, began to cross the Apennines. Lashed by torrents of rain and knee-deep in mud, they struggled up the slippery slopes with a hundred Swiss soldiers harnessed to the cannons. Sick and exhausted, they descended into the valley of the Taro, along a mountain stream flowing north into the Po River.

Here they camped at the village of Fornovo, on the right bank of the stream. The massed army of the league was waiting for them in the plain below—on the same side of the stream, which was swollen by the rain.

Early the next morning, July 6, 1495, Charles appeared before his troops on Savoia, his black charger, wearing a white-and-violet tunic over his shining armor, and violet plumes on his helmet. Again, he was living his dream of conquest. This time, it was a battle that would decide the fate of his army—and its king.

"They outnumber us ten to one!" he cried in a high-pitched voice. "Take heart, for we will destroy them all and return to France in glory!" He turned his horse and raised his sword for the attack. "With God on our side, I shall learn today who are my friends, and with them I go forth to live or to die!"

Commines, his envoy, was amazed. The self-indulgent, ugly little man had been transformed into a real king leading his subjects into battle—though the odds were not as high as he imagined. The garrisoning of Naples, plus sickness and desertions, had reduced his troops to less than ten thousand. The league, at the most, had twice that number under Francesco Gonzaga, fourth marquis of Mantua.

Charles led his troops across the swollen stream and resumed his march north in a torrent of rain with claps of thunder. Farther on, the higher waters delayed Francesco Gonzaga's crossing, separating him from some of his units. Despite this, the battle began in his favor. His stradiots, a vicious Balkan

cavalry, swam the stream to charge the French flank, impaling the heads of those killed on their lances, each head worth one ducat.

Both sides fought bravely. Charles fearlessly charged into the thick of the fray, and he was close to being captured by the Milanese cavalry, when its commander, Francesco da Sanseverino, count of Caiazzo and brother of Galeazzo, ordered a retreat. Secret orders from the Moor prescribed neither a total victory for his Venetian allies nor a total break with the king of France.

Unaware of this treachery, Gonzaga, commander of the allied forces, had his horse killed under him. He fought on foot, broke his sword, then seized another sword and mounted the horse of a fallen knight. His mercenaries, however, were no match for the bravery and ferocity of the French troops. Fighting for their lives and a return home, they routed the Italians, killing them without mercy as they fled back across the Taro. At this point, the stradiots deserted their comrades to plunder the French baggage train, allowing the invaders to resume their march toward Asti.

So ended the bloodiest Italian battle in two hundred years. Gonzaga's uncle Rodolfo, a veteran condottiere, had fallen in the field—as had three cousins and many others from princely families of the Renaissance. Instead of being held for ransom, as customary in Italy, they were killed where they lay. Rushing into the field, the king's teamsters, servants, and camp followers slaughtered the wounded and fallen, using axes and kitchen knives. Commines grimly noted that three or four persons were needed to hack through heavy armor. Such wanton savagery brought the Italian death toll to 3,500, with the French casualties numbering just 200.

Both sides claimed victory. The French had held off the combined armies of the league. The Italians had sent them scuttling over the Alps and captured French baggage and booty worth 100,000 ducats. In the king's tent, they found a sword and helmet said to have belonged to Charlemagne, a silver casket with the royal seals, a set of rich hangings and altar plate, a jeweled cross containing a sacred thorn and wood from the True Cross, a vest of the Virgin Mary, a pickled finger of Saint Denis—and a book filled with drawings depicting naked women raped by French troops. The religious relics were returned to the king, who graciously sent back the hilt of Gonzaga's broken sword and a favorite white warhorse captured in battle.

4.

Louis of Orléans, believing Milan was in his grasp, entered Italy from Asti with a force of eight thousand. Novara, whose populace hated the Sforza rule of Milan, opened its gates to him. Finally, he was ready. He needed only

the French army and cannons to breach the walls of the Sforza castle. His cousin Charles, however, wanted no more war. Anne of Brittany had warned there were no more fighting men left in France. At that point, Gonzaga arrived from Fornovo to surround Novara. Louis was trapped, but he refused to surrender.

A siege mounted against the city cut off its water supply and thereby crippled the wheat mills, which could no longer produce the flour for bread. The city starved. People ate cats, dogs, and rats, and soldiers ate their horses. Soon the streets were filled with corpses. With the rains, an epidemic swept through Novara. In silent homes, the dead lay scattered from bedroom to latrine. They were piled up before churches without salvation from the Virgin Maria. Many went insane and wandered the streets, jabbering nonsense to strangers.

Commines finally arranged a truce on October 10, 1495. The duke of Orléans was allowed to depart with the honors of war, leaving two thousand dead comrades in arms. During their retreat, several hundred more perished from starvation and from drinking ditch water. The humiliated Louis swore to return, redeem his honor, and drive the treacherous Sforza into exile. The Moor dismissed the threat. Charles had renounced support of his cousin's claims to Milan.

As a result, for a brief period of time—between the sworn revenge of a humiliated, expectant king of France, and the Moor's dalliance with the lovely Lucrezia Crivelli, his wife's lady-in-waiting Leonardo was able to continue his search for the face of Christ and why the trusted disciple Judas would betray Him.

THE *LAST SUPPER*

AND THE SFORZA EXILE

MILAN
SANTA MARIA DELLE GRAZIE

October 1495

PADRE VINCENZO FOUND THE CONVENT GARDENER on his knees, tending a rosebush.

"Pasquale, at Mass this morning, I poured wine into the chalice and found your rose petals floating in what was to become the blood of Christ."

The gardener glanced at a rose cupped in his dark, gnarled hand—a white rose with a pink blush. He looked at his prior and smiled.

"In the chalice? How did that happen?"

"Don't fool with me, Pasquale. For the third time this month, I've drunk the Lord's blood with your petals floating in it. You're getting old and forgetful. To sweeten the air for the chalice, you don't have to put your petals into it."

"It took ten years," Pasquale replied. "They were either too red or too white or streaked with red. Then I got this pink blush of the Virgin when the angel tells her she will be the mother of our Lord. Isn't it beautiful? The color of her holy cheeks and without any thorns—"

"I know all that," replied Vincenzo, cutting him off. "Your Annunciation rose. We sent one to the Holy Father for his Vatican gardens. But you can be sure he's not drinking the precious blood of our Lord with your petals floating in it."

Pasquale glanced again at the flower in his hand. Then he looked at his prior and smiled, as though the rose confirmed the miracle of its petals.

His prior felt a surge of anger, then sudden doubt. Had the sin of pride blinded him to what was happening here? Saint Thomas defined a miracle as an occurrence beyond the power of nature—an event full of wonder, its cause absolutely hidden from all. It came from God, and it could include something as small as a rose with the blush of the Virgin Mary. Was this simple lay brother, dwelling among his flowers, closer to God than a priest and prior of his convent?

"*Buongiorno, Padre.*"

Leonardo stood under the arches of the garden arcade, drawing in a notebook. His light brown sleeveless tunic and cream-colored shirt were the color of the walls and stones around him. Vincenzo shuddered. It was like a spirit recording his encounter with Pasquale. In the notebook, he saw it confirmed—a sketch of the kneeling gardener holding a rose. In an upper corner, his own face appeared—like that of God witnessing the unfolding of a miracle.

"What's this for?"

"It could be Christ seeking his stepfather, Saint Joseph. Nobody's done that one."

"Very funny . . . me as Christ. You must be in real trouble."

"It's His image."

"I told you that was impossible," replied the Dominican. "Besides, I heard you were using a young count serving Cardinal del Mortaro."

"Only his hands."

Vincenzo took his friend's arm, and they walked under the courtyard arches.

"You can't continue this way, Nardo. The Moor will call Perugino or someone else to do your *Last Supper*. As for Judas . . ." The friar stopped and faced his friend. "He says you've decided to use me and finds it amusing. Did you really say that?"

Leonardo smiled, delighted. "*Caro Vincenzo*, it's the Moor's way of getting you to do what you're doing now."

They began to walk again, and the Dominican said, "*Caro mio*, you seek the impossible. Giotto, Cimabue, Lorenzetti, Masaccio, and our own Fra Angelico came close. . . . Don't they lead you somewhere?"

"Not where I'm going. Tell me, Padre, doesn't the Son resemble His Father?"

"Saint Augustine said the Son alone is the image of the Father . . . and our Saint Thomas says there's nothing to prevent there being a single image for Father and Son, since they are one."

"And since this man is without sin, He has only one counterpart."

"Adam, of course . . . before the Fall."

"Who contained within himself a woman."

"Aha! I should have expected this from you. . . . In Saint Jerome's translation of Genesis, God makes a woman from the rib of a man called Adam. It's more explicit in the original Hebrew. Adam is called *ha-adam*, or a man who is *zakhar-u-neqeva*—that is, male and female. So he's specifically an

androgynous groundling who is potentially fertile, with two undivided parts."

"So Jesus, a new Adam, contained elements or attributes of man and woman."

The Dominican hesitated. They were seated on a low wall between two Ionic columns of the arcade. Before them, in the sunlight, the fountain waters fell into a basin with a low murmur. He brushed an ant off his black cloak.

"Jesus as mother? . . . Beginning in the twelfth century, maternal imagery came with a new sense of God. Clement, Origen, Irenaeus, John Chrysostom, Ambrose, and Augustine all describe Christ as mother. It stressed his creative power, his love, his presence in the physical body of Christ, and in the flesh and blood of the Eucharist."

"Then I believe I have found the face of Christ."

"Be careful, Nardo. Christ was a man, not a woman. The later fathers suppressed 'mother' from his list of titles."

"It doesn't matter. I can still do it."

2.

Returning to his study, Leonardo sought an old notebook containing his first sketches of Cecilia. There were seven or eight of them, bound in clouded goatskin from the de Predis workshop. The first one contained drawings of Milan from the top of the Duomo, showing its walls and network of canals. The sketches were like forgotten friends. Others were total strangers, but the notes made them familiar.

Then he found the drawings of Cecilia, and he configured one of them in size and intensity of line with one of Vincenzo in the convent rose garden. Using vellum transparencies, he placed the transparency of Cecilia over the image of Vincenzo. Her oval head elongated the broader skull, bringing it closer to the traditional concept of the Hebrew male. The pugilist cheekbones sank beneath the softer malars of a woman, yet the clifflike brow remained. The strong mandibles embraced the feminine mouth and lips.

Another person had emerged—a familiar face, yet also one of a stranger awaiting his arrival. This was what he wanted. The reciprocal infinities of a woman and a man of God had been realized in a single human—a *ha-adam*, with elements of *zakhar-u-neqeva*. That was how life began, with the prenatal cognation of male and female. You could see the duality in this face—strength and compassion, judgment and humility, omnipotence and docility, manly grace and female resilience. And its soul was there within its shadows, as letters on a tombstone are read in the slanting light of evening.

Here was a basic image for the face of Christ. It was only the beginning, however. The unstable compounds of two mortals had to be projected into an immutable, immortal image of the Son of God. To get there, where no man had ever been, he had to pierce the veil of reality and every fragment of time and memory.

Most likely, help would arrive in unexpected ways. It had occurred with Albi, Ginevra, and Cecilia in seeking their interiors . . . so why not with this holy man? And then, as his image came to life on the wall, he was bound to speak and make demands at critical moments in the laying of line and color while approaching the singular yet universal face of a God-man.

MILAN

November 1496 – July 1497

O N A FOG-SHROUDED DAY IN NOVEMBER, Lodovico Sforza, brilliant duke of Milan and master of his destiny, began to discover he was no longer "the man whom Fortune loved."

It began with the sudden loss of little Bianca Sforza, his natural daughter and the child bride of Galeazzo da Sanseverino. Not quite eight when she married her famous knight, she began to fail after consummating her marriage at thirteen. A year later, in November 1496, she died of a "stomach seizure" at their palace in Vigevano. Galeazzo, blaming himself for her death, shut himself in his rooms at the castle, vowing he would emerge only *con la lingua per terra*—licking the floor.

Lodovico was heartbroken. Little Bianca . . . so young, so gay, gone forever. God did move in mysterious ways. Ambrogio claimed it wasn't God. The stars had determined the child's destiny. He reassured the Moor, however, they were in perfect alignment for Lucrezia Crivelli, lady-in-waiting to Duchess Beatrice, who was pregnant with his child.

"None of these evil motions will affect Lady Lucrezia or your son. By Ptolemy's rule, your lady's Hyleg is nowhere near Anareta or her eighth house."

Neither Lodovico nor his astrologer bothered to track Beatrice's astral destiny in the next turn of fortune's wheel. In the swirling life at court, she had loved Bianca as her own child and intimate friend. Pregnant again, and already the mother of two boys, she prayed each day at Bianca's tomb in Santa Maria delle Grazie, asking for a girl like the one she had lost.

In the midst of her trauma, Beatrice discovered her husband's affair with Lucrezia Crivelli—her trusted lady-in-waiting. They weren't just coupling on the sly. God help us, they had started another family. The Judas bitch was three months pregnant and getting a lot more than a baby. Her indulgent husband, Giovanni di Monasterolo, had received a post at the court. Her

brother, a priest, had enriched himself with benefices. And Leonardo had been asked to do a portrait of this latest mistress.

Adding to her humiliation, Beatrice heard of it from her sister Isabella in Mantua. Raging with fury, she went to her husband's office, where spies could not overhear them.

"I'm told Crivelli is pregnant with your child."

"Who says so?"

"Answer me. I'm carrying your third child. Do you expect a fourth one from that bitch?"

"Don't be ridiculous. If she's with child, it must be her husband's."

"Why did you ask Leonardo to do her portrait? He's never finished mine."

"Because you always put it off, so he gave it to Boltraffio. If he's doing Lucrezia, it's probably for her husband."

Beatrice wanted to believe him. She had banished Cecilia from the palace and won her husband's love and respect. But she knew he was lying. He closed his eyes before each lie, while his restless hands tried to run away.

"Toto, little Toto," he said, taking her in his arms. "Don't you believe me?"

"Yes, I do. I know you love me."

No other reply was possible. They had to live with it. They soon discovered, however, that it consumed what they had sought to save. Sex became desperate, Lucrezia haunted them both, and court gossip turned their private drama into a public farce. Nothing could assuage Beatrice's shame and sorrow.

The despair drove her to excess—savage cruelty in hunting, orgies of unbridled lust, and frenzy in dancing. Her doctors became alarmed and warned that her child's life was in danger. Despite this, she went on dancing through the gay nights of the Milan winter—until the evening of January 2, 1497.

At the height of a ball, the frantic Beatrice gave a short cry and collapsed. The musicians continued to play, unaware their duchess lay on the ballroom floor—her pregnancy concealed under a black satin gown embroidered with flames of gold and a scattering of bloodred rubies.

From the floor, Beatrice saw Lucrezia among those kneeling beside her. She was going to lose her baby, while this one would keep hers.

"*Giuda! Non toccarmi!*"

With this desperate cry—"Judas! Don't touch me!"—she began to struggle for air. Then she saw Lodovico, his eyes wide with terror. As though

aware it was the end, she tried to say good-bye. "*Povero Cocco, mi spiace* . . ." Her sorrow for poor Cocco ended there. With a desperate gasp, her face turned white and she lost consciousness.

Cecilia shoved frantically through the crowd to kneel by her side. Placing her mouth upon Beatrice's, she forced air into her lungs. After a few minutes, the fallen duchess opened her eyes. Seeing Cecilia, who had become a friend, she stroked her cheek and smiled—only to begin losing water from her womb. Her five-month-old child was on its way into the world.

"O *Dío!*" gasped Cecilia. "Take her to her room!"

Seated in a chair and leaving a trail of fluid and blood, she was borne to the Rocca by Galeazzo and his friend, Gaspare da Vimercate. Palace midwives rushed in, vainly seeking to stem the bleeding amid birth seizures and screams from Beatrice, who was clawing wildly at herself. Finally, the infant emerged, and she saw them lifting it up. Covered with mucus and blood, it resembled a dead rat with a tail—the dangling umbilical cord.

"*Poveretta.*" She moaned for the poor little thing. "*Povera noi.*" She sighed for Cocco and herself. Then she closed her eyes and slowly bled to death.

2.

When the gray winter dawn arrived, with mists shrouding the castle, the twenty-one-year-old Este princess, duchess of Milan, lay in her bed—her childish features coarsened, her restless little hands now still, a crucifix thrust into her little fingers, her mouth, with its short upper lip and sharp white teeth, finally closed in death. Lodovico lay next to her, sobbing with remorse and the fear of suddenly being alone. His wife and friend, his tiny Toto, was gone—and with her, the baby girl they had wanted.

Haunted by fear and guilt, he put on a long mourning cloak, closed himself in a small room hung with black, and took his meals standing. The palace fell silent, and its courtiers crept through the halls as though the corpse were still among them. Beatrice's secretary sadly noted, "Everything went to ruin. The court changed from a merry paradise into a gloomy hell."

Lodovico prayed daily before her stone sarcophagus at the convent, lit by a hundred burning candles, asking her forgiveness and promising to explain everything when they met again in heaven. The Dominican friars received Beatrice's gold and silver fabrics, and her summertime villa, La Sforzesca, at Vigevano. Seeking further atonement, the Moor placed Beatrice's image on the ducal seal, opened a new city gate named Porta Beatrice, and conjoined her initials with his own on major public buildings.

Two months later, however, he reverted to his old ways. Lucrezia Crivelli gave him a beautiful boy, Gian Paolo—a sign from God that all was forgiven. In exchange, he deeded Lucrezia a rich estate, citing *ingentem voluptatem*—his pleasure in her person.

"We've come through a bad storm." He sighed. "But now we're in calmer waters. King Charles is making noises that he wants to reclaim Naples, but he's enjoying life too much to risk another Fornovo."

As usual, Lodovico Sforza was well informed. He could not foresee, however, that the little king would soon strike his head on a fireplace mantel at Château d'Amboise and die of a brain concussion on April 7, 1498. Louis, duke of Orléans, ascended the throne as King Louis XII, claiming he was also king of Naples and duke of Milan. From his throne, he vowed to cross the Alps and drive the despised "Signor Sforza" from Milan, which rightfully belonged to him as a Visconti heir.

MILAN
SANTA MARIA DELLE GRAZIE

September 1497

DONATO BRAMANTE LED THE WAY up the circular stairs to the parapet inside his great dome over the church at Santa Maria delle Grazie. Vincenzo Bandello and Cecilia Gallerani followed. It was the Dominican's first visit to the soaring dome, which was nearing completion, and he had invited Cecilia to join him. The priest and the lady both grasped the railing as they emerged onto the high walkway. Far below them—some 163 feet—they saw the altar and the great stone pulpit with an assembly of sixteen vaults supporting the dome.

"It feels like heaven," murmured Cecelia.

Vincenzo nodded, delighted. "In the pulpit, we have only to point upward."

Donato laughed. "Better wait until it's frescoed with skies and a few angels."

He had rebuilt the apse, cloister, and sacristy. The dome was to be his crowning work—precursor to a career in Rome as first architect of St. Peter's Basilica.

"Something terrible has happened to the Maestro Leonardo!"

It was Matteo Bandello rushing onto the parapet. After racing up the stairs, the young seminarian and nephew of Vincenzo paused to catch his breath.

"He was standing in the refectory, looking at his wall painting . . ."

"O *dio!*" cried Cecilia. "What happened?"

"He fell to his knees and moaned and cried 'Noooh!' like he'd found somebody dead. His helpers came running, but when they saw me, they chased me away."

"Madonna, save us!" cried Cecilia, running along the parapet toward the stairs.

The priest and architect followed with Matteo.

2.

In the convent refectory, Leonardo saw it first, a little flake of blue azurite and white lead from Matthew's robe . . . on the floor below the wall painting.

"Here's another one," said Giovanni Antonio Boltraffio.

It was dark ochre with *giallorino,* from James Major's tunic.

"And this, too," said Marco d'Oggiono, pointing to a red flake in the shape of a tiny star.

That was gum lac from the robe of Jesus. So they all were flaking. He shuddered and closed his eyes. Little by little, they would all come down like a collapsing rainbow. No, this was too much. . . . Ton abandoned in the foundry shed, and now these men crumbling on the wall.

"What happened, maestro?" asked Giovanni.

"Why is it coming apart?" Marco inquired.

Leonardo shook his head. There was no reason for this. He had used the same technique for an altar panel at Bergamo and a Virgin for Calco—blending colors with resin oil, honey, lime white, gum arabic, and egg yolk without its white, which caused tempera to crack and peel. Also, the wall had received five layers of well-honed plaster, until it was smooth as a wooden panel.

The wall . . . that was it! The entire convent was cold and damp. Here, it was worse. On the other side of this wall, vapors from the convent kitchen had seeped into it. This had caused salt and acid to exude from lime in the mortar, penetrate the wall, and erode the painting. Milan's weather had done the rest. The drastic temperature change from day to night, in freezing winters and blistering summers, had subjected it to small earthquakes and further humidity. *Porca miseria,* it was clear now . . . when it was too late.

"What can we do?" asked Marco.

"I don't know yet. . . ." Leonardo's mouth was dry, his heart pounding. "Until then, we say nothing of this to anyone. No one, you understand? Sweep away anything on the floor, and keep it clean."

With fury and despair, he climbed onto the scaffold. The painting bore down on him and he had trouble breathing. He sat down in his work chair, wondering how he could say good-bye to any of these men—this band of brothers, this family that had been coming to him for years, especially at night—dark forms passing before his mind. Yet even as ghosts, they would remain forever . . . as Christ expected his disciples to be with Him forever. Then he recalled Ton, alone in the foundry shed, and he closed his eyes, fighting back the tears.

"Nardo! Where are you?"

It was Vincenzo, rushing into the refectory with Donato and Cecilia, accompanied by young Matteo—the little devil who used to spy on him from under the refectory tables. In his paint-splattered tan tunic, he waved reluctantly from the scaffold.

"Nardo!" cried Cecilia. "Are you all right?"

"Of course. Why do you ask?"

"Matteo said you were having trouble."

"Has he ever reported anything else?"

The group stared at Matteo. The boy frowned and shook his head.

"I saw him fall to his knees."

Leonardo smiled. "In this convent, is that a cause for alarm?"

Everyone laughed and climbed onto the scaffold platform. Aware of the boy's discomfort, Leonardo placed a hand upon his shoulder.

"You're welcome, Matteo, as always."

"Thank you, master."

The group passed slowly from one disciple to another, until they came to Judas and Christ, their hands almost touching.

"So that's Judas," observed Donato. "Where did you finally find the monster?"

"It's Leonardo's revenge," replied Vincenzo with a short laugh. "Padre Mariani, the Franciscan who falsely sent him to prison."

"You can see how he hates him," said Donato.

"It's not that simple," replied the artist. "More than the man, it's the act itself . . . and more than any single act of a Mariani or a Judas, it's the potential for betrayal in all of us."

"What led you to this face of Jesus?" asked Cecilia.

He paused. . . . Did she see her image fused with Vincenzo's? He had told no one about it.

"A young count with Cardinal del Mortaro . . . I began with him."

"Master, is this the face of all faces?" asked Matteo.

No one spoke. They looked at Christ on the wall, then at Leonardo.

"No, Matteo," he said, smiling at the boy. "It's not exactly that."

"It's more than that," asserted the Dominican prior, turning to Leonardo. "Do you want to explain it to them?"

"Padre, you know this better than I do," he said, wishing they would leave.

The Dominican waved his hand across the face of the painting.

"First of all, this portrays two events at the same time—the betrayal and the institution of the Eucharist. To do this, Leonardo arranged the twelve disciples into four groups of three, with six figures on each side of Christ."

Everyone looked at the two groups of three on the left and on the right.

"The duality of the moment creates dual reactions on both sides. On the dark side, to the left, they appear to react mainly to the betrayal. Peter has risen with a knife, Judas is alarmed, and John, the beloved disciple, is close to tears."

None of the falling flakes, Leonardo realized, came from this shaded side. The afternoon sunlight warmed the right half only, before the wall plunged into the chill of night, causing the paint to contract and flake. For Vincenzo, however, this play of light was a blessing.

"Now on the right side, with its redeeming light, we witness a mixed reaction to the proposed liturgy of the Eucharist. Thomas points upward with a finger of doubt. James Major stares with disbelief at the bread and wine, Phillip prepares to rend his tunic, and Matthew is arguing with Thaddeus and Simon."

"About what?" asked Donato. "The Judas betrayal or the command to drink wine as the Master's blood?"

"It could be either. That's the infinite wonder of this painting. In reacting separately to the two events, the two halves of the table also reflect the opposite side in ambiguous gestures and expressions."

"So it's never clearly one thing or the other?" asked Cecilia.

"Or it's everything," Vincenzo replied. "Note how ambiguities also flow from Christ Himself. In gestures, dress, and in His face, He radiates both the human and the hieratic."

"Meaning?"

"The turmoil of the angry and bewildered disciples flows back and forth, like waves around Him, and then into Him . . . into this man-God as a sanctuary of peace, a reservoir of love and forgiveness. . . . Leonardo has created another masterpiece for the centuries."

As everyone stared at the flow of despair and wonder around Christ, the artist sought to save Him.

"*Padre mío,* we have a problem. This place is not healthy for any of the disciples or Jesus. There's too much humidity and too many changes in temperature."

"Nardo, I told you we never heat our convents or chapels. If our brothers can take it, so can your disciples and Jesus." He looked at the painting. "Besides, what can happen to it?"

If Vincenzo knew, so would the Moor. It had to be concealed as long as possible. He turned to his mural and felt the eyes of Christ again upon him.

So I can't save you, he thought. We're both lost. Now he was where he was not. When he looked again, Cecilia was also staring at Jesus. Then she

turned to him, and he realized she had seen something else. Was it shades of herself in Christ's face? Or the flaking of His robe? He shook his head, and she lowered her eyes. Then, with innate guile, she spoke to the boy.

"Tell us, Matteo, did you come here to spy on Maestro Leonardo?"

"To see the face of Jesus, the face of all faces, but now he says it's not there."

"It's waiting for him," she said. "The Virgin after the death of her son."

"What a marvelous idea!" exclaimed Donato. "Do we know anything about that?"

"We see her for the last time with the disciples at Pentecost," replied Vincenzo. "Then she disappears from the Gospel. We know only that Christ, in dying, placed her in the custody of John."

"Is that all?" persisted Cecilia. "Could the mother of Christ not give the disciples and the people of Jerusalem the same comfort and love she gives to you?"

"Perhaps," replied Vincenzo. "Except it's difficult to imagine the face of a woman containing the faces of all mankind."

For a moment, no one spoke. Then the priest sought to explain it.

"There's never been a portrait of Mary after the death of her son, other than the Madre Dolorosa in black mourning. She's never been seen with the apostles at Pentecost, or as the mother of Christ walking in the streets of Jerusalem." He closed his eyes. Then suddenly he said, "It could be beautiful! Our Lady among the disciples. . . . How do you see her, Nardo?"

He would begin with Albi, who had inspired all of his Madonnas. Then move her through time into an older, wiser woman after the death of her son. That would give him a Maria in Jerusalem at the dawn of Christianity—a hieratic figure with the aging beauty of a mortal woman.

"So how do you see her?" asked Vincenzo again.

"I don't know yet," he replied, looking at Cecilia. "But I expect you'll both be there when it happens."

MILAN
CASTELLO DUCALE
CORTE VECCHIO

September 1499

L ODOVICO SFORZA'S WHEEL OF FORTUNE continued to take him to the end of his spectacular reign—and to the collapse of Leonardo's world in Milan.

Louis of Orléans, now King Louis XII of France, departed in early September of 1499 to claim the throne of Milan. With an army of thirty thousand, he began his campaign by seizing key fortresses along the Lombardian border, including Annone, where the entire garrison was slaughtered.

Five years earlier, King Charles had come with dreams of glory that inspired his men. Louis came with a hatred for one man—"Signor Sforza," the usurper of the Visconti throne, who had humiliated him and his soldiers at Novara. Charles had resembled a slobbering parrot-nosed dwarf. Louis, frail and old at thirty-seven, had the aspect of a ghoul assembled from leftover parts of others—a small, narrow head on a scrawny neck, an Adam's apple the size of a walnut, bulging eyes between skeletal cheekbones, and a pointed chin with a twisted mouth. Beneath this disarray, however, there was a brilliant mind ruled by one obsession: "I'd rather have the throne of Milan for one year than live to be a hundred."

Lodovico, master of intrigue and deceit, was shocked to discover he had been outmaneuvered by the French king. His ambassadors sent alarming news. One by one, Milan was losing its allies. Venice joined the French to extend its domains into Lombardy. The Swiss cantons, furious with Sforza's betraying them for Emperor Maximilian, followed the others. Florence, seeking to reclaim Pisa, remained neutral. So did Duke Ercole of Ferrara, fearing Venice and the Pope. At Mantua, Francesco Gonzaga, commander of Italy's forces at Fornovo, demurred until it was too late.

Pope Alexander, Milan's former ally, also joined the French in order to marry his son, Cesare Borgia, into French royalty. To this end, he used the Holy See as a marriage-license bureau. King Louis, a Catholic, wanted a divorce in order to marry Anne of Brittany, the aging but rich widow of Charles. The Pope agreed to help. If he dissolved the French monarch's marriage to Jeanne, Louis XI's deformed daughter, could Louis find Cesare a royal French bride? Indeed he could. Charlotte d'Albret, princess of Navarre, was chosen for the papal bastard—a cardinal at eighteen, disavowed five years later, and spurned by Carlotta, daughter of the king of Naples, as a "perjured priest and son of a priest."

Cesare rode to France with the papal bull. Louis, finally free to invade Italy, made the dissolute youth duke of Valentinois and invited him to join in the conquest of Milan. Lodovico learned of it from Cardinal Ascanio Sforza, his brother in Rome: "The Pope is now quite French. The Most Christian King has offered a duchy to his son."

The Moor realized his hour had come. He faced a formidable French army, led by the awesome warrior Gian Giacomo Trivulzio—veteran general of Francesco Sforza, who had left Milan in a rage after the Moor made his son-in-law, Galeazzo da Sanseverino, commander of the Milanese forces. Nor was he alone. The duchy's other allies—Naples, Bologna, and Forlì—were also in danger. The king wanted Naples, while Cesare planned to seize all of Romagna, with the help of Leonardo, in a campaign of betrayal, terror, and murder.

Here lay the tragedy of Italy at the peak of its brilliant Renaissance. Five years previous, its separate states had united to drive a French king from their midst. Now they were separated again, allowing the entry of a second king. Lodovico knew it well. For nearly twenty years, he had used this inherent disunity to rule Milan. That which had given him power was about to take it from him—yet not without a desperate struggle.

As the French seized Tortona and Valenza, he hired mercenaries to increase his forces. He even turned to the Turkish sultan Beyazit II, offering fifty thousand ducats a year to attack Venice. He also appealed to the people of Milan, but it was too late. With the approaching French army, nobody listened to him.

Housewives stored food and provisions. In the streets and cafés, no man wanted the hated French, but the Moor's emergency taxes were bankrupting them. An angry mob murdered his treasurer. Alarmed members of his council began to defect. Then his allies among the nobility deserted him. Anticipating riches and titles from the new king, they exulted in the looming revenge of General Trivulzio: "Gian Giacomo is on his way!"

During his search for popular support, the Moor purchased a vineyard near Porta Vercellina for his court engineer and painter, Leonardo da Vinci. He proudly noted that the property had a vineyard and was large enough for Leonardo to build a house and "so strengthen the bonds which already unite him to Our Person."

Nothing of Milan's crisis appeared in the notes of Leonardo, nor did the departure of Lodovico Sforza—on September 2, 1499—with a small band of followers and a train of mules laden with pearls and 240,000 ducats. His two children, Massimiliano and Ermes, had departed the previous day with their uncle, Cardinal Ascanio, for the safety of Maximilian's court at Innsbruck.

KING LOUIS SEIZES MILAN

MILAN

October 1499

KING LOUIS ENTERED MILAN in triumph under a fur-lined golden canopy borne by Milanese doctors and nobles. The monarch rode a white stallion, his head high, his lips fixed in a grimace of revenge. His shriveled shoulders and sunken chest lay beneath the silver armor of Saint Andrew, wrapped in a cape of deep blue velvet embroidered with golden fleurs-de-lis. White plumes of valor waved above the spikes of his jeweled crown.

In less than a month, Louis had conquered the richest state in Italy with "spurs of wood." Milan's army had scattered, its castle taken by bribery, and its throne seized without a shot having been fired.

A procession of dukes, cardinals, ambassadors, and army commanders preceded him along the flower-strewn via Monte di Pietà. It included the Moor's turncoat relatives—Duke Ercole of Ferrara and Marchese Francesco of Mantua alongside Cesare Borgia's cavaliers in black velvet on horses caparisoned in gold and silver. Before such splendor, and the promise of reduced taxes, the Milanese cheered the French monarch as their liberator.

October – November 1499

THE *LAST SUPPER* overwhelmed Louis, who was graced with a culture lacking in the lascivious Charles. Gentlemen of his court waited while he stood in silence before the painting, bulging eyes brimming with wonder, thin lips parted in rapture. With a short laugh that seemed to free him from the spell, he inscribed a square in the air, jewels sparkling on his small white hand.

"We must have this in France."

Florimond Robertet, his secretary of state, expressed regrets that the painting could not be removed from its wall.

"Then send me the wall."

"Your Majesty, the painting is too fragile. To move it will destroy it."

"You say this painter is also a military engineer?"

"Yes, Your Majesty."

"Then see to it that we do not lose him."

Appearing at the Corte Vecchio studio, the French secretary of state assured Leonardo of his future in the court of King Louis XII.

"I spoke to His Majesty about you. He wants your services both as painter and engineer."

"I am most grateful," replied Leonardo, wondering what this man, whose equerry was waiting outside, really wanted.

"I have the pleasure to inform you the king would like a portrait—*Virgin and Child with Saint Anne*."

Louis probably knew nothing of this. Robertet would surprise him with the painting, while obtaining another one for himself.

"Does this surprise you?" he asked. "Louis is now married to Anne of Brittany, where Saint Anne is the patron saint. This could celebrate the birth of their first child."

"Thank you," replied Leonardo. "It will be a pleasure to serve His Majesty."

Robertet waited his turn. "There's no need to thank me. It's an honor to serve both the king and a famous Florentine."

After being shown around the studio, he played his card. "I shall never forget this day. To treasure it even more, could you arrange to send me a small painting of one of your Virgins?"

Leonardo smiled. Courtiers were all alike. The bigger they were, the more they wanted. Still, it was a small price for entry into the French court.

"Of course. That could be arranged."

The following day, he received another visitor—a tall, aristocratic figure with a mustache and goatee. He wore the elegant uniform of a French general, and introduced himself as Louis de Luxembourg, comte de Ligny, supreme commander of the Most Christian King's armed forces.

"Trivulzio is only in temporary command here," he announced.

Leonardo wondered what this one wanted. Caterina, his servant, brought an eight-year-old Barolo into the study. The count was delighted with its vintage.

"I heard you were a man of taste." He sighed, savoring the wine. "Also, I was told you could be trusted to keep your word."

Leonardo shook his head. "Take care, sire. I seldom produce a picture on time."

The count laughed. "This is something else, which I believe will interest you."

While in Naples with King Charles, the Compte de Ligny had married the princess of Altamura. Following her death, he now claimed his wife's Neapolitan possessions. To obtain them, he had urged Louis to reclaim Naples—only to find the venture postponed by Trivulzio. As result, he was mounting his own campaign to seize the principality of Altamura.

"Valentino confirms support from the Pope," he confided, referring to Cesare Borgia, now the French duke of Valentinois. "But to get there, we have to cross Florentine territory."

He sipped his wine. Leonardo nodded, and the adventurous count detailed his needs—a military engineer familiar with Florence's defenses and terrain. With this, Leonardo was offered another entrée to the French court from a far more reliable patron. He accepted the proposal, and Ligny left a memorandum requesting details of the Florentine state, its fortresses, and how they were defended.

The artist-engineer was on the threshold of a new life. Free of the Moor's petty tyranny, he would have the king of France as his patron, and the commander of the king's army as his companion in the Naples adventure,

which offered a rare chance to study military defenses along the way. On his return, he would be able to finish other projects—a revised flying machine, anatomy studies at the Ospedale Nuovo, and, yes, retrieve the Albi notebooks from Vinci for another attempt at *Maria in Jerusalem.*

2.

As had occurred in Naples with Charles, Louis's troops began to ravage the city—looting, raping women, and killing anyone who got in their way. Pope Alexander, a master of clerical and lay corruption, followed this with delight and contempt: "The French know a lot about conquering, but not how to hold their conquest."

The Milanese, who had cheered the invaders as liberators, now cursed them as criminals. Civilian unrest increased, until one day an enraged leather worker stabbed a soldier who was raping his wife. In return, he was hanged and quartered. The butchered remnants of his body were impaled on Milan's four main portals, with spikes in the severed hands and feet.

The duchy was ready to revolt. Finally, in mid-December, word came that Lodovico Sforza, backed by Emperor Maximilian, had assembled an army of twenty thousand Swiss and Germans to reclaim his throne and free Milan. Sforza partisans secretly prepared to assist his return. Leonardo's close friend, the architect and engineer Giacomo Andrea da Ferrara, confided his plan to help seize the castle by cutting iron bars for an underground entry. Leonardo told him this was insane.

"Giaco! Don't be a fool. They'll also hang you on the gates of Milan."

"What about yourself? You switched loyalties to King Louis, and his viceroy. Even worse, you've given your clay horse to Trivulzio, the Moor's sworn enemy."

"Who knows this?"

"He boasts about it at the palace. When the Moor hears this, he'll probably kick you out of the Corte Vecchia and take back the vineyard."

Leonardo heard this with a pounding heart. He now risked losing both the French king and the avenging Moor.

"Take a trip," suggested Giacomo. "If you're gone, it'll be difficult to say you were on either side."

"You're right. . . . Why didn't I see this?"

"Where would you go?"

"Florence and Vinci, where I have to see my uncle. I'd also want to see Mantua and Venice, and maybe Rome. Bramante is there and already knows the Pope."

MILAN
CORTE VECCHIA

November − December 1499

L EONARDO EXPECTED TO RETURN TO MILAN in a few weeks. Even
so, he had to prepare for a longer absence, which entailed closing his
studio. French troops could steal his paintings, the rare books, and his
secret inventions. All of it had to be removed before he left.

With mounting sadness, he dismantled his flying machine and closed
the workshop, loading two mule wagons with books, clothing, paintings,
sculptures, mechanical models, and gifts for Vinci—to be stored in Florence
pending his arrival. Yet there was no way to say good-bye to the Corte Vecchia.
This had been his world in Milan, a world that had challenged and nourished
him for eighteen years—the third phase, after Vinci and Florence, to have
shaped his life.

At the foundry, he promised Ton to be away only a short while, leaving
money with Gino to keep him damp until he returned. Marco and Giovanni
were given six months' pay—to begin their own careers or join him again upon
his return. His housekeeper, Caterina, wept and promised to wait forever.

A notebook memorandum revealed other concerns during the last days.
It began with cryptic words regarding Ligny, constrained to postpone his
Naples expedition. An apparent attempt at secrecy, with key words jumbled,
confirmed his commitment to the French general's conspiracy: "Find Ingil
[Ligny] and tell him you will wait for him a morra [at Roma], and you will go
with him in lo pana [to Napoli]."

The need to retain the donation of his vineyard appeared next in another
cryptic note for Ligny: "See that you fix e no igano dal [the donation]."

Other needs were tumbled together in a last-minute gathering of
scientific data, art materials, and various personal supplies. A cartoon for the
King Louis *Virgin and Child with Saint Anne* would go with him. So would

Robertet's unfinished painting of a Madonna and Child playing with a yarnwinder.

When everything seemed in order, he received an urgent note from Cecilia.

Carissimo Leonardo,
 Botticelli has completed a painting of the Madonna among the disciples. Padre Vincenzo saw it in Florence. Come to lunch tomorrow to hear about it when your favorite friar returns from Pisa. There is also another, more pleasant, surprise waiting for you.
 I embrace you . . .
 Cecilia

2.

Entering Cecilia's Palazzo del Verme, he passed a departing French colonel with an aide. When Rolando opened he door, she was also there, and clearly upset.

"Oh Nardo! Those awful French soldiers broke into Saronno," she explained, referring to the country estate given her by the Moor. "They stole all my silver, the wine in the cellar, all the pigs and sheep, and even Mirabella, my lovely mare. I haven't slept and must look awful."

There were dark shadows under her eyes, but she possessed a startling beauty—her dark hair drawn back in a broad plait ringed with pearls, a necklace of tiny blue topaz, and a silk dress with broad stripes of burnished gold, beige, and burnt sienna, its open sleeves tied and decorated with buff-white ribbons.

"You never looked more lovely."

"*Caro mio!*" She embraced him and sighed. "Now you're deserting me."

"They say Lodovico's returning with a big army."

"It's true, isn't it? He promised me before he left."

Padre Vincenzo arrived. Rolando offered to take his leather bag, but the friar placed it next to the divan. They sat in the living room before the fireplace with Cecilia's portrait above the mantel. The cathedral could be seen through two windows of transparent glass—a rare luxury. Cecilia smiled and nodded toward the bag.

"*Caro Vincenzo,* it's no longer a secret. Your father general is ill and everyone says you'll be the next vicar general of the Dominicans."

He shook his head sadly, and Leonardo wondered what this meant. He was sixty-four now, with graying hair and the blue veins of age on his hands. His face, however, contained physical strength and resolve—the broad

cheekbones of a warrior, arching nose, and gray eyes with the doubt and wonder of a searching priest. This man would make a great general of the Dominicans. His concern, however, was for the current general, Giovacchino Torriani.

"The poor man never recovered from our brother, Girolamo Savonarola, burned at the stake."

"Your master was there?"

"No, he left before the sacrilege in defrocking of Girolamo and his companions, Fra Domenico and Silvestro."

"Defrock a Dominican?"

Vincenzo nodded grimly. "They were stripped of their cloaks and tunics and hanged from a cross, with Girolamo in the middle. Then began the burning pyre. After the flames devoured their undergarments, the crowd jeered their nudity. One man shouted, 'O prophet, where are your miracles now?' Then the fire's updraft raised Girolamo's right arm, and for a moment he appeared to bless the crowd. . . ."

"O Dio mio!"exclaimed Cecilia.

"This man of God had been the ruler of Florence, his sermons had packed the cathedral, challenged the Pope in Rome, and led his followers, including Botticelli, to throw their most treasured worldly possessions into a Bonfire of the Vanities . . . and now in death, his hand was rising above the flames to forgive them all, including the Pope. Many fell to their knees with fright, weeping and praying for their souls. . . ."

"Madonna," murmured Cecilia, as though praying with them.

"It's more than that. A mob of boys began to throw stones at the half-consumed victims, and fragments of their bodies fell into the fire, until the stones opened Girolamo's stomach and his viscera fell out. That's what haunts him. When I last saw Master Giovacchino in bed, he said. 'God help us, they crucified him like Christ.' After that, he turned to the wall and spoke no more."

Lunch was served with rosé wine and grilled trout from Lago di Garda. Vincenzo raised his glass to Cecilia.

"To your beauty, untouched by time." Then to Leonardo: "To your quick return."

"Grazie. . . . Caro Padre, did Botticelli do a Madonna among the disciples?"

The friar laughed. "It's nothing to worry about, Nardo. You see her at the Pentecost, sitting above the disciples, who are waving their hands in terror at tongues of fire descending upon them."

"Still a young virgin?"

"O Dio, no! She's fat, with a wimple and a swollen belly."

"Maybe she's pregnant," suggested Cecilia.

"God forbid! No, she resembles an arrogant abbess, frightened that

God's tongues of fire will expose her greed and sins." He paused and turned to Cecilia. "To be more credible, Botticelli should have used someone like you."

"I'm not a virgin!"

"*Cara Cecilia,* traces of it remain within you . . . in the purity of your being."

Startled, Cecilia had no reply. Leonardo recalled her saying the priest desired her. And now *Cara Cecilia.* . . . Had Vincenzo conflated her physical beauty with his image of the Virgin? She laughed, embarrassed.

"You shouldn't say things like that. I'm not ready for it. . . . Besides, we don't agree on Maria's perpetual virginity. When she presents Jesus at the temple, Luke says, 'Every male that opens the womb shall be called holy to the Lord.' So did baby Jesus open her hymen like a door and close it upon leaving?"

Leonardo laughed, but Vincenzo was not amused.

"I'm not here to laugh at Our Lady."

"I'm sorry. I didn't intend to offend you, Padre. But when Jesus became a sky-God with his Father in the Holy Trinity, your theologians needed Maria, whom they had banished for two centuries. The people wanted a woman for their intimate problems. That's how her flesh, a woman's flesh, anchors the church to the material world. Without her, you priests are fish out of water."

"She means the Franciscans," suggested Leonardo, hoping to calm the friar.

Cecilia smiled. "How do you see her, Nardo? Our Maria among the disciples? Is she still a virgin, or finally a woman with other children?"

"It could be both."

"How is that possible?" asked Cecilia. "You either have it or you don't."

She laughed, but Vincenzo was enraged.

"This is not amusing. Maria is the virgin mother of God and no one else. That's what I expect to see in her portrait—her grief, her suffering, her courage, but, above all else, the perpetual virgin and vessel of God. . . ."

"And feminine face of the Church," interjected Cecilia.

The Dominican hesitated. "Feminine, but with a masculine element." He turned to Leonardo. "We went through this before. Your composite face of all humanity, to surpass even Christ in your *Last Supper* . . ." He smiled at his hostess. "Provided Cecilia doesn't convince you she's a bishop of the Church."

After he left, Cecilia sighed and sank into a sofa.

"*Caro Leonardo!* You saw how he looked at me . . . at my remnants of virginity? He doesn't realize it, but he wants a Virgin with the look of a woman who has known a man, whether it be of God or a human. Through this man, she has known all men. That would be your universal Virgin . . . the unknown Maria, who's waiting for you . . . and, *caro Nardo,* she's probably four months pregnant."

PART TWELVE

MANTUA AND VENICE

MANTUA

December 1499 – January 1500

L EONARDO LEFT MILAN FOR MANTUA in December, accompanied by Fra Luca Pacioli. The Franciscan mathematician had extended his grasp of mathematical symbols and their magnitude in relationship to figures, forms, and quantities. The artist, in turn, had illustrated the friar's seminal book on geometry, *De divina proportione*. The curly-haired Salai, now inseparable from his master, was also with them.

Before leaving, Comte de Ligny showed him a letter sent to the governing Venetian Grand Council, describing Leonardo da Vinci as "painter and military engineer without equal." Pacioli also had an invitation from Marchesa Isabella d'Este for them to stay at Mantua.

"There's no woman like her," he said. "They call her 'the first lady of the world.' She summons the most famous poets, painters, and musicians to Ferrara."

"I heard she's suing Perugino over a painting. What have you promised her, Luca?"

"Nothing! We're old friends She'll captivate you. Her wit and charm with kings, bishops, and knights have often saved the duchy."

At Mantua, Marchesa Isabella met them, surrounded by four barking dogs— fluffy white Bolognese terriers. With the dogs, she led her guests to a noble suite in the castle. On the way, she saw the painting crate with the cartoon of *Virgin and Child with Saint Anne* for King Louis and the *Madonna* painting for Robertet.

"How exciting!" she exclaimed. "You have paintings to show me."

Leonardo hesitated. If this woman saw either work, she would want it— or a copy.

"Not yet . . . these are unfinished."

The marchesa apologized for the absence of her husband.

"Francesco is in Venice. Sultan Beyazit's army has invaded Istria and Friuli with their savage horsemen, those terrible Sufis." She sighed. "But we will have another noble guest for you next week . . . except he'll have to stay in the piazza."

She smiled brightly, waiting for a reply—an impatient princess in a light blue *gamurra* embroidered with violet lilies. A rippling of pink and violet stripes ran across her bodice into puffed sleeves. A necklace of loose golden strands held a Roman cameo of Apollo and Marsyas. Leonardo met her challenge.

"An Arabian stallion from Spain?"

"No, it's Virgil!"

An antique bust of the Roman poet had been found and would be installed before the castle in Piazza San Pietro. All Mantua anxiously awaited the return of their local hero, born on a nearby farm seventy years before the birth of Christ.

Isabella was larger than Beatrice, Leonardo noted, but with similar features—a small mouth, fat jowls, a high-arching forehead, and a less perky nose. The eyes were darker amber, darting with impatience and an acute awareness lacking in her sister.

"Mantegna is designing the pedestal," she said. "Bronze has the proper nobility, but he wants it in marble, since the bust is marble, and also we won't be tempted to melt it into cannons or church bells!" She sighed and shook her head. "Sometimes he's so stubborn."

"What will it be?" asked Pacioli.

"Bronze, of course."

She waved her hand as though brushing the artist aside. Leonardo was fascinated and repelled. Here was the imperious woman he had heard so much about—a female Moor in the vestments of Cecilia.

"Cecilia Gallerani kindly lent me your portrait of her," she said. "It never leaves my mind. I told myself, Here is a man who understands women."

"Cecilia says that, as well. Perhaps you can explain it to me."

"I don't know if I can. . . . Maybe if you do my portrait, I'll understand it better."

"As Your Ladyship desires."

There was no way to avoid this now, or satisfy her. She expected the beauty and mystery of Cecilia, which was impossible. Perhaps in the sketching, some solution would appear.

At a gala dinner that evening, Leonardo met his old friend Atalante Migliorotti. They sang their songs of eighteen years ago in Milan at the court of Il Moro. Isabella, godmother to Atalante's son, also sang and played an ornate silver lyre, created by the Florentine Lorenzo Gugnasco.

Mantegna sat near Leonardo at dinner. At sixty-nine, he was wrinkled and had gray hair, but the creative force appeared to remain in his wit and flinty, tough-minded manner. Before them, on the walls of the banquet hall, were seven of his projected ten canvases in his series the *Triumph of Caesar*—a military parade, described by Suetonius, of the Roman general returning with spoils of war.

Leonardo was impressed by Mantegna's knowledge of archaeology and military grandeur in depicting armaments, battle equipment, drums, trophies, costumes, slaves, prisoners, and decorative pieces. At the same time, this was a sad waste of genius. In a humanist's passion for the idyllic civilization of Rome, Mantegna had lost all artistic freedom. As a guest, Leonardo raised his glass.

"Our Florentine humanists, who speak Latin and wear their robes like Roman togas, would hail you as the greatest painter of all time."

Mantegna smiled. "Not their great Leonardo with his famous Virgins?"

"There's no contest. I can't even speak their Latin."

"But you have the king of France. I hear he wants to take your *Last Supper* back to Paris."

"He's a restless patron. Your Isabella is fixed in Mantua. So you win again."

"Has she asked you to do her portrait?"

"I prefer you take that honor."

"Oh, no!" Mantegna laughed. "This is all yours, *caro Leonardo*." He paused, amused. "Don't worry. She'll tell you exactly how to do it. Painters are told what to paint and given tape measures for the desired size. If they hesitate, her agents leave a down payment, such as twenty-five ducats, which the painter spends. After that, she badgers them until they comply, or sues them, as she's now suing Perugino."

Leonardo smiled, imagining the princess chasing Pietro.

"And if she doesn't get what she wants, she goes to Suor Osanna, who talks to Saint Catherine for her . . . would you believe it?" asked Mantegna, referring to the ecstatic visionary, beatified by Pope Innocent XII as Blessed Osanna Andreasi of Mantua.

"She's more generous with you?"

"Hardly! In my *Parnassus* for her *studiolo,* she insisted on being the leading dancer. But they're all like that. Pope Innocent treated me like a slave, then refused to pay me. *Caro Leonardo,* never go to Rome. The Popes are worse than their courtesans."

"I'm told you have a magnificent Christ in your studio."

"I would be pleased to have your opinion of it. Come tomorrow toward midday."

2.

On his way to Mantegna's studio, Leonardo wondered how the painter's mysterious *Cristo Scurto*, or *Dark Christ*, could possibly surpass what he had seen around the palace. Andrea was a superb draughtsman, whose hard, clear lines appeared to cut figures from metal or rock. He also had a formidable archaeological knowledge, and a grasp of perspective and pictorial space, providing extraordinary angles of vision. He was an abbreviator, however, similar to Botticelli or Piero della Francesca, who sought poetic harmony of line and color in nature. Mantegna, in pursuit of the antique, had also reduced the pulsating life of nature to an architectural system of rocks and imperial arches. His humanity, garbed in Roman robes, was trapped in a limbo between immovable stone or metal and the moving life of paint.

At the painter's residence in Borgo San Sebastiano near the Mincio River, a young assistant said the maestro would appear shortly. Then he led Leonardo to the painting of the dead Christ. It hung on a wall, light from a garden window illuminating it—a human cadaver on a stone slab, seen below eye-level and drawn in reverse perspective. As a result, the body seemed to plunge toward the viewer like an oncoming projectile. Leonardo, taking a deep breath, realized he had moved to the right of the picture. Was that to avoid the plunging Christ, or an instinctive positioning for an autopsy? No, something else was contained in the painting, charging it with a life . . . even now, in death.

Slowly, he began to note the anamorphic anatomy, beginning with the small cold feet in the foreground. Their spike wounds, congealed in dark brown fissures of dried blood, were ringed with gray decomposing flesh. The shroud cloth was swollen at the crotch, its metallic folds indicating large genitals with penile swelling. The wounds in the hands were also old and dry, and the fingers curved under like claws. The arms, alongside broad shoulders with strong pectoral muscles, had a marble white rib cage and rippling abdominal muscles. The centurion's spear wound was diminished in the horizontal view to a small jagged slash in the right chest, above the heart's aorta.

In reverse perspective, the body parts raced upward toward the head, a mass of dark curly hair and a halo transparent as a spider's web. The head itself, turned slightly to the left, lay on a cushion with the color of splotched blood from the mortuary slab.

Here there was no peace in death. The agony of the cross remained stamped on its features—the knitted brow, the furrowed cheek in a last grimace, the eyes with their long, dark lashes closed in pain, the broad mouth under its

thick mustache clamped shut, the teeth clenched in the rigor of final departure. Had there been no reply to the cry *My God, my God, why hast Thou forsaken me?* It was overwhelming. Mantegna had somehow freed himself from the bonds of humanism—discarding its ancient models and archaic stillness to enter the true canon of the human figure. Or had this Christ escaped his hand to become something more and unexpected—retaining in death the primal seed of the Holy Ghost from the womb of the Virgin?

"Are you ready for lunch?"

It was Mantegna, dressed in a tunic splotched with ultramarine, saffron, and greenish-gray. They walked across a rotunda to a dining room adorned with antique shields, medallions, and cartoons for the Caesar series. The lunch was delicious—sweet winter melon with grilled fish carpione, a salmon trout from Lake Garda, prized by the Roman Popes, and chilled Vernaccia from Colli Morenici. When Leonardo referred to *Cristo Scuro* as a masterpiece, Mantegna nodded and drank his wine. After the second glass, he sighed.

"So you really liked it?"

"Stupendous . . . Who is it for?"

"No one. It's for me. Maybe I'll add his weeping mother, but that's all."

"Something happened when you made this?"

Mantegna nodded and sipped his wine.

"Something you did not expect?"

Again a nod.

"Where do you think it came from?"

"I don't know. Maybe it was waiting for me."

There it was again, Leonardo realized—the mystery of a figure waiting in the wings of the mind. Cecilia had seen it: *Maria, who's waiting for you . . . probably four months pregnant.* Maybe she was waiting in Vinci, among the drawings of Albi. He felt suddenly lonely and wanted to leave Mantua as soon as possible.

After lunch, he returned to the palace. Fra Pacioli was waiting for him.

"The Moor has captured Como and is moving toward Milan. But the French caught your friend Giacomo Andrea breaking into the castle. They quartered his body and impaled its parts on the gates of Milan."

"*Cristo,* that was stupid. I begged him not to do it."

He imagined Giacomo's head dangling at the gate, his blond hair matted with blood, the blue eyes that had dreamed of freedom now staring at circling dogs. More than ever, he wanted to leave Mantua.

"I'm sorry, Nardo. It's hard to lose a friend."

"He couldn't help it. The dream took him there."

"Isabella wants you to begin her portrait tomorrow, before her husband returns."

"I don't want to do it. I want to leave."

"You promised her, Nardo. Also, Mantegna is old. They'll soon need another court painter."

"Not here, not with her."

"Start it anyway. She believes she's pregnant with an heir for Francesco."

"How does she know it's a boy? At least that's beyond her control."

"Ask her yourself."

The next morning, as he left to meet Isabella, Pacioli had an urgent message.

"The Grand Council wants you in Venice. Apparently, Comte de Ligny told them you were a great military engineer."

"Isabella is waiting for her portrait."

"Do it fast. The Turks are approaching the Isonzo, a three-day march from Venice."

3.

Leonardo departed two days later with a drawing of Isabella in profile, done in black lead and red chalk with pastel highlights. He left her a tracing of the drawing, with a promise to transfer the original to a panel and paint it later.

It had started badly. The resolute marchesa was waiting with a triumphant smile in her *studiolo*. She finally had the great Leonardo. He would immortalize her as Isabella d'Este, first lady of the world—glowing with jewels and bright colors in a silk gown of blue and yellow stripes, its bodice hemmed at the top with a string of sapphire and topaz gems that ran across her bosom and onto her shoulders. Its puffed sleeves were attached by a flowering of blue and yellow ribbons, their colors reflected in a necklace of latticed gold with sparkling blue diamonds, accompanied by matching earrings.

He had expected something more—the evolving mystery of pregnancy in a woman. Sitting to the left, he began her portrait in profile. More rapid than a frontal view, it would hasten his departure for Venice.

"I expected it to be like this," she said, turning to face him, her eyes glancing off to the left. "Like Cecilia Gallerani, no?"

"No," he replied, moving farther to her side. "This will bring me closer to you."

"Well, I feel it this way," she asserted, facing him again.

"I'm sorry," he replied, laying aside his red chalk and the large drawing folio.

The princess reared back in anger, her mouth clamped on a curled lip, her eyes narrowed in the fixed stare of a trapped animal. Leonardo waited. Clearly, she had to accept this or lose him. With a short laugh, she finally relented.

"All right . . . but why not as I want it?"

"It's more than you, Marchesa. . . ." He paused. "It's the mother with child."

"Oh . . ."

She looked down and placed her hand on the swollen sheath of blue and yellow stripes. There was a smile, and her face softened.

"Yes, of course."

He began to draw again. Dark brown hair cascaded into a net of gold strands with a fillet of diamonds around the brow. From this portal of hair, the face emerged like a fox from its bushy den—bulbous eyes fixed on its prey, with a forehead curving into the long nose with its thick tip. Fleshy nostrils and lips hung above a strong jaw and double chin.

"How far along are you?" he asked.

"He's hardly begun. I missed my moon cycle only two weeks ago."

"How do you know it's a boy?"

"Suor Osanna says we can expect one. You know about her? She's a saint with more power than any astrologer, priest, or even the Pope. She talks to Saint Catherine every night, who claims he'll be a Scorpio or a Sagittarius. I want the archer for Ferrara. . . ." She laughed. "There're too many scorpions already in my court!"

Leonardo was fascinated. This first lady of the world, who imposed her concepts on poets and painters, was prescribing the sex and astrological sign of an imagined fetus through a living saint talking to a dead one. She was smiling again, as though the next marchese of Ferrara were packaged and ready for delivery.

"Fra Luca says you know human anatomy. When will my boy start to breathe?"

"Until he's born, you breathe for him and feed him through your body."

"When does he get a soul?"

"No one knows. Perhaps with the emergence of a brain. But until birth, your soul governs both bodies, just as your desires, fears, and pains are impressed upon him."

"Don't tell me! I don't want to know about that."

When he had finished, she saw herself stripped of regal artifice—her head lifted defiantly in pride of self and expected motherhood.

"My jewels," she said, touching her necklace. "You left them out."

"They'll come later," he said, knowing there would be no later.

That was how it had gone, and now, on the road to Venice, he decided she was everything Mantegna had said . . . and more. The Moor, for all his defects, gave his artists free rein. He looked for secret places in his paintings. He went into them to find himself or Cecilia, unlike Isabella, who dictated her presence and then had nowhere else to go.

Then he recalled how she had altered when he spoke of her pregnancy—the smile, the face softening as she placed her hand upon her belly. That could be visible in the face of *Maria Among the Disciples*. Cecilia was right. She had to be pregnant again.

VENICE

January – April 1500

VENICE WAS SHROUDED IN FOG when Leonardo and his companions arrived at Punta San Giuliano, a staging area on the far shores of the west lagoon. After stabling their horses and pack mule, they loaded their bags onto a gondola. It was sea blue, with golden lions in its blue carpets, its barrel-chested gondolier in a white jacket with red-, white-, and blue-striped leggings.

After Pacioli directed him to the palazzo of Ambassador Alvise Manenti, near Santa Maria del Giglio, they shoved off into the fog, with Salai seated happily below the gondolier in his bright leggings. Pacioli sat with Leonardo, outside the gondola cabin.

"Alvise says he knows you . . . from Florence."

"Perhaps, but I don't recall."

"Ooh-eeh!" cried the gondolier as they moved through the fog on the lagoon.

Another gondola cry returned from up ahead. Their gondolier repeated his call, and a third warning came from farther across the lagoon.

"There're ten thousand of these gondolas," explained Pacioli. "One for every fifteen people."

Leaving the lagoon, they took the Cannaregio Canal, then the smaller Rio Marin across the Sestieri di Santa Croce. The fog increased in the narrow waterway below the soaring Friary Church, and the blue shell of their craft passed within inches of green moss on a palace wall at low tide. During each thrust and drag of the oar, the gondola veered and returned with the roll of an undulating heart.

A sudden cry from an invisible craft brought an instant reply from their gondolier.

"Ooh-eeh!"

"He can't see," said Pacioli. "But he knows exactly where the other gondola is."

"It's in the nature of sound," observed Leonardo. "If each call has the same tone and pitch, a trained ear can determine distance through variations in a fixed speed-time frame."

The unseen black gondola appeared suddenly, sliding by in silence with a raised oar—forbidding as black-robed Misericordia in the predawn limbo of Florence. He shuddered. This was how Charon took the souls of the damned across the Styx to Hades. Then a shoreline appeared, and he saw two huge gray rats on a palazzo doorstep, scrambling over rotten garbage. *Santo cielo.* Here was the slime and decay of Venice. . . .

"Oreste says we're coming out of it!" called Salai, crouched below the gondolier.

"Thank God!" replied Pacioli.

"*Caro Padre,*" replied Oreste. "While you're talking to God, tell him to stuff these fogs up his holy *culo.*"

At Ca' Foscari, they turned into the Grand Canal. Oreste was right. Here the fog was lifting, driven by a breeze whipping up little waves. The facades of palaces began to emerge in pastel colors of brown, green, and muted Venetian red. Below them, the stark reality of an advancing sea swirled around brilliantly striped mooring poles and private gondolas. Then the sun broke through, and the palazzi appeared upside down in shimmering waters.

They were now among other gondolas, flat-bottom boats, and barges moving at tide's pace in the Grand Canal. Nearing the Manenti palace, they saw a tall three-masted galleon arriving from overseas. Here was the famed lifeline of Venice, and Oreste directed their gondola into the San Marco Basin, moving toward the great ship with its flying banners—the red lion of Saint Mark on its foremast, the captain's flag at mainmast quartered with the arms of Venice.

Sails furled, it was being towed by oarsmen in four tugboats toward the quay, where a crowd had gathered—merchants with horse-drawn wagons and anxious families of the seamen. A sudden flare of trumpets was followed by a cannon's blast. The horses bolted, the crowd waved and cheered, and boys and girls in green uniforms threw flowers into the narrowing gap of water between them and their returning loved ones.

Piazza San Marco appeared, with the two guardians of the Venetian Republic sternly surveying the seas from soaring columns of granite—the winged lion of Saint Mark and a bearded Saint Theodore spearing a crocodile. Leonardo was transfixed. The piazza seemed to rise from the sea as an immense yet intimate *salotto*. Sunlight, streaking through rising mist, engulfed it in a prism of light, with colors and shadows refracted back and forth upon one another, like multiple sounds reverberating in a drum.

The visible harmonic was everywhere. To the right, a great palazzo with a pink-and-white geometric facade seemed to float in the air on two tiers of lacelike Gothic arches. He closed his eyes, and the colors whirled in his mind—a vertiginous galaxy of anamorphic images. They could be captured with an infinite dappling of color, using tiny brushstrokes. . . .

"You're looking at the Ducal Palace," said Pacioli.

"Looks like an old duchess in lace."

"A cruel duchess that has beheaded or blinded some of her doges, and murdered citizens in their beds. . . . She made Venice a proud queen of the seas . . . and there, *caro maestro,* is where you will be summoned as their military engineer."

"To see the doge?"

"He doesn't determine foreign policy or war, nor do his six privy councilors. Deliberative power is in the hands of the Senate, elected by some fifteen hundred aristocrats in the Grand Council. You are born into it and listed in the Libro d'Oro. There's also the secret Council of Ten, which controls the judiciary system, with police and spies everywhere, while an administrative Collegio oversees affairs of state."

"Sounds again like Florence . . . a republic in name, run by rich merchants."

"Exactly, if you're not in the Libro d'Oro, you have no right of suffrage."

"Is your friend the ambassador, in this book of gold?"

"Of course. He's just returned from seeking the release of our soldiers and merchants captured by the Turks. Sultan Beyazit laughed at him. 'Your prisoners will remain with me until peace is made, if it's ever possible.' Then he said, 'Venice is no longer a queen of the seas. We possess more of it than you do!' The doge and his councilors were furious and desperate. That's why they called you—"

Leonardo interrupted him, crying, "There you are!" as though finding a lost child.

The four bronze horses from Constantinople appeared above the central doorway of San Marco. Prancing with arched necks, they glowed in the sunlight. He had dreamed of seeing these creatures for years, only to be floating past them now, prisoner of a gondola.

"I'll come soon," he promised. "After my master, Verrocchio."

At the Manenti palace, a servant took their bags through a water-level entry chamber for the envoy's private gondola, then up a flight of marble stairs and into a reception room. Alvise Manenti appeared with open arms for Pacioli.

"Caro Padre Luca!"

The ambassador, a handsome man with gray hair to the shoulder, dressed in a blue knee-length doublet with a wide fur collar and golden chain, seemed equally pleased to meet Leonardo and Salai.

"Maestro Leonardo, I told this rascal Franciscan that I would never speak to him again if he took you anywhere else."

Here we go, Leonardo thought. He wants a portrait of himself, his mistress, or the Virgin.

"I'm in debt to you," he confessed. "Many years ago, you knew a relative of mine, Bernardo Bembo."

They were similar, Leonardo noted—the sea gray eyes, a large brow, a high nose, and a thin gray beard, with a jagged scar on the left cheek suggesting a saber wound.

"You saved him at a critical moment."

So it wasn't a painting. It was the discovery of His Lordship Bembo's bare ass at the gates of his mountain tiger, Ginevra de' Benci. Leonardo smiled with relief.

"I loved that lady."

"As did Bembo," replied Manenti. "So you're doubly welcome." Then to Pacioli, "Your publisher wants to see *De divina proportione* with Maestro Leonardo's drawings."

"And the Council? When do they want him as military engineer?"

"We'll know at any moment. Also tonight, I have a surprise for you. Lorenzo Gugnasco is coming to dinner with a friend."

Leonardo looked forward to meeting the gifted craftsman of musical instruments—creator of the beautiful lyre that Isabella had played at Mantua.

"Is his friend a musician?"

"He's a young painter, Giorgio da Castelfranco—a pupil of Giovanni Bellini—and he is anxious to meet you."

"Is our friend Grimani also coming?" asked Pacioli.

"Hardly... He's in prison."

"Antonio Grimani, commander of the Venetian fleet?"

"Sultan Beyazit's warships outnumbered ours two to one. Despite this, Grimani had four spectacular victories in August. Then the Turks seized Lepanto and harbors along our Greek trading route. Venice went wild and the war council brought him back in chains. This noble man, now facing death or exile, was procurator of San Marco and served our republic for forty years. . . . A patriot, he wanted no pay for taking the naval command, and he even lent the state one hundred and sixty thousand ducats. Take care, Leonardo, these are the same people who now want you to save them."

"So Pacioli was right. This queen of the seas has no mercy."

"None, especially with a foreigner. Do you want to reconsider?"

"No, I'll take my chances. They betrayed Verrocchio but then relented, and he was able to finish his horse and rider."

"That's not how it is in Venice," replied Manenti. "Everyone thinks Leopardi finished the work. They call him 'Alessandro del Cavallo.' Even Luca says so in his book, which you've illustrated."

"*Cristo,* Luca, you should know better! I can't believe this. It's worse than murder. . . . It's stealing another man's soul."

"It's there for you to see," suggested Manenti. "Depending on how you read the inscription, he's the creator of the work."

"In Piazza San Marco? I must see it now."

"Colleoni made that part of his gift, but he's in Piazza di San Giovanni e Paolo, before the Scuola di San Marco."

"*Santo cielo!* Is there any limit to betrayal here?"

"I warned you," said Manenti.

Leonardo excused himself, and with increasing rage, hurried across Venice toward the remote piazza, until it was suddenly before him—the horse of many dreams, with its fierce warlord turning in his saddle to command his troops amid the clash of arms and the screams of the fallen, his hurled oaths and rage visible in the wild fury of his war mount. Yet now the great stallion seemed to be looking at him alone.

Overwhelmed, he knelt on the cobblestones. From here, Andrea had looked up at that triumphant beast as he closed his eyes and whispered good-bye . . . and there was the betrayal in huge letters decorating the girth of the horse: ALESSANDRO. LEOPARDUS. V.F. OPUS. As Manenti said, it depended upon how you read it. The letter *F* could be *Fundit,* as in "Founded," or *Fecitas,* as in "Made." That was how this son of a bitch had stolen Andrea's lifetime dream. If you looked at his pedestal, however, you could see the man was not only a fraud but also a mediocre sculptor.

Couldn't anybody in Venice note this? It was there, in every detail of the frieze below the plinth. The lion heads were little more than big cats compared to Andrea's fierce creatures on the Colleoni arms. The Medusa head was falling asleep, and the forelegs of the winged horses hung limply, as in death. None of it had the crisp detail and grace integral to the life and power of Andrea's horse and rider. All of it was there, as conceived in Florence—except it was now in bronze, with another man claiming it belonged to him.

Manenti apologized as he returned to the palazzo.

"*Caro maestro,* after you left, I realized you must be right. The monument was erected eight years after the death of your master, giving Leopardi time to steal the honor and credit for the great masterpiece."

"Thank you, sire. He could lie, but his pedestal cannot."

That evening at dinner, Leonardo enjoyed Giorgio da Castelfranco. The young painter had auburn hair and amber eyes, as well as a searching mind,

similar to his own years ago when he left Verrocchio—not at all certain of where it would take him. This apprentice, however, seemed to know what he wanted.

"I've seen your *Adoration* in Florence," he said. "Also a copy of the Virgin in a cave with Jesus and Saint John. They contain the entire universe."

"Thank you, Giorgio."

He hoped that would end it, but after dinner, Gugnasco insisted on seeing the drawing of Isabella d'Este.

"It's incredible!" exclaimed the musician. "You've captured every part of her."

"She feels naked without her jewels."

"With you, she doesn't need them. I'll write her tomorrow . . . what is this?"

On a table for review, Leonardo had placed the cartoon of *Virgin and Child with Saint Anne.* Giorgio was visibly overcome.

"There it is," he said. "The sfumato of light and shadow that's in the *Adoration* . . . and within the harmony and depth of the landscape, the Mother and Child enter the mysteries of our minds, as we enter into theirs—am I right, maestro?"

Leonardo was stunned. In a few words, this boy had grasped the dynamic of the picture. He looked at the youth, who was waiting for some reply, and saw himself at twenty-two—the same loneliness and hunger and dreams of an outsider. It was intriguing, but also sad. There had been so many lost years.

"I can feel it," said the youth. "So it must be there, but I don't know how it got there."

"It's there, Giorgio, if you feel it. . . ." The author of a *Treatise on Painting* then made a rare confession: "It can't be taught, if you don't feel it."

In the ten years that remained before the plague of 1510 took him away at thirty-two, Giorgione, or "Big Giorgio," would infuse his masterpieces with elements from Leonardo—the Christ at San Rocco, or oval-faced Madonnas against landscapes containing mysteries of the mind. His technique and vision, inspired by Leonardo, would become a pivotal force in Venetian art, notably in the formation of Sebastiano del Piombo and Titian.

It was close to midnight when a military summons was delivered to S.E. Ambasciatore Alvise Manenti.

"It's for you," he told Leonardo. "Francesco Priuli, captain general of the Venetian forces, wants to see you as soon as possible. The Turks are on the banks of the Isonzo, only two days march from here."

2.

The next morning, with sunlight sparkling on the lagoon, Leonardo and Alvise Manenti walked toward the Ducal Palace. Along the quay, men were unloading Oriental spices, perfumes, rubber, and immense elephant tusks from a trading frigate. At the Basilica of San Marco, Leonardo paused below the four bronze horses with their golden trappings striding forth into another Venetian day.

"So there you are." He sighed. "From the workshop of Lysippus, three hundred years before Christ."

"And the pride of Emperor Theodosius at his Hippodrome in Constantinople," noted Manenti. "Our crusaders ripped open his grave, stole his robes and jewels, and used his coffin for a horse trough. . . . It's a miracle those barbarians didn't melt these creatures for their copper, silver, and gold."

"It's stylized anatomy . . . but with an inner mystery," observed Leonardo. "Giotto had it in his robed figures."

They entered the Ducal Palace, passing beneath a high relief of a doge kneeling before the lion of Saint Mark, its paw on an open book. Passing through a maze of *ante cameras,* Leonardo was finally admitted alone into the war room of Venice.

Francesco Priuli, in the dark green uniform with gold epaulets of captain general, sat behind his desk. He had immense arms and shoulders and the face of a warrior—massive brow over deep-set eyes, high cheekbones, an arching nose, and a powerful jaw. They were all similar, these men who were legends in their lifetime—Francesco Sforza, Federico da Montefeltro, and Bartolomeo Colleoni astride Verrocchio's warhorse.

Nine men sat around the general like a scattered deck of royal cards. Three staff officers on his right wore uniforms of blue and green. On his left, two councilors of the doge were in scarlet robes. Two members of the Senate's Committee on Peace and War had red robes, and two officials from the Council of Ten wore purple.

Manenti had warned him to expect resentment and jealousy—as he had experienced when presenting military proposals during the Florentine war, and again at the court in Milan. It came immediately from General Priuli as Leonardo remained standing before his desk.

"We have heard of Messer Leonardo da Vinci, as a master painter, and also as exceptional military engineer for Duke Sforza, the Moor of Milan. . . ."

He paused and Leonardo waited.

"Your Moor paid the Turks fifty thousand ducats to wage war upon us and prevent us from joining our French allies . . . How may we know that you had no part in this base treachery?"

"It should be obvious, sire," he replied. "For neither of us are fools. Your espionage network is without equal in Europe. If I had had any part in that conspiracy, I would never have risked coming here. Nor would your personal honor have permitted my summons for other than what I may offer you in this urgent hour."

Priuli smiled. "Very well, what do you propose?"

"First, we should look at your war map," he suggested, nodding toward a long curtain on a bare wall beyond the general's desk.

"Just a minute. . . . How does he know it's there?"

Here we go, thought Leonardo. It's hardly begun, and already an idiot pops up. He stared coldly at the protester in a purple robe of the feared Council of Ten.

"How do I know? I see it nowhere else."

The captain general smiled again, and an adjutant drew back the curtain. The large map, visible to everyone seated in the room, revealed the Turkish army encamped in the banks of the Isonzo. A Venetian fort on the road to Venice was on the opposite bank. Another fort farther north stood on a promontory over the river as it wound through a narrow mountain pass. Leonardo pointed to the lower fort.

"Massing troops around this fort can serve as a diversion."

"Diversion from what?" demanded an officer in the olive green uniform of the artillery.

"General Morosini commands those forts," explained Priuli.

"A diversion would help when we begin up here," replied Leonardo, indicating the higher fort. "In this first channel through the mountain pass, a few men, with the aid of this river, can equal a large number—"

"Have you ever been there?" asked Morosini, interrupting him. He sniffed the air like a rodent with a thin mustache.

"No."

"How do you know there are mountains?"

"The river tells me so. . . . May I proceed?"

Priuli nodded, and Leonardo outlined his plan.

"We dam the river here," he said, pointing to the first curve in the mountains. "That will back it up onto the plain. Sluice gates will regulate the flow. When the sultan starts to cross, we'll open the gates and drown his army. Then he'll realize who is the real Queen of the Seas."

There were smiles and brief laughter, but Morosini shook his head.

"Dam that river? Who can do that?"

"Your famed arsenal of Venice. If it can build a ship in one day, there should be no problem in placing the piles and planks."

The captain general seemed intrigued by the plan.

"The man-made flood," he mused. "Cyrus, king of the Persians, used it. So did Aexander and Caesar. But before considering this, Messer Leonardo, we must have detailed plans and drawings after you've seen the river and determined if it can be held back . . . and this as soon as possible."

With a military aide and mules, Leonardo journeyed through the valleys of Friuli, across the rivers Piave and Tagliamento, then up the Isonzo Valley to Tolmino, twenty-five miles above the Ottoman encampment. In a narrow mountain pass below Santa Lucia, he drew upon his experience with Lombardian canals to construct a river dam with sluice gates. Men would work under cover at night, using lanterns on long poles painted black and erected at sunset, each one having "one overseer for every five sappers so that the work may be rapid," he noted. The dam would be at four ells, or fifteen feet, above the average level of the river. Stones and bottom refuse would pass beneath its gates. Trees, uprooted by floods, would float over its zigzag top.

Back in Venice, the war council questioned the cost of the project, the manpower required, and the feasibility of completing the work in sufficient time. A month passed with no decision, despite the threat of encamped Turks. Leonardo was disgusted but not surprised. Manenti had warned him to expect this also—a war council paralyzed by indecision, which had given victory to the Turks and imprisoned a Venetian patriot. During nights of fitful sleep, Leonardo pondered other ways to block the Turkish advance.

One day, while watching a merchant ship being loaded, he followed its hull as it sank lower into the water with increased cargo. There, he realized, was a way to attack the Turks. Sink their ships by boring holes into their hulls underwater. Alberti had sent Genovese divers to the bottom of Lake Nemi to raise sunken Roman galleys. In Siena, Taccola had devised an air bag to go over a diver's head. Aristotle also had conceived of a diving bell for working on the seabed with a breathing pipe "like an elephant's trunk." Yet more was needed, and he recalled stories of Indies pearl fishers wearing a "special dress" for work under the sea. Returning to the palace, he designed a diver's suit:

> This instrument used in the Indian Sea for excavating pearls, is made of leather with frequent hoops, so that the sea shall not compress it . . . above there is a companion with a boat, while the diver may seize pearls and coral (using) eyepieces of snow-glass and a cuirass with spikes.

The diving suit would have a shirt of webbed armor and a tube for urination. A glass mask, with tubes to nose and mouth, would receive air from a large bladder as the diver, weighted with disposable sandbags, sank into the ocean. Two or three empty bladders would be inflated for a return to the surface.

The diver, swimming underwater to the ship, would bore a small hole into the hull at the end of a plank. A screw with prongs would widen the hole until the ship was leaking beyond repair. While this was under way, a submerged vessel would approach other galleys and fire explosive shells into their hulls.

A drawing of this "ship to sink other ships" showed a saucer-shaped vessel for one person in a crouching position. With its occupant aboard, it would be lowered into the water, leaving a raised part for viewing—in effect, a periscope. Leonardo warned: "Remember, before getting in and closing down, to push out the l—t." The letters suggested *alito,* presumably the secret air supply.

These underwater raids would demolish the sultan's fleet and make Leonardo rich. In freeing Venetians captured by the Turks, he could collect ransoms promised by their families. The notary's son stipulated how this would be accomplished: "First, draw up a legal contract so as to obtain half the ransom . . . let delivery of the prisoners be in charge of Maneto (Manenti) and payment made to Maneto . . . of said prize money."

Nothing came of this project. Meanwhile, work had begun on the Isonzo dam. Workmen from the arsenal shipyards drove in pilings above the height of the riverbank, half a *braccia* apart, and then closed them with wooden planks. Years later, while constructing sluices in the Loire, Leonardo would note: "Let the barrier be movable, as I arranged in Friuli." Then the project was abandoned. Sultan Beyazit, fearing an advance on Venice would result in an alliance of Italian states, never crossed the Isonzo.

3.

Leonardo learned the Moor had returned in triumph to Milan—only to lose it once more due to the betrayal of eight thousand Swiss mercenaries, on whom he had spent his entire fortune. During the siege of Novara, the French offered them more money to withdraw. Overnight, they refused to fight other Swiss in the French army and decamped for a return home. To escape capture, the desperate Sforza disguised himself as a Swiss pikeman and joined their ranks—only to have a Swiss captain named Trumann betray him to the French. The Swiss saw no wrong in deserting the battlefield, but to deliver an employer to the enemy was cowardly treason. They promptly executed the traitor.

So ended the dream of returning to the old days in Milan, and a new career at the French court. King Louis had returned to France with Robertet. Louis de Ligny also left, escorting Lodovico Sforza to the fortress of Lys-Saint-Georges at Berry, where Louis took final revenge in parading "Signor Sforza" through the streets like a wild animal.

Leonardo bitterly noted abandoned works of art and loss of "buildings by Bramante." Important men had been swept away like leaves in the wind, including Galeazzo Visconti, the bright court favorite of Beatrice: "Visconti carried off . . . and then his son died," and also Ambrogio della Rosa, the Moor's crafty astrologer: "Gian della Rosa was deprived of his money." Leonardo's final words were for his patron of eighteen years, the once powerful and brilliant prince who had been the envy of Europe: "The duke has lost his states, his personal fortune, and his freedom; and none of his works came to completion."

This wasn't true, of course. Lodovico Sforza had completed many important works—new hospitals, universities with brilliant professors, major libraries, a network of canals, flourishing trade and agriculture, magnificent churches, municipal buildings, and many works of art. If anything, Leonardo was referring to his own unfinished projects.

He needed to be alone, and he left the palace to walk through a drifting fog along the whispering quays and silent side canals. Suddenly, it was before him, rearing up in the swirling mist—the great horse and rider. The warrior was Andrea, rising up in triumph above his great horse. He was part of it, fused into its molten bronze. Leopardi would be fused elsewhere—among the falsifiers and pimps in Dante's Ninth Circle of Hell, scuttling like pigs in gnawing at one another's flesh.

When the work was part of you, no one could steal it. Nor could you escape the need for it. The master, on his war mount, was saying it once again: *Figlio mio, follow your dreams and keep working. Even a simple sketch can turn you around. Your daemon will respond to that. It will take you far from here.* Then, turning away into the evening shadows, Leonardo addressed his master: *Padre mio, I never left you. . . . I need you now, more than ever.*

FLORENCE OPENS HER ARMS

FLORENCE

April – June 1500

FLORENCE OPENED HER ARMS to Leonardo. He had left with some renown—the brilliant thirty-year-old disciple of Verrocchio. At that time, his paintings had included a mysterious unfinished *Adoration*, the Virgin and Child appearing amid a swirling cloud of humanity. Eighteen years later, he was a legendary painter, sculptor, and engineer of spectacles from the most brilliant court in Europe, as well as an imposing figure.

At forty-eight, he retained the erect posture and the muscular strength of youth, with an athlete's ease and grace of movement. The years, however, had left their mark. A fine network of wrinkles spread out from the eyes. Two creases descended from the nostrils into a flowing mustache and auburn beard with a scattering of gray hairs. He needed glasses now to describe the flight of birds or trace the cranial nerves of sight.

His voice remained that of a baritone, and he spoke in a measured manner—pausing occasionally, as though entering an unseen room within the endless labyrinth of his mind. He laughed softly and smiled as one does with a fond memory. In his manners and gestures, there was the air of a nobleman with total disdain for passing fashions.

He found a different Florence upon his return. The war to reclaim Pisa was crippling the city, closing banks, and driving merchants and guilds into bankruptcy. Ghirlandaio was dead, as were Verrocchio's rivals, the Pollaiuolo brothers. Lorenzo di Credi ran Andrea's workshop with diminished vision and talent.

Doors once closed were open to him now. At Landucci's apothecary shop, silence no longer met the homosexual bastard of a slave and Ser Piero da Vinci, former notary for the Signoria. Strangers sought to press his hand, women stared in wonder, and merchant barons asked for religious figures or family portraits. The Benedictine nuns at Sant' Ambrogio sought the angel Gabriel as he appeared to the Virgin. He gave them a close-up of a bare-

breasted youth with a foreshortened arm pointing toward the adolescent Virgin, the woman destined to receive the seed of the Holy Ghost.

Other commissions were accepted, though never without bitter memories of treacherous Florentine aristocrats, merchants, and clergy. Among them, Francesco del Giocondo, a rich Florentine silk merchant and a powerful Buonuomini counselor of the Signoria, requested a portrait of his pregnant wife, Lisa Gherardini—but after he sketched her, she said she wanted to wait until after she had had her child.

The Servites—Servants of the Blessed Virgin Mary—requested an altar painting, *Virgin and Child with Saint Anne,* for their church, Santissima Annunziata. He accepted immediately. For the French king, he already had a cartoon of Anne and Mary with Jesus blessing Saint John. The friars, delighted to obtain the creator of the famous *Last Supper,* gave him a studio in their monastery, as well as living quarters for him and his pupil, Salai.

Ser Piero da Vinci, procurator for the monastery, took credit for this. Leonardo knew otherwise. Filippino Lippi had brought him to the Servites. He thanked his father anyway. It was useless to expect love or affection from him. Yet there remained, like stains on old walls, a hunger and hope his father's attitude might change one day.

This ambivalence appeared in an earlier letter to his father, sent from Milan following the death of Ser Piero's third wife, Marguerita di Francesco. The greeting, with a suggestion of intimacy, becomes stiff and formal: "Dearest Father . . . within its small compass (your letter) brought me joy and sorrow, joy because I learned of your good health, for which I thank God, and sorrow because I learned of your misfortune. . . ."

Yet nothing had stopped Ser Piero. He was finally producing legitimate heirs: Marguerita had had five children who survived. At fifty, a year after Marguerita's death, he had taken a fourth wife, Lucrezia di Guglielmo Cortigiani, orphan of another well-known notary, who was to present hin with six additional children. As legitimate heirs, these half brothers and sisters were bitterly opposed to Leonardo's inheriting Francesco's half-share of the Vinci estate, which could confer on him the Vinci legitimacy denied by his father.

Leonardo avoided them and his father's palace. Where once Albi had loved him, there was only hatred. Even more, the image of Piero still making babies was disgusting. Into the inferno with all of them.

It was time to see Checco again. Now that he had a studio and lodgings with the Servites, he could reclaim the early drawings of Albi. Their free-flowing lines, *lineamente inculte,* could help to infuse the visible body of the woman he loved with the invisible being of another one he sought—Maria the disciple in the streets of Jerusalem.

June 1500

MOUNTING CASSIO, HIS NEW BLACK STALLION, Leonardo took the high road across the mountain slopes. At Vinci, Francesco emerged from the barn to embrace his beloved nephew.

"So God has ears," he said.

"*Caro Checco,* he heard both of us."

At sixty-four, his uncle was thin and frail, with gray hair. But his eyes were bright, his hand had strength, and he climbed the slope to the house without effort.

"Your notebooks?" he said. "We hid them in a barrel in the cellar."

Upon lifting the barrel, however, there was a stench of rats. Opening the box, they discovered that rodents had eaten the goatskin covers and pages of fourteen notebooks, leaving scatterings of encrusted excrement. One by one, Leonardo opened them with increasing despair. Precious pages had been consumed, including sketches of Albi during her pregnancy. The drawings at Anchiano had suffered even more. In the field of wildflowers, only the left half of Albi's head remained, under a mangled straw hat with a half-devoured neck above an intact left shoulder and left breast.

"Madonna." Checco sighed. "They chewed her up everywhere."

His gnarled index finger touched the stump of Albi's right leg.

"*O Dío,* Nardo . . . is it all lost?"

Leonardo looked at his uncle. He was weeping.

"Don't worry, Checco."

"I mean, can we use any of it?"

"Yes, we can. . . . Don't worry."

It was a mindless butchery. Yet somehow the rats had invested the remaining parts with greater intensity—the chewed-off smile on the left cheek, the lobe of the left ear with its coral earring in the dark cascade of hair, the right foot and ankle without its leg. Each remnant in the ink drawing extended curving lines of life toward the missing parts. So she remained, this woman he

loved, lingering in frayed moments of time like the fading *Last Supper* in Milan, or the projectile cadaver in Mantegna's *Cristo Scurto*.

Still, this was not what he needed. He had hoped to go beyond sketches of passing moments, beyond memories inflated through the years, into another reality. Clearly, he needed an older, reflective Albi—projected in time beyond the death of her son. Perhaps her picture in the church had something more.

"Is it still there?" he asked.

Checco nodded. "A young priest was caught selling it to a Florentine merchant, and he ran out of town before they threw him into a well."

"And Don Piero?"

"Oh yes! He's seventy now, but still with us. Olga's gone, though. . . . She died after riding Nascita through a storm to deliver a baby. Mona Pippa's still brewing her herbs at the cemetery in moonlight, and everyone uses them. Some foolish people have accused her of being a witch, but Don Piero put an end to that."

Leonardo nodded. "That's our priest. . . . If only they were all like that."

Mass had ended and the church was empty when they arrived. Checco went to the sacristy to find Don Piero while Leonardo looked for his picture of Albi. The wooden statue of the Virgin was still there, to the left of the altar . . . and there she was—Albi with her baby in a chapel lit by a cluster of burning candles.

He approached it with wonder. Little more than a pen sketch, colored with sepia and white highlights, it was a shallow work. Yet this inspired moment had taken him across the years into all the Madonnas that had followed, one upon the other. Within them all, however, there was this first one, drawn at night in lamplight to bring this woman back into life from a morgue crawling with red-eyed rats.

"Nardino!"

Don Piero embraced him with searching brown eyes. His hair was gray now, and blue veins traversed his sunken temples.

"How does she seem to you now?" he asked.

"I wonder how I did it."

"So do many others. You want to do another one?"

"After she's lost her son . . . Maria among the disciples in Jerusalem."

The priest looked at Vinci's venerated *Madonna of Childbirth*.

"Of course! They needed her as much as we do."

He pointed to a confessional booth next to the chapel.

"People unload everything on me in that box," he said. "Not only their sins, but everything else . . . 'Why did my baby have to die?' 'Why did God let

an ax cut off Mario's hand?' 'Why the death of a cow, or my wheat without rain?'. . ." He smiled sadly. "Then they say, 'Why is God angry with me?' I tell them he isn't, but it's never enough. So they pray before your picture for what I can't give them."

Leonardo recalled Maria's going to sleep when he wanted her to save Albi.

"Sometimes she does nothing at all."

"It doesn't matter. They come back again and again for an answer, for some hope. They have no one else. A man like Jesus can't handle their intimate problems. Maria understands everyone, even in our dialect. So yes, Nardo, I see her among the disciples, though she must have been a holy mystery for those men!"

"A mystery?"

"They were only human, no? How could they not look at her and think, The Holy Ghost was inside her, then it came out as our Savior!"

"So the disciples would see her in two ways?"

The priest hesitated. "The Virgin and the Holy Mother with Child . . . and, yes, a disciple with the others. How do you see her?"

"A woman known to millions, yet seen by no one."

PART FOURTEEN

EXPLORING THE

ORIGINS OF LIFE

SANTA MARIA NOVELLA HOSPITAL

June – December 1500

I N HIS SEARCH FOR THE PRIMAL ELEMENTS of human life, Leonardo realized that inherited concepts of medicine and anatomy would never take him where he wanted to go. There was only one answer to this. It lay in the hospital of Santa Maria Novella in Florence, where one could find him exploring dark corridors and opening windows to unseen medical dawns.

No one had ever spent nights dissecting cadavers to show their nerves, muscles, and organs in superimposed layers—defying professors and their illustrated texts. No one had revealed, in the meticulous care of dissection, such concern for life in any form. Nor had anyone dared to oppose the universally accepted formulations of Claudius Galen, the second-century Greek physician and favorite of Marcus Aurelius after he had cured the emperor of a stomachache.

Galen was a formidable opponent for anyone exploring the dynamics of human physiology. The author of five hundred texts claiming to follow Hippocrates, his magisterial dictates freed physicians for a thousand years from attempting specific protocols or otherwise exploring human illness. Toscanelli had led Leonardo to the works of Avicenna, among Arab interpreters, and to Mondino de' Luzzi, who drew from both Galen and other Arabs.

Yet now, Leonardo once again questioned them. In Milan, while probing the eye's anatomy and physiology, he had reversed the Greek concept of vision. In Florence, with embryology, he would abandon numerous canons of Galen, Plato, and Aristotle, exclaiming, "I have wasted my time!"

He also faced another barrier within himself. The sexual act was a hideous affair. If not for the beauty of faces, their ornaments, and the liberation of the spirit, the human race would perish overnight. Yet generation in man and beast was ordained by nature, which had been his home since childhood. So he did not expect to flounder in crossing the shoals of sex, or the mysterious

eddies in the womb and fetus of the gestating female. This began by correcting Mondino, using his Latin name:

> . . . The female has 2 spermatic vessels in the shape of testicles (the ovaries). . . . You, Mundinus, state that these "spermatic vessels"' or testicles do not excrete real semen, but only a certain saliva-like humor, ordained by Nature for the delight of women in coition . . . yet the mother's testicles have an influence on the embryo equal to the father's.

Successive pages portrayed the male generative organ with its spermatic vessels next to drawings of the female ovary and its vessels. Other drawings appeared to descend further into the dark recesses of Leonardo's libido. One of the most startling was the portrayal of a vagina as a dark, yawning orifice, its urethra without clitoris or labia minora. Overcoming this repugnance, he eventually drew the vulva and large labia, noting they served as "gatekeeper of the castle." The vagina's size, however, created problems for both sexes:

> In general, a woman's desire is opposite the man's. She likes the genital size of the man to be as large as possible, while the man desires the opposite from the woman's genital parts, so that neither ever attains what is desired. . . . Nature, who cannot be blamed, has so provided because of parturition. Compared to the size of her womb, woman has larger genital organs than any other species of animal. . . .

Under the female buttocks, he drew the tight closure of the anus with the five muscles of the sphincter "gatekeeper." Then his pen drifted on, drawing them into the petals of a fleur-de-lis, followed by the plan of a pentagonal fortress surrounded by a moat. On other pages, he examined male and female organs—uterus and uterine vessels, ovaries and cotyledons, pubic bone and muscles, seminal vessels, ejaculatory ducts, longitudinal and transverse sections of the penis.

Here again, he corrected the ancient concept of a seven-chambered uterus, yet retained Avicenna's notion—eventually discarded—of two penile passages: the upper for passing the spirit or soul into the future embryo, the lower for semen or urine. The sperm, he noted, was actually created in the testes, then stored in a holding area of a "seminal vesicle" until needed for ejaculation through a single penile channel.

In another leap across the centuries, he discovered that male and female cotyledons joined the placenta and fetus in utero "like the fingers of one hand between the digits of the other." So the embryo, in its initial stage, contained

both sexes—exactly as he had imagined in seeking the purity of Christ. He then turned to the developing embryo, drawing a transverse view of a five-month fetus with surrounding membranes. For the first time in history, the child was shown curled up in the womb. With beauty and transparent clarity, it appeared asleep within its mother.

In another breakthrough, he found the circulatory system of the child in the placenta to be separate from that of its mother:

> The vessels of the infant do not ramify in the substance of the uterus of its mother, but rather in the secondines which coat the uterus, and to which it is connected (but not united) by means of cotyledons.

This discovery was followed by a description of the developing fetus. Here he was unable to free himself from the Greek-Arabic belief that the mother's heart alone served the embryo until the moment of birth:

> The heart of the child does not beat, nor does it breathe because it continually lies in water . . . breathing is not necessary because (it is) nourished by the life and food of the mother. . . . Therefore one concludes that one and the same soul governs these two bodies, and the desires, fears, and pains are in common

Still, he plunged ahead, a man alone among flickering oil lamps and decomposing cadavers, driving himself through endless nights in a search for the source of human life. Cadavers were rare, however, which often forced him to use pigs, horses, oxen, and monkeys. This led to other errors, as in his depiction of a human throat, using a dog's larynx with a pig's thyroid. When he finally did obtain an entire body, he made a remarkable discovery in a cause of death among the aged—the key to longevity and its role in his own life.

The opportunity came with the sudden death in the hospital of a man named Marcellino, who had lived for an astounding one hundred years. Upon receiving the body for dissection, he noted:

> . . . the great ease of working with a body, devoid of either fat or moisture . . . when I opened the body to ascertain the cause of so peaceful a death, I found it proceeded from a weakness through failure of blood and of the artery that feeds the heart and the lower members, which I found to be parched and shrunken and withered.
>
> The old who enjoy good health die from a lack of sustenance. And this is brought about by the passage to the meseraic veins becoming

continually restricted by the thickening of the skin of these veins; and the process continues until it affects the capillary veins, which are the first to close up altogether. . . .

In another autopsy on a child of two years, I found everything contrary to what it was in the case of the old man.

With this description of arteriosclerosis and gerontology, Leonardo suspended his odyssey into the origin of human life. He was finally ready to begin his portrait of the universal mother: *María Among the Apostles.*

Salai arrived with an urgent letter from the Signoria. Addressed to "Il Signor Leonardo da Vinci," it was from "Ser Piero da Vinci, Notary of the Republic":

> Leonardo,
>
> Once again, you are a grave disappointment. I sought to help you with the Servi di Maria, but you have betrayed their trust and faith, and embarrassed me as their notary and legal advisor.
>
> Their Father General, Padre Jacopo da Cremona, can wait no longer. Either you produce your Virgin and Child with Saint Anne, or you will be asked to leave his convent. Be further warned: Your savings at Santa Maria Novella will be attached to pay for a more than year's lodgings and failure to honor your contract with these devout servants of Our Lady. . . . Ser Piero

The words swirled with a returning sadness of childhood. The neat notary's script: "Ser Piero". . . not Your Piero, or even Your Father. The Vinci door once again slammed shut on the unwanted bastard of a slave. He threw the letter into the fire.

"All right, I heard you. . . . Now you'll hear from me."

THE FRIARS AND
VIRGIN AND CHILD
WITH SAINT ANNE

FLORENCE
SANTISSIMA ANNUNCIATA

April 1501

I N EARLY APRIL, LEONARDO placed a variation of the cartoon intended for Louis XII on the altar of the Servite church, Santissima Annunziata. From there, it was easy to imagine the eventual painting *Virgin and Child with Saint Anne* above the altar.

The friars immediately came to stare at an amazing pyramid of entwined figures, drawn on light brown tinted paper using charcoal, soft black chalk, and white chalk for highlights. Atop this embryonic intermingling of bodies and limbs, the face of Saint Anne appeared above her daughter's right shoulder, smiling with the pale, shadowed features of an older sister.

To their wonder, the Virgin was sitting sidesaddle on the right leg of her mother, a radiant beauty in her face. She had soft, velvety shoulders and a full throat with the pulse of a heartbeat, and her arms were extended toward her infant, hugging its pet like anybody's child might. It was a lamb, however, the symbol of the Passion. Saint Anne, aware of the child's destiny, sought to restrain her daughter's futile gesture.

Fra Jacopo of Cremona appeared, and they all moved aside for their father general—a tall man in a brown cassock, with dark curly hair cut in a ragged line across a massive brow, a long nose, and deep-set gray eyes. It was the face of a mystic, with the reality of a jagged scar across the left cheek—a white rivulet on the cheek's dark plane slowly curving into a smile.

"*Madonna mia*," he murmured. "He has it going in two directions."

None of his brethren understood this. Padre Agostino looked at Mary pulling her son, and the child pulling the lamb—all of it going in one direction. He grasped a wooden crucifix dangling from a rope belt, symbol of where the pink baby would one day be impaled.

"Two directions?" he asked.

"Look at Saint Anne," commanded the father general.

Everyone looked at the face of the mother saint peering over Mary's shoulder. She looked like Mary, with a similar nose and mouth, the same

enigmatic smile, the eyes in dark shadow. God's legendary matrix for Mary had emerged from the shades of night to attend the impending sacrifice of her playful grandchild.

The pink tip of Padre Agostino's tongue slid across his upper lip.

"She's going somewhere else?"

The Servite general turned, his face dark, the dueling scar a white streak.

"For the love of God, can't you see it? The two women reflect each other. God created Mary as he conceived Saint Anne. This is exactly what we want."

The friars stared again at the cartoon. They believed Saint Anne was also a virgin in the divine scheme of redemption—a belief that had spread throughout Europe. Having conceived "without the action of man," she was as pure as her daughter and so deserved similar veneration.

While the friars stared at the picture, Padre Jacopo spoke for them.

"Finally, a credible Metterza and a real Saint Anne. They're usually piled up on top of each other like a hay pole."

Leonardo smiled. This was an unusual friar—a cultured Servite general with a dueling scar, a man who could ridicule the ritualized iconography of Santa Anna Metterza, or Saint Anne the Third: a popular portrayal of Anne with her daughter and grandson in a maternal Holy Trinity. Leonardo knew it well. Masaccio and Gozzoli had painted it. At Vinci, they did resemble a hay pole on holy cards during a feast day, and he had sketched his own Metterza using Albi, Caterina, and her little boy, Franco.

Padre Jacopo turned to Leonardo.

"I thought it was impossible to reveal the legendary truth of Saint Anne's role in the redemption . . . that she's aware of what lies ahead, while her daughter does not . . ." He looked again to the picture. "Even more, you can also discern within the shadows an intermingling of selfless love, going beyond ourselves to the realm of otherness."

He paused, returning to another reality. "So, maestro, when do we get the final painting?"

"I will need six to eight months."

"Let me warn you, sire. We can wait no longer than that."

Yet there was no waiting in Florence. Word spread that Leonardo da Vinci had created another masterpiece, one where, once again, people of every sort would find themselves. Crowds gathered before the convent, and for two days men, women, and children were allowed to enter the courtyard, where the sainted figures appeared to be alive and waiting for them.

From the arcade, Leonardo studied their reactions and listened to their hushed words. He had what he wanted. The painting spoke not only to the friars and their general, but also to the multitude.

SECRETS OF

MASACCIO'S MARIAS

❧ SERVITE MONASTERY

URING THE NIGHT, LEONARDO AWOKE to the song of a nightingale. He listened for a while, seeking repeated lyrics. Then he rose to review new portraits of Albi, taken from Vinci notebook remnants—black and red chalk with pastel, brushed charcoal, tempera, and brown ink wash—but it was going nowhere. To move her through time, as Maria after the death of her son, he needed something more. Perhaps Masaccio had an answer. He had made similar passages with his own Virgins—two of them, created at separate intervals.

He went first to Sant' Ambrogio, where Masaccio's *Virgin and Child with Saint Anne* hung above the altar. Maria held her child in her lap, while Saint Anne in a wimple was perched above them. Florentines wanted their Madonnas to stare with love at the Child. Masaccio's looked at the viewer with the innate self-assurance of a young mother. This was the Masaccio who hated the sweet Gothic, facile ways of Florence. This woman projected a psychological truth no one had ever dared to reveal. It was in her eyes. The face glowed with youth, but the eyes were already old, with an air of apprehension bordering on defiance.

Masaccio's next portrait, after the death of her son, was in his *Trinity* fresco at Santa Maria Novella. He had to go there now. Before leaving, however, he paused before the tomb of Verrocchio. It was always sad to look at this. Andrea had requested burial in Venice, near his horse and rider, but Lorenzo di Credi had brought him to this cold family vault in Sant' Ambrogio.

He waited, head bowed, for something more than the bronze inscription in the marble floor: ANDREAE VERROCCHII QVI OBIIT VENETIIS MCCCCLXXXVIII. Nothing came because Andrea wasn't here. He was in Venice, where he had fallen beneath his horse and rider. In Florence, there was more of him in his wooden scalpel—that gift of love from Donatello, which contained them both.

"Good-bye, dear friend. . . . I'll find our Maria soon."

With that, he left for his other master. On via dell' Oriuolo, he met Padre Agostino. The fat Servite in his black habit, with a freshly shaven white tonsure, seemed delighted to be outside his convent.

"O signore!" he exclaimed, holding Leonardo's arm, "A young master came to make a copy of your picture."

"A copy?"

The friar nodded. "In a notebook. He's also a Florentine, Michelangelo Buonarroti. . . . You know him?"

"No, Padre."

On his return to Florence, Leonardo had heard of Michelangelo, the child prodigy whose fresco technique came from Ghirlandaio, his sculpting from stonemasons, and his clay modeling from Bertoldo in the Medici gardens. At fifteen, he had carved a Roman satyr, which led to Lorenzo de' Medici's bringing the boy into his family. Clearly, he took whatever he needed. The Servite's *Virgin and Child with Saint Anne* would probably resurface as a Holy Family in one form or other.

"The Strozzi have a bronze *Hercules* he did at eighteen," said the friar. "And in Rome, he did a marble *Pietà* with Christ lying across the lap of Our Lady as if she were an altar. Everybody's talking about it, even the Holy Father. . . . Have you met this young master?"

"Not yet."

Nor did he want to meet him. He had seen the former boy wonder walking the streets of Florence, head down, looking at no one—short and lean, with large shoulders and hands, a round, ugly face with tiny eyes, a busted nose, and big ears.

"At Landucci's, they say he can sculpt like he has marble dust in his veins and, *signore mio,* he prefers boys like Donatello and . . ."

The friar paused, and Leonardo realized he must have been about to say, "like Leonardo da Vinci with his pretty boy, Salai."

"Behind a shed at the Duomo," confided Fra Agostino. "He's secretly carving a giant from an enormous block of marble. Nobody could do anything with it, so they gave it to him. . . ."

Leonardo knew it well. The ruling *gonfaloniere,* Piero Soderini, had given it to this famous sculptor of Hercules, erotic Madonnas, and male nudes.

"How is it possible you two haven't met?" Fra Agostino persisted.

"I haven't any idea. . . . *Buongiorno.*"

Leonardo, upset by the delay, hurried on to Santa Maria Novella, the Dominican mother church, and Masaccio's Maria after the death of her son.

He hadn't been there for years, but when he stood before the *Trinity* fresco in the left nave, it seemed an old and familiar dream. Then with a shock, he realized it was similar to his *Last Supper*.

The crucified Christ, with God the Father above him, appeared in the accelerated perspective of a fictive chapel—the perspective he, Leonardo, had used for the supper room of his disciples in his painting. More startling, the red tunic with the blue robe worn by Masaccio's God the Father was the same as the one he had given his Christ at the Passover table. Even the face of Christ had a similar nose and mouth.

What had happened? How could this fresco have lain dormant in his mind, then reappeared under his own hand without his recalling Masaccio? He looked again. It was soaring upward toward heaven, with God the Father standing behind his crucified Son—huge and somber, with immense shoulders, a square face, and yellow-flecked eyes. A white dove of the Holy Spirit was flying down from his brown beard toward the crucified Son.

Maria and Saint John stood at either side of the cross. Maria's eyes, at the level of her son's knees, were turned toward the viewer, while she pointed at her dead son. It was an older face now, beyond tears or lament, but with a stark duality—the naked, defenseless self on the left side, the tense, alert being on the right. Her left eye, glazed with the horror of her son's slow and agonizing death, stared aimlessly toward his white legs. The right eye, to an infinite degree, was cocked toward the viewer. With the pointing hand, she asked the world to witness this atrocity.

Here was the difference between the painter's younger and older Maria. The resolve of a mother to keep her newborn child had been forged into smoldering anger and blind defiance of this brutal, senseless killing. Once again, Masaccio impelled you to face the vast turmoil in this woman's troubled soul.

Why had God allowed such suffering of His own Son? The miracles, the parables, the promises of a new, loving world—where were they now, with flies on his blood among the thorns? The Master had promised his disciples to be with them always, but none believed Him, and at Gethsemane they had all run away, including Peter, the rock of faith, who disgraced himself three times in denying he had ever known his martyred Master.

Yet Maria would soon know otherwise. Her son would leave his tomb, greet a weeping Mary Magdalene, walk with two disciples on the road to Emmaus, join his apostles — eating meat in Jerusalem, consuming bread and fried fish with friends, walking through closed doors, and allowing Thomas, with the distrust of a Florentine, to stick his finger into the lance wound.

So it wasn't the end, but rather the onset of a new life for the mother of the risen Christ. Further, if any doubts remained, they were consumed at Pentecost, when the Holy Spirit's tongues of fire descended upon her and the other disciples, giving them the gift of many tongues for the streets of Jerusalem, the scattered tribes of Judea, and other lands beyond the counting.

This would have invested her with the slow dignity and gravity of Masaccio's saints—a universal woman with an understanding and acceptance of life in all its forms . . . a Maria that Masaccio could have portrayed had he not died suddenly in Rome at twenty-six. More than ever, Leonardo knew this was his destiny—to finish this legacy of Tommaso, known as Masaccio. It would be the major painting of his life, using everything he had learned from nature and the dual nature of man.

Cesare Borgia, Machiavelli, and Capturing the Arno

STUDIO
SERVITE MONASTERY

July 1502

H E WAS AT WORK ON A NEW VERSION of Maria when Salai brought
the scroll, sealed with wax bearing a motto: *Aut Cesare aut Nihil*—
"Either Caesar or nothing".
"The messenger wants some reply."
"Tell him to wait, boy; we're not in his service. Now leave me alone," he
said, opening the letter.

> Most Excellent and Esteemed Maestro Leonardo da Vinci,
>
> Since our encounter in Milan, we are ever mindful of your
> masterful works, and the high esteem for your person held by his Most
> Christian Majesty, King Louis XII, as well as Comte de Ligny's
> enlistment of your invaluable talents. Now that Seigneur Ligny has
> departed for France, it would please and honor us to enlist your services
> as our architect and military engineer.
>
> Duc de Valentinois

Cesare Borgia, son of Pope Alexander and a Roman courtesan, was now
duke of Valentinois, married to a French princess, cousin of the king—his
reward for the papal dispensation allowing Louis XII to marry Anne of
Brittany. Leonardo and he had met when Valentino entered Milan, as envoy of
the Pope, in the train of the triumphant King Louis.

Could this be a new patron? He apparently knew about everything,
including the secret pact with Ligny. *Va bene,* Cesare Borgia was also a monster.
A former cardinal at eighteen, he had murdered his brother to become captain
general of the papal armies, seduced his sister Lucrezia, married her to a prince,
then killed him to advance both their careers.

Now this papal bastard was creating a new kingdom on the Adriatic. His army had swept across the Marshes and Romagna, burning villages, destroying crops, and murdering anyone in his way. Faenza, Imola, and Forlî had fallen to him, along with Caterina Sforza, whom he had raped. An invasion of Florentine territory in the south had driven terrorized peasants into the city with tales of horror. As a result, the frightened Signoria had agreed to pay Cesare Valentino a salary of thirty-six thousand ducats a year to leave them alone.

Yet it was like that all over Italy. The lower classes were in constant revolt, while rich patricians accepted anyone, even a ruthless Valentino, to restore order and security. It had always been that way with the Sforzas in Milan, the Estes in Ferrara, the Gonzagas in Mantua. And here, an emerging dynasty of Papal States on the Adriatic needed a court painter as well as a military engineer. Rather than penny-pinching Servites, the prince would provide all he needed—more money, people of influence, facilities for scientific pursuits, and the quiet harbor of a studio to finally realize the Maria portrait.

The Servite painting was long overdue, but it would have to wait for his return. Leaving Salai in charge of the workshop, with instructions to write him daily, he departed in late July to join the duke of Valentinois in his court at La Rocca, the fortress at Imola, which controlled Florence's outlet to the Adriatic.

❧ IMOLA AND FLORENCE ❧

March 1503

EIGHT MONTHS LATER, LEONARDO LEFT CESARE BORGIA in Arezzo to return to Florence. As Valentino's architect, military engineer, and "master of water," he had drawn maps of towns and river basins, designed fortifications, projected palaces, and channeled waterways at Cesena and elsewhere in central Italy.

His travels to Imola, Arezzo, and Piombino had also included a trip to Rome. Bramante, engaged in building San Pietro in Montorio, had led his friend through Rome's imperial ruins, where once Alberti had guided Ghiberti and Donatello. And where his Florentine masters had been overwhelmed by Greek and Roman sculpture, so was Leonardo.

One particular work, more than ruins in the Forum or sculpture in the Vatican, extended his concept of horses at war. An antique sarcophagus in Aracoeli contained a bas-relief of the fall of Phaeton—the reckless youth in his sun chariot, tumbling to earth from an angry Zeus's bolt of lightning. He sketched two mythical horses with flaring nostrils, gnashing teeth, wind-tossed forelocks and manes. More than those with long, thin muzzles in his *Adoration,* or his war mount for the Sforza monument, these creatures of antiquity, interlocked in fury, could be used in a battle scene.

Returning to Florence from Arezzo, he rode with a new friend—Niccolò Machiavelli, secretary of the Second Chancery of Florence, who had spent the past three months reporting the movements of Cesare Borgia. With Cesare's army now in the south, and no immediate threat to Florence, Niccolò was returning to his Chancery position. His fellow Florentine, Leonardo, privy to Cesare's plans, had served as an unidentified source in Niccolò's reports to Florence.

Leonardo had also left, pending transfer of Valentino's command to an established court at Cesena. He was also long overdue in Florence. He had to finish the Servite painting, and there were other waiting commissions.

It had rained for a week, but now the sun was out and it warmed them on the road along the Arno. Swollen and brown from the rains, its waters surged through green reeds along its banks. The fields to the left, yellow-green with winter wheat, were lined with straggling poplars, pastoral groves of old gray oaks, and occasional clumps of yellow mimosa.

Niccolò looked forward to the joys of his young wife, Marietta. As they forded a stream swollen with rains, he reached down alongside his bay gelding, cupped up some water, and drank it.

"Crossing the Lethe!" he exclaimed.

Leonardo laughed, delighted. Dante, in seeking to leave Purgatory, had to drink from the Lethe before meeting his beloved Beatrice, a virgin in Paradise. Niccolò drank as though three months' absence had returned his beloved Marietta to a similar state in a more accessible paradise.

The Chancery secretary was dressed in the black of his office. He had a deceptive face, with an unruly fringe of dark hair across a massive brow, a curved Florentine nose, a small receding chin, thin lips, an upturned mouth, and the arched eyebrows of a clown. The eyes alone, dark and wide apart, gave some insight into the quick, probing mind of a diplomat, political philosopher, musician, and historian.

As they emerged from the stream, he warned Leonardo not to count on a future with Cesare Borgia.

"If his father dies soon, he will lose the papal armies and everything else . . . especially if the next Pope is Giuliano della Rovere, who hates the Borgias."

Leonardo resisted this. His gray stallion was a gift from Cesare. He had designed a palace for Cesare's duchy at Cesena. And from the first day, he had been drawn to him—the dark face of Andalusia, the grace and strength of a bullfighter, the sharp mind, proud bearing, scorn of convention . . . and yes, a bastard like himself, with an inherited name that imparted eminence, yet never respectability. Cesare knew it, too. *Maestro mio!* he had cried with an embrace that meant, *Fratello mio!*

"And you?" replied Leonardo, looking at Niccolò. "I can go to another patron. Where will you go, with your political theories structured on a fallen prince?"

During their long nights at Imola and Cesena, Niccolò had forecast the impending ruin of Italy unless it was united into a nation, free of Church or empire. A free republic was better than any rule by a prince or tyrant, but until Italy was politically mature, a powerful despot was needed for internal unity and external defense. Cesare Borgia was ideal for this. His audacity, diplomatic skill, avoidance of half measures, populist rule of conquered provinces, and

adroit use of cruelty and deceit could bring Italy into the new era of nation-states.

"There are two rules in taking a state," Niccolò explained. "You extirpate the ruling family but leave intact its laws and taxes."

Leonardo disagreed. "His condottiere rebel against him, and he forgives them, invites them to lunch, then strangles two of them and murders two others on the way to Rome. Where is the virtue in that?"

"It's lawless nature, *caro mio*. All men obey but one force—necessity. That's the reality of human life. If Cesare is a lie, then life itself is a lie."

Leonardo reined in his horse. Here was a critical difference—his view of nature as created by God, and Niccolò's concept of human nature.

"*Caro Niccolò*, nature has its own laws. Nor is necessity a blind force. It's the enlightened mistress and guardian, the bridle and law of nature. Once you grasp this, you'll have something more in your hands than political theories that strip us of any faith in life or our own humanity."

The diplomat and poet snorted with anger. "And you, *caro Leonardo*, where is your moral high road? While Valentino was burning villages, his men raping their women, you were enjoying yourself, building canals and giving him military maps that threatened your friends in Florence."

"What friends?" Leonardo replied, suddenly angry. "They imprison me, then praise me when I'm protected by the Medici or the Sforzas . . . cackling hens and pigs, empty-headed fillers of privies."

Niccolò laughed. "Don't tell me. I send my reports to a barnyard of idiots. Nor do they realize your potential to help us breach the walls of Pisa."

Pisa's independence, after the port was delivered to Charles VIII by craven Piero de' Medici, had severely damaged Florentine overseas trade. Nine years of war and French betrayals had failed to return its harbor to Florence.

"Forget the walls," replied Leonardo. He pointed toward the Arno on their right. "Take that away from Pisa."

As they crossed the river at Incisa, he outlined his plan. Diverting the Arno away from Pisa would not only end the war; it would also increase the power and wealth of Florence.

"We could enter the open seas without need of Pisa," he explained. "Our countrymen Cristoforo Colombo and Amerigo Vespucci discovered the New World, but where are we now? Spanish and Portuguese ships are racing there for its gold. That should be our destiny."

"We should be there now," replied Niccolò. "How do you see this?"

"A channel into the sea above Livorno will bypass Pisa, provide flood control, and power watermills for saltpeter, silk, wool, paper, wood, pottery,

and even metal polishing. Also, unlimited irrigation will bring immense riches to the valley. The cities of Prato, Pistoia, and Lucca, as well as Florence, could have an annual income of two hundred thousand ducats."

"*Per Dio!* We'll capture Pisa and change the course of history with a river."

"More than a river," predicted Leonardo. "We'll need someone as ruthless as your ideal prince."

FLORENCE AND PISA

June 1503 – October 1504

IN LATE JUNE, LEONARDO received orders from the Council of Ten to inspect La Verruca, a strategic fort near Pisa, seized by Florentine forces in a siege to recover their historic port city. Machiavelli had convinced the war council that the famous court painter was also the military genius who had fortified La Rocca, Cesare Borgia's formidable fortress at Imola.

Leonardo's report from Verruca, with detailed drawings for increased defenses, was approved and a master builder was engaged to strengthen the fort. While at Camposanto, outside of Pisa, he devised a method of breaching its walls by toppling their upper part inward, with mortar fire covering entry into the city.

The field commanders stared in wonder but finally pushed it aside as impractical. The Signoria was impressed, however, and the Council of Ten then asked Leonardo to survey the Arno Valley with a view to "drying up Pisa" by diverting the river southward toward the Stagno, a marshy pond north of Livorno.

The cost of his project, with his detailed drawings of machines and operating methods, alarmed bankers and merchants on the Grand Council. They decided to wait. The Pisa war and taxes were ruining them all. Sooner or later, Pisa would be starved into submission.

On June 1, 1504, Machiavelli informed them that a force of "two hundred fifty men at arms and three thousand Infantrymen" had left Naples to "overthrow our government and bring Tuscany under Spain's control." The endless squabbling ceased. In addition to loss of freedom, Spanish troops would return the despicable Piero de' Medici. They also learned the port city was no longer isolated. Lucca, Siena, and Genoa were supplying it by sea, and foreign troops had joined the Pisans.

An alarmed Signoria—in August 1504—authorized its Council of Ten to proceed with diverting the Arno. Also, as outlined by Machiavelli and

Leonardo, it could turn Florence into a seaport with water-powered industries strung along its valley.

As Chancery secretary, Machiavelli ordered the field commissioner, Giuliano Lapi, and the hydraulic engineer, Colombino, to follow Leonardo's diversion plans. From a deep breach opening onto the river—eighty feet wide, thirty feet deep—a pair of two-mile-long thirty-foot ditches would divert the Arno into Stagno marshes above Livorno. Leonardo estimated this would require the removal of one million tons of earth.

Colombino, ignoring Leonardo, excavated two ditches, fourteen feet deep, without a broad opening onto the Arno. He also halved the time and workers needed. An enraged Machiavelli foretold disaster. By not following Leonardo, they were making it "much easier for the Pisans to direct the Arno back into its own course." This was dismissed. A fortnight later, he sent an urgent request from the Council of Ten. "We would like to know if the bed of the Arno is shallower or deeper than that of your ditch, and (if so) we think it proper to make up for it."

It was too late. Colombino had opened the weir, a temporary barrier along the banks of the Arno. The river flowed into the shallow ditches, then returned to its old channel. Worse still, a crosscurrent weir increased the river flow, further deepening the channel below Colombino's shallow ditches.

In panic, disgusted workers began to leave, and a desperate Colombino claimed sabotage. Niccolò ordered him "to not abandon the project . . . make the mouth onto the second ditch as large as possible." At Leonardo's urging, a Lombardian specialist was sent to oversee the recovery. With this, Niccolò predicted victory in "seven or eight days."

This was also too late. On October 3, 1504, a violent tempest, similar to that of Leonardo's childhood, struck the campsite. The walls of the ditches collapsed, and the critical crosscurrent weir was swept away in raging waters. The tempest roared onward, giving Pisa another miraculous victory. Amid the wreckage, Tommaso Tosinghi, Florentine army commander, asked for recall. His troops were withdrawn, the camp abandoned, and Pisans quickly filled in the ditches—clinging to their liberty, before eventually losing it in a later Florence siege led by the relentless Machiavelli.

THE BATTLE OF ANGHIARI AND EXILE OF CESARE BORGIA

FLORENCE

October — November 1503

I N OCTOBER 1503, the previous year, while Leonardo was planning to divert the Arno, a delighted Niccolò Machiavelli had informed his friend that he had been awarded the biggest painting commission of his life. The Signoria had decided to cover two immense walls in its Grand Council Chamber with frescoes of heroic episodes in Florentine history.

On the first wall, to the right of a *gonfaloniere* throne, Leonardo would illustrate the Florentine defeat of Milanese forces in 1440 at Anghiari, near Borgo San Sepolcro. Leonardo had nodded with a bitter smile at this honor from a city that had placed him in prison and refused to testify to his innocence.

"At Anghiari," explained Niccolò, "we stopped the duke of Milan from seizing Florence and all of Tuscany. Your mural will portray the power and freedom of our republic, and who knows?" He sighed. "The few who are not congenitally blind might realize we need civic unity to survive."

"War is a bestial madness," replied Leonardo. "I'll show it with all its infinite horrors."

"Good . . . no one will ever equal it, nor, thank God, understand your real message." He laughed again, and made a promise. "By the time you're finished, we'll have conquered Pisa and you can put that victory on the other wall."

Leonardo was given living quarters and working space in the Sala del Papa, or papal apartment, with adjacent rooms in the cloister of Santa Maria Novella. It was ideal for him. Popes Martin V and Eugenius IV, Emperor Frederick III, and King Christian of Denmark had all stayed there. He left the Servites in late October, promising to finish their painting, and moved into the cloister residence to set up a workshop for his *Battle of Anghiari.*

As described in his notes, it would portray the demonic fury of war:

> You must first show smoke of the artillery, mingled in the air with dust raised by movement of horses and combatants . . . arrows flying in

all directions . . . show a horse dragging its dead master, leaving tracks where the corpse has been hauled through dust and mud . . . show the conquered, beaten and pale . . . teeth parted as if to wail in lamentation . . . the spilt blood of the dead running its perverted course from the body into the dust, turning it into red mud . . .

One who has fallen to the ground covers himself with a shield as the enemy bends low to deal him the death blow . . . show a river with horses galloping, engulfing the water in great swirling waves of foam . . . and not a single flat place that is not trampled and saturated with blood.

For the bestial madness of men and horses in battle, he returned to sketches of the Roman sarcophagus—red chalk studies of horses with gnashing teeth and snorting nostrils, rearing up to trample a fallen foe, turning fiercely to bite one another, horses falling upon dying warriors, others galloping away in fright. Occasionally, his pen left this bestial madness for sudden islands of peace and beauty—sketches of male nudes with muscular legs astride powerful horses, others with the soft round chin, small mouth, and the sleepy eyes of Salai . . . then a young woman with similar features.

2.

Early one morning in late October, Machiavelli appeared suddenly in the studio. He was leaving for Rome to represent the Republic of Florence at the funeral of one Pope and the election of a new one.

After the death of Pope Alexander, the feeble cardinal of Siena had emerged as Pius III, a compromise pontiff from a deadlocked conclave. A bleeding ulcer had carried him away twenty-six days later, allowing two contestants for the papal throne to regroup their forces in a new conclave.

"The odds favor Cardinal de Rouen," Niccolò predicted. "Valentino's bloc of Spanish cardinals will put him on the throne and save your patron prince with his little empire."

"Cardinal delle Rovere has no chance?"

"He hates the Borgias and would do anything to be Pope, but Cesare is too clever and too powerful, and this is his last chance. . . . Not even poison will stop him."

All of Rome, according to Niccolò, believed Pope Alexander and Cesare had been poisoned. During an August heat wave, they had dined at the Monte Mario vineyard of Cardinal Adriano Castellesi. Shortly afterward, they were

seized by a violent fever. Six days later, father and son lay near death in adjoining rooms at the Vatican. Upon learning that his father had died, Cesare rose from his bed, shaking from poison and fever, to empty the papal death chamber of its treasures. Niccolò's report was alarming.

"When the chamberlains arrived," he said, "they found only chairs, the bed, and the corpse turned into a monstrous cadaver, black and swollen, the cheeks puffed like a black toad, the nose a poisonous mushroom, a yellow tongue sprouting from its mouth, as though rooted in the brain."

"Sounds like the plague," replied Leonardo.

"It gets worse. . . . The coffin was too small for the bloated carcass. So they stomped on it, with gas hissing from its bowels, green foam gurgling from the mouth, until the lid was closed. No, it was poison, pure and simple."

In November, following the victory of Giuliano della Rovere as Julius II, Leonardo received a bitter note from his friend Machiavelli:

> . . . I couldn't believe it! The duke took leave of his senses. In the conclave, his Spanish cardinals gave Giuliano della Rovere the tiara, in exchange for the Pope's promise to confirm him as commander of the papal armies and guarantee the integrity of his states in Romagna.
>
> A child would laugh at this! As soon as Valentino started back to Romagna, this Genovese Pope who despises every Borgia, dead or alive, had him arrested and returned to the Vatican. . . .
>
> Yet the truth remains. All men obey but one force—Necessity, which you, Leonardo, also recognize as the prime force of Nature. Our prince acted on this truth. . . .
>
> Yet despair not, *carissimo amico!* Florence remains your patron. After the Anghiari mural, we will give you the other wall for our coming Pisan Victory. . . .

Leonardo dropped the letter onto his desk amid drawings of screaming warriors and interlocked horses in battle. It was all gone—the promise of Valentino, the engineering projects at Cesena, the court of the new dukedom. Florence was no substitute. She devoured her artists or drove them into exile.

With the Moor in a French prison, he considered returning to Milan. Florimond Robertet, in offering to make him court painter and engineer, had asked for a painting. He would send him a painting of the *Madonna and Child* playing with a yarnwinder, along with a drawing of the *Virgin and Child with Saint Anne* for his sovereign. You had to seize fortune quickly by the forelock, for she was bald in the rear.

The Death of Piero and the Creation of Maria

STUDIO
SANTA MARIA NOVELLA
CLOISTER

July 1501

L EONARDO HAD AWAKENED EARLY with a recurrent dream from
earliest memory—a child of three lying in a basket of field greens. A
black raven from the sky settled on the basket handle, thrusting its
fluttering tail into his mouth. . . . Was this a warning of something new . . . or
an old fear of the unknown? He didn't know, but it was often there, even
during the day.

Walking through the great hall of the Santa Maria Novella cloister, he
passed two long tables with scattered drawings in red chalk of men and horses
interlocked in furious combat for the Florentine battle standard in the *Battle of
Anghiari*. When defined, they would be transferred to a sixty-six-foot long,
twenty-six-foot high panel of linen-backed paper on the wall to his left—the
colored cartoon for the painting. Below this, a mobile platform could raise or
lower him to any sector along the wall.

In an adjoining room, he passed before four paintings under way with
the help of three assistants: *Leda and the Swan, Hercules, Neptune with Sea Horses,* and
the Servites' *Virgin and Child with Saint Anne*.

Moving on, he entered the hall that contained his latest attempt at a
flying machine. In theory, it was quite possible when the rate of speed and wing
area produced a lift force superior to the weight of the ornithopter, or flying
machine. In Milan, he had built several of them, using pine bathed in lime for
the frame, pine lathes and reeds for the chassis, and light canvas or sized silk
covering the wings. Leather, treated with alum or grease, served for lanyard
straps, along with steel springs, horn levers, and raw silk cords for the pulleys. He
had found, however, that prone or standing pilots could not muster sufficient
strength to "beat artificial wings against resistant air (and) rise above it."

Frustrated, he designed a spring-driven helicopter—again without success. Yet man could surely use wind and air currents to soar upward on outspread, motionless wings like great birds of prey. Autopsies of several species revealed their wing surface in ells equaled the square root of their weight in Florentine pounds. Based on this, he had built a lighter glider bird, weighing four hundred pounds, with a wingspan of eight ells, or thirty feet. It was now before him in his studio—a blue-and-yellow creature, waiting to take him into the skies and fly with the eagles . . . and the black raven of memory.

It had to happen soon, before someone else claimed the glory. The previous January, a mathematician named Gian Battista Dante had attempted flight from the bell tower of Santa Maria della Vergine in Perugia. For a moment, his flying machine had hovered above a startled wedding crowd. Then its wings had folded and the poor man crashed onto the roof, suffering only a broken leg—acclaimed by the crowd as a miracle, since the Virgin would never tolerate anyone, not even a madman, to perish on top of her church. . . .

"Master . . ."

Salai had arrived. When he said "Master," it was a serious matter.

"The herald just left," he said, referring to couriers bearing public notices to each quarter of Florence.

Leonardo waited. The youth touched his shoulder, and he knew it wasn't good.

"He said your father died last night."

"Last night? And we know it only now?"

"The funeral is today in the Badia at the third hour."

"I must leave at once Stay here!"

2.

Approaching his father's palazzo on via Ghibellina, he saw a bay gelding tied to a bridle ring on the palazzo wall. It had been ridden hard and was flecked with foam on neck and withers. Its gleaming coat was twitching off the blue flies of July. The doorkeeper looked up from her knitting.

"Third floor," she said.

In place of old Marietta at via delle Prestanze, this was a fat one, with her legs crossed, knitting a doily. The little dog beside her snarled at him.

"That horse outside needs to be washed and wiped down," he said.

"I know. The brother of the dead notary came rushing in here, telling me to take care of it. I sent for a stable boy."

That was a relief. Checco, his uncle Francesco, was here. Two signori passed him, dressed in the somber cloth of mourning. He followed them up the stairs.

Giuliano, the second son after Leonardo, met them as they entered. Wearing the red robe of a notary, with a black mourning band, he embraced the two arrivals, murmuring condolences. Seeing his half brother, he indicated the master bedroom down the hall.

"It's the last door," he said.

"I had no word from you. . . . No one came to tell me."

There was a sudden scowl, the mouth clamped in anger. Here was another Ser Piero, with the same gray eyes, deep forehead, high cheekbones, and arched nose. Below the nose, however, the face collapsed into a small mouth and a receding chin. The diminished replica turned to a shorter, darker youth behind them.

"The monks said they didn't know where you were."

It was a lie, of course. The Servites knew he was at Santa Maria Novella. All of Florence knew it, except this squalid offspring of Piero's lust and greed. . . .

"Nardo!"

It was Checco, a stubble of beard on his face, his gray hair in disarray, his indigo blue doublet and leggings covered with dust from the forced ride. He took his nephew into his arms.

"I asked them where you were. They said no one knew how to find you."

"They never have."

"Go and see him; then we can talk."

Entering the bedroom, he saw the women in prayer vigil—huddled black figures beyond the bed. His father, dressed in the notary's red robe with black stocking hose, lay on a floral bedcover. He seemed suddenly small. His face was sunken but relaxed, with his mouth on the edge of a smile. Those lips, now cold and aimless, had kissed Albi in every way. Did any particle of her linger beneath that brow of ochre-and-white lead?

He touched the forehead with his lips. There was the chill of death— nothing more. Albi had left him long ago, in the field at Anchiano, murmuring, *I don't care, Nardo. I want you. I need you with me.* And he had kissed her tears, whispering, *Yes. . . Yes.*

He found Checco arguing with Giuliano when he returned.

"Nardo's the eldest son," he said. "He comes with me before any of you."

Giuliano shook his head. "We can't have him up front."

So it was family precedence in following the bier to the church and cemetery. Francesco, as Piero's brother, would be first. He wanted Leonardo with him.

"Not possible, " insisted Giuliano. "We're the legitimate heirs, not your fancy nephew."

Francesco saw him and took his arm. "There's a problem, Nardo."

"It's an old one," he replied. "Inherited by these jackals."

"You're the bastard jackal of a slave!" shouted Giuliano.

"Let's go, Nardo," replied Checco.

Walking to the door, he seemed close to tears.

"Piero would never have wanted this," he said. "He was difficult, but he was a good man. . . . You believe that, don't you?"

Leonardo embraced him. The man who had taught him to wrestle, to shoe a horse and break a stallion, this giant of his youth was now small in his arms.

"Come to me soon, *figlio,* before I also go into the Great Sea. I want to leave you everything of mine at Vinci."

3.

Returning to the street, Leonardo recalled the other palazzo of his youth, with Tara, the slave girl, weeping over a Christian lullaby in Albi's music box. That was gone, but Albi remained. She had continued to live as his Virgin in the *Annunciation,* the young mother in the *Adoration,* and the Madonna in *Madonna and Child with Infant Saint John. Per Dio!* . . . There was the way to a Maria of the ages.

Overwhelmed, he hurried along via del Proconsolo to Michelangelo's *David* on its pedestal before Palazzo della Signoria. It was late afternoon when he arrived. Slanting sunlight filled the piazza, and *David* seemed to be waiting for him. Departing light lay upon the tousled hair, the taut neck tendons, the bulging veins in the lowered right hand, and the extended left arm with the slingshot slung over his shoulder. Leonardo didn't need any of it. The shadows spoke: *Yes, that was how it happened.*

Yet what had Michelangelo taken with him into this block of marble to create its ligaments and veins, the flexing muscles, and the eyes without fear before the giant Goliath? What compound of lingering memories? The anatomy of dead criminals in the Santa Maria Novella Hospital? The bodies of youths he had known and loved?

"What else was there?" he asked, and left without waiting for an answer.

Passing Orsanmichele, the oratory church encircled by patron saints of the Florentine guilds, he paused before Donatello's *Saint George.* Here, in its shadowed niche, was the sculptor's defining masterpiece. Perfectly poised, internally balanced, the body of the saint was all but visible beneath the dynamics of its battle dress. No one since the Greeks and Romans had been able to achieve this—eighty-seven years before Michelangelo's *David.*

"And you Donato, who or what led your way?"

This youth was no muscular David with a shepherd's field weapons. He also seemed much younger, with the purity of a saint or an angel and a vision of what was immortal in human life.

The face seemed familiar, however. Indeed, it closely resembled Donato's Virgin in his *Annunciation* on the Cavalcanti altar in Santa Croce. Leonardo recalled the details he had sketched while working on Verrocchio's lifeless *Annunciation*.

The Virgin's hand, grasping her missal, resembled that of the saint in thrusting his spear through flaming jaws into the heart of the dragon. There was also the same high, pointed nose and curved upper lip, the soft fold of the cheeks, and the faintly similar chin. Even more startling, both saint and Virgin appeared to be staring at the startling arrival of an unexpected visitor.

Here it was again—a collapse of time in Donato's Virgin. His Saint George had ridden with her image into the flames of the fire-spewing dragon in 1417—eighteen years prior to her portrayal in Santa Croce.

"*Grazie*, Donato," he said, turning down via Calzaiuolo.

October 1504 – February 1505

MARIA, THE MOTHER OF JESUS, had been within him for a long time. Indeed, it seemed like forever. Now, however, he planned to bring her to light in one moment of time containing her spiritual journey and transcendent passage from tragedy to hope in the early, formative years of a Christian faith.

Up to this moment, his Marias had been fixed in Christian time and place—variously as Virgins in the *Annunciation,* the *Adoration,* and successive Virgins with Child. This time, it would be different, and closer to how it was. In timeless Judaism, Maria would appear without regard to time or place.

To get there, to slip through time into eternity, he would portray her in the Valley of Creation. Amid its primordial waters, with the veiled haze of distant mountains, she would appear again from across the centuries—a full-bodied woman in her early thirties, her virginal beauty and mysteries known only to the Holy Ghost, her flesh and bones ageless as the valley's fluvial earth and rocks, her eyes staring far beyond the plains of Judea.

So she would appear—a visible Maria, waiting to reveal the invisible, for someone to speak to her, to sit with her in the evening while she spoke of how it began with her son, and the look of heaven in His eyes. How His invisible presence remained among them, and how the crowds followed her in the streets of Jerusalem—the Holy Mother and disciple in the apostolic community of James, brother of Jesus, riven by the rivalry of apostles Peter and Paul.

In his *Last Supper,* he had collapsed two moments of time to portray the betrayal and the institution of the Eucharist. And for a conceptual face of Christ, he had fused Cecelia with Vincenzo. Similarly, he would now collapse

his portrayals of Albi, variously as Virgin, mother, and Madonna, into a single image. Then he would fuse her with himself and his interior image of Maria. From this, he expected to obtain an induced concept of a figure to be used in portraying the flesh and blood reality of the woman—beyond her diaphanous presence in the prayers of millions.

That was what he expected—only to discover that he had produced the revolting two-part face of a hermaphrodite. His prominent nose and high forehead sat on top of the soft, round cheeks and the little chin of Albi! It was too obvious, even ridiculous—except for the slightly parted mouth and the heavy-lidded almond-shaped eyes.

Clearly, they belonged to Maria, for they brought the two-part face into clear focus with a veiled mystery of the centuries. To go beyond the veil, into her reality as a woman, he then anastamosed her image to a proportionate drawing of Lisa Gherardini in the fifth month of her pregnancy. This produced a figure of ambiguous duality, as often occurred in his paintings, where people of any faith could find whatever they were looking for.

Finally ready, he began the great venture with a thin panel of fine-grain yellow poplar, clean and dry, without knotholes or other flaws—30.3 inches high by an estimated 25 inches in width.* Here there could be no mistakes. Rather than have an assistant prepare the panel, he did it himself in the meticulous manner of Cennini and Verrocchio. To further prepare it against the ravages of time, he gave the wooden panel a stabilizing wash of his own urine.**

After further applications of gypsum, arsenic, alcohol, linseed oil, varnish, and a final polishing, the panel was ready to receive the combined image of Maria.

He spoke to it as if they were taking a long journey.

"Here he we go," he said, while transferring it to the panel.

To develop the figure, he began with fine charcoal made from small strips of willow to render halftones and darks for bone structure, folds of flesh, and the enveloping dress with veils. When it was ready for a closer focus, he swept away the top charcoal with goose-feather barbs. Next, he reinforced the

* At an unknown date, it was reduced to its current size, 30.24 inches by 20.87 inches.

** Cennini and Verrocchio believed urine protected a wooden panel from corrosion. Five hundred years later, H. A. Krebs's studies of nitrogenous waste excretion and Linus Pauling's work on enzyme structures proved that chemical elements in the urea of urine—two parts ammonia to one part carbon—blocked the structural degradation of naturally occurring enzymes in nature's incessant corrosion of all matter.

remnant outline with a small miniver-bristle brush and watery ink, followed by stronger ink washes in creating body shadows and garment folds, until she emerged as a black-and-white figure.

He was now ready for the next critical passage—laying on colors with nuances and tonal variations to reflect this woman's interior being. The first step was traditional—an underpainting, or *imprimatura,* using a thin wash of blue-green verdigris mixed with egg yolk, which left the black-and-white figure still visible on its white gesso ground.

From this middle ground, he went up into light and down into dark, using lead white for highlights of the flesh, the dress, and the veils, and a lean black from burned peach stones for the shadows and darker folds of her dress— gradually creating form and volume on a gray-green ground, as he had with his *Saint Jerome* and *Adoration of the Magi.*

He was into it now, deep into it and alone, moving through lights and shadows into crevices of flesh, and applying colors in a way to further invest the portrait with its subtle mysteries. It was a moment of truth, with an infinity of transparent, thin resin-oil glazes of "clean and beautiful colors." The colors were infused, allowing them to rise upward through layers of varying transparent glazes—a technique that invested the shadows with the "translucent veil of light at sunset."

Some parts were scumbled, however, with a dry brush pushing one wet color into another to create a thin haze of nuances in color and tone. At other times, he used his fingers or the ball of his palm, as though probing for states of mind and soul in the emerging figure.

As the months went by, he felt the figure leading him into an infinite play of ambiguities within the slightest, most delicate shading—flesh built cell upon cell, the flow of arterial and venous blood, the tissues and ligaments anchored to pillars and levers of bone . . . until she was finally alive, and he began to leave her, to emerge from the depths of her being, until, as in rising from a profound slumber, he came back into himself.

There she was, seated on a loggia in the Valley of Creation—a robust woman of thirty with a veil over her dark hair, which was parted in the middle and fell loosely along porcelain white cheeks, its curls touching a deep-cut brocade gown with an embroidered border drawn tightly over full breasts. There was no jewelry touching her long slim neck and sloping shoulders, nor rings on the folded hands emerging from the turbulent folds of her gown.

Nor did she need them to intensify her presence as a woman. The vast silence of an empty cathedral seemed to lie upon her, as though all of nature knew this was the aging handmaiden of God, in whom the ideal and the real,

the immortal and the mortal, and faith with doubt coexisted with a purity lost in the Garden—the mystery of it all appearing on her lips at the edge of an emerging smile.

She had come from a nowhere that was everywhere, without fixed name or place, and veiled with the ambiguities of an empty tomb. The mother of Jesus, the marginal Jew, was waiting for other marginal souls to speak to her— her hands folded upon her pregnant belly, her lips appearing to move in the brief eternity of a surfacing smile.

For Leonardo, it was a moment of recognition. His Maria was not only far from her homeland, but also from her home in his soul. Still, you had to expect that. They always left you once you had given them life. When he had opened the eyes of Ton, the great horse was looking toward distant plains and mountains. Most probably, Maria had left him when he descended into the depths of her eyes, among flecks of light the color of her flesh. Now they were waiting for him to speak to her.

"There you are," he said, but it didn't help.

Her eyes remained upon him, waiting for more. Nor, he realized, would it end there. This was going to happen to many others who walked into her silence with a sudden awareness that this woman had always known them— known who they were, their secret dreams, and why tomorrow was always temporary. That was how it would be for them, even if they didn't know the lady was Maria, or why she was there in a picture frame.*

* There is no mention in any of Leonardo's twenty-five surviving notebooks of his creation of this painting, which later became known as the *Mona Lisa*.

PART TWENTY

THE

LEONARDO—MICHELANGELO

BATTLES

FLORENCE

February 1505 – April 1506

I N FEBRUARY, LEONARDO WAS SHOCKED to learn that Michelangelo had been assigned the second wall, to the left of the throne, in the Grand Council Chamber. This would pit them against each other before all of Florence. It was a betrayal.

"You promised me that wall, Niccolò," he protested. "I signed a contract giving it to me."

"Michelangelo demanded it when he heard of your *Anghiari*."

"Why didn't you protest?"

"It was Piero's idea," Niccolò replied, meaning Piero Soderini, *gonfaloniere* of Florence.

"What's his subject?"

"He's keeping it secret, but it's the Battle of Cascina."

Leonardo nodded grimly. He might have expected this. Michelangelo had chosen a more popular battle. The conquest of Pisa, on July 29, 1364, was celebrated as a Florentine feast day. Niccolò sought to make light of it. "Piero says we'll have the two greatest artists of our time engaged in a battle of battles, rather than in ugly squabbles in the Council Hall."

Leonardo was not amused. Once again, Florence had betrayed him. He needed a patron, not these idiots with crumbling banks and family tyrannies. It wouldn't happen when Louis XII summoned him to Paris or Milan. After receiving his *Madonna of the Yarnwinder*, Robertet had replied: ". . . His Majesty, upon seeing your exquisite painting, desires one from you in Milan. So I pray you, *cher maître*, satisfy my most noble sovereign before I am constrained to give him mine!"

The treachery of Piero Soderini soon went beyond the Council Hall, with the *gonfaloniere* claiming Michelangelo "stood above all others in Italy, or anywhere in the world." To ensure this, he provided his hero with a large room in the Dyers' Hospital at Sant' Onofrio, complete with assistants, scaffolding, a large pasteboard, and supplies for his cartoon.

Nothing of the sort had been done for Leonardo at Santa Maria. He had to repair the roof, build his own workshop, install studio windows, erect a scaffold to lift and move him across the fifty-nine-foot wall, and, worst of all, haggle for proper supplies from the commune. Despite his fifty-three years, he now slept only five or six hours, then rose at dawn to return to the Anghiari battle. Hours later, he would be found modeling clay war mounts, or on the scaffolding, projecting them with pen and charcoal into the interlocking fury of men and horses.

Leonardo had three assistants for the great wall painting. He noted a new arrival, Lorenzo di Marco: "1505—Tuesday evening, 14 April, Lorenzo came to live with me; he says he's seventeen years old." Another was "Ferrando Spagnolo"—Ferrando the Spaniard, probably Hernando Yáñez de la Almedina, who later did an *Epiphany* and a *Pietà* in Spain's Cuenca Cathedral, both of which show the influence of Leonardo and Raphael. A third member of this working family was Tommaso di Giovanni Masini, called "Zoroastro," a color grinder and old friend from early days in Florence.

2.

By late April, Leonardo began painting the battle of men and horses to retain possession of the Florentine flag—a central drama in the narrative of three segments across the fifty-nine-foot Council Chamber wall. Before transferring its cartoon onto the wall, he had taken every care that the largest commission of his life would not suffer the fate of his *Last Supper.* Its stone surface had been sealed against humidity and built up with layers of glue and rough gypsum to ensure a stable field. A pen and ink wash, defining the figures with white highlights and spatial shadows, had been followed by a transparent ochre wash. Onto this tonal middle ground, he applied his colors—a relatively quick-drying emulsion of pigments mixed, drop by drop, with sunbaked linseed oil.

The portrait of Maria had required ambiguous glazes and shadows. In this wall painting, however, he sought to focus on the immediate moment of "fury, hate, and rage in men and horses" engulfed in the *pazzia bestialissima* of war. This was also his reply to Paolo Uccello's three *Rout of San Romano* panels of men and horses frozen in a perspective network of lyrical, abstract patterns on a battlefield without blood, manure, or any human cry.

Scattered sketches among his notes provided a rare insight into the mind of the creator. From fantasia came the first images—men screaming with rage, nude men in various postures, horsemen impaling a fallen foe, wild war mounts

with teeth bared, a roaring lion, cavalry charging into battle. All of them were, he wrote, ". . . inventions made from your imagination . . . rough parts of figures, focusing first on movements appropriate to mental motions of the protagonists . . . proceeding then to take away and add until you are satisfied."

To achieve this, he had used clay models to move or discard cartoon figures. In the vortex of close combat for the flag, he combined two horses into one, discarded a fallen mount, interlocked two others with gnashing teeth, placed a fallen warrior with raised shield beneath plunging hooves, while another soldier stabbed his enemy in the throat beneath a rearing charger. So it went, until he had created an entwined mass of man and beast, swirling with the centrifugal force of a cyclone. Horses fought like men, legs crushing, teeth gnashing, while men howled and fought like animals.

One morning, the central battle scene now finished, Leonardo was on the scaffold platform when he saw an agitated Niccolò walking back and forth before the high wall painting.

"You've won the joust, Nardo. Buonarroti can never equal this."

Leonardo smiled. "Florentines, especially their women, love his half-naked youths bathing in the river."

"Populist nonsense," snorted Niccolò, waving his hand. "The bestiality of war will prevail over nudity on a riverbank. *Caro mio,* you have anchored our republic into history with a cry for peace and reason that will echo through the centuries."

Many others came to witness the "battle of battles"—not only Florentines but also artists from all over Italy—including Benvenuto Cellini, who described the work of the two masters as an historic event and "a school for the world."

On Sundays, crowds in the Council Chamber stared at the Anghiari battle scene with its screaming warriors and horses biting anything they could grab with their teeth. Then at Sant' Onofrio, they looked at Michelangelo's cartoon of bathing, half-naked soldiers suddenly called to battle. Many decided the man from Vinci was the victor. This infuriated Michelangelo. They were all idiots.

3.

On a bright spring morning in April, Leonardo was crossing Piazza Santa Trinità with the painter Giovanni di Gavina when Michelangelo entered the piazza from Santa Trinità, the ancient mother church of the Vallombrosan Order. He was walking rapidly with his head down, his dark hair rumpled over a massive brow. Leonardo's friend Giovanni waved to him.

"*Salve, Michele!*"

The sculptor stopped, and Leonardo noted the dark face with its busted nose, the leather jerkin splotched with paint and encrusted marble dust. He knew it well. That man had slept in those clothes, night after night, with no sense of time or place, aware only of an ephemeral vision somewhere within a block of marble, or perhaps in his battle cartoon at the Dyers' Hospital.

Suddenly, he felt close to him. Here was a young giant, like his *David*— one of great promise, who also secretly admired him, Leonardo. Had he not copied his Servite cartoon of Saint Anne and Maria? If they had met anywhere else, this youth would also be close to him, like Raphael, Giorgio in Venice, or Boltraffio in Milan. The Florentines, with their vicious tongues, had created a bitter rivalry that didn't have to exist.

"*Buongiorno,* Signor Michelangelo . . ."

The sculptor stared at his friend Giovanni, then at the man he detested. He, Michelangelo di Lodovico Buonarroti Simoni, was descended from the knights of Canossa. He could wear rags, and it wouldn't matter. But this bastard of a fucking slave in Vinci paraded the streets of Florence in a rose-colored cloak with the air of a royal prince. His lover boy, Salai, strutted beside him like a peacock in a mauve doublet of silk embroidered with golden fleurs-de-lis—a Medici conceit granted to them alone by the king of France.

Michelangelo seemed upset, but Leonardo persisted.

"*Per favore,* just a moment . . ."

He turned to two elderly patriarchs sitting in weak sunlight on a stone bench outside Palazzo Spini. One of them seemed familiar. It was the judge who had put him in prison. . . . An old man now, he was nodding as though all was forgiven. Leonardo pointed to the scowling sculptor.

"Signor Giudice, here is the creator of the giant *David* standing before our Signoria, and a man who will bring Florence greater glory through his art and invention."

Michelangelo spun around with fury. "You, who made a project for a horse in bronze but couldn't cast it, and, to your shame, just left it there. You are a fine one to speak of glory." Walking away, he struck again. "And those fools in Milan believed someone like you!"

Leonardo paused, pale with rage. Before him, the startled judge expected to hear his defense. To hell with you, he thought. Then Giovanni spoke for his friend.

"Michele is mistaken," he said. "Leonardo was ready to cast his great horse when the duke of Milan sent all the bronze to Ferrara to make cannons against the French. That's the truth of it."

The old judge waited, expecting further proof. Clearly, if Michelangelo said it, there had to be some truth in it. So there it was again, Leonardo realized—another trial on false charges. Now the wives of both patriarchs would scurry to Landucci's with the verdict: Have you heard? *Michelangelo insulted Leonardo in the piazza, calling him an imposter, unable to cast his gran cavallo . . . and Leonardo was unable to reply!*

He turned away with disgust. Giovanni caught up with him.

"That was outrageous, but you have to expect it. Michele's very competitive. He wants out from your shadow as the reigning master."

"By shouting insults?"

"*Caro Nardo,* you'll prove he's wrong when you get the bronze and do the casting."

Leonardo shook his head. This was going nowhere.

"Why not?" asked Giovanni. "Don't you still have the horse?"

There was the cruelest thrust. As a sculptor, Michelangelo knew a clay horse would perish unless watered . . . *and, to your shame, you just left it there.* A spasm of fear seized him. Gino had promised to water Ton every day, but there had been no word from him for over a month.

"Forgive me, Gianni. I must leave you."

At Ponte Santa Trinità, he crossed the Arno and turned right at the monk's hospice to walk upstream. Alone now by the river, the cold fury and whiplash of insult was even more unbearable. He leaned on the parapet above the stream.

Maybe Gianni was right: *He wants out from your shadow as the reigning master.* But why was the judge there turning it into a public trial? *Cristo!* Would it never end? Was there no playground or public piazza without human betrayal? Without scudding stones or insults hurled at the offered hand?

He had no answer, and looked at the river. Its waters were running high and red with the spring rains. The Carraia Bridge, with its ridiculous arches flat against the current, was again in danger of being swept away. The limb of a willow tree, caught under one arch, waved in the current with a gesture of farewell.

He turned away, to enter nearby Santa Maria del Carmine and the Brancacci Chapel with its frescoes by Masaccio. Here time was free of its river. Here it lay waiting in fragments of memory. Here he had found a boy like himself painting the unseen shadow of Peter. Here he knew he would become a painter and capture that mystical shadow. Here Albi had prayed for a child and had taken him into her arms, believing Jesus had listened to her. He could feel her arms again and hear the whispered words: *May he give me a son as beautiful as you are. . . .*

He breathed easier now. Nothing could take this away from him. No doubting judge in a piazza, no gossip at Landucci's, no treachery from vile Florentines could savage the beauty of their union—nor its destiny in his painting of Maria among the disciples.

He looked at the fresco of Eve being driven from the Garden—her open mouth a dark well of woe, her hands covering the sudden shame that came with the knowledge of good and evil. Here was the infinite mystery of the human odyssey. The restless, searching mind, the daemonic drive of the spirit, the rebirth of life in distant, unseen lands—all of it contained in the moving body of this wellspring of life. His Maria, with her human burden, descended directly from this woman of Masaccio. . . . So there was his reply to Michelangelo:

You can create perfect male bodies, beautiful Madonnas, and a giant *David* with great skill and knowledge of anatomy. However, the souls of your creatures remain trapped in their marble. My Maria is far beyond your grasp. Her return from across the centuries will haunt the minds and souls of those who look into her eyes, seeking some answer, some safe harbor for their drifting lives, even as she appears to move and change within their vision. Against this, you will never prevail nor escape from my shadow.

There was nothing more to say. He turned to leave, pausing again before Eve being driven with Adam from the Garden. This punitive passage of mankind was simply called *Expulsion.* Just so, the title of his portrait had to be shortened. Any viewer would know that, following the death of her son, Maria would be among the disciples in Jerusalem. So it would be simply *Maria.* There was no reason to call her anything else.

FLYING ON BLUE WINGS

FLORENCE AND FIESOLE

May – June 1506

I N LATE MAY, LEONARDO HASTENED TO FIESOLE, above Florence, to
further his *Treatise on Birds*—and, God willing, to fly with them.

As a vegetarian, he was still lean, in good condition—but at fifty-four, he
could not wait much longer. With cartoons ready for the two side panels of the
Anghiari painting, he was well ahead of Michelangelo, and Niccolò had
obtained a three-month extension for the completed work.

For this venture, he brought along his old friend and assistant, Zoroastro,
or Zoro. They stayed with Albi's brother, Alessandro Amadori, the canon of
Fiesole—a short cleric with a round head, a stubby beard, and almond eyes that
resembled Albi's. Known to his flock as Padre Sandro, he proudly claimed he
was "Uncle" Sandro for Leonardo.

It had been a verdant spring, and from Fiesole they could see men and
women harvesting wheat in the lower fields of Settignano. During the day, the
sun warmed the hillside, and in the early evening, a breeze swept up the slopes
from Florence and the valley of the Arno. The rising airflow seemed perfect
for a takeoff of Leonardo's glider bird.

After years of trial and error, he noted the moment had arrived to fly
into the heavens: "The big bird will take its first flight above the back of Great
Cecero, filling the universe with amazement, filling the chronicles with its
fame, and bringing eternal glory to the nest where it was born."

He would launch himself by running downhill into the rising air current,
then soar upon the rising air thermals like a great bird with outstretched wings.
Somewhere in the skies, another blackbird was waiting for him. Why else
would the winged creature have inserted its tail into his mouth? This was
ridiculous, of course, yet the dream remained.

With Sandro and Zoro, he took the glider to Monte Ceceri, near Fiesole.
The craft's bamboo framework entwined with yellow silk was ready to fly on
twelve-foot blue wings of sized silk. For strength and limited weight, silk ropes
served as wing sinews, with tanned leather at the joints. Pulley cables of raw

silk, to the vertical and lateral tail fins, controlled direction and elevation. Inside the open frame, there were handgrips with armrests to serve when running to launch the craft, and a sliding seat to sit on once one was aloft.

It was late afternoon, with a soft breeze coming up the slope, but this was not enough. The three men climbed the hill with the glider to where the slope was steeper and the wind much stronger. This was what they needed. As Leonardo adjusted the harness, the wings of his craft trembled for takeoff. Sandro tried to stop him.

"It's too high, Nardo. From here, you can fall and break your neck."

"I know that."

From this height, he would immediately soar far above the lower slope. He knew the inherent dangers and had carefully noted them:

> The destruction of a (flying) machine may occur in two ways. The first is that the machine might break up. The second would be if the machine turned on its side, or nearly on its side, because it should always descend at a very obtuse angle, and almost exactly balanced on its center. To prevent breaking up, the machine should be made as strong as possible in whatever part may tend it to turn over.

To avoid this, he had planned to test it *"over water with a lifebelt, so as to do yourself no harm if you fall."* Below the Fiesole hilltop, however, there was no lake— only grape and olive groves. Nor was there a parachute for safe descent. Never having tested the glider in flight, he faced every danger. But to fly one day from the top of Monte Ceceri, or Swan Mountain, there had to be a trial run. Here the weather and wind were perfect, and the tail fins would turn him back when needed.

"Don't worry, I won't go too far."

Harnessed into the open frame, he ran down the hillside in a maroon doublet with blue-green leggings. The wind caught the wings with a sudden jerk, lifting the glider upward. He was flying! A jab from the right armrest brought the spring-driven body cradle under him, and he slid forward to balance the craft.

Pulling a cable to raise the lateral tail fin, he leveled off in flight. Then he gradually lowered it, and the craft began to climb upward on the wind. The big bird with blue wings was moving through the silence of the heavens toward the blackbird of his dreams. As he passed over Settignano, the men and women below stared with wonder, and he waved to them. He came next to green olive groves, dark lines of cypresses, white roads, then checkered fields of yellow grain.

"Come back, Nardo! . . . Come back!"

It was Sandro calling. Florence lay ahead, with sunlight glinting off the red tiles and white ribs of Brunelleschi's great dome.

"Naar . . . dooOOH!"

He turned the vertical tail fin to the right, then raised its lateral to begin an oblique descent over the olive groves. In that moment, he was caught by a turbulent crosswind. It bounced the glider upward, then caught its right wing and flipped it over. *Santo Dio!* . . . It was exactly as he had feared!

He quickly pulled the tail fins to level off and climb, but the craft was out of control and spiraling downward. The olive groves were coming up at him, spinning around in circles. Then he spun into them with a *SWISSH! CaarAAK! CWWAAH!* of broken branches and shattered wings in a giant olive tree.

Sandro and Zoro found him upside down in his twisted harness, amid a bower of green leaves and broken blue wings, a cluster of olive leaves in his graying beard, two leaves sprouting from a doublet pocket, and blood flowing from a gash in his ripped blue-green legging.

"*Grazie a Dio,*" murmured the canon, crossing himself.

Zoro, with tears of relief, climbed into the tree to free his master. When seated on the ground, the man who would defy Icarus moved his arms and legs. His right arm was numb, and his right leg was painful and bleeding. But it was a shallow wound, and nothing was broken.

"You flew like a bird!" cried a relieved Zoro, beaming with pride.

"The tail fins," he replied. "They have to be larger . . . with flaps on the wings."

Still able to walk, he returned to the parish, his glider a wreck but his dream intact. He had met the call of the blackbird and seen Florence waiting for him. On another day, he would fly from the back of Swan Mountain at thirteen hundred feet—but with larger tail fins and wing flaps.

Earlier that morning, Sandro had received a letter from Isabella d'Este, asking him to help with Leonardo: ". . . If not for my promised portrait, then anything that pleases the Magnificent Maestro would bring great honor to us and my infinite gratitude for your Christian kindness," she wrote.

Perugino, Titian, and Raphael had acceded to the incessant demands of the insatiable marchesa—but not Leonardo.

"Tell her I've grown weary of the brush. If it changes, we'll let her know," Leonardo informed Sandro later that day.

Back in Florence, he was rendering a sketch of Leda with her swan and a pair of twins emerging from immense eggs when Salai brought a pearl gray envelope with the royal seal of France, addressed in ink the color of dried blood: "Most Esteemed and Honorable Maître Léonard de Vince."

"The messenger is outside," Salai said. "He says His Excellency, the governor of Milan, wants a reply."

"Let him wait. This is going to take some time."

Leonardo opened the letter. It was from Charles d'Amboise, comte de Chaumont and regent of Milan.

> *Cher Maître,*
>
> I am pleased to inform you that His Majesty, our beloved Sovereign Louis XII, expects to encounter you upon his return to Milan. As this may occur at any time, I respectfully urge you come immediately.
>
> It would be an honor to have you as my guest until you are settled in your previous studio at the Corte Vecchia, which is available for you and your assistants.
>
> I await your reply without the slightest doubt that it will graciously reflect the wishes of my Sovereign.
>
> I also look forward to your counsel on a palace I wish to erect alongside the beautiful Acqua Lunga. Were it to receive but a fraction of Your Lordship's many Excellencies, it would contain a beauty and grandeur beyond compare.
>
> By God's grace for our Most Christian King,
> Charles d'Amboise,
> *Seigneur de Chaumont,*
> *Régence du Milan*

He put the letter down with a sigh. There was no way to refuse this. Florimond Robertet and Louis de Ligny had offered to make him royal engineer and painter to His Majesty. Now it was Charles d'Amboise, the king's viceroy.

Salai saw the look on his master's face. "So we're going back?"

Leonardo nodded. The youth gasped with joy.

"Thank God . . . When do we start packing?"

"We do nothing and you say nothing, you hear me? This request must formally go through the Signoria. We have enough enemies."

"What are a few more?"

"*Santo Dio!*"

He looked at Salai, who was smiling, delighted to have scored once again. He was twenty-five now, his blond hair turning brown and his body getting fat. His work coat, embroidered with the name *Giacomo,* was without paint or any sign of labor. It was disgusting.

"Leave me alone," Leonardo said.

He thought of the two remaining Anghiari panels on the wall of the Council Chamber. They would have to wait for his return. Niccolò would understand. He, too, obliged his patrons.

This was what he needed. A royal patron who adored the *Last Supper*. A request to return to the Corte Vecchia was most considerate of Charles d'Amboise. Designing a palace for him would be a pleasure.

2.

A month later, May 30, 1506, the Signoria agreed to Leonardo's departure, provided he returned within three months to finish the Anghiari mural—or face a fine of 150 ducats. Clearly, this was hardly possible. He signed a contract anyway, and left in early June with Salai; the new apprentice, Lorenzo; a young servant known as Il Fanfoia; and two mules bearing his collected paintings and supplies, notebooks, and trunk of clothes with personal items.

Michelangelo also departed from Florence, summoned to Rome by Pope Julius II for a tomb to rival those of Egyptian pharaohs . . . and to paint the Sistine Chapel. His *Battle of Cascina* cartoon and Leonardo's *Battle of Anghiari* were doomed.

Michelangelo's cartoon would be lost during the Florentine uprising in 1512 against a ruthless Medici's return to power—cut to pieces by second-rate artists and plundering merchants. Leonardo's mural would live on for another half-century. A 1549 guide to Florence noted: "When you have climbed the staircase to the Great Chamber, look carefully at a group of horses, which will seem a marvelous thing to you."

Florentine freedom—celebrated in the Anghiari mural—would finally be crushed by one of its own sons, Clement VII, the Medici Pope. In 1530, he sent Spanish troops to starve his native city into submission, abolish the 250-year-old magistracy of the Signoria, and install his Medici family as the hereditary dukes of Florence. Under another Cosimo de' Medici—Duke Cosimo I, later grand duke of Tuscany—all vestiges of the last republic were removed, and a ghetto was mandated for Florentine Jews. Puppet historians and artists—that shameful tribe of traitors, which flourish under any tyranny— glorified this Medici's reign and his extended Tuscan State.

Giorgio Vasari, historian, architect, and painter, covered Leonardo's *Battle of Anghiari* with mediocre, pupil-assisted scenes of Florentine battles against Siena and Pisa. In his *Lives of the Most Eminent Painters, Sculptors and*

Architects, he made no mention of burying a living work of art, which had excited a generation of artists, including Peter Paul Rubens. On his mural, however, he left a small, cryptic inscription, *"Cerca Trova."* Meaning "Seek and You Shall Find," it suggested Leonardo's work might still survive beneath an overlay of brick.

Thus one more masterpiece was lost in the turmoil of anarchy and violence, which eventually extinguished the miraculous flame of the Italian Renaissance. A curious fragment from the twilight of those glorious years appeared in a marble relief entitled *Cosimo I as Patron of Pisa*—created by Pierino da Vinci, the only Vinci to follow Leonardo. As with his illustrious uncle, he took the best patron he could find.

THE HERESY OF A
THREE-PART VIRGIN

MILAN

July 1506

As Leonardo rode through Porta Romana, Milan enveloped him like a mantle from an old dream—its mists, the slow canals with croaking frogs, the circular moats and gateways into neighborhoods like little towns, the forest of saints on the ashen face of the cathedral, the broad streets with rumbling wagons, cracking whips, and scurrying pedestrians.

With his companions and two pack mules, he entered the immense piazza of the Sforza castle, its towers now flying French banners with the royal crown and fleur-de-lis. Two wagons with wine barrels rumbled across the castle's drawbridge and the moat with its drifting swans. Above it stood the immense entry gate and tower of Antonio Filarete, creator of St. Peter's bronze doors in Rome and Milan's Ospedale Maggiore, with its symmetrical cross-shaped wards. Before being driven from Milan by mediocre architects and masons, the brilliant Florentine had created this castle entrance, its grandeur alone proclaiming an eminent rule of the Sforzas.

Two cavalrymen emerged on the drawbridge, followed by two men on foot. They seemed familiar. . . . Then he recognized them: Gianni Boltraffio and Marco d'Oggiono! As they approached, Leonardo descended from his black stallion.

"Maestro!"

There was joy in their eyes, and they embraced him as a father.

"Incredible!" exclaimed Gianni. "We heard you were painting a wall four times larger than the *Last Supper* and thought you'd never return."

"We missed you." Marco sighed. "Now it's like living in rented rooms."

"You're getting commissions from the royal court?"

"Nothing," replied Gianni. "The French wait for their king who never comes. They called us today to help with a masked ball for the Milanese."

"They hate the French," said Marco.

"They hated the Moor," added Gianni. "But at least there was Beatrice, like a shooting star."

"There's no stars now." Marco sighed again. "Only rented rooms and no way out. With the Moor in prison, there's only his friend Maximilian, who also wants Lombardy. Sooner or later, he'll make a deal with Venice and the Pope to send the French back where they belong."

"God help us," said Gianni. "*Caro maestro,* are you and Salai moving into the castle?"

"Charles d'Amboise has arranged for the Corte Vecchia."

"The comte de Chaumont!" exclaimed Marco. "So you are back in the royal court!"

Leonardo wasn't in the royal court—not yet. Everything depended upon Charles d'Amboise, who wanted a royal palace for himself.

"Take care," warned Gianni. "Everyone says Amboise is worse than the sly Moor."

Leonardo had heard enough. After obtaining their address, he mounted his horse and approached the drawbridge. The captain of the guard saluted him and his followers. His Excellency, Seigneur de Chaumont, would be delighted to know they had arrived. An equerry and two servants took their mules, and a guard escorted them to quarters formerly occupied by Bona of Savoy.

2.

Charles d'Amboise received Leonardo graciously in the throne room formerly occupied by Lodovico Sforza.

"Messer Leonardo, I am honored and delighted to see you. . . ." He smiled. "I presume you are no stranger to this room."

Tapestries with the glories of King Louis XII had replaced frescoes celebrating Francesco Sforza. In place of the Moor's kidney-shaped conference table, there was a golden desk with ornate legs terminating in carved lion paws. Leonardo and the governor sat in matching chairs of gold with lion-paw armrests.

"I assure you, sire, I have often felt like a stranger here."

Charles laughed, delighted. This was a good sign. Maybe Marco was wrong. The comte de Chaumont and grand master of France was a large, portly figure with a broad forehead, a round face, and a black goatee and mustache. He had the relaxed manner of one long used to power.

"The Moor was not a bad ruler. . . ." He smiled and nodded. "He had the good sense to employ someone like you. . . ." He paused again, pursing his close-cropped mustache and fat lips. "The Hapsburg emperor wants us to free him, but we can't do that. Still, we allow him as much liberty as possible at

Loches. He has a library, servants, goes hunting with his guards . . . without the headache of governing this city."

"It was never easy for him."

"*Mon Dieu!* You can imagine how it is for a Frenchman."

This was surprising. Chaumont seemed to realize the Milanese hated his rule.

"Still, we now have total cooperation," he declared. "In every quarter, the priests and nobles refer their problems to us, and we take care of them. It's like Paris that way. You work through those who control each quarter."

That was how the Moor had ruled, Leonardo recalled, with Milanese nobility part of the game. And where the Moor believed he was safe behind his treaties, this Frenchman had similar illusions about Emperor Maximilian.

"We have an agreement. The Pope can crown him as emperor of the Holy Roman Empire, but then he goes back home. . . . Have you brought your plans for my palace?"

Leonardo opened a portfolio on the low table before them.

"Let me see!" exclaimed Charles, bending over the drawings.

He saw a palace with a loggia and bright, airy interiors. A stream of cool water flowed through an arcade courtyard with splashing fountains to relieve the oppressive heat of Milan's summers. Behind its chapel, the palace extended into a second palatial living area with its own courtyard and fountains.

"What's this for?" Charles asked.

"The privacy of a king," replied Leonardo.

"A king?"

"If he should visit you, seeking a retreat with a man he can trust."

"Oh! Of course."

"Or if you need similar freedom to explore your own thoughts and feelings in utmost privacy. . . ."

This delighted Charles, whose love of wine and women was couched in classical terms—that is, he was equally fond of Bacchus and Venus.

"What are these?" he asked, pointing to illustrations of a park with gardens.

Avenues of orange and lemon trees and evergreen cedars were lined with rare plants of flickering colors. Streams of water rippled along the walks, spilling into large ponds with tropical fish and underwater racks for cooling wine. Over this paradise, copper netting enclosed an immense aviary for exotic birds.

"Many kinds of birds," Leonardo explained. "So you will have music all the time, mixed with the scent of flowers, cedars, and citrons."

"Perhaps a French madrigal?" asked Charles. "That would delight my sovereign."

"Of course. You can also have places where the water will suddenly spray your visitors, or sprinkle the ladies' dresses."

"That would delight him even more! *Cher Leonardo,* you have brought me an enchanted paradise. . . . Welcome to the court of France."

3.

The gate to the courtyard of Corte Vecchia was open, and he entered. Climbing the stairs, he found a group of men and women cleaning the floors and repairing windows and drains. During the Milanese uprising, and the Moor's attempt to regain his throne, mobs had sacked the palace.

He wandered through its chambers with mixed emotions. So many years had passed, and now these rooms were waiting like old friends. He was there, once again overlooking the square, when Salai returned from delivering a note to Cecilia at Palazzo del Verme.

"She's coming back from her Saronno villa tomorrow," Salai reported. "Remember Rolando? He'll tell her we are at the castle with the comte de Chaumont. She'll be very excited to know you've brought her the painting of—"

"No-ooh! You told him about *Maria?*"

The youth hesitated, then shook his head.

"Don't lie to me, Salai. Did you tell him or not?"

"No, I didn't," he protested.

"Listen to me, boy. You know nothing about that picture, and you do not talk about it to anybody. Is that clear?"

"Yes, I promise."

"Good. . . . You also went to the foundry?"

Salai looked away, and Leonardo knew the news would be bad.

"He's not there."

"Where is he?"

Salai had found the carcass of the great horse in a far corner of the sculpture yard—a gray hulk with its armature exposed like the ribs of a rotting elephant. Clay had fallen from its powerful thighs, leaving prancing rods of rust. Gray clumps clung to the fierce eye sockets. Pieces dangled within wires that had once held ears in battle-alert. Green flies swarmed over piles of feces behind the huge carcass, where foundry workers had squatted amid brown-splotched mulberry leaves.

Here was the revolting end of his master's great dream. Trembling with fear and loathing, Salia had sat on a broken bust of a noble Lombard in a

Roman toga. Some flies had followed him, and he'd swung at them a couple of times. Then he'd given up and begun to sob like a child. . . .

"*Per Dio!* Tell me what happened!"

"The French shot him full of arrows until he fell to pieces."

"Gino! Where was Gino?"

"He's dead. There's a new owner, Castrico, a man with squinty eyes."

"Nothing's left?"

"Nothing . . . I'm sorry, master."

The youth took his master in his arms. Leonardo sighed. This at least was sincere, even with the disaster. The spirit of Ton was somewhere else, waiting for his return like his warriors on the battlefield of Anghiari. One day this spirit would enter another war mount, perhaps for Marshal Trivulzio. That's how it went. As Christ faded from the *Last Supper,* something of Him had entered the portrait of Maria. So they lived on, terrestrial-bound spirits waiting their return to life.

4.

At Santa Maria delle Grazie, the portal brother refused him entry. The prior was absent, he said, and he could admit no one without his permission. Shoving past him, Leonardo hurried across the courtyard, passing roses and a splashing fountain, to enter the refectory—only to find his *Last Supper* hidden behind a brown curtain across the end wall. Two breathless Dominicans arrived. The first one, a tall friar with a small mouth and a hooked nose, accosted him.

"I'm Pietro da Tortona, the convent prior. Father General Bandello wants no one here without his permission. Now I must ask you to leave."

"You don't understand. . . ." Leonardo paused, trying to remain calm. "I created this painting for him . . . your master, Vincenzo Bandello, when he was prior here, and I'm not leaving without seeing it."

"It's very sad," said Brother Bruno, the second friar. "Your painting is falling apart."

"That's what I must see."

"I understand," replied Prior Pietro. "But it will have to wait for our master's return tomorrow."

"Get out of my way!"

At the wall, Leonardo seized a cord and pulled back the curtain. They were still there! The flaking had left a scattering of gesso spots like snowflakes, especially on the right side. Yet everyone was there. Then he noted something far more grievous: a glistening over the entire surface. Moisture was condensing behind the curtain.

"Now have you seen enough?" demanded Prior Pietro.

"You have to remove this curtain," Leonardo replied. "It's creating moisture on the painting."

"Our master says it keeps out the humidity."

"Your master is wrong. Moisture is coming through the wall."

Leaping onto a chair, Leonardo ran his hand across the feet of Christ.

"You see this? If you're not blind, what do you see?"

"Looks like water," replied Brother Bruno.

"Blood! That's the blood of Christ and also my blood—can you see that?"

"That's enough," sputtered the angry prior. "We will inform our master. Now we will close this, and you must leave."

"Close it, never!"

Wild with fury, he tore the curtain from its railing and it fell to the floor.

"*O Dio!*" gasped Brother Bruno, sinking to his knees.

Prior Pietro's hooked nose wiggled with rage. "This is blasphemy! We will prosecute you for this."

"Not when your father general learns you're ruining his *Last Supper*. . . . Good-day."

Leaving the convent, he walked through the woods toward the castle. Its massive redbrick towers soon appeared through the trees, and he entered the immense piazza where Ton had once reigned amid Europe's royalty. Then looking at his sundial watch, he realized he was late for his meeting with Charles d'Amboise. At the castle's drawbridge, the captain of the guards saluted him.

"Maestro Leonardo! This just arrived for you."

A scented pale gray envelope from Contessa Lodovico Bergamini . . . his Cecilia!

Carissimo,

I can't wait to see you, to embrace you. Come to lunch tomorrow. Padre Vincenzo is coming from Genoa before returning to Rome. So we can surprise him with your return.

Rolando says you have a painting of the Virgin Maria to show me. Is it the one you promised? If so, please bring it when you come . . . and please tell me you won't ever again deprive me of your presence in my life.

La tua Cecilia

Salai had lied, of course. He had talked about the painting with Rolando. Even so, this was exactly what he needed—the reaction of a priest and a woman like Cecilia to *Maria,* a woman with no discernible presence in time or place.

5.

Once again, it felt like a returning dream—the palazzo's massive oaken portal, Rolando smiling at the door, the salon frequented by the literary and social world of Milan, the view onto the distant piazza and cathedral, his portrait of Cecilia above the fireplace—and then she was embracing him.

"*Caro Leonardo! . . . Amore mio,* I've missed you so!"

The years were on her now. Small lines surrounded her mouth, shadows lay beneath her eyes, and there was a fold beneath her chin. But the mouth with its buried smile, and the expectant glance of dark amber eyes, remained on the shores of womanhood. Suddenly, she saw the wicker painting case next to a sofa chair.

"You brought her! . . . It's Maria!"

He nodded, and she knelt on the floor as he withdrew the painting from the case.

"*O Dio,*" she whispered, placing it against the chair. "*Mio Dio . . .* there she is."

Leonardo saw her weeping and knelt to take her into his arms. After many years, they once again shared their tears. A bell rang, and she rose quickly to her feet.

"It's Padre Vincenzo. . . . Let's put this holy lady where she belongs."

As she hung the painting above the fireplace, in place of her portrait, light from the piazza flooded the room and *Maria* seemed to belong there. Rolando opened the door, and Vincenzo Bandello, father general of the Order of Preachers, appeared in the black habit and white cassock of an ordinary Dominican.

He was bowing to Cecilia and making a gesture of kissing her hand, when he saw Leonardo standing beneath *Maria.*

"*Figlio perduto!*" he exclaimed, hugging the lost son.

The powerful preacher was heavier now. The hungry hollows in his granite face were gone, his ears and nose seemed larger, and deep furrows creased his brow and cheeks. But the voice that could fill a cathedral had retained its deep timbre, and the deep blue eyes were there—the waiting pools of a mystic, suddenly filled with wonder at the painting above the fireplace.

"*Madonna ci salve,*" he murmured, asking the Madonna for help with the one before him. He turned to Leonardo.

"This is our *Maria in Jerusalem?*"

"The woman they saw. I now call it *Maria.*"

Leonardo waited. This man had always been able to enter his paintings—a priest capable of going beyond inflexible dogma.

"The Holy Ghost is still there," the padre declared. "He's still upon her . . . from the beginning of time."

He began to trace the flow of waters from lofty mountains in the background, pausing suddenly to look at Leonardo.

"How did you do this? How did you get to her?"

"She came from me and others," he admitted. "At different times and places."

"And, a mother once again," noted Cecilia.

"A what? A mother?"

"She's pregnant."

"No . . . no, it's not possible. Leonardo, tell me it's not true."

"Cecilia sees it that way."

"*Santo cielo!* Don't play with me! Is it true or not?"

"You can see it for yourself," replied Cecilia. "She sits back in the chair to relieve the weight of her child. Look at her breast and puffy hands folded over her belly. The woman is at least five months along."

Vincenzo stared at the picture. Then he shook his gray head and sank onto the sofa. "Nardo, I have been your friend. How could you betray me this way?"

"I'm sorry, Padre. It's how she came to me."

"To you? . . . *Figlio mio*, do you realize what this is? Every day, millions pray to her, *Beata María, sempre vergine*. For centuries, Christian art, music, poetry, theology, and legend have portrayed her as a perpetual Virgin. Even the most troublesome saints and theologians never questioned this. . ."

"Permit me, Padre," replied Cecilia. "In the Gospel, there's nothing about her remaining a virgin. Matthew and Luke imply otherwise. Also, you told me that some theologians, like Origen in Alexandria and Tertullian in Africa, believed a retained virginity refuted the human nature of the Savior. So it's not a universal article of faith."

"Donna, don't lecture me! The ancient concept of Mary being *virga intacta post partum* is rooted in our belief and prayers to her. Her virgin birth is an essential sign of goodness and purity in the godhead. And the *post partum* suspense of natural order is a critical sign of her divinity. It must be there for all who turn to her in need."

"And so it is," replied Leonardo. "That's how you saw her first."

"I don't know what I saw anymore. . . . The Virgin maybe, but an older one."

"Bravo, Padre!" replied Leonardo, delighted. "I knew you'd see it. . . . There's been a fusion of time here, as you perceived in my *Last Supper* and *Virgin and Child with Saint Anne*. Here are three successive states of Maria's life—the

Madonna with child, the Holy Mother grieving at the Crucifixion, and Beata Maria as a disciple of her son and the universal woman of the ages."

Overwhelmed, Vincenzo realized it was all there—everything he had imagined in this woman he loved. Alone at the window overlooking cathedral square, he spoke in a whisper, as though referring his comments to the cathedral.

"All right," he said, turning to Leonardo. "We accept her as conceived by an epinoia."

"Another Holy Ghost?" asked Cecilia.

"Perhaps in part," replied the priest. "An epinoia is a sacred creative consciousness, which places her beyond our reach, with a life of her own. We cannot alter or diminish her purity as the mother of our Lord. Nor can any suggestion of a pregnancy profane this glimpse of the divine."

He turned to the picture. "I see her on the altar at our San Domenico convent in Genoa."

Leonardo shook his head. Mantegna had kept his *Cristo Scurto*. He was keeping *Maria*.

"I'm keeping her . . . at least for now."

Vincenzo frowned. "I thought this one was for us. . . ." He paused. "If it's a matter of price . . ."

"No, Padre. . . . If she ever leaves, it will be for you."

"Until then, you'd better not show her to anyone, especially the king of France. He will want her, and you'll be unable to refuse him or answer all his questions. . . . How many know she may be with child?"

"No one except Cecilia."

"No one else?"

"No one."

The priest stared at him, knowing this could not be true.

"Listen to me, maestro. If becomes known that this figure of Our Lady is pregnant with another child, its power and beauty will ensure its destruction. Nothing you can do will prevent someone from cutting her to pieces or burning your studio, not to mention what they will do to you."

As he left after lunch, Vincenzo returned to dangers inherent in the painting.

"It doesn't matter who sees her, as long as you deny any talk of pregnancy. This is an immortal work, beyond even the *Last Supper*. We must treat it with jealous care and reverence. Is that agreed between us?"

Leonardo and Cecilia nodded. The father general embraced them both, then left.

"What will we do?" said Cecilia. "Salai told Rolando . . . and how many others?"

"I don't know."

"This can cause serious trouble for your friend. What can we do about it?"

He looked at the portrait. To deny any part, including the pregnancy, would betray everything that had made it possible. Besides, *Maria* now had a life of her own. She would speak for herself to anyone who saw her. Nothing they said or did could alter this.

"You promised to deny it."

"I can't do that."

"Then Vincenzo is right. They will try to destroy her."

6.

As expected, the portrait soon began to speak to others, beyond any control of Leonardo or Vincenzo Bandello. One morning, during a July heat wave, three Franciscans from the Confraternity of the Immaculate Conception appeared at the palace entrance to Leonardo's studio. Salai met them—three friars in cowled brown robes standing in the blazing light of the piazza.

"We've come to see how Uriel is faring," said Fra Battista, the first one.

Leonardo had retrieved the painting from Ambrogio's studio—their alternate version for the Franciscans: the Virgin in a desert cave with the infants Jesus and Saint John and the angel Uriel.

Salai hesitated. Leonardo was with Charles d'Amboise, planning a gala reception with street festivities for a pending return of King Louis.

"I'm sorry, Padre, but the maestro is away."

"We have to see if the angel is still pointing at Saint John," the friar explained.

The other two nodded—tonsured heads ringed with a circle of black hair above the ears. To avoid further trouble, Salai led them to the painting studio. Upon entering, they encountered a painting of a nude woman—Leda enveloped within the wings of an immense swan. Below this erotic coupling, a pair of twins were emerging from immense eggshells.

"Madonna," murmured one friar. "She's doing it with a bird."

"And has laid big eggs with children in them," noted the second one.

"Close your eyes!" cried Fra Battista. "That's Greek heresy!"

The large painting of the *Virgin of the Rocks*—as it became known—appeared next. The friars huddled before it, nodding at the figure of Uriel, who no longer pointed to the infant Saint John. The bell rang, and Salai left

them to admit someone delivering food. Upon returning, he found all three friars looking at the *Maria* on its easel in Leonardo's private study.

"You must leave immediately," he told them. "You have no right to be here."

Fra Battista's finger touched Maria's abdomen, drawing a murmur of assent from his two brethren.

"And Pino, the butcher's boy?" sneered Battista. "If your asshole friend sees this heresy, so can we."

The finger moved up to the breasts, bringing more murmurs.

"Stop doing that!" screamed Salai, grabbing Friar Battista by his white waist cord.

Its clasp broke and the cord—with three knots for vows of poverty, chastity, and obedience—fell to the floor, along with its clattering crucifix. Battista dropped to his knees, wiped the olive crucifix with his sleeve, and kissed it three times. From his knees, he glared at Salai.

"Dirty slut of a sodomite, you cast our Lord onto the ground."

"Get out of here!"

"With a Holy Virgin pregnant from sexual lust, like that prostitute Leda copulating with a swan. Our Holy Father will condemn your heresies!"

Wild with fear, Salai drove them away. When Leonardo returned, he was still trembling.

"Those people are terrifying. They felt her with their fingers and called you a monster and me a whore." He began to sob. "I'm frightened. . . . What can we do now?"

"They'll tell their Franciscan Pope that I made a pregnant Virgin for the Dominican heretic Bandello. We have to warn him as soon as possible," Leonardo replied.

PART TWENTY-THREE

BANDELLO DEFIES THE POPE AND DIES OF POISON

ROME, MILAN
AND THE VATICAN

July – August 1506

I N EARLY JULY, Vincenzo Bandello arrived in Rome in the company of
his nephew, Fra Matteo, and two lay brothers with pack mules. Two days
later, Father General Bandello was summoned to an audience with Pope
Julius.

Before leaving the convent at Santa Maria Sopra Minerva, Matteo gave
his uncle a letter from Leonardo describing the Franciscan episode.

> *Carissimo e Amato Padre,*
>
> . . . these friars claim I have created a pregnant Virgin to support
> your concept of her sanctification while in the womb of her mother. I
> have sought to dissuade them, but their cries of heresy are probably
> spreading throughout their Order, including the pope who alas! is also
> a Franciscan.
>
> This is what you feared, and I am deeply grieved it now includes
> your most reverend and holy person. . . .
>
> *Sempre tuo Leonardo*

Did Julius know this already? the father general wondered. No matter, it
was bound to happen sooner or later. Now he could personally explain the
portrait, before the Pope heard any more nonsense from crazy friars. Also, he
would take Matteo to see his first Pope and increase his vision, resolve, and
pride in the Dominican Order of Preachers.

At the Apostolic Palace, Swiss Guards ushered them up to the papal
antechamber with its frescoes showing Saint Francis shaking the paw of the
Gubbio wolf, speaking to birds, giving his coat to a leper, sailing across the sea,
and jumping into a fire in front of the sultan—the latter exactly what the young
friar feared would happen to them.

Paride de Grassi, master of ceremonies, inscribed Matteo as *"Frate Matteo Bandello O.P., secretarius ab epistolis."* Then the papal secretary, Sigismondo da Foligno, brought Father General Bandello and Friar Matteo into the audience hall, where they stood beside a privy chamberlain while waiting to be summoned.

Matteo felt his knees shaking. Pope Julius was seated before them in a golden throne chair on a three-tiered platform with Oriental rugs rippling down its broad steps. The warrior-Pope, as Vincenzo called him, was now attired in the holy robes of a pontiff—a white soutane and a red silk mantle trimmed with white ermine. A matching *camauro* covered his head down to the sunken plane of his temples. He was a big man, this vicar, with a handsome face that somewhat resembled Vincenzo's—a high, straight nose with a jutting jaw. Dark eyes were set deep under the protruding brow of a gladiator. His arms lay languidly over the throne's golden-tasseled armrest, and there were jeweled rings on both his hands.

He was staring at them now, while Sigismondo whispered into his ear. Then he nodded and the papal secretary summoned *"Vincentius Bandellus, praedicatorum generalis magister."*

The Dominican father general knelt at the throne in a spotless white robe with black mantle. His beard, now gray in his seventieth year, had been neatly trimmed. His head, freshly shaven at the top, had a three-finger-wide band of encircling gray hair above the ears.

As he kissed the papal ring, Julius extended his other hand toward Sigismondo, who gave him a small book.

"Frate Bandello!" cried Julius, his voice echoing in the hall. "The bull *Grave Nimis* of Pope Sixtus provides for the excommunication of those who foment discord in the worship of the Blessed Virgin. We note with sadness that you have not heeded this warning."

Vincenzo looked up. As a servant of the Lord, he had knelt in reverence to the Vicar of Christ. As a Dominican, he now rose to speak to a Franciscan. Before doing so, he respectfully backed away from the throne—a stark figure in black and white, his tonsured head glistening.

"May it please Your Holiness, I am not aware that I have failed in this matter."

"Then what is this?" demanded Julius, brandishing the little book, his ring jewels flashing.

Matteo held his breath. It looked like the Dominican breviary with prescribed daily prayers and offices.

"I presume it's our breviary."

"You presume? By God's body, you know it is!" cried the pontiff, his voice booming. "You also know that you've inserted an office to Our Lady for"— he looked at a page marked by a red ribbon—"for the holy sanctification of the Blessed Virgin by an infusion of her pure soul while in the womb of her sainted mother."

He snapped the book shut with a look of disgust and held it out for his secretary.

"Fra Vincenzo, you are guilty of discord! This instructs your Dominicans all over the world to say the Holy Virgin was initially conceived with the stain of original sin instead of an immaculate conception."

"That depends upon how Your Holiness defines *conception*. For four hundred years, it has been taken to mean the entry of the soul into an individual, sometime between the sexual act and the beginning of life in the womb. Our sanctification occurs within that time. This was reviewed by your uncle, Pope Sixtus, who refrained from final judgment, as have three other Popes, including Your Holiness It would thus seem that, until you can determine the actual onset of life, our beliefs cannot be called discordant."

Julius nodded impatiently, as though anxious to turn to other matters. Matteo hoped his uncle would say no more. But he was a born fighter, like the man before him.

"Your Holiness, the Franciscan belief that Our Lady was sanctified by her pure soul immediately after sexual congress, before there was any body to receive a soul, requires a denial of Saint Thomas, or an encyclical sanctifying the seed of Joachim."

"Enough!" cried Julius, bouncing on his throne as though in the saddle. "Saint Francis could unseat your Saint Thomas in one joust!"

"I doubt your saint would ever joust with ours."

"And why not?" demanded the Pope.

"Saint Francis would refuse, believing he would win anyway."

The Pope laughed, as did his secretary and the privy chamberlain. Julius began to talk as though to a friend.

"So you can't win this one, Fra Vincenzo, and you've just admitted it."

The Dominican father general simply nodded. Julius's jeweled hands grasped the throne chair, and he leaned forward.

"We have learned that Leonardo da Vinci has created a masterwork which you have seen, although he's hiding it from the king of France."

"May it please Your Holiness, Leonardo has many masterpieces. It would surprise me if the king did not want them all."

"Cacca!" cried the warrior-Pope, meaning horse shit. "You know exactly

that it's it a painting of our Holy Mother, pregnant with a second child, to support your heretical view of her conception."

"Permit me, Your Holiness. That is total nonsense from some friars who do not understand that the artist painted a composite virgin."

"'Composite'? How can Our Lady be composed of anything but herself?"

"Your Holiness is aware that King Louis wanted to take Leonardo's composite *Last Supper* to France."

"*Santo cielo!* Another composite—of what?"

"It portrays two events—the Judas betrayal and the first Eucharist as occurring in the same moment. Just so, Leonardo has created a multiple Virgin from various stages of her life. So where Jesus appears in two simultaneous events, here there are three for Maria—as the Madonna with Child, the Holy Mother grieving at the Crucifixion, and our Beata Maria as a Jerusalem disciple of her Son and the universal woman of the ages."

"*Basta!* Maria is not a *cacciucco*," declared Julius, referring to a Livornese fish stew. "There are many Madonnas and Virgins, but they're not mixed up or condensed into one old woman. The faithful need them to be one thing only and ready for urgent prayer. In battle, we have half a dozen, and there are many more for the poor and helpless, including traitors and corrupt cardinals in our Curia. . . ."

He paused to glare at his attendant chamberlains. "Padre Vincenzo, have you lost your mind? The faithful will never accept your Holy Mother stained with sin, or one who's pregnant again. None of the teachings of our Franciscan fathers, or the theology of your Saint Thomas, can prevail against this. That's why your crusade is unpopular and creating serious discord in the Church. That's why"— he leaned forward from his throne—"using Leonardo to create a multiple Madonna for your Maculist heresy is most dangerous for a man of your age and position, especially at this moment in time."

With a wave of his hand, Julius indicated that the audience was at an end. As Vincenzo bowed to take leave, he whispered, "I will pray for you, brother in Christ."

Leaving the palace, Matteo watched Vincenzo. He was deeply disturbed but remained silent as their carriage rumbled over Ponte Sant' Angelo to their convent.

"We're in trouble," Vincenzo said, sighing. "You heard the Pope. Leonardo's *Maria* was created to support my Maculist heresy. That's insane. But now he'll do anything to destroy it."

"And you, as well."

"He can't touch me, but *Maria* is in danger. It's an old story in Rome. Tertullian predicted that if Christ returned, we would crucify Him all over

again. And a Beata Maria who doesn't resemble her image on the altars would pass unseen among us . . . or be destroyed by this bloodthirsty Pope."

"So what do we do now?"

"I don't know, Matteo. We can only wait and see what happens."

ALTOMONTE

August 1506

Aᴄᴛᴇʀ ꜰɪᴠᴇ ᴅᴀʏꜱ ɪɴ Nᴀᴘʟᴇꜱ, Father General Bandello and his nephew, Fra Matteo, departed for their Dominican convent in Altomonte, Calabria. Later, the young friar recalled it in intimate detail:

> I am still haunted by that night in Calabria. Every moment remains with me like a series of moving frescoes in the mind. It was a night when the rain came from the weeping of angels, when my tears mingled with my uncle's to wash him clean, when the wind moaned in the bell tower like Saint Dominic before the altar of God. . . .

It began in early evening, August 26, 1506, as the father general and his four traveling companions climbed toward Santa Maria della Consolazione. Located on the crest of a hill, the convent, with its walls and bell tower, rose above them against a flaming sunset. Its massive gates swung open for them to ride into the courtyard.

The prior, Fra Mariano, was there to greet them—a short, stocky Neapolitan with a tangled gray beard and sunken black eyes that shifted as he spoke, so that his words seemed to tumble out in different directions.

Matteo had noted this at other convents. The priors were invariably nervous as the father general arrived to inspect their internal lives, observance of the Rule, free election of the prior, relations with the community and the local bishop. They were also divided over Bandello's revised constitution for the Dominican Order. Most priories had approved it, believing it long overdue. An entrenched minority, however, bitterly opposed any change that would weaken their positions of privilege.

After supper, Vincenzo complained of a headache and sudden fatigue. Matteo assumed it was from their long ride. Early the next morning, however, his uncle appeared pale and weak. After celebrating Matins and Lauds—the

first ecclesiastical offices of the day—Matteo had the convent doctor examine the father general.

Fra Ubaldo, a little man with a white beard and the ears of an elf, looked into Vincenzo's mouth, felt his stomach, and smelled his urine. Then he took a deep sigh and said the father general was probably coming down with intestinal grippe.

"A south wind must have caught you when you were cooling off under a walnut tree."

"Nonsense," said Vincenzo.

"It'll do it every time, especially if you were sweating."

"Balls," replied the Dominican.

After celebrating Terce and community Mass, the father general ate only part of his midday meal, complaining of nausea, a dry mouth, and blurring of vision. Fra Ubaldo delivered a new diagnosis.

"You probably ate wild boar marinated in bad wine," he affirmed. "But don't worry. I have a special physic for this—a theriac of seventy herbs, brewed by Brother Teodoro at the University of Padua."

The father general was given this antidote, together with a broth made of rosemary leaves, cassia, and sugar boiled in white wine, to serve as a purge and a stimulant. It had no effect, however. He became weaker, his mouth remained dry, and he experienced difficulty in swallowing and speaking. With great effort, Vincenzo forced himself to sit up on his pallet.

"We're in trouble, Matteo. There's no chance now for Leonardo's *Maria* to survive public exposure. The Pope and his Franciscan rat pack will seize it like wild dogs."

He closed his eyes and sighed, which caused him to cough until he was shaking. In the lamplight, his broad face was pale, his blue eyes now dark gray and streaked with yellow.

"Go to bed, Matteo. We can talk tomorrow."

"I'm frightened. If anything happens to you, what will I do?"

"You can live for me. That would be very beautiful."

Matteo was close to tears. He wanted to sleep on the floor beside his uncle but knew his offer would be refused. He touched his hand. It was cold, but it moved to grasp his own.

"Good night, son."

"Good night, Father."

Closing the door, Matteo carried the image of Vincenzo's eyes. They were saying good-bye. He began to sob and, kneeling before his cell fresco of Saint Dominic at the cross, he poured his remorse and guilt into the Confiteor. Looking up, he saw Vincenzo at the cross and knew he was going to die.

A few hours later, he awoke upon hearing Vincenzo's door being closed across the corridor. Lifting the latch slowly, he saw two figures—Fra Mariano, the prior, and the short, gray-tonsured doctor, Fra Ubaldo. They were whispering in the long corridor, lit by small lamps before cells of sleeping friars, where a cough or jangling keys reverberated as in a cave.

"There's nothing to do," confided Fra Ubaldo. "It's creeping up on him. His legs and arms are already cold. When it gets to his bowels and lungs, he'll stop breathing and go to the Lord."

"*Santo Cristo!* How soon?" asked Fra Mariano.

"A few hours maybe. He's already gasping for air and urinating blood."

"Is it the plague? We don't want the Black Death here."

"It's moving too fast for that. He's probably been poisoned. They have the slow-moving kind now, so you don't know you've taken it until—whiff!—it grabs you later and off you go. . . . Cardinal Carrafa says the Pope warned Bandello that his life was in danger. . . ."

"Are you saying the Holy Father did it?"

"Not personally, but maybe someone else—you know, to please His Holiness, or even some of our brethren who despise him and his new constitution for our Order."

"Listen to me," whispered the prior in a hissing fury. "Our father general wasn't poisoned anywhere, by the Pope or any of our brethren, you hear me? Nowhere! Until the Order decides otherwise, he had a bowel blockage, and he died after receiving all our loving care and the holy sacraments. Nothing else. You understand?"

Bong! . . . bong! . . .

The sacristan was tolling the midnight bell for summer Matins and Lauds. The two figures hurried on down the corridor. Matteo, his heart pounding with rage, found Vincenzo propped up by one of his bags, staring at the fresco of Saint Dominic and Christ. He feebly extended his hand.

"Matteo . . . little Matteo," he said, breathing with difficulty.

"We must go from here, Father. Fra Ubaldo says you were poisoned."

Vincenzo looked at him but said nothing. His face was round and pale, like the moon. His blue-black eyes stared at Matteo. Their pupils were fixed and dilated, like those of animals at night.

"Fra Mariano wants nobody to know it. So they're going to say it was an intestinal blockage. I heard them in the corridor."

Vincenzo shuddered as from a sudden chill. His eyes closed, then opened again, fixed on his nephew.

"It could have been something during the trip. . . . Old men can go suddenly, like blown leaves. But if it was poison, what can we do about it?" He

paused for breath. "I've given my life for my Lord and our Blessed Lady. . . . That's what it's all about, Matteo. Sacrifice is the meaning and the glory of all we do. Never forget that, and never speak of poisoning. . . . You promise?"

"What do I say if they doubt me?"

"Doubt is never to be questioned. It's part of your faith. It defines and strengthens the pluses and minuses by which we measure our small existence and awareness of God. . . . Remember what Elihu told Job: God speaks first in one way, then in another, but no one notices. He speaks by dreams and visions in the night, and when we are asleep in bed, He whispers in our ears."

The priory bell ceased ringing, meaning the friars were now assembled. Fra Mariano would now inform them that their father general was dying. Vincenzo began to speak with greater urgency.

"I'll never see Leonardo again . . . or his Lady, who's in danger. You must tell him to deny the pregnancy, or else remove her name . . . at least for now. She will survive without it. Anyone who sees it will sense the mystery and know who she is."

He shuddered again and took his nephew's hand.

"Matteo . . . are we still alone?"

"Yes, Father."

"I have loved you like my own son. . . . Did you ever feel you were really my son?"

"Oh, yes . . . often," his nephew replied, weeping.

Vincenzo kissed his hand and received his kisses. He shuddered again, and his breathing faltered. The youth helped him to lie flat on the pallet; then he sat with him, holding his hand. The dying Dominican stared at the fresco, his lips moving in silent prayer. It began to rain, and the wind could be heard in the bell tower.

"They'll want to keep me here," he said. "But you must not let them."

"Yes, Father."

"Take me to Naples, to our own church, where I can rest in peace. Promise me that, my son."

"I promise, Father."

FOLLOWING THE DEATH AND INTERMENT of Vincentius Bandellus de Castro Novo in the Naples convent of San Domenico Maggiore, Fra Matteo hastened to Milan to deliver his message to Leonardo.

Salai led him through a painting workshop and up winding stairs to the master's private studio. Salai opened the door, and they found him injecting melted wax with a syringe into vessels in a bloodred mass.

"It's an ox brain," whispered Salai.

Without looking up, Leonardo spoke angrily.

"I told you to let no one in here." Then he relented. "Oh, Fra Matteo . . . please stay."

Salai left them, and the young friar watched Leonardo using wax to determine the shape and extent of the brain's cavities. They were in a large studio with a long window for north light and muslin draw curtains. Glancing at another work desk, he saw a red wax model of a human heart, laid opened to reveal its four chambers and valves. A large black cat with speckled eyes dozed between the severed heart and the skeleton of a human foot. A strange lamp, immersed in a glass cylinder of water, emitted an exceptionally bright light—suggesting the master had been at work before dawn, or perhaps through the night.

When he finally turned, Matteo saw a face furrowed with time. Deep shadows lay under the gray-green eyes. His beard, once a virile shock of auburn hair, had streaks of gray. Yet at fifty-four, he appeared as strong and vigorous as ever.

"I heard about it," he said. "What happened? When I last saw Vincenzo, he was in good health."

"He died of an intestinal blockage . . . something he ate during the journey."

"After he died, did you look at his hands?"

"I placed the rosary in them."

"And the fingernails?"

"Ugly . . . dark as the prayer beads."

"Then he was poisoned. Someone murdered your uncle."

Matteo shuddered. It was true, but he had promised to deny it.

"We . . . we don't know it for sure."

"It was to stop his Maculist war against the Pope. They probably used La Cantarella of the Borgias . . . equal parts of phosphorous and arsenic in sweetmeats. . . . Who do you think did it?"

"Machiavelli warned of our own Dominicans. Many old priors hated his revised constitution for our Order. The Pope was also enraged by your pregnant Virgin, claiming it supported Vincenzo's belief in the Virgin's sanctification in the womb . . . an intolerable heresy and most dangerous for him personally."

Seeing Matteo close to tears, Leonardo took his hand.

"You don't have to say any more. . . . Come with me."

He placed a metal vessel over the dissected brain to close out the air, and the cat. Then he led Matteo across the studio to the portrait on an easel under a gray muslin cover. As it was removed, the young friar stepped back in shock.

"*Santo Dio,*" he murmured. "So that's why he spoke to her as he lay dying."

Leonardo took him in his arms, as he had the little boy spying on the *Last Supper.*

"Little Matteo," he said.

"He spoke of you at the end, when he was blind, fumbling for my hand, saying, 'I'll never see Leonardo again . . . nor his Lady, who's in danger.' He said the Franciscans will track her down like a pack of wild dogs."

"I know that."

"He said the painting would survive without her name. In fact, she would assume an even greater mystery." The young friar forced a smile. "She's waited two thousand years for this, so what's a few more before she can reappear?"

"*Caro Matteo,* it's not possible. She would be there, staring at me, asking why I was betraying her. . . . No, I could never do it."

2.

Shortly after Matteo's departure, Charles d'Amboise, viceroy of Milan, arrived to review Leonardo's plans for the return of King Louis XII.

"He nearly died from a grave illness," confided Charles. "Now he won't listen to his doctors, the queen, or anyone else. Nothing will stop him from coming back to crush the rebellion in Genoa, and enjoy the throne of Milan."

The viceroy was shown drawings of three triumphal arches for the monarch's solemn entry into Milan, the streets lined with clergy and youths in glistening doublets of blue silk embroidered with golden fleurs-de-lis. It was old theater for Leonardo, but Charles was delighted.

"This is exactly what we need. It will move crowds to cheer for His Majesty . . . and, *caro maestro*, it will move you into his royal court." He glanced around the studio. "I'm told you have a portrait of a pregnant Virgin, done at the request of the Dominican father general, Vincenzo Bandello."

"Bandello took it with him when he left for Rome."

"We heard the Holy Father was furious with him; then Padre Vincenzo died suddenly in Calabria. What do you know about that?"

"I'm told he was looking at the painting when he died, but then it vanished."

"So they both disappeared," observed Charles, his dark eyes narrowing, his manicured hands stroking a tiny pointed beard.

"So what is that one?" he asked, pointing toward the distant *Maria*.

Cristo, there she was . . . uncovered and waiting to speak to her visitor.

"Who is this woman?" he asked, walking toward the portrait.

"She's a Florentine lady . . . not yet finished."

"She seems finished to me. His Majesty will want to have this."

"I'm sorry, it belongs to that lady."

"Messer Leonardo, we must avoid at all costs any offense to my sovereign. Far better it happens to a Florentine matron than to a French king who needs a royal artist and engineer in Milan."

He hesitated. Entry into the royal court now hung in the balance.

Charles sighed. "*Cher maestro,* how often do Florentine families end up in exile, even the best ones? Take my counsel. In the royal collection of France, this lady will be assured of immortality . . . as will her creator."

He looked at *Maria.* There was no other way, but only after he had entered the Great Sea.

"Thank you, sire. Eventually, I will place her in the royal collection of France."

"Ah! This will please His Majesty."

After the viceroy left, he spoke to his woman of the ages.

"Perhaps it's better this way. . . . You will live with the king of France, maybe in his dressing room as *Portrait of a Florentine Lady.* . . ."

He paused, recalling another pregnancy—that of Lisa Gherardini, wife of Francesco del Giocondo, the wealthy Florentine silk merchant.

"Or maybe you'll be Monna Lisa."*

Until then, however, she had to disappear. He stretched a linen canvas over her panel, sketched a Saint Sebastian upon it, and placed it among other unfinished paintings. That will do it, he thought. Until she goes to King Louis, this will save her from the indiscretions of Salai, or the knives of the Franciscans.

* The word *monna*, a contraction of *Mía Donna* (meaning "Madonna" or "My lady"), became Mona Lisa in English, due to a spelling error.

KING LOUIS RETURNS WITH REVENGE

May 1507 – April 1508

AFTER SEIZING GENOA, Louis XII entered Milan in triumph in mid-May. Twelve years before, as the duke of Orléans, he had left in bitter defeat with his broken army, vowing to return, claim the duchy as a Visconti heir, and drive the despicable "Signor Sforza" into exile.

Now king of France, he rode beneath a blue-and-gold canopy borne by Milanese doctors and magistrates, amid children with flaming torches and chanting clergy bearing a golden effigy of Saint Ambrose. The crowds cheered as he passed beneath Leonardo's arches along Monte di Pietà—an imperial figure of a monarch on a white stallion, white plumes waving from the spikes of his jeweled crown, his shrunken body encased in the silver armor of Saint Andrew, with a flowing cape of dark blue velvet sprinkled with golden fleurs-de-lis.

At the castle, Louis and his court began a week of festivities that included games and charades, the staged fables of Correggio and Poliziano, stag and boar hunts, and a five-day joust in the piazza before the castle. Milan had its own *festa* in the streets, with tables of free wine and cakes, roving bands of troubadours, acrobats, jugglers, and *cantastorie*—itinerant minstrels reciting *Orlando Furioso* and other popular legends in verse.

The week climaxed in a grand ball. Once again, flaming torches lit the castle, with its nine hundred servants and liveried courtiers. Milan's nobility, delighted with a return to old times, rolled into the courtyard in gleaming black carriages, while breathless wives checked the pecking order. Leonardo, accompanied by Cecilia and Galeazzo da Sanseverino, arrived in high spirits. He had been confirmed as royal engineer and painter to his Most Christian Majesty, who was delighted by the triumphal arches, floats, spectacles, and Leonardo's astonishing projects to extend Milan's canals, increase river navigation, and measure the flow of water to detect thieves and tax evaders.

During the ball, a courtier brought Leonardo to King Louis's informal court in a corner of the grand salon. As he approached, the comte de Chaumont whispered to his sovereign. Louis nodded and motioned for his artist-engineer to come forward.

"Our dear, well-beloved Léonard de Vince! Finally, we meet. I apologize for this delay."

This was pleasing—a graceful Italian with rolled *r*'s on a French tongue.

"Your Majesty, the delay has only heightened the pleasure and honor of this moment, for your affairs of state are far more important."

"Than the creator of the *Last Supper*? I confess, *cher maître*, that I was unable to speak when I saw it. Now Chaumont tells us you are finishing a *Virgin and Child with Saint Anne* for my queen . . . and you have a portrait of a Florentine lady for us, as well."

He was ready for this, but not the physical state of the king. At forty-five, he had sunken cheeks that bore the hue of death—gum lac red, mixed with white ochre and white lead. This man would not live to inherit *Maria*.

"I regret, your Majesty, that the painting has already been sold, and the owners came to claim it. If it pleases you, I will do another, or perhaps —"

"Perhaps what?" demanded Louis.

"Instead of a Florentine matron, you might prefer a young Leda with an aroused swan."

"'An aroused swan'?"

He laughed, the sound close to a squeal, and Chaumont quickly followed suit.

"Sire, the *Leda* is most desirable."

"*Bravo!* So we expect the naughty Leda and two saintly *ladies*," declared Louis.

"You will receive them," promised Leonardo.

Still, this man might live. The eyes had an inner fire and pride, which had driven him from a sickbed to lead an army into battle and claim the throne of Milan.

2.

Leonardo now entered the last, great creative period of his career. With an income from a royal patron, revenue from the San Cristoforo canal, the return of his vineyard, and *Maria* no longer of immediate concern, he was free as never before in his life.

Once again, he received the recognition denied him in Florence. This included the support of King Louis, who was annoyed by Soderini's demands

that Leonardo return to finish his *Battle of Anghiari*. From the court at Bois, Louis had sent an imperious letter to the Signoria, which relied heavily on its alliance with France.

> *Illustre Signeur Gonfaloniere Soderini,*
> ... We have particular need of Maître Léonard de Vince, painter from your city of Florence, and we intend to command from him some work of his hand.... As soon as you receive this letter, you may inform him that he is not to move from Milan until our arrival.

Nor did Leonardo want anything more of Soderini. From his account in Santa Maria Novella, he repaid the 150 florins advanced for *Anghiari*, thereby acquitting himself of breach of contract and severing all remaining ties with the city of broken dreams.

"I want to work miracles!" he cried, driving himself, at fifty-five, with the energy and enthusiasm of someone half his age.

He invented an inclined flatbed printing press with a moving platen for the eventual editing of thirteen thousand pages of notes and drawings from the vast realms of his mind. At the same time, he began to explore the telluric unity of man with nature, as manifest in painting, sculpture, architecture, anatomy, botany, geology, the hydraulics of water, the structure of the heavens, and man's role in the universe.

In pursuit of "the science and movements of water," he created a hydraulic water counter, extended Milan's sixty-four miles of canals, and improved some of its forty-two locks—gates lifted by chains on a windlass, or cantilevered trapdoors governed by drawbars. To further this, he provided a centrifugal pump "for draining marshes bordering on the sea with a sixteen-blade screw propeller to flush stagnant canal eddies."

To expand Lombardy's network of waterways, he proposed to make the river Adda navigable, with a thirty-meter dam and a tunnel through the mountains to Milan. Recalling the Arno project, he noted, "If land has to be purchased, the king will pay the price out of dues received in a single year."

He also fixed his eyes once more on the heavens. All of his previous thinking had led him to the conclusion that the earth could not be the center of the universe: "The earth is not in the center of the circle of the sun, nor in the center of the universe, but is in fact in the center of its elements, which accompany it and are united to it.... THE SUN DOES NOT MOVE."

This collapsed the entire metaphysical system of the cosmos from the time of Aristotle and the Arab astronomers. It was also astrological anathema for Church dogma. So was its consequent corollary. The universe was not

centered on man, the most perfect of all created beings, nor was the earth in his image. The passage of his body and soul were totally irrelevant to the stars in their sweep across the dark heavens.

3.

Shortly after Easter in 1508, Marshal Gian Giacomo Trivulzio appeared at the Corte Vecchia studio.

Leonardo recalled how he had whispered to the wounded Ton, pierced with arrows from Gascon archers. A powerful man, he had a head that bore the scars of war and the furrows of time and seemed rough-hewn from granite.

"I've come for the horse you promised me," he said.

For Leonardo, this was the final solace. *Maria* had redeemed the crumbling *Last Supper*. The Adda canal would replace his failed Arno project. And now the ghost of Ton would enter a warhorse bearing a famous condottiere, a monument to join Andrea's *Colleoni* in Venice.

"And you will have it, Your Excellency . . . a war mount for a great warrior."

"I see myself on it above my tomb," suggested Trivulzio. "As we agreed when I was viceroy."

"A life-size charger," agreed Leonardo. "With you leading your troops into battle."

"I knew I could count on you," replied the marshal, slapping his sculptor on the shoulder as he would a foot soldier—or a warhorse.

4.

While designing the Trivulzio monument and calculating its cost, another boy entered the life of Leonardo. He found him one morning in the studio, watching Gianni Boltraffio at work on the background of *Virgin and Child with Saint Anne*. Seeing Leonardo, Gianni lay down his brush.

"*Caro Maestro,* I have another apprentice for you. He's Francesco Melzi, and his father is a captain in service to the king."

From his dress and bearing, this lad came from a noble family. Leonardo liked him immediately—the modest nod, a child's face with fair skin, wide almond eyes, a straight nose, a broad, generous mouth, and a cascade of dark hair to the shoulders.

"I found him at the convent, drawing your *Last Supper*."

"Welcome, Messer Melzi," replied Leonardo, extending his hand.

The boy hesitated, then smiled and placed his hand in that of the master.

"Thank you, sire."

"How old are you?"

"Fifteen, sire."

Gianni smiled. "His drawings are over there, on the drafting table."

Leonardo found what he had expected—uninspired work, yet remarkably faithful in every detail. This was a rare boy at a critical moment, without fixed ego or false humility, without the scars of poverty or rejection—a pure, unformed creature seeking entry into a life known only in dreams.

"That color," he said, pointing to the sky behind the Virgin and Saint Anne. "Do you have any idea what it is?"

"Ultramarine blue, sire."

There was an expectant look, and Leonardo's heart sank. There he was, waiting before Andrea Verrocchio, who didn't want him.

"How is this color made?"

"You begin with lapis lazuli of a good stone having a rich blue color, pound it in a bronze mortar, mix it with pine rosin, gum mastic, and new wax...."

"So you've memorized Cennini?"

"It happened, sire, in seeking to follow him."

Sire ... Those eyes expressed something that went beyond *Maestro*. They were those of a respectful son addressing his father. He sighed. The boy was waiting expectantly, and he saw Andrea in tears, opening his arms ... *Figlio mio!* That moment had changed his life. When his father wouldn't touch his hand, Andrea's heart had opened to him. Now it was happening again—an opening to love, to be as close as he had been to Andrea, without the depravity of sex.

He shook himself. These were but fantasies, born of a need to replace Salai ... or were they? Nature and life were full of infinite causes, which did not come with experience ... and who knew? He returned to the words of Andrea.

"All right, Gianni," he said. "Get him a work tunic."

MILAN AND THE
VENETO BATTLEFIELDS

May 1509 – June 1513

PRIOR TO ENTERING ITALY, King Louis had joined the League of Cambrai—an alliance formed by Pope Julius, along with Emperor Maximilian and Frederick II of Aragon, to recover territory seized by the Venetians that belonged to the Holy See, the Holy Roman Empire, and lands that once belonged to the Visconti Duchy of Milan.

Louis hardly needed to recover territory. With the Duchy of Milan, and its subject cities of Pavia, Piacenza, Parma, Como, and Genoa, his net revenues topped those of the king of England, the Holy Roman Emperor, or the Vicar of Christ in Rome. Despite this, he wanted to extend his dominion to include the rich fields of the Veneto.

Louis, clad in white, entered the field with a train of young nobles in glittering gold. Ignoring Trivulzio's dire warnings, he led his troops across the river Adda, while demolishing bridges to prevent retreat. Advancing with speed and ruthless brutality, the Most Christian King routed the Venetians at the battle of Agnadello, May 14, 1509, leaving sixteen thousand dead on a blood-soaked field. Driving onward with allied forces, he seized all of Venice's possessions except Treviso.

Leonardo, as the king's military engineer, focused mainly on geology and topography—he sketched the river Serchio, various canal locks and pumps, the approach to Bergamo, and the fields and river tributaries before Brescia, as though planning a hydraulic development in the region. When Louis returned to Milan in July of 1509, Leonardo celebrated the monarch's conquest with a rare spectacle before the cathedral.

At the edge of a sea, a mechanical lion drove a dragon from its waters onto the shore, where a fierce Gallic cock, its feathers the colors of France, gouged out the dragon's eyes—to the delight of his royal patron and a vast crowd. The victory festivities, however, were marred by tragedy. An overcharged

cannon burst apart, its iron fragments knocking a French nobleman off his horse and killing a little boy—an omen of impending disaster.

It soon came. Devastated by losses in the open field, Venice resorted to the secret corridors of diplomacy, offering Julius rights to Rimini, Faenza, Cervia, and Ravenna. The devious Pope demurred until also promised Treviso. Then he switched sides and, through bribes and concessions, brought Ferdinand II of Aragon, Emperor Maximilian of Germany, and Henry VIII of England into a Holy League to drive the French once again from Italy.

Shocked by this betrayal, the French were even more amazed when Julius, the warrior-Pope, rushed to Bologna to enter the campaign. In 1510, racked by gout and syphilis, and bedridden with tertian fever, the Vicar of Christ had himself carried by litter into combat, swearing, "I'll poison myself before a Frenchman gets me!" He then amazed his troops, directing cannon fire on a battlefield swept by January sleet and snow, crying, "Now let's see who's got better balls . . . me or the king of France!"

King Louis, however, had returned to France. The comte de Chaumont led his troops, until, weakened by malaria, the noble Charles d'Amboise died that February, after the defeat at Correggio. Gaston de Foix, nephew of the king, succeeded him as viceroy. A brilliant commander, he led his army through snow and ice over the Apennines to seize Brescia, then Bologna. His French, German, Swiss, and Italian armada of 25,000 then engaged 20,000 papal and Spanish troops at Ravenna on Easter Sunday, 1512.

In the epic battle, Spanish battle chariots with murderous wheel sickles, similar to those designed by Leonardo, were pitted against French cannons, which "sent helmets and heads into the air like bloody, wingless birds." Finally, the Spanish fled in panic, leaving seven thousand of their dead on the field. The French losses of three thousand sadly included the heroic Gaston de Foix, who had fought to the end, suffering eighteen wounds.

Julius struck back with fury. "I'll bet one hundred thousand ducats, and even my tiara, that I'll drive the French barbarians from Italy!"

He turned to more treachery. He had already forced Maximilian, who needed the Pope to crown him Emperor, to withdraw his landsknecht troops, which had been essential at Ravenna. Then Julius secretly enlisted the Swiss mercenaries by paying more than the French.

"Our Swiss malady is readily cured by gold," confessed their commander, Matthaeus Schinner, archbishop of Sion, upon accepting a fortune in gold from Julius, a cardinal's hat, and the Papal Legacy of Lombardy.

The Swiss army of eighteen thousand, bearing red flags of the Passion, descended from their cantons to seize Milan. It was over before it began. The French, demoralized and in disarray without their king or a strong viceroy, fled

over the Alps in June 1512, cursing their sovereign, who had brought them to this end.

Leonardo also fled to the Melzi estate at Vaprio d'Adda, outside of Milan—a guest of Captain Girolamo Melzi, father of young Francesco—pending the return of King Louis to reclaim his duchy. He waited in vain. A French army, under the command of Trivulzio and La Trémouille, returned once more, with Venice now their ally—but without the force and spirit of King Louis, who remained in France. While encamped at the village of Ariotta, near Novara, ten thousand Swiss caught them by surprise on June 6, 1513, killing twelve thousand, seizing their arms and equipment, and driving the shattered French army again in flight across the Alps.

Once again, Leonardo had lost a royal patron. At sixty-one, it was a devastating blow. His world in Milan had collapsed, taking with it his studio, assistants, and projected projects—notably the illustrated volume on anatomy, the studies on flight, the laws of optics, and the hydrostatics of liquids relative to their capillary behavior. Even more painful was the loss of his redemptive trinity of dreams: *Maria* would no longer go to France, the Adda canal would never serve Milan, and the spirit of Ton would never reappear with glory in the Trivulzio monument.

September 1513

D URING LEONARDO'S BITTER LIMBO, a new patron had suddenly appeared, following the death of Julius II on February 20, 1513. A deadlocked conclave of twenty-five bickering cardinals, upon being reduced to a vegetable diet, had finally, on March 11, chosen a sickly cardinal as an interim Pope: Giovanni de' Medici, second of Lorenzo's three sons.

Giovanni was thirty-seven, but he was incurably ill with a stomach ulcer and an anal fistula, which wet his robes. Apparently too weak to ride a horse, he had been borne by litter from Florence to Rome for the conclave. Was this a ploy to get the papal throne? No matter, this gross, self-indulgent Medici would not drag his cardinals off to war like Julius, nor live long enough to greatly delay someone else's bid for the throne of Saint Peter.

The new Pope chose to be called Leo X. His brother, Giuliano, became *gonfaloniere* and commander in chief of papal forces—and Leonardo's new patron. The Magnificent Giuliano dreamed of trapping the sun to run the woolen mills of Florence, heat the Medici palazzi and villas in winter, and install an automated stable for 128 horses. To pursue these and other projects for his brother the Pope, Giuliano proposed to lodge his personal artist-engineer at the Belvedere Palace inside the Vatican.

This seemed ideal to Leonardo. Pope Leo was a fellow Florentine and patron of the arts. Barely six months into his reign, artists, architects, poets, and musicians were pouring into Rome. Perhaps the young pontiff would remember him from the early days with his father, Lorenzo. No matter, he had many friends in Rome. Donato Bramante, a favorite of Pope Julius, had begun to rebuild the Basilica of Saint Peter, and Giuliano Sangallo was to erect a palace for the Medici at Piazza Navona. In preparing for his departure, Leonardo shrouded *Maria* under a canvas of Saint Anthony until they were settled in the Belvedere Palace.

It had been seven years since he had left Florence for a new life in Milan. The departure, to seek a new beginning in Rome, was briefly recorded in a new notebook: "I left Milan for Rome on 24 September 1513, in the company of Giovan Francesco Melzi, Salai, Lorenzo (pupil from Florence), and Il Fanfoia (a servant)."

MEDICI POPE:

PROMISE AND BETRAYAL

ROME AND THE VATICAN

A
T FIRST, IT APPEARED TO BE A PARADISE. The Belvedere, a palatial villa within the Vatican, stood on a high northern spur above its Leonine walls. Built by Innocent VIII to escape his papacy periodically, it had been altered by Bramante in one of his first projects for Pope Julius.

Terraced gardens descended into an immense courtyard, designed for open-air theater, jousts, and bullfights. Next to the villa, among orange trees and green laurel, Leonardo encountered white marble gods unearthed in recent excavations—a slender young *Apollo,* the snake-encoiled *Laocoön,* a *Venus Felix,* and a lovely *Ariadne.* Marble stairs led to further wonders: a botanical garden of exotic plants from around the world.

From the villa windows, he could see the Vatican's covered escape corridor to the safety of Castel Sant' Angelo. Beyond this, lay the tawny waters of the encircling Tiber, its arching bridges, the red-and-gray carpet of Rome's rooftops, snake-twisting streets, a scattering of mushroom church domes, the elephant-gray carcass of the Colosseum, grazing goats on the Capitoline Hill, pigs and cows among the bone white ruins of the Roman forum, and, in the far distance, the vast plain of the Roman Campagna.

Strolling through the villa, he came upon small paintings of Milan, Venice, Florence, and Rome by Pinturicchio. In the papal chapel, he found Mantegna's frescoes of Plato's four Virtues and the three Christian frescoes.

Il Magnifico Giuliano arrived later in the day to inspect his protégé's plans for a workshop where he could make large concave mirrors and, in particular, a parabolic mirror for trapping the sun's energy, and a power-driven draw bench to turn out uniform strips of copper for soldering the huge solar mirror.

"The sun to power our textile mills!" exclaimed the delighted Medici. "To heat our damp palaces and villas and even the bathwater!"

Turning from the luxury of captured sunlight, he inspected the living quarters of his artist-engineer.

"Donato Bramante lived here," he said. "Didn't you know him in Milan?"

"Of course, and I predicted one day he would rebuild St. Peter's. I assume he's adopted the Greek cross structure we found at San Lorenzo in Milan?"

Giuliano nodded. "You should visit your friend. He's suffering from gout, the disease of my family. My grandfather Piero endured it for years, but it took my father quickly. . . . *Santo Dío,* who is that?"

It was *María* hanging in the bedroom. Light from a window fell upon her right side, as in the picture. Beyond the window, the distant hills of the Roman Campagna appeared as foothills to those in the portrait. As Giuliano sat on the bed to look at the painting, Leonardo recalled that Lorenzo had said he had three starkly different sons. The vain one had been driven from Florence as Piero the Exile. The wise one, Giovanni, was now Pope Leo X. The good one, Giuliano, *gonfaloniere* of the Holy See, was his new patron.

This Medici was large of body, with a distorted assembly of his family's features. The long, crooked nose had the round tip of Lorenzo's, and his gray-blue eyes held shades of melancholy. A light brown mustache encircled the small, delicate mouth of Piero and curved downward into a short beard. Long, slender hands indicated Lorenzo's innate sensitivity. Lacking his father's focused drive, Giuliano's perceptive yet restless spirit found no rest or solace in women, music, or the occult mysteries of alchemy. Now, however, he appeared to have found it in the painting before him.

"I know that lady," he said. "She could only be the Virgin I've heard about."

Leonardo nodded. There was no way to deny it. Once again, *María* had spoken, and this lonely man had heard her. It was remarkable, yet also dangerous.

"I heard she was pregnant. . . . Is that so?"

"She is what you see . . . no more, no less."

"I see only her eyes and the mouth with its haunting smile."

"Then that is what she is for you."

"I want her. . . . I need her. What do you want for her, *maestro mio?*"

"Nothing, your lordship," replied Leonardo. "She will freely come to you when I go into the Great Sea."

Il Magnifico Giuliano frowned and turned to the portrait as though seeking some answer. Finally, he nodded.

"*Va bene* . . . I see how she is for you . . . but we must not speak of this to Papa Giovanni. If he sees this woman, we'll both lose her."

2.

Leaving the Vatican to meet Donato, Leonardo plunged into the narrow streets of the ancient *borgo* beneath the walls of the city-state—a labyrinth of houses with latticed windows, protruding upper floors, and balconies with birdcages, cats, dogs, flowerpots, and laundry. For centuries, these huddled homes had sheltered successive generations of Romans serving the Vatican in every capacity—as cooks, gardeners, apostolic clerks, papal footmen, and an occasional priest.

Women's faces peered from dark interiors onto bustling via Borgo Vecchio, which variously murmured, cried, and roared in many ways: "*Olaah!...Porco juda!*" from cursing pedestrians; "*Ooee...oeeee!*"—the muleteer's warning; *Cliog...cling!* from the tinsmith shop; *Tick-tock* of donkey hooves; "*Vonghele! vonghele!*"—the fishmonger's cry; "*Cali...cali!*" from the chestnut vendor.

A short, fat woman approached with a stack of brown bread and green chicory balanced on her head. Leonardo smiled, and she paused, grasping her load to greet this elegant signore with a long gray beard.

"*Buongiorno, Eccellenza!*"

Nearing Castel Sant' Angelo, he passed inns with fragments of columns and cornices stolen from Roman ruins, with signs for pilgrims in every European language. From one inn, a priest emerged with an elegant signore in a fur-collared maroon cloak. They were speaking Latin.

Leonardo nodded and the signore returned his greeting. The priest, in a silk cassock and sporting a red ribbon on his brimmed hat, stared straight ahead. He had a thin nose, bloodless lips, and a scrawny neck. Then the signore spoke in Italian.

"Monsignore, we paid two hundred ducats for two people, my father and uncle. The bishop said it would release them both, but now he says it's not enough."

The priest made no reply, and Leonardo smiled. In Florence, the clergy had a rhyme for this outrageous swindle—payment for indulgences to free a soul in purgatory for its ascent to heaven: "Each coin with a golden glow, frees a soul from down below."

A liveried servant admitted him to Donato's palace in the exclusive sector of Borgo Vecchio. Donato met him in his study.

"Leonardo! What took you so long?"

His friend wore a blue velvet jacket with the entwined oak insignia of Pope Julius.

"You old *mangia prete*," he replied, meaning priest eater. "You appear to have swallowed the top dog and taken his clothes."

Donato laughed. He was almost seventy now, and the lower half of his pale face had shrunk, bringing the flared nostrils closer to his mouth. The wide cheekbones, the bull neck, the deep, reflective eyes were the same, but the high dome of his head was bald and silver tufts of hair hung over his ears. The hand of death, alas, was also visible in his hands, which were reddish blue and swollen with gout.

"You see it, don't you?" he said, noting Leonardo's glance. "Now it's going to my feet. . . ." He took a deep breath. "But I'm not giving up, Nardo."

"You were always a fighter, *caro Donato.*"

They sat before a large fire and a servant brought chilled Vernaccia.

"You came too late, my friend. You missed a great Pope who could have used you. Even your musical friend Atalante Migliorotti has scrambled on board as supervisor of Vatican works."

"What's wrong with this Pope?" asked Leonardo. "He's a cultivated Medici. Poets, painters, musicians, and architects are pouring into Rome."

"Don't get your hopes up. Julius had balls. This one has an ulcerated asshole, and he is so frightened of death that he took his doctors into the conclave. His festering *culo,* promising an early departure, got him elected. Except he now says, 'God gave us this papacy, let's enjoy it.'"

"So are you reaping its rewards, *caro Donato,* and a lot of others. You're building St. Peter's, Raphael is frescoing the papal apartments, and Michelangelo is also here."

"Another egomaniac who wants my church! *Grazie a Dio,* Raphael will get it when my time comes. . . . Don't expect the Pope to understand your genius, Nardo. Or that he will keep any promise he makes."

Returning to the Belvedere, Leonardo paused before the remaining shell of the millennial basilica of Constantine. Beyond its atrium, a temporary tabernacle had been erected for religious services and pilgrims. Next to it, the new basilica was under way. Four great piers reached to the cornice, their connecting arches adorned with sunken panels.

Donato wouldn't live to see his Olympus rising into the skies. Even so, this much could not be taken from him. If Raphael or Michelangelo altered the plan, these piers would remain as a skeleton of his church. The passing of Popes, the loss of a patron, the crumbling of a painting, or the collapse of a riverbank— nothing would ever alter the immortal presence of Bramante in this place.

At the Belvedere, he found Francesco Melzi in the sculpture garden. He was standing before the marble Apollo, drawing it with charcoal and ink wash. When Leonardo arrived, he was laying in a shadow on the right side of the face, with darker shading beneath the chin and the encircling mantle. A soft veil of light

permeated the shading of the right pectoral muscle and the outer slope of the thigh.

"Bravo, Franchino. The truth begins there, in primitive and derivative shadows, the second principle in the science of painting."

"And what emerges from it . . . or rather, appears to emerge."

"*Bravo, figliolo,*" he said, stroking his hair.

The touch, the caress, would remain there. This was the son he had wanted in Salai, only to lose it in the bestiality of sex. Melzi turned from the Greek god to look at his master. This old man, the greatest artist in the world, seemed to need him in ways he did not understand, though it gave him deep pleasure each time he thought about it.

"Maestro!"

Salai was at the edge of the garden.

"Il Magnifico Giuliano is here to take you to meet the Pope. He says to hurry, because His Holiness is going on a hunt."

3.

They descended toward the Belvedere courtyard on a spiraling ramp supported by four orders of elegant white stone columns. Bramante had built it of soft brick for mounted horses "to climb toward heaven." On the way down, Giuliano explained the urgency of the meeting with the Pope.

"Papa Giovanni wants to see you right away," he said. "Last night, he dreamt of the Borgia Pope dying in the room near him—swollen and black, foaming at the mouth—and men using their feet to stuff the putrefying corpse into a coffin."

"I know about that. . . . Why does he want to see me?"

"He believes such a death comes from malaria in the Pontine Marshes, so he wants them cleaned up. . . . I told him you could do it for us."

Leonardo was ready for this. Under Cesare Borgia, he had planned to drain similar marshes at Piombino. They entered the courtyard, which was crowded with the papal hunting party.

"They're going to Magliano for the hunt," explained Giuliano, lifting his floral *gamurra* of crimson velvet to step over a fresh deposit of equine excrement. "Canon law forbids this, but my brother can't give it up any more than he can his love for gambling, old manuscripts, and music, especially that of Consilium and Festa."

One of the Noble Guard admitted them to a secret stairway leading to the papal antechambers. Paride de Grassi, master of ceremonies, met them as another guard opened the door.

"*Eminenza!* . . . He's not ready, but he wants to see you anyway. . . ." He lowered his voice. "Despite my counsel, they're putting him in tall boots. How can people kiss his foot if he has boots on?"

Pope Leo X, in white robes embroidered with green laurel and hunting trumpets, lay on his back upon a divan. Two chamberlains were pulling on a white leather boot with golden spurs.

"*Santità!* . . . keep your left leg stiff," urged one chamberlain.

"There . . . you have it, *Santità*," murmured the other.

With both boots on, the Holy Father began to wave his arms like an overturned turtle. His attendants quickly came to the rescue, raising the massive body upright on short, spindly legs. Leaning on their shoulders, he waddled over to a high chair and sat down with a sigh. Bulging gray-blue eyes stared toward Leonardo with the drift of the nearsighted. Then, using a blue eyeglass studded with sapphires, he bent forward to focus on his visitor, as though reading an incunabulum in Latin.

Leonardo waited. Here was a monstrous miscarriage of Medici physiognomy. The head, huge and close to deformity, sat on powerful shoulders, with no neck apparent. The pale face, like a stranded moon, appeared to wait for the arrival of life. From its desolate surface, a nose rose up, huge and imperious, only to be betrayed by a small, lascivious mouth. The sensuous lips were similar to Giuliano's, but the hands belonged to different souls. Where his brother's were pale and passive, the Pope's puffy white hands rose and fell like birds with clipped wings. He spoke to his brother.

"Does he know what we want, Giuliano?"

"He does."

"Messer Leonardo, we've been given a plan to clean out the pestilent Pontine Marshes and their putrid swamps by forcing the Rio Martin river to flow into them."

The voice was surprising—soft and small, as from a child. Yet the tone and timbre could deceive. Big men often had tiny voices.

"As former engineer to the king of France, how would you do it?" asked Leo, lowering his eyeglass.

"I submit to Your Holiness that without an outlet to the sea, the marshlands and swamps would only be extended."

Giuliano nodded, but the Pope shook his head.

"You tried to divert the Arno with Machiavelli and failed."

"Permit me, *Santità*. Soderini and the Signoria imposed incompetent engineers upon us, then withdrew support when we were about to succeed."

"That man was a disaster. We exiled him upon our return," scoffed the Pope, referring to his family's return to power after twenty years of exile.

Leonardo noted his lips as they modulated the letters *b, f,* and *m.* For the book on anatomy, he still had to explore the motor muscles of the lips and tongue, the role of membranes and cavities in forming vowels and consonants.

"Very well." Leo sighed. "Since my brother accepts this project at his own risk, let's see what happens."

"There's much more," replied Giuliano. "The maestro is making a huge concave mirror to bring the sun's energy into our textile mills."

"In battle," suggested Leonardo, "a focused battery of mirrors could blind the enemy to a sudden charge of encircling cavalry."

Leo closed his eyes, fat jowls quivering. "Signor Maestro! We've had enough wars for three Popes. . . ." The blue-gray eyes opened with a look of disgust. "I hear you painted our Virgin pregnant with another child."

"*Santità,* I would never portray the Virgin with any child but Jesus. Some Franciscans in Milan spread that calumny, probably because the portrait was for the Dominican father general Vincenzo Bandello. As you know, they disagreed on the Virgin's immaculate conception."

"Another ridiculous war. In Plato's *Phaedrus,* Marsilio Ficino found a miraculous forecast of a virgin with an immortal body and a soul. . . ." The pontiff continued in Latin: "'The soul in her totality has the care of inanimate beings everywhere, and traverses the whole heaven in diverse forms. . . . Perfect and fully winged, she soars upward and orders the whole world.' There it is in Plato, our Virgin conceived without sin, or any need to squabble at the bedside of copulating parents."

A puffy white hand waved away the unpalatable image.

"I'm told you were painting a *Virgin and Child with Saint Anne* for King Louis?"

"I was, before leaving Milan."

"You also left Florence without finishing either your *Adoration* or the *Battle of Anghiari.* May we presume you will remain long enough in Rome to finish a painting for me?"

"I would be honored, *Santità.* . . . What did you have in mind?"

"A *John the Baptist* for my San Giovanni dei Fiorentini church across the Tiber. . . . Perhaps you could infuse the forerunner of Christ with the grace of Plato's pre-Christian virgin?"

Startled, Leonardo looked for some clue to this proposed twining of a man and a woman in the precursor saint. Did this Pope, with his many spies, know how *Maria* had been created? Or was it merely the result of a nimble mind imbued with the classics of humanism? Either way, it was an intriguing challenge.

"So what is it?" demanded Leo. "Maybe we lost you. . . . Are you ignorant of Latin?"

This was too much. In Florence, he had suffered the snobbery of Latin pedants. Now he faced it again, in this fat, tiny-voiced monster on the throne of Saint Peter. Donato was right. *Don't expect the Pope to understand your genius, Nardo.*

"With all due respect, *Santità,* I was nurtured on the language of Dante and Guido Cavalcanti."

The Pope turned to his brother, a smirk on his wet, lascivious lips.

"*Caro fratello,* with all his famous art and mechanical wizardry, your maestro is incapable of opening the door to the great minds of the ancients."

Giuliano, seeing Leonardo's dark anger, stepped back from the throne.

"Maestro Leonardo has opened countless doors in paintings and drawings, and all of Florence came to stare at them, besides other doors as military engineer for Cesare Borgia and the king of France, who wept before his *Last Supper.*"

"Enough! I'm late!" cried Leo, rising abruptly without help.

His attendants hastily wrapped him in a red velvet cape lined with white ermine, embroidered with his coat of arms, which bore five Medici balls and three French lilies. The matching hat with a jaunty pheasant's tail on his massive head would inform the faithful that this Vicar of Christ was on his way to kill innocent creatures of the forest.

Leonardo and his royal patron left in silence. In the San Damasus courtyard, two startled pigeons flew upward above their heads. Giuliano followed their flight.

"I heard you built a mechanical bird to fly."

"Several," said Leonardo. "None of them performed as expected, other than a bat-winged glider."

"You will fly farther one day," replied Giuliano, nodding toward the soaring birds. Then he added, "I'm ashamed of the way my brother spoke to you. He also does that to me, even though he loves me."

"You are brothers."

"*Caro Leonardo,* you and I are related in a more profound way. . . ."

The birds circled back toward them, and the young prince in magenta robes placed his arm around the older man with a long gray beard. Leonardo, with immense relief, embraced his friend and patron. Donato had been right about Leo. But he didn't know his brother. With the Magnificent Giuliano, anything would be possible in this golden age of Rome—including a painting of Saint John fused with Plato's virgin.

THE PONTINE MARSHES
AND THE BELVEDERE STUDIO

March 1514 – April 1515

To STUDY THE PONTINE MARSHES, Leonardo rode south with Melzi into the marshland. Amid craters of extant volcanoes, deep lakes, and swamps, he found rivers carrying mud and slime. This had resulted in creating coastal shoals, which hemmed in the marshes. On a detailed blue-and-sepia map, with place names inscribed by Melzi, he outlined his solution: The stagnant marshes would be filled with freshwater from small streams, then flushed into an enlarged and regulated Rio Martino river. Another river, the Livoli, would be diverted to carry this water onward to an artificial outlet into the sea.

Giuliano, who would own the reclaimed land, was delighted. Vatican engineers, however, blocked the project as "another hole in the water by the painter who couldn't move the Arno one inch"—thereby reserving it for themselves when the next Pope came along.

The arrogant dismissal by papal bureaucrats was followed by the death of Donato Bramante in mid-April. Leonardo had expected this, but it left him suddenly alone. A friend and remnant of past glory was gone. Only Giuliano Sangallo remained . . . and at seventy-one, he would soon follow. Then he shrugged it off. He was nine years younger.

At the Belvedere, he had been given two German workmen to assist in creating the parabolic mirror for the sun's energy. Besides this, he was assembling notes for a book on painting, *Trattato della pittura.* He had joined the Florentine Confraternity of San Giovanni and begun their *Saint John,* who would contain elements of Plato's virgin, as requested by Pope Leo. And at the San Spirito hospital, founded by Pope Sixtus, he had obtained a cadaver to explore the mycology of the mouth for a *Treatise on Speech,* together with the ramifications of the bronchial tree for Giuliano, who appeared to be suffering from consumption.

2.

At the Apostolic Palace, Giovanni Battista dell' Aquila, the Pope's privy chamberlain, led Leonardo to his office. He spoke with a Tuscan accent, and a picture of the Palazzo della Signoria hung next to a portrait of Pope Leo. So this was a Florentine, perhaps a trusted Medici relative among the gaggle of fortune-seekers around the sybaritic Pope.

He looked forward to meeting the Pope again. His *Treatise on Speech* would fascinate the humanist scholar, as would the secrets of plant life in the Belvedere gardens. Sap, in defiance of gravity, rose upward through its capillaries. For sunlight and moisture, leaves and buds were arranged in eleven different ways. Most of all, a sketch of his *Saint John* would redress the slanderous gossip that Leonardo da Vinci never finished anything.

"Illustrious Maestro. . ." The chamberlain paused to sigh and shake his head. "I regret the Holy Father is unable to see you today."

"There must be some mistake. Il Magnifico Giuliani said the Holy Father was anxious to see me. . . . Perhaps tomorrow?"

"I'm sorry"—there was dismissive flutter of yellow-white hands—"but it's not possible in these days. . . ." He glanced at the portfolio. "But the Holy Father is grateful for your gifts."

Leonardo resented this. He hadn't come with a ham or a cheap painting.

"Gifts they are not."

"Then what are they?"

"Sightings into unknown worlds."

"Rest assured, the Holy Father will personally explore your unknown worlds."

Leonardo had no option. Humiliated and furious, he later noted that he had left his portfolio on December 14, 1514. Before reaching the Pope, each note and drawing would be a subject of envy and ridicule. Unlike the Pontine Marshes project, however, these had a better chance with the humanist Medici—especially the *Saint John* sketch, which Giuliano believed would delight him.

3.

Two weeks later, three friars in brown robes from the San Giovanni congregation appeared at the studio.

"I'm the prior, Fra Giovanni," said the first one. "The Holy Father wants us to look at your painting of Saint John."

In the studio, the friars stared in wonder, uncertain of how to react. Instead of the traditionally ascetic, wasted desert prophet, they saw a young Greek god with a haunting, epicene face emerging from a timeless cavern of ambiguous shadows. Most shocking, he was completely nude, his private parts covered by the left leg crossing over the right knee. The right arm pointed to the prophetic cross of a river reed.

"This is San Giovanni?" asked the second friar, who was short and fat.

Leonardo nodded. "The prophet upon receiving the holy word, before going into the desert as the precursor of the Lord."

Prior Fra Giovanni sighed and shook his head. Leonardo repressed a smile. It was an old story . . . and exactly as Giuliano had predicted.

"We need a look of hunger," said the prior. "The later saint searching for souls."

"Also an animal skin," blurted the fat friar. "He's completely nude while holding the holy cross."

"That's scandalous," declared the prior. "We can never put this on our altar . . . or even allow it inside our convent."

Leonardo had heard enough. "The Holy Father asked for this. If you want something else, tell him about it, not me."

After they left, he decided, or at least hoped, the Pope would laugh and do nothing. No matter, there was a better way to portray this prophet and the mystery of his being—the face alone with a pointing hand emerging from the dark ground of faith. Melzi could finish that one, with the help of Lorenzo and Salai.

That evening, a desperate Giuliano unexpectedly appeared at the villa. An unwanted bride had been thrust upon him by Pope Leo—Princess Philiberta of Savoy, widow of the duke of Orléans and a cousin of King Louis XII, who wanted to use her for closer ties with Rome. So did Leo, in decreeing the marital alliance.

"It's a nightmare," Giuliano told Leonardo. "She has a humped back, a pinched face, an empty brain, and a squeaky voice. Why couldn't I get a fresh one like Louis got for himself?"

For a similar bonding with England, after the death of Anne of Brittany, the French king had convinced Henry VII to give him his lovely daughter, Mary Tudor, barely eighteen.

"Louis is old and worn out at fifty-two," he noted. Then with a laugh, he added, "In trying to satisfy his anxious virgin, he'll probably tumble into his grave."

Pale and racked by a troubling cough, the reluctant Medici departed Rome on a cold, gray morning in January. Leonardo was present to bid him

farewell, among a small gathering of friends who expected a French princess to enliven their lives, and join in Leo's plan to seize the crown of Naples.

Chilled to the bone, Leonardo returned to the Belvedere with a sense of impending disaster. It came three days later with the death of Louis XII, whom he had counted on in the event of losing Giuliano's support.

4.

Leonardo discovered he could no longer practice anatomy at Santo Spirito when Paolo, the gatekeeper, barred his entry.

"Dottore Stefanelli says the Holy Father forbids your coming here anymore," he said, referring to the hospital director.

"That's impossible. I have work to finish. It can't wait."

He had labored through the night on the corpse of a slave, found with knife wounds behind the Colonna Palace—a young Moroccan with the name Amir tattooed on his right shoulder.

"Paolo, listen to me. I have a dissected cadaver waiting in the mortuary."

"I'm sorry, Dottore, they got rid of it."

"Where? . . . Where is he?"

"I heard they dumped him into the Tiber with other surgical rubbish."

"Rubbish? *Per Dio,* those were remnants of the man's soul."

"They packed your knives and scissors in a box with some bottles of pickled human parts."

In compiling the *Treatise on Speech,* he had excised a tongue with its twenty-four muscles, six at its root with canine vessels, the movable palate of the epiglottis forming the vowels, veins nourishing arteries with vital spirit, nerves bringing sensation from the brain. . . .

"There's some mistake, Paolo. The Holy Father knows me personally. He respects my work and would never do this to me."

"They say you're doing witchcraft on corpses."

"That's ridiculous! Necromancy is the stuff of charlatans. Come on, Paolo, how can spirits speak without tongues? With no organic instrument, how can they create storms, darken the earth, turn men into cats, wolves, or other beasts? It's total nonsense."

Paolo's broad, pug-nosed face smiled with relief. "So it's not true?"

"Of course not. I'll tell Stefanelli myself."

"I'm sorry, Dottore. He says there's nothing to do. You have to talk to the Pope. . . . Where do you want us to send the box and bottles?"

"Never mind," Leonardo said, turning away. "I'll send for them."

Walking toward the Tiber, he had trouble breathing. One after another, his projects had been discarded or ridiculed. This was the final blow. Not even Giuliano could prevent hospital ridicule and laughter from his peers—especially Michelangelo, who would delight in every detail.

At the Ponte Sisto, he opened a notebook and wrote: "The Medici created me and destroyed me." He looked at the Tiber and imagined Amir being flushed through the hospital's underground conduit into its waters. A fir limb appeared, turning awkwardly as it struck an arch of the bridge. Then a child's shoe with blue and yellow ribbons came bobbing in the current. That made three victims of violence, three brief elements of time in the timeless current—the fir limb torn by winds from the slopes above Arezzo; the child, a possible victim of drowning; and Amir tumbling with his little companion in the deeper currents on their way to the sea.

He saw the Moroccan again, waiting for him on the gray marble slab—the gaping hollow of the sternum without heart or left lung, the slender body of youth, the beautiful face with golden fuzz on the upper lip, the brown loins with modest genitals and graceful legs—an insensate rendering of self to the knife cutting through flesh, muscle, and bone in the pursuit of life.

The Pope could never halt this by any edict. It was beyond him or any other mortal. An unknown slave with a tattooed name, found in the back alley of a Roman palazzo, would enter the immortal annals of medicine. Each organ, muscle, and nerve, at the moment of passing from cadaver into notes on human anatomy, defied death with redemptive sightings of life. And he, Leonardo, would be with another Amir, somewhere else beyond this city of papal corruption.

At the Belvedere, he watched the night descend on Rome, yellow street-lamps flickering like summer's first fireflies. A new world lay somewhere beyond those lights . . . waiting for him to finish his revised *Saint John* and edit his notebooks for publication. He recalled Andrea's counsel: *Remember, ragazzo, whenever you are lost, listen to your daemon. . . .*

He took a deep breath. There was no longer any doubt. All that remained was to find some way out of this Babylon of a Medici Pope.

THE VATICAN
THE BELVEDERE STUDIO

December 1515

I N MID-DECEMBER, Leonardo was at work on his *Deluge* drawings, when Giuliano suddenly appeared at the Belvedere.

"Look at this!" he exclaimed.

It was an embossed invitation in elegant script from Seigneur Florimond Robertet, the French secretary of state:

> Our Most Christian King, His Majesty, Francis I, requests the honor of the presence of Maestro Leonardo da Vinci, Most Excellent Engineer and Painter, to review matters of mutual interest. Following his peace agreement with Pope Leo X in Bologna, His Majesty has returned to Milan to celebrate Christmas where he would be pleased to encounter the esteemed creator of the Last Supper.

"There's your future," said the delighted Medici. "When he sees your *Last Supper*, he'll take you on as royal painter and engineer to the crown. . . ."

"I'm not leaving you . . . not even for a king."

"*Caro Nardo.*" He sighed. "I know how you feel, but—"

He broke off with a paroxysm of coughing. Phlegm came up, and he turned away to conceal it in a handkerchief. When he looked again at Leonardo, there was blood at the corner of his mouth.

"Forgive me," he said, embarrassed.

"How long has this been going on?"

Giuliano wiped his lip. "So you know how it is. . . . As God would have it, I was to sustain you, but now it is you who sustains me . . . as will the French king."

Leonardo felt the large arms around him, the beating heart against his own. Overwhelmed, he kissed him on the cheek. Giuliano did the same, a fleck of dried blood on his lower lip. Then he sighed and released his friend.

"Francis will be fortunate to have you and *Maria*. Tell him she was a mistress of mine. He'll still desire her, maybe even more. After that, *Maria* will speak to him in her own way. . . as long as she is not exposed to the religious fanaticism of another king or, worse, a repentant mistress."

KING FRANCIS

AND THE GREAT SEA

MILAN AND MARIGNANO

Fall, 1515

I N SEPTEMBER, KING FRANCIS and his mighty army of forty thousand
had descended on Italy like a wolf on the fold. They had come through
the Col de Larche, a narrow, dangerous mountain pass, rather than
through the two passes the Swiss had expected them to use. They then had
captured a surprised Roman general, Prospero Colonna, on the Piedmont
plane near Cuneo, while also outflanking the Swiss, who had been waiting for
their assault in the Susa Valley.

Driving onward, the French had scattered the combined forces of Milan,
Spain, and Emperor Maximilian in Pope Leo's defensive league. The
formidable Swiss mercenaries remained, however, and Francis tried to buy
them off. When this failed, he faced a major battle at Marignano that would
give him Milan—or drive him back to France.

Though he had just turned twenty-one, he was well prepared. Raised on
horseback from the age of six, he was tall, with a powerful body hardened by
sports, the hunt, jousts, and sham battles. For combat, he had trained his war
mount to turn and charge by leg command alone. This allowed him to fight
like the mythic centaur—a human torso joined to a horse—with both arms free
for the pinioned lance, the slashing saber, or bone-crushing *estoc*.

He had been king for barely nine months, but in that time he had
emerged from the petticoat government of his mother as a gifted ruler. Swift
of mind and a master of detail, he had surrounded himself with dedicated
ministers and loyal generals. Most important, he inspired his men by his ability
to both command and lead.

The formidable Swiss army, the first in Europe to march to music,
appeared on the horizon in a cloud of dust under a clear blue sky. Slowly they
came into view—a front line of skirmishers, followed by massed blocks of
pikemen—each block with seven thousand men in ranks of one hundred across
and ten deep. They wore half armor on chest and thighs, pot helmets, and

striped clothing with a white cross as a field sign. The blocks advanced in stepped echelons—one forward, the others farther back to guard its flanks and act as reserve. Their warrior-pastor, Cardinal Schinner, followed with two hundred papal horse and eight pieces of artillery.

Before them lay a deep drainage canal and France's first line of defense—seventy-four cannons with ten thousand infantry under the veteran warrior Charles de Bourbon. Behind him were ten thousand German mercenary landsknechts, with almost one thousand mounted men at arms. Farther back, a second block of nine thousand landsknechts waited on the command of Francis, accompanied by his gendarmerie—five companies of cavalry and foot troops commanded by French noblemen. Unaware that the decisive battle was under way, three hundred horse under Francis's brother-in-law, Charles d'Alencon, waited at nearby Lodi with their Venetian allies.

Nothing could match the ferocity of impoverished Swiss mountaineers charging with wild cries and eighteen-foot pikes pointing downward to better eviscerate the enemy. Wading through the canal-swamp and a barrage of arrows, they broke Bourbon's first line of defense, then plunged toward the artillery, which had failed to get their range.

Francis charged the Swiss flank with two hundred gendarmes. Seeing the white helmet plumes of their king, his troops rallied with cries of "*Pour la France!*" With equal fury, the veteran Bourbon led his infantry into the exposed flank, cutting down a reported five or six thousand. Their reserve landsknechts, in two blocks of fourteen thousand pikemen, charged into a massive slaughter, leaving thousands mutilated and dead on the field.

The sun was setting, but the two armies continued to skirmish under the moon until it vanished. In sudden darkness, the Swiss cornet was heard, followed by the French trumpet, indicating a night's rest. Camp attendants scurried forth in the dark to reassemble their exhausted troops—many having dropped wherever they were, among the dead and dying.

Francis had reached his limit. In thirty charges, he had lost his bodyguard, yet he'd continued to fight along with his mounted gendarmerie. His elegant armor had repelled direct pike thrusts and steel-tipped arrows from three-hundred-pound crossbows. His leg cuisse was blood-splattered, with bone and flesh fragments lodged in the crevices of the knee poleyns and foot sabatons. His helmet and shoulder pauldron had withstood crushing blows from a horseman's mace. A lance had struck the slit opening in his beaked visor, causing blood to flow from his left cheek onto his neck, flannel undershirt, and into a sticky armpit.

In the dark, he removed his helmet and felt the cheek wound. Mercifully, it was closed and superficial. He gave his horse to the equerry and asked for

water. His trumpeter brought some from the canal, but it was mixed with Swiss blood, and he vomited. Caked with sweat and bone-weary on the dark plain, he lowered himself onto a gun carriage and slept in full armor under a fleeting silver moon.

The Swiss reassembled before dawn, devoured food that Schinner had had sent from Milan, and renewed the battle, with three lateral blocks of pikemen advancing to engage the entire French line. Against the odds, the French fought on. They were about to collapse when cries of "*San Marco! San Marco!*" rang across the field. Charles d'Alencon and his Venetian cavalry had ridden through the night.

Francis wheeled his horse to meet his ally, his troops took renewed courage, and he led them into a combined counterattack. Four hours later, at eleven o'clock, the Swiss were forced to retreat.

"It was startling," noted one witness, "to see the routed Swiss return to Milan. One had lost an arm, another a leg, a third maimed by the cannon. They carried one another tenderly, like sinners in Dante's Ninth Circle of the Inferno."

"I've fought seventeen battles," declared Marshal Trivulzio. "They were but children's play compared to this battle of giants."

On the killing field, the dead lay under a blazing sun. Grave diggers counted more than 16,500—two Swiss for every Frenchman. French nobles were eviscerated, tagged, and wrapped in muslin for shipment back to France. All the others were dumped into huge ditches—former enemies in a blind brotherhood of death, lips and arms intermingling, the Cross of Lorraine upon the white cross of Switzerland.

THE VATICAN AND MILAN

FOLLOWING THE FRENCH VICTORY, Marino Giorgi, the Venetian ambassador, had appeared at the Vatican shortly after daybreak, demanding an immediate audience with Pope Leo. Serapica, his private chamberlain, shook his head.

"His Holiness is still in bed."

In fact, His Holiness had retired later than usual, after celebrating news of a French defeat in the first day of battle.

"Then wake him up," insisted the envoy. "I have other news for him."

"I regret, Your Excellency, it can't be done."

"You poor fool," replied the diplomat. "Your career will be finished when the Holy Father hears of this."

In the papal bedroom, Georgi found that the fat Holy Father was being dressed by two other chamberlains. Serapica sought to explain.

"Your Holiness—"

"Get out of here!" cried the Pope. Then he turned to the diplomat and said, "Are you mad, signore? What in God's name do you want at this hour?"

"Holy Father," replied Giorgi. "After the example of Christ, I return you good for bad. Yesterday, Your Holiness gave me bad news that was false. Today I bring you good news that is true. The French have routed the Swiss and seized Milan."

Leo was stunned. He sat on his bed, a middle-aged Holy Father in mortal exposure—naked to the waist, a scattering of red pimples on the folds of a turnip white stomach, gray-brown hair in wild disarray, tiny dark eyes wavering with fear.

"*Santo Dío!*" he cried. "What is to become of us?" Then, recalling the French humiliation of Alexander, he muttered to himself, "And what is to become of you?"

Two days later, Giorgi found the Roman pontiff was prepared for an abject submission to the French conquest.

"We will throw ourselves into the arms of the Most Christian King and beg his mercy."

The Venetian diplomat veiled his joy with a fervent reply.

"Most Holy Father, if you do so, it will be neither to your detriment nor to that of the Holy See. The king is a true son of the Church."

A treaty was quickly worked out in a flurry of diplomatic exchanges. A fortnight later, Lorenzo de' Medici, grandson of the Magnificent Lorenzo and son of Piero the Exile, rode to Milan with the deed of ratification. As an envoy of the Pope, he would meet the French king—one more step in Leo's plans to insinuate the Medici into French royalty. Giuliano had married a cousin of the king. This lightweight, arrogant nephew was next on the list . . . and eventually, Catherine de' Medici would also be useful in some way.

Francis accepted the treaty but insisted on meeting Pope Leo to discuss other matters. Rome was out of the question. So was Florence. Cardinal Giulio de' Medici, the future Pope Clement VII, had warned his cousin of lurking dangers among anti-Medici enemies. That left Bologna, at the beginning of December.

Leo accepted and, after a consistory of fifteen cardinals gave consent for him to meet the French king, he left for Bologna in late November with an ailing Giuliano and Leonardo in his entourage. In Florence, during a week of festivities for the Medici Pope, Giuliano was unable to continue to Bologna.

"Go on without me," he urged Leonardo. "Only you can bring me all the comedy . . . especially if at Mass, the Most Christian King serves as altar boy for a Holy Father who despises the French!"

2.

Leonardo arrived in Milan on December 18, expecting to meet King Francis at Santa Maria delle Grazie for a viewing of his *Last Supper*—an encounter arranged in Bologna by Florimond Robertet, who also honored him with a suite in the former Sforza castle.

The artist was early, fearing his disciples would be ghosts on a humid wall. *Grazie Dio,* they were still there. Indeed, the departing flakes had invested their anger, doubt, and wonder with greater urgency.

Francis entered suddenly with Robertet and went directly to the wall painting. For a few moments, he walked back and forth before the angry and incredulous disciples, as though facing an arrayed army, then finally halted and stared at Jesus.

This king, Leonardo realized, was but a youth. Tall and imperious, he had a warrior's physique and the regal air of a man long accustomed to power.

The face, under a blue velvet hat with white plumage, projected this duality—the narrow black beard, a bull neck straight as a granite pillar, and small, soft brown eyes with an exotic Oriental slant. A pencil-thin mustache curved down into the beard, encircling the small mouth above a square, virile chin. In the middle of this, an immense nose seemed to possess a separate existence—one of fierce pride from generations of warrior kings. With such a nose, men in battle saw a face that knew no fear. Women saw a knight Roland, and envisaged the length of another organ.

The monarch had knelt to cross himself before his Lord instituting the Eucharist.

"*Mon dieu, c'est ça,*" he murmured. "There they are, telling us how it began. Even then, it was war and peace."

Rising, he saw Robertet with Leonardo.

"So it is you . . . Maître Léonard de Vince?" asked the monarch in a softly accented Italian.

"Yes, Your Majesty."

"It's you who are majestic, monsieur. You rendered me humble, yet also free and filled with joy. How could you create these men—no, bring them back from a thousand years ago?"

Leonardo was amazed. The king of France had entered his painting and emerged humbled yet renewed. You could expect that from an older man, not a youth accustomed to spirited horses, jousting knights, and compliant women. Yet this one had also killed in battle, stared into eyes of the dying, known the stench of putrefying bodies, and those elegant white hands with jeweled rings had felt the warmth of human blood. Perhaps this had led him to what could not be inherited or seized by war. *How could you bring them back from a thousand years ago?* This man would surely intuit a similar return in *María.*

"*Mon cher maître,* you must come to France. Your presence will bring life to our court . . . to the endless round of my days."

Leonardo sighed. Here was the patron he had sought all his life—a king who could not be deposed by the Pope or petty Italian tyrants. Here was a last port of call to assemble thousands of notes and drawings into books, with royal archives to secure them for an eternity . . . together with *María.*

"I am honored, Your Majesty. As soon as I am free to leave Rome, if that would please you."

"As you wish." Francis turned to his secretary of state. "Florimond, make sure he comes to Amboise."

Before leaving Milan, Robertet reinstated Leonardo's Porta Vercellina estate with its vineyard, renewed his water rights in the San Cristoforo canal, and arranged for payments to be sent to his account at Santo Spirito in Florence.

3.

Following the death of Giuliano in Florence and Giuliano Sangallo in Rome, Leonardo departed for France with Melzi in late August of 1516. Salai would join them later, after building a home for his father on half of Leonardo's vineyard in Milan.

Planning never to return, the papal artist-engineer loaded all of his possessions onto an Amboise mule train sent by Robertet. Among them were his notebooks, totaling some thirteen thousand pages, and his paintings, including the *Virgin and Child with Saint Anne,* the rejected young *Saint John,* a second, unfinished version of the prophet, and a drawing of Saint Sebastian, which covered the *Maria*—destined for safekeeping with the king of France.

September 1506 — May 1519

WHILE CROSSING THE ALPS through the Montgenèvre Valley Pass, Leonardo and his companions were caught in a violent blizzard. Riding blindly into sleet-driven winds, the manes of their horses caked with ice, they eventually found refuge in a mountain inn.

Cold and soaking wet, they huddled before a blazing log fire, amid shouts of drunken Alpine muleteers and snarling dogs gnawing on bones from the table. After a meal of greasy mutton and sour wine, with onion stew and dark bread for Leonardo, they were given rooms in the attic—freezing chambers with only braziers of dying embers against winds whipping through the eaves.

In his sleep, Leonardo felt an oppressive weight upon his body. He struggled to throw it off, but it was too heavy. Then he saw himself as a baby again at Vinci, lying in a wicker basket of wild chicory. The black wings of an immense raven were suddenly over him, the bird's fluttering tail in his mouth. He listened for the sounds of his mother picking the greens nearby. Emerging from sleep, he heard the coughs and curses of muleteers in the courtyard, hitching up their wagons.

He opened his eyes. It was dawn. The room was freezing, and his right arm was still asleep. No, it was numb. *Perdio,* the hand was paralyzed! In a panic, he felt a numbness creeping through his body. Stop it, he thought. For the love of God, you know better. It's that arm again from the glider crash at Fiesole—except it's worse this time.

Now try to bend it.... Good, the biceps functioned. He sat up and shook his right hand like a rag. Nothing happened. Clearly, the anterior deltoid was affected. He bent the wrist, and the index finger trembled. No you don't, he thought. You're staying here with me ... all of you. He wiggled his toes and felt the right thigh. *Grazie Dio,* it was only the hand. The left arm could handle the paintings and notebooks in whatever time remained.

Besides, it would probably pass, as it had in Rome. This was more severe, however ... warnings of narrowing meseraic veins resulting from age. Death,

the Supreme Thief, would come that way—narrow veins blocking blood flow to every cell in the body. Was this in the dream of the black raven, those harbingers of death roosting on scaffolding prior to a lynching? No, *per Dio,* not yet.

He massaged the limp arm—an old friend, now a stranger who would betray him to a fluttering of courtiers in the court of King Francis. *Mon dieu! Did you see him? That Italian has arrived half-dead. He can't even use one hand. Has the king lost his mind? How can this creepy old man serve as painter, architect, and engineer of the realm?*

Somehow, it had to be disguised until he proved himself. Rising from the bed, he strode with fury across the cold floor. There, it could be done. In walking, the semiparalyzed arm swung in accord with the left. Also, if moved discreetly, the hand would appear normal. Rat-scurrying courtiers would never know the difference.

2.

King Francis received Leonardo with every honor. The famed Italian and his two companions—Melzi and Battista de Villanis, a new servant from Milan—were lodged in the royal manor of Clous, a short walk from the monarch's own residence in the Château d'Amboise.

Clous itself resembled a small château, with its redbrick facade, white sandstone borders, Gothic gable ends, delicate turrets, and steep slate roof. It stood on a slight rise, surrounded by gardens, a vineyard, a dovecote, sloping meadows, huge oak trees, a mill driven by a waterfall, and a winding stream flowing into the Loire. An underground tunnel linked the manor to the royal palace, providing cover during bad weather, as well as privacy of passage for royals and those seeking a discreet rendezvous at the manor.

A plump, pink-cheeked woman in a gaily quilted Provençal housedress opened its iron-studded wooden door.

"*Bonjour, Monsieur Maître,* I am Marie Mathurine, your serving madame."

She was Swiss Italian, *grazie Dio,* probably from Ticino.

"In Italian, 'Maria Maturina'?"

"*Sì, maestro!*" she laughed. "But Maturina is enough—there are too many Marias."

Leonardo entered the first of the manor's two wings. To his left was a small chapel decorated with a stone crown and three fleurs-de-lis of Charles VIII, together with Anne of Brittany's heraldic ermines. Farther on, a large hall for dining and visitors led to a kitchen with a terra-cotta floor, an immense fireplace, and huge crossbeams with iron rings for hams and wild game.

A spiral staircase in the central tower led to an upper landing with a large room over the dining hall, which could be a studio. Beyond this, above

the kitchen, he entered the master bedroom, which had chestnut ceiling beams, a large fireplace of carved stone, and wall tapestries of royal hunts. In the midst of the room stood an immense bed. Its four spiraling oak posters supported a gold baldachin with a swirling canopy of sea blue velvet embroidered with golden lilies—a ritual curtain for the erotic tumbling of French royalty. Leonardo stroked the velvet. This blue sea of wave-tossed golden lilies would probably envelope his last thoughts and dreams.

At the window, he saw the Château d'Amboise on a higher slope. Under drifting white clouds, its red battlement towers and ramparts overlooked the slow, shimmering waters of the Loire. The soft light of Touraine with its translucent shadows reminded him of autumn in Tuscany. For a moment, alone in the ornate room where he expected to die, he felt profoundly alone, overwhemed by nostalgia for Florence and the lost years of his youth.

Melzi and Battista arrived to hang *Maria* between the window and fireplace. From his bed, he would see her bathed in reflected daylight. At night, flames of the adjacent fireplace would play upon her, and in their flickering light, Albi would be with him during the dark hours.

"*Mon Dieu*, who is she?"

It was Francis, dressed for the hunt in a short green cape. A pheasant tail sprouted from a cap with a golden brooch of the royal crown. After a brief nod, he approached the painting with hesitant half steps.

"*Mon Dieu*," he said again in a whisper.

He moved to the left, then to the right, as though seeking some answer in the portrait's cascading waters of the distant mountain. Finally, he turned to Leonardo.

"Who is this woman?"

"A former mistress of my late patron, Giuliano de' Medici."

"A mistress only . . . Who was it?"

"A noble lady whose honor cannot be questioned."

Francis looked at the portrait, and Leonardo realized he sensed it was more than a mistress. This warrior king possessed incredible intuition. In Milan, he had entered the ambiguous drama of the *Last Supper*. Now it was the shadowed interior of *Maria*.

"Those eyes, that mouth . . . how old is she?"

"In her mid-thirties."

"This woman has known men, but she's not a mistress. In battle, fallen men call to their mothers, not to wives or lovers. You hear them calling, '*Bonne mère, bonne mère!*' Do you know why this is?"

Leonardo waited, fascinated.

"It's not only fear of dying, or a warhorse smashing their bowels and brains. They're asking their mothers, 'You, who gave me birth, tell me, is this really the end?'"

He turned back to the painting.

"This *bonne mère* would know what to tell them. . . . I must have her."

Giuliano had foreseen this. Leonardo had hoped to face it later, when he had the king's confidence.

"How much do you want, maestro? The price is not to divide us."

Divide us . . . There was no choice, other than delay.

"I ask no price, Your Majesty. She is yours. You have entered and understood her. She will come to you when my time comes . . . when I go into the Great Sea."

Francis frowned, puzzled by the Tuscan adage. Then he grasped it and appeared to be deeply moved. This Florentine of infinite wisdom was able to foresee his own death in tides of a Great Sea.

"Thank you, *mon cher Léonard,* I share your desire and will honor it. . . ." He smiled. "Now you must tell me who she is, other than a Medici mistress."

Giuliani had also warned against this. A fanatically religious queen or jealous mistress might fear this woman and destroy her. Did Francis also realize this? In those chestnut eyes with the amber-yellow of a lion, there was an animal instinct, an awareness of unseen dangers while hunting or on the battlefield. They had seen the souls of men dying in combat . . . and somehow had entered the interior of *Maria.*

"You hesitate, monsieur? I trust the need to protect this noble lady does not cast doubt on my discretion."

The eyes narrowed with a flicker of anger. Eventually, this monarch would have to be told the truth. For now, however, there was only one reply.

"I submit to Your Majesty. . . . She was Monna Lisa di Gherardini, wife of Francesco del Giocondo, a wealthy and noble Florentine." He paused. "I eventually saw her in the way you see here."

Francis studied the woman with the body of Lisa di Gherardini, whose five-month pregnancy had been sketched in detail. Then he nodded, as though he had heard from her.

"*Cher maître,* we know this creature, this fascinating Monna Lisa, will bind our friendship." He smiled and took his protégé's right arm.

"What happened to your hand?"

"A slight matter, Your Majesty. It will pass, as it has before. Besides, I am left-handed. . . ." He pumped his left arm, crunching its fingers. "This is the creative wing!"

Francis smiled, relieved. "I must see other paintings from that remarkable hand. But first, come to Amboise tomorrow. I have something to show you."

3.

The Château d'Amboise surprised Leonardo. Passing through the entrance tower of the medieval bastion, with its siege turrets and fierce embattlements, he entered the private world of the French kings—only to encounter Italian art and architecture at every turn. Gothic turrets with pointed ogive windows, gabled portals, and dark cornices had given way to Italian facades with stone foliage, rectangular windows, and broad doorways with lyrical bas-reliefs. Even Pope Leo's architect, Fra Giocondo da Verona, was there—his fat, bearded face surveying Italian triumphs from the keystone of a lofty arch. Then Leonardo heard the voice of a tall, thin Tuscan.

"Madonna! I didn't say you had no soul. I said it's your *maladetto* glass. Look into it and there's nothing there."

A white-haired mason paused with fury, holding a panel of leaded glass for the castle church of Saint Florentin.

"Your stone's as dead as your ass!" he shouted in Venetian dialect. "In freezing weather, you sit on it and feel nothing."

The Tuscan laughed. "Stone has a buried soul, unlike your empty glass. . . . As for assholes, I never suspected you liked to feel things with yours."

Leonardo approached, bidding them *Buongiorno.* The Tuscan, ignoring a flow of Venetian curses, spoke to the elegant signore in a fur-trimmed red cloak.

"*Dottore!* Have you ever heard of glass containing the life one finds in stone?"

Leonardo smiled, delighted. Michelangelo's boast of liberating life buried in stone was a common belief among Tuscan stonemasons.

"*Sì, signore,*" he replied. "You speak from a truth in your hands. Glass, made by mortals, is finite. Stone, from immortal nature, is infinite. . . . Tell me, how do you both happen to be here?"

"*Re* Carlos," replied the Tuscan, grinning in triumph.

"*Re* Luigi was better," grumbled the Venetian. "From Italy, he brought more of us with our families."

"Francesco's an Italian prince," declared the Tuscan. "With him, we have perfumers, jewelers, velvet weavers, chicken breeders, gardeners, and even a crazy Neapolitan with parrots."

At the castle, Francis was amused by the stonemason story.

"We conquered Italy three times, only to have you Italians take the field with your art and way of life. . . ." He paused, smiling. "The living stones of that Tuscan are why you are here today."

Turning to large map of France on a table, he pointed to a small town near the river Sauldre.

"This is Romorantin, the exact center of France. I want a château there—to include my court and my mother, Louise of Savoy. How do you see it . . . or do you need more time?"

Leonardo sought to remain calm. "*Mon liège,* I see it before me now."

He began with hasty sketches and concepts from a thousand interrupted dreams. The château would be spacious, but above all a comfortable dwelling with broad Italian steps, a spacious frontal piazza, and large inner courtyard for assembling troops and festive processions.

Flying galleries would connect its wings and join its keep, the château's inner stronghold, with an open double-spiral staircase for critical visibility of two-way traffic from floor to roof. A grand room for balls or royal ceremonies would be on the ground floor to ensure against a floor collapse "bringing numbers of dead." Wooden beams and wall supports would be "encased in bricks in event of fire."

Water was to flow everywhere—through toilets and baths, fountains, pavilions, exotic gardens, murmuring rivulets, with an aviary for birdsong, a lake for aquatic spectacles and for knights to fight from boats. . . .

"A joust on water!" exclaimed Francis. "Incredible . . . and toilets without odors."

The young king was fastidious about his personal hygiene, living quarters, and bed linens. Disgusted with courtiers who blew their noses through their fingers, he had decreed the use of handkerchiefs. He was also outraged by Italian travelers reporting the stench of the French court, especially an envoy of Isabella d'Este claiming French ladies were "rather filthy, having a little itch on their hands and other deposits of filth." There had to be a new mode of living similar to the Italians', to properly reflect a civilized France.

Leonardo's concepts raced on. Satellite suburbs of the ideal city, conceived for the Moor, would encircle the château. A network of rivers and waterways would spread to the rest of France, link the royal châteaux of Romorantin, Blois, and Amboise, enrich the countryside, while river barges would bypass muddy roads and icy winds in winter and relieve the scorching heat of summer.

He looked up at Francis. "Perhaps the living heart of your New France?"

"As you will be in mine," replied the king gallantly, overwhelmed by the emergence of his dream into a visible reality.

Leonardo left Amboise, delighted to have secured his services for a remarkable king and patron. Everything was in its place. In the sky, three cumulus congestus clouds prefigured the central and flanking towers of his château.

At that moment, on the steep hill path down to Clous, he tripped on a rock. Unable to grab the guardrail with his right hand, he fell onto stone steps—a brutal fall on his left side and head. He lay with his nose at the edge of a stone, blood thumping in his ears, acute pain at his temple, left hand, and elbow. He rolled over and felt his head and face. There was no blood. He lifted the arm. The wrist was scraped badly. *Grazie Dío,* nothing was broken . . . yet this was a warning.

You'll never make it, he thought. The grand château, the ideal city, the waterways through France . . . you'll never live to see them finished.

An ant crawled over his hand—a large black formicine, carrying a white egg twice its size. He had fallen in its path, yet it carried on, climbing over him. With a sigh, he spoke to his château towers in the blue sky of Touraine . . . and to the departing ant.

"I can go on," he said, rising to continue his descent.

4.

Leonardo did go on, driving himself into the last creative period of his life with the sudden brilliance of a setting sun. At Romorantin with Melzi, he projected a town plan centuries before its time. To supply it with water, he would channel the Loire into its tributary, the Beuvron, then into the Sauldre near Romorantin.

"If the flow of the Loire was turned into the river of Romorantin, the waters would fatten the land . . . render the country fertile, supply food to the inhabitants, and make navigable a channel for merchant shipping," he wrote.

There would be movable floodgates, "as I conceived in Friuli," to increase the current, deepen and clean the riverbed, prevent flooding, and empower mills along its banks. A weir would send turbid water toward the mills, with clearer mid-current water destined for Romorantin.

Yet where the rivers of Touraine would bring prosperity, those of Sologne, its neighboring province, had brought disaster. Floods wiped out crops and human lives. Marshlands with pestilent vapors spread disease among peasants living in squalor. Overwhelmed by the misery of Sologne, he decided to drain its marshland, as he had envisaged for Cesare Borgia at Piombino and for Pope Leo in the malaria-infested Pontine swamps.

5.

Increasingly drawn to his artist-engineer, Francis began to appear frequently at Clous. He would emerge from the castle tunnel without notice, a young king in search of an old master's insights into unconquered worlds of the mind—encounters he compared to those of Alexander with Aristotle.

Leonardo accepted this gracefully, though it consumed precious time needed to finish the alternate *Saint John,* along with *Saint Anne, Leda* . . . and, *santo Dio!* somehow assemble and edit the notebooks. Each time, Francis invariably sought the woman he knew as Monna Lisa.

He would sit on Leonardo's bed, staring at her in silence. Sometimes, his lips moved—as, no doubt, had those of his hero, Alexander, upon encountering the Ilian Athena at Troy. After a few minutes, he would rise with a sigh, briefly at ease. Then he began to find himself or relatives in other paintings, beginning with Saint Anne in the *Virgin and Child with Saint Anne.*

"Louis wanted this *Saint Anne* for his own Anne of Brittany. Did they send you her portrait?"

"No, Your Majesty."

The young king shook his head. "She was heavier than this . . . but still, it's like my wife's mother. How can you paint people you have never seen?"

"It happens in doing it."

"Where does that come from, maestro?"

"It's there, waiting for you. In battle, doesn't that happen to you?"

"*Mon Dieu!* . . . You even know that."

A large drawing of *Leda and the Swan,* with a pair of twins bursting from their eggs, delighted him.

"Incredible . . . animal lust for a woman has no limits. I can see them doing it. . . ." He broke into laughter. "But not how she lays those enormous eggs with bouncing bastards!"

"Royal ones," suggested Leonardo. "Helen of Troy and Clytemnestra, together with Castor and Pollux. Has Your Majesty noted that such offspring are often quite intelligent and brave?"

Francis smiled, apparently aware of the intent.

"*Cher Léonard,* you are not alone. Some of our greatest warriors and kings have been of natural birth."

When the two *Saint Johns* appeared, however, the royal visitor shook his head.

"That's the Baptist?" he asked, nodding toward the first version of the young saint seated on a rock.

"Pope Leo wanted a humanist Saint John, which he believed to exist in Plato. This was for some monks, who refused it as being too well fed."

"The fools!" Francis laughed. "He had to begin somewhere before going into the desert." He turned to the second version, which showed only the saint's face, with a crossing arm and pointing finger. "And this enigmatic creature is the same Baptist?"

"In the first one, he knows what's coming. In this one, he has seen the Lord and baptized him in the Jordan."

"They are both pointing upward."

"There are no words for the unexplainable."

"Their faces are also strange. . . . This one could be a man or a woman."

There was another smile, as though Francis knew this, as well. Good, Leonardo thought. It was the moment to see how the king felt about it.

"Sire, have you not seen a woman's face and felt she had been inside of you, waiting for your arrival?"

Francis frowned, undecided. "Perhaps, but how can that be?"

"The Greeks believed that man and woman were once united into a single being, but then split apart. Ever since, they have sought the lost half of themselves. Do you not feel this return when you hold a woman in your arms?"

"*Cher Léonard!* More than painter or engineer, you are the first philosopher of my realm! . . . But let's move on. I've heard you created for the duke of Milan a theatrical Paradise, with planets moving across the sky. Could you produce such a spectacle for my court?"

Leonardo hesitated. There were the unfinished paintings and dozens of notebooks with strings of different colors, which Melzi had inserted to help in collating them, and every morning it was harder to get out of bed. Didn't this simpatico king realize what he was asking? To find the artisans, assemble the material, and create machinery for another *Paradiso* would take at least four months. Francis waved a hand of sparkling jewels to dismiss any such thoughts.

"You can use the carriage workshop at the château. Guido, an Italian from Alexandria, can make anything, even a viola da gamba as good as those of Brescia. And our royal carpenter, Domenico da Cortona, can build a castle overnight."

"May I know the occasion for this *Paradiso*?"

"We will celebrate the baptism of my son, Francis, the dauphin, and the marriage of the Pope's nephew, Lorenzo de' Medici, to my Bourbon cousin, Madeleine de Boulogne." He smiled. "Your Medici Pope seems to think his seed is more potent than any treaty or conclave of cardinals."

Leonardo laughed, delighted. "No wonder Your Majesty is popular. You lower your standard to no one, not even the Pope, though you accept this?"

"As foreign policy, I celebrate this marriage of the Pope's nephew, though my nobles despise him as a Medici knave who boasts of conquests, without losing a single man or drop of blood. The Pope made him duke of Urbino, but he'll never hold on to it. . . . He's but a little merchant."

Leonardo took a deep breath. This would be the last one, the last big show of his life, created with the bitter reality of an exile. All that he had learned in his native land, all that he treasured from the historic flowering of Italian science, art, and letters, would now be used to honor a French king.

"Your Majesty, if it so pleases you, I will produce my *Paradiso* and help create a festival to surpass anything ever seen by the Moor or any court of Europe."

6.

Early one morning shortly after sunrise, Leonardo climbed the hill to inspect his triumphal arch for the festival celebrating the baptism of the dauphin as royal heir, and the marriage of Lorenzo de' Medici to the cousin of the king.

Melzi met him as he arrived. "Good morning, sire! How does it look?"

"Incredible, you managed to do it."

The youth had worked through the night with Domenico da Cortona to finish the festival gateway. He looked with pride at the structure as workmen cleared away its debris. Made of wood to resemble stone with painted images, it rose in triumph before the château. In the center, a naked youth held lilies and a dolphin—symbols of France and the royal dauphin. To the right, King Francis appeared in regal attire with his salamander emblem: *I Nourish the Good and Extinguish the Bad.* Queen Claude was opposite, in a chaste blue gown embroidered with her ermine device: *Death Before Dishonor.*

"It's like an Easter carnival," replied Melzi with mixed pride and joy.

Leonardo nodded, pleased. "Aristotle, in his *Poetics,* says the fearsome and piteous, arising in a spectacle, must leave a poetic wonder in the onlooker— which is just what we need for those entering here."

That evening, there was great excitement in the village of Amboise. Young Lorenzo de' Medici had arrived for the royal christening and his marriage to Madeleine de la Tour d'Auvergne. Accompanied by the papal legate, Cardinal Bernardo Bibbiena, and an immense train of attendants in crimson robes, he brought numerous gifts from his uncle, Pope Leo.

Among them were thirty-six Arabian horses, four religious paintings by Raphael and Giulio Romano . . . and an exquisite nuptial bed made of tortoiseshell and inlaid with mother-of-pearl and precious stones. The bed

astonished the French court. As could be expected, Francis laughed. The Medici Pope was exporting not only his seed but also a rather fancy vehicle for its planting.

Leonardo installed a canopy of lilies and white roses before the portal of Saint Florentin. Above it, the bride's Cross of Lorraine lay upon a floral shield with the Medici balls for the wedding. Cardinal Bibbiena imparted the Pope's blessings, attended by King Francis and his nobles, while a clutch of ladies lamented the fate of the bride, noting that those pockmarks on the groom's face were a hideous proof of an advanced case of syphilis.

The festival began with a tournament. From pavilions around the square, courtiers and noble ladies delighted in the prowess and bravery of their favorite knights sheathed in glistening armor. At the blast of a horn, they charged with muffled cries and a thunder of hooves, their oncoming adversary visible across the tilt barrier through a small slit in the helmet—a lethal opening that, at the instant of contact, had to be lowered against a lance's skull-piercing entry. In the sharp clash of steel, there was variously the crack of a broken lance, the thud of a falling body encased in armor, or a horn blast to repeat the charge.

For comic relief during an interval, Leonardo sent two clowns riding donkeys onto the noble field of knights. Wearing armor made of pots and pans, with toilet bowls for helmets, they bore thornbush poles used by chimney sweeps. Exchanging delightful insults, they whipped their donkeys into a trot with a clattering of pots and pans. As they clashed, the head of one clown popped off on a spring, his chamber pot crashed, and his donkey with headless rider ran in wild circles until whacks on its rear by the other clown drove it from the field—amid howls of laughter.

In the next joust, the crowd gasped when a young knight flew off his saddle, unaware that he had been mortally wounded from a spear piercing his helmet gorget and throat. Then they stared in awe at the huge figure of Francis entering the field in bright gilt armor, a cloud of black feathers hovering on his helmet. Charging with fury and strength, the warrior king splintered immense lances and toppled the most formidable of his knights, to emerge as victor in the "finest tournament ever held in France or in all of Christendom."

7.

On his return to Clous, Leonardo tripped again on the stone steps. Melzi caught him as he was falling.

"Hold on!" cried the youth. "Are you all right?"

He wasn't all right. His right leg had buckled, and his right hand could no longer hold anything. Earlier at the château, he had dropped a piece of

bread held in this hand. This was disgusting. So was eating with the hands. Small knives and forks would free them of grease and the smell of food. . . .

"I don't like this," said Melzi. "It's your leg again, isn't it?"

"It's everything," he said, furious and unwilling to talk about it. "I live in two exiles . . . in France and in the mind of its king."

Leonardo was tired and depressed. As they entered the manor, Melzi tried to help him.

"King Francis respects you," he said. "I think he even loves you."

"He lives for combat. I live in another world, one that intrigues him, but never long enough for him to enter into it."

"Even so," insisted Melzi, "if you ever need him, I'm sure he'll be there to help, whatever it is."

"I don't know . . . but thank you," he replied, embracing the youth before retiring to his bedroom.

Maria was waiting for him, but he wasn't ready for her. Once in bed, however, he glanced across the room. In the reflected light of the setting sun, her eyes spoke to him of another world, one that awaited him far beyond this land of exile. Sooner or later, you entered its cosmic flow . . . and you went alone.

Perdío, he wasn't ready for any off it. *Saint John, Leda,* and the notebooks had to be finished. Nor was *Maria* ready. If Francis discovered her identity, she risked being destroyed. If not, she would enter history under a false name. There had to be a solution for this.

He looked again at her portrait. The sunlight was gone, and in the penumbra her eyes spoke no more. There was only the buried smile—Albi waiting for some word from him.

8.

In the lingering shadows of twilight, the king's guests left the Château d'Amboise to attend their last spectacle at the Clous manor, where the king had lodged his Italian painter and engineer, Léonardo de Vince. In the warm May evening, almost everyone avoided the tunnel passage, preferring to descend the stone steps, which were lit by burning torches. Along the way, they buzzed with excitement. This was supposed to be a spectacular show. That man from Vinci was a genius . . . but how could anyone produce a court spectacle in that little manor of Clous?

They were startled to enter a great ballroom with twinkling stars and planets in a nighttime sky. A young Milanese, Galeazzo Visconti, sent a breathless report of the evening to the insatiable Isabella d'Este in Mantua.

The entire courtyard was canopied in sheets of sky-blue cloth, with stars in the likeness of the heavens, and then there were the principal planets, with the sun on one side and the moon on the other. It was a wonderful sight, with Mars and Jupiter in their proper order, and the twelve celestial signs. There must have been four hundred burning torches, so it seemed that night had been chased away. . . .

The guests remained for a magician's performance during a regal dinner, followed by music and dancing until early morning. As they left, Francis paused to thank Leonardo.

"The festival was splendid, especially your *piece de paradis.* Once again, you have been the architect of my dreams. I am most grateful, *cher Léonard.*"

"I am grateful to you, sire."

The monarch took his friend's right arm. "*Mon ami,* you seem very tired. We leave for Blois and Paris tomorrow. But if you need me, send your gentleman Melzi to the palace, and they will find me."

Melzi had predicted this, and there it was in his eyes, and the feel of his hand. *So he really wants to be with me . . . not for Maria, but for me alone.*

"Your Majesty. . ."

His voice broke. Unable to continue, he bent over to kiss the ringed hand. Francis pulled him up into an embrace.

"*Mon père.*" He sighed. "I'll be here for you."

9.

Once again, Leonardo could hear the murmur of waters in the Amasse and the flush of ringdove wings. The king was gone, the workmen had left, and he turned to his notebooks as one would to a long-absent friend.

Some of the entries were useless variations of earlier ones. Others were discarded concepts. Still others were totally unfamiliar. He could not recall writing them, nor the thoughts that had led to their formulation. The *Deluge* drawings were especially surprising. He read them with growing wonder at the fright and terror of human beings swept away in the raging waters.

> . . . darkness, wind, tempest at sea, floods of water, forests on fire, rain, bolts from heaven, earthquakes and the collapse of mountains, overthrow of cities . . . lightning from the clouds illuminating everything . . .

In the margin, he had sketched rocks raining down from the sky, violent whirlpools, foaming waves crashing against city walls. His notes raced on across a desolate wasteland of death and destruction.

> The fields covered with waters strewn with tables, bedsteads, boats and other contrivances made from necessity and the fear of death, to which clung men and women with their children amid sounds of lamentation and weeping . . . the winds, with their tempestuous violence, rolling over the bodies of the drowned, killing those in whom any life remained . . .

The next entry contained scenes with the *terribilità* of Dante's *Inferno*, Michelangelo's *Last Judgment*, or Paolo Uccello's *Deluge* with its floating corpses at Santa Maria Novella.

> Others, not content with shutting their eyes, laid their hands, one over the other, that they might not see the cruel slaughter of the human race at the hand of God. . . . Others, without hope of enduring such suffering . . . flung themselves from lofty rocks, others strangled themselves with their own hands, and others seized their own children and violently slew them with one blow. . . .
>
> Ah, how many mothers wept over their drowned sons, holding them upon their knees. . . . Others with clasped hands and clenched fingers gnawed them until they bled . . . birds, finding no land not occupied by living beings, began to settle on dead bodies of men and animals . . . above these judgments the air was covered with dark clouds pierced by forked flashes of raging bolts from heaven . . .

Franco Melzi sat at an adjacent table with five stacks of notebooks and bound folio quires to collate the material. It was an awesome task—pursuit of a lifetime into every subject known to mankind, extended across some thirteen thousand pages in notebooks of all sizes. Struggling to obtain order, Franco had divided the cosmic outpouring into categories: Painting and Sculpture, Architecture, Mathematics, Medicine and Anatomy, Zoology, Botany, Physiology, Optics, Astronomy, Geology, Geography, Flight, Hydraulics, Water, Naval Warfare, Mechanics, Movement, Weight, Ballistics, Acoustics, Musical Instruments, Philosophy, Maxims, Prophecies, Personal Records.

"Where do you put *Deluge*?" he asked. "In 'Water' or 'Geology'?"

"In 'Water,' Book 15, on 'Things Consumed by Water.'"

"Why not a folio on religion?"

"This deluge is prior to a rebirth of mankind. With or without Noah, it was destined to occur."

"By the will of God?"

"By the will of nature created by God. As in Saint John, the seed must die to bring forth new life. Similarly, the earth, in its desire for constant renewal, seeks to lose its life for a return beyond fire or flood."

"Including the disorder of chaos?"

"Franco, you haven't understood. There is order in chaos, governed by its own internal laws."

"Where do you see that?"

"The twisting power within its vortex contains a self-regenerating force."

"Is that occurring here?"

The youth pointed in jest to a pen and ink drawing over black chalk on coarse brown paper—a volcanic crater in cross section, as in Dante's *Inferno*, with a tempest descending onto numerous skeletons rising from their graves.

"Are they going to outrun the flood?"

Leonardo smiled. He enjoyed Franco's delight and wonder in the labyrinths of the *imaginative*.

"Like the earth, we experience constant destruction and rebirth. Our spent blood, blue with death, returns to the vortex furnace of our heart for new life while our lungs expel its noxious vapors."

"How do you know this?"

"Simply go backward. Nature commences with reason and ends in experience. We commence with experience to investigate the reasons."

"To the origin of life?"

"As it emerges from the seed."

That night, Leonardo awoke from a dream. He was lost within an immense seed that was dying, with endless corridors collapsing around him. He called for help and heard distant laughter, then a ghostly voice: *He wants out, the poor fool . . . before he finds the origin of life.*

He sat up, shaken and uncertain. He knew the origin of life perfectly well . . . or did he really? How did life actually begin within a seed? Just what seeded the seed? He recalled a homology between a plant's seed and the human uterus . . . but where was it?

He took the bed lamp and returned to his study. Franco had set it up brilliantly. Each notebook had a provisional number, with numbered pages for one or another subject in its relevant folio. Inside the one marked "Botany," he found extensive notes on trees and plants, then the note on the seed's anatomy.

All seeds have an umbilical cord, which breaks when the seed is mature. And in like manner, they have a womb and secundines, as is seen in all seeds which grow in pods. But those growing in shells, such as hazelnuts, pistachios, and the like, have a long umbilical cord, which shows itself in their infancy. . . .

So it wasn't there. He had not sought the primal origin of life in the seed. This was extraordinary. Turning the pages on Embryology in the "Anatomy" folio, he found countless drawings and notes made at Santa Maria Novella on the origin of human birth. Yet even here he had failed. There were drawings and notes on sexual arousal, the act of coitus, the seed's injection into the female, her uterus laid open to reveal its curled-up embryo—but nothing on the primary causation of birth, other than a duality of sexes in the cotyledons.

. . . as fingers of the hand, one in the interval of the other . . . so the fleshy villi of these little sponges (cotyledons) are interwoven, like burrs, one half within the other . . . At birth, the sexes divide: One half goes with the foetus when it is born with its coverings. . . . The other half remains with the uterus.

There it was in detail—the first formation of a child in the uterus. Yet here again, this lacked the etiology of life at its nuclear core. What happened as the seed's corridors collapsed and birth emerged from death? What informed one seed to produce wheat, another a rose, and still another a human being? And once under way, there had to be a program that instructed cells to make an ear, a nose, or a strand of hair.

Therein lay the primal, unseen dynamic of existence—a biological template with the protoself of every living thing on earth. It was at the heart of nature and had been there since the beginning of time. This had to be located and defined by experiments and mathematics.

Yet was that possible? None of the Greeks or Arabs had described it. Wherever it lay, this contained the protoself, which he and Albi had fused into the portrait of a pregnant woman after the death of her son. In Masaccio and Donatello, it had made their work immortal. And it was surely present, hovering within the corpse of Mantegna's *Cristo Scurto*.

He returned to his bed and looked across the room at *Maria*. In the dawn light from the window, he could barely see her. The lighter parts were visible—the face, the first slope of her bosom, and the folded hands.

"I know it's also there in you, but I haven't found it yet."

He mumbled good night and fell asleep.

10.

One morning in late March of 1519, he sat with Franco on the banks of the Loire, designing a dam and watermill for Clous. Storm clouds appeared with gusts of wind, and Franco looked at the sky.

"It's going to rain," he said. "We should go before it's too late."

"Not yet," Leonardo replied, designing a weir for the mill.

The first drops came, followed by a sudden downpour with a cold wind. They hurried up the hill to the manor but arrived soaking wet. Leonardo was shivering, and water dripped from his gray beard. Maturina took him in hand.

"Come, sit by the fire," she ordered.

She brought hot broth and wrapped a blanket over his bent shoulders.

"When that's inside you, get into bed."

A cold developed that went to his lungs. The following day, he began to cough, bringing up dark brown mucus while gasping for air. With this, the arm paralysis extended to his right leg. He was losing control, but he refused to give up.

Shortly after Easter, he knocked over a glass of red wine, which Maturina had insisted he take with hot chestnuts.

"It was the wrong glass," she said to relieve his discomfort and anger.

Franco, however, was alarmed. The eyes of an eagle were gone. The next morning, Leonardo rose from bed for the royal notary. He was waiting before the fireplace, his long gray beard on the fur-trimmed scarlet robe of the royal court, when Maturina rushed into the bedroom.

"That notary is here with a cartload of priests and Franciscans," she gasped. "Franco and Battista won't let them in."

This was alarming. The priests may have come to discuss the funeral. But Franciscans . . . had they heard of *María*?

"Maturina, take that painting off the wall and put it in the alcove among my clothes."

"Our Lady . . . why?" she asked.

What did that mean? *Our Lady* . . . Had Franco told her about it?

"Do it . . . immediately, please."

As she emerged from the alcove, Monsieur Guillaume Borian, the royal notary, stormed into the bedroom in his maroon robe with golden tassels.

"Signore! Your idiot assistant refuses to admit witnesses needed for this closure. He's blocking them at the doorway like thieves."

He laughed, and the notary darkened with rage.

"You should know, monsieur, that one Franciscan, Padre Michel, has confessed our lord, the Most Christian King."

This was beginning badly . . . priests and Franciscans on the doorstep, and a notary with a hooked nose, cold gray eyes, and the mean spirit of another Ser Piero.

"Unlike the king," replied Leonardo, "I don't need confession at this moment. . . . Why are the Franciscans here?"

"As witnesses and mendicants of Saint Francis, they accept gifts as an expression of faith in the final hour."

"Where are the documents you have prepared for me?"

From a worn leather case, the notary gave Leonardo da Vinci his last will and testament, written in ink on luminous parchment.

"We have followed your instructions, but I can do nothing without the witnesses."

Franco appeared, shaking his head. Leonardo nodded. There was no choice. This could result in a scandal at court and embarrass King Francis.

"Va bene . . . let the pious horde come up, and give me a pen to end this nonsense."

He signed his will—April 23, 1519, eight days into his sixty-eighth year—in the presence of seven witnesses: Francesco Melzi, Battista de Villanis, two priests, and three Franciscans.

As a protégé of a Christian king, Leonardo had no choice but to follow the socioreligious conventions of the time. It is inconceivable, however, that in his last hours this heroic mind would abandon the beliefs of a lifetime. Nature was the daughter of God . . . and he, Leonardo, was God's grandson. He feared death, as any man, but primarily as a Thief, robbing him of precious time at the onset of his last journey into the headwaters of creation, to find the primal, biological template governing every form of life.

II.

There was a loud baying of hounds and shouts from their handlers. Then Franco ran into the room, waving his hand in a farewell gesture, which usually meant that good news had arrived.

"The king is here with all his hounds! Does he expect you to join the hunt?"

Leonardo sought to rouse himself. He had dozed off again, as he did frequently. Maturina helped him to sit up, combed his hair and beard, and placed a blue mantle about his shoulders.

"He came because he loves you," she said proudly.

"And to go hunting in his beloved forests," noted Franco.

Francis appeared, as he had three years ago, in a short green cape, embroidered leggings, and a cap with a jaunty pheasant tail and a golden brooch of the royal crown.

"*Cher maître!*" he exclaimed. "They lied to me. You look like you're winning the joust."

Leonardo attempted a smile. It was a lie, but a pleasant one.

"They told me you were about to depart, but I refused to believe it."

"Not yet. . ." Leonardo shook his head. "I have too much to do."

Francis laughed, pretending relief.

"As long as you rage, they'll have difficulty in taking hold of you."

He tried another smile, then gave up. The king saw this and sat on the bed beside his friend. He had seen many men die, and here it could happen anytime soon—the skin a yellow pallor, the sunken temples with blue veins, and the gray eyes deep in the massive skull. That part was especially sad. Those eyes had known the flight of birds, the wheeling of the heavens, the mysteries of the human heart. Now they were clouded with a milky white film under a wild outcropping of gray eyebrows.

"*Mon père,* tell me this. When you go into the Great Sea, as you describe it, what happens then?"

"We mix with the waters, then rise from the sea into the sky, to return once again onto the peaks of the mountains."

"What happens then?"

"It's there, sire, in the background of your Monna Lisa," He lifted a pale hand toward the painting. "Do you not see the flowing waters of life's eternal return?"

"*Mon Dieu* . . . yes! I feel it happening around her. . . . Who is she really?"

They had come to the moment for Monna Lisa to become *Maria of the Ages.* Francis would be delighted to learn that the woman he loved was Maria in three critical moments of her life. A Franciscan confessor, however, would see only the pregnant Maria of the heretical Dominicans. That made it impossible.

"Who do you think she is?"

"An eternal woman," replied the king, staring at the portrait. "One who has lived a long time, maybe centuries, and seen everything . . . all of our sins and the possibility of redemption . . . like an aging *Vierge.*"

"So you know," said Leonardo. "You understand as much as I do."

"I knew it when I saw her," he said. "I'm eternally grateful for this . . . especially for your coming into my life." He sighed and placed a hand upon the Italian's shoulder. "I'll be away a few days for the baptism of my second son, Henri." He paused and whispered, "I'll return as soon as possible."

Leonardo nodded. It was easier this way. He took the ringed hand and pressed it against his bearded cheek.

"Thank you, Your Majesty . . . I will be here."

"*Mon père,*" whispered the king, drawing the frail body into his arms. "*Mon cher père,*" he murmured, kissing the wrinkled brow.

Then he said, "Will I see you again in raindrops?"

The words came suddenly, and Francis seemed startled by them . . . an unexpected prayer, which left him close to tears. It was too much to bear. He could watch men die in battle, but this man was a father he had never known. He took up his cap, squeezed a pale hand in mute farewell, and quickly left the room.

12.

During the night, Leonardo awoke with intense pain in his left shoulder. He touched it with his shriveled right hand, and the pain streaked down the arm. This was something other than an atrophying limb.

Outside the manor, a violent tempest had arrived with the *crack-boom* of thunderbolts. Rain lashed the windows and poured off the roof, as though the entire manor were sinking into the sea. Then a flash of lightning entered the room, and it happened suddenly . . . a bursting pain piercing his heart, streaking into legs and arms, flashing through his brain . . . then sudden darkness. The Thief had come—May 2, 1519—to take him into the Great Sea.

He began to drift in a boundless flowing of water. There was no inside and no outside, no above or below, no self or other, no right or wrong. Around him in the current were shades of every living creature, and he was part of each one, without a here or now, yet he was also alone in the waters, slowly rising upward toward sunlight. . . .

AFTERWORD

L EONARDO'S LAST SPECTACLE was his own funeral, detailed in his will with the care he gave to court entertainments during his life. With the king and his court and the Italian friends no longer at Amboise, sixty poor men were hired to carry lighted candles in a procession bearing his body uphill from Clous to the château for burial in the church of Saint Florentin. As a member of the royal court and intimate of the king, chaplains of the church, together with its prior, curates, and minor friars, carried his coffin. During three high Masses and thirty low Gregorian Masses, two great candles were lit and prayers were offered for his soul.

Battista de Villanis, Leonardo's faithful servant, was given the water toll of the Santo Cristoforo canal in Milan, as granted by Louis XII, together with one half of his vineyard outside of Milan. Salai, as another servant, received the other half of the property and the home, built with loans from Leonardo, where Salai had settled with his family. Maturina received a fur coat and a modest sum of money. His arrogant half brothers, cited as "brothers in blood," were given four hundred scudi on deposit at Santa Maria Novella in Florence, a vineyard in Fiesole, and the Vinci property Leonardo had inherited from his uncle Francesco.

Messer Francesco Melzi, gentleman of Milan and executor of his estate, was given all else—Leonardo's royal pension, property, clothes, books, writings, and all "the instruments and portraits appertaining to his art and calling as a painter."

The testament, complete in every detail, including the burial, lacked an inscription for his tombstone. Melzi, in a letter to the brothers in Florence, provided his own epitaph, saying that Leonardo was "like the best of fathers . . . it would be impossible for me to express the grief I have felt. . . . So long as my limbs endure, I shall posses a personal sorrow, and with good reason, for he showed to me, day by day, the warmest love and devotion. It would hurt anyone to lose such a man, for nature cannot again produce his like."

The unwanted bastard of Vinci, dying in exile from his native land, was destined for further dispersion in death. His burial church was pillaged during

the French Revolution. Eventually demolished, its stones and those of its graveyard were used to repair the château. A gardener named Goujon gathered some scattered bones for burial in a corner of the courtyard.

Haunted by the loss of Leonardo, the Parisian poet Arsène Houssaye excavated the site in 1863. He found a tombstone fragment—EO DUS VINC—which could have been LEONARDUS VINCIUS. Close to it, he found a near-complete skeleton with its arm bent and its exceptionally large skull resting on one hand. Overwhelmed, the poet was convinced he had found the mythic Leonardo.

"We have never before seen a head so magnificently designed by or for intelligence," he wrote, noting with pride and joy that even the bones of Leonardo were immortal. "After three and a half centuries, death had not yet been able to reduce the pride of this majestic head."

Buried again in the Chapel of Saint Hubert at the château, the skeleton and its immense skull are commemorated by a plaque, provided by the Comte de Paris, attesting that the interred bones are possibly those of Leonardo. So it is for the uncounted thousands who have found their way to this grave. A skeletal hand does indeed hold the great skull, which once contained the infinite wonders of the universe in flights of mind far beyond the grasp of any living mortal.